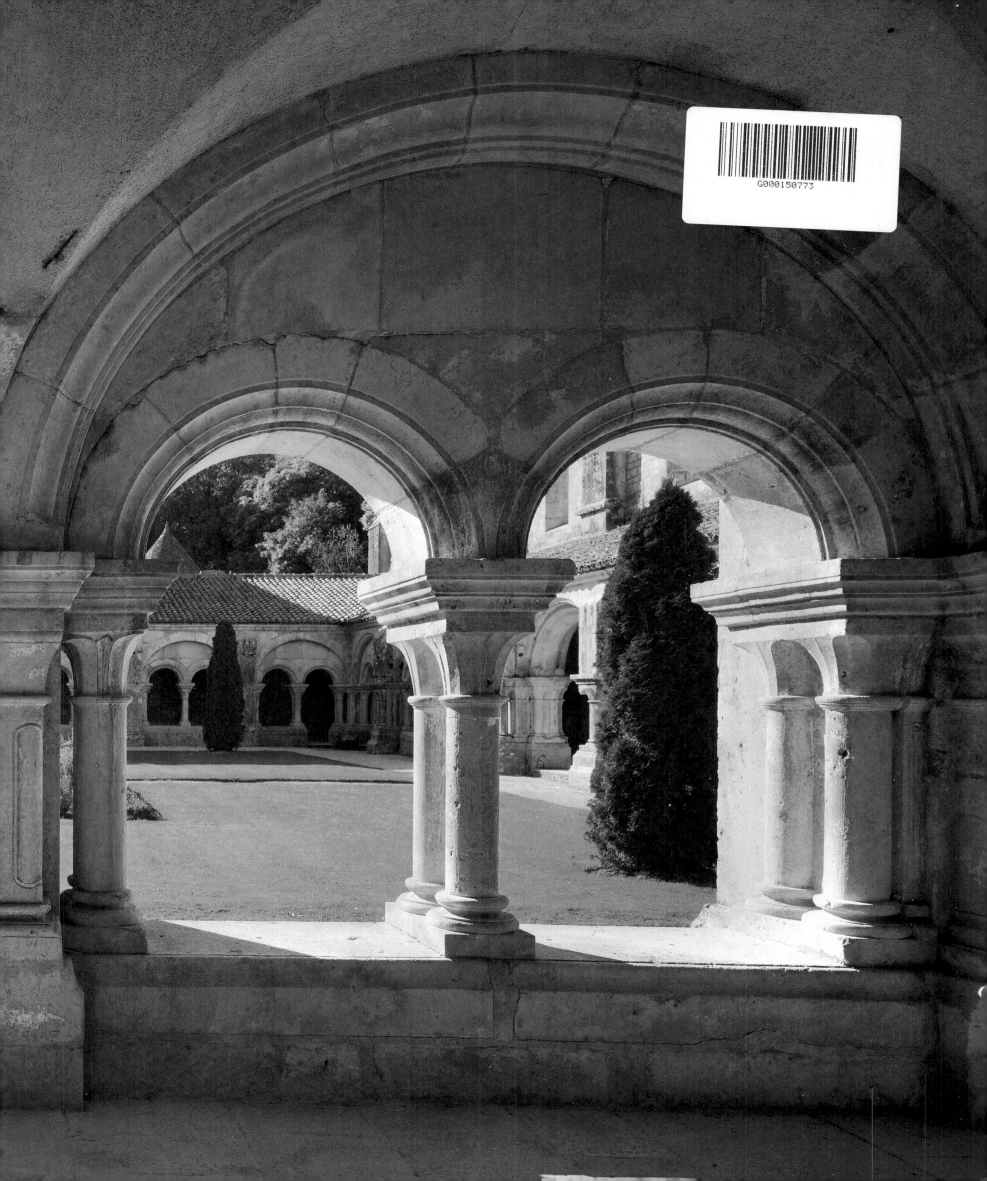

GREAT MONASTERIES OF EUROPE

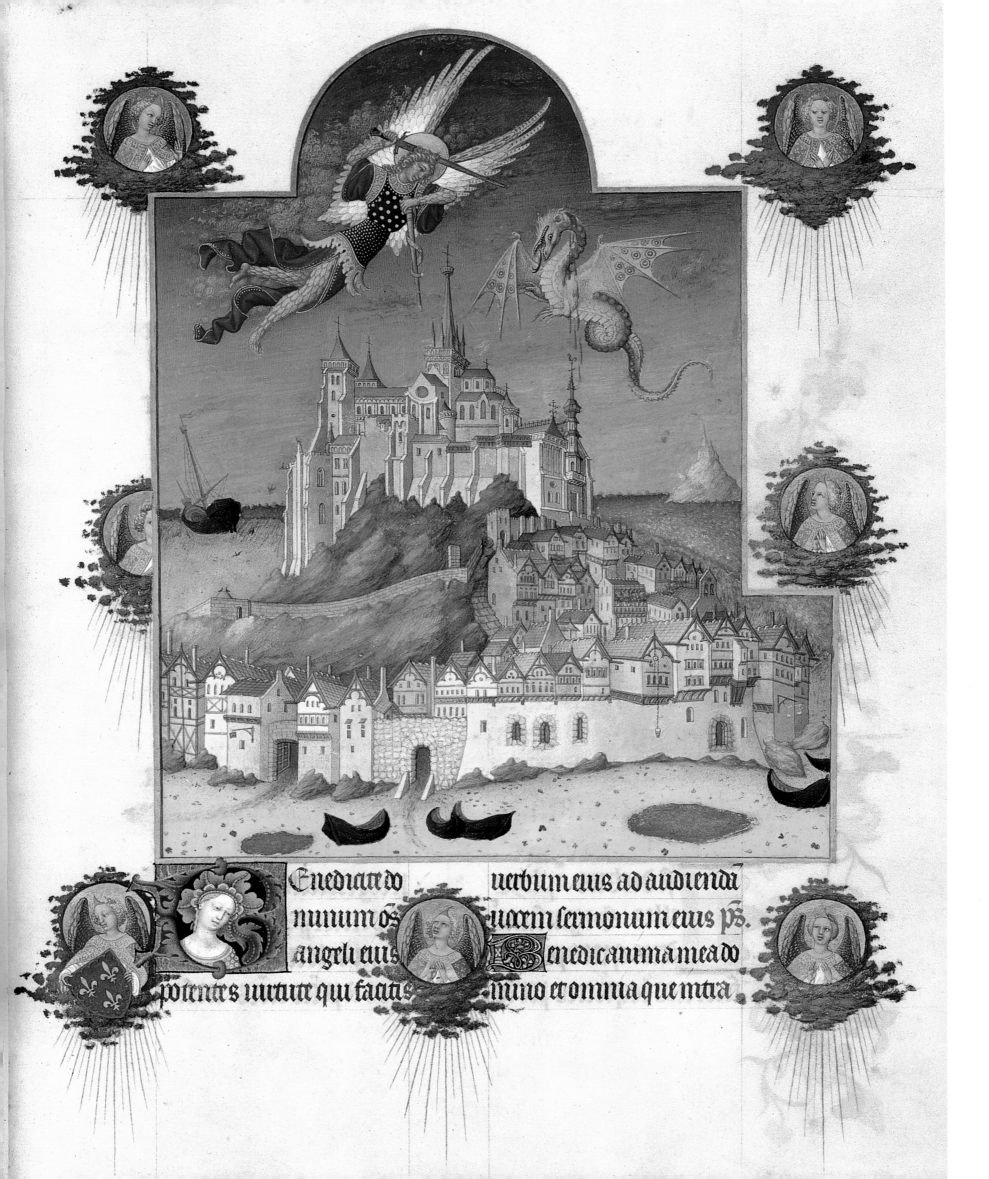

Enediate do uerbum eius ad audienda
nunium os uocem sermonum eius ps.
angeli eius Benedicanimameado
potentes uirtute qui facitis mino et omnia que intra

BERNHARD SCHÜTZ

GREAT
MONASTERIES
OF EUROPE

PHOTOGRAPHS BY

Henri Gaud, Joseph Martin, Florian Monheim,
Antonio Quattrone, and Marco Schneiders

TRANSLATED BY STEVEN LINDBERG

ABBEVILLE PRESS PUBLISHERS

New York • London

PAGE 1:
Gottfried Bernhard Götz, plan of the former Benedictine priory Hofen (today Friedrichshafen), on Lake Constance, by 1742; detail of the ceiling painting in the audience hall of the Weingarten monastery (see pp. 338–42)

PAGE 2:
Mont-Saint-Michel, miniature from Les Très Riches Heures du Duc de Berry, *fol. 195 recto. Chantilly, Musée Condé*

OPPOSITE PAGE:
Cloister of the Batalha monastery, Portugal (see pp. 66–69)

PAGE 6:
Front wall of the refectory of the former monastery Santa Apollonia, Florence, with frescoes by Andrea del Castagno, c. 1447. Lower zone: Last Supper; upper zone: Resurrection, Crucifixion, Entombment

PAGE 8:
Choir stalls of the monastery church, Ottobeuren (see pp. 343–47)

PAGE 9:
Library of the former Benedictine monastery Wiblingen, near Ulm, c. 1730–50

For the Original Edition
EDITOR: Margret Haase
DESIGN AND PRODUCTION: Joachim Wiesinger

For the English-language Edition
EDITOR: Susan Costello
COPYEDITOR: Mary Christian
PRODUCTION MANAGER: Louise Kurtz
TYPOGRAPHIC DESIGN: Patricia Fabricant
JACKET DESIGN: Misha Beletsky

First edition
9 8 7 6 5 4 3 2 1

Library of Congress Cataloging-in-Publication Data

Schütz, Bernhard.
 [Klöster in Europa. English]
 Great monasteries of Europe : architecture, art, and history / Bernhard Schütz ;
 photographs by Henri Gaud . . . [et al.].
 p. cm.
 Translation of: Klöster in Europa.
 Includes bibliographical references and index.
 ISBN 0-7892-0829-6 (alk. paper)
 Monasteries—Europe. I. Gaud, Henri. II. Title.

NA4850.S3813 2004
726'.7'0094—dc22 2004052818

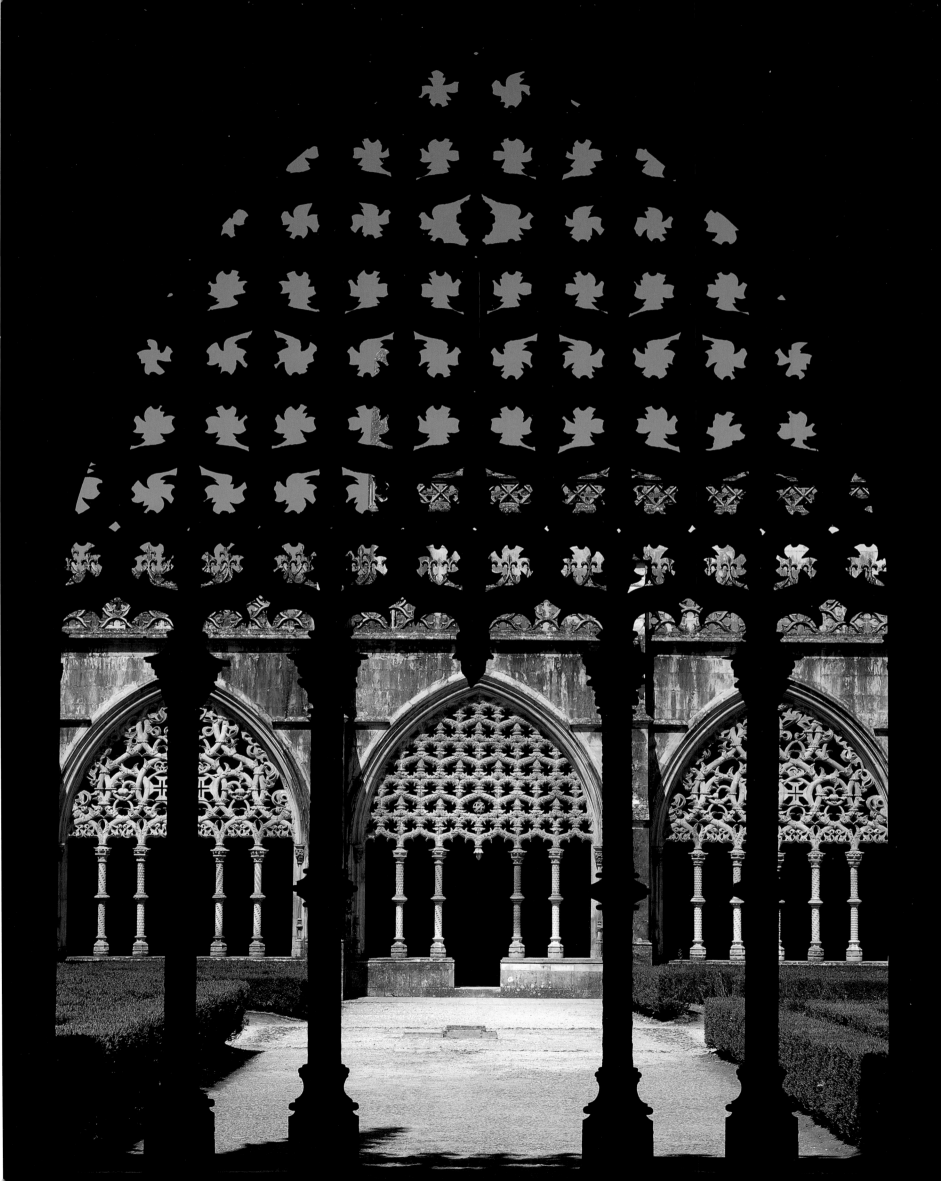

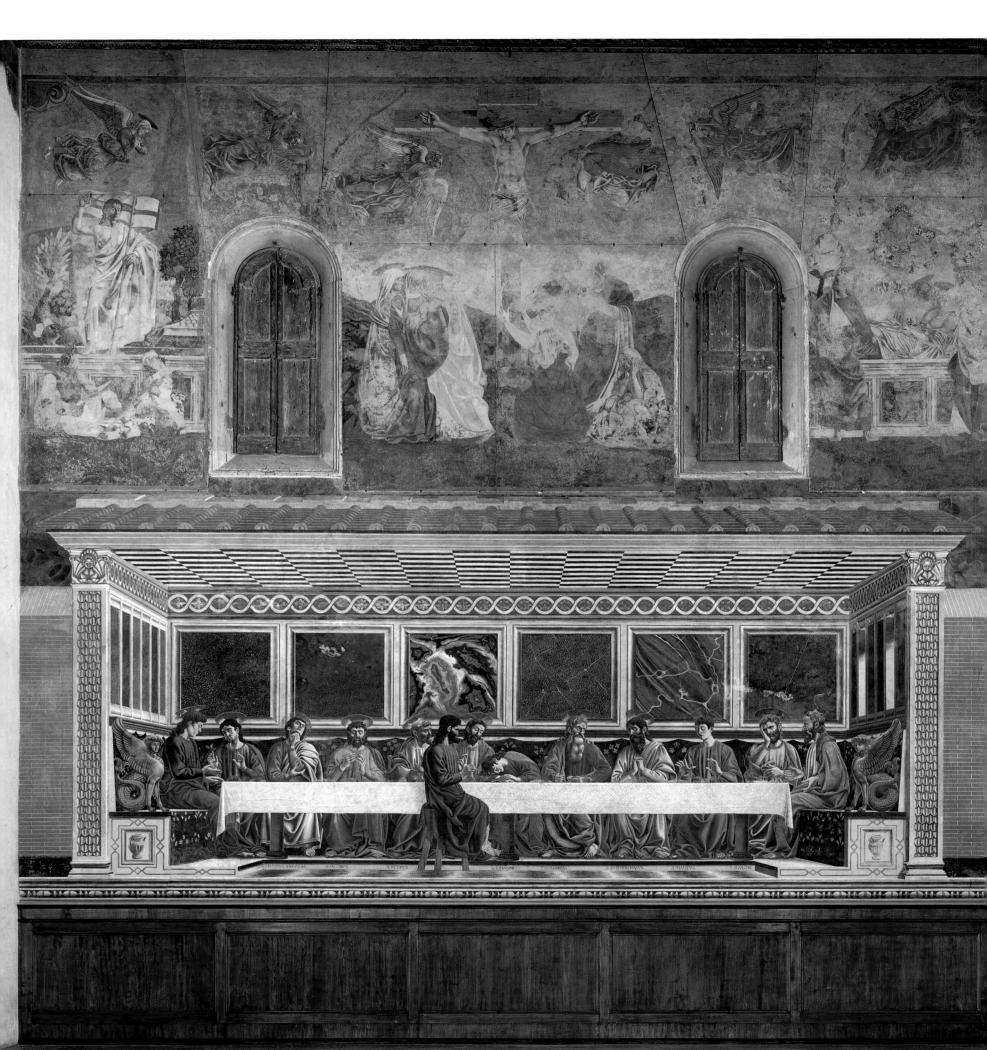

CONTENTS

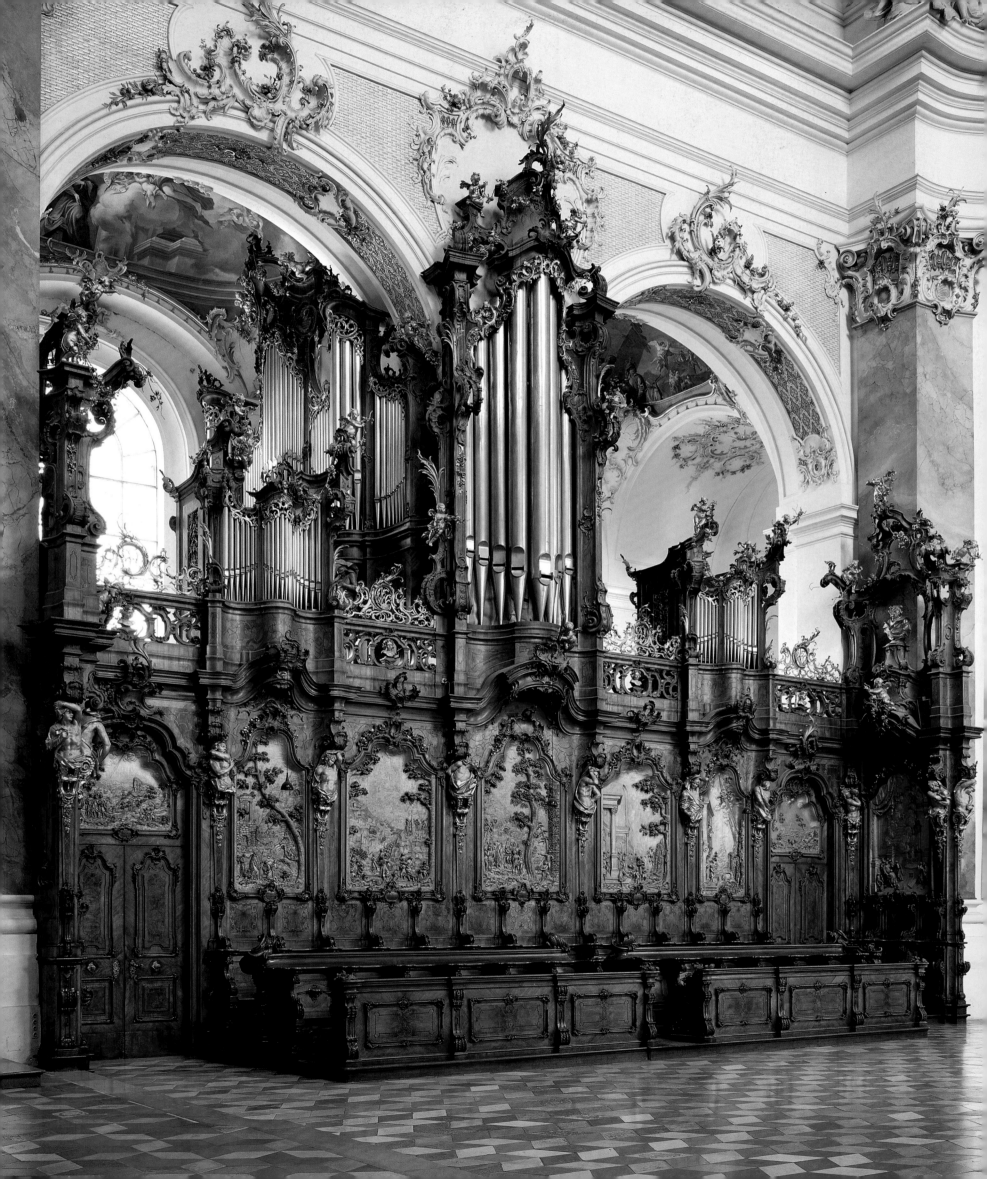

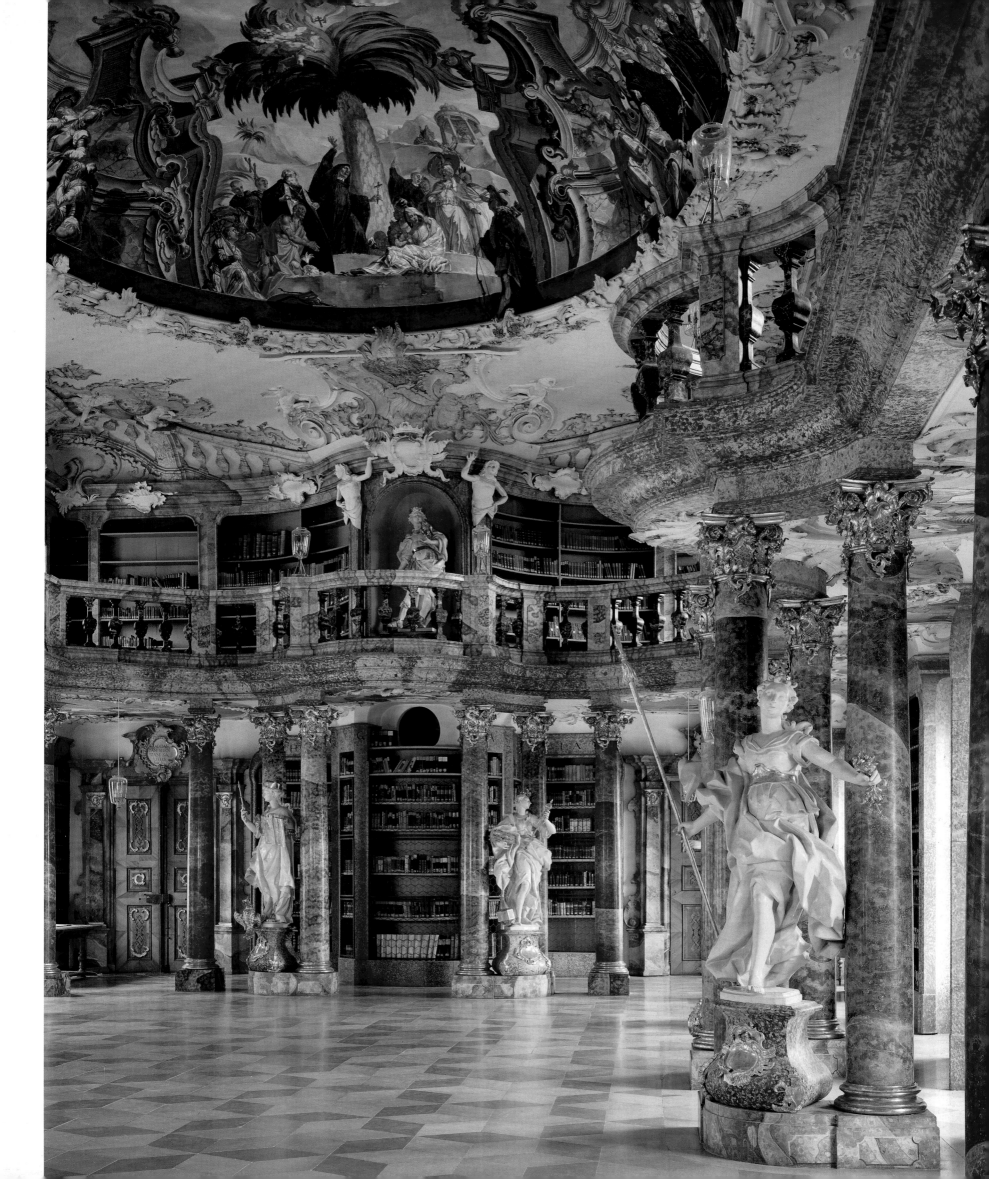

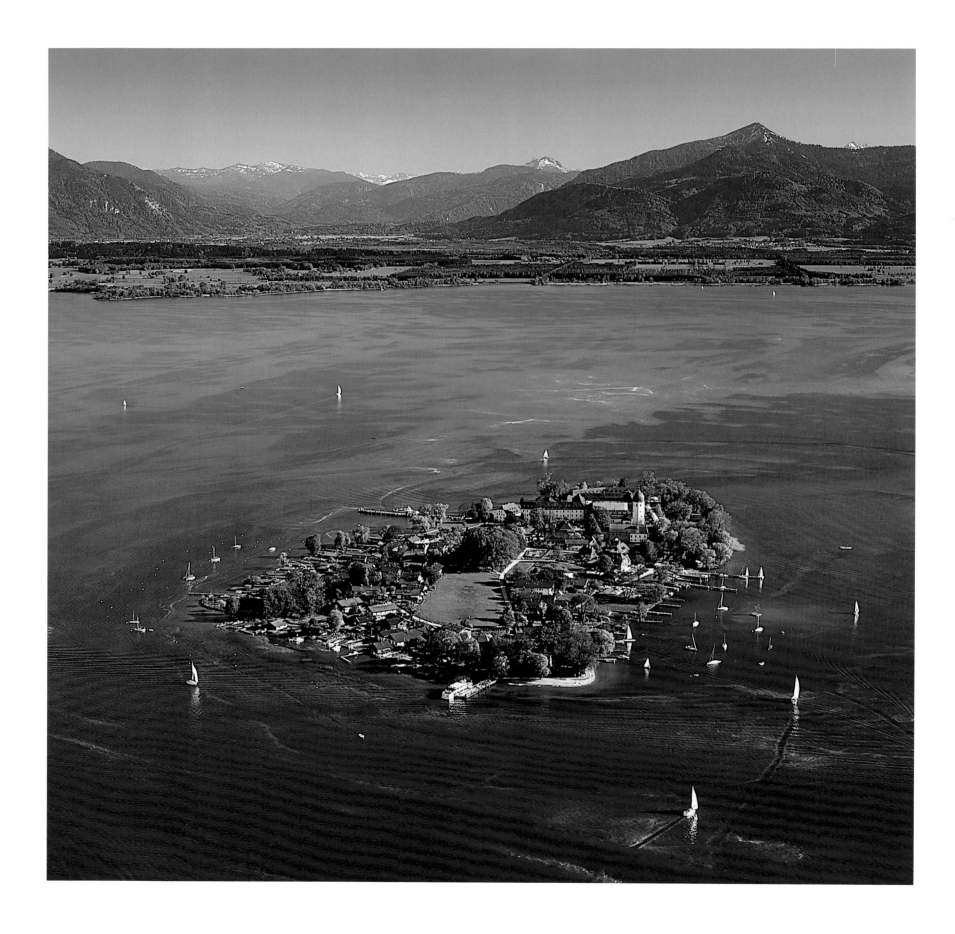

PREFACE

ONASTERIES ARE PLACES FOR MONASTIC LIFE, havens for the renunciation of the world, for prayer and the eternal praise of God, for silence, asceticism, and obedience. A monastery is the architectural expression of a life ordered by strict rules. Because of the extensive real estate of the complex, a monastery could also be a self-sufficient, profitable economic enterprise that produced goods for its own use and for sale. This provided some monastic communities with enormous wealth over the years.

Monasteries were essential to Europe's history. In the Middle Ages, and even into the modern era in certain regions, they were among the most important pioneering cultural institutions of the era following antiquity and the migration of nations, when the Occident began to form. Monasteries and their monks ensured that Christianity was introduced and established solid roots, forming the foundation for the entire culture. Education, science, and art were all the responsibility of the Church and were disseminated in the cathedral schools and, perhaps even more so, in the monasteries. Monasteries increasingly became institutions that supported the state: the body politic and the monarchy relied on them and even used them for administrative tasks and other royal services.

Over the centuries monasteries yielded tremendous architectural achievements. It is scarcely possible today to sense how important these were, since what survives is only fragmentary, yet those structures and remains are still greatly admired. The monks almost always sought out charming landscapes for their settlements, and it is no coincidence that a brisk tourist trade has developed around monasteries throughout Europe, regardless of which period or order produced them.

In art, too, their achievement was immeasurable, especially during the Middle Ages. As sites for education, science, and historiography, monasteries usually had several scriptoria for producing books and copying ancient and modern texts, thus employing bookbinders, calligraphers, and miniaturists. Many complexes—for example, Tours, Reichenau, and Fulda—were famous

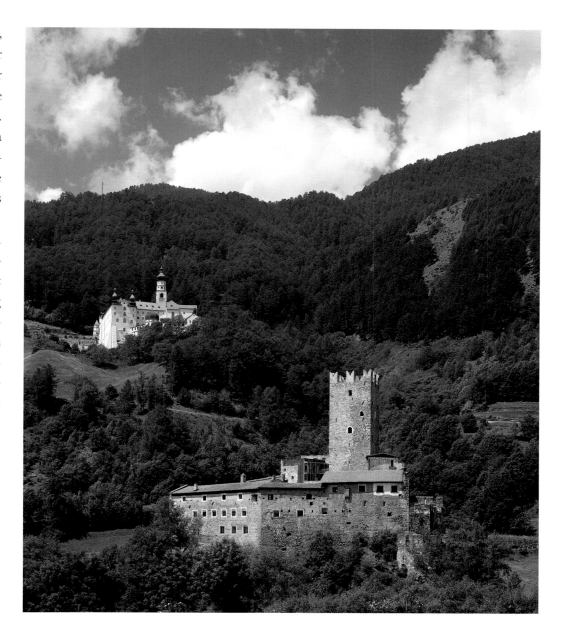

schools for book illumination. Calligraphers and painters were held in such great esteem that they were entitled to include their names, or even their portraits, in the codices they prepared. Some monasteries maintained workshops for sculpture, painting, and highly specialized branches of metalwork, ranging from gold work to large-format chased or cast objects, as was the case in Helmarshausen an der Diemel, for example. Nunneries cultivated the textile arts.

This book is not intended as an assessment of the spiritual life of monasticism—that would be its own

OPPOSITE PAGE:
The monastery island Frauenchiemsee, with the oldest Benedictine abbey in Bavaria, founded 782

ABOVE:
View of Malbork (Marienberg) monastery, near Burgeis (Alto Adige), with the royal fortress of the bishops of Chur in the foreground

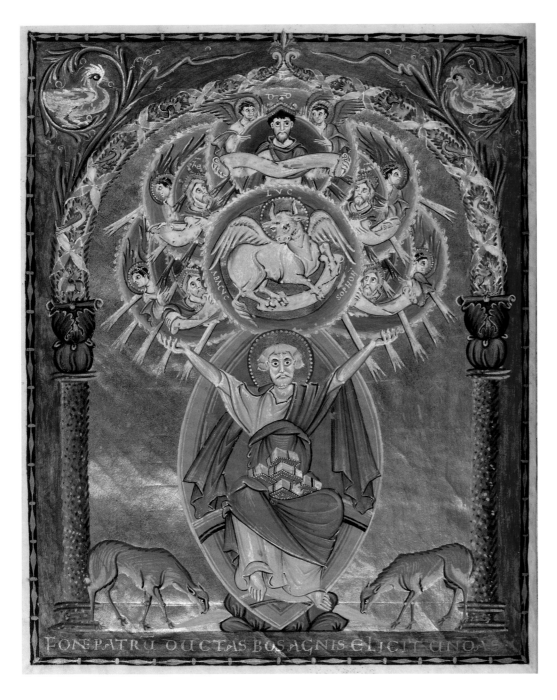

School of Reichenau, The Evangelist Luke *from Otto III's Gospel. Munich, Staatsbibliothek, Cod. Lat. 4455*

theological theme—but primarily its architecture and, in a few selected examples, its art. The text summarizes the history of various orders and presents illustrations, descriptions, and historical background of the important monasteries in order to present the beauty and variety of the buildings. This picture, however, is necessarily fragmentary, since of course not all monasteries could be included, and in many cases little more than the church survives of the original grounds. Those examples have also been represented here, however, since the church was always the monastery's most important building. This overview is limited to those countries in Europe where the sphere of activity of the Roman church was significant and is generally organized by region or country, and then, geographically. The organization differs somewhat in the chapter about Central Europe as this area was once dominated by the Holy Roman Empire, and it seemed more relevant to reflect cultural history rather than current political designations. The Counter-Reformation orders—the Jesuits, for example—have been left out because they were not monastic orders, thus their settlements were not monasteries in the strict sense.

The state of monastic architecture today varies widely among individual European countries. In England, due to the ecclesiastical policies of Henry VIII, nearly everything lies in ruins or was destroyed entirely. France, the center of monastic culture during the high Middle Ages, still has the greatest density of important monastery buildings from the Romanesque to the Gothic, despite the damage done during the French Revolution. Monastic culture in Spain and Portugal, developed only after the Reconquista (the reconquest from the Moors) and in the late period, increasingly tended toward richness and splendor. In Italy the picture is very uneven, but in general, the emphasis was on decoration, such as fresco cycles. In the countries of the Holy Roman Empire—Germany, the Netherlands and Belgium, Switzerland, Austria, and the Czech Republic—monastic culture ended abruptly with the Reformation. In the Catholic regions of southern Germany and in the Habsburg lands as far east as Poland, however, monasteries experienced a unique late flowering that did not take place elsewhere in Europe. Except for several examples, the modern era is not covered in the sections on the other European countries.

MUNICH
BERNHARD SCHÜTZ

WESTERN MONASTICISM

THE EARLY PERIOD

ANCHORITES AND CENOBITES

When were the first monasteries established? How did they come about? From its very beginnings monasticism was an escape from the world. Monks abandoned the human community in order to seek seclusion outside civilization and live in a manner pleasing to the sight of God, in abstinence, celibacy, penitence, and prayer. This urge, while common to many religions, was especially pronounced in early Christianity. Beginning in the third century increasing numbers of world-renouncing Christians, called anchorites, withdrew to the inhospitable deserts and wildernesses outside the populated areas of the southeast Mediterranean, first in Egypt, then in Asia Minor and Syria.

Initially the anchorites lived as hermits. The source of the Latin word for monk, *monachus*, can ultimately be traced back to the Greek *mónos*, or "alone." These hermits practiced the most severe asceticism. Many lived in holes in the ground or stayed in graves. Some, the stylites, sat for years on top of pillars, which won them a certain status. Others squatted in cages or in trees; still others stood on one leg in the scorching sun, lay on anthills, ate grass like cattle, or were thick with dirt because they never washed. All of them followed strict fasts and castigated themselves, since their objective was to mortify the needs of the human body—desire, pleasure, and, above all, sexuality. Since they believed life was supposed to be an endless tribulation, anchorites outdid one another with increasingly harsh self-tortures, as if to set competitive records.

The grand masters of anchoritism found admiring imitators. The most famous of them, Anthony Abbot (d. 356), is said to have lived to the age of 105; the legendary Paul of Thebes, whom Anthony visited shortly before his death, lived to be 115. This visit later became a popular subject in painting—found, for example, in Matthias Grünewald's Isenheim Altarpiece. The doctors of the church considered the lives of these two hermits to be exemplary, and Athanasius, bishop of Alexandria, wrote a biography of Anthony, and later Jerome wrote one of Paul.

The idea of escaping the world became so appealing that in the late fourth century the number of anchorites in Egypt alone is said to have reached twenty-four thousand, many of whom lived in the remote Thebais in southern Egypt. Soon the anchorites formed colonies, which required them to establish an ordered community life. Anthony had already begun this process, which is why he has been given the epithet *abbas* (Late Greek for "father") or *abbas ermitarium* (father of the hermits). Thus the hermits became "cenobites" (from the Greek *koinós*, or "common"). This was the origin of the Christian monastery.

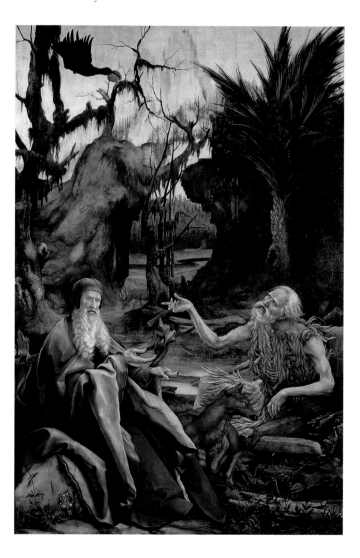

Matthias Grünewald, Saint Anthony Abbot Visiting the Anchorite Paul. *Wing of the Isenheim Altarpiece, c. 1512—16. Colmar, Musée d'Unterlinden*

Pachomius and Basil

The initiator of organized cenobitism was Pachomius, a former Roman soldier who founded a shared settlement of men dedicated to God in the Egyptian village Tabennese around 320–25. He provided the community with a set of highly regimented statutes that are considered the earliest Christian monastic rule. This turned the settlement into a *coenobium*—that is, into the fixed institution we call a monastery. At the time of his death in 346 or 347 Pachomius was in charge of nine monasteries and his sister oversaw two nunneries. The new cenobitic monasticism, which was still characterized by a withdrawal from the world, spread rapidly as far as Syria and throughout the East. This resulted in a decline in tax revenues, because no taxes could be extracted from such unpropertied monasteries.

These monasteries in the southeastern Mediterranean coexisted in a loose arrangement and, unlike later Western monasteries, they did not form a comprehensive community of orders. Nevertheless, the monks recognized certain guidelines that were created by Basil the Great, bishop of Caesarea in Cappadocia (c. 329–379). His writings, in the form of questions and answers, contain spiritual and practical instructions for living according to the ideal of the Gospels in a fraternal or sororal community. While they do not constitute a rule for an order, they became the basis for monasticism in the eastern Roman region up through the later Eastern Orthodox Church.

Early Western Roman Monasteries

During the second half of the fourth century the western Roman region produced the earliest large monasteries. The first evidence for a monastery is in 370 in Aquileia. Others soon followed in Rome. The oldest monastery in Gaul was founded by Martin de Tours (c. 316/7–397) in 361 in Ligugé, near Poitiers. After being named bishop of Tours in 371 Martin founded a second monastery in 375, Marmoutier (*maius monasterium,* the "larger monastery") outside the gates of Tours. After his death in 397, monks settled around his cell in Tours, which quickly became a flourishing pilgrimage site and eventually a large monastery. During the Carolingian period this cultic site around Saint Martin became one of France's major shrines. The monastic state of Lérins, on a group of islands on the Côte d'Azur off present-day Cannes, became the center of spiritual life in southern Gaul after Honoratus of Arles established a monastic community there around 410 (see pp. 136–37) that at one point included some 3,500 monks.

Augustine and Cassian

The evolution of western monasticism tended toward the Roman-Latin understanding of the order. It received a decisive impulse when Augustine of Hippo (354–430), bishop of Hippo in northern Africa and a doctor of the church, wrote a rule for the monastic community he established there around 390–95. There was another rule intended for women. These rules that regulated the life of the early Christian community became the model for communal life, the *vita communis.* The community was one heart and one soul, *anima una,* in brotherly or sisterly love, and the individual had to yield to the common goal, based on poverty, celibacy, obedience, and joint prayer and praise of God, as well as on work, which was part of a good life. Monks were supposed to be active outside the monastery, in the city and the diocese. In all practical questions the rule was left so general that it could later be adapted by very different orders.

Augustine's rule is just one of about thirty produced by various western European monasteries; in spite of some considerable differences, they shared much in common. At the turn of the fifth century a well-traveled authority on monasticism, John Cassian, who had been to Egypt and Syria before becoming the head of a monastery in Marseilles, wrote a two-volume compendium of eastern and western monasticism, *De institutis coenobriorum* and *Collationes patrum,* which would later be found in every good monastic library; in many monasteries they would be read aloud by chapter before the compline. Around 800 the reformer Benedict of Aniane produced a catalog of the thirty-one rules known to him, the *Codex regularum.*

Benedict of Nursia and the Benedictine Rule

In the sixth century Benedict of Nursia, hailed as the father of western monasticism, became far more important. Pope Gregory the Great wrote his posthumous vita as early as 593–94, which is embellished with legends and unreliable facts. Benedict began the monastic life as a hermit in a cave near Subiaco, around twenty-five miles east of Rome, where he became the spiritual father of a group of twelve new monasteries in the surrounding area, each of which had twelve monks. In 529 he withdrew to Montecassino with several of his loyal followers. There he founded a monastery in the mountains that has become famous, where he evidently remained until his death around 555–60. Benedict's life was later a frequent subject in art (see pp. 445, 460).

In Montecassino he worked out a new rule around 540–50—that is, about 150 years after Augustine—although many passages are borrowed almost literally from an older, anonymous rule, the *Regula magistri*. Benedict's rule was conceived for the community of laypersons seeking God, but several ordained priests had to be included to say mass and to administer the sacrament. The community was to remain of manageable size. In contrast to the enormous monasteries of the East, which sometimes had as many as three thousand residents, the monks at Montecassino at the time of Benedict's death numbered perhaps 150. According to his rule, the goal of a perfect life derived from the model of Christ and the apostolic Pentecostal community was life in seclusion from the world. In later monastic architecture this desire for seclusion led to strictly isolated enclosures. The hermitage that Benedict experienced himself in his early years certainly gained recognition in his rule, but it was nonetheless intended for a decidedly cenobitic monkhood. Everything was to be done collectively: prayer, praise of God, reading, eating, sleeping, and working. As in the other monastic rules, personal poverty, celibacy, chastity, and obedience were core requirements.

Very much in the style of the old Roman *pater familias*, the abbot was given absolute authority—an extremely important regulation that Benedict took from the *Regula magistri*. The abbot was required to consult with the monks regarding important questions, but in the end the decision was his alone. He was to be a responsible father to the monks, and was always aware that at the Last Judgment he would be held accountable for his leadership. For the management of the monastery Benedict provided the abbot with a prior to represent him, as well as a cellarer, who was responsible for provisions and was supposed "to look after all the equipment and goods of the monastery, such as altar vessels." The education of the new arrivals to the monastery was the responsibility of the novice master.

Residents of the monastery were subject to the dictate of *stabilitas loci* (stability of place), that is, an obligation to remain in place after submitting to the oath. The *stabilitas loci* was one of Benedict's general demands on every monk.

The frugal, unchanging daily life was not intended to be lived in complete silence, but at least in taciturnity (*taciturnitas*). At the center was the *opus Dei* (work of God), and common prayer at the nocturnal and diurnal hours of prime, terce, sext, none, vespers, and compline. There were also other offices and the mass. Prayers consisted of the Psalms—if possible all 150—were recited at least once a week. The length of the prayers was adapted to the length of the days: in the summer they were longer; in winter, shorter. Mistakes in their recital were met with severe punishments. The location for the common offices was a simple prayer room—an *oratorio*, not an elaborate church.

In addition to the *opus Dei* Benedict required that monks participate in physical or artisanal work in the service of the community. In keeping with its seclusion from the world, the monastery had to be economically autonomous: "If possible, the monastery should be set up such that everything necessary—water, mill, garden, and the workshops in which the various crafts are practiced—may be found within the monastery walls." For Benedict, work did not have a higher ethical value, but an educational one. It was a particular form of penitence that could prevent idleness, "the enemy of the soul." Depending on the season, work was set at six to eight hours a day; the prayers, about three and a half hours; and the same for meditation and reading.

Monks were not to carry out pastoral activities among the people, especially since most remained laypersons, nor did Benedict want monks to perform social or charitable work. The only social calling was that the abbot was obliged to offer hospitality to every guest as willingly as if he were Christ. The abbot's kitchen, which was to be separate from that of the convent, was also used to feed guests, and there were always guests in the monastery.

On the whole, Benedict's rule was distinguished from others by its simplicity, practical sense, and wise moderation, despite all its strictness. In the prologue Benedict, who knew human weaknesses and accounted for them, described his goal: "We must build a school of service to the Lord, in which we hope to create nothing harsh, nothing weighty [*nihil asperum, nihil grave*]." To achieve this, he brought the spiritual exercises in balance with physical work in such a new and influential way that from the late Middle Ages on the message of his rule could be summarized in a single succinct expression that, while not literally found in his rule, has nonetheless become proverbial for monastic life: *ora et labora* (pray and work).

In his lifetime Benedict had obtained such a reputation that he was even sought out by Totila, king of the Ostrogoths, in 543. Already by 577, however, the foundation of his monasteries around Montecassino threatened to collapse: the monks fled from the approaching Lombards, who destroyed Montecassino and went to

Rome, where they found a home in the Lateran. They took the original rule with them as their most valuable possession. In 717 a new monastery was built at Montecassino, and the original rule returned, but the monastery was evacuated in 883, when the Saracens threatened, and it burned three years later. Fortunately, a century earlier Charlemagne had ordered a copy of Benedict's rule to be made. It was preserved in the court library in Aachen, where it served as the source for other copies, such as the one for the reform monastery Inden, near Aachen, and from there for Reichenau and Sankt Gallen. In the end, then, we have that great emperor to thank for the Benedictine rule, the root of western monasticism, which survived in its exact wording. It would take two centuries after Benedict's death for his rule to gain ultimate acceptance.

CASSIODORUS

The counterpoint to Benedict's position, even during his lifetime, was represented by Cassiodorus (c. 490–c. 585), a highly educated man from Calabria, who was versed in the literature of antiquity and had served as a high official in the Ostrogothic realm. For a time he was a privy secretary and minister to Theodoric the Great. After leaving state service he founded the monastery Vivarium around 554 or earlier in his Calabrian homeland. Unlike Montecassino it would be a center of scholarship, with a famous library containing the last comprehensive collection of ancient authors, including pagan ones. Cassiodorus was himself the author of a twelve-volume history of the Goths and an encyclopedic theological work, the *Institutiones,* which served as an introduction to the study of the Bible, the church fathers, and the seven liberal arts. He made it obligatory for his monks to copy and study ancient texts. As a result, Vivarium—a unique stronghold of intellectual life, the cultivation of books, and diligent humanistic studies—became the most important precursor of the kind of monastic scholarship that would become widespread later in the scriptoria and schools of the Carolingian abbeys. It is not known what rule was followed in Vivarium, or even whether there was one, because apparently books were more important here than any rule. However, Vivarium seems to have had no immediate influence.

IRISH, SCOTTISH, AND ENGLISH MONASTICISM

First Ireland, then England and Scotland were far more important than Italy for the history of monasticism in the two centuries after Benedict's death. Remote Ireland became a place of refuge for Christians during the barbarian invasions associated with the migrations of nations. The Irish church, which had been founded around the middle of the fifth century by Patrick, the apostle of Ireland, with its see in Armagh, rapidly developed into a monastic church with pronounced ascetic features. The flow of commoners into the monasteries was inexorable. Soon there were settlements with several thousand members, including Clonard and Clonfert.

Irish monasticism differed from Benedictine monasticism in several features: the monasteries, which were sometimes double monasteries for men and women, were also concerned with the spiritual welfare of the laity. Above all, the inhabitants of the monastery submitted to unmercifully harsh ascetic practices: they flagellated one another, sang psalms through the night at the coast while standing in cold sea water, yoked themselves to the plow to labor as draft animals, slept little, and fasted. Services were also more strict. The physical tortures, which grew more intense with time, were intended first and foremost to mortify sexual desires and fantasies that became more oppressive and tormenting as the chastity requirement was more strictly observed. This was a universal problem in all forms of monasticism, one that is clear from countless autobiographical writings. In addition to asceticism, there was merciless punishment for even the smallest sin or offense, even an unintentional one. Penance followed according to precisely stipulated tables. One act of penance—the opposite of the Benedictine dictate of *stabilitas loci*—was a duty to wander eternally, so many monks drifted across the country.

The most important Irish monastery was Bangor in Ulster, which after its establishment around 559 quickly became an intellectual center of the country, in theology as well as in the natural sciences. Bangor and other monasteries functioned as educational centers for future clerics.

Missionary work in England began about a century and a half later than in Ireland. Pope Gregory the Great sent a group of about forty monks to England in 596. The leader of the group, Augustine of Canterbury (not to be confused with the doctor of the church), came to be known as the apostle of England. He was charged by the pope to found two metropolitan sees, or seats, with

twelve suffragan sees each. Thus Augustine established the founding order for the church's future in England. The pope bestowed the pallium of an archbishop on him in 601, but he did not make London his see, in keeping with his brief, but rather Canterbury. The second metropolitan see was York, where there had been a bishop even before the Anglo-Saxon conquest. One peculiarity of Canterbury, which was adopted by many other English dioceses, was that the canonical hours in the cathedral were carried out not by the canons but by monks. This led to the typically English establishment of a cathedral monastery whose abbot was the bishop.

Soon Irish monasticism spread rapidly to Scotland as well, primarily through the work of Columcille (521–597), also known as Columba. He founded monasteries in southwestern Scotland in 563, on the island of Hy, one of the Inner Hebrides (later known as Iona), and in Ireland near Durrow, around 575. Durrow became especially famous for the seventh-century *Book of Durrow,* the oldest Irish illuminated manuscript. Columcille established an organized association of Irish and Scottish monasteries.

The ascetic severity of the Irish monks was soon tempered in England by those such as Aidan, a gentle monk from Iona, who with King Oswald founded Lindisfarne on Holy Island, off the northeastern coast of England. Lindisfarne became the monastery for missionary work in Northumberland and is famous for an illuminated manuscript.

In England the Irish-Scottish variety of monasticism was soon replaced by another, however. Abbot Wilfred of Ripon, a former monk from Lindisfarne who was archbishop of York for a time, founded the monastery at Ripon under the Irish rule in 660 but soon introduced the Benedictine rule. At the Synod of Whitby in 664 he introduced at least the Roman liturgy, if not the rule. Other monasteries that Wilfred founded, including Hexham, were subject to the Benedictine rule. The second initiator was Benedict Biscop, whose very name reveals his program. He founded two Benedictine monasteries in Northumberland, Wearmouth in 674 and Jarrow in 681–82, which he made the greatest center of knowledge and the arts then in Ireland and England. It was here that the Venerable Bede (672/3–735) was active; as the formative historian of the early Anglo-Irish period and a paragon of scholarship, he was the guiding star for the learned Benedictine monastery.

COLUMBAN AND MONASTERIES ON THE EUROPEAN CONTINENT

Irish-Scottish monasticism also spread to France and Germany. The leader of this movement was the Irishman Columban (c. 543–615), a protégé of the monastery of Bangor, where he taught for decades. Together with twelve companions he traveled as an itinerant monk to northern France, where with support from the king and the nobility he founded three monasteries on the southern edge of the Vosges around 591–92. The most important of these, Luxeuil, became the center of a Franco-Irish monastic movement that gradually replaced the old Gallic monasticism of Tours and Lérins. Around 595 Columban composed a new and extraordinarily strict rule for ascetic monastic life that was supplemented by an extensive catalog of punishments for lapses among the monks. Even the slightest stirring of the senses was to be met with corporeal punishment, such as flagellation.

Luxeuil produced many offshoots. The Franco-Irish movement thus spread rapidly and became a power within the Merovingian state, because many members of the nobility joined. In 609 or 610, however, Columban left the country on the orders of King Theuderic II. He returned to Ireland and then moved to the Lake Constance region by way of Metz and Zurich to do missionary work; Gall, one of his pupils, would found Sankt Gallen there. Columban's destination was Lombard Italy, where with the support of King Agilulf and Queen Theodolinda, he founded the monastery of Bobbio, near Piacenza, in 612. He died there in 615.

In French monasteries, beginning around 628 the Columban rule began to intermingle with the less strict Benedictine rule. This began the age of mixed rules that would last into the reign of Charlemagne. The Benedictine rule became increasingly significant, however, because monks from the monastery of Fleury, founded in 651 in the heart of the Loire, discovered Benedict's bones in the ruins of Montecassino in 672 and returned them to Fleury. As a result, the monastery later received the name by which it is known today: Saint-Benoît-sur-Loire (see pp. 178–79).

THE MISSIONARIES OF GERMANIA AND BONIFACE

The Christianization of Germany, which began in the late seventh century but was only successful after the early eighth, was the work of Irish-Scottish and English monks. The Roman Curia deliberately exploited the itinerant life of the monks—the *peregrinatio pro Christo*—

Fulda, Saint Michael. Former cemetery church of the monastery, based on the Holy Sepulchre rotunda in Jerusalem, built 820–22, reconstructed c. 1000–30. The monastery church, about 325 feet (100 m) long and about 250 feet (77 m) across at the transept, was the largest Carolingian church. It was replaced by a Baroque building in the eighteenth century

thereafter, around 689. The later bishop of Würzburg, Burchard, was an Anglo-Saxon, as was Willibald, bishop of Eichstätt, and his brother Winnebald, founder of the monastery of Heidenheim in Franconia. Virgil, the bishop of Salzburg, was an Irishman from the Irish-Scottish monastery of Iona.

The most important of these missionaries, the apostle of the Germans, was Boniface. Born Winfrid in southern England, in 719 the pope gave him the name Boniface. The primary area of his missionary work was along the border between Hesse and Thuringia, where in a provocative action in 723, he felled the pagan Donar oak near Giesmar. In 732 he was named archbishop of Mainz, and as the papal legate he was involved in organizing the young dioceses of Bavaria. In 744, at the end of his mission, he founded the monastery of Fulda. In 754 he and his companions were murdered by robbers near Dokkum in Frisia. His body was ultimately brought to his monastery in Fulda, where his bones are still honored today. Thanks to Boniface's grave, in 969 the abbots of Fulda received the privilege to claim primacy over all the abbeys of Germania and Gaul. Boniface's successor on the cathedra of Mainz was his fellow Englishman Lullus, who founded the monastery of Hersfeld, not far from Fulda. Both monasteries rapidly developed into leading monastic centers of the northern Carolingian empire.

The itinerant missionary monks in Germania frequently had books sent from their Irish-Scottish and English homelands, for without books there would have been no reading or writing, no studies of scripture, no mission. Several of the monks visited not only the Holy Land and Rome on their pilgrimages but also, out of interest in the Benedictine rule, the reconstructed Montecassino. Sturmi, a Bavarian pupil of Boniface and the first abbot of Fulda, also traveled to Montecassino after founding his monastery and spent a year there studying the daily customs, the *consuetudines*.

to spread the mission as broadly as possible, and several of these monks were made bishops or archbishops, even though those institutions had not yet become securely established everywhere. Willibrod (c. 658–739), a pupil of Wilfred from the monastery of Ripon, is known as the Apostle of the Frisians. He became the archbishop of Utrecht and was a cofounder of the abbey of Ecternach, in what is now Luxembourg, where he is buried. The Irishman Kilian (c. 640–c. 689), the apostle of Franconia and the patron saint of vintners, received the new diocese of Würzburg, where he was murdered shortly

THE MONASTIC SYSTEM IN THE CAROLINGIAN PERIOD

EARLY LARGE MONASTERIES IN FRANCE

At the Frankish synods of 743 and 744 the Benedictine rule was declared binding for the monasteries of France. The Carolingian rulers soon recognized that the monastic system functioned most effectively when its organization was unified under a common rule. In practice the Benedictine rule had proven particularly successful. Charlemagne had even greater hopes for Benedictine monasticism. He had an interest in having a high level of education in the monasteries, so he decreed in the *Admonitio generalis* of 789 that schools be introduced into the monasteries and in the *Epistola de litteris colendis* that monks be required to cultivate scholarship and education.

As much as possible the Carolingians supported several large monasteries that were closely connected to the royal house: Saint-Denis, Tours, Corbie, Jumièges, and Centula. In Saint-Denis, where most of the Merovingian kings were buried, Pépin III and his sons, Carloman and Charlemagne had received the royal consecration from Pope Stephen II, which meant that the Merovingian royal house was replaced by the Carolingian dynasty with the blessing of the church. Pépin chose Saint-Denis as his burial place, and Charlemagne wanted to be buried there as well, in the west end of the church, beside his father. Charlemagne's nephew, Charles the Bald, was later transferred to the chancel of the church (see also pp. 198–201).

The monastery of Saint-Martin in Tours had meanwhile become a wealthy, highly respected monastic state, with some twenty thousand residents, not all of whom were monks. In 796 the Anglo-Saxon Alcuin became abbot of Tours. The premier scholar of his day, Charles the Bald had directed the famous cathedral school of York, the leading school in the Occident. He was then appointed to the court school in Aachen by Charlemagne in 781. In Tours he became the driving force behind the renewal of the entire cultural and educational system, from writing to art, that is known as the Carolingian Renaissance. In the second half of the ninth century Tours was the center of late Carolingian book making, producing large generously illustrated codices in its scriptorium. Emperor Charles the Bald was among those who ordered these codices.

In the monastery of Corbie, northeast of Amiens,

the abbots were, without exception, relatives of the rulers, such as Adalhard, who was one of Charlemagne's cousins and an important administrator. The convent of Corbie had three hundred monks and a hundred and fifty brothers or servants. It could accommodate as many as three hundred guests. Desiderius, the last Lombard king, was imprisoned there from 774 on. Jumièges, in Normandy on the loop of the Seine near Rouen, was where the Bavarian duke Tassilo III, Desiderius's son-in-law, was imprisoned after being deposed in 788. Centula, known today as Saint-Riquier, near Abbeville in the Picardy, was directed by the lay abbot Angilbert, one of Charlemagne's sons-in-law. The monastery was rebuilt around 790. It was an elaborately designed model site for three hundred monks and one hundred students; it cultivated an unusual form of the liturgy: a service with stations and orderly processions.

BENEDICT OF ANIANE

In 802 a synod called again for the introduction of the Benedictine rule. This regulation seems to have been no more successful than the earlier synodal resolutions. Soon after Charlemagne's death, in any case, Louis the Pious undertook a thorough, normalizing reform of the monasteries. This reform was the work of Benedict of Aniane (c. 745–821), a passionate monk and reformer who was the son of a Visigoth count. His real name was Witiza, but he took the name Benedict later. Even among his contemporaries he was considered the second Benedict, after Benedict of Nursia. He was educated at the royal court of Pépin and Charlemagne, where he held the honorary post of cupbearer. Early on he established connections to Charlemagne's son Louis, who was then king of Aquitaine and later emperor.

Benedict, who early in his career as a monk had considered the Benedictine rule to be too lax and preferred those of Pachomius and Basil, founded an especially strict monastery not far from Montpellier in Aniane, at the foot of the Cévennes Mountains. Its wooden buildings soon had to be replaced by roomier stone buildings, including a large church, when another three hundred or so monks arrived. Its columns were plundered antiquities from the ancient Roman city of Nîmes, brought at Charlemagne's request. From 792 onward Aniane was under royal protection.

Louis the Pious called Benedict of Aniane to his Aachen court in 814 and had him establish a relatively small model monastery nearby in Inden (present-day Cornelimünster), granting him the position of an arch- or

general abbot of all the monasteries in France. In this role Benedict insisted uncompromisingly that there be only one rule (*una regula et una consuetudo*). This perfectly suited Louis's desire for unity of church and state (*unitas ecclesiae et regni*). Hence in the monastic capitulary at the synod of Aachen in 815 the emperor declared the Benedictine rule, supplemented with special provisions relating to the *consuetudines,* the law of the empire, binding on all monasteries. This ruling was made more detailed and moderated somewhat at the synods of Aachen of 817 and 819. Only after these synods, presided over by Benedict of Aniane, was there a Benedictine order, an *ordo monasticus,* with uniform rules for all countries. At the synod of 816 the monastic order was distinguished from *ordo canonicus* in that the monk, unlike the canon, had to renounce personal property, and live in the monastery his entire life. He could not pursue ministry outside the monastery—though all of this had no immediate effect.

CAROLINGIAN MONASTIC ARCHITECTURE

The number of monasteries is almost incalculable even in the early period. Based on the available sources it has been possible to demonstrate the existence of 1,254 settlements in France alone by the middle of the ninth century. Almost nothing has survived of this architecture. To judge from written descriptions, the sites were—like lauras, the settlements of early Christian recluses—barely organized or disorganized arrays of small huts of wood, earth, or stone, with a wall surrounding the complex; Tours is one such example. Rather than one large monastery church there was often a cluster of churches, consisting of several small oratories or chapels. One impediment to understanding these descriptions is that it is not always clear whether the frequently occurring word *claustrum* refers to the enclosure or the cloister.

Jumièges was spectacular. It was a monastery of enormous dimensions founded around 655 by Abbot Philibert with the support of King Clovis II and his queen; it soon had nine hundred monks (see also pp. 205–6). According to an eighth-century report, the center of the square site was occupied by a cruciform church fortified with walls and towers; a dormitory attached to it, above the kitchen and wine cellar, was 290 feet long and 50 Carolingian feet wide (97 × 16 m), and it even had glass windows that made it easier for the monks to read as they rested. The dimensions given seem to have been exaggerated, because there was not a single dormitory of this size in later periods.

Centula

An idea of the look of large Carolingian monasteries can be gained only from Centula. Saint Riquier, who founded the monastery in the seventh century, is buried there. In 790 Charlemagne appointed his court chaplain and son-in-law, Angilbert, its lay abbot. Angilbert immediately had a new plan built to help fulfill his highly ambitious Carolingian enterprise of prestige. As he had done for his own imperial chapel in Aachen, Charlemagne brought in Roman columns and marble and assembled experienced artists. As late as the end of the eleventh century it was praised by the monastic chronicler Hariulf as the most outstanding and splendid church of its day. Its consecration followed in 799, and a year later Charlemagne celebrated Easter there.

In the seventeenth century French historians discovered in Hariulf's chronicle a brush drawing showing the exterior of a church. It was engraved in 1612, and a second engraving was published by Mabillon in 1673. These are both precious records, since Hariulf's drawing later burned. Hariulf's chronicle also includes two texts and several other remarks by Angilbert about Centula, which describe the monastery and his liturgical order. This material, supplemented by some sparse findings from excavations, provides a semireliable picture of the whole site.

The church, which was about 260 feet (80 m) long, was a structure with an atrium in front, a transept, crossing, and elaborate structure in the west dedicated to the Savior and reconstructed as a multistory westwork. Its upper church probably had galleries, as the westwork of Corvey did just over a century later (see pp. 282–83). The east and west exterior structures were distinguished by a group of three round towers. Multiple towers, extremely uncommon before that time, may be understood as a proud demonstration of Carolingian power, and they would be picked up again later in the imperial cathedrals on the Rhine. On the south side of the church a rectangular courtyard with sides 130 feet (40 m) long has been excavated; it was clearly a cloister. Attached to this, as the engravings show, was an extended area with an irregular triangular form and two smaller churches: the church of Mary, which was also dedicated to the twelve Apostles, and the church of Benedict. Covered passages ran between all three churches; the western one was about 1,000 feet (300 m) long. The ambition of the whole can be seen from the church of Mary, which according to excavation evidence was hexagonal inside and dodecagonal outside, in imitation of the imperial chapel of Aachen.

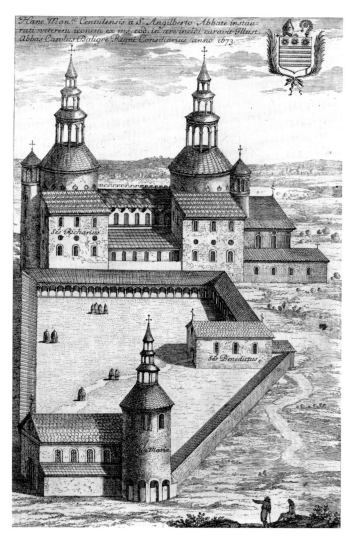

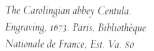

The Carolingian abbey Centula.
Engraving, 1673. Paris, Bibliothèque
Nationale de France, Est. Va. 80

The Cloister

During the reigns of Charlemagne and Louis the Pious there was a transformation in the overall outline of the enclosure buildings that would affect the evolution of the monastery until the Baroque period. The more or less arbitrary distribution of the accommodations that had been common in earlier lauras gave way to a regularized system of order, resulting in a layout that assigned individual buildings a location and orientation according to strict geometrical rules. The decisive innovation was the cloister: that is, a corridor placed in the center of the enclosure that is arranged around a square, or sometimes rectangular, interior courtyard and opening onto it through arcades. One of the four wings of the cloister is attached to the long side of the church; the other three wings are attached to the residential and utility buildings. All of these can be reached through the cloister, which functions as a distribution corridor for the whole enclosure and provides optimal communication between the spaces. It is the cloister that makes order and regularity possible: it provides a simple grid for a layout determined by the square and its axes.

Behind all this stands the rectangular coordinate system of antiquity, which is expressed in comparable ways not only in the Roman atrium house but also in the covered promenades of Roman villas or the atriums of early Christian churches. From the information available to us today, it seems that the cloister was an invention of the Carolingian period and soon became a fixed and distinct type. For all their rich variety, the decisive structural elements remained the same into the Gothic period: a gallery of arcades that rests not on the ground—as it does in a palace courtyard, for example—but on a low plinth wall. The courtyard and the cloister were supposed to remain separate.

The earliest known examples were excavated at Centula and at the imperial monastery of Lorsch (in the so-called Bau II). Both were about 130 feet (40 m) along the side and were probably built before 800. At Mittelzell, on Reichenau Island, there is evidence there was a Carolingian cloister. The oldest surviving cloisters are probably those of Sankt Pantaleon in Cologne (c. 965), Saint-Fortunat in Charlieu (late tenth century?), and Saint-Martin du Canigou (around 1010), which is even vaulted (see pp. 118–19).

The Plan of the Monastery of Sankt Gallen

That the layout of a monastery was meant to be regularized by the new system of order from its most basic features to its tiniest details is demonstrated by the most important document of the entire monastic system of the time: the plan of the monastery of Sankt Gallen. It is drawn in red ink (minium) on a $30\frac{3}{8} \times 44\frac{1}{8}$-in. (77 × 112–cm) parchment formed by joining five pieces together. It gives the layout for an ideal monastery, and is inscribed with about 350 annotations, some in verse, on the individual buildings. In the dedication Abbot Gozbert of Sankt Gallen is exhorted to study the plan carefully. In 830 Gozbert began the reconstruction of the church at his monastery. Haito I of Reichenau is thought to have sent him the plan, which was probably produced in Reichenau, but whether it is an original or a copy is not certain. The plan has frequently been linked to the monastic reform that Benedict of Aniane initiated in Aachen, because strict, regular order was a fundamental feature of his program. Moreover, the church recorded on the plan, with its western termination in a ring atrium and its two detached round towers, is very similar to the Cologne cathedral at the time, suggesting a direct connection to the Rhineland and, thus, to Aachen.

The year the plan was created appears to be indicated in a chronogram hidden in the annotation to the stalls for geese and chickens. It specifies the year 819.

The core of the monastery, the enclosure, is south of the church. Three wings surround the cloister, which, measuring about 80 feet (24 m) along the side, is rather small, a bit more than half the size of cloisters in Centula and Lorsch. Its square outline determines the overall arrangement and direction of the associated wings. The draftsman has folded back the arcades of the cloister so they can be seen in elevation. On each of the four sides there are two symmetrical sets of four arches and between them there is a taller middle arch, separated by pierlike sections of the wall. The northern wing served as a consultation room, a precursor of the later chapter house. The buildings of the enclosure are the dormitory, bath, latrine, refectory, changing room, kitchen, and the storeroom, where the wine barrels were kept.

This core was surrounded by utility buildings on all four sides, but the functions were strictly separated: to the west and south were the stalls, barns, and coach houses for agriculture and the workshops for cooperage, wood turning, brewing, and baking, as well as two mills. To the mills were attached residences for the artisans, two henhouses, the poultry farmer's house, and the garden. Pilgrims had their own inn with its own kitchen, directly alongside the western section of the church.

The areas in the north and east were reserved for the less profane functions of monastery. In the north was the house for distinguished guests, the school, and the abbot's residence—almost a villa—which had the scriptorium and the library above it. The eastern end was formed by the novitiate and the hospital, each of which had a miniature cloister, and which are separated by a small double-sanctuary church. There was even a residence for the doctor, with a separate house for bloodletting, and bathhouses for the sick and the novices. A graveyard was to the east, because light (and salvation) comes from this direction. The monks were even provided with beds and furniture—desks, benches, and wardrobes—unusual amenities for the monks. In terms of furnishings, even the imperial palaces were surpassed by such a monastery, as the former probably did not even have dining halls with permanent furnishings.

On the whole, the plan for the monastery of Sankt Gallen appears to be a kind of illustration of the catalog of the buildings necessary for a monastery that Benedict of Nursia had compiled in his monastic rule. Benedict lists not only *oratorium, refectorium, dormitorium,* and *coquina* (kitchen) but also *bibliotheca, hortus* (garden), *cella hospitum* (guesthouse), *cella novitiorum* (novitiate), *cella ostarii* (porter's house), and *cella infirmorum* (hospital).

Copy of schematic plan of Sankt Gallen monastery. Sankt Gallen, Stiftsbibliothek. Ideal plan for the layout of a Carolingian monastery, original prepared c. 819, probably on Reichenau Island

That was the year of the imperial synod in Aachen at which Louis the Pious finished establishing laws for the monasteries with the *Capitulare monasticum.*

Even the system of measurement is regularized down to the smallest detail. The plan is not based, as might be expected, on the Carolingian foot but on the Roman foot (11 5/8 in.; 29.63 cm) and hence a scale of 1:160, according to modern calculations. The drawing is based on a grid that is not visible but can be reconstructed with the ancient Roman division of the foot into sixteen parts, whereby each digit is in turn divided again by four. This produces a tight grid that assigns a place and size not only to the parts of the building but also to the furnishings, like the benches, beds, and stoves.

Furthermore, Benedict called for workshops, a mill, and a water supply. Something that does not appear in Benedict's catalog, however, is the part of the complex that, apart from the church, we most closely associate with a monastery today: the cloister. Nor did Benedict suggest how the many buildings could best be arranged. The plan for Sankt Gallen made up for all that.

The church sketched on the plan is of great documentary value for Carolingian architecture and liturgy. Based on the scale we can calculate a total interior length of about 260 feet (80 m) and a nave that would have been about 40 feet (12 m) wide; this is the same width as the church that Haito I had built at Mittelzell, on Reichenau Island. Its total length would have been about equal to that of Centula and about 65 feet (20 m) longer than Saint-Denis; thus it would have numbered among the larger Carolingian buildings. Of the monastery churches only Fulda was larger; it was 320 feet (98 m) long, with a transept that was 250 feet (76 m) long and a nave that was 56 feet (17 m) across. Fulda was comparable in size to Roman basilicas of late antiquity, such as Saint Peter's or San Paolo fuori le mura (Saint Paul's outside the Walls; see p. 454), although it did not achieve their stature.

Strangely, the dimensions indicated for the church, 200 Roman feet long and 40 wide, do not match the dimensions shown on the layout. Over the years scholars have proposed a number of explanations for this, but it has been shown that these dimensions apply not to the whole church, but only to the nave between the crossing and the western apse, called the *templum*.

The architectural concept for the church also expresses great ambitions that would only have been appropriate for an imperial monastery, with its privileged position. As a columned basilica the church was—as Saint-Denis, Centula, and Fulda—an example of the Carolingian Renaissance of early Christian buildings. It had two sanctuaries, however, like Fulda and the old cathedral of Cologne. There was a liturgical reason for having two sanctuaries, but it lay not, as used to be claimed frequently, in the polarity of *regnum* and *sacerdotium*—that is, secular and spiritual power—the tension that determined the early and high Middle Ages. Much like that of Centula, the eastern section consisted of a crossing, two transept arms, and a sanctuary that terminated in an apse. The crossing and the sanctuary each formed quadrates. Unlike the continuous "Roman" transept without a crossing—like the one in Fulda, built just before this on the model of Saint Peter's—the crossing on this plan was such an emphatic element of the

structure that it can only be thought of as being "marked off." That would correspond to Haito's building at Reichenau, the oldest surviving example of this type of crossing, which was then new but would become the way of the future.

In the nave of Sankt Gallen the position of the columns was determined by a square grid that was derived from the square of the crossing. This is another manifestation of the geometrical regularity that also left its stamp on other parts of the plan. The grid represented an early example, if not yet such an exact one, of a quadratic schema for the layout, which during the early Middle Ages began to replace the late antiquity tendency to place the columns closer together. Outside, each apse has a ringlike atrium in front; the western one even has two aisles. The western apse also has two detached round towers that stand like guards in front of the atrium. They are dedicated to the archangels Michael and Gabriel, who were believed to provide divine protection.

The plan of Sankt Gallen is also an invaluable document for understanding Carolingian monastery churches because it shows the liturgical arrangement in the church. In the middle of the sanctuary stands the main altar, dedicated to Mary and Saint Gall. Precisely beneath it, underground, is the *confessio*, where pilgrims worshiped at the saint's grave. It was accessed by a U-shaped chambered crypt located under the sanctuary. This system of dark passages served the cult of reliquaries, which became ever more important, producing in the Carolingian period not only chambered crypts but also ring crypts, outer crypts, and hall crypts consisting of rooms with four columns.

The west and east apses hold the altars of the Roman saints Peter and Paul; Peter's altar is in the west, as it is at Saint Peter's in Rome. The two altars are like two poles framing the crucifix altar located in the nave. In front of the crucifix altar is a baptismal font and an altar to Saint John; behind it is a pulpit in the form of a round ambo. There are additional altars at the eastern wall of the transept and at the eastern piers of the crossing. The other eight altars are in the aisles. Quite unusual compared to modern ideas of a church are the many barriers that block off several sections, including the baptismal area and the spaces around the crucifix altar, pulpit, chancel, and transept arms. Even individual altars are usually surrounded by barriers. These areas were not intended for large numbers of people, but probably served, as at Centula, for prayer processions from altar to altar.

Exterior and interior views of Ottonian
westwork, probably built after 984, Sankt
Pantaleon, Cologne

The liturgical center for the monks—the chancel for common prayer—was located in the crossing. There were indications for benches there and in the transept arms. They were not on the long sides, as later choir stalls would have been placed, rather they were set crosswise, facing east for the monks, much as pews are today. In monastery churches the crossing would long remain the site of the chancel. Only with the mendicant orders did it become common for the monks to go into the sanctuary, and the choir stall was moved right next to the high altar, making the sanctuary a space in the chancel.

It is impossible to say with certainty whether Carolingian monasteries ever truly fulfilled the architectural program that is shown on the Sankt Gallen plan. Almost nothing has survived of these monasteries, and little has been excavated. But at least the plan shows what was considered to be the ideal.

The Westwork

The pride of churches in imperial monasteries, canonical communities of women, and convents of the nobility was often a structure with multiple soaring towers on the western side. By the eighth century this so-called westwork developed into a particular genre. The only surviving one is that of Corvey, on the Upper Weser, built from 873 to 885 and altered, especially the external structure, in 1146. Other westworks have been excavated or recorded in written sources. Corvey, which is a very late example of the Carolingian period and thus clearly part of an older tradition, has always served as the model for reconstruction attempts (see pp. 282–83). To judge from Corvey, a westwork had the external appearance of a daunting religious fortress with three towers, while the interior was a separate two-story church with an entry hall on the ground floor and an

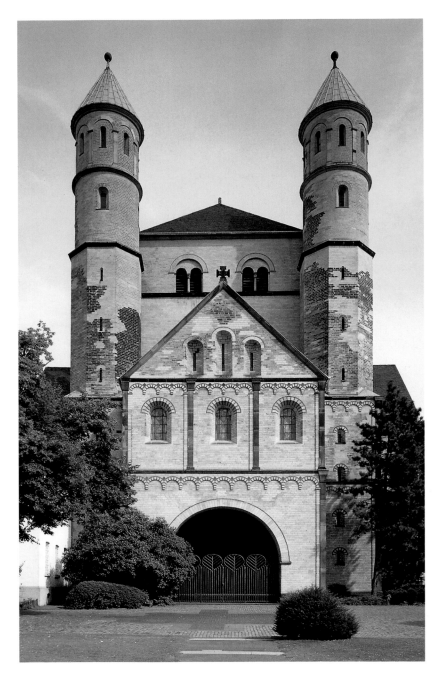

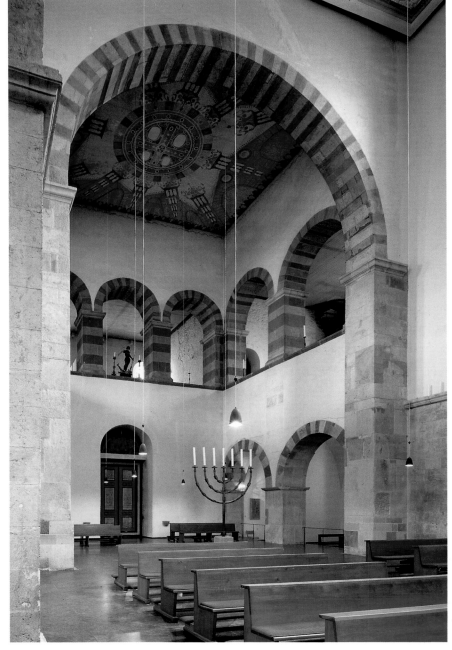

upper church with galleries on all sides. The oldest known westwork of this kind is thought to be that at Lorsch, which was built a century before Corvey. Centula followed in 790. Saint-Denis had a westwork with an apse and just two towers. In the Ottonian period many variations on westworks were built. Examples have survived in Essen, Essen-Werden, and at Sankt Pantaleon in Cologne; and it is possible to make conjectures about those in Gandersheim and in the cathedral in Minden. In other Ottonian westworks there was no upper church, just a gallery, as is the case at Gernrode. Whether these galleries were monarchical loges, chapels, or both is still in dispute.

The function that such a westwork may have served cannot be precisely determined from the sources. It is generally presumed that it was a separate imperial church built onto the nave, although the emperor's throne can only have been in the western gallery of the upper church. Both the interior and exterior of the westwork had such a monarchical, imposing effect that the presence of the emperor, represented by the empty throne and dramatized by the architecture, was felt even when he was not actually present.

The Gatehouse in Lorsch

That the great imperial monasteries were closely connected to the ruling house is manifest at Lorsch not only by its westwork but by a second building, the famous Torhalle (gatehouse). This exquisitely preserved stately building with an ornamental slab pattern was originally a freestanding monument in the middle of an atrium that extended in front of the church. Behind it, at some distance, looms the westwork. Despite its three passages the gatehouse was not actually conceived as a gate—the gate was farther west—but it was clearly in the tradition of the ancient Roman triumphal arch, a monument to imperial power. The structure was once thought to be a monument honoring Charlemagne, built either around 774 together with the church or around 800 on the occasion of the imperial coronation. In fact, however, it must have been built by Louis the German, one of Louis the Pious's sons, when he chose Lorsch as his burial site and was adding other rich ornaments. This would place the time of its construction around 860 or 870.

MONASTERY DONORS AND PROPRIETARY MONASTERIES

From the time of Charlemagne and Louis the Pious onward it became increasingly clear how monasteries formed. Because every monastery needed land on

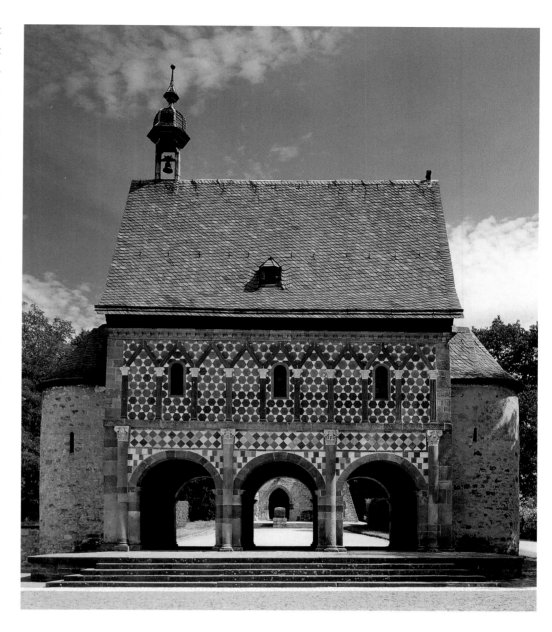

Carolingian "gatehouse," c. 860–70, of the former Benedictine abbey Lorsch

which to establish its existence, it was necessary for a donor, usually a nobleman, to offer land from his own property. Other gifts followed, and so with time a widely branched-out set of property was accrued. The founding convention of monks was appointed from another monastery. Few gifts were made entirely from philanthropic magnanimity. Rather, donors operated in their own self-interest, especially when—and this gradually became the norm—the monastery church was the donor's burial site. First, the monks had to pray for the donor's salvation. The tombs of the donors were often decorated with elaborate recumbent effigies. Two of the finest are the figures of Henry the Lion and his wife, Matilda, in the collegiate church in Brunswick, which the duke had constructed at his castle, Denkworderode. Donors could do even more for their own salvation if they entered their monasteries themselves in old age, which was a frequent occurrence. The second advantage was economic: a well-appointed and strictly run monastery was an important asset for the entire region.

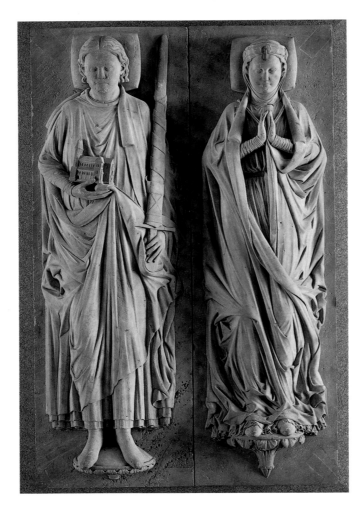

Tomb sculptures of donors, the ducal couple Henry the Lion and Matilda of England, second quarter of the thirteenth century. Brunswick cathedral (former collegiate church)

Depending on a monastery's founding statutes and its guaranteed rights, it could be a good source of income for the donor and his heirs. As a quid pro quo the monastery had to be offered protection—in legal disputes or in war, for example. The sovereign obligations of the donor family, such as administration, were entrusted to an overseer. With time the office of the overseer became inheritable. It was a highly desirable position because it guaranteed good revenues. Many overseers truly bled their monasteries; the complaints and laments on this theme are legion.

Frequently a donor would found a monastery in order to maintain unrestricted access to it, viewing it as a proprietary monastery from the start; then the donor had free rein over it, including the appointment of its residents, in particular the abbot. Proprietary monasteries and churches were widespread, especially in the early Middle Ages. Later this arrangement became considerably less frequent in response to the pressures of ecclesiastical reform, which sought to curb the influence of the laity on the church; eventually it disappeared entirely. Steinbach, near Michelstadt in the Odenwald, is an example of a Carolingian proprietary church, and Seiligenstadt on the Lower Main River, is a proprietary monastery; both were founded by Einhard,

Charlemagne's biographer, on lands that had been given to him by Louis the Pious in 815. They are among the few surviving Carolingian buildings.

Exemption and Immunity

Very much in contrast to the system of the proprietary church, a privileged monastery could be granted special rights, even in the Carolingian period, that guaranteed it certain freedoms. Among these was the free choice of an abbot. More important, however, was a monastery's right to independence, which could be either spiritual-ecclesiastical or secular-political. The ecclesiastical jurisdiction and responsibility for a monastery normally lay with the bishop of the relevant diocese. In some cases, however, the bishop could be bypassed, making the monastery the direct responsibility of the pope. This privilege was called "exemption"; it freed the monastery from episcopal jurisdiction. Exemption was granted to Bobbio in 613, to Montecassino in 748, to Fulda in 751, to Saint-Denis in 757, and to Farfa in northern Latium in 775. Other monasteries followed.

Secular-political independence applied to the landlord and his overseer. Because monasteries perceived landlords and, especially, overseers as oppressive, they sought to free themselves by being placed under the highest possible political authority: the king. This gave it immunity from the landlord. When this happened, the king had to grant the monastery his protection, employing overseers to represent the king. Both exemption and immunity were complicated legal processes that could vary considerably in their details from case to case.

Monasteries with immunity had the status of a royal or imperial abbey. Depending on their location, rank, and significance, they would receive generous gifts and privileges—necessary advantages, since imperial abbeys were called upon in the service of the king, the *servitium regis.* These abbeys could be responsible for provisioning armed soldiers and, above all, they were required to offer the king and his entourage food and lodging, occasionally for weeks at a time. Many monasteries, for example Reichenau, had a separate palace for royal visits. Because the entourage might include hundreds of people, the obligation to provide food represented an enormous burden, thus monasteries were always happy when the royal train arrived during Lent or other periods of fasting. Monasteries located along military routes were particularly affected. Twenty royal visits are documented for Corvey, in the Weser valley,

during the early and high Middle Ages, but the actual number was probably more than a hundred.

An imperial monastery with exemption had achieved nearly the maximum freedom; it could be expanded only by being raised to the rank of an imperial principality. In the post-Carolingian period the imperial monasteries of Italy and western France gradually lost their status and fell under the rule of smaller, regional power holders, usually counts. In East Franconia and the Lorraine—that is, in the emerging Holy Roman Empire—the opposite development took place: there the number of imperial monasteries increased. The Ottonian emperors, whose power was based primarily on the holders of ecclesiastical offices, brought both dioceses and imperial monasteries under the system of imperial churches; it supported them with gifts and privileges, for which it expected loyalty to the crown as a quid pro quo. In the investiture dispute many imperial monasteries then sided with the royals and against the reform monasteries. From the time of the Concordat of Worms in 1122 the abbots of imperial abbeys were invested with a scepter, as were bishops, and with regalia; they were thus granted power of disposition over the empire's worldly possessions. In the thirteenth century there were twenty-nine imperial monasteries and seventeen imperial convents. Even by that time many abbots rose to the rank of imperial prince (*princeps*), as Kuno of Ellwangen did in 1201 and as Hugh of Murbach, in Alsace, did later. More and more imperial monasteries were granted the status of imperial estates, which meant that the monastery's property became a territory that was independent of the empire and subject only to the emperor himself; in addition, the monastery no longer had an overseer but could be self-governing. The end of the overseer was perceived as liberation from long servitude and met with enthusiastic praise. The desire to be granted the status of an imperial estate, for which many monasteries paid enormous sums, remained undiminished right up to the period of secularization. Not counted among the imperial abbeys in the high Middle Ages were religious foundations under a provost as well as those monasteries that had supported a reform movement or joined a new order. Thanks to their elevated status, imperial monasteries

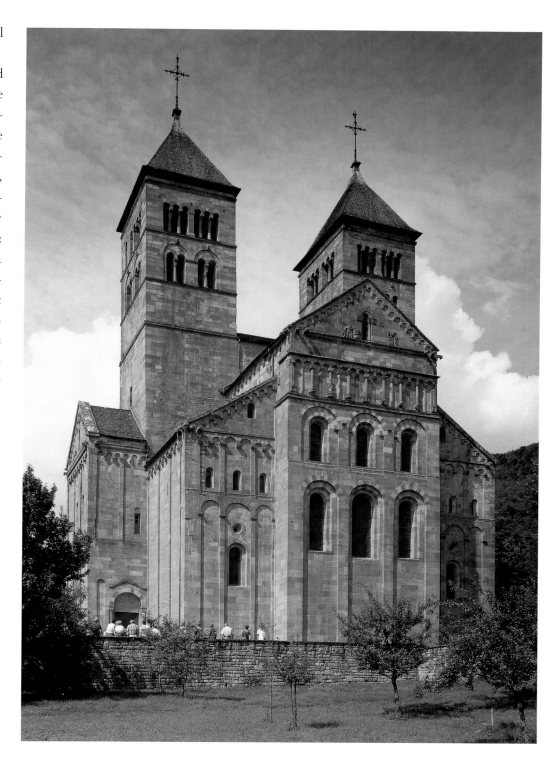

were a preferred refuge for the nobility. The degree to which the self-confidence of an imperial monastery could be expressed architecturally can be seen particularly well at the twelfth-century monastery Murbach, in Alsace. Its proudly towering chancel facade, which majestically projects into the Vosges valley, combines prestige for the state and monastic severity, asserting itself as an imperial monastery.

View from the east of the Romanesque Benedictine abbey church, c. 1130, Murbach, Alsace

THE GREAT MEDIEVAL REFORM MOVEMENTS AND THEIR ARCHITECTURE

It was in the nature of the monastic community that discipline, however strong it may have been in the beginning, soon diminished, and rules were no longer followed as rigorously. For that reason reform movements were repeatedly initiated by those monasteries that took the rules seriously. Some monasteries would join in with these; others, not. Many of the reforms were confined to certain localities, but a few of them led to associations of monasteries or congregations within the Benedictine order. Later they provided the impetus for the founding of new orders. One of the first widespread reform movements based on the Benedictine rule and on the reform of Benedict of Aniane radiated from the monastery of Gorze, in the Lorraine, south of Metz, from 934 onward. From that path, as well as by way of Saint Maximin, in Trier, the movement reached many monasteries in present-day Germany.

CLUNY

The Ascent to Power

Another driving force developed somewhat later at the Burgundian monastery of Cluny. After a slow start Cluny would become over next two centuries the greatest and most influential monastery of the western world and a world power in ecclesiastical politics. This unprecedented ascent was attributable to a series of important abbots who held the office for extended periods. The most important were Odo (927–42), Mayeul (c. 954–94), Odilo (994–1049), Hugh of Cluny (1049–1109), and Peter the Venerable (1122–57). Abbots could designate their successors and thus there was a certain continuity of direction.

Cluny was founded in 910. Duke William the Pious of Aquitaine gave Abbot Berno of Baume a domain in the valley of the Grosne, a small tributary of the Saône, to establish a reform monastery. This region, which was not part of the Holy Roman Empire and only loosely connected to the French kingdom, presented the most favorable conditions for a new monastery to develop freely, since it existed in a kind of vacuum of power politics. The root for this rapid development was planted in its founding statutes. The duke provided for the greatest freedom possible: he renounced all rights that would have been owed him as a donor and guaranteed that the abbot could be chosen freely. In addition, he placed the

monastery directly under the holy see, or papal jurisdiction, which freed it from the control of the bishop of Mâcon. The pope, in turn, permitted the community to accept monks from nonreform monasteries and allowed it to found subsidiaries that were independent of the parent. That essentially amounted to an invitation to form an association of monasteries under the direction of Cluny.

From the beginning Cluny devoted itself to the reform of monastic life. It placed great value on ceremonious elaboration of the liturgy, and in doing so, considerably expanded the *opus Dei.* The time for work was reduced accordingly. Of greater historical impact, however, was Cluny's attitude toward the church politics of its day. On the one hand, the abbots maintained good relations with the imperial house. Mayeul kept in contact with the Ottonians and Empress Adelaide, the wife of Otto the Great, whose vita would be written by Abbot Odilo soon after her death in 999. Hugh of Cluny, in turn, knew the Salic emperors personally, and in Cologne in 1051 he baptized Henry III's son, the future Emperor Henry IV, with whom he would remain associated. Yet Cluny, in its commitment to serious reform, supported efforts to purify the church of outside influences. Important among these was the effort to free the church from dependence on secular powers, which meant that the laity would no longer be permitted to have administrative power over church property and offices. Initially, this was directed against the system of proprietary churches. Later, however, it also touched upon the core issue of secular politics in the second half of the eleventh century: the late eleventh- and early twelfth-century investiture dispute between the pope and the Holy Roman Emperor regarding lay appointments of bishops and abbots. The two popes who were the driving forces for the Church arose out of the Cluniac reform: Pope Gregory VII had previously headed the monastery San Paolo fuori le mura, which was run by Cluny, and his successor, Pope Urban II, had been prior at Cluny. Consequently, the monastery was drawn into the events surrounding the excommunication of Holy Roman Emperor Henry IV, resulting in a profound crisis of loyalty in broad sections of the German clergy. Abbot Hugh tried to mediate in Henry's penitential pilgrimage to Canossa in 1077. Papal policies were not determined by Cluny during this period, but it was clear that no monastery had ever carried such political weight.

Cluny gradually built its position within the Benedictine order into that of a monastic empire; it never represented an independent order, but at most, a con-

gregation. Soon after it was founded the abbey had assumed leadership among reform-minded monasteries and founded new branches, but most of these were granted only the subordinate status of priories. There were countless smaller branches as well. The abbot of Cluny typically appointed the abbots and priors himself. Certain abbeys that were older than Cluny and already very significant—Fleury, for example—also sought to become affiliated with it. Many abbeys only flourished after such an affiliation, for example, Charité-sur-Loire, Saint-Bénigne in Dijon, Moissac, Vézelay, and Saint-Martial, in Limoges. Already under Abbot Odo the Cluniac association had spread to Italy—especially Rome, Pavia, and Montecassino—and then to Spain and England. Later Abbot Odilo sought to bring the monasteries and priories into a centrally organized monastic association and arrange for its members to have unrestricted freedom before the bishop. In the late twelfth and early thirteenth centuries, at the height of the expansion of Cluny's monastic empire, France was divided into six provinces under the order with about six hundred branches, five hundred of which were priories. Five of the priories, the *quinque filiae* (five daughters), had elevated status. Following the model of the Cistercian monasteries, after 1200 there was an annual general chapter, at which all the priories were required to be present. Cluny retained the right of regular visitations, but in turn it was visited as well—twice a year, by two abbots and two priors. We can only guess how many Cluniac branches existed in Europe as a whole; estimates vary between 1,500 and 2,000.

The unlimited power of the abbot and the strict, disciplined organization of the entire association was summed up critically by Odilo's contemporary, the Bishop of Laon, who compared Odilo to a king and the monks to the military. Although the abbots hardly ruled like kings, they were indeed something like grand abbots.

The excellent organization of Cluny was, moreover, responsible for the fact that pilgrimages to Santiago de Compostela, which began in the ninth century, became a European mass movement, as travelers could pass from one monastic branch to another at intervals of a day along four different routes in France.

The wealth and number of monks in Cluny also grew with mounting significance. When Odilo took office in 994 there were not even one hundred monks; under Hugh of Cluny the number increased to about three hundred; and under Peter the Venerable there were nearly four hundred. The buildings had to accommodate this growth.

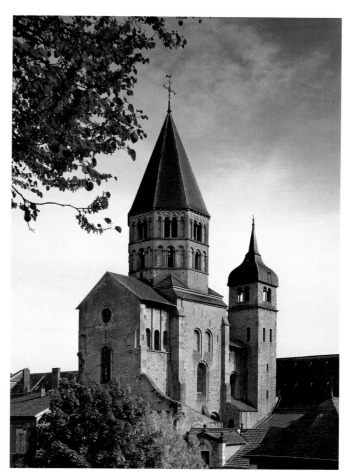

View of the tower above the southern transept at Cluny, the only surviving section of the former abbey church Cluny III

The first church, Cluny I, was built under Berno. Consecrated in 915, it seems to have been only a small oratory. Cluny II, begun in 948 and consecrated by Mayeul in 981, was more significant. Cluny scholar Kenneth J. Conant has reconstructed its basic features from spot excavations and written sources. The church, also known as the Mayeul building, had what was most likely a longitudinal barrel vault, which probably postdates the consecration. It was a three-nave basilica about 190 feet (58 m) long, with a substantially projecting transept and an east end of seven sections in echelon that consisted of a sanctuary of three naves terminating in an apse and an adjoining boxlike room running along each side. These rooms could be closed off by iron doors, and may have served as penitential cells for the monks. On the transept, or east end, there was another apsidiole each on the left and right. The eastern complex, which was topped with a crossing tower, was an early example of a particular architectural type, the chancel in echelon. On the west end, the main block had a three-nave antechurch, the so-called *galilaea,* which had two towers on its facade and was added later in place of an atrium. Cluny II, in particular its chancel in echelon, was widely imitated, for example at Châteaumeillant, in the Berry, and Saint-Sever in the Gascogne. The churches in the Romainmoutier, in southeastern France, and in the Payerne, in Switzerland, also seem to be reflections of Cluny II.

The Monastery Buildings under Abbot Odilo

Under Odilo the monastery was rebuilt. No traces survive, and there have been no excavations, but Conant was able to reconstruct the basic features using written sources. The only aspect of the buildings emphasized in Odilo's vita is the cloister that he had built near the end of his tenure, thus around 1040, which had marble columns that had been transported by way of the Durande and Rhône rivers. The columns must therefore have been Roman spoils from Provence. Odilo's monastery soon had a reputation as a site to visit. Members of the clergy—but not laypersons—who were passing through were permitted to view it, guided by the prior, during the hours when the monks were in church. A description of the monastery, written by a Roman clergyman who came to Cluny in the company of Cardinal Peter Damian in 1063, emphasizes admiringly that hidden canals provided running water to everyone in the monastery and that the dormitory and refectory offered ample space.

Other, more precise, references can be found in the *consuetudines* of the monastery Farfa, north of Rome, which were written in 1042. It contains a detailed description of the rooms a monastery should have, with indications of dimensions and location. This architectural program is clearly nothing other than a description of Odilo's monastery at Cluny. Twenty-five buildings are listed in all. No mention is made of the cloister, however, although its marble columns made it a particular attraction. It would thus seem that it had not yet been built at the time this eyewitness visited

Cluny. The area set aside for the cloister, however, can be inferred from the description.

The architectural program largely corresponds to the Sankt Gallen plan, however the chapter house in the enclosure is new; attached to it were a Lady chapel and locutorium, on the east side of the cloister. The locutorium was a necessity because absolute silence was mandatory in the cloister, dormitory, and refectory. The chapter house is one of the earliest documented examples. On its west side, facing the cloister, it had twelve "*balcones*" with double columns. It is unclear what this word was intended to describe: perhaps arcades opening onto the cloister, but probably, as with choir stalls later, sedilia niches for the twelve most important members of the convention. On the upper story of the cloister's east wing the dormitory ran the entire length of the chapter house, the locutorium, and the workroom. It was about twenty feet (6 m) longer than the church and lit by more than ninety-seven tall, narrow glass windows. One of the most remarkable spaces was the latrine, which was astonishingly large—half as long as the church. It had forty-five seats, each ventilated by its own small window. The size of the latrine can probably be explained by the rush caused by the limited time allotted between the offices. On the other hand, there were only twelve bathtubs for the entire convention: each monk bathed twice a year. Guests and their mounted retinues were provided with a *palatium* next to the *galilaea* (antechurch). It offered comfortable luxury accommodations, with a total of seventy beds and an equal number of toilets: for forty men on one side, and on the other, separately, for thirty countesses or noblewomen. Between them was a common dining hall with built-in tables. Immediately adjacent lay the modest lodgings for pilgrims.

Another forward-looking innovation was a building in the west for the *famuli,* the monastery's servants; this was an enlongated section with a dormitory and refectory on the upper floor and horse stables on the ground floor.

Monks and Conversi

Over time the *famuli* grew in significance until they became a separate class within the residents of the monasteries: the lay brothers who converted to a life in the monastery (conversi). In early monasticism, prayer and work were still a unity in equilibrium, and the choir monks shared these activities with the much larger group of lay monks. As the liturgy grew longer, the balance of work and prayer shifted in favor of prayer.

Consequently, the two areas began to separate. Among the monks, most of whom at Cluny were from the nobility, the number of priests increased while the number of lay monks decreased. As if as a substitute for the lay monks the institution of the conversi developed on the margins of the monastery. Conversi performed the rougher labors, except for field work, which was increasingly left to leaseholders. They had the status of serving, working lay brothers. Like the monks, conversi were bound to the monastery by an oath. Their daily lives were ordered according to different regulations, with less emphasis on liturgy. This separation into two classes, monks and conversi, was a gradual development, a result of tighter regulations for the liturgy. Cluny provided a decisive impetus to the multiclass system.

Cluny III

Over the long term the monastery's buildings became inadequate for the constantly growing convention. The church soon proved to be too small, and even its architecture no longer did justice to the monastery's higher aspirations. Shortly after his fortieth year in office Abbot

Hugh of Cluny began construction of a new church of incomparable size: Cluny III. Money was donated from all over: King Peter I of Aragon, King Henry I of England, and, above all, Alfonso VI of Castile and León stood out for their generosity. Alfonso promised ten thousand talents from the Arab spoils taken when Toledo was reconquered, and after meeting with Abbot Hugh in Burgos he promised an additional two hundred ounces of gold. According to a legendary report in Hugh's vita, the driving force behind the new construction was the former abbot of Baume, Gunzo, who spent the end of his life as a monk at Cluny. As he lay sick on the verge of death, Saints Peter, Paul, and Stephen appeared to him and revealed to him their wish for a new church. Peter marked out the length and width with a rope and indicated the architectural style. Gunzo recovered and persuaded the abbot that a new building was necessary. Gunzo's vision precluded any possible criticism of the reconstruction, since Peter himself had prescribed the dimensions and style. The church was erected on an unbuilt site north of the monastery. Thus the old church could be used in the interim.

Ground plan of Cluny III and the abbey buildings, c. 1050 (after Conant and Braunfels)

A *Monastery church*
B *Lady chapel*
C *Hospital*
D *Refectory*
E *Pantry*
F *Gateway*
G–H–I *Lodging and stables*
K *Novitiate*
L *Cemetery chapel*
M *Addition to dormitory (?)*
N *Abbot's chapel*

1 *Old church*
1a *Old galilaea*
2 *Chapter house*
3 *Locutorium*
4 *Monks' hall*
5 *Dormitory (upper story)*
6 *Latrines*
8 *Calefactory*
11 *Well house*
12 *Kitchen for the monks*
13 *Kitchen for the laymen*
14 *Storeroom*
15 *Room for the guardian of the poor*
19 *Cemetery*
32 *Bakery*
36 *Guesthouse for women*
37 *Guesthouse for men*
41 *Stable building and house for the conversi*
42 *Latrines*

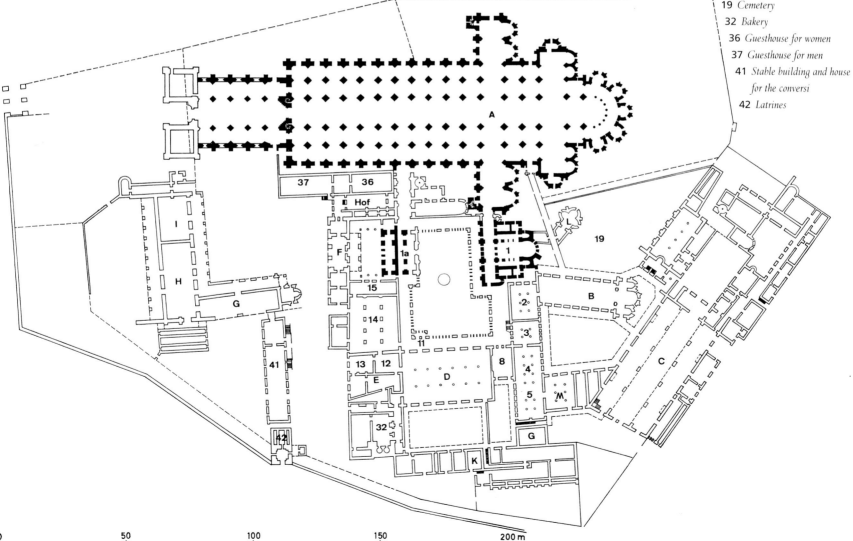

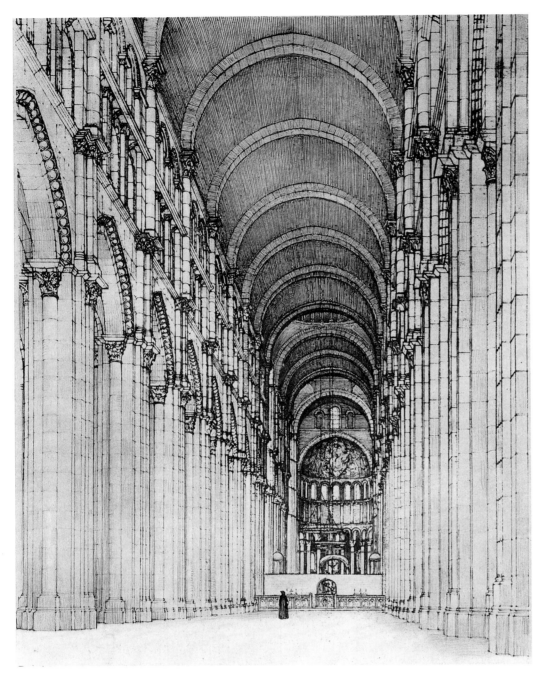

View of the nave toward the east, Cluny III, reconstruction after Bannister and Conant

part of the antechurch built; it was completed in 1147. The western parts were constructed around 1225 under Abbot Roland de Hainaut. Following the French Revolution and the closure of the monastery in 1790 the church was torn down by the citizens of Cluny. Only the southern part of the transept remained.

Cluny III was by far the largest church in the world at the time it was built. Even without the antechurch it was 463 feet (141 m) long and thus about 23 feet (7 m) longer than the cathedral in Speyer, the notable building of the Salic emperors, which had been the largest church of the preceding era. Emperor Henry IV, who in 1077 in Canossa was at the nadir of his power, had just begun reconstruction at Speyer. It is possible that Abbot Hugh, Henry's godfather, wished to compete with imperial Speyer; in any case Hugh's vita notes in his praise that the emperor would have been worthy of admiration if he had been able to construct a building like Cluny in such a short time. At Speyer, however, the nave was substantially larger than that of Cluny; at 46 feet (14 m) across and 108 feet (33 m) tall, it was 13 feet (4 m) wider and 10 feet (3 m) taller, quite significant in a vaulted structure. Yet the length of the transept in Speyer was nowhere near the 243 feet (74 m) of Cluny's. After the antechurch was added Cluny had a total length of 614 feet (187 m). Nothing competed with these dimensions for some time. Only in the early fourteenth century did Old Saint Paul's Cathedral in London, at more than 591 feet (180 m), nearly reach the size of Cluny. Cluny was finally surpassed after 1600 by Saint Peter's in Rome, when the new nave and entry brought its total length to 692 feet (211 m).

The ambition of Cluny III is expressed in the Roman five-nave construction, modeled on Saint Peter's and San Paolo fuori le mura. The east end was truly a triumphal example of the architecture of power that offered an immense architectural prospect with a double transept topped by four towers; it was comparable to the later churches in England. The eastern termination was no longer the chancel in echelon of Cluny II but the modern type of an ambulatory choir with radial chapels. With its multiple groupings of building parts the prospect offers a sumptuous abundance like no other east end of the Romanesque period in France. Not only power and pride were demonstrated here by boundless riches. Cluny's eastern prospect was intended to be impressive.

The five naves were staggered in height. In the central nave this resulted in extremely tall nave arcades whose arches had a slightly pointed shape. By contrast,

In 1088 a papal legate lay the foundation stone. The speed with which the construction progressed is astounding. By 1095 Pope Urban II, the former prior of Cluny, could consecrate the main altar in the chancel and several other altars. The church must have been functional by 1121, for in that year the main block of the old church was torn down. Ten years later, in 1131, after forty-three years of construction, Pope Innocent II performed the final consecration, which might have taken place even earlier if part of the vault in the center bay had not collapsed in 1125, as the repair took some time. As part of this work the nave walls were reinforced with an external buttress, one of the earliest examples of an exposed buttress. A canon from Liège, the mathematician Hezelo, was involved in directing the construction, but it is not known what precisely may be attributed to him. Finally, Abbot Peter the Venerable had the eastern

the higher floors—the triforium and the windowed clerestory—were quite low and had tiny windows. The articulation of the walls included both rounded projections and channeled pilasters; the legacy of antique forms lived on here. The central nave was vaulted by a longitudinal barrel vault lined with belts. The space of the endlessly long nave, with a width-to-height ratio of 1:3, must have seemed like a steep, oppressively narrow, dark ravine. This impression, which has something inhuman about it, can still be felt in the surviving transept wing. After a caesura created by the two domes of the crossing, the nave leads up to the apse and its cramped wreath of arches, whose columns, nearly thirty-three feet (10 m) tall but only nineteen inches (48 cm) in diameter, were thin to the point of fragility.

Everything about Cluny's church thrived on extremes. Only in the narthex, which had a cross rib vault, in contrast to the longitudinal barrel vault of the nave, was this tendency to exaggerate the spatial relationships substantially mitigated. The two eastern bays, built when Peter the Venerable was still abbot, boast the four-level wall design that would soon become characteristic of French buildings in the early Gothic period. The antechurch was an unusually large stepped portal with a tympanum and inset jamb posts in front, a structure that would soon be imitated in countless portals, particularly in Germany. Of its successors in France the much smaller, less steep abbey church Paray-le-Monial, where this wall design is cited almost exactly, has been known since Conant as a "pocket edition" of the mother church (see pp. 152–54). In other buildings—such as the cathedral of Autun, the collegiate church in Beaune, and the cathedral of Langres—the archetype was handled with more freedom and autonomy. In the Gothic period the influence of Cluny was a thing of the past, except for the cathedral of Bourges, whose staggered five-nave design with tall nave arcades represents an original reconception of Cluny.

Under Hugh of Cluny and Peter the Venerable the convent buildings, which were terribly cramped, were redesigned. All that was retained of the old church (Cluny II) was the eastern complex, because it had been the burial site of the abbots, and the western section of the antechurch, which was now an entry hall for the enclosure. The space once occupied by the demolished nave was used to extend the cloister. Along with a series of small buildings, an astonishingly large hospital, a refectory with a mural of the Last Judgment, and a spacious wing for guests were added. Already in the twelfth century as many as twelve hundred fathers and brothers were living in the monastery. The buildings were so large, it was proudly noted, that in 1245, at a summit meeting including Louis IX, Pope Innocent IV, and the emperor of Byzantium, they offered space for twelve cardinals and twenty bishops as well as the entire retinues of the great lords, without disturbing the lives of the monks.

The decline followed the death of Peter the Venerable in 1156. A century later, in 1252, Cluny renounced its

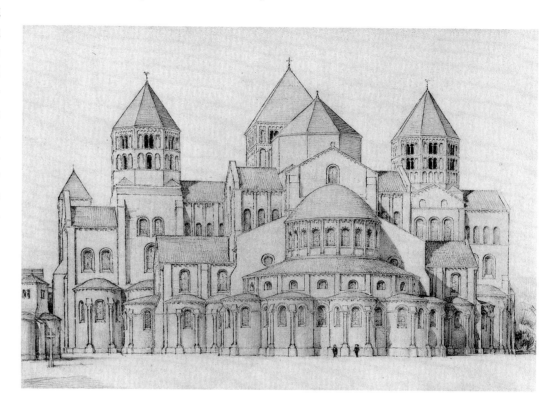

View of the choir, Cluny III, reconstruction by Conant

autonomy and its free choice of abbot and submitted to the protection of the king. In the modern period in France, commendatory abbots who were resident in Paris were commonly awarded the monastery—for example, Richelieu, Mazarin, and finally, after 1757, La Rochefoucauld, who had his own château at Cluny for his rare visits. In 1727 the buildings of the old monastery were demolished. They were to be replaced by a château, but it was not built until 1750, and only parts of it were completed. While the church was torn down, the monastery's château was kept, although the reverse would have been more appropriate.

Cluniac Influences

Apart from monasteries and priories directly subject to Cluny, there were other congregations throughout Europe that had espoused reform. Although they were clearly influenced by Cluny, they preserved their autonomy or had only loose connections to Cluny. A large association with about three hundred branches spread through southern Italy from the La Cava dei Tirreni

monastery near Salerno, initiated by Abbot Peter, who was from Cluny and had been appointed by Gregory VII. Toward the end of the tenth century another association of monasteries formed in the Pyrenees region around Cuxa and Lézat. Soon after it joined with monasteries beyond the Pyrenees. It was led by Oliba (Oliva), abbot of the Spanish monastery Ripoll, who also founded Montserrat and Saint-Martin du Canigou (see pp. 118-19). Oliba held the position of a grand abbot in this region. Beginning in 1091, the Cuxa-Ripoll association of monasteries, which represented just one parallel strand to Cluny, was absorbed into the new reform association of Saint-Victor, in Marseilles.

William of Volpiano

One of the most successful reformers in the early eleventh century was William of Volpiano (d. 1031). He came from the nobility of northern Italy; his godfather was Emperor Otto the Great. In 987 William was called to Cluny by Abbot Mayeul. Three years later, in 990, he took over as abbot of the Saint-Bénigne monastery in Dijon. From there he was intensely active in a modified version of Cluniac reform in Burgundy, Lorraine, northern Italy, and Normandy, although he did not organize the monasteries into an association. In Normandy the large monasteries Jumièges and Fécamp joined the reform movement, as did the young branch of Mont-Saint-Michel. William turned Fruttuaria, the monastery he had founded near Ivrea, into the most important center of reform in northern Italy; it was subject only to the holy see, not even to Cluny. From there William's reform spread along the southern edge of the Alps, where it included fifty-four branches, including San Ambrogio in Milan (see pp. 398-400).

Germany, which was always in the Gorze reform's sphere of influence, remained unaffected by Cluny's expansion, which ended in southern Lorraine, roughly at the border of the Holy Roman Empire. Cluniac influence reached Germany only indirectly. One starting point was Fruttuaria, and from there the Saint Blasien monastery, in the Black Forest. Several of William's monks had brought the *consuetudines* of Fruttaria to Saint Blasien at the request of Empress Agnes, the widow of Henry III, who, in contrast to her son Henry IV, inclined toward the pope and supported the reform. From Saint Blasien the reform was adopted by many important monasteries in southern Germany, Switzerland, and Austria, such as Ellwangen, Wiblingen, Ochsenhausen, Muri, Lambach, and Göttweig. A second distribution point for William's reform in Germany was Siegburg

abbey, near Cologne, which was followed by the Cologne monasteries of Sankt Pantaleon and Gross Sankt Martin, as well as by monasteries in Deutz and Brauweiler. Beginning in 1126, with the help of the bishop of Regensburg, who had been abbot at Siegburg, it spread to southern Germany—for example, to Mondsee (now in Austria).

Hirsau

The most important gate of entry for Cluniac influence in Germany was the Hirsau monastery, in the Black Forest, near Calw, which along with neighboring Saint Blasien, became the decisive center of reform in the southern empire. In 1049 the monastery had been revived by Count Adalbert of Calw, a nephew of the reformist Pope Leo IX, under whose order the revival took place, and in 1065 the monastery was provided with a convention from Einsiedeln in Switzerland. The rise of Hirsau truly began, however, under Abbot William, who came from the Saint Emmeram monastery in Regensburg. He was highly educated, and as a scholar he specialized in astronomy and music theory. After he was appointed abbot of Hirsau in 1069 he turned the monastery into a stronghold of reform, as well as an asylum for partisans of the pope against the empire. An encounter with Gregory VII in Rome in 1075 led him to orient his reform efforts around Cluny, but for that purpose he needed to see the *consuetudines* there. At William's request a monk at Cluny named Udalric wrote them out in detail in three books between 1079 and 1086.

Udalric, from Bavaria, was a godchild of Emperor Henry II and a member of the court chapel. At Cluny he held an elevated position as father confessor of the convent and advisor to Abbot Hugh. Udalric's *Antiquiores consuetudines cluniacensis monasterii* is the best possible source of information about daily life at Cluny as well as the monastery's whole organization and its various areas of competence. For verification William sent monks from Hirsau to Cluny on three occasions. In addition, he had a copy of the *Ordo cluniacensis,* which had been written at Cluny in 1086–88 by the monk Bernard at the request of Abbot Hugh. On the basis of these two texts William, who had never been to Cluny, drew up the constitution for his own monastery: the *Constitutiones Hirsaugienses,* which was completed in 1088.

William borrowed from Cluny the stricter and expanded approach to the *opus Dei,* regulating the course of the day very precisely, down to the ringing of bells and how the bell pull was to be attached. He divided the monastic convention into two classes, based on the

model of Cluny. The first and more important class consisted of the *cantores* (singers) or *literati*—that is, those monks who had had some degree of education and had mastered choral singing in Latin. William placed particularly high value on these things. The second class, the *illiterati* or *idiotae*, was composed of those monks who lacked sufficient Latin to master choral song (*qui cantare nescieunt* [who did not know how to sing]). At Cluny this class gradually grew, to the point where they are now usually referred to as *conversi*. In the monastic community at Hirsau there was a third class: the *exteriores fratres* (external brothers). These were lay brothers who did not belong to the monastic convention and lived outside the enclosure but inside the monastery. Because they wore beards, they were also called *barbari*. They were responsible for agriculture and crafts; at the start of the Hirsau reform, at least, they seem to have built the buildings as well.

In 1082 William of Hirsau ordered work to begin on Saints Peter and Paul, the new monastery church at Hirsau. It was consecrated eleven weeks before his death in 1091. Because the convention had quickly grown to 150 members, the church was built to be sufficiently large. At a total length of 318 feet (97 m), including the antechurch, built after William's death, it was one of the largest churches of the Romanesque period in Germany. In 1692 it was burned by French troops under General Mélac, and then dismantled by the citizens of Calw, who used its ruins as a quarry for rebuilding the burned city. All that stands today is the Eulenturm (owl tower), the left tower of the west facade.

Cluny III may have been planned but not yet begun when construction was starting at Hirsau. The basic disposition is thus that of Cluny II, which was still in use. Three-nave construction was used for the presbytery, but the adjoining side chambers were dispensed with and the three apses were replaced by flat terminating walls, with seven altar niches on the inner walls, three in the middle and two in each aisle. Because relics were no longer kept underground but in altars, for better display, there was no need at Hirsau for the crypt that was otherwise still universal in Germany, so it was dropped from the program. Cluny also dispensed with a crypt. Also like Cluny II, Hirsau was oriented around the western part, with a three-nave antechurch, designed for processions, with a two-tower facade.

In its construction and formal language, however, Hirsau had nothing in common with Cluny II; rather, it was very much in the tradition of eleventh-century German architecture. It was closely related to the house

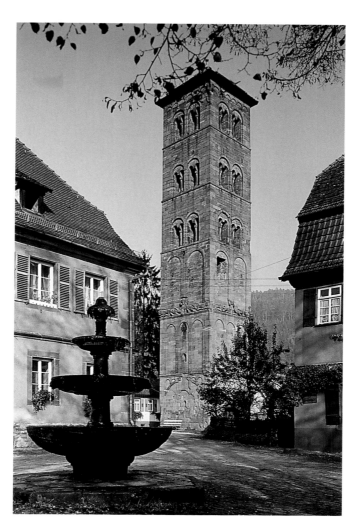

LEFT:
Remnant of the two-tower facade, Eulenturm (Owl tower), of the Romanesque monastery church Hirsau, early twelfth century

BELOW:
Plan, monastery church of Saints Peter and Paul, Hirsau

monastery of the Salic dynasty, which survives only as a ruin, built a half-century earlier in nearby Limburg an der Haardt. In both cases the church was a columned basilica with a flat ceiling and a quadratic transept, separated by cruciform piers and diaphragm arches. The east end was dominated by the quadratic scheme of the floor plan, since the presbytery and the arms of the transept formed a square. The distinguishing features in the nave were its columns with block capitals whose four sides were shaped like semicircular shields.

In Hirsau the liturgical use of the church and its subparts was laid out very precisely by William. The crossing, which was three steps higher than the transept arms and had barriers to the north and south, served as the *chorus maior* (larger chancel). Here, on two rows of U-shaped benches, the farther of which was elevated like later choir stalls, the *cantores* or *literati* sang their prayers. They were supervised by the abbot and prior, whose seats were in the west end.

In addition to the *chorus maior*, Hirsau had a *chorus minor.* It connected directly to the west side of the crossing and was separated from the nave by cruciform piers and a diaphragm arch that spanned the room. Here the piers took the place of the columns. The *chorus minor* was blocked off toward the middle vessel—not below the

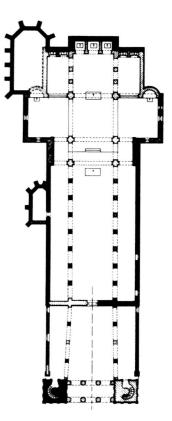

flying buttress but displaced a little to the east, toward the crossing. In a separate chapter of his *Constitutiones* William assigned the *chorus minor,* which was very close to his heart, to the *literati* as well, though in this case only to those who were no longer suited to the severe demands of choral prayer—for reasons of age or health, for example—and would therefore have been a disturbance in the *chorus maior.* William took this distinction between a larger and a smaller chancel from Cluny. In his scheme the transept was for the second class of monks, the *illiterati.* Weak or frail monks inside the monastery could use the Lady chapel for prayer. William says little about the third class of monastery residents, the working brothers. All that was left for them during services was the nave. In sum, the concept of the church may be understood as a building that had derived from the Salic tradition but was tailored to the needs of the Cluniac liturgy.

The Hirsau reform spread as rapidly as the others. In German-speaking lands it had more than 120 branches, though not in all regions. A new trend can be seen here that had not previously been so pronounced: certain distinct building practices established at Hirsau were passed on along with the reforms. For example, when a new monastery was founded the mother abbey sent not only the convention of monks but a troupe of stonemasons trained for the task of building the church. Many of the churches are so similar to one another that one can speak of a Hirsau school of architecture. The surviving examples include the monastery churches of Schaffhausen am Rhein, Alpirsbach, and Gengenbach, in the Black Forest (see p. 281); Paulinzella, in Thuringia (see pp. 278–79); Kleincomburg, near Schwäbisch Hall (see pp. 304, 308); and several others. Hirsau's influence can also be found in monasteries that did not join the reform.

Easily recognizable features from Hirsau include the *chorus minor,* which in later periods was no longer marked by diaphragm arches and cruciform piers but by a single square pier; the tripartite east end without a crypt; and the characteristic block capital with cusplike spurs. Stonemasons soon developed the ability to work ashlar and make elements such as round-arched corbel tables with extreme precision. By contrast, the art of the vault, as it was increasingly practiced and refined in other buildings of the time, was not a strength of these builders. Consequently, Hirsau architecture soon fell behind developments and, despite its high quality, became a tradition-bound, minor tributary that lacked innovative power.

THE CISTERCIANS

When Cluny reached the height of its development in the late eleventh century, as Cluny III was still being built, a new reform movement began. Three new orders would result: the Cistercians, the Carthusians, and the Premonstratensians. Each developed its own distinct aims and objectives. The most successful were the Cistercians, who soon became a mass movement comparable to the Cluniacs before them.

Foundation and Statutes of the Order

The origin of the Cistercians lay, once again, in withdrawal from the world, the desire for the remote existence of a hermit in a small community. The first impulse came from Robert of Molesme, the scion of a family from the upper nobility of Champagne. After a restless, itinerant period in his life that brought him to three different monasteries, he finally founded a monastery for his group of hermits in Molesme, in the diocese of Langres, in 1075. Because Robert believed that the Benedictine rule was followed only with lax indifference, he left there in 1098 and took twenty-one companions to an existing estate in a forested area south of Dijon. There he started a monastery that initially had no name (*novum monasterium* [new monastery]). Around 1119 it finally took the name Cîteaux (Cistercium), from which the name Cistercian is derived. The etymological root of Cistercium is uncertain: possibly *cisterna* (marshy terrain), *cistel* (gorse), or *cis tertium lapidem miliarium* ("beyond the third milestone" on the ancient Roman road between Langres and Chalon-sur-Saône). Before founding his monastery Robert secured protection from the archbishop of Lyons and the duke of Burgundy. The land was donated by Renaud, vîcomte de Beaune. The first buildings were wooden huts, and even the oratory that was consecrated the year of the founding, 1098, was a wooden structure.

Robert remained in the new monastery for just over a year, however, as by papal order he had to return to his previous monastery, Molesme, in 1099. There he was active as abbot until his death. His successor at Cîteaux was the former prior, Alberic, an old companion of Robert's, who removed the branch to a more favorable location not far away. It was consecrated in 1106. It was also Alberic who decreed that the monks wear, instead of the black habit of the Benedictines, a white one of undyed wool, which is why the Cistercians are known as the "white monks." Their work and travel clothes were, however, gray. Alberic's greatest success was when Pope

Paschal II, at Alberic's initiative, placed the monastery directly under the holy see and prohibited secular intervention. For life in the monastery Alberic established first guidelines in the *Instituta monachorum Cisterciensium de Molismo venientium* that were of decisive importance to further developments. The monks were supposed to follow the Benedictine rule precisely and conscientiously. Alberic insisted on the *puritas regulae* and the *rectitudo regulae:* that is, the rule's purity—that it be kept unadulterated—and its rectitude—that it not be called into question. The monastery was to be self-sufficient. For that reason outside donations were absolutely forbidden. To ensure that as the association of monasteries spread—as Alberic expected it to—each would retain its autonomy, new monasteries could only be established in remote, uninhabited areas.

The monks were required to do manual labor, but they could take in lay brothers to assist them. This soon led to a system of two classes, monks and conversi. The latter took an oath, like the monks, but they remained lay brothers outside the convention of monks. Their status corresponded to that of the *exteriores fratres* of the Hirsau reform, not that of the conversi of Cluny. Most entered only as adults, with talents in the crafts that allowed them to serve the church. Even donors to monasteries would often, in old age, enter the monastery they had established as conversi. In addition to conversi there were servants who took no oath, the *homines mercenarii* (hired men).

Alberic was succeeded in 1109 by the English nobleman Stephen Harding, who had come to Cîteaux together with Robert and Alberic. He directed the monastery until 1133 and died a year later. In its early years the monastery, which was struggling to survive, scarcely grew at all. That changed abruptly when in 1112 or 1113 the Burgundian nobleman Bernard of Fontaine, later known as Bernard of Clairvaux, entered the monastery with thirty companions. These included four of his five brothers, an uncle, and a cousin; his youngest brother and his father came later. With the arrival of this group, the size of the convention doubled. From then on an astonishing stream of new monks arrived. Soon it was necessary to found four daughter monasteries: La Ferté (*firmitas*), near Chalon-sur-Saône in 1113; Pontigny, near Auxerre, in 1114; Clairvaux (*clara vallis*), in southern Champagne, in 1115; and Morimond, near Langres, that same year. Cîteaux always remained the mother abbey, but when the order later spread, these first four filiations obtained the rank of primary abbeys. The founding convention in a filiation consisted of the abbot and twelve monks. They occupied provisional buildings on the land provided by the donor that had to be in place when they arrived.

In order to give the monasteries and their filiations a unified constitution, Stephen Harding worked out his *Carta caritatis* (Charter of charity). The word *caritas* was included in the title because the cohesion of the monastery, on which Stephen Harding placed great value, was supposed to be founded in mutual love, esteem, and harmony. The *Carta* was written in several stages. The experience gained founding the primary abbeys soon flowed into the original version. The result, completed around 1114, is now known as the *Carta caritatis prior.* A thorough revision, called the *Carta caritatis posterior,* followed around 1165–73. A final supplement followed in 1265.

In essence, the *Carta* aimed to establish the legal status of the filiations and the overall organization of the association. In contrast to the Cluniacs, whose many priories and even several abbeys were dependent on Cluny, every monastery was to be autonomous and self-sufficient. Each had the right to establish its own daughter monasteries, which in turn could continue to produce filiations. On the whole, this resulted in a picture like a genealogical tree with Cîteaux its trunk and the four primary abbeys branches that continued to ramify. As in genealogy, the four branches with their respective ramifications were called *lineae* (lines). Every monastery, regardless of its generation of filiation, was obliged each year to permit a visit from its mother monastery and to visit its daughter monasteries. The privilege of visiting Cîteaux itself was reserved for the primary abbeys. Their abbots, who had the rank of proto-abbots, had the right to discipline and even remove the abbot of Cîteaux in case of misconduct.

In addition, the charter specified that each year in September there would be a general chapter in Cîteaux with obligatory attendance for all abbots; this obligation was soon relaxed, however, so that abbots from especially distant monasteries only had to attend every third year and could obtain a dispensation under special circumstances. Abbots from Scotland, Ireland, Portugal, and Sicily needed to appear only every fourth year; from Greece, every fifth; and from Syria, every seventh. The charter was approved by Pope Calixtus II in 1119. The Cistercians were thus approved as an independent order by the highest ecclesiastical authority. The final confirmation came only in 1152, under Pope Eugenius III, who had been a monk at Clairvaux and was a pupil of Bernard.

If monastic life and customs were to remain unified even as the order spread further, the order's headquarters had to provide written information and instructions for all the monasteries. Because experience from daily life at the filiations had to be taken into account, these texts had to be augmented, supplemented, and altered several times, which is why it is often difficult to determine exactly when they were written. There is a brief report on the history of the founding of the order called the *Exordium Cisterciensis cenobii,* also known as the *Exordium parvum,* to which the *Carta caritatis* was appended. It was followed by an expanded guide titled the *Exordium Cisterciensis et capitula,* which contained not only a summa of the *Carta caritatis* but also a first collection of the resolutions of the general chapter. It was also known as the *Exordium magnum.* As usual, the *consuetudines* provided information about the customs of life in the monastery. They consisted of three parts: the *liber usuum* (book of practices), the *ecclesiastica officia* (ecclesiastic offices), and the *usus conversorum* (practices of the conversi). These were the regulations for general practices, divine services, and the lives of the conversi, respectively.

After Stephen Harding died, a commission under Bernard's leadership was set up to govern the liturgy in accordance with the Benedictine rule. In 1147 the general chapter approved the resolutions, making them binding. A strict, uncommonly harsh life was thus made obligatory for the monks. Depending on the season, the day began either at 1 or 2 A.M. and ended at 4 P.M. in the winter and 8 P.M. in the summer. In between there were six to seven hours of choral singing, with interruptions, in the unheated church. The other rooms of the monastery were also miserably cold—so cold that the soup was sometimes frozen when brought to the table. The monks prayed, fasted, and literally froze to death. It is no wonder that they did not grow old. In the cold regions of Europe their life expectancy was under thirty years.

Over time, the question of which guidelines the general chapter—the supreme authority for decisions—was meant to follow became problematic. In 1119 it met for the first time, but the *Instituta generalis capituli* was not published until 1151. The full assembly gradually became much too large to permit discussion and consultations. Hence a smaller, more effective committee, limited to twenty-five abbots—the *definitorium*—was established in 1197. Its composition, however, led to such a conflict among the abbots of Cîteaux and the four primary abbeys that in 1265 Pope Clement IV sought to preside over the matter from the highest level, but even

this succeeded only after a second attempt, thanks to a compromise: the general chapter retained the right to approve or reject the proposals of the *definitorium.* The resolutions of the general chapter were published in the *Libellus definitionum,* first compiled in 1202 and then updated several times, every twenty years or so. It was thoroughly reworked in 1316, and with supplements from 1356 it was considered valid for later periods. The *Libellus* represented a kind of constitution for the order; it had to be present in every monastery.

Bernard of Clairvaux

Even if the charter was written by Stephen Harding, at least in its original form, and even though Bernard called him *noster omnium pater* (father of us all), it was Bernard who was the leading personality during the order's early period. In 1115, at the age of twenty-five, Bernard become the abbot of the newly founded monastery Clairvaux. The flow of new monks was so incessant that on average two new monasteries could be established from Clairvaux every year. The Benedictine commandment of *stabilitas loci*—the obligation to remain at the monastery—was scarcely followed by Bernard. He was so much in demand as an adviser in spiritual and political questions that he traveled around Europe several times, actively engaged in politics. It was thanks to his arbitration that the schism between Anacletus II and Innocent II could be ended. This obligation to be active outside the monastery led Bernard to call himself the "chimera of the century," half monk and half layman. Despite his desire to follow his monastic obligations properly, from 1145 onward he ceded to Pope Eugenius III's request that he preach in Germany and France in support of a crusade. He had great success in the cathedral of Speyer, for example, where he won King Conrad III over to the cause. When the crusade failed miserably, Bernard immediately took the initiative for a new crusade, but it found no support. He had personal and written contact with many great men of the world, including the abbots Peter the Venerable of Cluny and Suger of Saint-Denis. Bernard sharply condemned the splendor of Cluny and every other kind of luxury (*superfluitas*) in his *Apologia* of 1124, which became famous, and he rejected Suger's new building at Saint-Denis even more forcefully. His monastic ideals were simplicity and plainness, paired with a piety that had aspects of a mystical absorption.

The Spread of the Order

Without Bernard's charismatic powers of persuasion, which he used to demand frugal, puritanical strictness from the monks, the Cistercians would surely not have attracted so many new members. In the briefest span the order spread throughout Europe, even to its most remote regions, an impact that not even the Cluniacs had enjoyed. In 1147 an entire association of monasteries joined the Cistercians: the congregation of Savigny, in southern Normandy, which included thirty-one abbeys. Several smaller congregations joined as well (Grandselve, Obazine, Dalon, and Cadouin). By the time of Bernard's death in 1153, 70 monasteries had been founded from Clairvaux, the homes of some 700 monks and conversi. In France at the time there were more than 180 Cistercian monasteries, and about 350 in Europe. By around 1200 the number in France had increased to about 225, and in Europe to 530. About 50 years later the growth in France ceased, but in Europe there were 170 more monasteries. The European peak, 742 branches, was reached at the end of the thirteenth century. Of these, just under half (355) could be traced back to Clairvaux. Morimond had 193 branches, most of them in German-speaking regions; and the mother monastery, Cîteaux, had 109. The other two primary abbeys had many fewer: Pontigny's filiation consisted of 43 monasteries and Le Ferté's, just 17.

A little later a congregation of nunneries arose in parallel with Cîteaux. The starting point was Le Tart, northeast of Cîteaux, founded in 1125. On the model of the Cistercians it also had a general chapter and a system of visitations. The congregation of the Spanish nunnery Las Huelgas, near Burgos, founded in 1187, had a similar organization. Around 1196 both these communities were incorporated into the Cistercian order, which had a fully entitled branch for nuns alongside that for monks. In much of Europe there were many more Cisterican nunneries than monasteries. The branches of the order were so densely distributed around Europe that the historian Bishop Otto of Friesing, a scion of the Babenberg margrave of Austria and a former abbot of Morimond, could write that the world had become Cistercian. The new foundations grew ever closer. To prevent the monasteries' beleaguering one another as a result of too much proximity, the general chapter decreed in 1152 that from then on permission would be required to found a new monastery. In addition, there had to be a minimum distance of fifteen thousand steps, about six miles, to the nearest monastery.

To the same extent that the Cistercian monasteries were overrun with monks, the numbers of Benedictine monks decreased rapidly, even in large and famous abbeys, sometimes dropping nearly to zero. The Cistercians had a power of attraction that is difficult to explain, particularly with knights, who joined in massive numbers once they put aside their youthful days of adventurous battles, jousting, and courtly love. Those who had once confronted enemies and opponents could now fight Satan and his temptations.

Donors and Colonization

Another reason for the inexorable and triumphal rise of the Cistercians was surely that the order had an army of specialists in agriculture and forestry and possessed well-equipped estates everywhere—the so-called granges (from the Latin *grangia,* or granary). Their agriculture benefited from the unusually mild climate of the period. Food could be guaranteed, with the help of large fish ponds. This may have moved many to enter monasteries, especially since Europe's population was growing so quickly that it is estimated to have doubled between 1050 and 1200. If the existing agricultural resources were not sufficient for this growth, the Cistercians could at least ensure that output rose accordingly in order to keep hunger within limits. That is why most donors wanted the monasteries they established to be occupied by Cistercians, even though they demanded the freedoms from donors that Alberic had guaranteed. While in the beginning, donors could not be buried in the monastery church—once an important motivation for founding a monastery—in 1157 this prohibition was lifted, and from 1180 onward not only donors, but kings and queens could be buried in Cistercian churches.

Moreover, the order had from the start prohibited donors from setting up an administration that might have influenced the monastery's development. The protectorate was either a *defensio specialis* with the king or a *defensio imperialis* with the emperor. Because the Cistercians, at least according to their charter, could only settle in unpopulated seclusion, donors liked to employ them to colonize land: they cleared forests, drained swamps, and made great stretches of land arable in order to work them. Many conversi were required for such tasks. Frequently they were twice as numerous as the monks, sometimes more than three times—for example, at Rievaulx in England, which had 150 monks and 500 conversi in 1165.

The charter was not followed everywhere, however. In many regions—for example, in Bavaria and

Lombardy—there was scarcely any wilderness left, so monasteries were founded in populated landscapes, sometimes even—though this was strictly forbidden—in close proximity to a city or town, like Chiaravalle, near Milan, or Riddagshausen, near Brunswick in Lower Saxony. Frequently enough, the founding convention either took over an existing monastery that had belonged to another order or took up temporary residence in the donor's castle, thus sparing themselves the trouble of building the first provisional huts. That a monastery would be moved from its original site to a more favorable one—usually a broad river valley with plenty of water—was more the rule than the exception. Sites on mountains, large rivers or lakes, at the sea, or on a small island were all scorned. A Cistercian monastery in a remote river valley, surrounded by hills, fields, and forests, always offered the charm of a peaceful, idyllic landscape, an inviting *locus amoenus* (delightful place) that offered a retreat from the world. The desire for isolation had its unpleasant side, however: when the Cistercians were granted a nearby village, they would ruthlessly drive away the farmers living there or, if necessary, use them as paid laborers. Already in the twelfth century this caused some of the population to hate the white monks. The complaints multiplied.

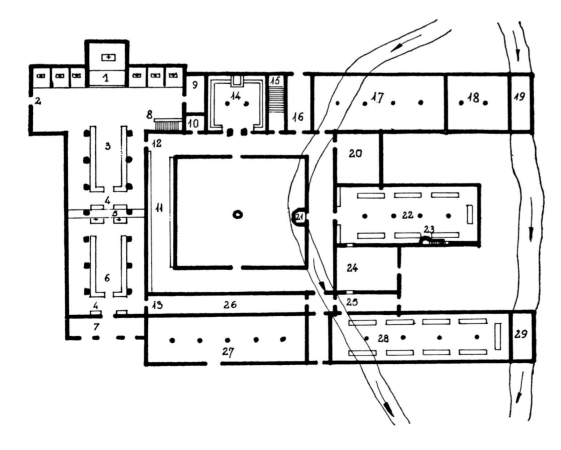

Cistercian Architecture

In the beginning the monastery buildings, as the Norman Benedictine Ordericus Vitalis emphasized, were to be constructed by the monks themselves—that is, by conversi—in secluded forests. At many sites, however, construction tasks were soon given to paid stonemasons, as is evident from the fact that the stonework reveals markings that were required to settle accounts. The layout of the core area of the monastery soon evolved into a schema that was so simple and functional it would be used everywhere, with slight alterations demanded by the locality. Unlike those of other orders, every Cistercian monastery was a double monastery in terms of construction, since it consisted of two separate parts with distinct functions: one part was intended for the monks and was grouped around the cloister, much as it was on the Sankt Gallen plan; the other was a wing on the west end, parallel to the cloister, for the conversi. Between the two, in many monasteries there was a lane—the "conversi lane"—separating the two classes even more.

The basic elements for the monks' area consisted of the chapter house, which was always in the east; an adjoining workroom, which was sometimes connected to the novitiate; an upper-floor dormitory that extended around the entire lower floor; a stove room on the south side of the cloister—the only common room that could be heated—along with the refectory; and, opposite the refectory's entrance, a well house that extended into the courtyard. In the conversi wing, the ground floor had the storeroom and the refectory; the upper floor consisted entirely of the dormitory, which was often enormous. The kitchen was usually on the south side of the cloister, between the refectories for the monks and for the conversi. As a rule, all rooms were vaulted. For the chapter house, which was nearly always square, the traditional four-column room was usually preferred, while the elongated rooms—the refectory, the dormitory, and the workroom—usually had two aisles, but sometimes only one and, rarely, three.

The farm building was located outside the core area. Also important, finally, were the subterranean canals used to bring water from the river: first, for the well house and second, to drain the latrines for the monks and the conversi. Already by the time of Fontenay (see pp. 166–170), the second daughter abbey of Clairvaux, founded in 1118 but at its present location only since 1130, this schema was exemplarily developed. Of the core area, the church, the cloister, and the rooms of the east end have survived. The monks' refectory, the well house, and the entire conversi's wing are lost.

The same schema for the layout, with some additional buildings, was used for Cîteaux and Clairvaux. Unfortunately, the medieval buildings of Cîteaux and the four primary abbeys were almost entirely destroyed, except for the church at Pontigny, when the monasteries were closed in 1790. There are, however, engravings of the overall layout that date from the Baroque period. The first wooden buildings at Clairvaux were extremely modest. There was a square church, which the layout shows to have been constructed similar to Norwegian stave churches, and an attached building with the kitchen and refectory on the ground floor and the dormitory on the upper floor—all without a cloister. Bernard himself lived in a cramped, dark cell above the stairs in which he could not even stand upright. This cell was preserved as if a relic, and it was still shown to guests during the Baroque period. Only many years after the monastery was founded did Bernard, under the pressure of the rising numbers of monks, allow himself to be persuaded to build a completely new, sufficiently large monastery some 1,000 feet (300 m) to the west. The decision was probably made just before 1130. The driving force behind the new building was Bernard's cousin Godfrey, who was prior at the time. Bernard received generous outside donations for the building, which he used to pay the wage laborers. But conversi still worked alongside them. From Cîteaux and Clairvaux this schema for the layout spread, as can be seen not only from Fontenay, but also from the contemporaneous English abbey Fountains (see pp. 232–239), where Bernard sent his architectural adviser, Geoffrey d'Alaine, in 1135. Rievaulx abbey, whose buildings were begun around 1132 by William, Bernard's former secretary, also holds to this schema, which took only a few decades to spread throughout Europe. This process was aided by exact measurements taken at Clairvaux by the builders of other monasteries and then passed on to others.

As precise as the charter of the order may have been in other respects, it contained no detailed instructions for the buildings, not even the church, only some general prohibitions. It proscribed stone towers, as well as any extravagance of decoration that would have distracted the monks, like stained-glass windows or figurative depictions. It called for simplicity. Despite this lack of rules, a striking number of Cistercian churches share a common schema in their eastern sections: a projecting, often low transept, with multiple chapels to the left and right of the sanctuary—sometimes just two, but often four (Fontenay) or six (Pontigny in its original state), and on rare occasions as many as eight (La Ferté).

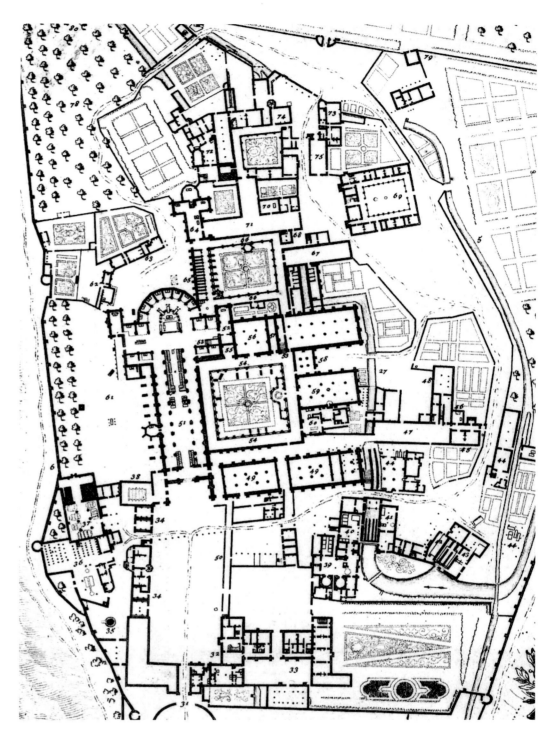

Plan of Clairvaux, engraving by C. Lucas, 1708

The sanctuary and chapels have either flat terminations or apses. The chapels were used by the choir monks for their daily private mass. The larger the convention was, the more chapels were required. When more chapels were necessary, they were sometimes placed in the west side of the transept and along its north and south end walls (Pontigny). Because this schema is particularly common in the filiations of Clairvaux, it is often called the Bernardinian plan. It may indeed have been developed at Clairvaux by Bernard and his builders: the first stone church here (Clairvaux II), probably begun in 1130, appears to have had eight chapels on the east end of the transept, as La Ferté did later.

The schema for the layout offered a wide variety of possibilities for the structure, to accommodate the

building practices of a given region. In the Burgundian tradition, any part of the church could have pointed barrel vaults. The classic early example is Fontenay, which also had the peculiarities of side aisle bays that were replaced by aisles with transverse barrel vaults and a middle bay that had no clerestory. Transverse barrel vaults optimally brace the lateral thrust of the longitudinally oriented vault of a middle bay. In other

For divine services and choral prayer the monks had their place in the east end of the nave; the conversi, in the west end. In each case, choir stalls were placed along the pillars. To make the space less crowded, they were placed as close to the pillars as possible. Consequently, the projections of the pillars did not start at the floor, as was otherwise usual, but only above the stall, on corbels—another widespread characteristic feature of

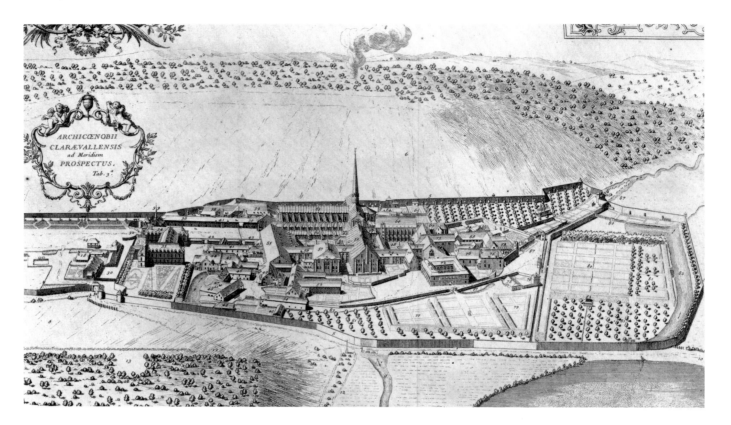

churches, especially in southern France, the side aisles are often vaulted with rampant half vaults that provide an abutment for the main vault across its entire length. This technique for vaults had been tried in the early Romanesque period in the south, for example in the galleries of the large pilgrimage churches. In England the Cistercians built in the local Norman tradition; in the Po valley they adapted their buildings to Lombardian brick architecture; and in Germany they occasionally revived the traditional column basilica, with or without alternating columns and piers. In the early period the overall picture is highly uniform.

Other than the schematic layout of the Bernardinian plan, the order did not develop a binding, specific Cistercian architectural style. The masons' guilds placed great value on precise stonework, as if in compensation for architectural ornament, which was forbidden. The ashlar was not only hewn but frequently also polished smooth, something that would otherwise only be done on articulating elements such as wall projections or engaged pillars.

Cistercian architecture. The area for the monks was separated from that of the conversi by a barrier. The two classes remained separate even in the church, and they also had separate entrances. The monks entered the church directly from the dormitory by a stairway or from the cloister through a door; the conversi had an entrance in the west end. The common people had no access, although they were at least allowed to go into the entrance hall, which in many Cistercian churches, though by no means all, extended in front of the main block in the west.

Because the number of monks was always increasing in the large abbeys, soon the Bernardinian plan was no longer sufficient, because it did not have enough chapels or altar positions. More elaborate solutions for the east end were inevitable. Clairvaux took the first step. Around 1148, while Bernard was still alive, a substantially larger church (Clairvaux III) was begun, which was about 390 feet (120 m) long, including the entrance hall. By contrast, Clairvaux II is estimated to have been only about 200 to 230 feet (60 to 70 m) long. The new

church was consecrated in 1174, at the same time that Bernard was canonized. The Norman king William I of Sicily donated a handsome sum for its construction, and after its consecration the English king Henry II donated a lead covering for the roofs.

The new element of the conception was the introduction of a periapsidal aisle with chapels, which forms a semicircle around the apse of the sanctuary, following the model of Cluny. Unlike Cluny, however, the chapels were placed close together, forming a wreath. Because they all had flat terminations, on the outside they represented nine sides of a sixteen-sided polygon. The periapsidal aisle was higher than the chapels and had its own annular windows. This staggering of heights resembled Cluny, but the compact series of chapels was more like Saint-Denis and the first Gothic cathedrals, which were then just being developed. Clairvaux had eight more chapels on the east and west sides of the transept, which brought the total number of altars in the east end to seventeen. The schema for the layout of Clairvaux III was soon imitated—nearly literally at Alcobaça in Portugal and in slightly altered form at Pontigny. There, beginning around 1180–85, the recently completed church was given a new east end with thirteen chapels in the periapsidal aisle. Together with the twelve existing chapels in the transept, the church had a total of twenty-five altars. In later Cistercian churches with periapsidal aisles, the Gothic cathedral had more and more influence—for example, at Longpont, Royaumont, Valmagne, and Altenberg. Another example was the church of Vaucelles, near Cambrai, which has disappeared without a trace; at a length of about 425 feet (130 m) it was larger than any other Cistercian church. In the first half of the thirteenth century the architect Villard de Honnecourt was so struck by the ground plan of the east end that he recorded it in his sketchbook.

Another possibility for increasing the number of chapels was tried at Cîteaux. The church was consecrated in 1193, not quite twenty years after Clairvaux. It is not clear whether the whole church, which was some 300 feet (90 m) long, was built during this campaign, or whether (as scholars generally believe) there was an older church based on the Bernardinian plan, to which a new east end was added. The east end is generally known as Cîteaux III. In contrast to Clairvaux, the ground plan here is still rectangular. A U-shaped periapsidal aisle with a series of ten or twelve rectangular chapels was built around a boxlike sanctuary. Since there were also chapels in the transept, the east end had a total of about twenty-one altars. As at Clairvaux the

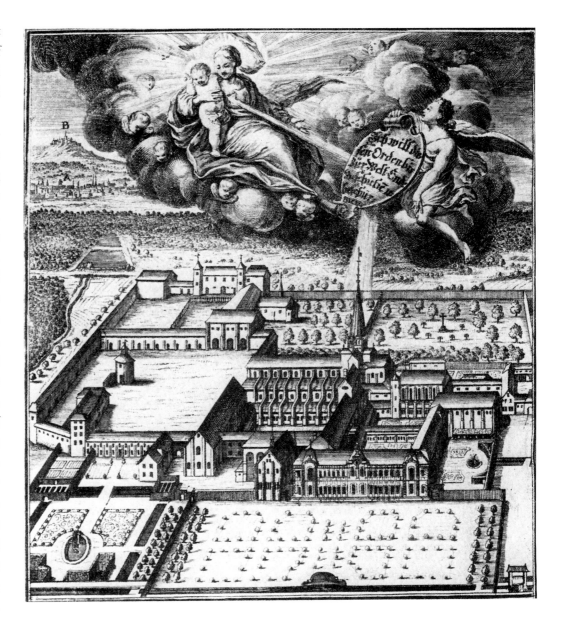

Cîteaux, head monastery of the Cistercians, seventeenth-century engraving

periapsidal aisle was higher than the chapels and had its own windows. This solution, which is similar to that sketched by Villard de Honnecourt, soon became a defined type, which spread widely in a number of variations—for example, in the German Cistercian churches Ebrach and Riddagshausen.

Morimond offered another variation on Cîteaux III. Here the east end, which can be dated to around 1180–85, has nearly the same rectangular ground plan, but its periapsidal aisle and chapels are at the same height, and together they form a U-shaped, two-nave hall around the sanctuary. The chapels were separated only by barriers. Placing the periapsidal aisle and the chapels on the same level was analogous to the chancel of Abbot Suger's church, Saint-Denis, but it had a different ground plan—namely, that of the French periapsidal aisle with a radial wreath of chapels. Morimond's solution also became a type. Its successors include Lilienfeld in Austria, Walkenried am Harz, and later, in its basic layout, Salem on Lake Constance.

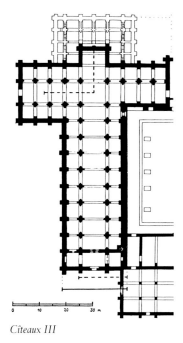

Cîteaux III

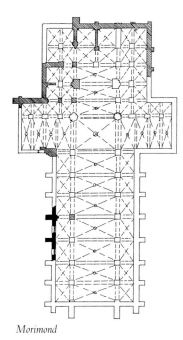

Morimond

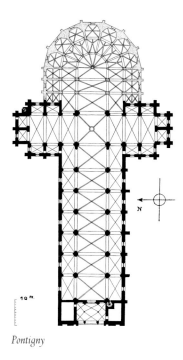

Pontigny

Structurally, Clairvaux, Cîteaux, Pontigny, and Morimond had innovations over such earlier buildings as Fontenay, in that their vaults abandoned the uniform shape of the barrel vault and introduced the cross vault, first with groins and then with bands. The vault used in combination with wall projections no longer divided the naves into segments but into clearly articulated bays—that is, into spatial units out of which the naves are composed step by step. Later, in classical cathedrals, the trave system was developed, in which a more or less square aisle bay was placed on either side, left and right, of a lateral oblong middle bay. The design of the wall had two levels: a nave arcade and a clerestory. One exemplary use of this structure is Pontigny, but it is also found in the German monastery Ebrach in Franconia and in Italy's Fossanova, south of Rome. Cistercian architecture had now become international. In countries outside France where the Romanesque still dominated, especially in Germany, the Cistercians became the pioneers of the Gothic. Over the course of the Gothic period its architecture increasingly adapted to regional developments, like the early English style. It may have lost some of its uniqueness, but never its quality.

The Order in the Late and Post-Middle Ages

The monasteries of the order were soon producing not only for their own needs but also for sale, and thus they took part in the money economy. Many monasteries specialized in iron smelting; others had saltworks; still others purchased entire markets and cities and drove farmers from the villages. Nearly all of them were involved in trade by means of inns that they set up themselves. The monasteries grew rich. In the late Middle Ages the number of conversi declined and monasteries were forced to lease their land, although in fact this was prohibited. At the insistence of Stephen Lexington, who was born in England and was abbot of Clairvaux after 1243, a college, attached to the university but with its own professors, was founded in Paris to provide theological education. Soon there were similar Cistercian colleges in other university cities as well.

In the thirteenth century and especially in the fourteenth, the inexorable decline of the order began. Mendicant orders in the cities began to increase their numbers. Many Cistercian monasteries became poor or perished entirely. Within the order, which increasingly deteriorated, particularly in France, there were reforms attempting to resurrect its original ascetic ideals. The La Trappe abbey was particularly important here. During the first half of the seventeenth century it introduced to the order the distinctive movement of Strict Observance, which from then on continued to exist alongside the Common Observance. In 1893 Pope Leo XIII elevated the Cistercians of the Strict Observance to the rank of an independent order, now known as the Trappist order. At present the two orders have almost equal numbers of branches: the Trappists have ninety-six monasteries and sixty-six convents; the Cistercians have eighty-eight monasteries and sixty-six convents.

The Hermitic Orders

Like the comprehensively organized community life of the Benedictines, the ideal of the strictly isolated existence of a hermit, which had marked the beginnings of Christian monasticism in the fourth century, had never been forgotten. In the tenth century it had a revival, propagated by Adalbert, the apostle of the Czechs and bishop of Prague (murdered in 997 as a missionary among the pagan Prussians [*Pruzzen*]), and the Byzantine Nilus of Rossano (d. 1005), the founder of Grottaferrata, near Rome. An independent hermitic order, the Camaldoli, grew out of the hermitage of that name in a remote valley in the Apennines, near Arezzo. Its founder was Romuald, a scion of a ducal house of Ravenna. Romuald had such an influence on the young emperor Otto III, who had sought him out, that Otto himself considered withdrawing from the world. The order was established soon after 1000. John Gualbert also lived as a hermit in Camaldoli; in 1038–39 he founded a contemplative hermitic order, the Vallombrosans, with strict seclusion and a vow of silence, in Vallombrosa (shady glen) near Florence. In this monastery and order, for the first time, the lay brothers, the conversi, were accepted into the community as regular members beside the monks who performed choral duties. The passionate spokesman of the hermitic movement was Peter Damian of Ravenna (1007–1072), a highly educated man who had lived for a time as a hermit before he was appointed bishop of Ostia and papal legate. In his writings, influenced by eastern monasticism and Romuald, he praised hermitage as the path to the truth and to God. The idea that only monks could escape the torments of hell—an idea that would be prevalent later, taken up even by Anselm of Canterbury—goes back to Peter Damian. It was a good reason to enter the monastery. Peter Damian advocated that even worldly persons who belonged to no order should at least live like monks.

The Carthusians

The desire for monasticism based on hermitage spread rapidly to the northernmost parts of Europe. Around 1070 Robert of Molesme, who founded Cîteaux, was the head of a group of hermits in the forests of Colan in East Franconia, and he founded Molesme as a hermitage. Around 1080 Bruno of Cologne, the former director of the cathedral school at Reims and then chancellor to the archbishop there, withdrew to Molesme. One of his pupils later became Pope Urban II. In 1084 Bruno and six companions settled in the wild mountain landscapes at the foot of the Alps north of Grenoble, where he founded a wooden hermitage at an elevation of 3,870 feet (1180 m), called a charterhouse (*cartusia*). Just six years later, however, Urban II called him to Rome, and from there he went to Calabria, where he founded a second charterhouse. There he died in 1101. The charterhouse near Grenoble was destroyed by an avalanche in 1132 and moved to its present location. It was built as the center of the new Carthusian order, the Grande Chartreuse. The branches of this order had no abbot, only priors. The Carthusian rule (*consuetudines cartusiae*) was not written until 1127, by Guigo, the fifth prior of Grande Chartreuse and a friend of Peter the Venerable of Cluny and Bernard of Clairvaux. The rule was confirmed by Pope Innocent II in 1133, and the order as an autonomous institution by Alexander III in 1176. Like the Cistercians, it had exemption. The Carthusians also held an annual chapter, which was obligatory from 1155 onward.

The rule tried to combine two practices that are really mutually exclusive: life as a hermit and life in a community. The monks were united in the church—a simple oratory with a single nave—during approximately eight hours of choral prayer and the daily mass, as well as in the chapter house during meetings on Sunday morning and in the refectory on Sundays and holidays. Otherwise, each monk lived as a hermit under a strict vow of silence in his own small house that consisted of an entry room with heating, a cell with a side chamber, a small workshop, the corridor to a somewhat private latrine, and a garden surrounded by a high wall. Water and food were handed to the monks through a hatch in the door. There was no contact with neighboring houses. These little houses were aligned identically, wall to wall, along the cloister. The cemetery was located in the cloister; it was a constant memento mori for the monks. Nothing essential about this schema for the layout, which is as simple as it is functional, changed over the years, just as the order itself never underwent reform.

Each monastery was to have just twelve monks and a prior, but later there were double charterhouses with twenty-four monks. Two classes of lay brothers were responsible for providing for them: the conversi, who, as in other orders, had taken a vow, and the *donnés*, who lived in the monastery without having taken a vow and thus were free to leave. Both classes lived separate from the monks in individual cells arranged around a separate, smaller cloister. It tended to be placed next to the west end of the church, between the large cloister and the farmyard, not far from the prior's house. In the church the monks had their place in the eastern section, the conversi and donnés in the west. The two areas were separated by a rood screen, sometimes with the large cloister passing through the church to serve as that screen. Such cloister-screens, which offered the monks an especially practical means of entering the church, were particularly widespread in German-speaking lands. The only one to have survived in good condition is in the charterhouse Buxheim, near Memmingen in Swabia.

This order spread much less quickly than the Cistercians. Around 1200 there were only 37 charterhouses in all of Europe, then 56 in 1258, and more than 170 in 1360. In the early sixteenth century the order had 195 monasteries in 17 provinces. Although the Carthusians were a hermitic order, from the fourteenth century onward there were many monasteries on the outskirts of cities and sometimes even in them, although high walls preserved the hermitage ideal—such was the case, for example, in Paris, Cologne, Basel, Nuremberg, and Rome (at the Baths of Diocletian). In Nuremberg, for example, donors and contributors to urban charterhouses included whole groups of wealthy citizens, each of whom would finance a small house in exchange for a guarantee of prayers of intercession. Several charterhouses were founded from the start as burial sites for high-ranking donors, who paid enormous sums for prayers of intercession. Famous examples include Certosa del Galluzzo, on a rocky plateau outside Florence, which Nicola Acciaiuoli, one of the richest men of his century, had built in 1342; the charterhouse Villeneuve-lès-Avignon, founded with Pope Innocent VI as donor in 1356 and then expanded by three nephews, all bishops, until it exceeded the Grande Chartreuse; Certosa di Pavia, founded in 1390 with Visconti dukes of Milan as donors and later magnificently expanded by their successors, the Sforza (see pp. 404–7); and finally, probably the most famous example, the burial site of the dukes of Burgundy, Champmol, near Dijon, founded in 1385

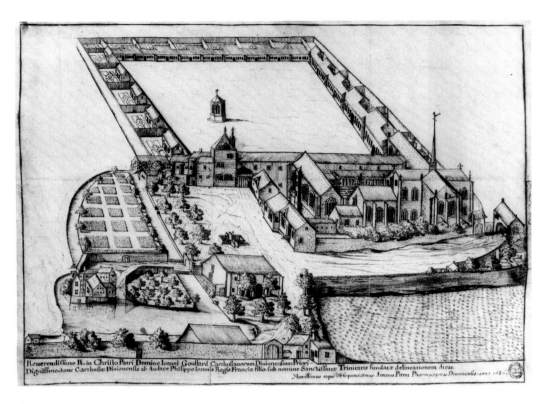

ABOVE:
*View of the charterhouse at Champmol,
near Dijon, 1686*

BELOW:
*The Grande Chartreuse, near Grenoble,
after the seventeenth-century
reconstruction. Hand-colored ink drawing,
private collection*

with Philip the Bold as donor and decorated with an abundantly rich, princely luxury by the finest masters of the time. The tombs of Philip, his son John the Fearless, and John's wife were decorated with sculptures and placed in the middle of the chancel so that they would always be reached by the monks' prayers. This princely pomp on a tomb was quite contrary to the hermitic ideal of the order.

The Carmelites

Approximately a century after the Carthusians, in the context of the Crusades and pilgrimages to the Holy Land, another hermitic order arose, called the Carmelite order, after Mount Carmel, where its first brothers settled. The first rule was written for it between 1206 and 1214 by the patriarch, Albert of Jerusalem. Soon after, between 1247 and 1253, when the Carmelites had to withdraw to Europe in flight from the Muslims, Pope Innocent IV transformed their order, with a modified rule, into a mendicant order. Only in this form did the Carmelites become significant in Europe.

THE CANONICAL ORDERS

In addition to monks there were other clerics who also led a regulated community life but who, as secular clergymen, did not belong to an order: the canons. In cathedrals their principal task was to serve in the choir. The collegiate foundations were communities of this kind formed at important nonepiscopal churches. Bishop Chrodegang of Metz established the first rule for the life of cathedral canons around 745–50; with alterations it was pronounced imperial law by Louis the Pious at the synod of Aachen in 816. It took all the communities that did not belong to the *ordo monasticus* and joined them into an *ordo canonicus.* Unlike the monks, the canons could retain their property and did not need to take an oath. Private property increasingly became a point of dispute and cause for offense.

Over the course of the great eleventh-century reform of the church, therefore, the Lateran synod of 1059 established new regulations for the status of canons by urgently recommending that they "eat in a community, sleep in a community, and receive their earnings in a community." The secular clergy was supposed to be "regulated" in the *vita communis* just like the clergy of the orders. Those who followed the resolution became "canon regulars"; those who did not became "secular canons." The canon regulars were soon subject to the same three oaths as the monks: obedience, poverty, and chastity. Unlike the monks, however, the canons retained the opportunity to provide pastoral care, to preach, and to convert others—very much in keeping with the Great Commission given to the apostles—but also to do good works outside of the foundation, such as caring for the poor or education.

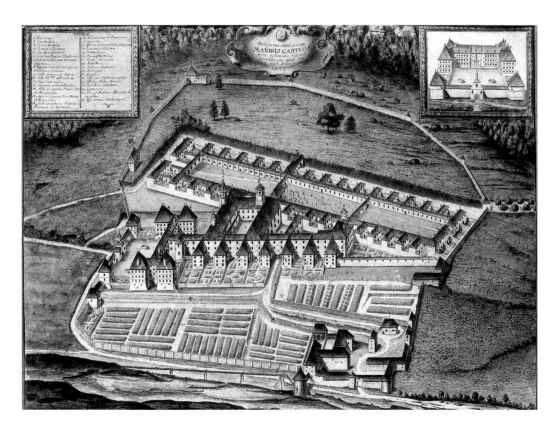

Augustinian Canons

The Benedictine rule was not as well suited to the latter goals as the broader, vaguer Augustinian rule. Consequently, the founding of the order of Augustinian canons cannot be determined precisely or attributed to a single person or group; rather it arose gradually over a long period. The starting points were San Frediano in Lucca, Saint-Ruf outside Avignon, Saint-Victor in Paris, Rottenbuch in Bavaria, and the cathedral chapter of Salzburg.

The Augustinian canons did not have a central administration; instead they formed numerous congregations, each with its own *consuetudines*. The order was marked by great variety, evident alone from the fact that in the Romance languages the head of a religious association is called the equivalent of "abbot" and his representative, the equivalent of "prior," but in German the equivalents are provost (German *Propst,* from the Latin *praepositus,* or someone placed in charge) and dean. Around the middle of the twelfth century the reform movement had more than 150 religious associations across Europe; just before the Reformation the number was more than 1,600.

Premonstratensians

The canon regulars were brought closer to the monastic orders by Norbert of Xanten (c. 1080–1134), who came from a family of counts of the Lower Rhineland and found his calling in traveling the country as an itinerant preacher. His ideal was a hermitic or Cistercian monasticism that also saw pastoral care, preaching, and good works as its tasks. That is why he chose the Augustinian rule over the Benedictine one, despite his fascination with the strictness of the Cistercians. In 1120 he and several companions founded the monastery Prémontré (Praemonstratum in Latin) in a remote valley near Laon, which was soon joined by eight more religious associations. At his newly established monastery Norbert sought to make the life of the canons far stricter than that of the Augustinian canons, approaching that of the monks. In 1126 Pope Honorius confirmed the new community as "canons of Saint Augustine according to the practices of Prémontré." That was the start of the Premonstratensians as a church-recognized order. That same year Norbert was appointed archbishop of Magdeburg. From there he made a concerted effort to use his new order, with the Liebfrauenkloster in Magdeburg as its center, for missionary work east of the Elbe River. That is why the cathedral chapters of Brandenburg, Riga, Ratzeburg, and Havelberg had Premonstratensian canons.

At the mother monastery, Prémontré, it was Norbert's successor, Hugh, who first gave the order a charter and uniform liturgy. Following the model of the Cistercians he introduced not only the establishment of a general chapter, but also the mother monastery's right to visit the daughter institutions. The order, which was divided into provinces called circaries, was most widespread around 1200. It included more than 500 religious associations throughout Europe, of which 150 were in Germany. Neither the Augustinian canons nor the Premonstratensians had a unique architectural style. They adapted to regional traditions and building customs, but in doing so they often achieved high artistic quality—for example at Knechtseden, near Cologne, and Jerichow, near Tangermünde (see pp. 263–66).

Canonical Communities of Women

Alongside the male canons there were also canonesses, who were likewise not required to take an oath and who could retain their possessions, which did not become community property. In addition, they were allowed to leave the monastery either temporarily or permanently. They were even permitted to have a servant. The community of canonesses were under the direction of an abbess, and followed certain rules for communal life, common prayer, and divine searches, much like the canons among the men. The canonical communities of women (*Kanonissenstifte*), which from the late Middle Ages onward were also known as communities of ladies (*Damenstifte*), were ideal establishments to provide for high-ranking widows and unmarried or unmarriageable daughters of the nobility. As an institution they were already flourishing in the Carolingian period, but they thrived even more during the Ottonian period. A few religious associations, which had a rank like that of imperial associations, were reserved for the higher nobility. The highest ranking of them included, above all, Quendlinburg, then Gandersheim, Herford, and Essen, but also Gernrode, Nivelles, and Freckenhorst. Not infrequently their abbesses came from the house of the current ruler. No less than nine abbesses were of Ottonian origin, although three of these were in charge of a monastery, rather than an association. In Essen this is evident in another way: the interior of the westwork is an imitation, in polygonal concha form, of Charlemagne's imperial chapel in Aachen—that is, the very symbol of imperial rule. It was commissioned by the abbess, Theophano, a granddaughter of Empress Theophano and Emperor Otto II. In northern Germany many of the noble religious asso-

RIGHT:

Essen Cathedral (former church of the canonical community of women), three-sided termination of the Ottonian westwork modeled after the imperial chapel in Aachen

BELOW:

Former church of the canonical community of women, Freckenhorst, Westphalia, consecrated 1129

ciations became Protestant with the Reformation and continued to exist in that form. Former convents also became religious associations. Such communities of ladies continue to exist today—for example, Fischbeck, on the Upper Weser; Preetz, near Kiel; and the "heath monasteries" Wienhausen and Lüne.

THE RELIGIOUS ORDERS OF KNIGHTS AND THE HOSPITAL ORDERS

The Knights Templars and the Knights of Saint John

The crusades to the Holy Land produced a new kind of order: the religious orders of knights. They combined the military, battle-ready knighthood with the monastic ideals of obedience, poverty, and chastity. The First Crusade to Jerusalem had taken place in 1099, and pilgrimages there were becoming more frequent; to provide protection and hospital care, several societies formed that were concerned with both defense and charity: first the Knights Templars, then the Knights of Saint John of Jerusalem, and finally the Teutonic Order. The head of each order was a master or grand master.

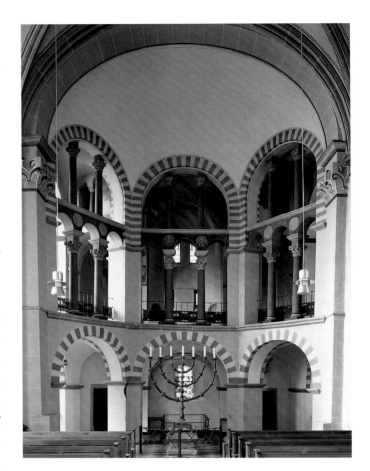

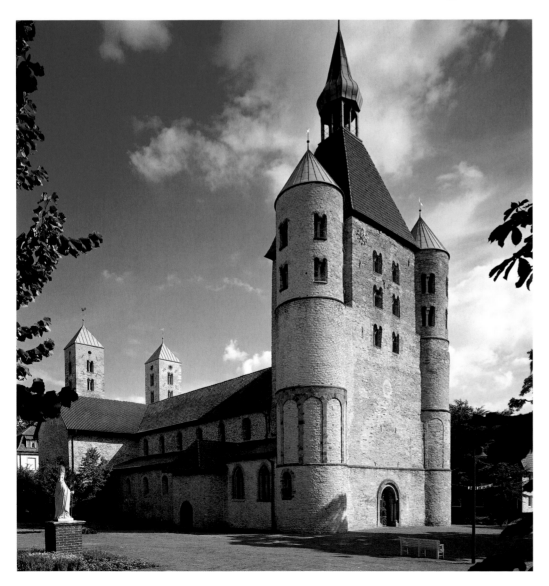

The first branch of the Knights Templars was founded in Jerusalem by the French nobleman Hugues of Payens. King Baldwin provided his palace on the site of the Temple of Solomon for accommodations, which gave the order its name. The order's statutes, which as those of the other great orders of knights were based on the Augustinian rule, were established in their final form at the Council of Troyes in 1129. Bernard of Clairvaux was a participant in the council, and later, in his propaganda piece *De laude novae militiae,* he enthusiastically defended the unusual combination of prayer and battle that had been criticized by some.

The Knights of Saint John arose from a fraternity at the Hospital of Saint John in Jerusalem. Only over the course of the twelfth century did it evolve into an order of knights, although it continued to maintain a large hospital. The order was confirmed in 1154. Its most important task was defending the Holy Land and its fortifications against the Muslims.

All three orders of knights soon had astonishing holdings of estates (known as *commendams*) throughout Europe, whose profits were used to finance expensive activities in the Holy Land. The Templars in particular became specialists in the circulation of money, which was then still uncommon. Their buildings, most of which were quite simple, were sometimes imitations of the Holy Sepulchre rotunda in Jerusalem: round or polygonal central-plan buildings, which were rare at

the time. There are surviving examples in London, Cambridge, Laon, and Tomar. The Knights Templars and the Knights of Saint John were also active in the Reconquista in Spain. There several smaller local orders of knights were founded as well, such as those of Calatrava (run by the Cistercian monastery Morimond), Alcántara, Santiago, and Avis. In the end, however, the three great orders of knights were unable to prevent the Muslim conquest of the Holy Land. The last important Christian stronghold, Accon, fell in 1291. The orders returned to Europe, where they sought out new tasks.

The Knights of Saint John moved their main seat to the island of Rhodes, which they conquered in 1306 and built into an enormous fortress. Their military power was now based on a powerful fleet. When Rhodes was conquered by the Turks in 1522, Emperor Charles V gave the Knights of Saint John the island of Malta, after which they were known as the Knights of Malta. Malta, which they turned into an autonomous state and successfully defended against the Turks, remained their main seat until 1798.

Soon after being driven from the Holy Land, the Knights Templars were destroyed at the instigation of the French crown. Their fate was terrible. In 1307 King Philip IV the Fair had all the Knights Templars arrested in a secret police action at dawn and brought charges against them. They were accused of a whole catalog of evil offenses: loss of faith, blasphemy, cultivating obscene rituals, fornicating with animals, homosexuality, and idolatry. Once confessions had been obtained by torture, fifty-four Knights Templars were burned to death in Paris. Pope Clement V ordered arrests of Knights Templars in other parts of Europe. In 1312 the General Council of Vienne dissolved the order, and in 1314 the master of the order and his three highest knights were burned to death in Paris. The primary beneficiaries of these show trials and arbitrary judgments, in which the Inquisition distinguished itself, were the Knights of Saint John. They received part of the goods belonging to the Knights Templars, doubling their property. The other part rewarded the king's men who had carried out the trial. The successor to the Knights Templars in Portugal was the Order of the Knights of Christ, which King Dinis I founded in 1318 as an order of knights and which soon obtained immeasurable wealth with Portugal's rise.

The Teutonic Order

The Teutonic Order, founded in 1198–99, was a hospital fraternity transformed into an order of knights. It took its rule from the Knights Templars and the Knights of Saint John, but it did not receive legal standing equal to theirs until 1221. Its rise was owed to support from the Hohenstaufen emperor Frederick II, who maintained close contacts with the grand master, Hermann of Salza, and Landgrave Conrad of Thuringia.

Long before it was driven from the Holy Land the Teutonic Order had founded its own state in Europe. First, the order was brought by the Hungarian king Andrew II to Transylvania, where it settled near Kronstadt, in the Burzenland, as a protecting power against the pagan Comans. There the knights built their first Marienburg (Fortress of Mary) as their seat. Soon thereafter, in 1225, the king forcefully expelled the order from the country because he considered it too independent. Then a Polish duke, Conrad of Masovia, called on the order to secure his northern border against the pagan Prussians (*Pruzzen*). In countless military campaigns over more than half a century, between 1231 and 1285, the order succeeded in conquering the areas between Masovia and the Baltic Sea, which would later become East and West Prussia, and founded its own state there. To these were added the regions that make up today's Latvia and Estonia, where the Order of the Brothers of the Sword had once done missionary work, near Riga. Later Pomerelia to the west, the land bridge to the German Empire, with Gdańsk (Danzig) as its most important city, was added as well. Only Latvia could not be conquered. To secure the territory of the state the order established a network of more than forty fortresses across their lands. The largest and most splendid of these, Marienburg (now Malbork) in West Prussia, became the seat of the grand master in 1309 (see pp. 254–55). Until that time the grand master had resided in Venice. After losing the Battle of Tannenberg (also known as the Battle of Grunwald) to the Poles, the order was forced to recognize the supremacy of the Poles. The part of the order's state that remained, East Prussia, joined with Brandenburg as a secular duchy in 1618; thus it formed the core of the later kingdom of Prussia, to which it lent its name. That a religious order of knights could achieve the power to form states and such historical importance was unique and would remain so. In southern Germany the order has survived into the present. In Mergentheim and Ellingen it built two splendid Baroque princely residences, perhaps as substitutes for Marienburg, the seat it had lost.

From the time of the crusades onward several hospital orders (or Hospitallers) arose alongside the religious orders of knights. In addition to the three monastic oaths, its members took a fourth: to care for the sick and provide for the poor. The most important of these orders were the Antonines. They developed out of a hospital in Dauphiné, in southern France, that was near a church in which the relics of the hermit Anthony Abbot were believed to be preserved. Later the place was called Saint-Antoine-en-Viennois. The hospital treated ergotism, which was then known as Saint Anthony's fire. From there its fraternities spread across Europe. In 1247 it was elevated to the rank of an order under the Augustinian rule. The order's importance is evident from the church at its seat, which is a large, stately, cathedral-like late Gothic building.

Another hospital order was the Knights of the Holy Cross, of which there were several branches. They were extremely important in Poland, Silesia, and Bohemia, as testified by their elaborate, ambitious churches in Prague (at the bridge over the Vltava), Karlovy Vary, Nysa, and Miechów, near Kraków.

The Mendicant Orders

Franciscans and Dominicans

Approximately a century after the great reform movements around 1100, two new orders were established that pushed the monastic ideal of poverty much more rigorously than had been the case: the Franciscans and the Dominicans, named after their respective founders, Francis of Assisi and Dominic. Both orders sought a life of humility, simplicity, complete renunciation of property, penance, and active charity; both saw their calling in pastoral care and preaching. In contrast to earlier orders, they settled in cities, since that was where the audience for their preaching was, as was the large number of almsgivers on whom the orders depended. In the beginning they renounced not only personal property but also a monastery's property, but clearly that could not be sustained. Their churches and monasteries were financed by the citizens of the town. Monks were bound by oath for life to the order but not to a particular monastery. The individual branches were grouped into provinces, which in turn were all under the direction of the order's superior general. All the superiors—of the monasteries, of the provinces, and of the whole order—were elected for a limited time, giving their constitution a certain democratic character. The direc-

tor of a Franciscan monastery is called a guardian, of a Dominican one, a prior.

Francis of Assisi (1182–1226) founded his order in the Portiuncola Chapel in his native city of Assisi. In conscious contrast to the city's upper classes, to which he himself had previously belonged, he wanted to place his order as low as possible, so he called it the *ordo fratrum minorum* (order of minor brothers). The order consisted of priests who devoted themselves to study, pastoral care, and preaching, and of laymen who worked or begged in the environs but were also allowed to preach penance. In 1210 the rule that Francis had drawn up received oral approval from Pope Innocent III; the confirmation of the final, revised version only came in 1223 by Honorius III. The burial church San Francesco in Assisi, which was exceptionally richly decorated with frescoes, became the center of the cult of Francis and the associated monastery became the order's motherhouse (see pp. 428–31).

The order soon split into different branches: the "first order," of men, and the "second order," the order of Clare, also from Assisi, which was founded with its own rule and whose members are known as the Clares. These were joined when Francis was still alive by the "third order," the Tertiaries, who were laymen who wanted to live in the world as penitents. The monks of the first order further split into two directions: the Spirituals wanted to realize Francis's rule of poverty unconditionally, while the Conventuals lowered their sights in this regard, with the approval of the pope, because quotidian practice demanded it. The Observants later arose from the Spirituals.

Dominic de Guzmán (1170–1221), born in Spain, encountered in southern France the radical call for poverty made by Cathari and Waldenses, with reference to Christ. Although the church held these to be heresies, Dominic was so impressed by them that he made poverty the first principle of his new order, and lifelong study, the second. The order was founded in Toulouse in 1215. Dominic placed it under the Augustinian rule and thus made it one of the canonical orders. He considered the order's main task to be preaching, and so in 1218 Honorius III called the order the *ordo fratrum praedicatorum* (order of preaching brothers). This was a privilege, as preaching was actually supposed to be the responsibility of bishops and the secular priests. Monks were supposed to obtain and retain the ability to preach through intensive, continuous studies; no earlier order had ever so exclusively emphasized preaching. The order received its ultimate constitutions at the general chapters of 1220 and 1221 in Bologna.

Both orders immediately enjoyed even greater inflow of members than the Cistercians before them. They spread rapidly through Europe, with the Franciscans appealing more to ordinary people and the Dominicans more to the educated, producing such great scholars as Albertus Magnus and Thomas Aquinas. The Dominicans received a new task, which was unwelcome at first, when Gregory IX made them responsible for carrying out the Inquisition that he had begun in 1231 to fight off heresy. The Franciscans also participated in this effort but to a much lesser extent. In 1252 Pope Innocent IV permitted torture as well, and in the end it was the Dominicans who in 1487 provided the handbook for the witch trials: the notorious *Malleus maleficarum* (witch hammer), a nadir in the history of the order. It is no wonder that as a result of the Inquisition, commoners feared the Dominicans as the *Domini canes* (dogs of the Lord), which tarnished their reputation.

In 1358 the Dominicans had a total of 630 monasteries and 157 convents. They were especially widespread on the British Isles, in northeast France, Flanders, Germany, and as far as Bohemia and Poland, as well as in northern Spain, southern France, and northern Italy. The Franciscans were concentrated around Italy, but they could also be found everywhere the Dominicans were. In 1282 the Franciscans had 669 branches in Italy alone, divided into fourteen provinces. In total, they far outnumbered the Dominicans. Just sixty years after they were founded the two mendicant orders together had three times as many branches as the Cistercians.

In the cities the two orders became competitive in a fruitful way. No sooner had one settled in a place, the other followed—provided the town had two thousand residents or more, for smaller towns could only support one monastery from a mendicant order. Commoners streamed en masse to their sermons, which is why their churches, even in smaller places, were astonishingly large, often—as in Venice—the largest churches in the city. In the beginning, the ideal of poverty was applied to their architecture. In many cases the main block, which was intended for commoners, was not vaulted, even in the Gothic period, and its architectural forms were so bare and unadorned—particularly in many Italian churches of the mendicant orders—that several observers called the spaces "sermon barns." The orders did not evolve a specific architectural type in their churches. The picture is diverse, but it frequently recalls Cistercian architecture and the Bernardinian plan. On the other hand, in many buildings, particularly in Germany, the length of the one-nave presbytery is striking. This was where the convention had its place, separated from the nave by a rood screen (which has rarely survived), for this reason the presbytery became the chancel in the modern sense. The length of the chancel gives an idea of the size of the convention. Medieval cities are inconceivable without monasteries and churches of the mendicant orders, and perhaps the most impressive examples are Venice and Florence (see pp. 420–25, 432–43), but also Erfurt, Regensburg, Vienna, Kraków, and many others.

The other mendicant orders that were founded later had only minor significance compared to the Franciscans and Dominicans, and they played hardly any role in the urban landscape. They include the Carmelites, the Discalced Carmelites, the Barmherzige Brüder, the Capuchins, the Augustinian Hermits, the Discalced Augustinians, the Servites, the Minims, and the Hieronymites.

MONASTERIES IN THE MODERN PERIOD

CLOSURE OF THE MONASTERIES AND THE REFORMATION

Toward the close of the Middle Ages there was a general decline among the orders and their monasteries, and in many regions—England, Scotland, and in large parts of Germany—the end came about in the sixteenth century. In England, where the monasteries and cathedrals after the Norman Conquest represented a level of building activity on the part of the new rulers that would have been inconceivable before then, and where the Cistercians in particular had a considerable number of immense abbeys, the number of monks and nuns began to decrease continuously as early as the fifteenth century. King Henry VIII, who by an act of supremacy named himself, instead of the pope, the highest worldly head of the Church of England, closed all of the smaller monasteries in 1536 and the larger ones in 1540, a total of more than eight hundred branches with some ten thousand monks, nuns, canons, and brothers. The property fell to the crown, and most of it was sold. The monasteries were used as quarries, which is why English monasteries have either disappeared entirely or survive only in ruins. Henry did elevate several former monastery churches to cathedrals, which thus escaped being dismantled: Bristol, Chester, Gloucester, Oxford, and Peterborough. In the nineteenth century Ripon, Saint Albans, and Southwell were made cathedrals as well. The cathedral monasteries typical of the English Middle Ages, in which not canons but monks were responsible for choral services, were closed by Henry and the monks were replaced by secular priests. Protestantism was introduced to Scotland in 1567, when Queen Mary Stuart abdicated. Twenty years later, by act of Parliament, the possessions of the dioceses and monasteries fell to the crown, which transferred most of it to the Scottish nobility. The monasteries and cathedrals had already been destroyed or damaged during invasions by English troops in 1544 and 1547. As in England, the monasteries lay in ruins.

In Germany it was the Reformation that brought drastic losses to the monasteries. Luther, who had himself been an Augustinian hermit, turned fervently against the monasteries and their way of life, the depravity of which was proverbial and pilloried in broadsides. The Peace of Augsburg of 1555 gave the imperial princes the choice of having their lands remain Catholic or making them Lutheran, though the memorable motto stating that the ruler has the right to choose his subject's religion—*cuius regio, eius religio* ("he who rules, his religion")—was coined only later. In the Lutheran regions this led to the secularization of nearly all monasteries. Hardly a single prince passed up the opportunity to take the monasteries' property for the state, though a few monasteries did survive as Protestant associations that served the nobility. Others, like Maulbronn or Schulpforta, near Naumburg, were transformed into schools. Because about half of the imperial lands—excluding Austria—became Protestant, the loss of monasteries was correspondingly high.

COUNTER-REFORMATION ORDERS

In Italy, from the time of the Council of Trent (1545–63), monasticism was pushed to the side by a new ecclesiastical movement: the Counter-Reformation orders, above all the Jesuits, who soon after their founding in 1539 spread rapidly through Catholic Europe as the militant spearhead of the Counter-Reformation. Above all, they took education, including the universities, into their hands. The Jesuits were not conceived as a monastic community but as a priestly order of regular clerics. Soon there were assistants from the clergy and laity as well, the coadjutors. A Jesuit settlement is called a college, not a monastery. By around 1700 there were more than seven hundred colleges. Moving outward from Rome, the Jesuits developed a unique architectural style for their college buildings and spacious hall churches that would have a lasting influence on the European Baroque in Catholic countries in the seventeenth century. In their impact the Jesuits were comparable only to the Cistercians and the mendicant orders before them. The Theatines, founded by Gaetano di Tiene in Rome in 1524, and the Oratory of Philip Neri, approved in 1575, were far less important. All these were concerned with reviving the church and the clergy by means of thoroughgoing reforms, for which the old orders barely had the strength any longer.

THE COMMENDATORY SYSTEM

In France, Italy, Spain, and Portugal monasticism suffered considerable damage as the result of an arrangement that the Roman Curia had itself promoted: the commendatory system. This was the awarding of ecclesiastical offices to holders who would control

the income but would not be obliged to fulfill the religious tasks associated with the office. An office *in commendam* was a benefice with nothing offered in return. They were often granted when an abbot's position became free. In 1514 Pope Leo X restricted the right to grant offices *in commendam* to the holy see, but in 1519 he conferred the right on King Francis I of France, and it was later conferred on other sovereigns as well. Thus the church introduced, with the supreme blessing of the pope, the very lay investiture that it had so bitterly combated in the eleventh and twelfth centuries. The newly appointed abbots, known as commendatory abbots, used their positions solely as means of support, virtually ignoring monastic concerns and living outside their monasteries. The beneficiaries of the commendatory system were favorites of the crown—including laymen, even Protestants—though usually they were high-ranking church dignitaries and statesmen. Some accumulated many such offices. For example, Richelieu is said to have been abbot or prior of twenty monasteries at a time; Mazarin, as many as twenty-seven. Because there was no strict oversight in the monasteries, the discipline and spirituality of monastic life sank lower than ever, even though there continued to be reform movements, like that of the Maurists. The old monastery sites were replaced by stately castles—at Cluny and Prémontré, for example—and the monks were given beautifully appointed apartments. However, the most important aspect of the old monasticism, the strict regulation of their entire lives, was lost.

MONASTERY CASTLES

In Spain the large monasteries of Poblet and Santes Creus had the unusual characteristic of also serving as royal residences and fortresses in the Middle Ages. It was from this tradition that the royal monastery castle El Escorial evolved in a regularized, ideal form during the sixteenth century. It was Philip II's prestige building, but compared to medieval sites it was more castle than monastery (see pp. 82–85). In Portugal, where the abbeys Batalha and Belém also belong to the king, an even larger counterpart to El Escorial was built under King John V: the monastery castle Mafra, which surely no visitor has ever felt was truly a monastery.

In the modern period the Catholic parts of southern Germany and the Habsburg lands of Austria, Bohemia, Moravia, and Silesia were the only regions in Europe in which monasteries flourished again culturally under their own initiative. Nearly every rural

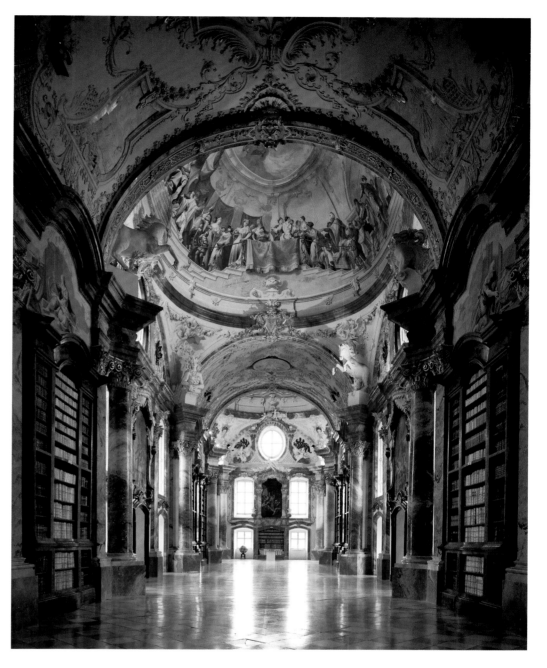

Library of the Benedictine monastery Altenburg (Lower Austria), 1742

monastery, regardless of order, built new castlelike buildings and a richly ornamented church, and sometimes a pilgrimage church as well. The pilgrimage church Vierzehnheiligen, on the Main River, was built by the Langheim monastery; Birnau, on Lake Constance, by Salem; Wies, in Upper Bavaria, by Steingaden; and Steinhausen, in the Allgäu, by Schussenried. Most of the monasteries in the Swabian region between Lake Constance and the Danube had the status of a free imperial abbey with its own territory. Politically they were subject only to the emperor, and hence their abbots had a status similar to princes. Several of them were de jure imperial princes. New buildings were constructed to do justice to the status of an imperial abbey. Monasteries in the electorate of Bavaria, where their properties took up more than half the land, did not have the status of imperial abbeys and were subject to the sovereign in Munich. But their passion to build was not diminished

OPPOSITE PAGE:

TOP AND CENTER: *Exterior of the monastery and interior of the church, Dominican monastery La Tourette, near Lyons, based on plans by Le Corbusier*

BOTTOM: *Denis Quaillarbourou, interior of the modern church, Cîteaux, 1990–98*

by this, and frequently enough the building was mortgaged and the monastery was financially ruined. With one exception, in the Habsburg lands of Austria the monasteries were likewise not directly subordinate to the emperor. Like the monasteries in Bavaria, the monasteries of Upper and Lower Austria were subject to the sovereign, but the situation proved to be rather different, because the Austrian sovereign was at the same time an emperor, to whom the imperial abbeys outside Austria were also subject. Within the church the monasteries belonged to the diocese of Passau. But because Passau lay outside the Habsburg patrimonial lands, the monasteries tried, with Habsburg assistance, to escape episcopal jurisdiction and turn their territories into a kind of monastic diocese with power of disposition over the rectories. All of this gave them a status that in practice amounted to that of an imperial abbey. In Austria, Bohemia, and Silesia monasteries were built in the grandest style and at the greatest expense. This resulted in monastery castles of imposing power, comparable to El Escorial, but with the difference that no king stood behind them, and for all their prestige worthy of a prince, they retained the character of a religious residence. Baroque abbeys displayed their pomp not only in the size of their monastery castles but also in their interiors, with stately ceremonial rooms. These included a banquet or imperial hall, grand staircases, and occasionally a theater. Above all, however, was the library, which was a resplendent hall that celebrated scholarship and, therefore, the abbey itself.

ENLIGHTENMENT, REVOLUTION, AND SECULARIZATION

The second half of the eighteenth century heralded the end of monasteries nearly everywhere in Catholic Europe. From the time of the Peace of Westphalia, which affirmed the secularization of church property in the Protestant lands, there were time and again journalistic and political appeals to dissolve the religious estates of the empire—that is, the prince-bishoprics and the imperial abbeys, as well as the mendicant orders and the contemplative communities, as it was asserted they brought no benefit and could even cause harm. These trends grew stronger during the Enlightenment. The Jesuits were the first order to be dissolved, under pressure from the Bourbon royal houses: in Portugal as early as 1759, in France in 1762, and in Spain and Naples in 1767, until Pope Clement XIV prohibited the order entirely in 1773. In France, beginning in 1666, nearly 400

other branches of orders were closed, even before the Revolution. In the patrimonial lands of the Habsburgs in Austria, beginning in 1780, Emperor Joseph II reduced the number of monasteries by about 740 and allowed to exist only those communities that served a social purpose, such as care for the sick or education. He transferred church property to the "religion fund" for the improvement of pastoral care.

The impulse to secularize nearly all monasteries was provided by the French Revolution in 1789 and the Napoleonic Wars in its wake. All church property was nationalized in France in 1789. A year later the constituent assembly issued a decree to dissolve fifty-one dioceses and all orders that did not work for educational or charitable causes. A prohibition on the remaining religious communities followed in 1792. As a result of these resolutions, devastation was waged with a special hatred directed in particular against those abbeys that had once been the pride of France—above all Cluny, Tours, Cîteaux, and the four Cistercian primary abbeys. The losses were immeasurable.

In the Holy Roman Empire the Peace of Lunéville in 1801, in which all areas to the west of the Rhine had to be ceded to Napoleonic France, provided the occasion for the Reichsdeputationshauptschluss of 1803, by which princes to the west of the Rhine were compensated by being awarded properties taken from monasteries to the east of the Rhine and the religious estates of the empire were eliminated. The monasteries of the provincial estates—above all in Württemberg and Bavaria—fell to the corresponding sovereign, who usually sold them. Admittedly, this was not always a money-making practice, as sometimes the profits barely covered the debts of the monastery. Nor did this secularization sufficiently consider the fact that the state had to find a substitute for the monasteries when they had been operating schools. That generated expenses that once again drained profits. Secularization scarcely paid off for the state. Fortunately, only rarely were monasteries sold off for demolition, as happened in France; rather, their grounds were used as barracks, prisons, mental institutions, hospitals, or factories, while the churches became parish churches. Thus, much of the architecture survived. Monasteries in Austria were not dissolved, to the extent that they still existed after Joseph II, nor were those in the regions of Italy that did not belong to Austria or Spain. In Portugal the religious orders were not dissolved until 1834, and they returned in 1860. In Spain the expropriation of church property came in 1836, after violent conflicts

between the clerical and progressive movements that were nearly on the scale of a civil war.

The Monastic System after 1850

Over the remainder of the nineteenth century, the orders, including the Jesuits, were permitted again; and new ones were established, including John Bosco's Salesian Society, the Salvatorian Fathers, the Pallotines, and several communities of women. Many of these concentrated on missionary activities. Often an old monastery could be occupied again, sometimes by an order other than its original one. King Ludwig I of Bavaria pursued a true "counter-secularization," although its extent was comparatively limited. The orders also gained a foothold outside of Europe. During the twentieth century, however, secularization and the destruction of monasteries returned: in the conflict between church and state in France in 1901–5, in Portugal during the revolution of 1910, in Spain during the antireligious legislation of the Second Republic and the civil war from 1936 to 1939, under National Socialism in Germany, and Communism in Eastern Europe. Monasticism survived, however, and in Poland it found new adherents.

Nevertheless, compared to its expansion and importance in the Middle Ages, monasticism in modern western European society remains a marginal phenomenon that threatens to die out altogether, especially in those orders where ancient lifestyles that have become alien since the Enlightenment continue to be practiced. Even so, today the numbers of people who participate in monastic life at least for a time are not insignificant. Many monasteries offer the possibility of contemplative reflection that is cheerfully accepted, especially by those living in large cities. The other tasks of the monastery in modern society include hospitals maintained by several orders and schools, often with boarding. In addition, monks often take on the functions of a priest for many abandoned rectories. In the twentieth century there have also been efforts to build completely new monasteries in a modern architectural style—for example, Sühnekloster in the former concentration camp Dachau, near Munich; the Carthusian monastery Marienau, in the Allgäu; and the reoccupied Cîteaux. The most famous example is the Dominican monastery La Tourette, near Lyons, built in 1956–60 based on plans by Le Corbusier. It is a concrete structure in which the architect used his unique formal language to combine the time-honored schema for a monastery with the needs of an open center for study.

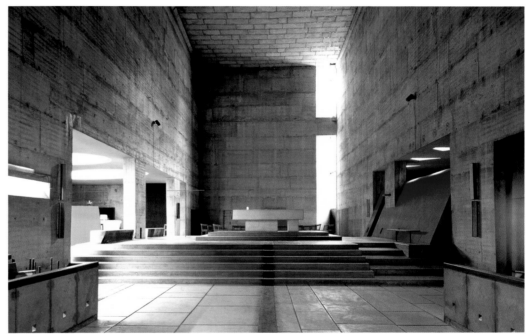

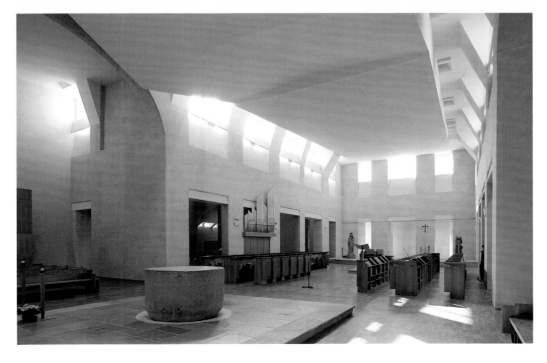

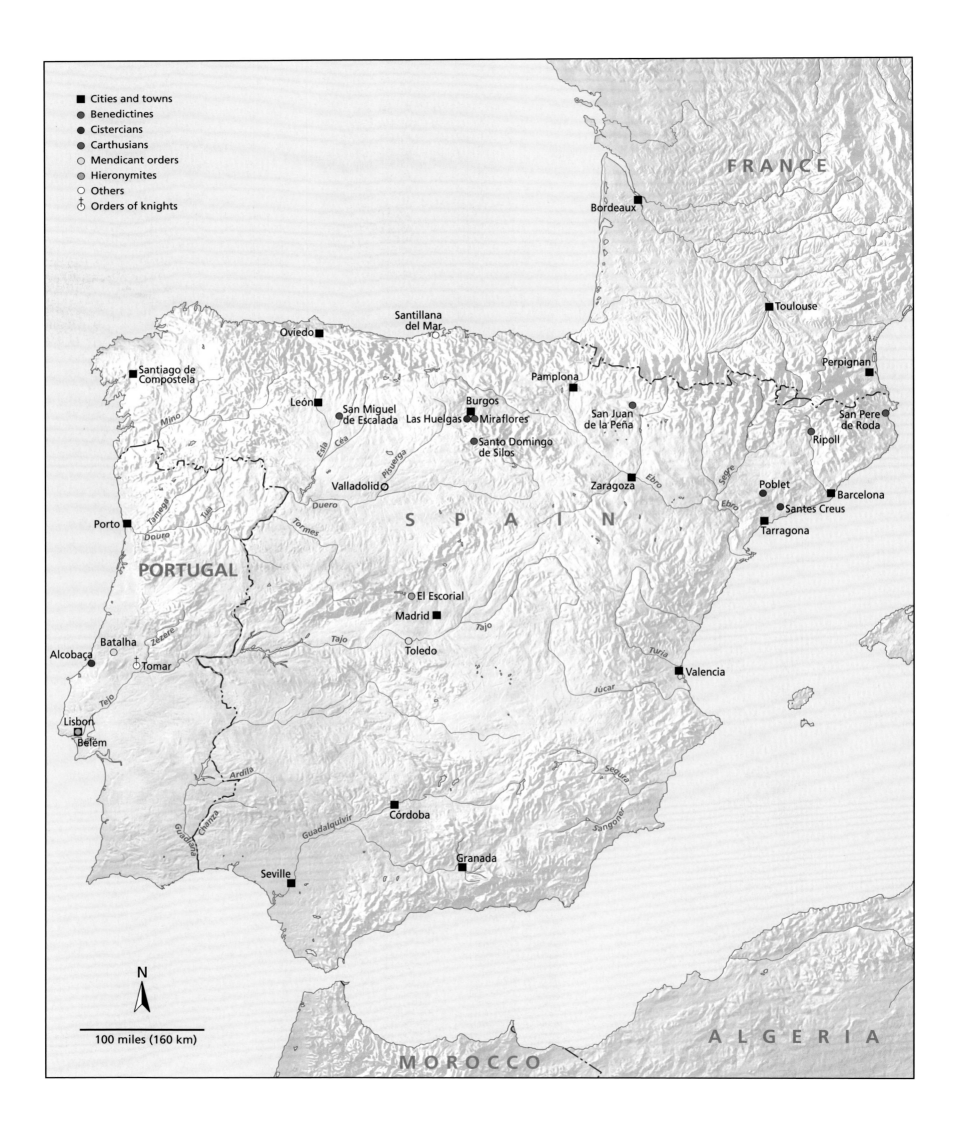

Cities and towns
● Benedictines
● Cistercians
● Carthusians
○ Mendicant orders
● Hieronymites
○ Others
✝ Orders of knights

FRANCE

Bordeaux

Toulouse

Perpignan

Santillana
del Mar

Oviedo

Pamplona

San Pere
de Roda

Santiago de
Compostela

León

San Miguel
de Escalada

Burgos
Las Huelgas ● Miraflores

San Juan
de la Peña

Ripoll

Santo Domingo
de Silos

Poblet

Barcelona

Valladolid

Zaragoza

Santes Creus

Porto

S P A I N

Tarragona

PORTUGAL

El Escorial

Madrid

Batalha

Valencia

Alcobaça

Toledo

Tomar

Lisbon

Belém

Córdoba

Granada

Seville

ALGERIA

MOROCCO

N

100 miles (160 km)

Rivers labeled: Miño, Esla, Cea, Pisuerga, Duero, Tua, Tâmega, Tormes, Douro, Ebro, Segre, Ebro, Tejo, Zêzere, Tajo, Tajo, Turia, Júcar, Ardila, Segura, Songoner, Guadiana, Chanza, Guadalquivir

IBERIAN PENINSULA
PORTUGAL · SPAIN

ALCOBAÇA

BELOW LEFT:
Cloister with the well house, Alcobaça

BELOW RIGHT:
Interior of the well house

OPPOSITE PAGE:
Cloister and west end of the church

PAGE 60:
Side aisle of the church

PAGE 61:
Middle bay

ALCOBAÇA IS ONE OF THE LARGEST AND BEST preserved Cistercian abbeys in Europe; it was added to UNESCO's World Heritage List in 1985. Lying near the Atlantic coast in the Portuguese province of Leiria, it is the westernmost Cistercian monastery on the continent. Its founder was Afonso I (Afonso Henriques), the first king of Portugal. Following his victory over the Moors near Santarém in 1147, he sought to colonize the sparsely populated regions that had been reconquered, most of which lay fallow. To that end he brought the Cistercians into the area. As is documented in the surviving *Carta dos coutos*, in 1152 or 1153 he transferred to Bernard of Clairvaux large dioce-

ses where the Alcoa and Baça rivers meet, on the condition that he make the land arable. The general chapter in Cîteaux consented. Alcobaça was the last of Clairvaux's filiations that Bernard himself initiated; the monastery founded six more on its own between 1172 and 1221. It suffered a difficult setback in 1195, when the Moors returned in a counterattack, destroying the buildings and murdering many of the monks. Soon after a new convent arrived from Clairvaux. The reconstruction of the monastery took place under Abbot Fernando Mendez and was largely completed, except for the church, by 1222.

Alcobaça, which received privileges from both the king and the pope, remained Portugal's largest Cistercian abbey. Beginning in the late twelfth century its abbots often came from the ruling house. In the late Middle Ages they belonged to the royal council and to the Cortes—the assembly of the estates—and at court they held the rank of grand almoners and grand chaplains. In addition, they received jurisdiction over the Order of the Knights of Christ and the Knights of Aviz, whom they had helped to establish.

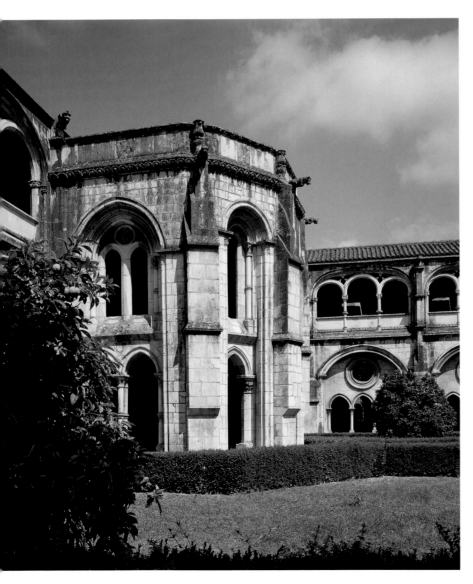

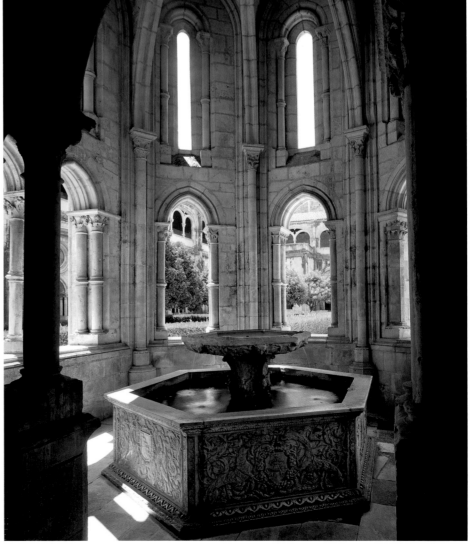

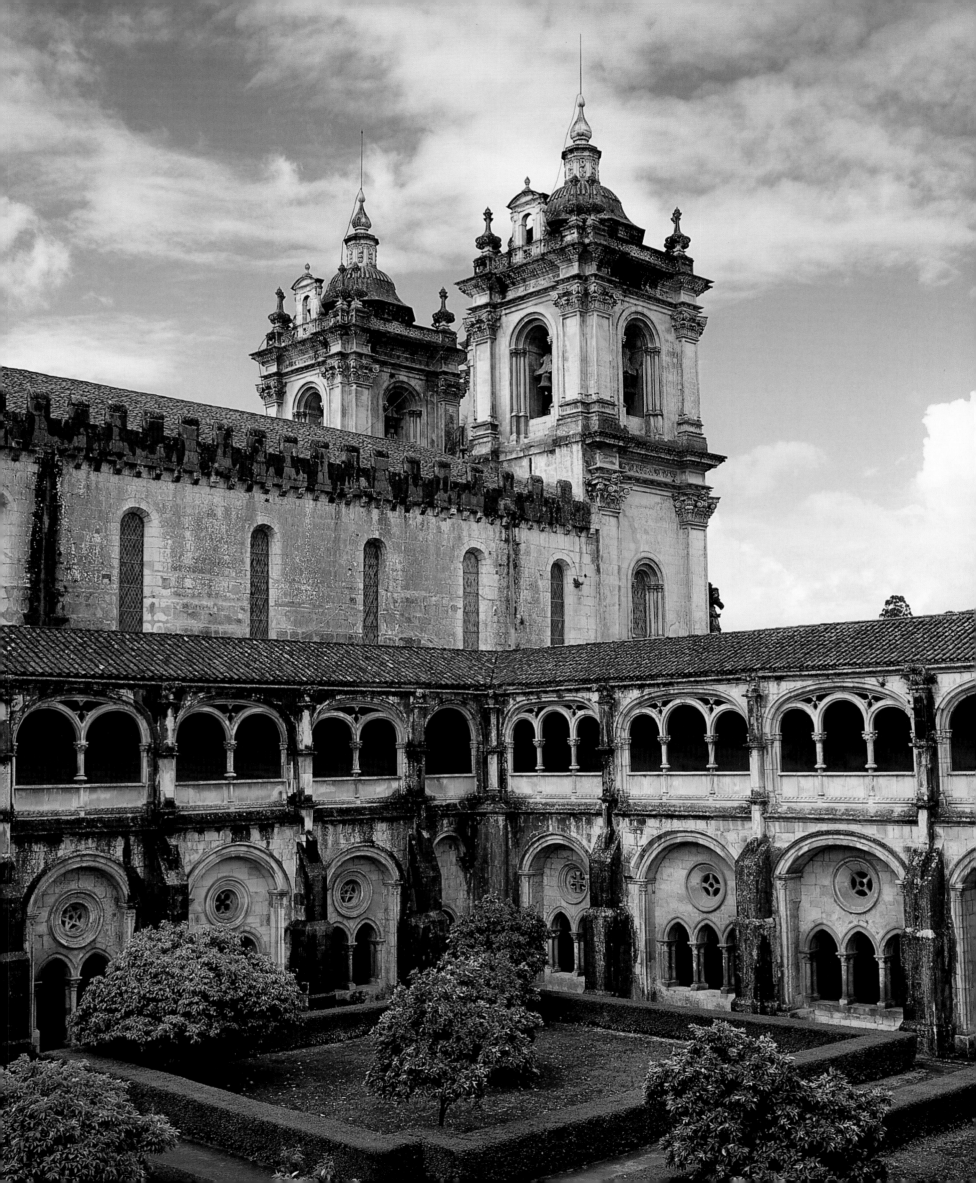

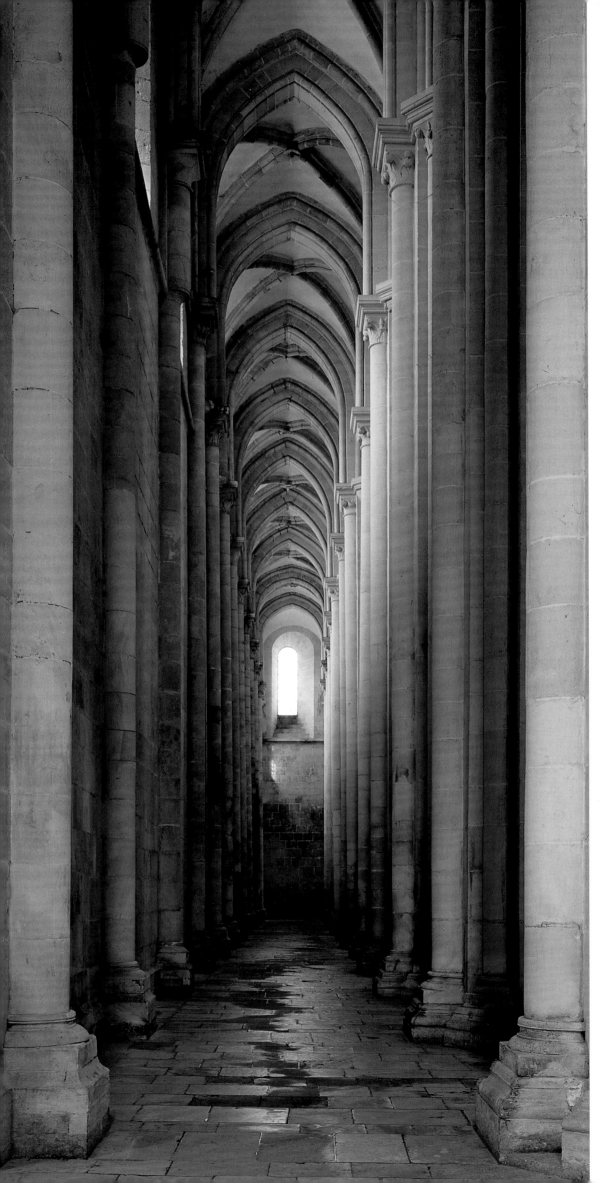

Their lands reached from the Atlantic to the Serra dos Candeeiros to the east, more than two hundred square miles of scattered holdings that included thirteen cities and three ports. The monastery produced wine, grain, and olives, and also operated mines, forges, and salt works and had its own ships to export salt. It was involved in the founding of the university in Lisbon. Alcobaça also established its own Portuguese congregation within the Cistercian order, which gave it a certain independence vis-à-vis Cîteaux. In keeping with the importance of the monastery, its convention was quite large. According to legend it had 999 members at its peak. The speed with which the convent grew is seen, for example, in the fact that the convention had had only 40 members when it was founded in the thirteenth century, but 150 monks died of the plague there one hundred years later, in 1348.

Its decline began, as so often in the southern lands, with the commendatory system. In 1475 the abbot sold the monastery *in commendam* to the archbishop of Lisbon. With that, morals declined but profits grew consistently until the eighteenth century, when the abbey was richer than ever before. In keeping with the baroque age's need for prestige, around 1679—probably using plans by João Turriano, a monk-architect of Italian origin—the church was given a new two-tower facade that incorporated the existing portal and the large rose window. The monastery building, attached to the church on its north side, received a new, simple facade that gave the older substance of the building a uniform facing. In 1725 a mirror-image counterpart to this facade was constructed to the south of the church. The whole monastery facade, with the church at its center, reaches the enormous width of 725 feet (221 m). These building projects, which left the wings of the medieval structure untouched, sought to make the abbey appear, at least from the outside, to be symmetrical with the Baroque monastery castle located around the church, analogous to the Mafra monastery, the Portuguese version of El Escorial, which had been begun shortly before 1725.

The church is one of the most impressive and unusual examples of Cistercian architecture. Construction began in 1178. The Moorish invasion of 1195 probably led to an extended interruption in building activity. There is documentation of a consecration in 1223, when the monks were able to occupy the finished portions, and of a final consecration in 1252. The architectural history has yet to be systematically researched. The church, at a length of 350 feet (106 m), is one of the

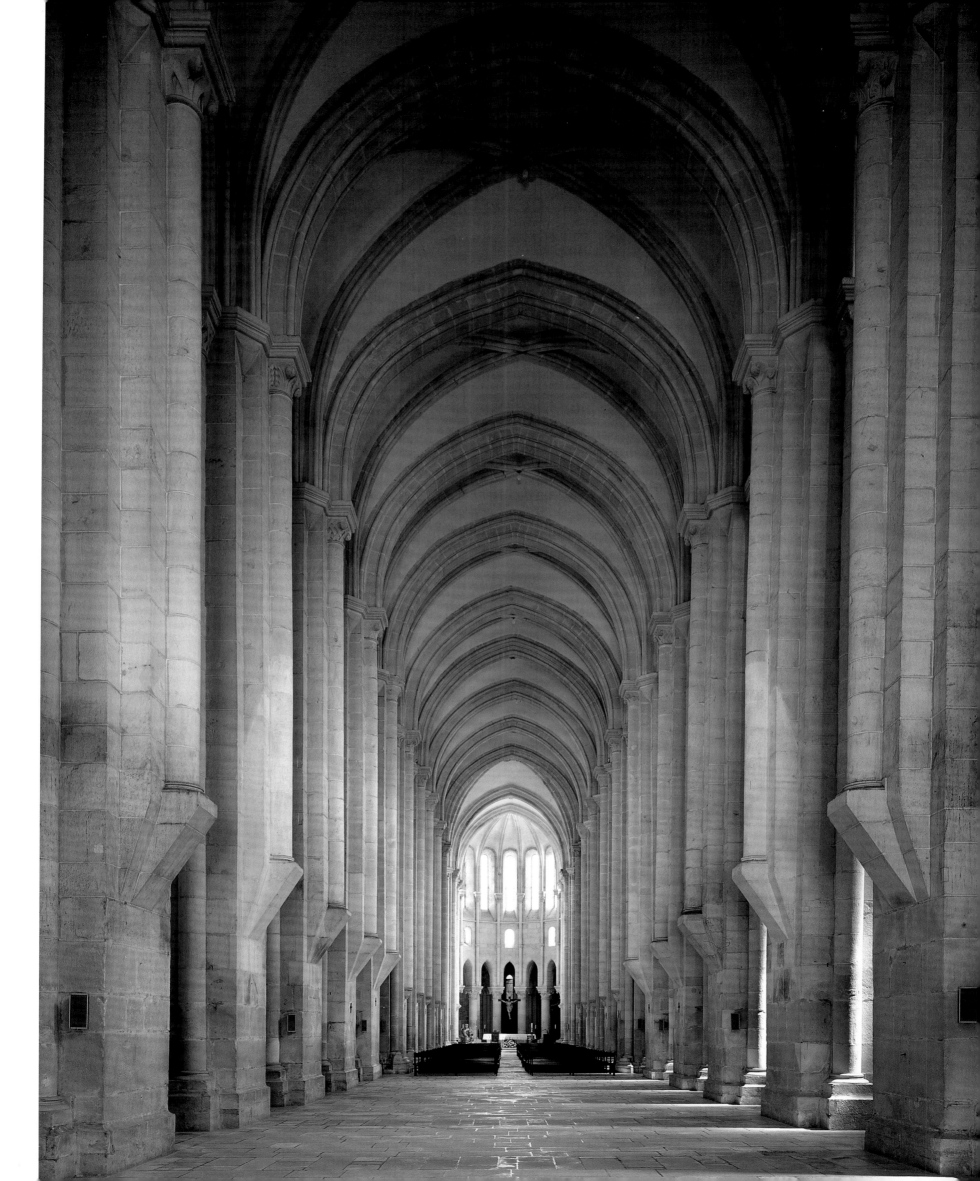

largest Cistercian churches. The third church of its mother abbey, Clairvaux, was roughly the same size. Alcobaça borrowed, almost word for word, the ground plan of the east end of that church: the three-nave transept with an eastern aisle consisting of chapels with partition walls, and the sanctuary with a semicircular periapsidal aisle and a wreath of chapels that is subdivided into no fewer than nine sections. This large number, corresponding to nine sides of an eighteen-sided polygon, means that the round piers of the apse are extraordinarily close together and the windows of the apse are very narrow. The periapsidal aisle and chapels are on the same level, unlike those of Clairvaux, where they were staggered and the periapsidal aisle had its own clerestory. The chapels, all of which have barrel vaults, terminate on the outside in a broad semicircle subdivided by pier buttresses. Exposed flying buttresses swing up from the piers over the periapsidal aisle to the apse—a construction of remarkably light elegance.

The main block is constructed using the bay system, with laterally oblong bays in the main block and roughly square ones in the side aisles, all of which have cross rib vaults. The robust piers stand very close together, making it possible to incorporate thirteen bays, in astonishingly rapid sequence, into the main block—two more than at Clairvaux, in more or less the same amount of space. The placement of the pillars

Two views of the tomb of King Peter (Pedro) I in the monastery church, Alcobaça, 1360. Above left: *Tracery rose as a wheel of fortune at the head of the sarcophagus;* Bottom right: *Side view of the sarcophagus*

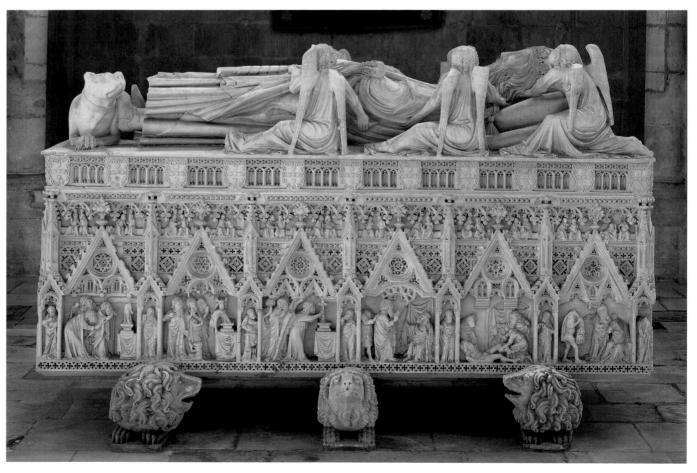

clearly separates the aisles from the nave in our picture of the space. As closely as the church is related to that of Clairvaux in its ground plan, so different—indeed opposite—is its structure. The basilica type was not chosen as the basis for Alcobaça—as was common at the time in all Cisterican churches, even the primary abbeys—rather it is a hall church with three naves of approximately the same height. This resulted in such narrow and steep proportions for the side aisles that they scarcely resemble separate aisles at all and feel more like narrow corridors accompanying the main block, with no intrinsic spatial value whatsoever. This is all the more striking because they are hardly visible from the main block. In the transept the central and west aisles are also the same height, though the chapels of the east end are low.

As far as we know, Alcobaça is a singular case, for the Cistercians had not previously employed the hall church type. The choice is all the more astonishing given that the ground plan of the bays, especially in this pronounced form, is better suited to a basilica than a hall church. It remains unclear what led the builders to this decision, especially since there were no models for the architectural form realized here, even if one looks beyond Cistercian architecture.

Yet another trademark is striking: the pillars on the side facing the nave have a rectangular projection and a second semicircular one in front of that. Both are

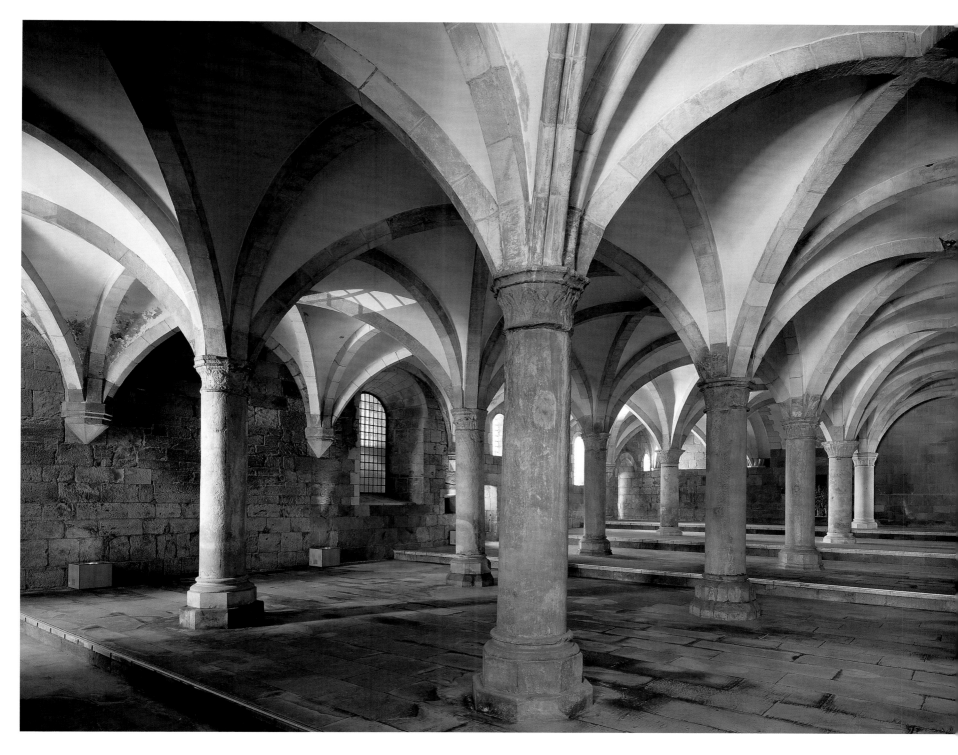

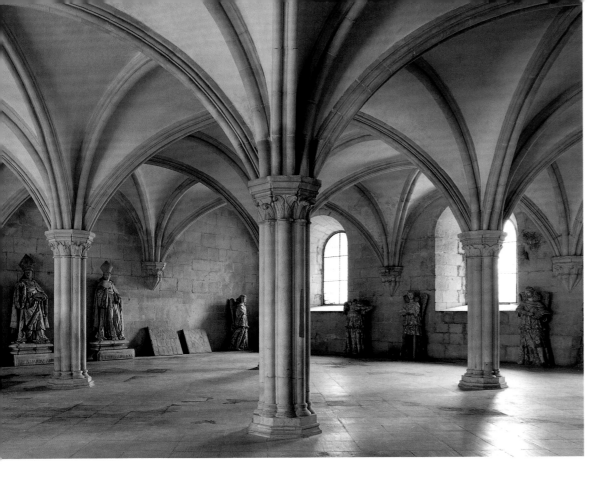

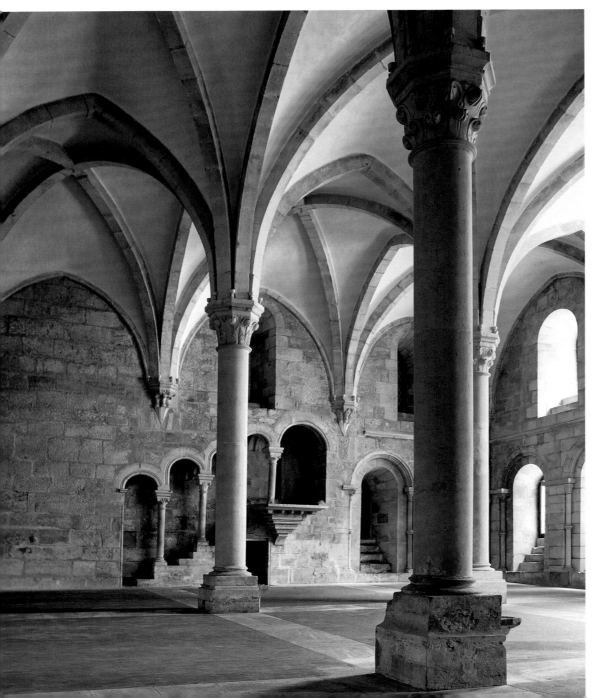

supported just above the floor by a beveled corbel. Corbel construction was in wide use by the Cistercians, but here it was taken a step further in that both projections were capped up to the core of the pillar, with the result that the pillar seems to project a little. In the east end of the nave, where the monks' chancel was located, the treatment was less rigorous, and the usual cruciform projection was at least permitted.

The most important decorations in the church are the two sarcophagi of white limestone, which are as alike as twins. They once stood in the Panteão Real, next to the south transept, and were placed in the north and south transepts on the occasion of a visit from the Queen of England in 1956. In 1360 King Peter (Pedro) I had one of the sarcophagi prepared for himself and the other for Ines de Castro. A tragic love story is behind this: Ines was a cousin and lady-in-waiting of Peter's wife, Constanza, who became his lover after his wife's death in 1348 and bore him four children. It is even said that he was secretly married to her. Ines was murdered in 1355 by the order of Peter's father, King Afonso IV. When Peter ascended to the throne two years later, he had her body exhumed and ceremoniously crowned queen in the cathedral of Coimbra.

Recumbent effigies of the departed are laid out on the lids of the sarcophagi, watched over by praying angels. Ines de Castro wears a crown, just like the king. The framing on the long sides of the sarcophagi have reliefs with Gothic tracery and gabled architecture enclosing the Passion, the Last Judgment, the Resurrection, and other scenes. At the head of the king's sarcophagus, a wheel of fortune in the form of a tracery rose alludes to the love story and the unpredictability of human fate. The sarcophagi, made by followers of Master Pere of Aragon, recall ivory carving in their delicate workmanship, and are the greatest achievements of Portuguese sculpture of that period.

The buildings for the convention are ideal examples of Cistercian monastery architecture. Except for the conversi wing, which was later altered, all of the buildings and rooms still exist. The cloister, known as the Claustro do Silêncio, is 160 feet (50 m) long on the sides, making it one of the largest of this order. It opens to the courtyard through an arcade of tripartite arches with double columns, above which sits an oculus of rich tracery latticework in the tympanum. On the courtyard side, each section of the wall has a projecting basket-handle arch on pier buttresses that joins the tripartite arcade and the oculus in a self-contained motif. Inside the cloister, despite Gothic construction, round

arches dominate, even in the case of the vault ribs, which attach to corbels on both sides. Stylistically, the cloister seems like early Gothic, but it was built in the early fourteenth century. The architects were Domingo and Diogo Domingues, who carried out the work between 1308 and 1311 under a commission from King Dinis. In 1484 the cloister was heightened by adding an ambulatory as a second floor. The early Gothic well house had a two-story structure from the start, and is closed off from the cloister by a double arcade on pedestals and an oculus.

The three-nave hall of the dormitory, consisting of eleven bays and totaling 215 feet (66 m) in length, is austere in its simplicity. The arches of the vaults, which rest on thick, round pillars, have a simple box profile. The frater—the workroom or scriptorium of the monks— is similar. Here, to account for the floor height of the dormitory above, the arches of the vaults have a very flat profile, which remains well below the crown of a semicircle and feels oddly squashed.

The chapter house is much more elaborate. It embodies the usual type of four-support room. Unlike in the dormitory and frater, each of the rising vault arches has a corresponding projection on the piers. There are eight in all, which converge to form a bundle. The same pier form is also found in the Panteão Real, the two-nave royal burial chapel next to the south end of the transept.

The most spacious and surely most beautiful of the halls is the three-nave refectory, with its unusually tall, round piers. The staircase to the projecting pulpit for the mealtime reader is recessed in the wall and it opens to the hall with a rising arcature; it resembles that of the refectory of the Huerta monastery in Castile. In the eighteenth century the calefactory was converted into a kitchen, which is impressive for its ninety-five-foot (29-m) length and its enormous exhaust chimney, which is sixty feet (18 m) tall. Everything in the rooms around the cloister, including the water canal for the kitchen, is so well preserved that even today the monks could move back in immediately.

OPPOSITE:
Top: *Chapter house;* BOTTOM: *Refectory*

TOP RIGHT:
Cloister

BOTTOM RIGHT:
Dormitory

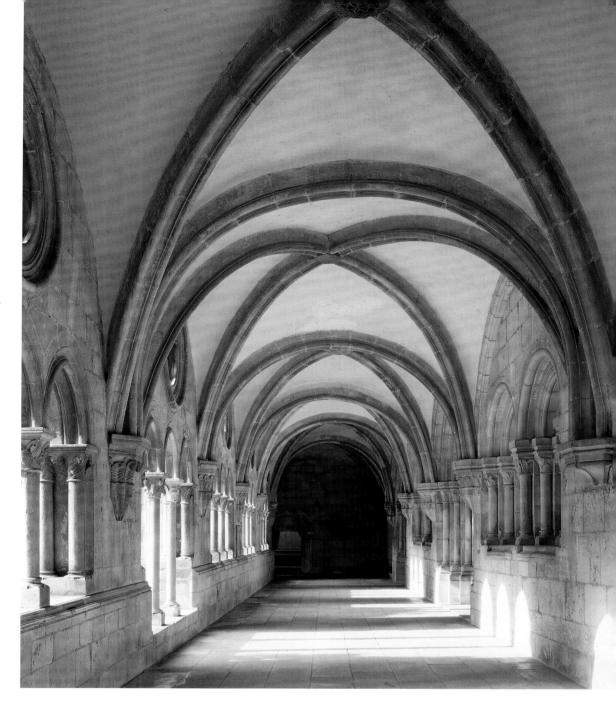

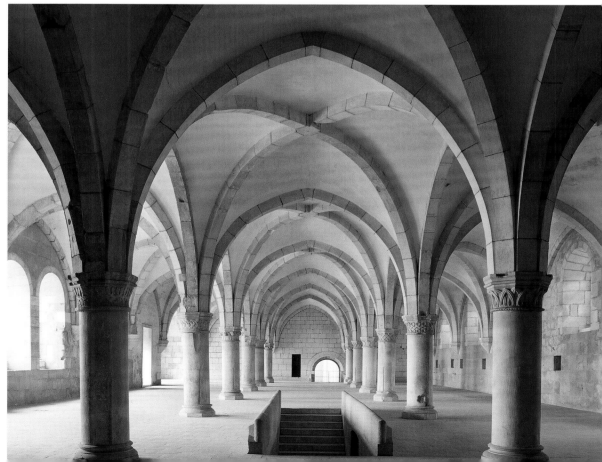

BATALHA

THE KINGDOM OF PORTUGAL, WHICH FROM THE early Middle Ages onward had gradually broken free of its association with the neighboring Spanish realm of Castile and Léon and simultaneously freed itself from Moorish rule, was in danger of losing its independence when King Ferdinand (Fernando) I died in 1383 without a male heir. King John (Juan) I of Castile laid claim to succession to the Portuguese throne, based on his marriage to Ferdinand's daughter, Beatriz. But the Cortes in Coimbra chose another John (João), the grand master of the Knights of Aviz (a branch of the Knights of Calatrava), to be king. The newly elected king was an illegitimate son of King Peter (Pedro) I. Soon after this vote John of Castile invaded Portugal, but the Portuguese John defeated him on August 14 in the decisive battle of Aljubarrota. This victory legitimized the royal dynasty that the latter had founded and named Aviz, after the order of knights. Before the battle John vowed to found a monastery if he proved victorious. The monastery's name, Batalha, means "battle"—analogous to Battle Abbey at the site of the Battle of Hastings, in England, or Wahlstatt, in Silesia, at the site of the battle against the Mongols near Liegnitz (now Legnica). Two years after his impressive victory John began the construction of the Santa Maria da Vitoria monastery near the site of the battle, six miles south of Leiria. In 1388 he handed it over to the Dominicans. By building it, King John was not only fulfilling his oath but ensuring a worthy burial site for the house of Aviz. He was married to Philippa, the daughter of the duke of Lancaster.

With its church, attached chapels, and monastery buildings, Batalha was a resplendent royal building of state, and it is evident that nothing was spared for it. Construction was directed from 1388 to 1402 by the Portuguese architect Afonso Domingues, who lived in Lisbon. He was succeeded by David Huet (also known as Huguet, Huguete, Ouguete), a Frenchman familiar with the most recent French and English architecture, the latter through the Portuguese royal house and its

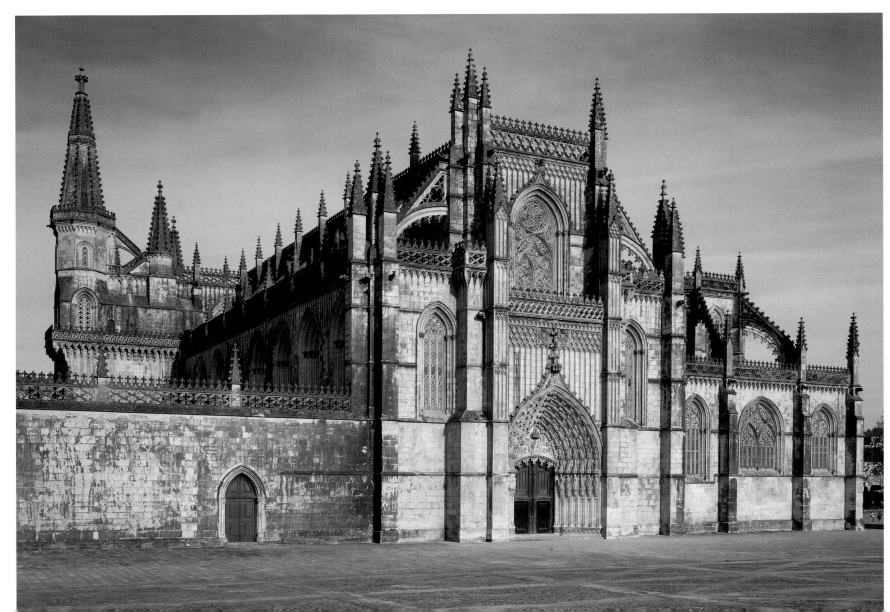

close ties to England. Huet completed the church, including the founder's chapel, the basic structure of the cloister, and the chapter house. The church, whose nave Huet made even taller than the one planned by Domingues, is a three-nave basilica with transept, transept chapels, and sanctuary. Its proportions are very unusual. The nave, with nave arcades that reach way up, seems narrow and extremely steep; the ratio of width to height is nearly 1:4, which is quite rare in the history of architecture. Late Gothic splendor is displayed in the exposed buttresses of the external structure, in the clerestory, and above all on the west facade, which is covered by a fine lace veil of tracery. It combines the French flamboyant ("flaming") style that governs the large center window with the greater verticality of the English perpendicular style.

In the south end of the main block, attached to the side aisle, is the Capela do Fundador, the mausoleum of the house of Aviz. About sixty-five feet (20 m) long on its side, the chapel is a one-story square structure with a towering, two-story octagon in the center that on the ground floor opens up onto a periapsidal aisle through eight columned arcades. The upper floor is a clerestory, terminated by an eight-pointed star vault. In the floor in the middle, resting on eight lions, is the double sarcophagus of King John (João) I and his wife, Philippa. In the wall niches at the south end are the tombs of their sons, Peter (Pedro); John (João); Ferdinand (Fernão), who died in slavery in Morocco in 1443; and Henry (Henriques) the Navigator. As grand master of the Order of the Knights of Christ, Henry participated in conquering Ceuta in Morocco and organized the Portuguese expansion along the African coast to the Azores, the Cape Verde Islands, Madeira, and Sierra Leone. This expansion, which the popes declared a crusade, established the basis for Portugal's wealth, which also found expression in Batalha. The tombs of Afonso V (d. 1481), John (João) II (d. 1495), and the latter's son Afonso were added to the west end in 1901.

John I's successor, his eldest son, Edward (Duarte), a highly educated philosopher-king who ruled from 1433 to 1438, is the only one of the five sons not to be buried in the founder's chapel. He had David Huet build a separate, much larger mausoleum at the apex of the church: an octagon sixty-five feet (20 m) in diameter with a wreath of seven radial chapels and six smaller intermediate chapels in a pentagonal arrangement, which would have offered space for many other burials. Because the king and his architect died prematurely, the building remained unfinished. Later King Manuel I and

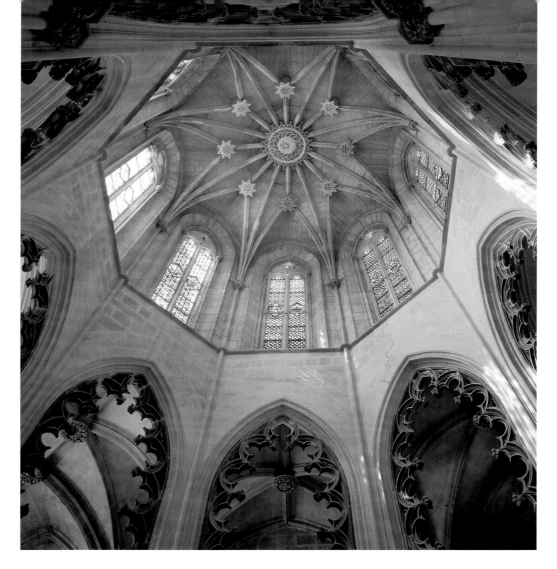

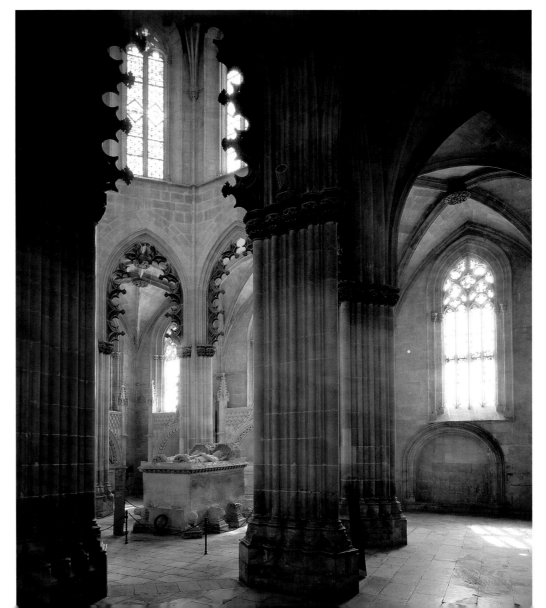

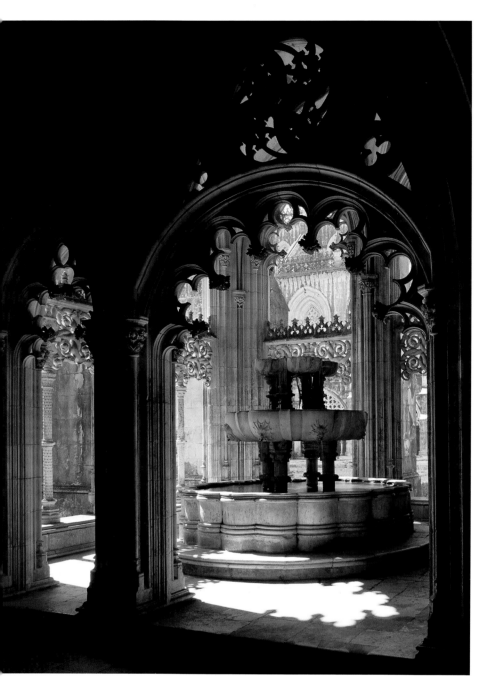

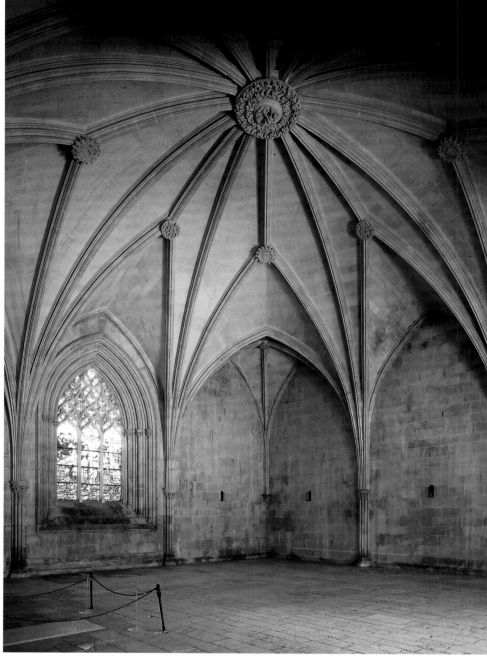

ABOVE LEFT:
Well house in the cloister, Batalha
(see also p. 5)

ABOVE RIGHT:
Chapter house

OPPOSITE PAGE:
Capelas Imperfeitas

John (João) III began construction again in the first half of the sixteenth century, above all adding ornamentation throughout. The torso of the mausoleum in which Edward and his spouse, Leonor of Aragon, were laid to rest is referred to in the plural as the Capelas Imperfeitas, because of its many chapels.

Huet was also responsible for the large royal cloister and the adjacent chapter house to its east, a stately square building, sixty-two feet (19 m) long along the side, topped by an octagon-like eight-pointed star vault. It freely spans the space without a central support—a feat of technical and artistic bravura of which the tale is told that only those who had been condemned to death were allowed to work there, because it collapsed twice during construction. When the scaffolding was removed, the architect is said to have spent three days and nights beneath the spectacular vault before the monks dared to enter the chapter house. The tracery in the arcades of the cloister was installed only under King Manuel, by Mateus Fernandes and Diego Boitac. In the opulent richness of its motifs and in its inexhaustible imagination, this tracery forms dense lattices that recall the highly elaborate decorative art of Islam and sometimes Indian forms as well (see p. 5). These filigrees are showpieces of the Manueline style that bear witness to Portugal's heyday and its wealth.

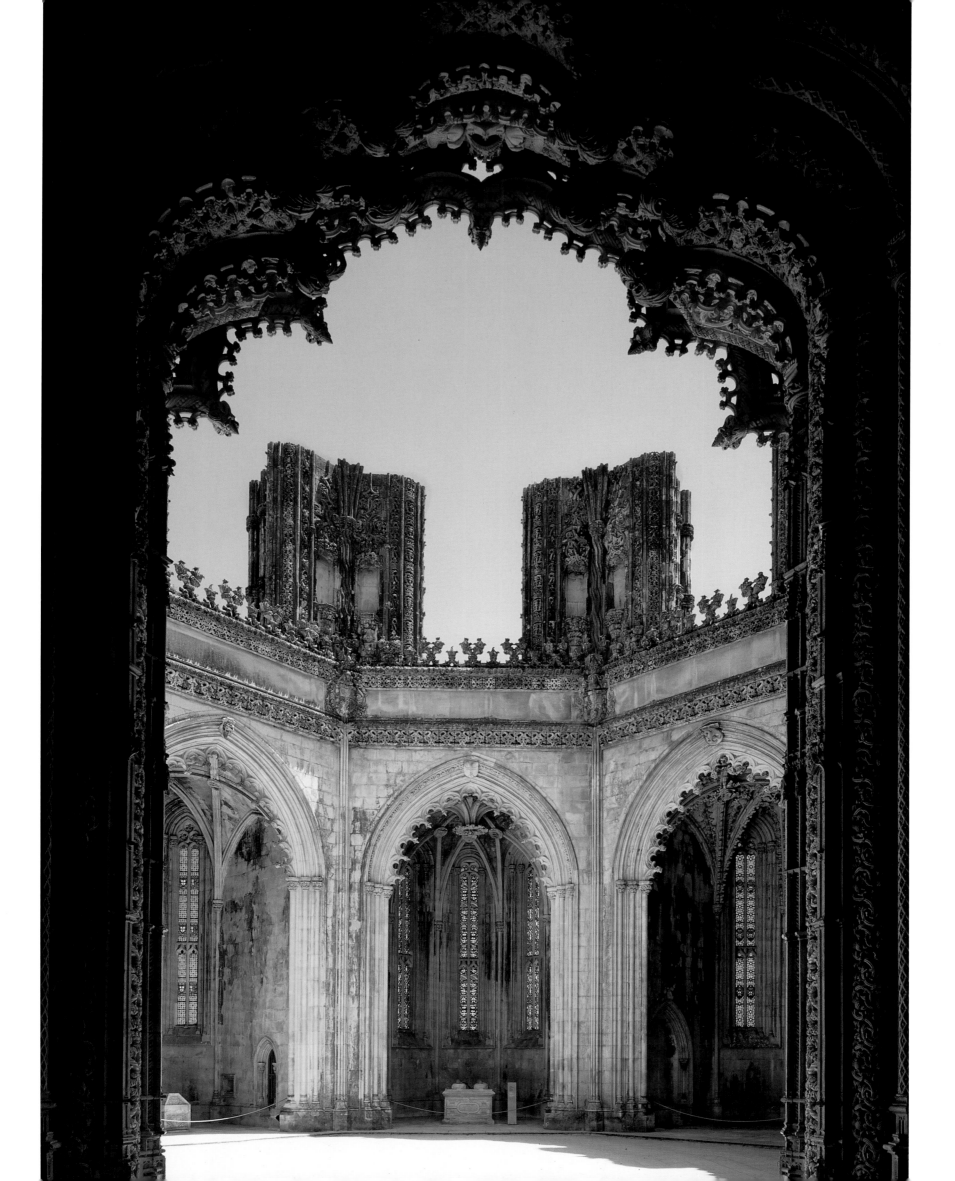

TOMAR

BELOW:
Fortification of the church from the southeast, Tomar

OPPOSITE PAGE:
Interior views of the church

THE MONASTERY CASTLE TOMAR, APPROXI-mately thirty miles southeast of Leiria, was orig-inally the seat of the Knights Templars in Portugal. In 1159, out of gratitude for the efforts of the Knights Templars in the Reconquista, Afonso I (Afonso Henriques) presented the order with the Castelo de Ceras, in the Nabão river valley. Shortly after Gualdim Pais was named master of the order in Portugal, its seat was moved to its present location, which was more advantageous strategically. Pais gave the site the Arabic name for the Nabão River: Tomar. On the mountain ridge the order built a fortress in the shape of an irregu-lar pentagon with a freestanding donjon in the middle. In 1190 the fortress was successfully defended against the Moorish Almohads. What has survived of the Templars' fortress, apart from wall ruins, is the church, also known as the Charola. It was built next to the fortification wall and also served as a defensive tower. Work on the church, which began soon after the castle was founded, was interrupted by the siege of 1190. Only around the middle of the thirteenth century—and hence in the Gothic period—was the church completed. As was so often the case with churches belonging to the Templars, it is a central-plan structure. The steeply rising enclosure wall, reinforced by pier buttresses, forms a sixteen-sided poly-gon and looks less like a church than a crenellated bas-tion. The wall surrounds a second central-plan building inside, a two-story octagon that is placed in the middle as a structure unto itself, resembling a ciborium. On the ground floor it opens up through arcades, which already hint at the Gothic style, and on the upper floor through

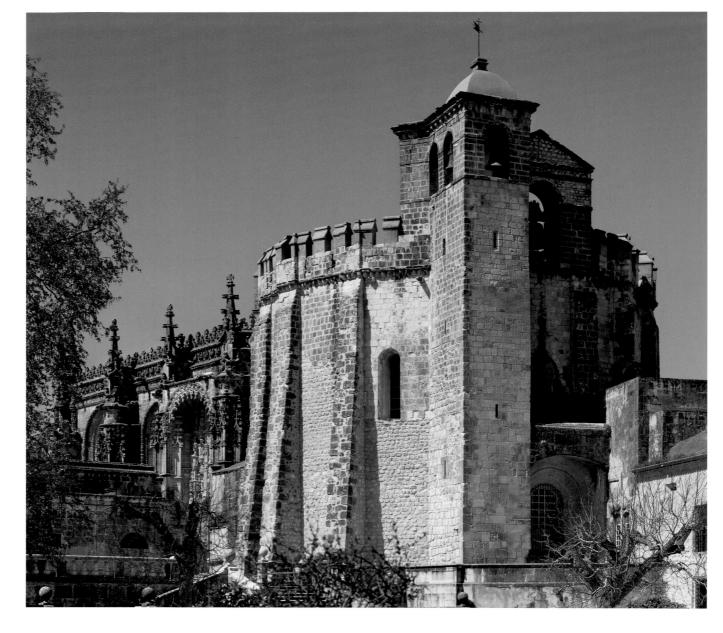

windows. Between the octagon and the enclosure wall runs an ambulatory with a soaring barrel vault. The vaulting mediates between the sixteen-sided enclosure and the octagon of the core building in that the sixteen fields of the vault taper trapezoidally toward the center. The bands that enclose the fields run radially from the outer points to the center. The whole structure is an original reformation of the church of the Holy Sepulchre in Jerusalem.

After the Knights Templars were dissolved by the pope in 1312, under pressure from the French king, all their possessions that could be found had been distributed to kings, princes, and the Hospitallers of Saint John. After the successful completion of the Reconquista, the Portuguese king Dinis I was eager to protect and expand the young Portuguese nation, and in 1318 he founded the Order of the Knights of Christ "to defend the faith, to fight the Moors, and to expand the Portuguese monarchy." The order was confirmed by the pope that year. At the same time, the sovereign king offered refuge to the fleeing Templars and transferred the movable property they had saved to the new order. In 1350 the pope decreed that members of the royal family should lead the order. The Knights of Christ, whose grand master in the fifteenth century was Prince Henry (Dom Henriques) the Navigator (d. 1460), took part in the Portuguese seafaring voyages of discovery, which is why the caravels equipped by Henry had the symbol of the order on their sails. In the late Middle Ages the Knights of Christ were one of the richest orders. In Tomar the order gradually converted its fortress into a magnificent residence, which had no fewer than eight cloisters (or arcaded courtyards), some dating to the time of Henry the Navigator.

In Portugal's heyday of discovery in the early sixteenth century, when the country had grown unimaginably rich from trade with India after Vasco da Gama's circumnavigation of Africa in 1498 and the occupation of Brazil in 1500, King Manuel commissioned the architect Diogo de Arruda in 1510 to supplement the old central-plan church with a new building whose upper floor could serve the Knights of Christ as a chancel for the divine office and whose ground floor could be used as a chapter house. The old church thus took over the function of a sanctuary. In 1515 Arruda was succeeded by João de Castilho, who finished the work. The structure of the chancel is simple on the inside but all the richer on the outside, particularly on the south side, where the entry portal is relieved by a lavishly ornamented basket-handle arch. Here the Gothic architectural forms—such as the tracery portiere of the arch—seem to have

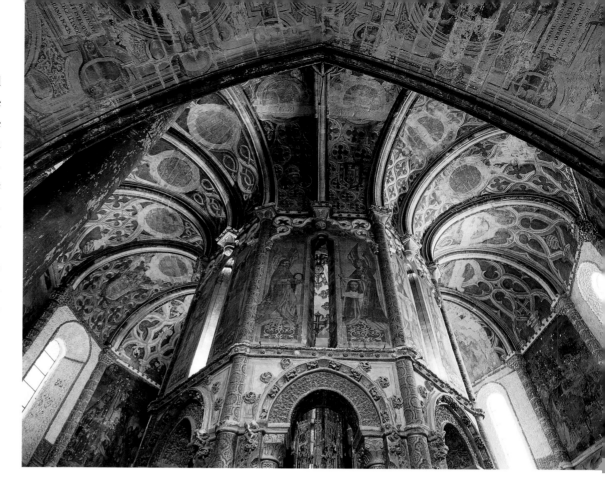

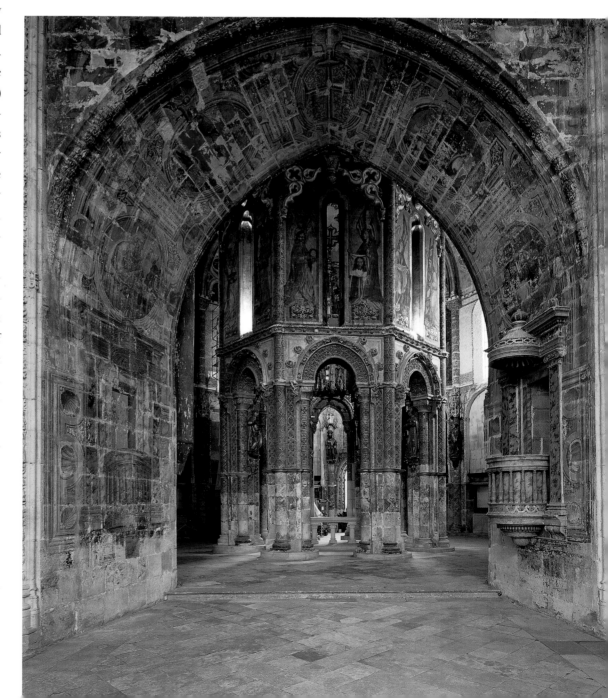

metamorphosed into plants and begun to proliferate. In general, the south portal recalls less the court art of King Manuel—the Manueline style—than the equally rich plateresque style of the late Gothic period in Spain.

By contrast, the famous ornamental window of the west end is a major, if not the major, work of the Manueline style. The ornamental forms enjoy an inexhaustible, unsurpassable richness that may be seen as the very picture of the literal wealth that reigned in Portugal at the time. The window, which sits like a jewel in a bare wall, presents itself like a singular phantasmagoria with the charm of the surprising, even the unimaginable. The forms proliferate almost like a rash over the two Gothic pinnacles that frame the window on each side, with symbols of the Order of the Garter and the religious orders of knights. There are such objects from the sea and seafaring as hawsers, coral, shells, and algae. At the very top, there is an armillary sphere—an astronomical instrument—on either side of King Manuel's coat of arms, symbols for finding position at sea, and thus for Portuguese seafaring and love of discovery in general. It may be that the overflowing splendor has deeper meaning as well. This may be suggested, for example, by the mysterious old man at the very bottom, who is embracing the roots of an oak tree, analogous to the root of Jesse, out of which Christ grows. The prophet Isaiah refers to Christ as Immanuel. The window may thus allude to the connection between the names Immanuel and Manuel. The old man would then be an ancestor of the king, just as Jesse was a precursor of Christ, and the whole window would demonstrate the splendor to which this young tree had grown under King Manuel's reign.

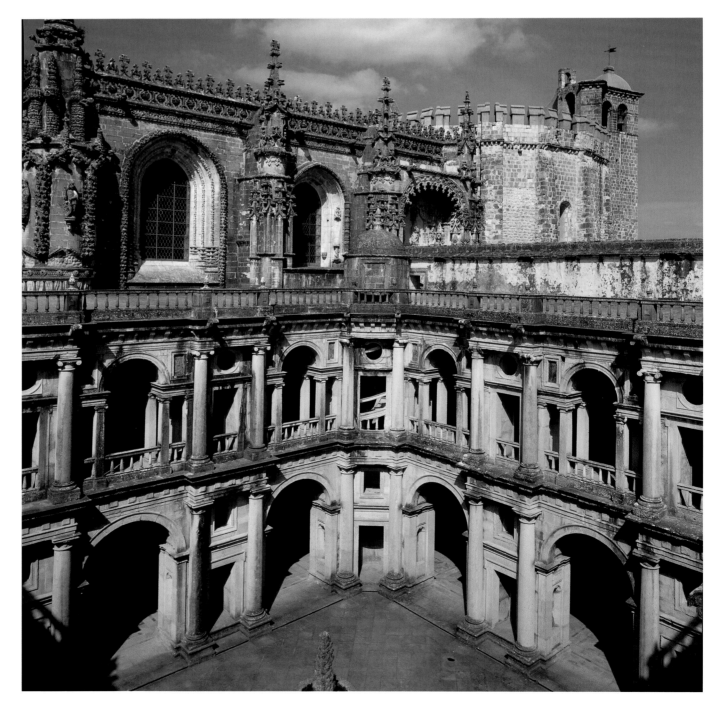

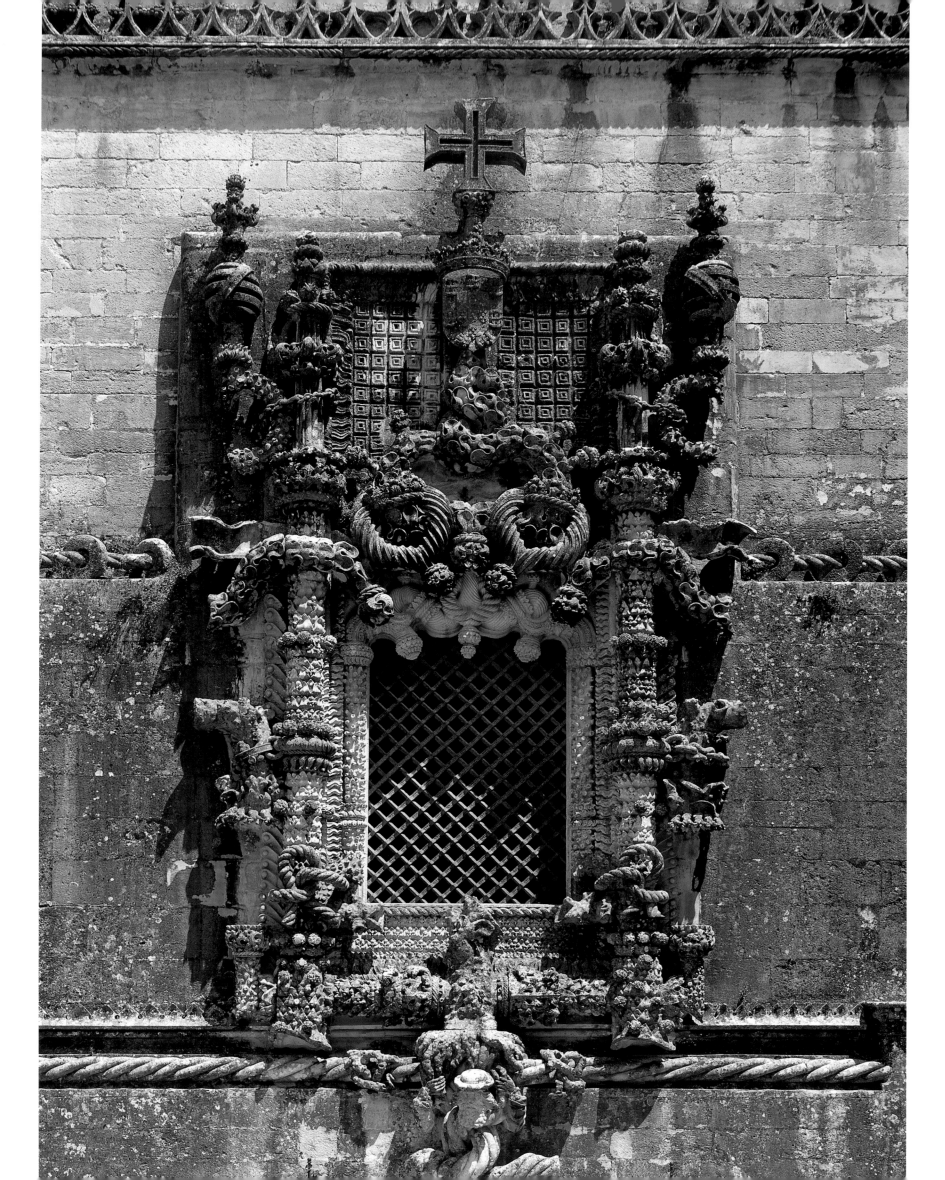

In 1550 work on expanding the site to the west was begun, under the direction of João de Castilho; the plan was to group six cloisters around a cruciform building, the Cruzeiro. That conception remained unfinished, and the main cloister was torn down soon after its completion, when King John (João) III had a new main cloister built, the Claustro dos Filippes. From 1551 onward the Portuguese kings also served as grand masters of the order. In 1557 Diogo de Torralva, Portugal's most prominent architect in the sixteenth century, was commissioned for the project. In 1562 the cloister was largely finished. After a twenty-year interruption in construction, it was finally completed in 1587 by Filippo Terzi of Bologna, who kept to de Torralva's original conception.

The two-story structure was now dominated by the Italian high Renaissance in the style of Palladio, although the architect consistently pulled out one more stop in the repertoire of motifs than Palladio himself would have done. The basic unit of the articulation of the walls is the "rhythmic bay," which is divided into three parts following the model of ancient triumphal arches, and it consists of one wide bay with arcade openings and two framing narrow bays. At the four corners of the cloister, the narrow bays form an oblique transition, concealing spiral staircases. In the column orders the architect has employed the powerful motif of full columns, and in the openings of the wide bays there is a pier arcade on the ground floor and a *serliana* on the upper floor. The enormous thickness of the walls is quite striking, giving the structure an unusual volume of depth. The architecture is a singular protest against the overabundant Manueline appetite for ornament, but the effect of the whole is to be more Italian than an authentic Italian style, which makes it evident that it is in fact not Italian.

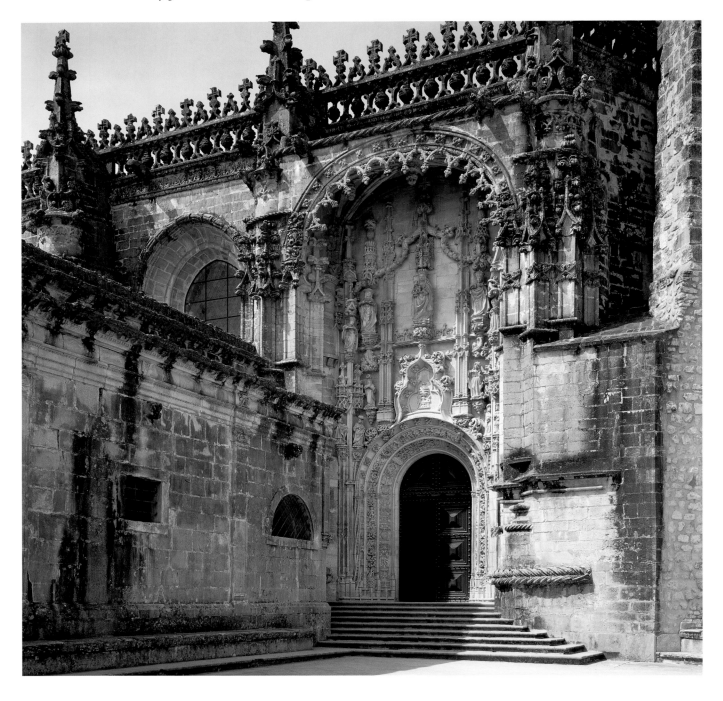

BELÉM

The Hieronymite monastery Belém lies on the outskirts of the Portuguese capital, Lisbon, on the banks of the Tejo River, at the point where it spreads out to the width of a sea inlet. Together with neighboring Torre de Belém the monastery forms a prestigious outpost of a capital that was a colonial empire that reached around the world. For departing seafarers Belém was the last opportunity for worship, and the first for those arriving. The monastery was established in 1496 by King Manuel I on the site of a charterhouse belonging to the Order of the Knights of Christ. In 1498, two years after Belém was founded, Vasco da Gama circumnavigated Africa by order of the king, and the Portuguese thus opened up the sea route to India, something Columbus and the Spanish had failed to do six years earlier. Vasco da Gama's nautical success would soon make Portugal the

leader in world trade, displacing Venice. In recognition of his services Vasco da Gama was granted the honor of being buried in the Belém monastery church, beneath the western gallery, where a figurative tomb sculpture was erected for him, though not until the late nineteenth century. Mindful of Portugal's accomplishment, King Manuel was all the more generous in decorating the church. Hence the buildings became a

Side portal of the south facade, Belém

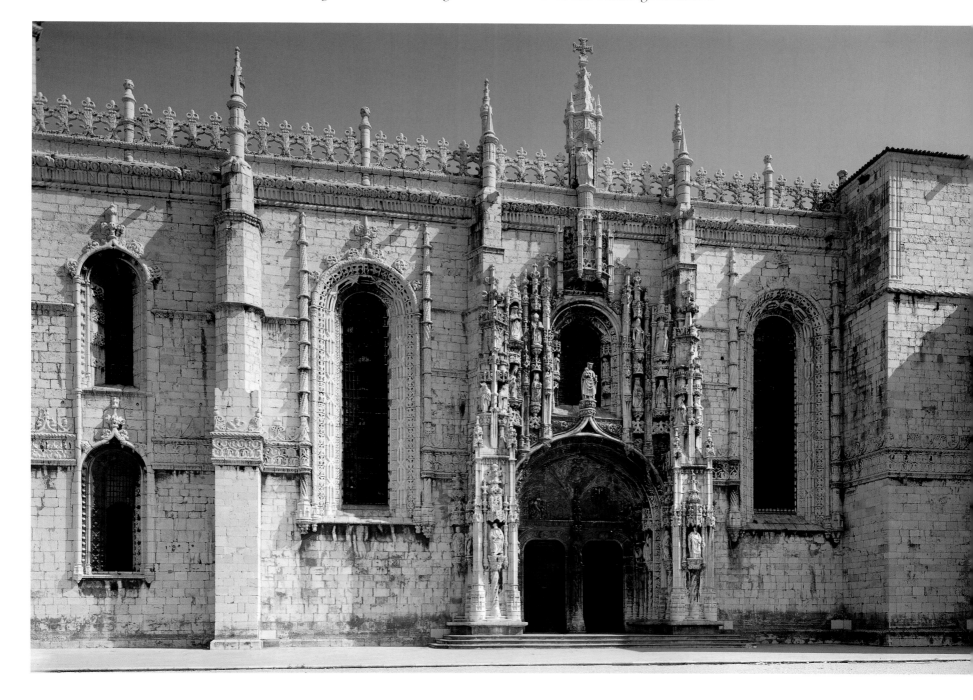

demonstration of Manueline wealth, which seemed to be constantly surpassing itself.

The first architect was Diogo Boitac (also known as Boytac and de Boytica). He planned a layout with four cloisters and began the church in 1501. He was succeeded in 1517 by Spanish-born João de Castilho, who completed the church. It is an unusually spacious hall church, 300 feet (92 m) long with narrow octagonal piers approximately 65 feet (20 m) tall and completely covered in Renaissance ornament. With no arches or bands separating the nave from the side aisles, the tracery vault reaches across the borders of the aisles and bays and unifies the space. It is so perfectly constructed technically that it even survived the earthquake of 1755. The Capela-mor that once adjoined the church on the east side, where Manuel and his descendants were buried, was torn down in 1563 and later replaced by a new building whose cool severity presents a hard contrast to the rest of the church. To make room for additional tomb monuments, the transept arms were extended by adding chapels.

The Manueline style is only truly realized in the decor. The main portal in the west and the secondary portal on the south, which faces the Tejo, are particularly richly decorated with filigree of late Gothic ornamental work and sculptural decorations. The portals had been planned by Boitac, but they were executed by João de Castilho and the Frenchman Nicolas Chanterenne. The cloister is the culmination of this delight in ornamentation. Its sides are 180 feet (55 m) long, with the peculiarity that the corners are veiled by oblique arches that conceal the piers. The lower gallery was the work of Boitac; the upper, of Castilho. The detailed decor of the tracery openings is typical of the Manueline style, but larger forms still reign in the pier arcades that contain the tracery. Large and small forms combine for an effect that justifies Belém's worldwide fame. Of the buildings for the convention, only the refectory west of the cloister reflects architectural ambition, which is expressed in the series of shallow star vaults that span the otherwise simple, elongated room.

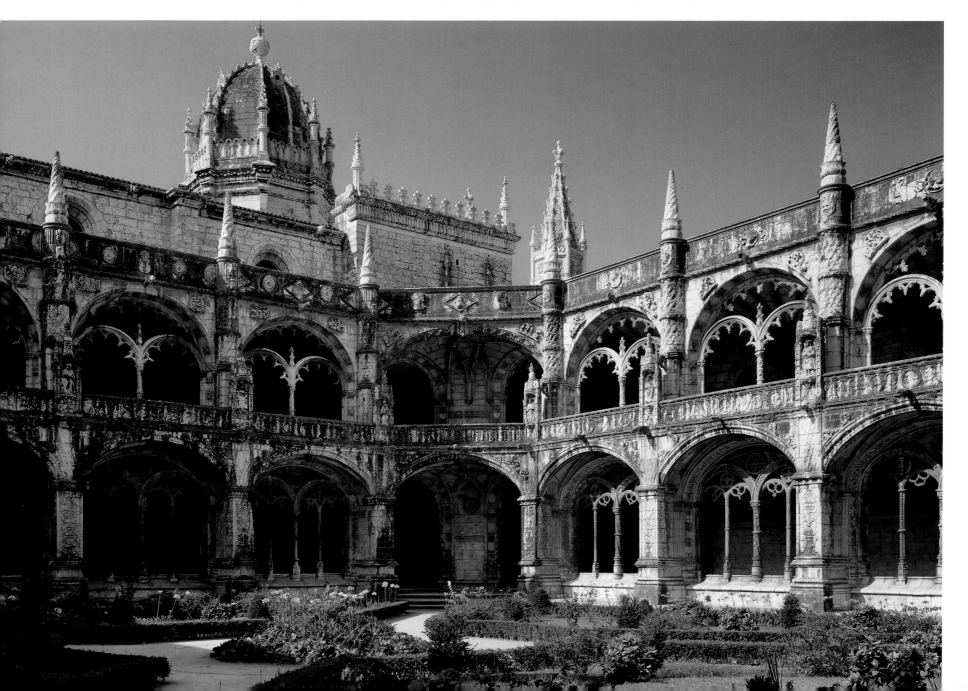

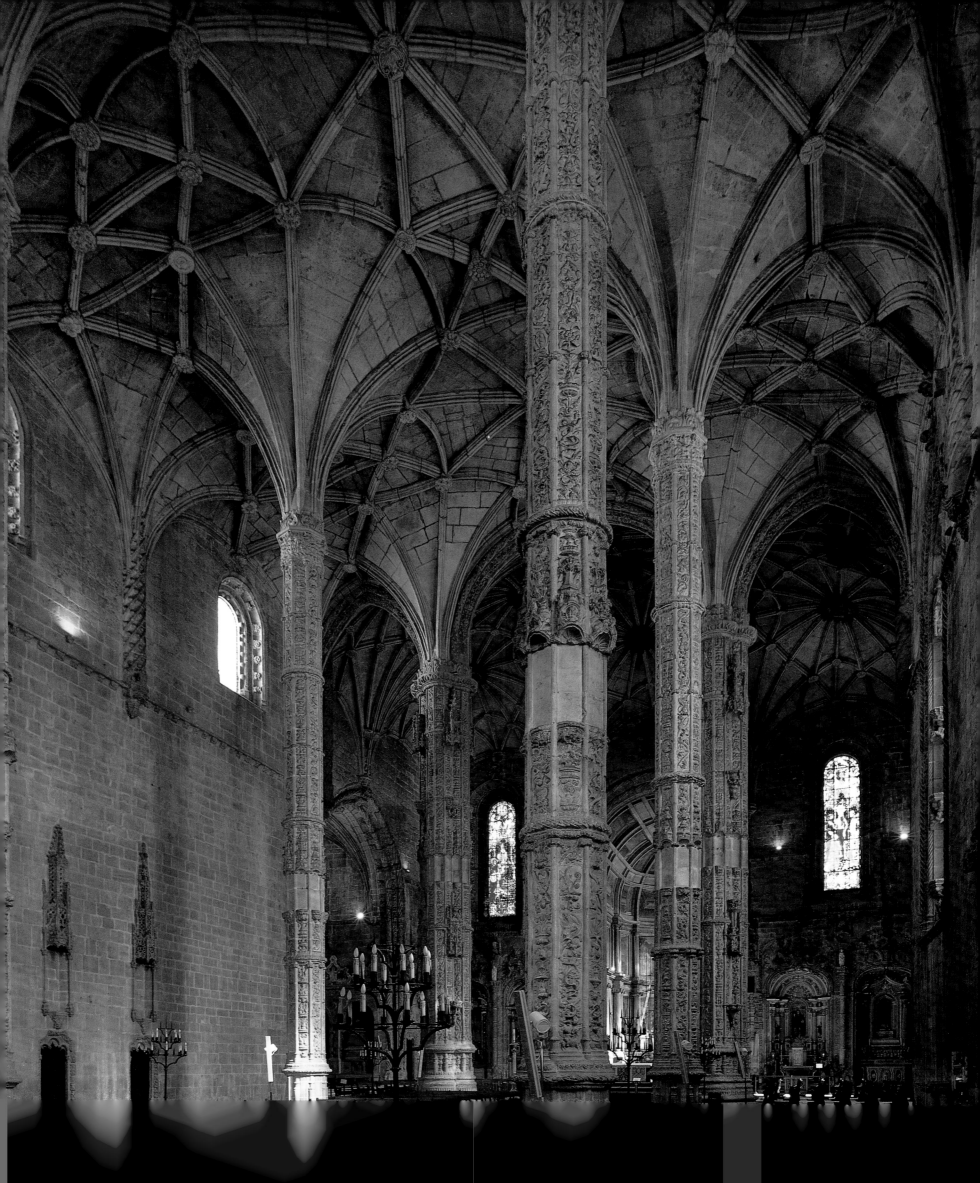

TOLEDO
SAN JUAN DE LOS REYES

ON THE WESTERN EDGE OF THE CITY, HIGH above the Tajo River and Saint Martin's Bridge, directly across from the Puerta del Cambrón, the Franciscan monastery San Juan de los Reyes lies like a fortress. This district of the city was formerly the Jewish quarter, but the Jews had to leave Toledo in 1492 when they were expelled from Spain by royal edict. The monastery was founded in 1476 by the Catholic royals Ferdinand of Aragon and Isabella of Castile, who, following their marriage in 1469, gradually united the two Spanish kingdoms under joint reign. They chose this monastery as their burial site. The immediate occasion for establishing it was the victory over the Portuguese at Toro. In 1504, however, it was decided to build their burial site not in Toledo but in Granada, the last stronghold of the Moors, which had fallen in 1492. There, from 1506 onward, their ultimate burial site, the Capilla Real, was built. Even before that, around 1495, the church of San Juan de Los Reyes had nearly been completed. It is an ambitious major work of the Isabelline style, also known as the Estilo Hispano-flamenco, a movement in Spanish architecture that fused the older Mudejar style with influences from northern European late Gothic to create a richly decorative ornamental style. At the time a number of architects and stonemasons were brought to Spain from France, the Netherlands, and

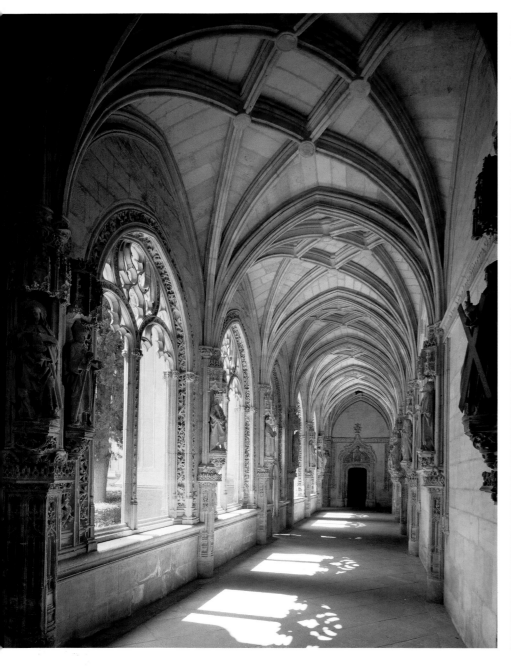

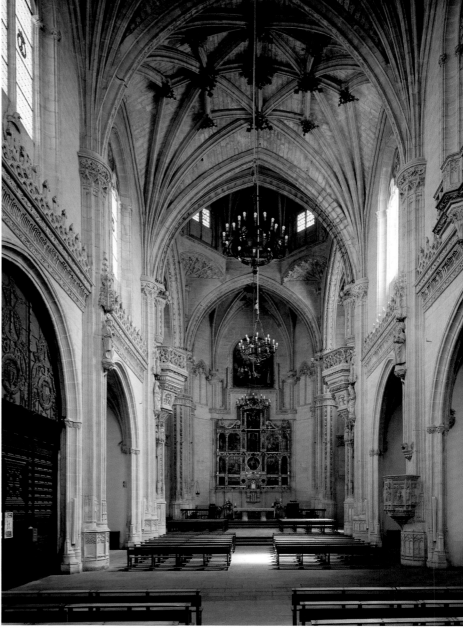

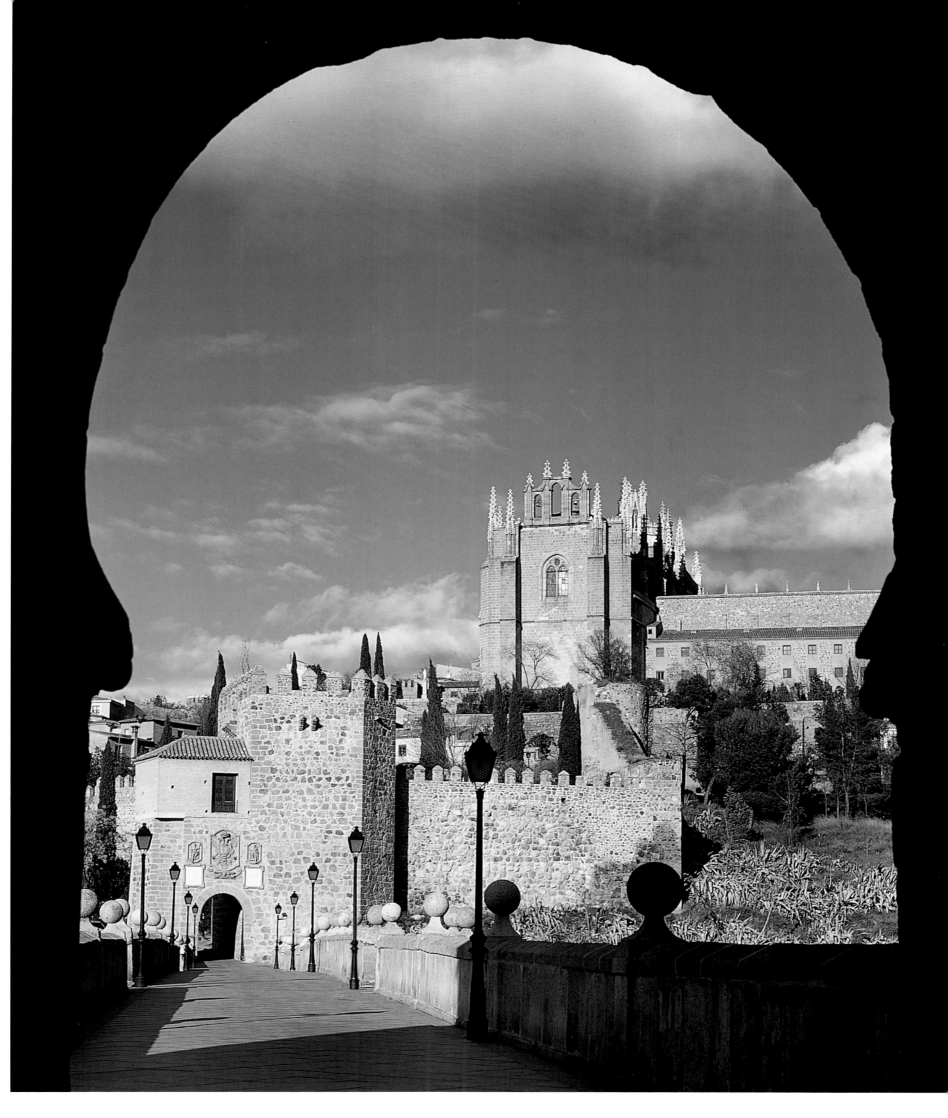

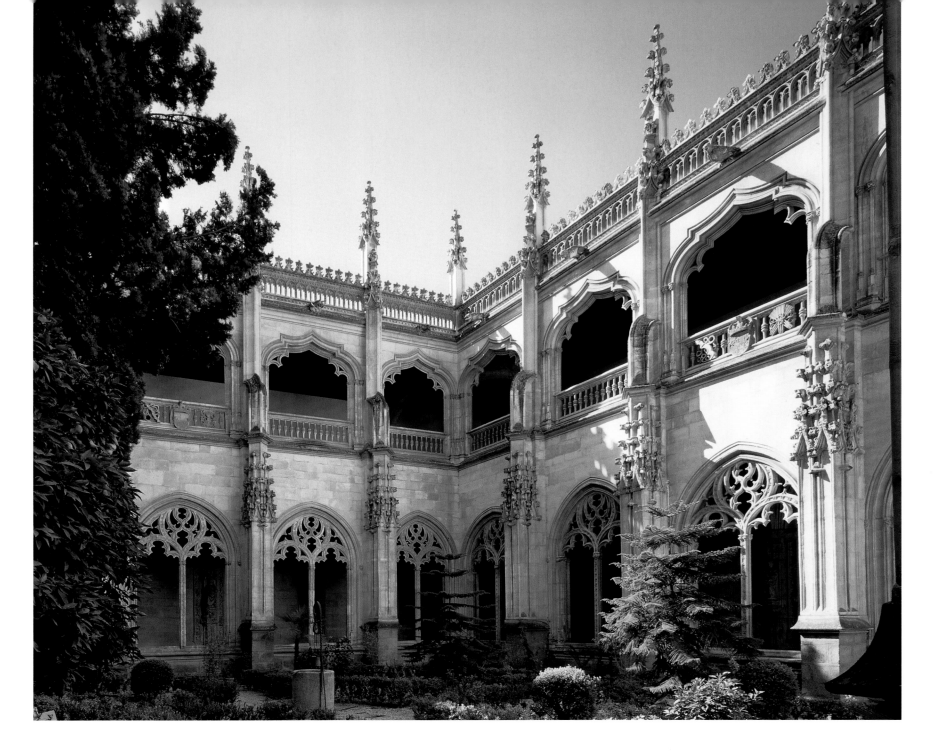

Cloister, San Juan de los Reyes

Germany, such as Juan Guas (Jean Wast), who, according to his will, was from Lyons and whose father was probably from Breton. He had worked on the cathedral in Toledo under Flemish masters and rose to become the primary royal architect. From 1477 until his death in 1496 he directed the construction of the church San Juan de los Reyes.

It is laid out as a single nave with side chapels, transept, and choir, with an octagonal dome on a drum above the crossing. The two-story structure obtains its unmistakable look from a half-height frieze that is as delicate as embroidery, with inscriptions that glorify the conquest of Granada and the expulsion of the Jews. The royal initials, Y and F, are found everywhere. In the crossing, where the tombs probably would have been placed under the dome, these friezes make their way around the piers in the form of a projecting balcony—a motif that bears a striking resemblance to the choir of the Lorenzkirche in Nuremberg, which was built just a little earlier. The star vaults in the main block and transept are also technological and artistic masterpieces. The octagonal dome on a drum above the crossing is vaulted by a shallow dome with underlying ribs.

The cloister was built after 1500 by Enrique Egas, a Spanish master of Flemish origin. The two-story structure with tracery windows on the ground floor and portiere arches on the upper floor is subdivided by piers in the form of large pinnacles, known as *colossi*. The bright ivory-colored stone lends the whole a cheery, almost profanely festive atmosphere, as if it were not the cloister of strict nuns but rather the courtyard of a profligately rich royal palace.

COLEGIO DE SAN GREGORIO

The Castilian city of Valladolid—from 1346 onward the seat of a university and in 1469 the scene of the wedding of Ferdinand of Aragon and Isabella of Castile and León, which was of extraordinary historical significance—was, for a time, the capital of Spain. It was the meeting place of the Cortes, the assembly of the estates, and, after the discovery of America, of the Council of the Indies. One major work of the Spanish late Gothic in the Isabelline style is the Colegio de San Gregorio (now a museum) in Valladolid, which was founded by the bishop of Palencia, Fray Alonso de Burgos, who was for a time father confessor to Queen Isabella. There is just one chapel in the Colegio, the work of Juan Guas. San Pablo—the adjacent church, belonging to the ecclesiastical association—and the chapel both had exceedingly richly adorned facades, decorated with sculptures, in the style of Spanish altar retables of the late Gothic. San Gregorio's facade was begun in 1487, together with the entire association complex. It is attributed to Juan Guas and the sculptor Gil de Siloé, or sometimes to Diego de la Cruz. San Pablo's facade followed in 1492, designed by Simón de Colonia, the son of Juan de

Colonia, the architect of the Burgos cathedral. The patio of the Colegio is less a cloister than a magnificent two-story palace courtyard. The model was the courtyard of the palace in Guadalajara, which Juan Guas and Egas Cueman of Brussels had built in just three years, beginning in 1480. At San Gregorio the forms of the arcades are less elaborate: on the ground floor, tall twisted columns with shallow basket-handle arches; on the upper story, low biforia with opulent decor on the balustrade and within the arch, where inverted double arches are employed as a motif in relief—all of this is a typical Spanish mixture of forms from the earlier, Moorish-influenced Mudejar style and northern European late Gothic.

Cloister, Colegio de San Gregorio, Valladolid

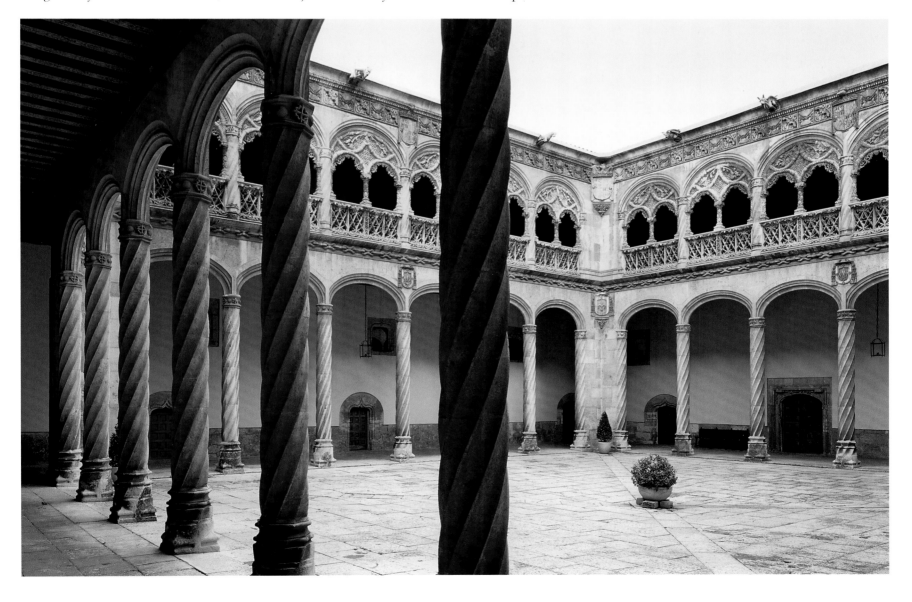

EL ESCORIAL

EL ESCORIAL IS THE EARLIEST MONASTERY CASTLE in history to be built according to a uniform plan; indeed, despite the two-tower dome church, its overall appearance is more like a castle than a monastery. It is located thirty miles northwest of the capital, Madrid, at an altitude of 3,400 feet (1050 m), on the southern face of the Sierra de Guadarrama, whose mountains are often covered in snow. From the beginning the driving force behind the building was King Philip II, who wanted to place a manifesto in stone, in truly regal proportions, of how the Spanish house of the Habsburgs conceived its reign as an indissoluble unity of the Catholic church and the state. After the recent conclusion of the Council of Trent, Philip saw

himself as the hegemonic champion of Christianity, as the only one who could guarantee the preservation of the pure and true faith. This challenge, which he set both for himself and for the Spanish kingdom, was to be expressed in the building like a powerful symbol created for eternity, and so Philip not only determined its conception down to the details but also personally supervised its execution. The external occasion for the founding of the monastery castle was the victory over the French King Henry II near Saint-Quentin, on Saint Lawrence's Day in 1557. Consequently, El Escorial was dedicated to Saint Lawrence.

The site was to combine a church, royal burial site, palace, monastery, college, library, and administrative center. The contemplative order of the Hieronymites, which the Spanish court had favored since the fifteenth century, was chosen for the monastery. The technical planning and execution were undertaken by Juan Bautista de Toledo, who had studied in Italy, and, after Bautista's death in 1567, by the architectural theoretician Juan de Herrera, who developed a sober, barracks-like formal language that was very much in keeping with the strict spirit of the Counter-Reformation: the

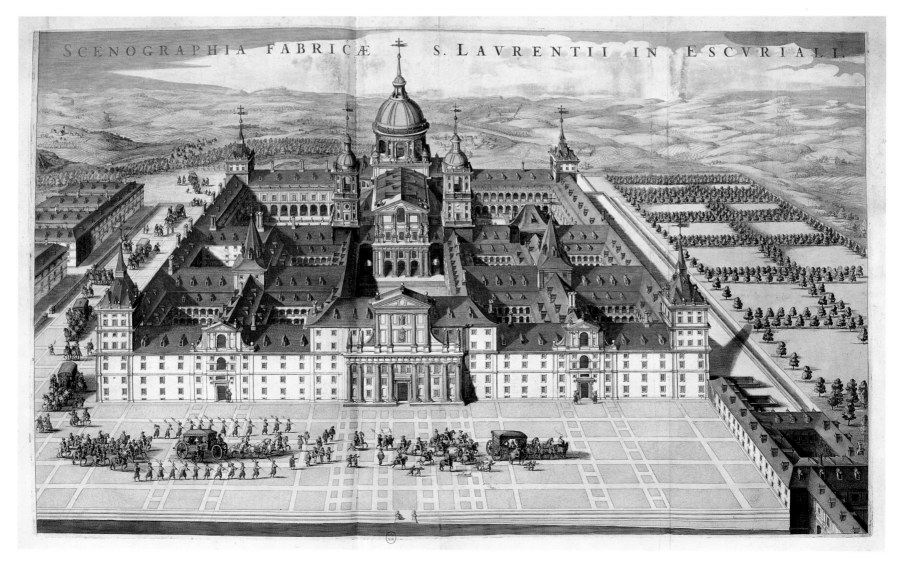

SCENOGRAPHIA FABRICÆ ✦ S. LAVRENTII IN ESCVRIALI.

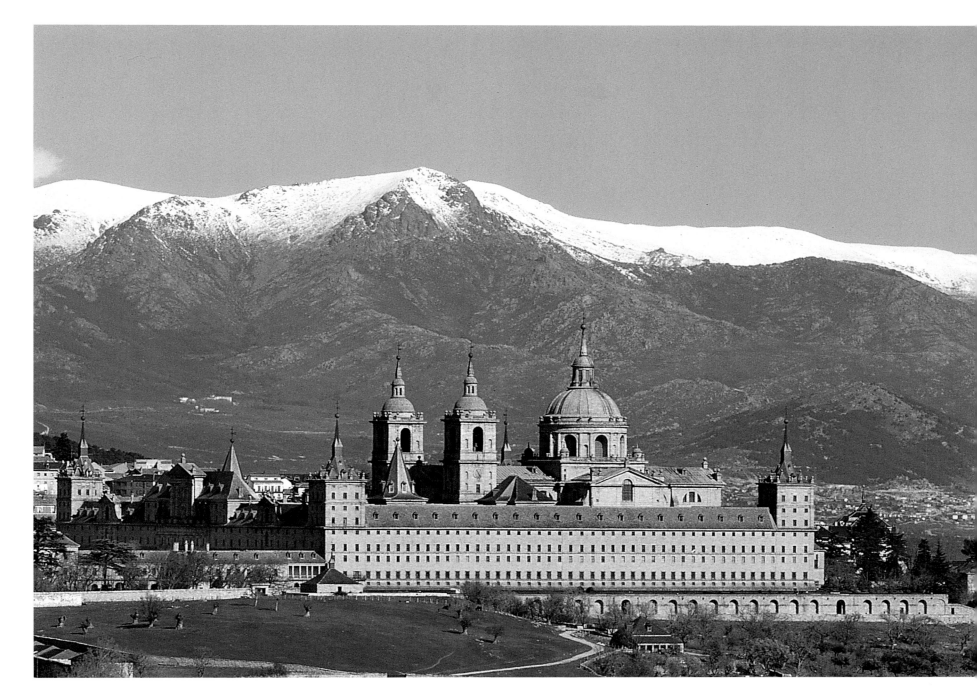

View of the monastery complex from the south

somewhat joyless Herrera style. The entire structure was built in grayish white granite between 1563 and 1584. It covers an area of 675 feet by 525 feet (206 × 161 m) and contains no fewer than sixteen courtyards arranged according to a strict axis, although not symmetrical throughout. The architectural regulations of the Hieronymites required that a monastery have several courtyards, around which the monks' cells could be arranged. The size and number of the courtyards here, however, which were initially designed for a convention of fifty monks, then one hundred, and finally two hundred, exceeded all precedents. The site is framed by a fortress with four towers in the corners. The entrance in the middle of the western side is designed like the facade of an Italian church in the manner of Vignola and leads into the library wing and from there into a courtyard with a two-tower facade on the far side. This last

belonged to the antechurch for the commoners, above which was the monks' gallery. The church itself is a cruciform, central-plan building articulated by an order of Doric piers with a round dome on a drum. The whole interior has a Spartan rigor and an off-putting aloofness, like a mausoleum in which everything living has petrified into dead stone. Twenty-two projects for the church were worked out by the leading Italian architects, including Palladio, Alessi, and Vignola, but Philip rejected them all. In the church, in the side niches of the chancel on the left and right, there are bronze sculptures of the families of Philip II and his father, Charles V, kneeling in eternal worship as they face the high altar; they are the work of the Italian sculptors Pompeo and Leone Leoni. Philip had the mortal remains of the royal family buried in the church's crypt. The king's residential palace, with its own courtyard, was constructed

El Escorial. Top right: *Philip II's bedroom;* Bottom left and right: *Pompeo and Leone Leoni, bronze sculptures of the families of Charles V and Philip II in eternal worship, in the altar room of the church*

Opposite page:
Luca Giordano, ceiling fresco in the stairwell, 1692–93

behind the choir of the church, so that the view from his bed was of the high altar, as was also the case at Charles V's last residence, in the Yuste monastery.

One showpiece of Herrera's architecture is the stairwell that occupies the center of the west wing of the large cloister, the Patio de los Evangelistas. It is the first stairwell of the modern age to demand and occupy its own framework. The stairs begin with a central flight that separates at a turning platform into a symmetrical stair with two flights, much like the great stairwells of the Baroque, such as the Würzburg residence. The stairwell at El Escorial was an architectural invention almost without precedent. The room was given particular magnificence later by the large ceiling fresco, by Luca Giordano from Naples, who had been commissioned by Charles II, the last Habsburg king on the Spanish throne. The fresco, painted in 1692–93, shows the Trinity with Saint Lawrence interceding, revered by angels and by emperors and empresses—the whole work a celebration of the glory of the Spanish house of Habsburg.

ELEONORA ET MARIA SORORES
ILLA FRANC. HÆC HVNGAR. REGINÆ

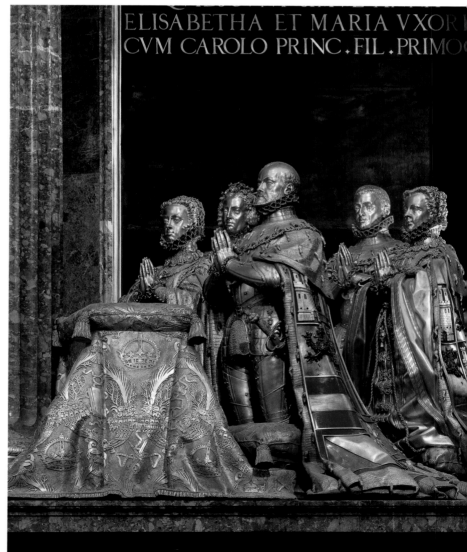

ELISABETHA ET MARIA VXOR
CVM CAROLO PRINC. FIL. PRIMO

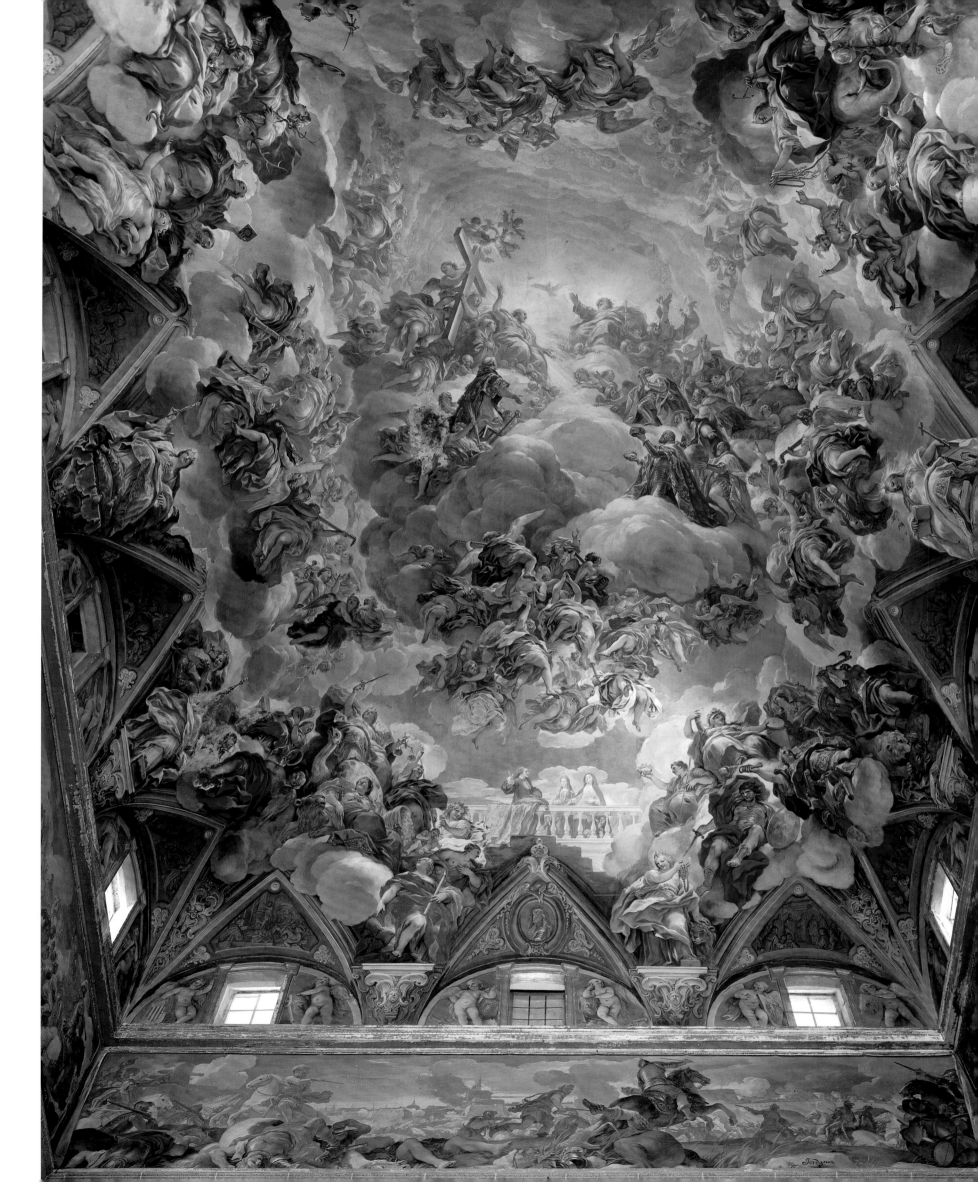

LAS HUELGAS REALES

BELOW:
*Interior of the chapter house,
Las Huelgas Reales*

OPPOSITE PAGE:
TOP: *North side of the church from
the outer courtyard;* BOTTOM:
Las Claustrillas cloister

THE MOST IMPORTANT ABBEY FOR CISTERCIAN nuns in Spain and the mother monastery of fourteen daughters was Las Huelgas, before the gates of the Castilian episcopal see of Burgos. The abbey was founded on the site of a summer residence, somewhere around 1179, by King Alfonso VIII (1158–1214), at the instigation of his wife, Eleanor Plantagenet, daughter of King Henry II of England and Eleanor of Aquitaine. The founding couple were later buried in the chancel of the church. Pope Clement III confirmed the new monastery in 1187, and Alfonso transferred the founding charter to the abbess, an event that is depicted in relief on the king's sarcophagus.

Just like the Le Tart convent near Cîteaux, Las Huelgas was a separate congregation, with a right of visitation for the abbess from the mother convent and annual general chapters. Both congregations were organized similarly to the Cistercian monks, but they were not legally incorporated into the order until around 1196, after a protracted process and not a little resistance from within the order. Las Huelgas became the retirement home and burial site of the dynasty of Castilian kings as well as the head of all convents in the Castilian kingdom. In addition, the abbess had full civil jurisdiction over sixty-four localities, which gave her a rank similar to that of a prince. No other abbess anywhere in Europe had such powers. This circumstance occasioned the silly remark from Cardinal Aldobrandini in 1605 that if the pope were to marry, the abbess of Las Huelgas would be the appropriate partner.

The church was begun around 1220–25, about the same time as the nearby cathedral of Burgos. It followed the victory of Las Navas de Tolosa, in which the united armies of Castile, Navarre, and Aragon crushed the Almohad sultan an-Nasir. The church is a three-nave basilica based on the Bernardinian plan with a transept that has two chapels on each side. The chapels have flat terminations and the ribs of the vault describe a polygon in their interiors. The sanctuary projects considerably and terminates with five sides of an octagon to form an apse. The two-story structure of the church is a typical example of bare Cistercian early Gothic. The nun's chancel is in the nave; it is closed off from the remainder of the church by choir stalls, a rood screen, and Flemish tapestries. At the east part of the chancel, on a platform with steps, stands the double sarcophagus of the royal founders. Both parts of the sarcophagus are constructed as stone chests with saddle roofs and triangular gables, decorated with reliefs and coats of arms: the castles of Castile and the crowned leopard of the Plantagenets. The king and queen both died in 1214. Their nephew Ferdinand III the Saint commissioned the sarcophagus. Thirty other members of the royal house are also buried in the church, including, in a freestanding sarcophagus in the northern side aisle, Infante Alfonso de la Cerda (d. 1333), the first-born son of

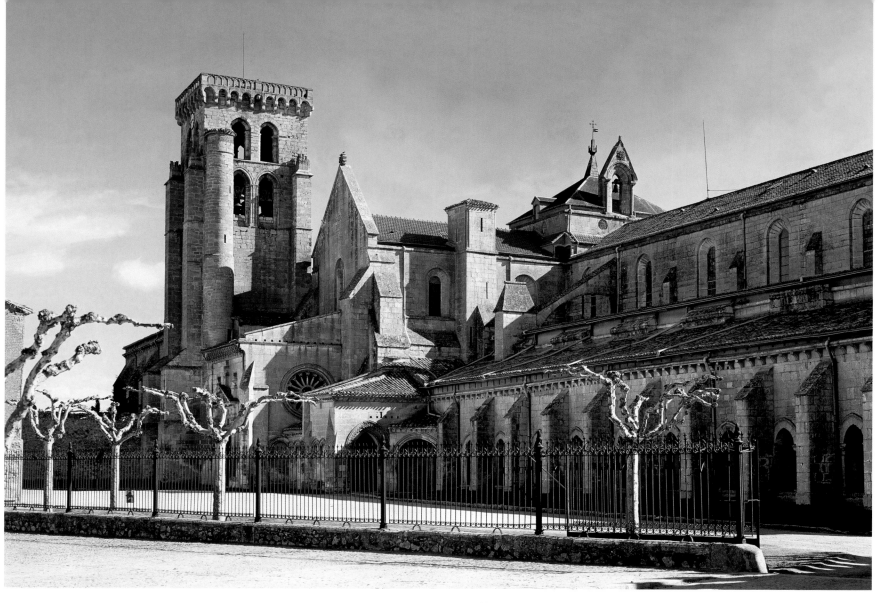

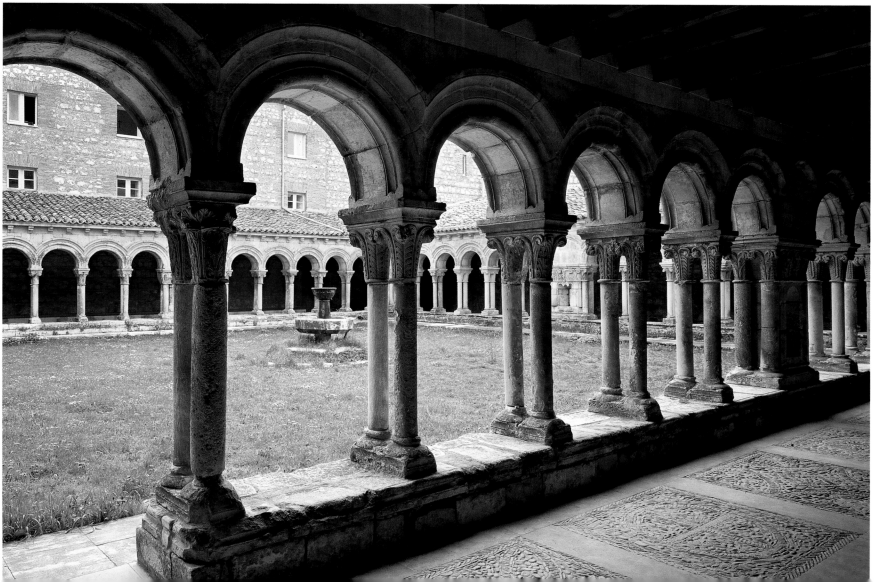

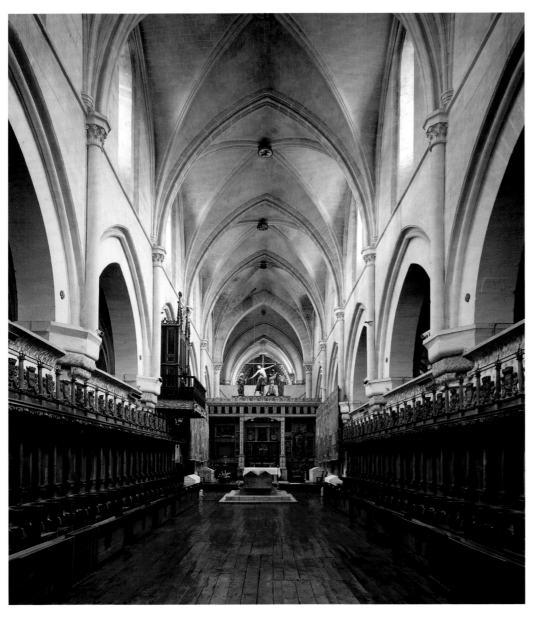

Fernando de la Cerda, and Sancho the Brave's rival as successor to the crown. The coats of arms on the front face include the castle of Castile, the lion of León, and French fleurs-de-lis, which allude to Alfonso's mother, Blanche, daughter of the French king Saint Louis. The kingdoms of Castile and León were united from 1230 onward, as is evident from this coat of arms.

The monastery buildings, surrounded by a defensive wall with crenellations, were begun soon after its founding by an architect named Ricardo and in 1203—before construction of the church began—they were largely finished. The small cloister, known as Las Claustrillas, has survived from this period; it has a square layout with twelve perfectly shaped arches on each side, each of which has double columns and a round arch with three steps on the front face. The arcade is interrupted in the middle by a pillar with four small columns at its corners that lends a certain rhythm to the gallery. Somewhat later, around 1230, followed the four-support room of the extraordinarily large chapter house, with its cross rib vaults and piers surrounded by eight monolithic engaged pillars. The most striking features are the primitive capitals and pedestals. They look as if they have been left unfinished, just raw, unhewn blocks, which give a crude overtone to the otherwise elegant architecture.

Las Huelgas Reales. TOP LEFT: *Nun's chancel;* BOTTOM LEFT: *Sarcophagi of donors Alfonso VIII and Eleanor Plantagenet;* BOTTOM RIGHT: *Sarcophagus of Infante Alfonso de la Cerda*

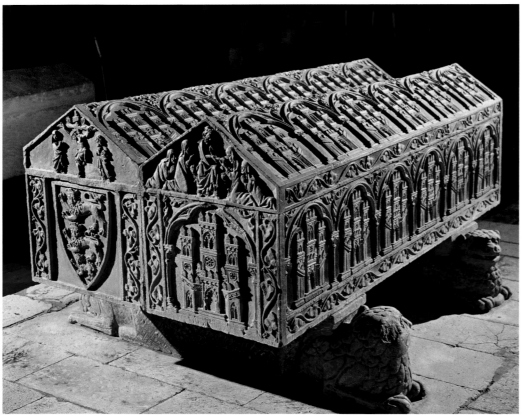

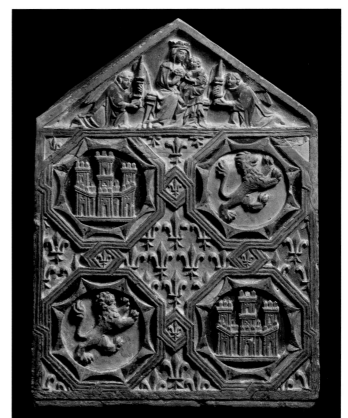

A BOUT TWO AND A HALF MILES EAST OF BURGOS, upstream on the Arlanzón River, lies the charterhouse of Miraflores. It was previously the site of King Henry III's hunting castle, which, shortly before his death in 1406, he had willed to the Carthusians to build a monastery. Henry's son and successor, John II, who was just a year old when his father died, fulfilled this testamentary obligation only much later, at the insistence of Bishop Alonso de Cartagena. The first charterhouse was built in 1441 and had to be restored after a fire in 1452. Two years later King John commissioned Juan de Colonia (John of Cologne), the German-born architect responsible for the cathedral at Burgos, to draw up plans for the church, but nothing was done with them, as the king died the same year. Only in 1477 could the architect begin work, now with a commission from Queen Isabella of Castile, who wanted to create a burial site worthy of her parents, King John II and his second wife, Isabella of Portugal. In 1478 Simon de Colonia, Juan's son, took over after the death of García Fernández de Matienzo, who had briefly succeeded after the death of Juan, and within a decade he had completed construction. In keeping with the Carthusian ideal, the church is a towerless single-nave structure with bare walls, cross rib vaults, and a polygonal apse. The only original decorations in the interior are the tracery ribs of the apse.

In addition to the tombs for her parents, which are given the place of honor at the center of the chancel, Isabella also had a monument—a niche tomb in the wall—built for her brother, Infante Alfonso, who would have been heir to the throne had he not died in 1468. In 1486 she commissioned the Flemish sculptor Gilles, known in Spain as Gil de Siloé, for both works. He created the wooden retable for the high altar, with its extremely elaborate figures and ornaments and the kneeling figures of those buried in the chancel: the royal couple, John and Isabella. The gold for the polychromy is said to be from the first gold transport from the Americas. The altar was the last of the three works to be completed, in 1499.

The double alabaster tomb, on which the king and queen are separated by an ornamental ridge and are also turned away from each other, consists of a lozenge-shaped base placed crosswise, with the rectangular tomb slab rotated a half phase relative to it so that the combined figures form an eight-pointed star. The baldachin above their heads and the ornamental patterns on the surfaces of their garments and pillows are opulent and regal in their richness. Richer still is the tomb

CARTUJA DE MIRAFLORES

niche of the Infante Alfonso, especially its frame, which proliferates like rank growth. The young prince, in magnificent garments, is kneeling and praying before a stool with a prayer book whose pages are being turned by the hand of an invisible person—presumably Death. A depiction of the departed praying but not facing an altar or a saint was a bold innovation in tomb art. The theme is not public piety, but quiet, contemplative, private piety, though here it is displayed with all royal pomp.

BELOW:

Gil de Siloé, tomb of Infante Alfonso (d. 1468), Cartuja de Miraflores

PAGE 90:

Gil de Siloé, double tomb of the Castilian royal couple, John II and Isabella of Portugal, in front of a high altar retable, 1486–99

PAGE 91: *Detail of retable*

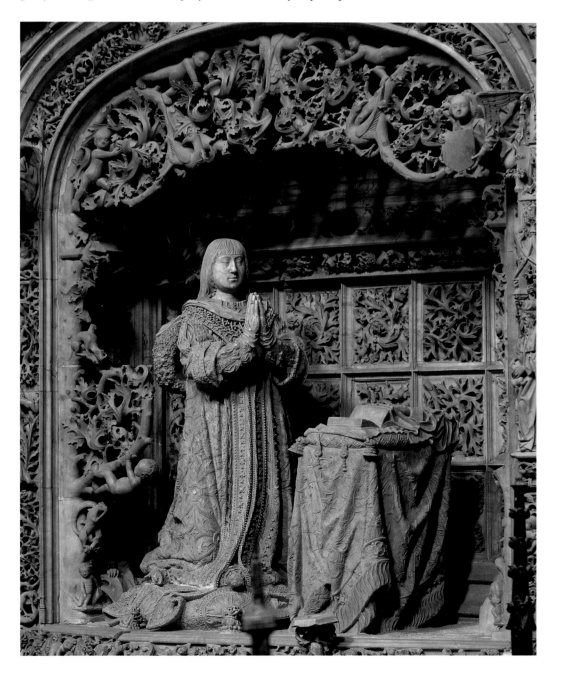

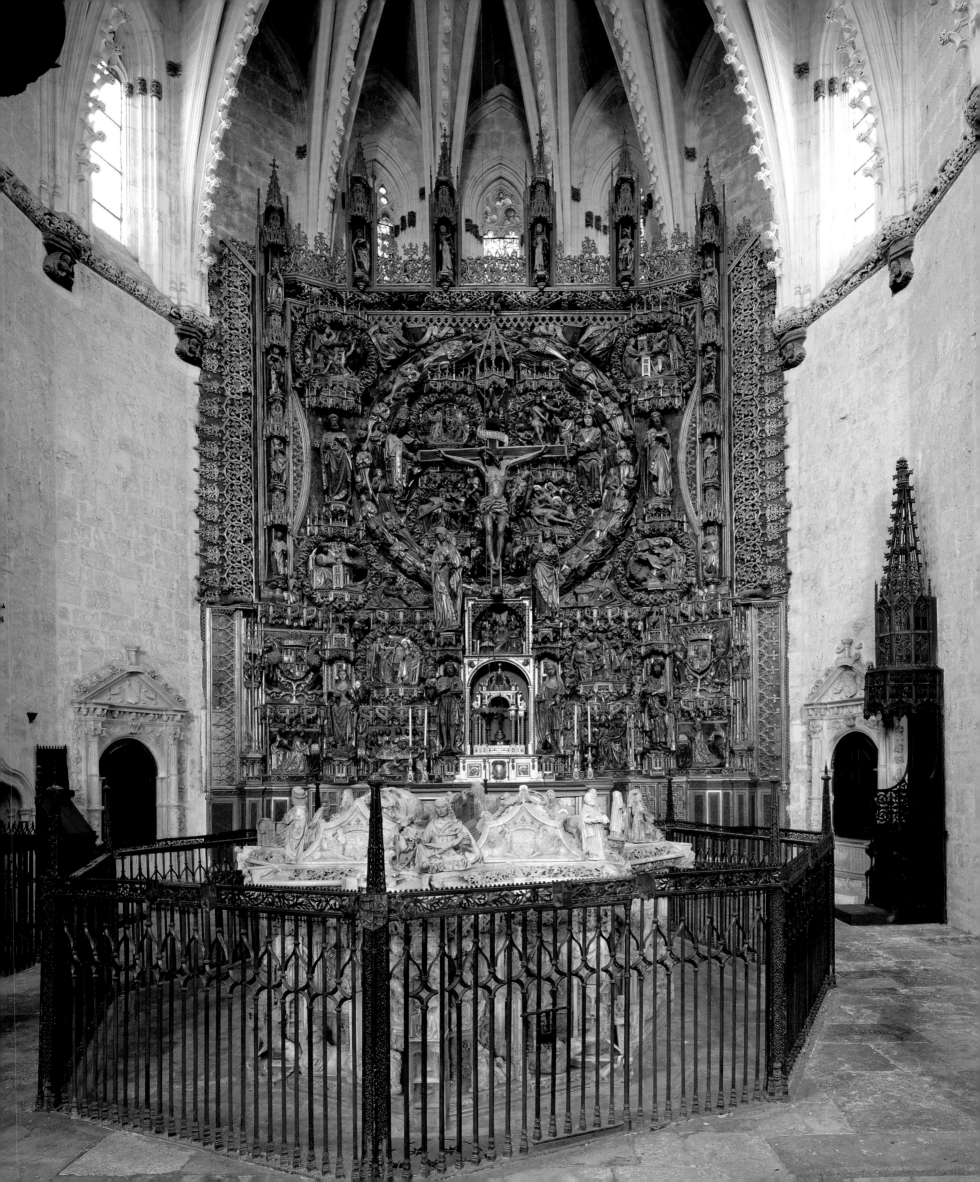

POBLET

TOP RIGHT:
Crossing tower of the church, Poblet

BOTTOM:
Overview of the monastery site from the west

OPPOSITE PAGE:
Interior of the church

POBLET (HORTUS POPULETI), IN CATALONIA, IS ONE of the largest and best-preserved Cistercian monasteries in Europe. It lies in the mountainous region halfway between Tarragona and Lérida (Lleida). Its history in the Middle Ages was closely associated with the ruling house. It was founded in 1149 by the count of Barcelona, Ramon Berengar IV, in gratitude for his victory over the Moors. In 1151 the convention, under Abbot Stephen, came from the Fontfroide abbey, near Narbonne, in southern France, and Poblet itself produced seven Spanish daughter monasteries in the

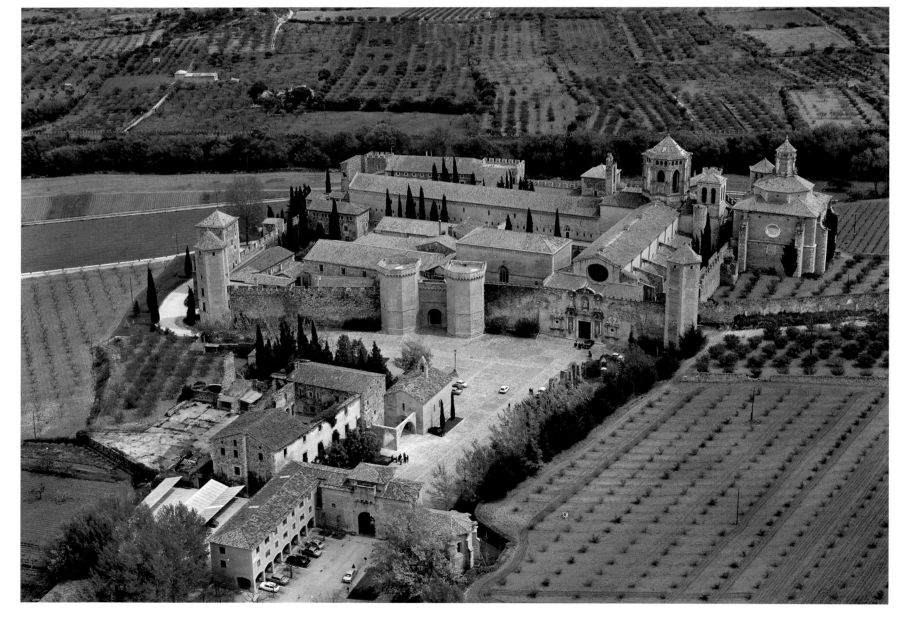

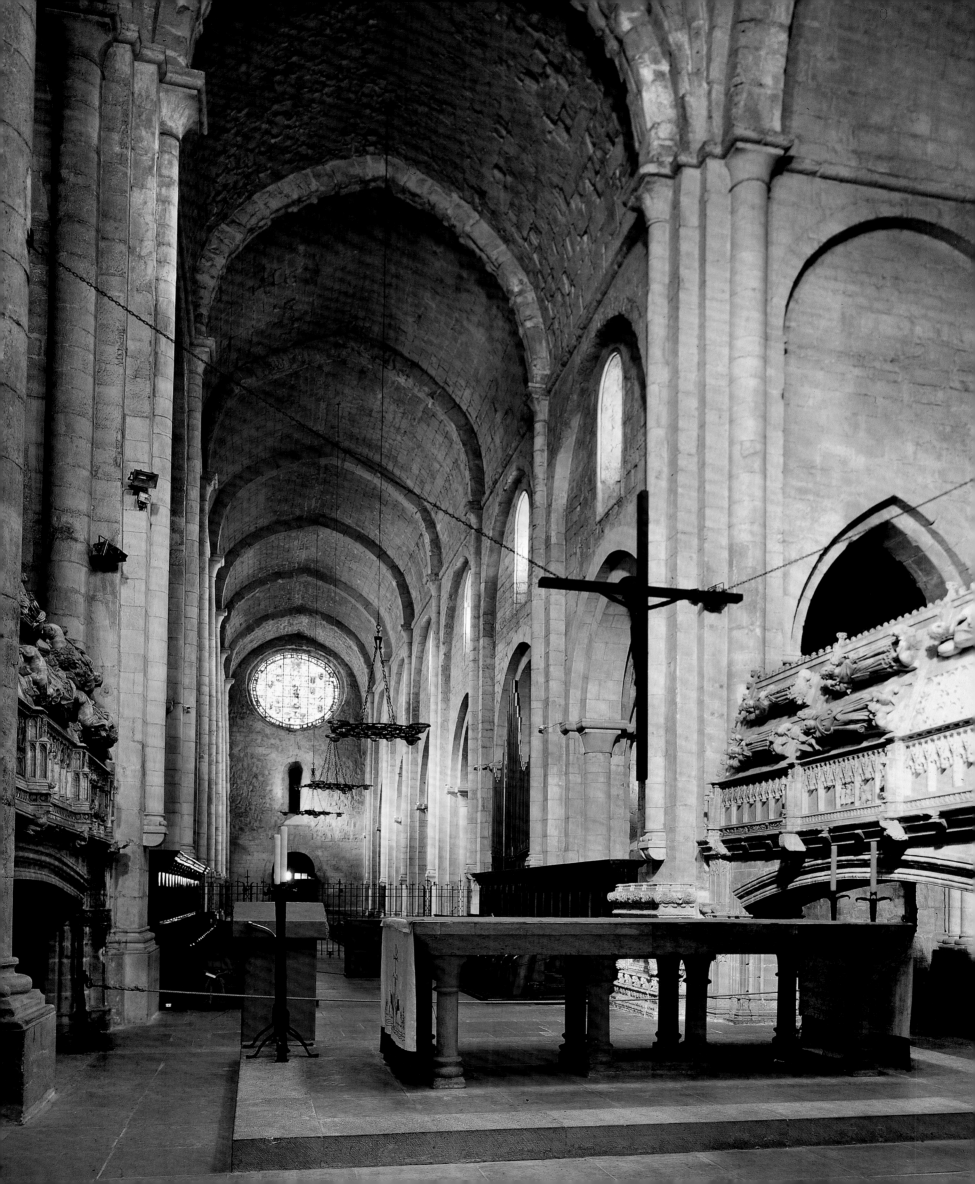

Top:
*Tombs of royalty in front of the church's
transept, Poblet*

Bottom:
Tombs of nobility in the cloister

Opposite page:
Poblet. Top: *Well house;*
Bottom: *Chapter house*

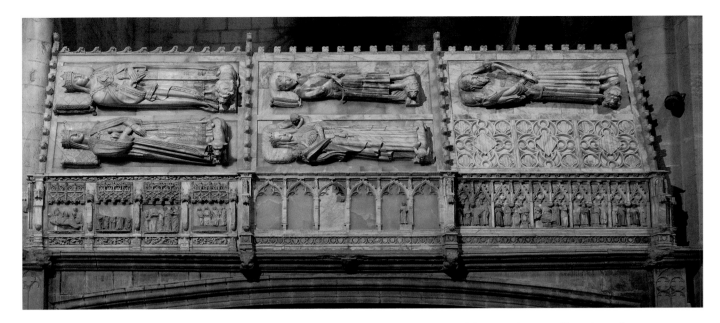

period that followed. The son of the founder, King Alfonso II of Aragon (d. 1196), known as Alfonso the Chaste, chose the monastery as his own burial site and that of the royal house. Poblet thus replaced two older royal burial sites: San Juan de la Peña, in Aragon, and Ripoll, in Catalonia. Poblet remained the royal burial place into the fifteenth century. In 1183 the monastery was placed directly under the king and in 1220 it received exemption. The abbots held the office of grand almoner to the king and, from the middle of the fourteenth century, usually that of vicar of the Cistercian order for Spain as well. The high rank it held is evident from the fact that the abbey was allowed to have the royal coat of arms on its banner. Thus a monk of the monastery could remark proudly: "Populetum … toto orbe cristiana nulli secundum" (Poblet is second to nothing in the whole Christian world).

In 1367 King Peter IV the Ceremonious ordered that the monastery be fortified to protect the royal bones. A crenellated defensive wall was built, two thousand feet (600 m) long, with twelve forty-foot- (20-m-) tall towers and a royal gate with two towers that commanded respect. Inside the wall's protection Peter had a royal palace built east of the monastery buildings. King Martin the Humane began a new palace around 1397, but the building, which would have been Spain's largest Gothic palace, remains unfinished. The abbey was closed in 1835, but it was resettled in 1940 by monks from Italy.

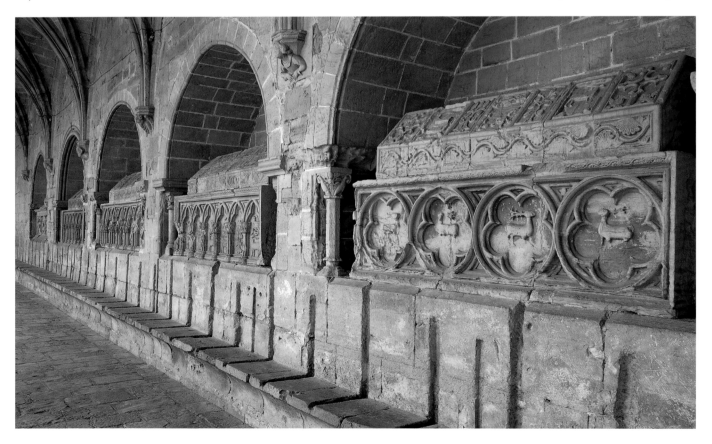

Little is known about the construction of the present-day church, which is 280 feet (85 m) long. It was probably begun around 1170, after a quarry had been donated to the monastery. The east end must have been completed by 1196, when King Alfonso was buried there. Its ground plan, consisting of five sides of a decagon, has an ambulatory with a wreath of five semicircular radial chapels, tightly arranged, much like those found in three other northern Spanish Cistercian churches from this period: Veruela, in Aragon; Fitero, in Navarre; and Moreruela, near Zamora. These four structures form a coherent group. At Poblet the piers of the apse are stocky cantoned round piers. The nave and the equally tall (ninety-two feet [28 m]) transept have pointed barrel vaults; those in the nave have underlying bands. The side aisles, by contrast, have cross vaults with rounded ribs. Unlike in most barrel-vaulted churches in southern France, here in the nave a windowed clerestory is inserted between the nave arcades and the barrel vault and crossed by a blind ornament—which makes the space steeper, with the consequence that external flying buttresses had to be added later to take up the lateral thrust of the vault. In marked contrast to the Cistercian severity of the interior, the exterior has an octagonal crossing tower (a cimborio) with open tracery, pier buttresses, and canopy windows. It was left unfinished as a consequence of the plague of 1348, which claimed both Abbot Copons and the tower's architect, the monk and mathematician Bernard de Paulu.

The monastery buildings north of the church, built in the late twelfth century, are well preserved, including the cloister, the hexagonal well house, the very large chapter house with its three ornamental windows, and the 285-foot- (87-m-) long dormitory, which is covered by stone transverse arches and a wooden saddle roof.

The placement of the royal tombs is extremely unusual. They are not on the floor but on flat arches that span from one crossing pier to the other in front of both transept arms; each supports a small house with a saddle roof. The tomb slabs are attached to the slopes of the saddle roofs. Presumably these were originally protected by another roof with rich traceried gables. These floating mausoleums were built in 1339 by Peter IV, who engaged Master Aloi of Flanders and Jaume Gascalls de Berga for the project. The sarcophagi of lower-ranking nobility were placed in wall niches in the cloister.

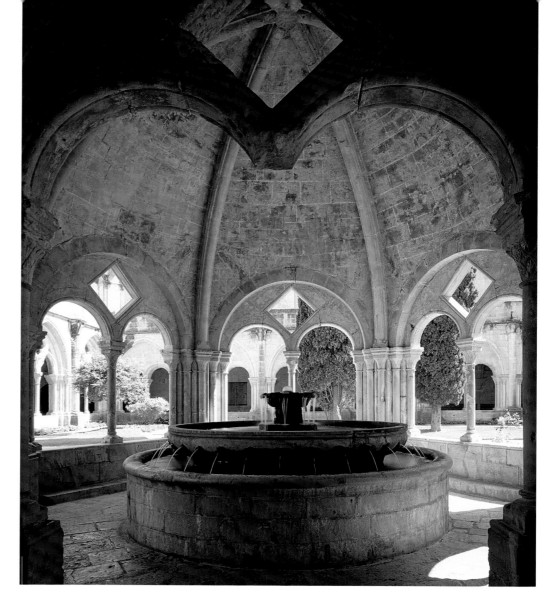

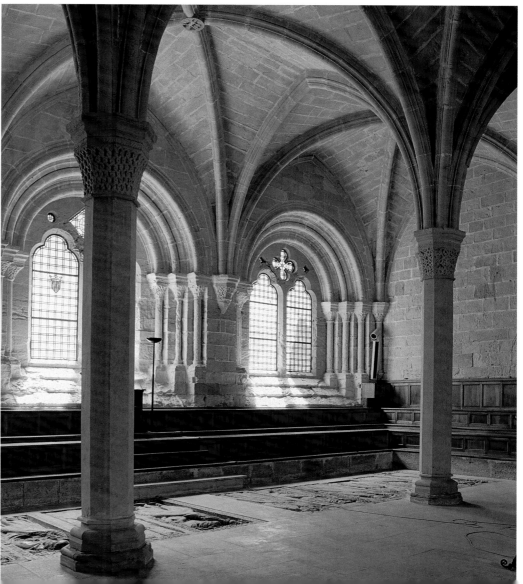

SANTES CREUS

which had put itself under the direction of Clairvaux, at Valdaura del Valles. In 1153 the monastery moved for the first time, and then in 1168 settled in its present location. A few years later the powerful seigneur of Montpellier, Guillaume V, entered the monastery as a converso. The kings of Aragon supported it, like Poblet, with gifts and privileges. The royal seal could be used for important documents at Santes Creus, and from 1297

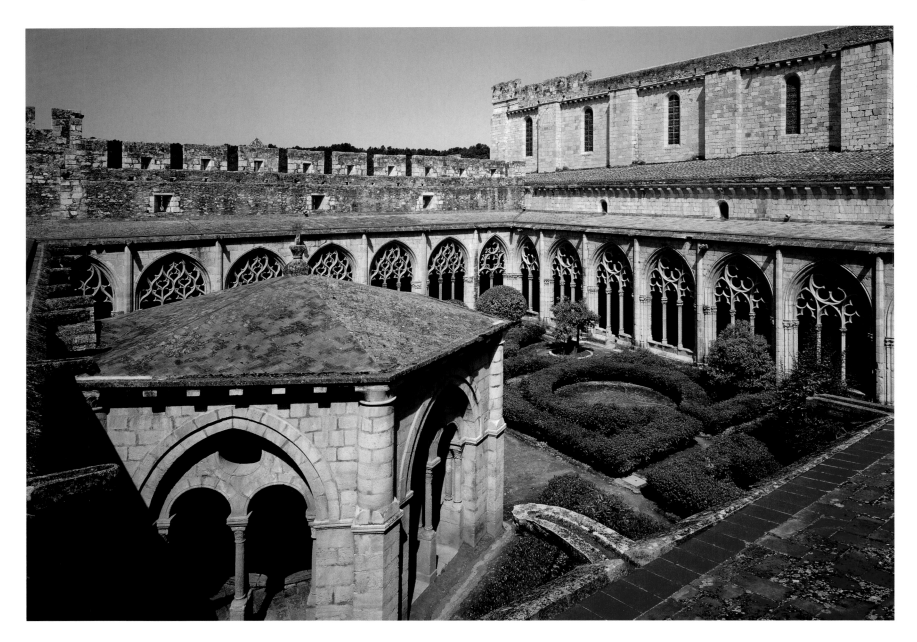

POBLET AND SANTES CREUS ARE THE CISTERCIAN royal abbeys of Aragon and Catalonia. The name Santes Creus derives from several crosses that were placed in memory of a supernatural light that appeared here. The abbey lies about forty-five miles west of Barcelona, on the left bank of the abounding Gaya River, on a plateau surrounded by mountains, about fifteen miles from Poblet (see pp. 92–95). It was founded by Guillem Ramon IV de Montcada, the grand seneschal of the count of Barcelona. In 1150 he resettled monks from the Grandselve monastery, near Toulouse,

until the time of Philip II the abbots here were also royal chaplains. The abbey was famous for its large library. The political significance its abbots enjoyed is evident from the fact that Abbot Pere Alegre was able to found the Military Order of Montesa, in the interests of his king, James II of Aragon, which was visited by the Cistercians. In the kingdom of Valencia and Aragon, the Order of Montesa succeeded the Knights Templars, which had been dissolved in 1312, and in that region they were also granted the privileges of the Hospitallers of Saint John.

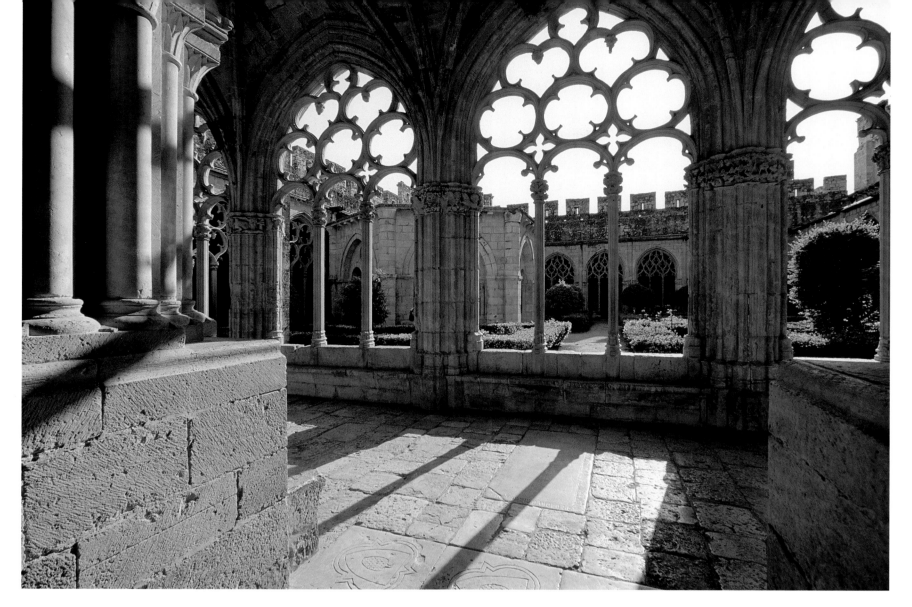

The royal burial site may have been Poblet, which raised the rank of that abbey, but Peter III, known as the Great (reigned 1276–85), chose Santa Creus as his burial site, as did his son James II (reigned 1291–1327) for both himself and his wife, Blanche of Anjou. Each of those kings had a palace built on the east end of the site, and a third palace was built on the foundations of the first under Peter IV, known as the Ceremonious (d. 1387). Unlike at Poblet, here the king's wish to convert the monastery into a fortress was resisted. The defensive wall that nevertheless was begun later, was never completed.

The church, which at a length of 233 feet (71 m) can be included among the medium-sized Cistercian churches, was begun in 1174 and put into operation in 1211. It is an archaic pier basilica built on the Bernardinian plan, with a transept, box-shaped sanctuary, and two chapels with flat terminations on either side. The piers and walls are unusually thick, between eight and ten feet (2.5–3 m). Cross rib vaults were planned for the side aisles, but in the end the vaults were built with thick box ribs. The nave, whose walls are distinguished by broad vaulting shafts on corbels with eight steps, also had rib vaulting.

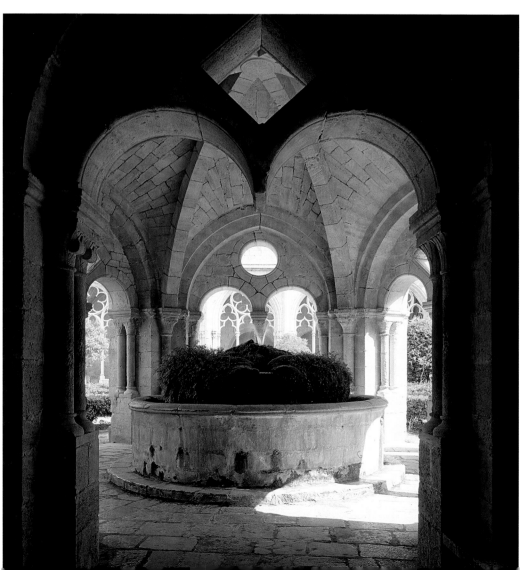

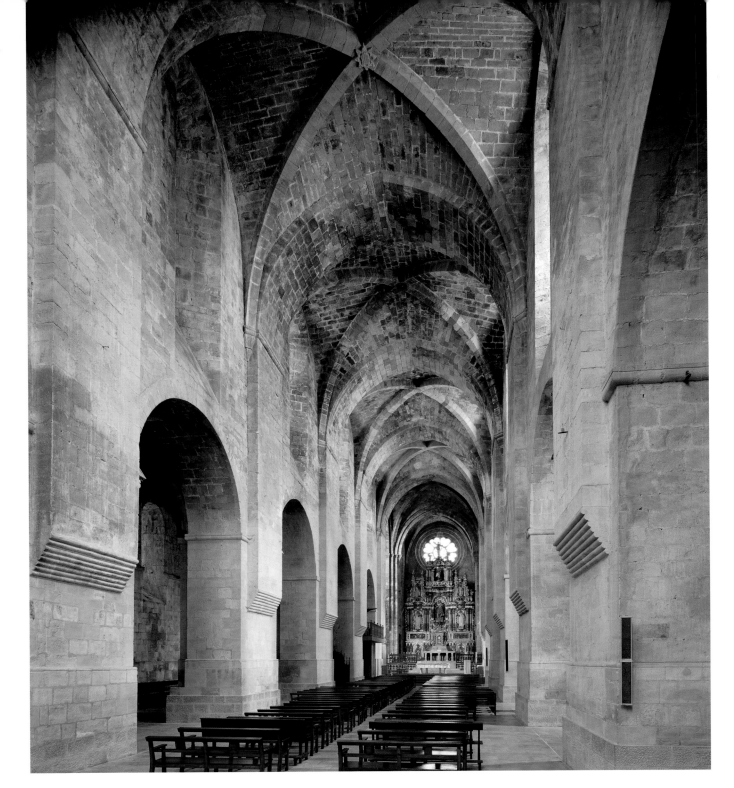

The four-support, rib-vaulted chapter house was built at the same time, but in comparison to the leaden walls of the church, it has a lighter elegance, as does the hexagonal well house. The latter, with its double arcades and ribs, is the elder sister of Poblet's well house. The dormitory, which at ninety feet (46 m) in length is just a little more than half the size of the one at Poblet, is, like the latter, a wide hall with thick walls and transverse arches on which a saddle roof lies: a very simple architecture. The cloister of the infirmary that adjoins it to the east is equally simple, with its pointed arch arcades, which are simply bare cutouts from the wall. The original main cloister, which may be imagined as having had forms similar to those of the well house that was part of it, was replaced by the present Gothic construction between 1313 and 1341. This later cloister is distinguished by its rich tracery windows and exquisite figurative capitals. In 1326, a year before his death, King James II donated fifty thousand coins for the cloister. The window tracery is identical in all four wings, but the wings themselves differ. In the north, east, and south the dominating form is the circle, in many variations; in the west wing, however, after the first northern bay the tracery immediately turns to completely different flamboyant forms. These windows are the earliest examples of the flamboyant style in Spain. The new forms were evidently introduced by the Englishman Reinard Fonoll, who was active in Santes Creus between 1331 and 1341.

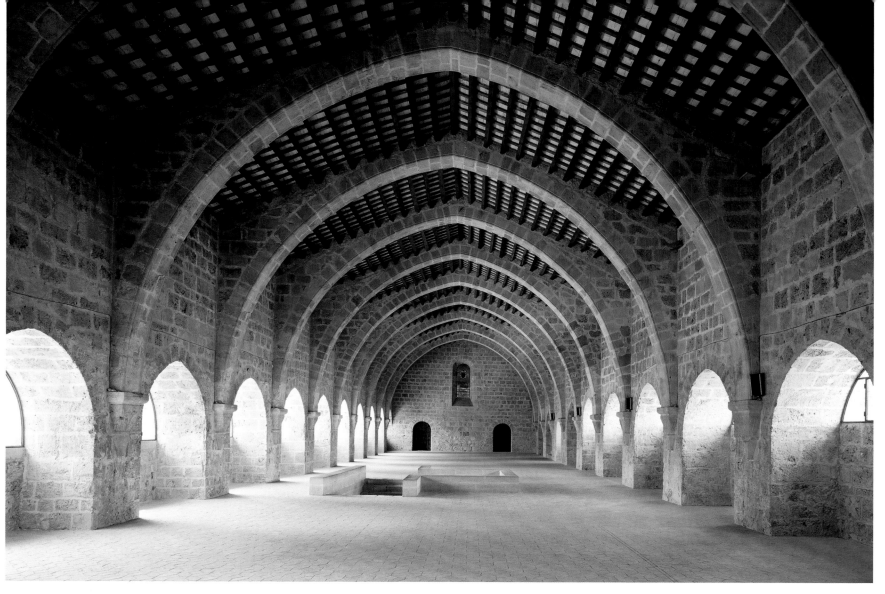
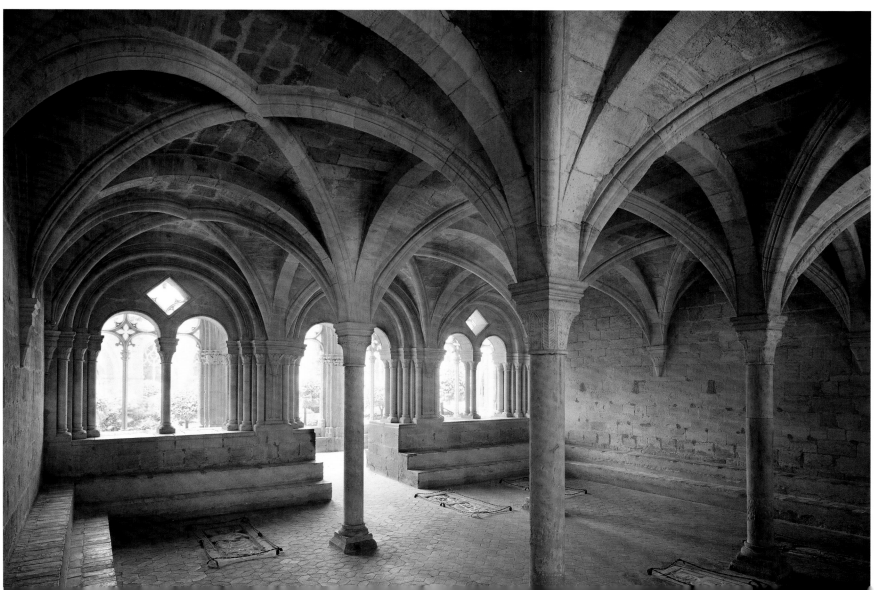

SANTO DOMINGO DE SILOS

TOP RIGHT:
Capital in the cloister, Santo Domingo de Silos

BOTTOM LEFT:
Relief in the cloister with Doubting Thomas

OPPOSITE PAGE:
Cloister

THE MONASTERY SANTO DOMINGO DE SILOS, located about thirty miles south of Burgos, on Castile's eastern border, is famous for its Romanesque cloister and its sculptural ornaments; by contrast, the scant remains of the church were replaced by a new building in 1880. The monastery was founded around 593 by the Visigoth king Rekkared. Devastated by the Moors, it regained importance in the eleventh century under Abbot Domingo, who directed the monastery from 1041 to 1073. He had been prior of San Millán de la Cogolla, but he soon had to flee from King García I of Navarre to Castile, where King Ferdinand I of Castile and León appointed him abbot of the San Sebastián monastery in Silos. Once there, Domingo called for ecclesiastical reform in Spain. When he was canonized in the thirteenth century, the monastery took his name and became an important pilgrimage site.

Abbot Domingo began the construction of the monastery. The cloister, which was designed from the beginning to have two stories, seems to have been begun around 1085. The date of completion has been recorded as 1158. The galleries of the four flat-ceilinged arms consist of round arch arcades with double columns and piers at the corners. Two different sculptors worked on the sixty-four double columns, creating imaginative birds and mythological creatures in many variations. The six famous large reliefs on the interiors of the corner piers are attributed to the better of these two sculptors. They depict events from the New Testament with many figures, including one with the doubting Thomas with Christ and the other eleven disciples. This scene is depicted as taking place within the interior of a round arch, with the figures arranged in three rows behind and above one another. The crossed legs of the figures in front indicate almost dance-like movement. Accompanied by this phalanx of closely-stacked disciples, Christ lifts his right arm high and reveals the wound in his side, into which Thomas places his finger: a depiction whose hushed and austere simplicity achieves an articulate, moving, expressive power.

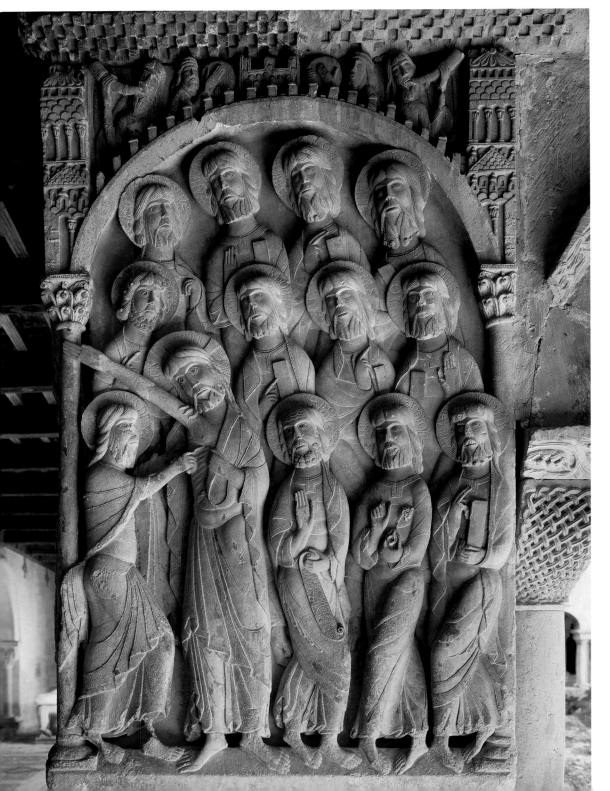

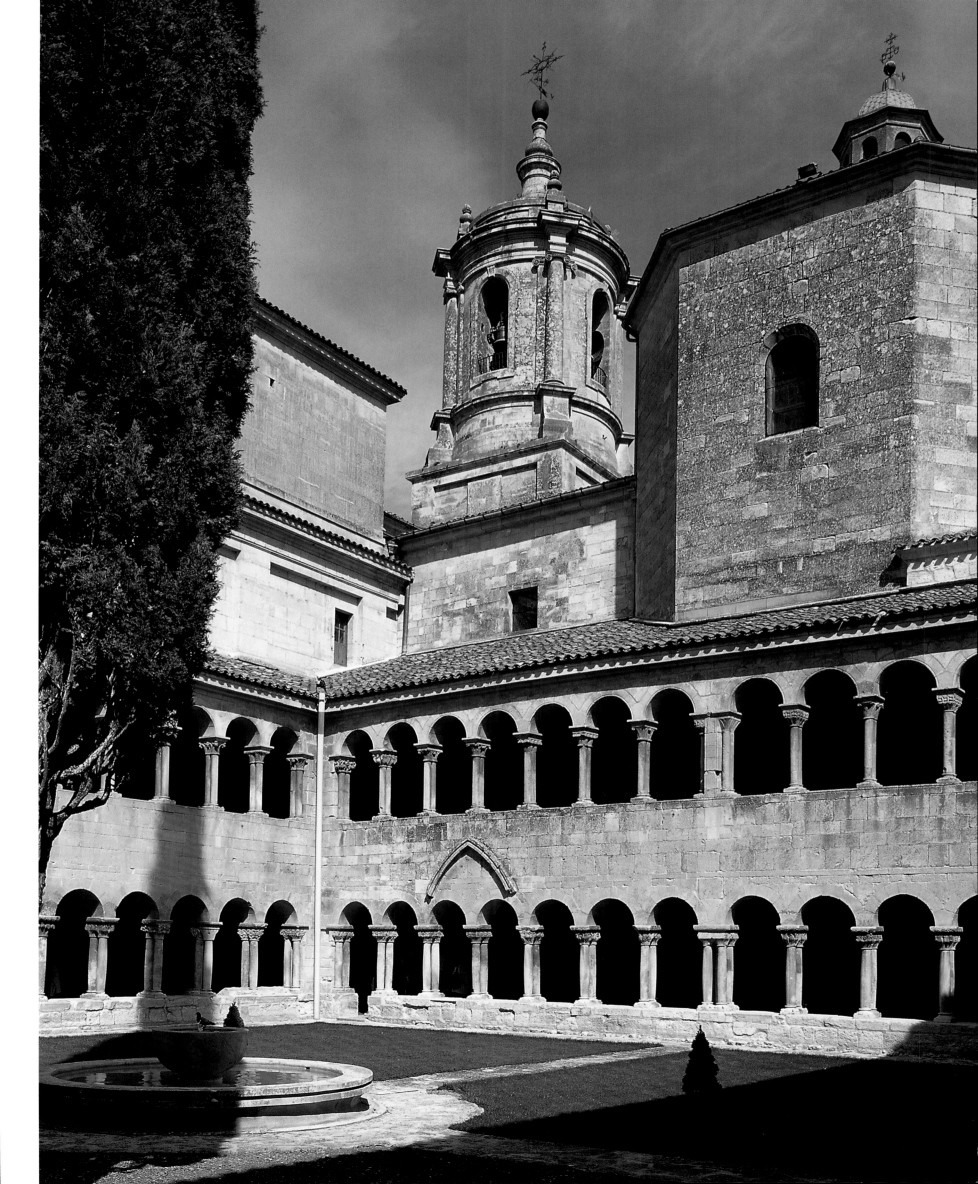

RIPOLL

geometry, and music—that is, the quadrivium of the seven liberal arts—which he then taught as director of the cathedral school in Reims. Gerbert was closely connected to the house of the Ottonian emperors, especially Otto III, and he ascended to the papal chair in 999 as Sylvester II. Under the great abbot Oliba (Oliva) the collections of Ripoll's library were doubled from 121 to 246 manuscripts. Oliba was a nephew of the monastery's

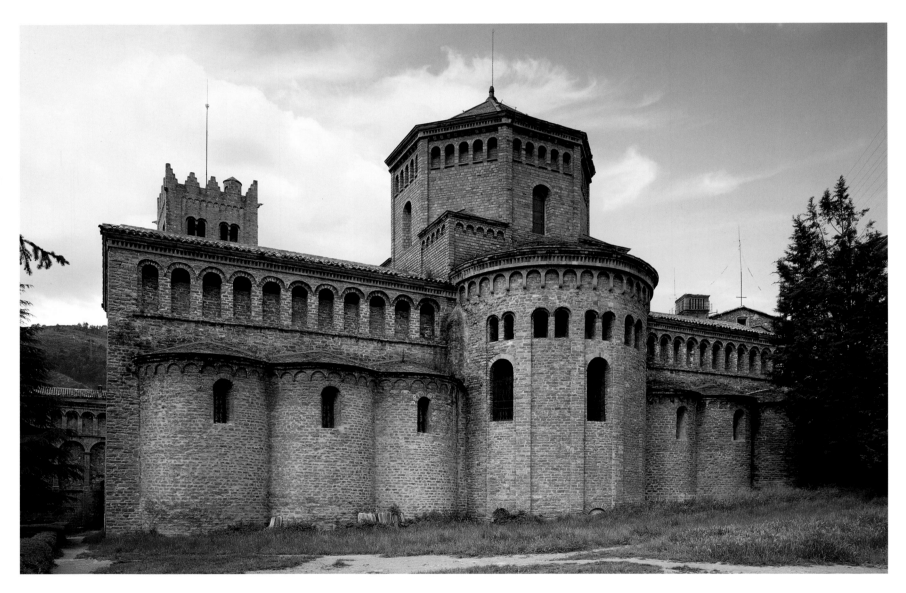

ABOVE:
East end of the church, Ripoll

OPPOSITE PAGE:
West portal of the church with Romanesque iconostasis

THE MOST IMPORTANT MONASTERY IN CATALONIA in the early Middle Ages was Ripoll, in the present-day province of Gerona, about twenty-five miles north of Vich. It was founded in 879 by Guifre el Pilós, the first count of Barcelona, who funded it generously and chose it as the burial site for himself and his family. In 888 the bishop of Vich consecrated the first church. Ripoll received privileges in 939 and 982 from the French kings Louis IV and Lothaire, the last rulers of the Carolingian dynasty. The monastery and its important library, whose inventories survive, was the intellectual center of Catalonia. Here in 967 the great scholar Gerbert of Aurillac studied treatises on arithmetic, astronomy,

founder, Guifre, and the son of count Oliba "Cabreta" of Cerdaña-Besalú. In 1008 he became abbot of both Ripoll and Cuxa, beyond the Pyrenees, and was the director of an association of monasteries that included Montserrat and Saint-Martin-du-Canigou, which he had founded. Oliba was a friend and adviser to King Sanchez the Great of Navarre and maintained close relations to Fleury abbey in central France, present-day Saint-Benoît-sur-Loire. Oliba was close to Cluniac reform, but his association of monasteries remained independent of Cluny and was never subject to it. Despite Ripoll's immunity, which had been confirmed by the pope in 951, Oliba gave the monastery to the counts of Besalú. After governing it for

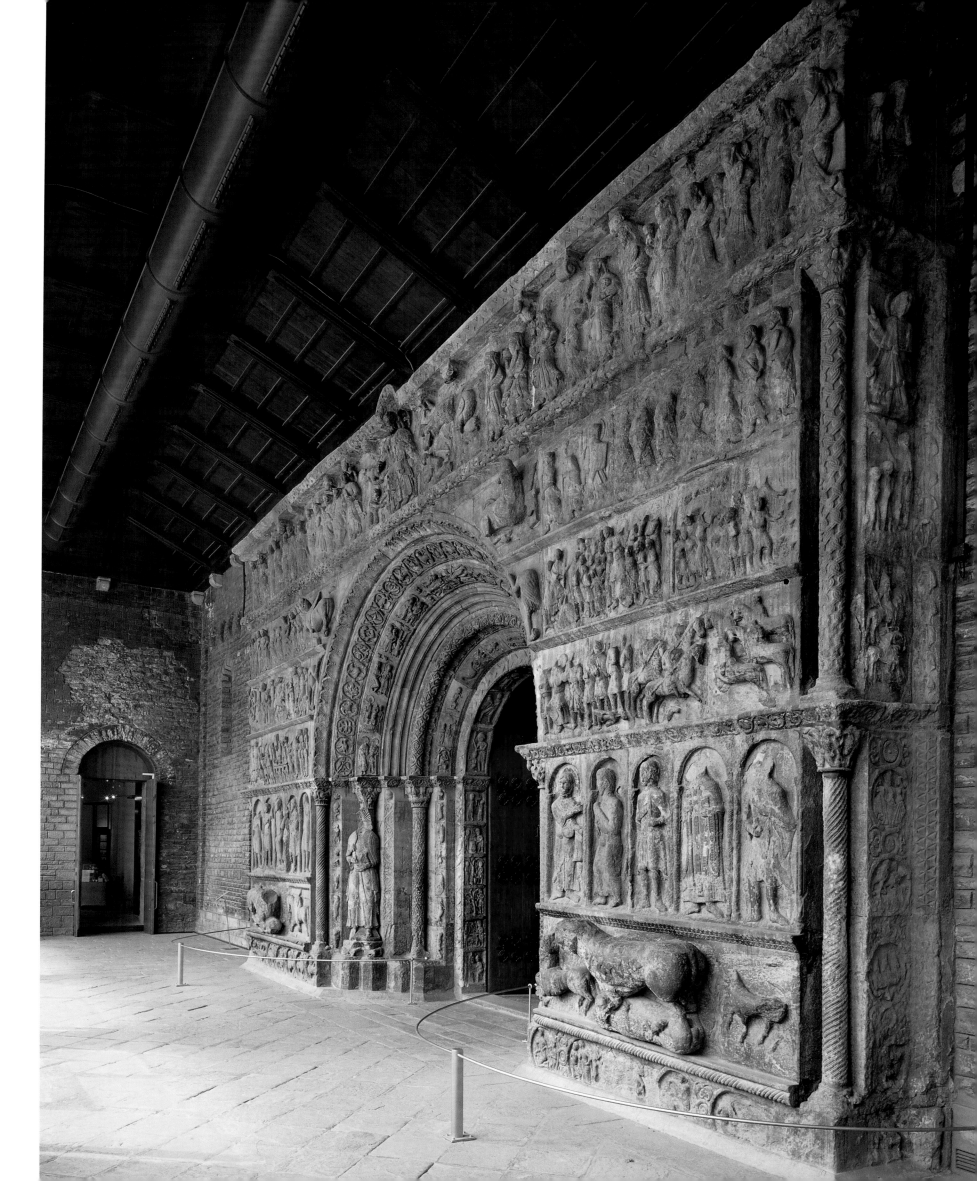

ten years, he was appointed bishop of Vich as well, where he served until 1046. The new patrons, the counts, provided the monastery with many gifts, and in 1070 they transferred it to Saint-Victor abbey in Marseilles for the purpose of reform. In 1169, after Marseilles had refused to recognize the selection of Ramon de Bergà as abbot, King Alfonso II of Aragon arranged for the monastery, with its seventy-five monks, to leave that association. In 1215

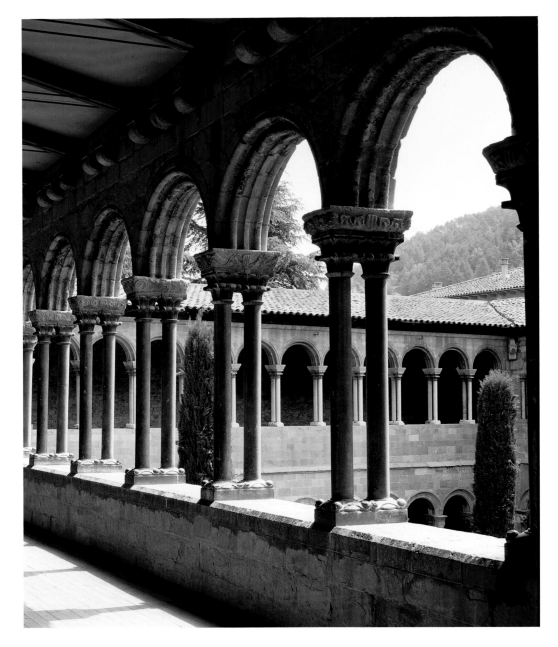

Ripoll joined with Claustrales of Tarragona to form a congregation in which, according to the resolutions of the fourth Lateran Council, all Benedictine convents that existed in each Spanish ecclesiastical province were united. Later, the importance of the abbey declined under the abbots *in commendam,* as happened nearly everywhere. By 1482 there were only twenty-two monks here.

The church, which was consecrated in 888, had to be expanded twice, as the importance of the abbey grew during the tenth century: first in 935 at the instigation of counts Miron and Sunyer, and then under the abbots Arnulf, who was also bishop of Gerona, and his successor, Guidiscle. This second expansion was made possible by bequests from Count Oliba Cabreta. The consecration followed in 977. The church that was completed at this time was two hundred feet (60 m) long and, following the model of the great Roman basilicas that Arnulf had seen during a journey to the papal court, had five naves. In the central nave it had pier arcades, in the side aisles, a simple alternation of piers and columns. The overall layout of the main block had a certain resemblance to the cathedral in Cologne, but columns and piers alternated in pairs in the side aisles. The east end of Ripoll had a transept with no fewer than five parallel apses. Soon, however, the church was no longer adequate—it lacked sufficient altars—so Abbot Oliba had the transept widened and added an apse to each arm, bringing the total number of apses to seven. It would be difficult to find an equally imposing parade of interlocking, bulbously arching apses. The west end was given a new facade with two square towers and an entry hall. Workmen were brought from Lombardy for this work, and the consecration followed in 1032.

The church was disfigured in the nineteenth century. First, the nave arcades in the side aisles were removed. Then the building fell into disrepair after the monastery was abandoned in the revolution of 1835. From 1886 to 1893 the architect Elias Rogent restored the church, which in the east in particular amounted to new construction. One of the free inventions is the octagonal crossing tower.

Fortunately, the iconostasis around the splendid west portal, protected by an entry hall, survived; it is a major work of Catalan sculpture from the second half of the twelfth century, and its opulent richness is incomparable. Above the animals of the pedestal there are four registers; the lower two depict large individual figures, including Moses and King David; above that are narrative reliefs with scenes from the Old Testament; and uppermost Christ enthroned with symbols of the evangelists and the twenty-four elders of the Apocalypse. The jambs of the portal depict the apostles Peter and Paul, and in the archivolts there are numerous individual images, ranging from Genesis by way of the labors of the months and the stories of Jonah and Daniel on to the martyrdoms of Peter and Paul. The cloister was begun under Abbot Ramon de Bergà (1172–1206) but only completed in the fourteenth and fifteenth centuries; it was largely reconstructed in the nineteenth century. The only surviving Romanesque section is the wing along the church.

T HE WELL-PRESERVED MEDIEVAL CITY SANTIL-
lana del Mar lies in the northern Spanish
province of Cantabria, on the Atlantic coast
between the provincial capital, Santander, and the caves
of Altamira. The name of the site comes from Juliana, a
saint whose hagiography is ambiguous. She was a mar-
tyr from Bitinia whose bones were brought in the sixth
century to Planes, later called Santillana. Already by the

SANTILLANA DEL MAR

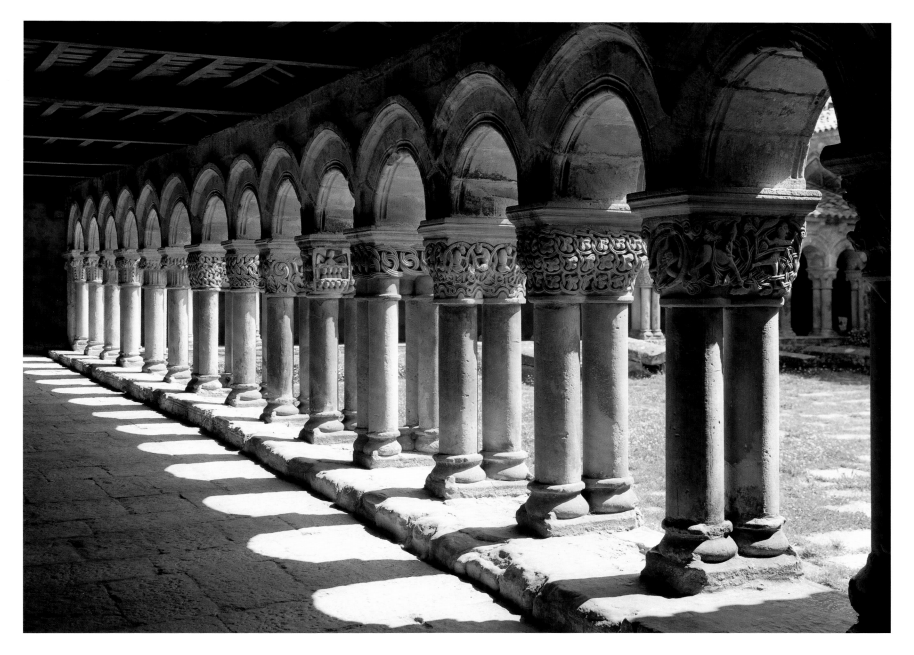

eighth century the reputation of her bones' miraculous
powers was widespread. One of northern Spain's most
immense collegiate monasteries was built here, sup-
ported by the Asturian and later the Castilian kings. The
surviving medieval buildings include the three-nave
Romanesque church, which terminates in the east with
no transept, but three apses; the atrium, with four
monolithic columns; and three wings of the cloister.
The round arch arcades of the latter, which date from

around 1200, with their short, stout pairs of columns (or
sometimes groups of four columns), stand on a low
plinth. Each column has its own base, but each pair
shares a double capital. These capitals reveal a sculptural
richness that falls into two categories: ornamental pla-
nar patterns with winding vines, on the one hand, and
narrative reliefs, on the other. The latter mainly relate
the story of Christ, but also the beheading of John the
Baptist, Daniel in the lions' den, and other events.

Cloister of the collegiate church,
Santillana del Mar

SAN MIGUEL DE ESCALADA

The tiny church, just seventy-two feet (22 m) long, is one of the best-preserved examples of Mozarabic architecture in Spain: a three-nave basilica with an exposed roof truss and three parallel apses arranged according to a horseshoe ground plan. The horseshoe shape of the arches of the columned arcades in the main block is a characteristic feature, and it is repeated in the triple arcature that cuts across the space, separating

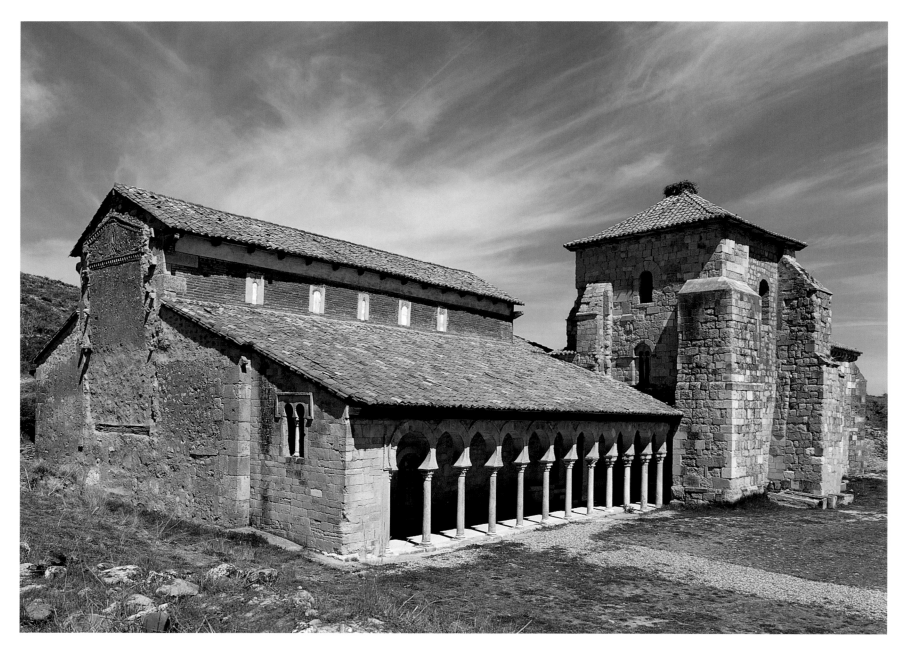

A FEW MILES EAST OF LEÓN, ON A DESOLATE mountain terrace, lie the remains of a monastery: the church San Miguel de Escalada. A dedicatory inscription that has survived in a copy relates that "Adefonsus Abbas Codubensis" found the ruins of the church, which had been consecrated long before by the archangel Michael, and that his monks rebuilt it themselves in less than twelve months, without exploiting the commoners. It was consecrated in 913 by Bishop Gennadius of Astorga.

the chancel from the nave. The secondary chancels are blocked off by low, richly decorated barriers. The exterior of the church on the south side is an exposed gallery consisting of a columned arcade with horseshoe arches; next to it is a massive stub of a tower with bulky pier buttresses that overwhelms the church's small structure. On the whole, the church is an ideal model for horseshoe arches—that is, for the definitive motif of Mozarabic architecture, taken over directly from the Moors, for example, from the mosque in Córdoba.

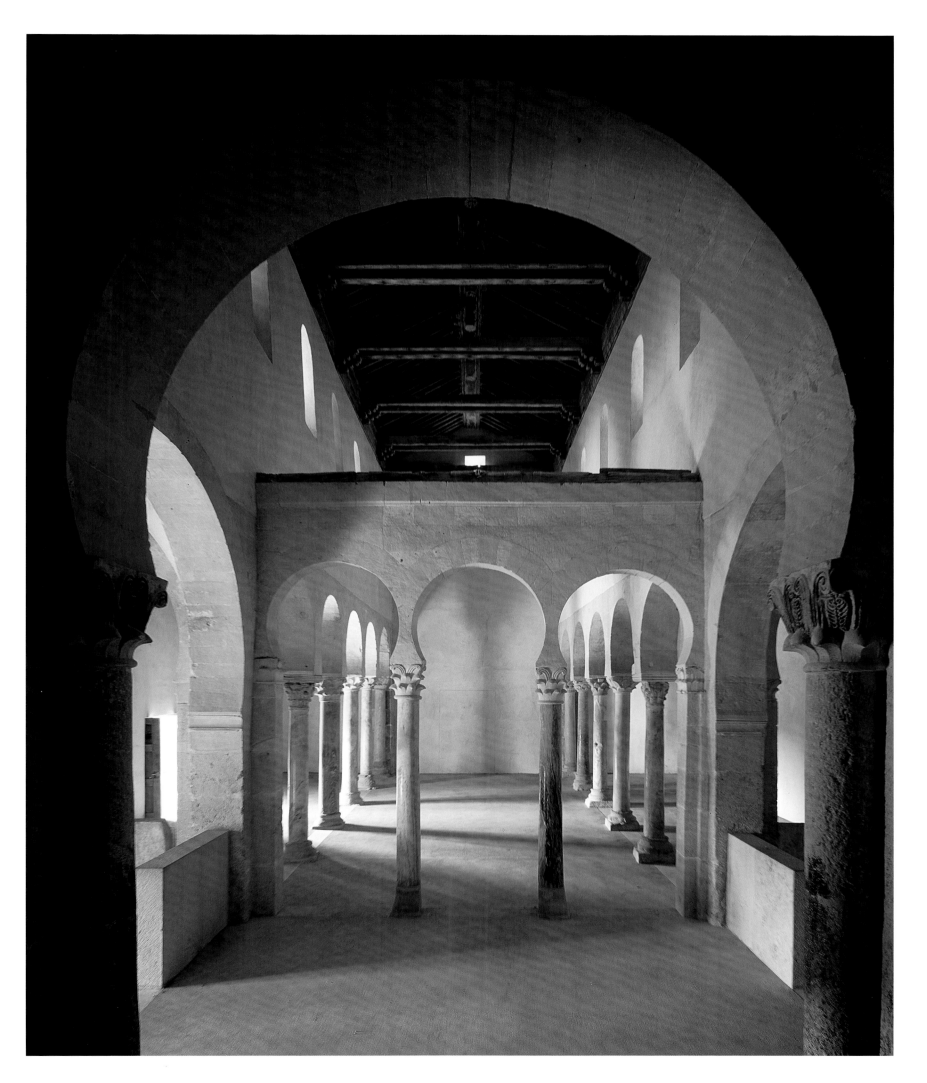

SAN JUAN DE LA PEÑA

Near the Aragon River, seventeen miles southwest of the small episcopal city of Jaca, lies the former Benedictine monastery San Juan de la Peña, which is famous above all for its spectacular site beneath an enormous overhanging reddish cliff on Mont Oreol. When the Visigoth empire was conquered by the Moors in 711, the Christians withdrew here and built a fortress, Pano, which was destroyed in 734 by the Umayyads. Later the hermit Juan settled under this cliff, where there was a spring, and built a small oratory, which developed into a monastery in the ninth century. King García Íñiguez presented Abbot Atilo with a donation in 855, which made it possible to build a two-nave church with two apses, the present-day crypt. The king was buried in this church. Later, the kings of Navarre, and from 1134 onward those of Aragon, regularly sent the monastery gifts, making it wealthy. It tried to achieve other advantages through the tried-and-true means of forging documents, which led to a sharp conflict with the bishops of Jaca. In the eleventh century the monastery joined with the Cluniac reform, and in 1071 it adopted the Roman liturgy in place of the Mozarabic one. Immediately thereafter a new church was built on top of the old one; it was consecrated in 1094 by the archbishop of Bordeaux, assisted by the bishops of Jaca and Maguelone. The tall, single-nave space gets its light from a group of windows on the western wall. The east end was soon expanded by adding three parallel apses in the cliff, which serves as the roof of the church in this part. The church was the burial place for the kings of Navarre and Aragon. Following a fire, the

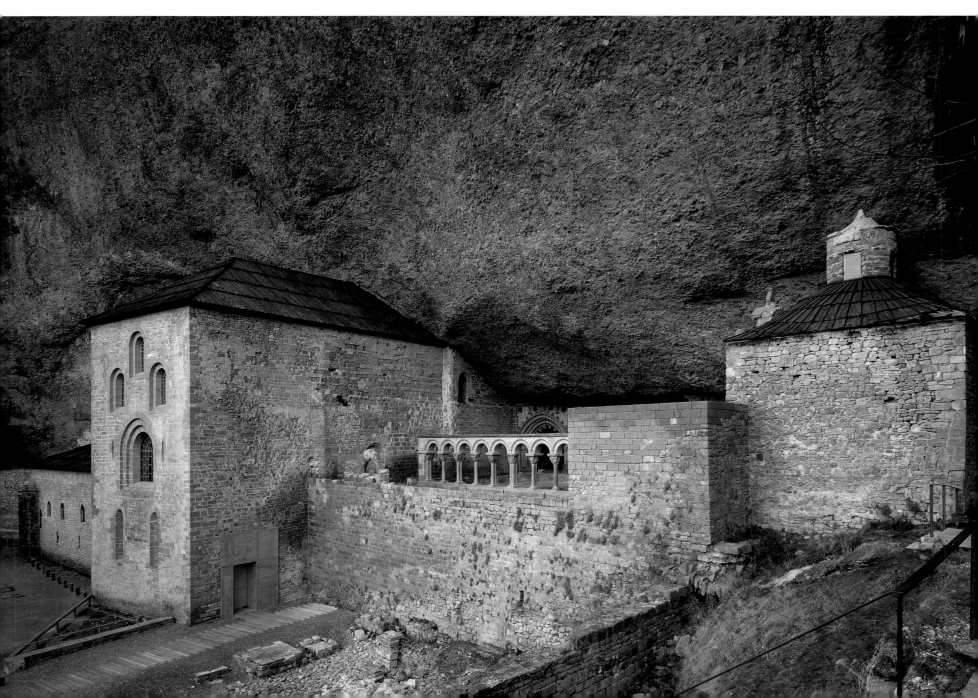

decision was made in 1647 to abandon the settlement and maintain only the royal burial site. The convention moved to another monastery building on the plateau, which was destroyed by Napoleonic troops in 1809, but is currently being rebuilt.

The surviving buildings of the old monastery include the church, the late Gothic abbot's chapel in the cliff, and the remains of the cloister from the second half of the twelfth century. Half of the cloister is covered by the cliff, and only the west wing is free. The arcaded gallery, with columns of various forms and rich figurative capitals depicting scenes from the Old and New Testaments, still stands, though partially reconstructed. The arcades in this unique landscape are one of the great fascinations of Romanesque architecture in Spain. Especially charming is the view from the late Gothic portal of the abbot's chapel over the arcades and into the forested ravine.

TOP LEFT: *View from the abbot's chapel;*
BELOW: *Arcades of the cloister*

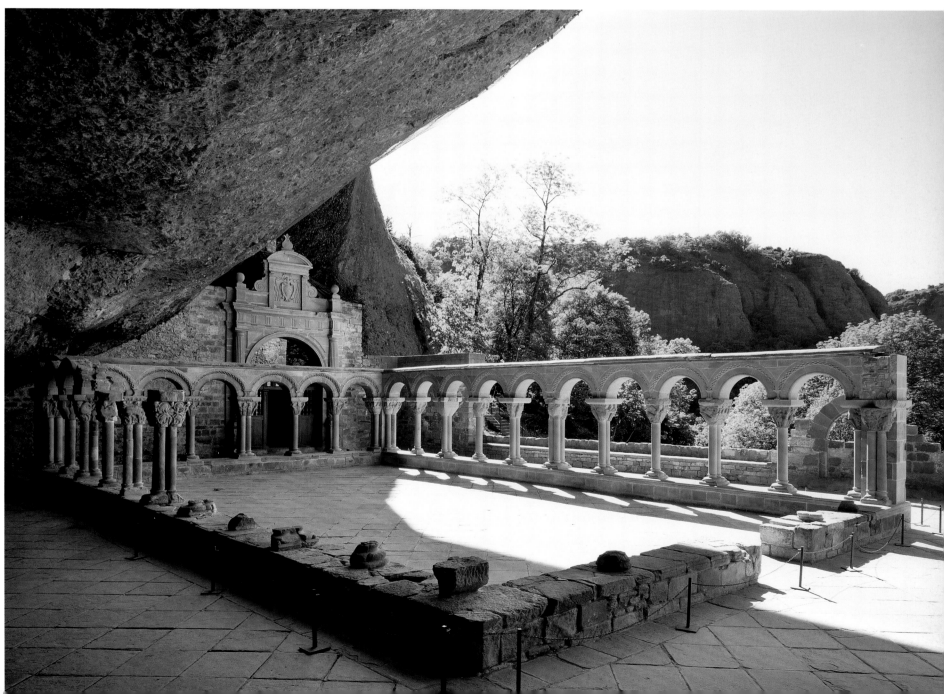

SAN PERE DE RODA

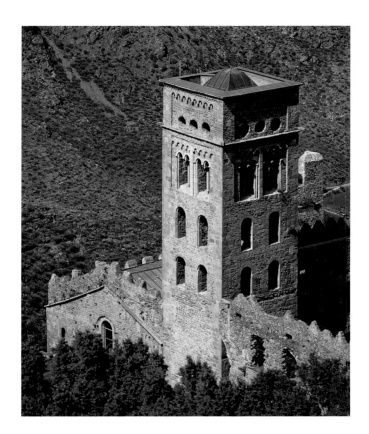

San Pere de Roda. TOP RIGHT:
Campanile of the church; BOTTOM:
View from the northwest

THE TOWERING, FORTRESSLIKE RUINS OF THE former Benedictine monastery San Pere (Pedro) de Roda, in the province of Gerona, lie impressively at an altitude of 1,970 feet (600 m), just below the peak of San Cristóbal, near the Mediterranean. From here one has a broad view of the coast between Cerebère, in France, and Cap Creus, in Catalonia. The monastery, which is first mentioned in 878, when it was subject to Banyolas, became independent in 927. In 943 Louis IV of France confirmed its privileges, a sign of Catalonia's close ties to the regions beyond the

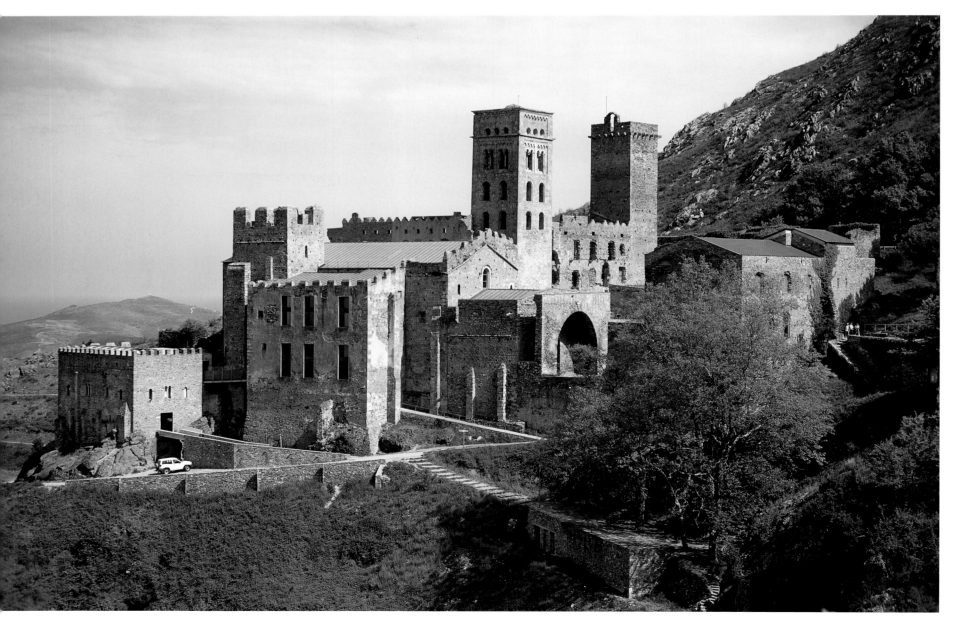

Pyrenees. Within the church, the monastery was subject only to the pope. Its crucial supporter was Tassion de Perelada. He appointed his son Hildesind abbot, and he held the office from 947 to 991, nearly half a century. Construction of the monastery buildings began in 943, but the church was not begun until 979. In 1022 it was consecrated, and that year the monastery was expanded and the two towers were added. The left-hand tower, with its open arcades, served as a campanile; the windowless right tower, which faces the slope, as a donjon. The monastery has been uninhabited since the eighteenth century; it was plundered and gradually declined, but it was not used systematically as a quarry, as happened so frequently.

The better part of the church has survived, even its vaults. It is a relatively small three-nave construction, just 165 feet (50 m) long and less than 23 feet (7 m) wide at the nave, which grows continually narrower as it approaches the chancel. It is vaulted with a longitudinal barrel vault with underlying box-shaped ribs. There is no clerestory; the nave arcades extend nearly to the base of the vault. The side aisles, which are really just narrow walkways, have rampant half vaults that incline from the outside in, as abutments to counter the thrust of the main vault. The nave and the longitudinal vault run up to the chancel without a separate crossing, and the side aisles extend to form a low chancel ambulatory with no chapels. Outside, the transverse arms project along the alignments of the side aisles, with an apse in each. As in the mosque in Córdoba, the brickwork of the piers alternates horizontal and vertical courses (a soga y tizón). The defining motifs of the interior are monolithic columns on tall plinths in front of the piers. They are found both in the jambs of the nave arcades and on the side facing the nave, where the lower column has a second one joining it. Together with the nave arcades and the ribs, these columns form the articulating structure and give the space its characteristic, unmistakable face. Such projecting columns—and barrel vaults with ribs—had a history in northern Spain that went back to the ninth century, if not to the Visigoth period, which was picked up here and elaborated.

The extraordinarily delicately worked capitals are a particular treasure in this church. They combine influences from Córdoba, Lombardy, and ultimately Byzantium or Venice into a distinctive overall form with a markedly original character.

San Pere de Roda is considered the cradle of Catalan Romanesque architecture, whose synthesis of Visigoth and Mozarabic elements distinguishes it from the more Lombardian style of Romanesque found, for example, in Cuxa, on the other side of the Pyrenees (see pp. 114–16). The building's monumentality exceeds that of any earlier church in Spain, such as the Visigoth church San Pedro de la Nave, the ninth- and tenth-century buildings around Oviedo, or San Miguel de Escalada, near León (see pp. 106–7).

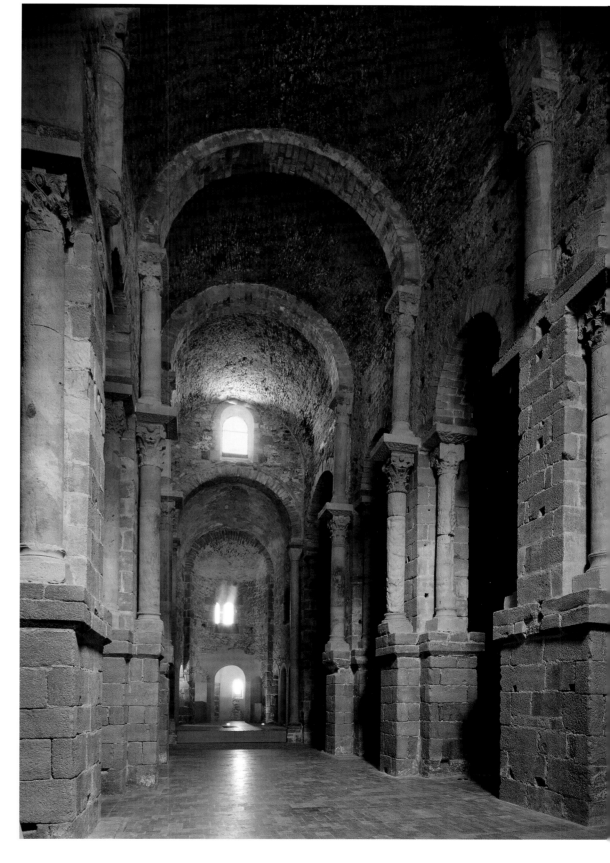

Interior of the church, facing east

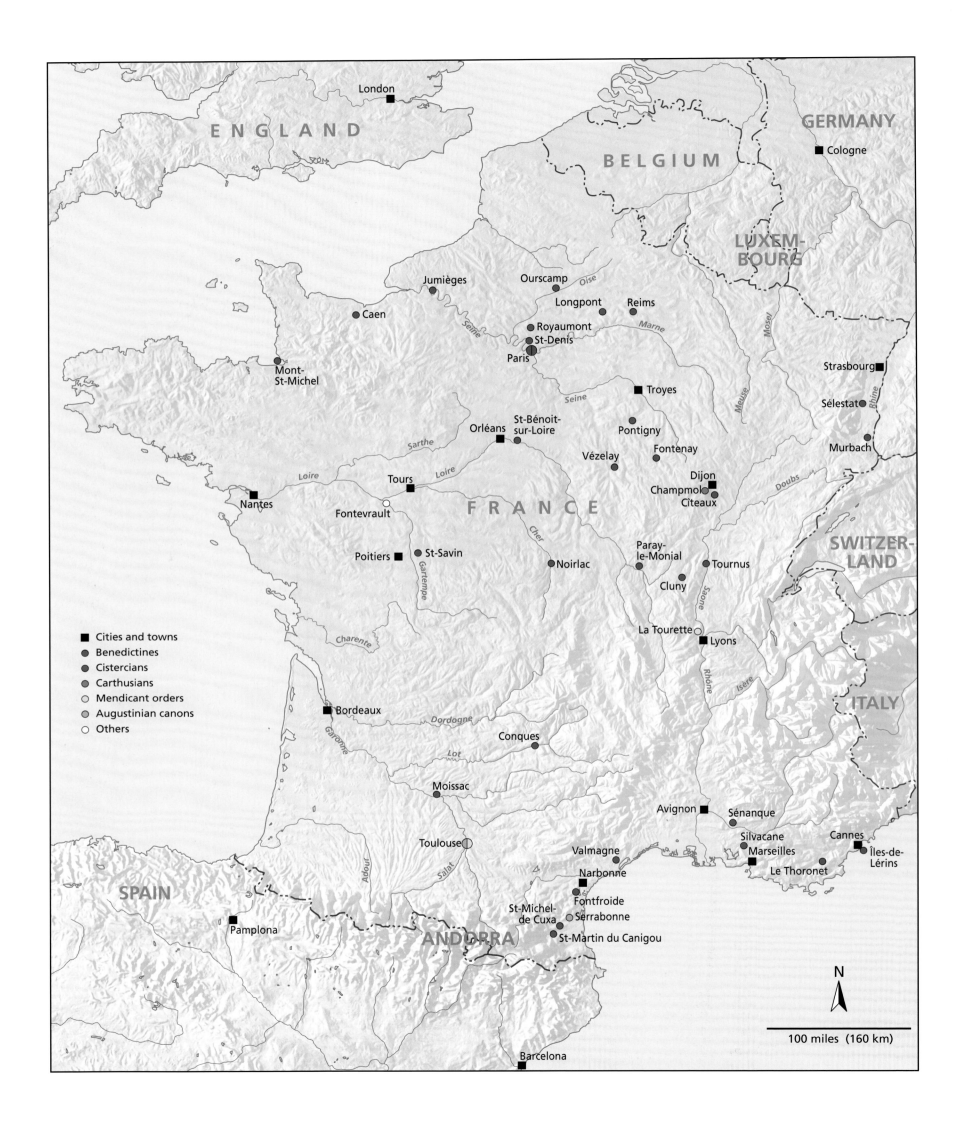

ENGLAND

GERMANY

BELGIUM

London

Cologne

LUXEM-
BOURG

Jumièges

Ourscamp

Oise

Longpont

Reims

Caen

Royaumont

St-Denis

Marne

Mosel

Strasbourg

Paris

Seine

Troyes

Sélestat

Mont-
St-Michel

Seine

St-Bénoit-
sur-Loire

Pontigny

Murbach

Sarthe

Orléans

Vézelay

Fontenay

Rhine

Loire

Tours

Loire

Dijon

Doubs

Nantes

Champmol

FRANCE

Fontevrault

Cîteaux

SWITZER-
LAND

Cher

Poitiers

St-Savin

Noirlac

Paray-
le-Monial

Tournus

Gartempe

Cluny

Saône

Charente

La Tourette

Lyons

■ Cities and towns

● Benedictines

● Cistercians

● Carthusians

○ Mendicant orders

● Augustinian canons

○ Others

Rhône

Isère

ITALY

Bordeaux

Dordogne

Garonne

Conques

Lot

SPAIN

Moissac

Avignon

Sénanque

Toulouse

Silvacane

Cannes

Valmagne

Marseilles

Îles-de-
Lérins

Narbonne

Le Thoronet

St-Michel-
de Cuxa

Fontfroide

Sèrrabonne

ANDORRA

St-Martin du Canigou

Pamplona

N

Barcelona

100 miles (160 km)

Adour

Salat

FRANCE

SAINT-MICHEL-DE CUXA

BELOW:
View of Saint-Michel-de Cuxa from the southeast, with the surviving south tower

OPPOSITE PAGE:
Reconstructed cloister

PAGE 116:
TOP: *View into the south transept of the church and the secondary chapels;*
BOTTOM: *Lower church of the western central-plan building: Crypte de la Vierge de la Crèche*

C UXA LIES ON THE NORTH EDGE OF THE PYRE-nees, near the Canigou massif and the tiny town of Prades, which has become world famous, thanks to the Catalan cellist Pau (Pablo) Casals, who lived here in exile and founded an international music festival. Cuxa was a Benedictine monastery. It maintained close relations with Catalonia, on the other side of the Pyrenees, particularly with Ripoll abbey. It was founded in 878 when a group of monks fled here; a

flood had driven them from their monastery, which lay up the Têt River. Two of Cuxa's abbots were particularly important: Guarinus, in the second half of the tenth century, and later, Oliba (Oliva). Guarinus, a well-traveled man who had visited Rome four times and Jerusalem once, brought with him from Italy not only Pietro Orseolo, who resigned as doge of Venice and spent his retirement in Cuxa, but also Romuald, who would later found the Camaldolese order. The famous scholar Gerbert of Aurillac spent time at Cuxa, as well as at Ripoll, to use the libraries; Gerbert, a friend of Emperor Otto III, would later become pope as Sylvester II. Oliba, one of Count Oliba Cabreta's sons, was abbot from 1008 to 1048. He was also abbot of Ripoll and headed a small association of monasteries. In 1018 he became bishop of Vich, in Catalonia, as well. Roussillon became part of the French kingdom once and for all in 1659; Cuxa was plundered in 1793, in the wake of

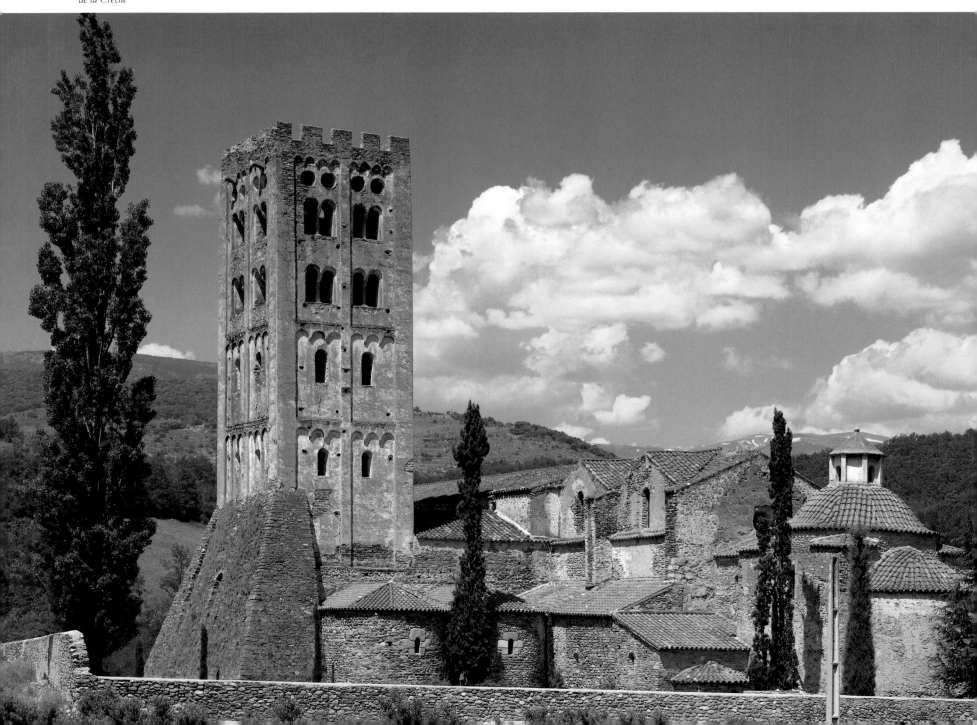

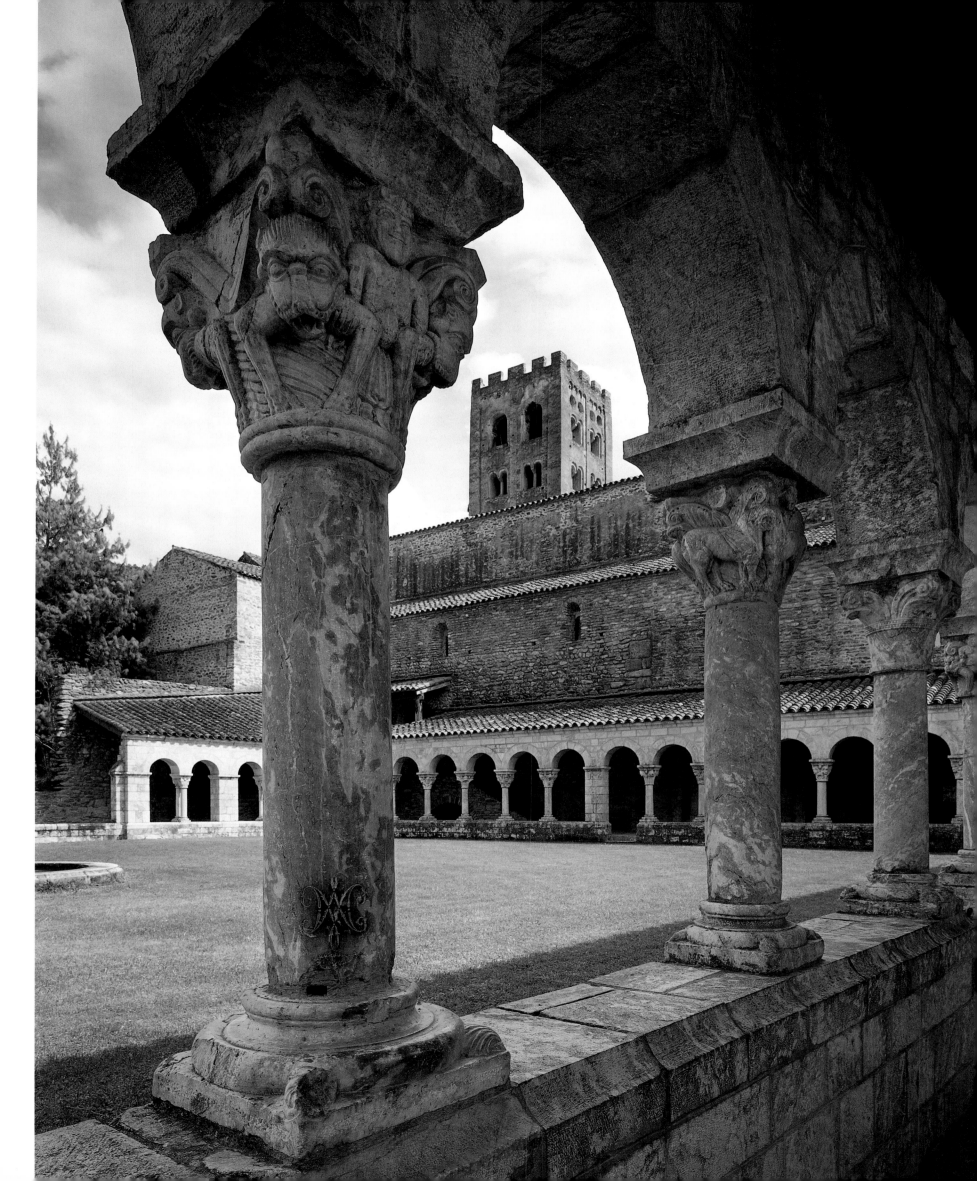

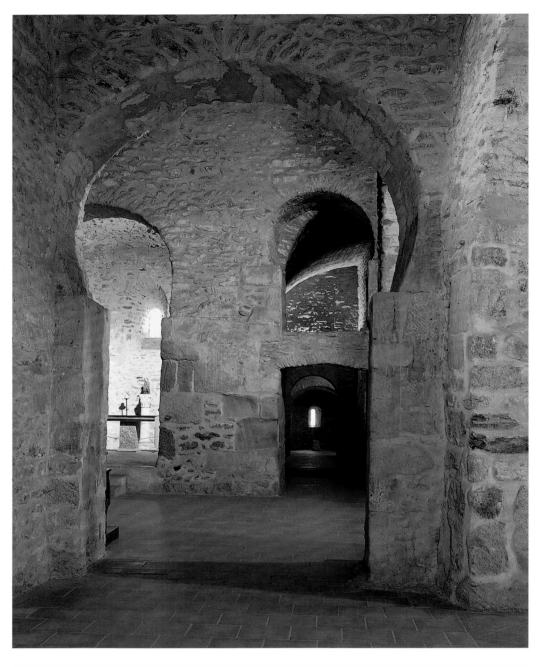

the French Revolution. In 1835 the church roof collapsed, followed in 1839 by the north tower, damaging the cloister so seriously that it had to be torn down, its columns and capitals strewn by the winds. In 1907 a large portion of the cloister was purchased by the American sculptor and art collector George Grey Barnard, who brought the pieces to the United States. Then John D. Rockefeller, Jr., purchased Barnard's collection, which included remnants of other cloisters in southern France, and presented it to the Metropolitan Museum of Art, New York. The Cloisters, a museum overlooking the Hudson River that was built specially to house the collection and make it accessible to the public, opened in 1938, with the centerpiece of the museum the cloister from Cuxa.

Monks reoccupied Cuxa in 1919. They came from Fontfroide and began reconstructing the ruined site. In 1965 Cuxa was taken over by monks from the Montserrat monastery in Spain, the abbey that Oliba had founded around 1023–27. The cloister, which at 154 by 128 feet (49 × 39 m), had been one of the largest ever. From 1950 to 1953 the south wing and parts of the east and west wings were reconstructed. The only original elements are the columns and marble capitals that had been found in various places nearby. Several of them appear to have originally belonged not to the cloister but to a gallery in the church, much like the one at Serabonne.

The present church, which was preceded by three other structures, was consecrated under Abbot Guarinus in 974. It is a primitive three-nave pier basilica with horseshoe arches. The east end consists of a boxlike sanctuary and a projecting transept that once had four apses but now has just three. Abbot Oliba had a U-shaped ambulatory built around the sanctuary that included three apses on the east side, bringing the total to seven. Oliba had two 131-foot- (40-m-) tall crossing towers built, one on each end of the transept, in the rich forms of the Lombardian Romanesque. Only the southern one is still standing, an impressive landmark that can be seen from a great distance. Oliba had a courtyard added in the west as well as a two-story central-plan building. Of the latter, only the lower church, the Crypte de la Vierge de la Crèche, survives: an archaic round structure with a bulky round pier in the center and a ring vault. A piece of Jesus' manger, the most valuable relic that Cuxa possessed, was kept here.

SERRABONNE

SERRABONNE, WHICH LIES IN TOTAL ISOLATION on a barren ridge between the Tech and Têt valleys in the French Pyrenees, was once a prior of Augustinian canons. The earliest confirmed mention dates from 1082, when a provost was freely chosen for the first time. Its heyday appears to have been around the middle of the twelfth century. That was when a singers' tribune was added to the church, the core of which dates back to the eleventh century. This rood screen–like addition between the east and west sides of the church is made from the pink-and-white-checked marble of the Pyrenees, with three columned arcades richly decorated on the side facing the commoners' area. Behind the arcades there is a columned hall that is two bays wide. The vaults have underlying rounded cross ribs. The main attractions of this hall are the capitals, with their imaginative reliefs of plants and animals; they have a sculptural power that gives them a remarkable vividness. The reliefs in the spandrels are much flatter by contrast. The capitals were probably produced at the Saint-Michel-de Cuxa abbey (see pp. 114–116), which had a similar tribune, of which only modest fragments have survived.

Singers' tribune in the church, Serrabonne

SAINT-MARTIN DU CANIGOU

THE FORMER BENEDICTINE MONASTERY SAINT-Martin lies on the French side of the Pyrenees, at an altitude of 3,600 feet (1100 m), at the foot of the Canigou massif. It was founded in 1005 by Count Guifred Cabreta and his younger brother Oliba, the abbot of both neighboring Cuxa and Ripoll, in Catalonia. In 1011 Guifred arranged for its protection by the holy see. In 1035 he entered the monastery himself and

was buried there in 1049.

The church was built immediately after the monastery was founded; it was consecrated for the first time in 1009 and then again in 1028. An earthquake in 1428 caused large parts of the structure to collapse. After that, things grew quiet around the monastery. The last monks abandoned it in 1783. In the early twentieth century the monastery lay in ruins, apart from the tower and the east end of the church. Reconstruction was initiated by the bishop of Perpignan de Carsalade (d. 1932), as a joint project of Catalans on both sides of the Pyrenees; some of the original columns and capitals, which had been found nearby, could be included in the restoration. Beginning in 1952 Pater Bernard de Chabannes continued this reconstruction with the help of volunteers; it was completed in 1974. In 1988 the Communauté des Béatitudes occupied the abbey, and it has enjoyed a monasterylike spiritual life ever since.

Architecturally, the present monastery is essentially a reconstruction, including the cloister, which originally had two stories, the lower of which was vaulted. One of the earliest vaulted cloisters, it was reconstructed as a one-story arcaded gallery. The church consists of a cryptlike lower church, with columns immured in thick piers, and a three-nave upper church with broad columned arcades. The naves are vaulted with three parallel longitudinal barrel vaults, with the center one somewhat higher than those on the sides. The whole design reflects a rather primitive architecture as it is one of the oldest examples of a church with multiple naves that was entirely vaulted. The landmark of the site is a well-preserved tower: this mighty, square block is perhaps the oldest example of Lombard articulation in the region.

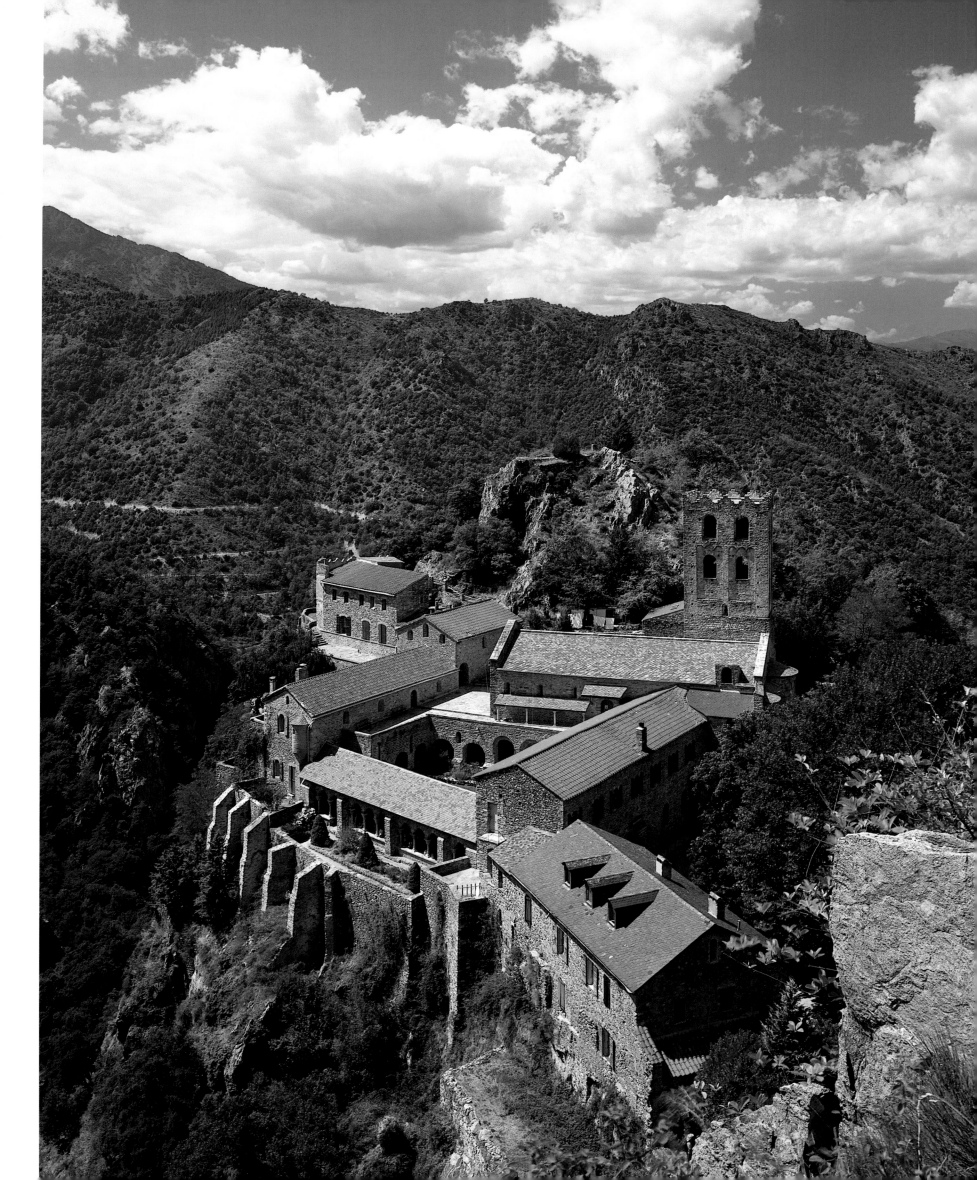

FONTFROIDE

Not far from Narbonne, in a small valley in the dry, barren mountains of the Corbières, lies the former Cistercian monastery Fontfroide, which was named after a very important spring with cold freshwater (*fons frigidus*). It is one of the best-preserved Cistercian monasteries in southern France. As early as 1093 the site had been settled by a group of hermits who had been granted the land by Aimery II, viscount of Narbonne. In 1118 these pious men apparently adopted the Benedictine rule. In 1144 they joined with the hermitic monastery Grandselve, near Toulouse, which had been founded by Gérard de Sales but which placed itself under Clairvaux in 1146, a year after Bernard made a trip to the Languedoc to preach against heresy. Thus Fontfroide, as a daughter monastery of Grandselve, became part of the filiation of Clairvaux, as

did the Catalan monastery Santes Creus, one of the royal abbeys of the house of Aragon on the far side of the Pyrenees (see pp. 96–99). In 1151 Fontfroide itself was responsible for the establishment of Poblet, the second royal abbey of Catalonia (see pp. 92–95). Fontfroide was supported by the higher nobility on both sides of the Pyrenees, as well as by the powerful counts of Toulouse and Alfonso of Aragon.

In the late twelfth and thirteenth centuries the abbey became actively involved in the struggle against the heretical movements of the Cathari and Albigenses, who represented a serious risk to the official Roman church in these regions. Fontfroide proved to be a secure bulwark against them, just as the nearby mountain fortresses of Montségur and Queribus were bastions of the enemy. Two monks from Fontfroide, Pierre de Castelnau and Raoul, were later put into action by Innocent II as papal legates against the heresy. This struggle was led by the abbot of Cîteaux, Arnaud Amaury, who had previously been abbot of Grandselve and Poblet and became archbishop of Narbonne in 1212. In 1209, after the impatient and fanatic Pierre de Castelnau was murdered, a bloody, twenty-year crusade of the Christian armies against the Christian Albigenses resulted, in which Arnaud Amaury played an inglorious role.

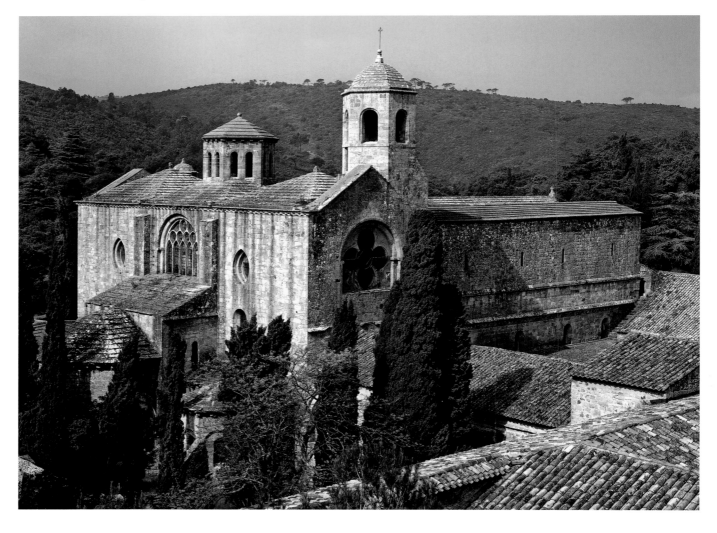

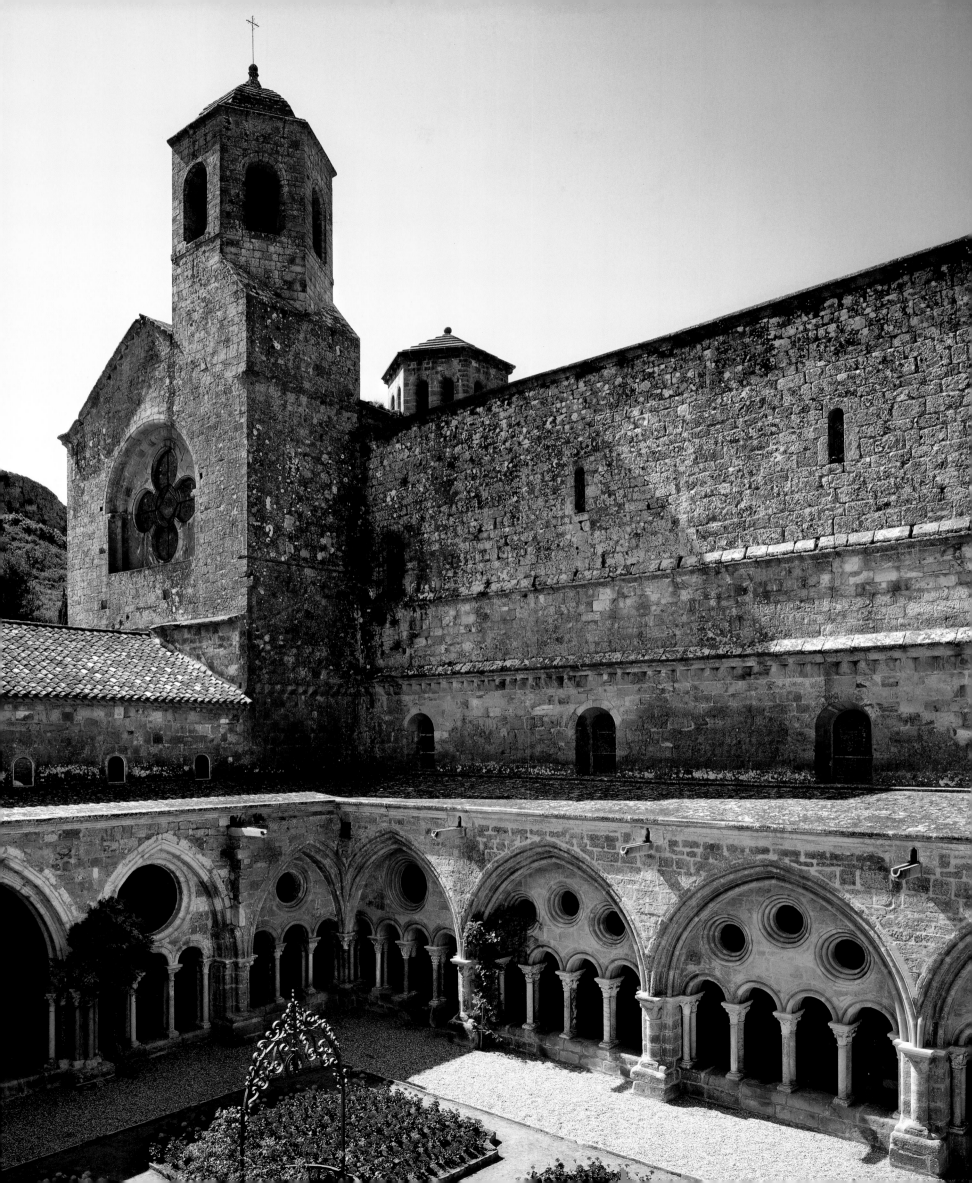

Especially at the beginning, he was responsible for the unbelievable massacre of Béziers in 1209, in which, on his orders, twenty thousand people, heretics or not, were slaughtered. He died at Fontfroide in 1225.

A century later another abbot of Fontfroide, Arnaud Nouvel, became adviser to Pope Clement V; yet another, Jacques Fournier, ascended to the papal chair as Benedict XII in 1334. It was he who had the older parts of the papal palace in Avignon built.

At that time Fontfroide became one of the richest abbeys of the order, with twenty-five granges. It became an abbey *in commendam* as early as 1476. After the monastery was closed, the city of Narbonne established a hospital there, which is why the buildings have survived.

The monastery church, begun at the end of the twelfth century, is built according to the Bernardinian plan in the east end, with the peculiarity that the sanctuary and the outer chapels terminate in a polygon, while the inner chapels have a flat termination. Also highly unusual is the oculus in the crown of the crossing vault to provide light; there is an octagonal dome above it on the outside. The nave—similar to that at Fontenay (see pp. 166–70)—is a unified space with a single pointed vault with very tall nave arcades of pointed arches that extend upward to just under the baseline of the vault. Unlike at Fontenay, however, there are narrow side aisles that run the entire length. They have rampant half vaults that provide, across the entire length, bracing for the nave's vault, but with the consequence that the side aisles seem less spatially independent and more like accompanying spaces for the nave. The overall continuity of the space tends to be that of a hall church, and in this it bears no resemblance any longer to the side aisles of Fontenay. Other striking features of the church include the high pedestals of the piers and the very low-seated corbels for the vaulting shafts, at head height. It gives the impression that the entire church has been lifted up off the ground to the height of one's head.

Of the monastery buildings the cloister, built in the thirteenth century against the brusque exterior wall of the church, is an architectural jewel. Its galleries consist of large, broadly sweeping pier arcades whose arcatures of three and four round arches and double columns are crowned by a single oculus or several smaller ones. Another jewel is the four-column room of the chapter house: its light, elegant architecture of columns and arches offers, together with the cloister, an image of rare transparency and columned splendor.

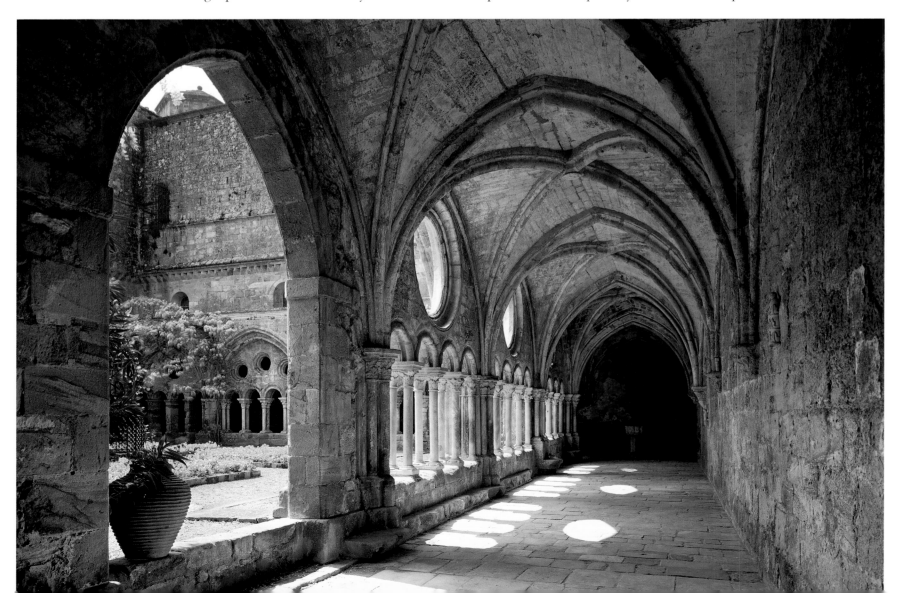

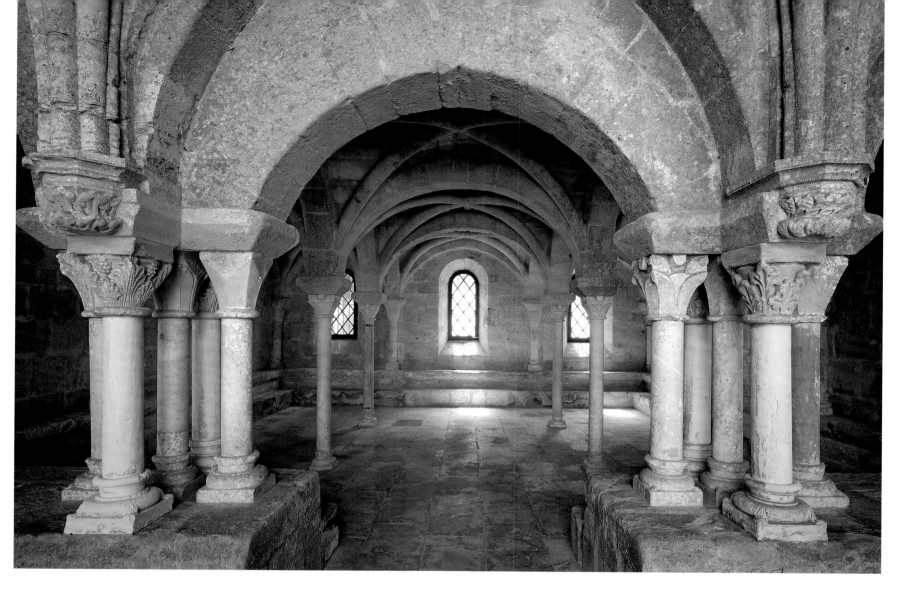
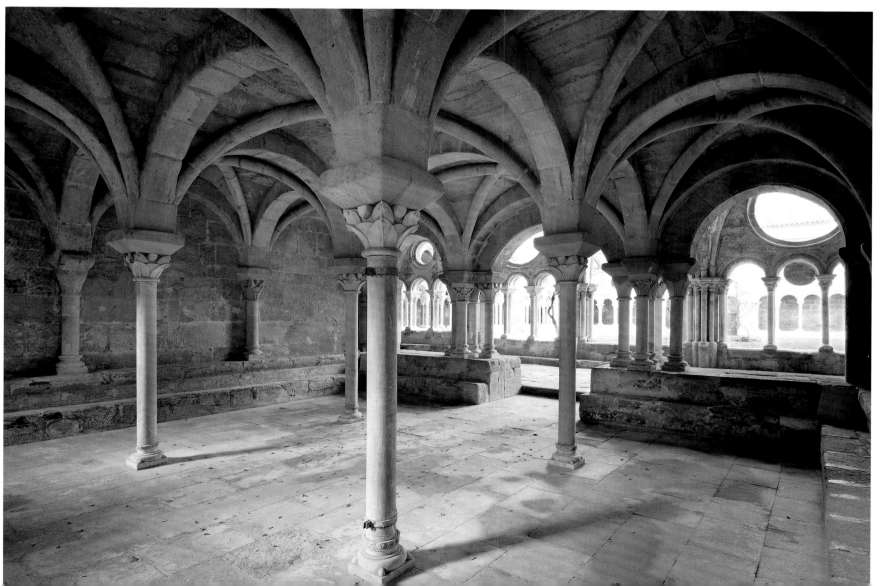

TOULOUSE
SAINT-SERNIN, LES JACOBINS

BELOW:
Reliefs in the chancel ambulatory, with Christ enthroned and two angels, basilica of Saint-Sernin, Toulouse

OPPOSITE PAGE:
Central nave facing east, basilica of Saint-Sernin, Toulouse

PAGE 126:
East end of Saint-Sernin

PAGE 127:
Dominican church of Les Jacobins and cloister

IN THE EARLY AND HIGH MIDDLE AGES THE RELIgious center of the southern French city of Toulouse was the collegiate and pilgrimage church Saint-Sernin. It was built on the grave of Saint Saturninus, the apostle of the Languedoc and the first bishop of Toulouse, who was martyred in 250. His grave soon became a pilgrimage site with a church. Charlemagne donated a significant number of relics to the church, including those from six apostles: it was the largest collection of relics in France. In the eleventh and twelfth centuries the monastery was an Augustinian canonic association that had to assert itself against the Cluniacs of neighboring Moissac, and to that end obtained papal protection from Gregory VII in 1083.

The present church, with an external length of 377 feet (115 m) and a transept 210 feet (64 m) long, is France's largest surviving Romanesque church (only Cluny III was larger); it was begun around 1080. In 1096 Pope Urban II consecrated the sections that had been completed, and a second consecration followed in 1119. At that time the construction was being directed by Canon Raymond Gayard, a member of the association who had been appointed *operarius aedificii* soon after 1090. It was largely completed by the time of his death in 1118. The work was supported by Count Guillaume and his daughter Philippa, as well as by her husband, Guillaume IX, duke of Aquitaine.

The church, constructed of brick interspersed with freestone, is a five-nave construction with a transept, around which the inner side aisles lead in a U-shape, continuing into a chancel ambulatory with five radial chapels. Thus pilgrims could walk in an unbroken path around the central nave, the transept, and the chancel. There were two additional chapels in each of the transept arms. With the main apse, the chancel ambulatory, and the many chapels in front of the broadly projecting transept, the east end of the church offers a powerful architectural prospect that is loomed over by an octagonal crossing tower pinnacle; richly ornamented with small columns and blind arches, it was added in the thirteenth century. In the interior the

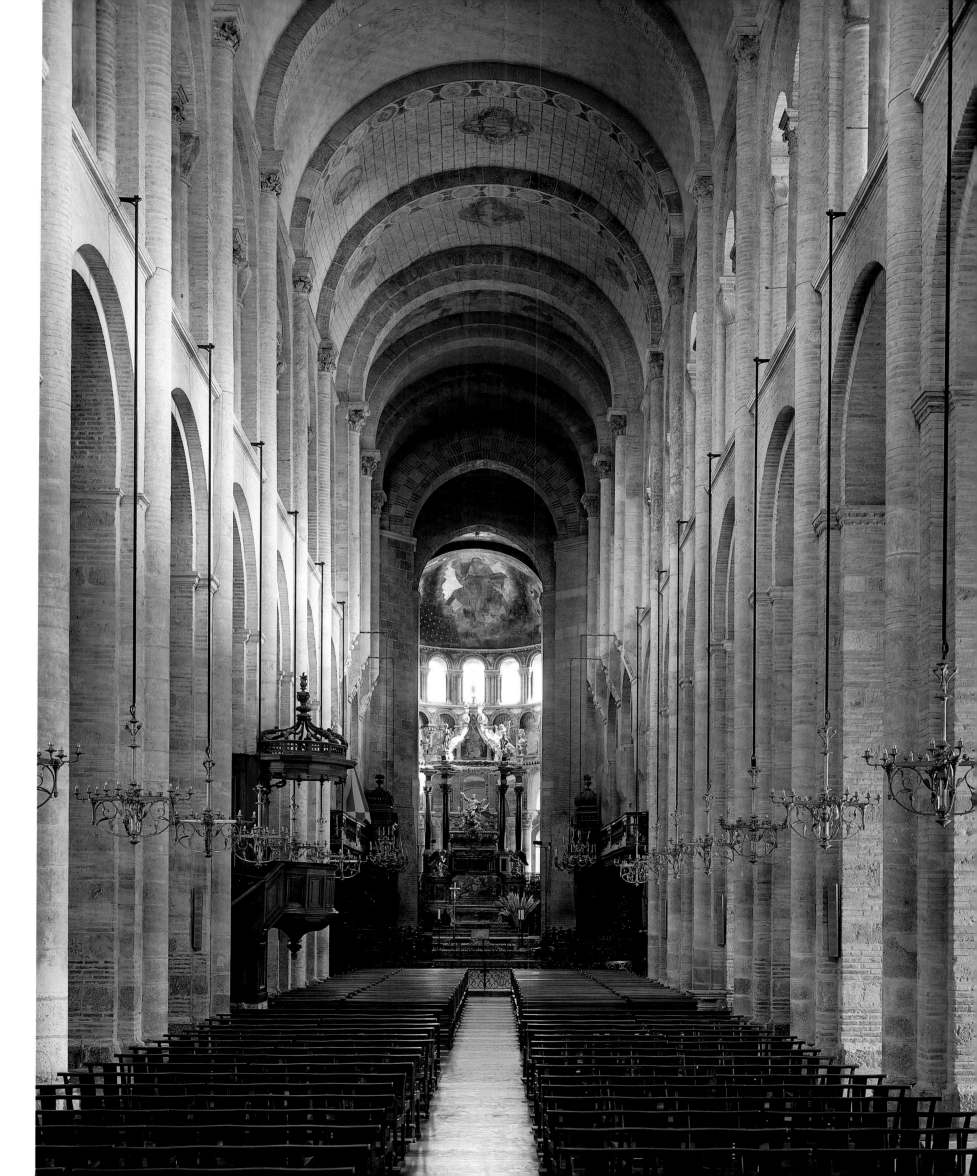

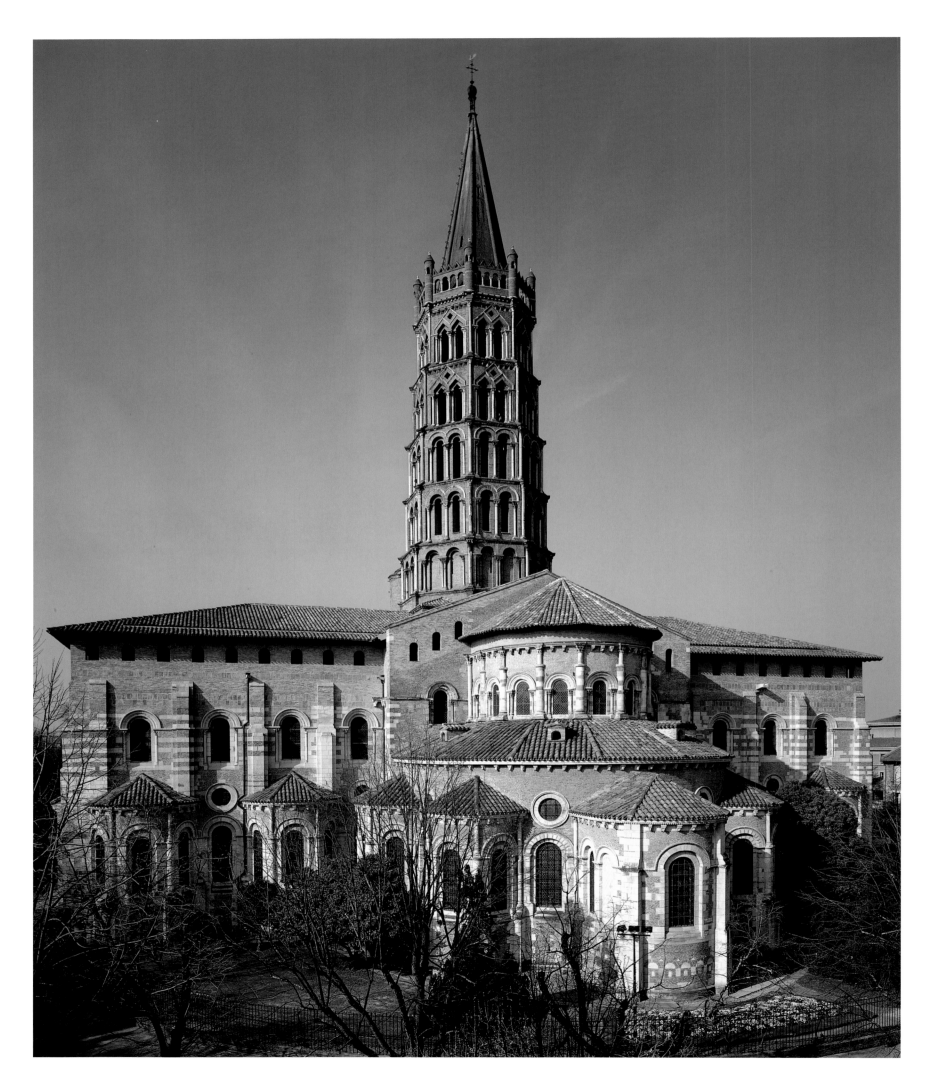

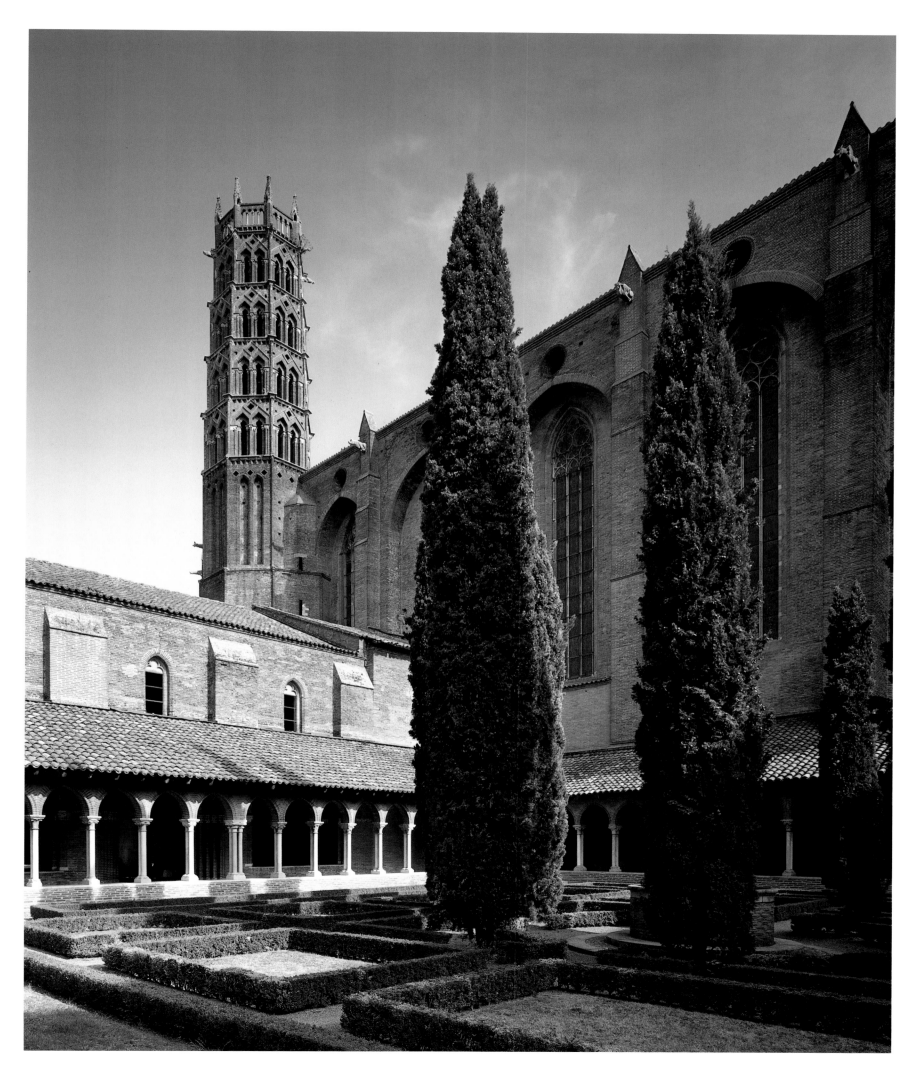

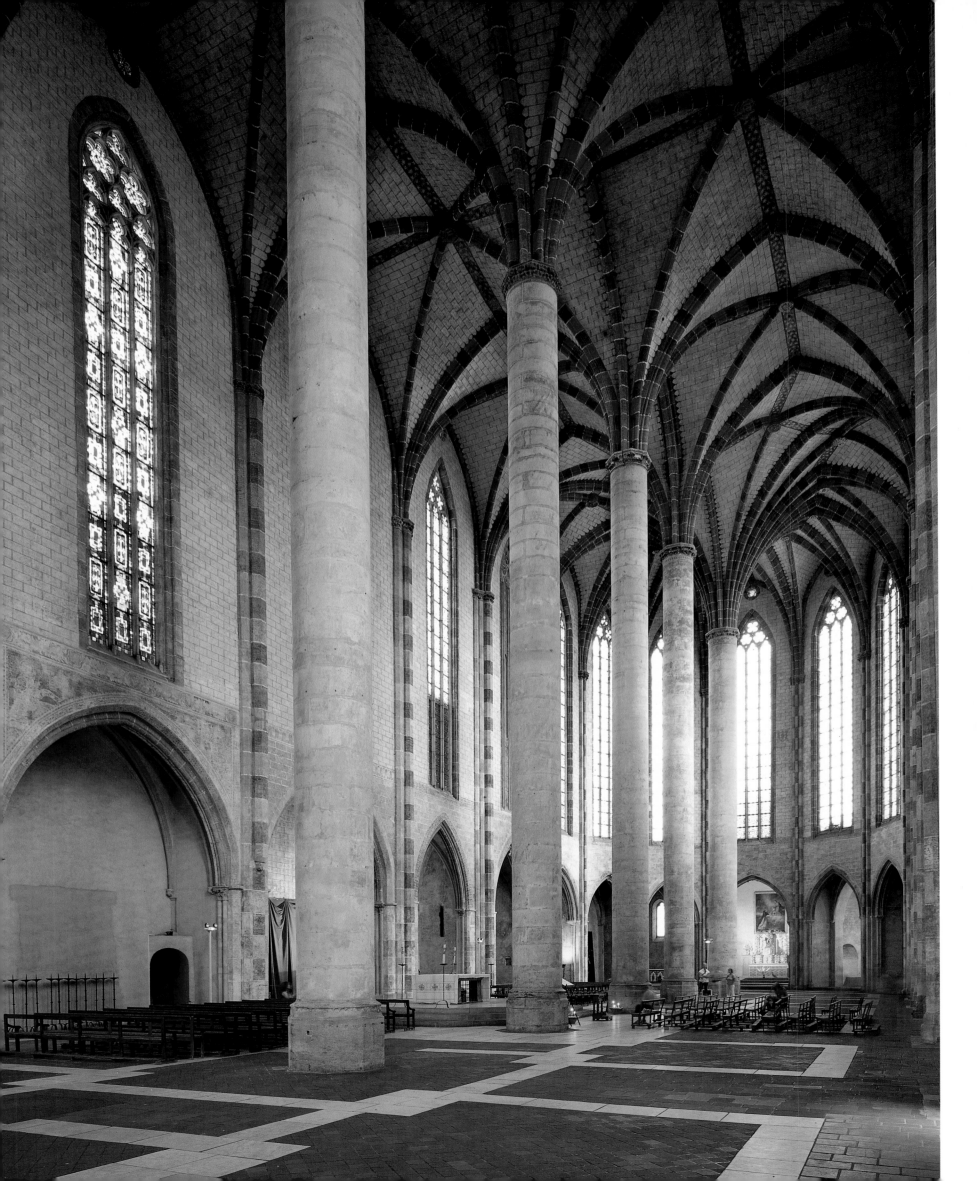

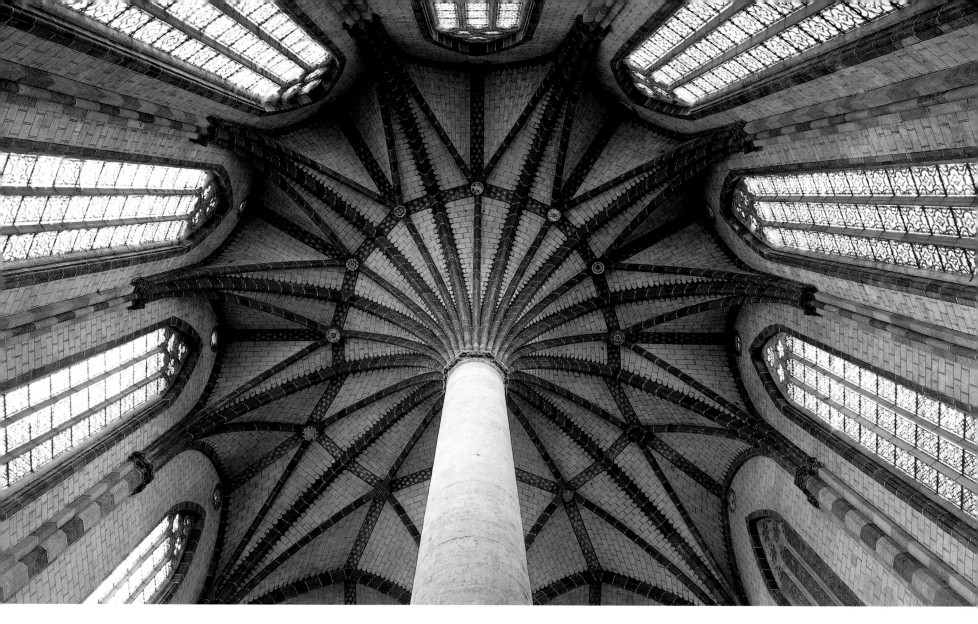

steeply rampant central nave and the cross aisle have barrel vaults with arch ribs. The trademark of this architecture is the galleries. They open up into biforia and run along the long sides of the nave and in a U-shape around the transept. They are vaulted by rampant half vaults that offer an abutment to the lateral thrust of the main vault. There is no clerestory; light enters indirectly, over the galleries and side aisles, which makes the space quite dark. This structure, which is repeated in similar fashion at Santiago de Compostela and Conques (see pp. 155–58), and originally at Saint-Martial, in Limoges, as well, is characteristic of the French pilgrimage church, for which Saint-Remi, in Reims, was an important preliminary stage (see pp. 202–3). Saint-Sernin also has sculpture of high quality; for example, on the portals, dating from about 1083 onward, there are seven large-format marble reliefs, including Christ enthroned in the mandorla with two accompanying angels. These reliefs, from the earliest period of French Romanesque sculpture, are probably by Bernardus Gelduinus, the master of the main altar that Urban II consecrated in 1096, and thus can be dated to this time as well.

The former Dominican church in Toulouse, known as Les Jacobins, is another building of European stature. The monastery, which was founded as early as 1216, was the mother monastery of the Dominican order. Beginning in 1230 the church was built in four separate stages spread over a full century. It is a spatial miracle, seemingly poured from a single mold, with towering, bare round pillars and a choir vault in which twenty-two ribs extend from the last pier like the branches of a tree, and spread out in all directions like a palm; it is held together by a wreath of large windows. Pope Urban V declared in 1368 that this Dominican church surpassed all others in beauty and majesty, and thus he decided that the bones of Thomas Aquinas, who had been canonized in 1323—which had been sought by Toulouse, Paris, and Naples—should be transferred here. From the monastery's early days the Dominicans were also professors of a university constructed within its walls, the second oldest in France. It was for the latter's bells, not those of the church, that a tower was built after the chancel was completed; it looms over the cloister and other buildings, as if in reply to the crossing tower of Saint-Sernin.

OPPOSITE PAGE:
Interior of Les Jacobins, facing east

ABOVE:
Upper termination of the chancel

MOISSAC

ONE OF THE MOST FAMOUS SITES OF Romanesque art in France is the former abbey Saint-Pierre in Moissac. It lies in the Tarn Valley, in southwest France, just before the Tarn flows into the Garonne, near the old trade road from Toulouse to Bordeaux. In the Middle Ages Moissac was an important stop on the pilgrimage route to Santiago de Compostela, which leads from the episcopal city of Cahors by way of Condom and the Roncesvalles and passes through the Pyrenees into Pamplona, in Spain. Moissac was already a city in Roman times, with *thermae.* According to legend the abbey was founded by the Frankish king Clovis, after he defeated the Visigoths in

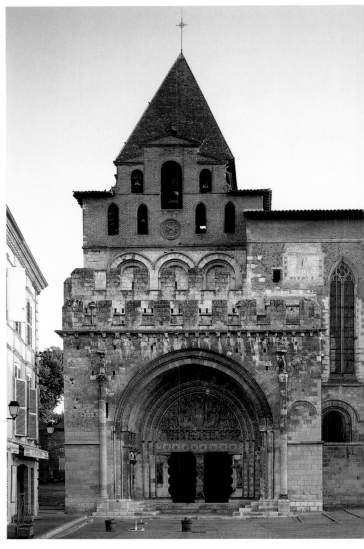

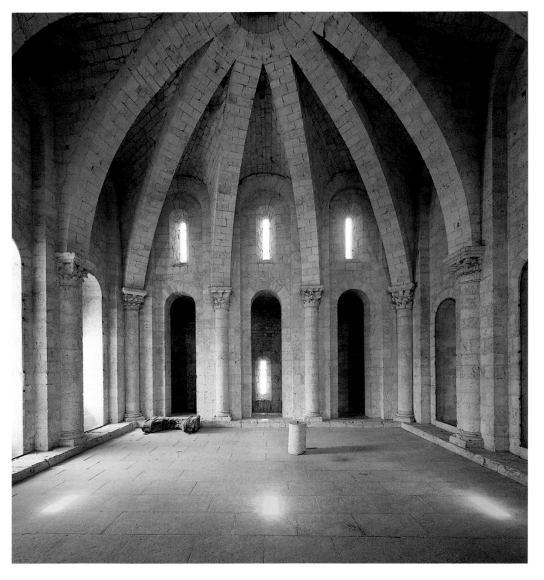

the Battle of Vouillé, near Poitiers, in 507, and drove them from southern France. In fact, however, it seems to have been founded only around 630, during the reign of King Dagobert I, by Abbot Amandus under the initiative of Didier, bishop of Cahors. The first five abbots, whose rule extended into the eighth century, were praised as saints by later historians of the abbey but were never canonized. Between the early eighth century and the early tenth centuries Moissac was destroyed repeatedly: twice by the Saracens, who penetrated the Pyrenees from Spain to France; and then several times by the Normans, who rowed up the Garonne; and finally by the Magyars.

Moissac's last great period began in 1048, when the abbey joined in with the Cluniac reform, after having been, as a later chronicle lamented, a den of thieves for a time. At the time it had a secular abbot (*abbas saecularis*) as a worldly protector—an arrangement that would last into the twelfth century. When, late in life, Odilo, the abbot of Cluny, was staying with the bishop of Cahors while journeying in 1048, he accepted Moissac into the Cluniac association of monasteries and appointed as abbot a monk from Cluny, Durandus (Durand de

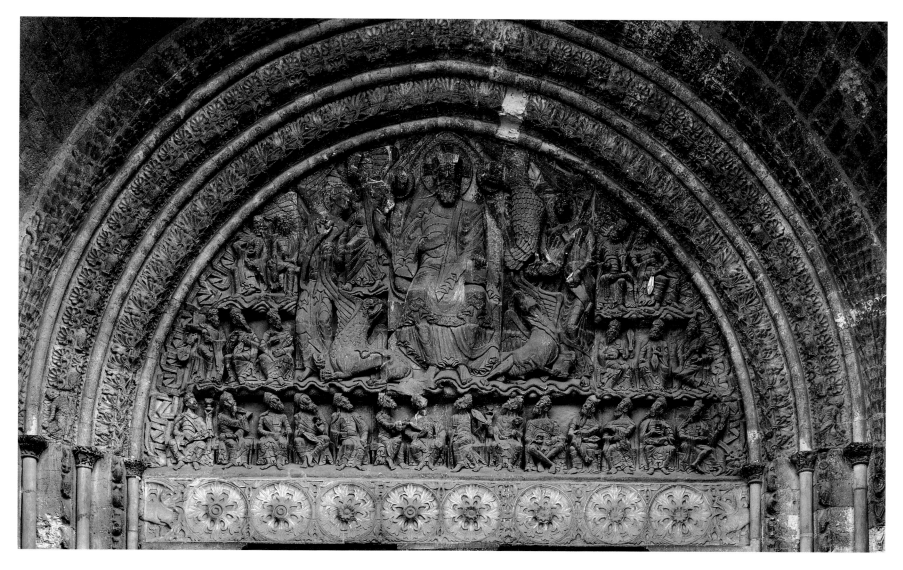

Bredon, from the Auvergne). Other monks arrived from Cluny along with him. Durandus (d. 1072) maintained close contact with Hugh of Cluny, Odilo's successor as abbot of Cluny. Ordinarily, abbeys that joined the reform had their status reduced to dependent priories. But Durandus was able to arrange that Moissac could retain its status as a free abbey. His position became that much more secure when, from 1059, he also held the office of bishop of Toulouse simultaneously. Within the Cluniac reform movement Moissac became the center of its own association of monasteries, with numerous abbeys, priories, and churches subordinate to it. Under the three abbots who succeeded Durandus—Hunaldus, Ansquetil, and Roger—the abbey maintained its lofty position until 1135, the year Roger died. In 1212, during the war with the Cathari, Simon of Montfort, the leader of the army crusading against the heretics, pillaged the buildings. Decline gradually set in thereafter, until the Benedictine convent was closed in 1626 and replaced by secular priests.

The Cluniac abbots saw to it that the monastery was renovated architecturally. Durandus had built a three-nave church, with extremely narrow side aisles and a chancel ambulatory that lacked radial chapels (consecrated in 1063). The cloister was built in 1100, according to an inscription, under Ansquetil, who was abbot from 1085 to 1115. Abbot Roger gave the west end of the church a two-story tower (*clocher porche*) that was then freestanding and had a narthex on the ground floor and a square cult room on the upper floor, which was reached by a spiral staircase. The building was heightened, using brick, and converted into a campanile only in the fifteenth century. The vault of the narthex has heavy, boxlike cross ribs. On the upper story the number of ribs is increased from four to twelve. They run radially up to a circle in the crown that was once open and support steeply rising vault caps; the whole figure of the vault is impressive for its primitive, archaic impact. The upper room, which has four enclosing walls with gatelike openings that reach almost to the floor, is clearly a built version of the square city of heaven that is described in the Book of Revelations, which had three gates on each side.

In a second phase of construction, still under Abbot Roger, reinforcements were added outside the tower, in particular a twenty-foot-thick wall on the south side,

Capitals in the cloister

into which a shallow narthex and a portal were inserted. This is dated to the period before 1130. It contains one of the earliest Romanesque tympana, which has a large-format, figurative relief. The theme is Christ enthroned and crowned, in strict frontality, with scarcely a hint of motion, his left hand resting on a book and his right hand raised in a gesture of majesty and blessing—a form that inspires fear and seems to know no leniency. In this enthroned Christ one senses the judge of the Last Days who will administer divine justice at the Last Judgment and mete out punishment with unswerving severity. Some observers see in this form less a judge than a menacing avenger who spreads fear and has something demonic about him. The relief does not, however, depict the Last Judgment but rather a vision of the Apocalypse in which Christ is surrounded by the four beasts—lion, calf, man, and

eagle—and by the twenty-four enthroned elders. Two slender angels join the four beasts.

The tympanum is so large that the horizontal door lintel that supports it—a stone beam ornamented with rosettes—had to be held up in the middle by a post, a *trumeau* (pier), whose front shows a bestiary of several lions placed crosswise and whose jambs reveal prophets. On the jagged outer posts one sees Saint Peter on the left and Christ on the right, both in ecstatically animated poses that become even more emphatic in later works inspired by Moissac, such as the portal at Souillac. The portal's program is completed on the side walls of the narthex, with reliefs of sins and vices on the left, juxtaposed on the right by the story of the young Christ.

Beyond the portal the church has been transformed into a hall with two sequential pendentive domes, very much following the model of the cathedral of Cahors,

which had been built only a little earlier. The church did not achieve its final form until the fifteenth century, when a Gothic chancel was added and the domes were replaced by cross rib vaults.

Another ensemble of high-quality sculpture at Moissac is found in the famous cloister. Built around 1100, it was rebuilt following a fire in 1212, but now using Romanesque columns and capitals and Gothic pointed arches. In the arcades of the flat-roofed walkways, single columns alternate with paired columns, with a pier at the center and in each of the corners. The latter have reliefs depicting the apostles; in addition, opposite the former chapter house there is a relief of the abbot Durandus with his attributes as bishop of Toulouse but also those of a saint. Ten reliefs have been preserved in all, as well as all seventy-six capitals, some of which have vegetal ornament and some scenes from the Old and New Testaments or other events. No overarching theological program is evident. The cloister, to which four or five sculptors contributed, is one of the oldest surviving and largest in France; the rich ornamentation of its capitals has no equal in the period around 1100. It was soon followed by the cloister of La Durade in Toulouse; a little later Master Gilabertus of Toulouse, one of the best sculptors of his day, brought the sculpture of capitals to its highest, most refined flowering (his work is now in the Musée des Augustins in Toulouse).

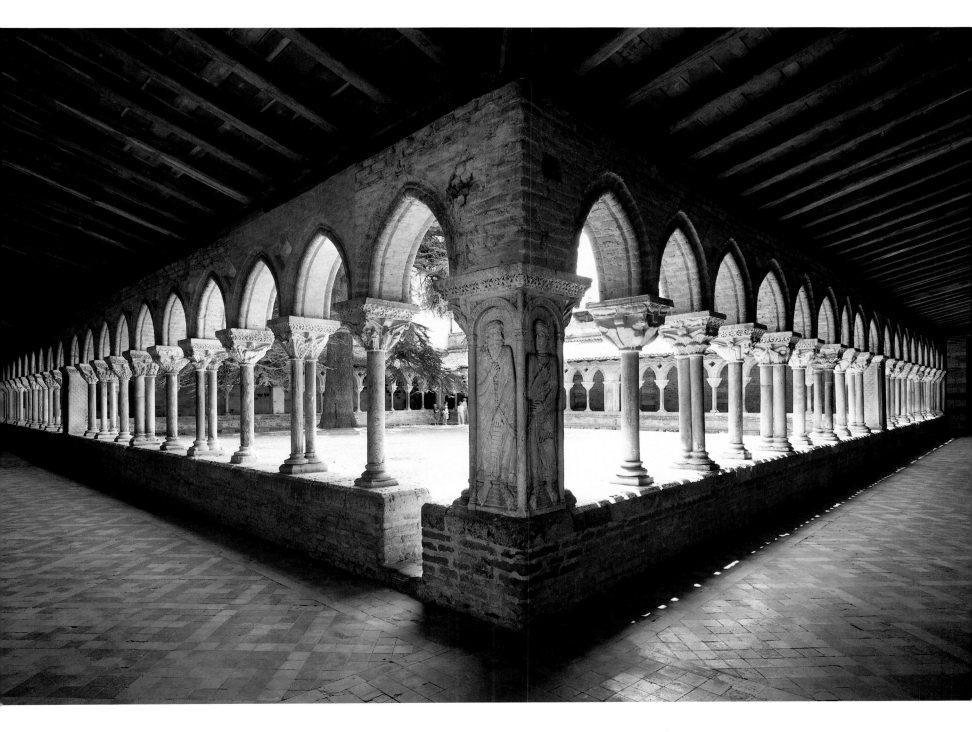

VALMAGNE

VINOUS VALMAGNE (FROM THE LATIN *vallis magna* [large valley] or *villa magna* [large villa]), in the Languedoc, near Mèze and Pézenas, at the foot of the Cévennes, was an important Cistercian abbey. In 1139 Raymond Trencavel, viscount of Béziers, founded a monastery here for Benedictine monks from Ardorel, an abbey in the diocese of Albi, which was associated with the congregation of Fontevrault. Ardorel soon placed itself under the Cistercian primary abbey Pontigny. The second abbot at Valmagne, Pierre, also sought, with the approval of his convention in 1144, to associate the monastery with the Cistercian order. This met with great resistance and was only achieved by papal decree in 1159. Earlier, in 1145, Cîteaux had included the monastery in the filiation of Bonnevaux, in the Dauphiné. The monastery grew rich, thanks to numerous donations and assignments of rights. In 1252 the abbey even founded its own college in Montpellier. The construction of the present church, which has long since been secularized, began in 1257. With a length of 272 feet (83 m), a height of 82 feet (25 m) at the nave, and a width of 98 feet (30 m) at the transept, it was far larger than its Romanesque predecessor had been. The church was completed in the early fourteenth century. It represented something entirely new for the Languedoc. The architect, who came from northern France, introduced cathedral Gothic to the region and created a true "Cistercian cathedral" with an ambulatory chancel of geometric perfection and a wreath of radial chapels composing seven sides of a dodecagon. The piers of the apse in the upper choir have not round but ovoid forms, which are better suited to the polygonal angles—a solution otherwise found in this period only in the cathedral of Cologne. The walls at Valmagne have a two-story structure, since they lack a triforium—another innovation. The apse originally had a wreath of large windows running around it; its upper story was thus filled with light. Today every other window has been bricked up, which severely compromises that effect. Following the monastery's closure the church was transformed into a wine cellar. As a result, many windows were bricked up to keep it cooler, and enormous vats were set up in the main block beneath added arches. The church is now often referred to as the Cathedral of Wine.

In the fourteenth century a new, larger cloister was constructed, with quadripartite arcature and circular openings in the crowns—or in some places triangles with curved sides. It is closely related to the cloister of Fontfroide (see pp. 120–23). Particularly charming is the octagonal well house, which instead of a vault above its arcaded galleries, has just ribs covered with grapevines, which turn the space into an airy pergola.

The five arches of the cloister that open up toward the chapter house have survived from the Romanesque monastery; they are splendid architecture of an unusual richness, in which, in lieu of massive piers to support the heavy arches of the wall, there are six small columns grouped into a see-through rectangle.

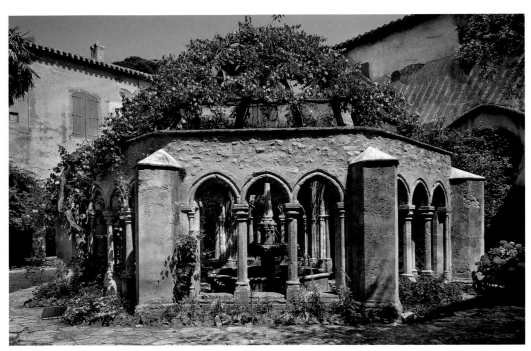

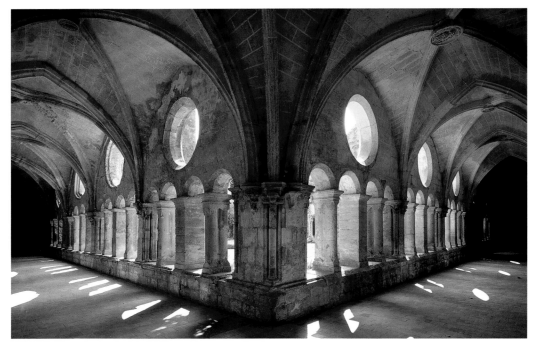

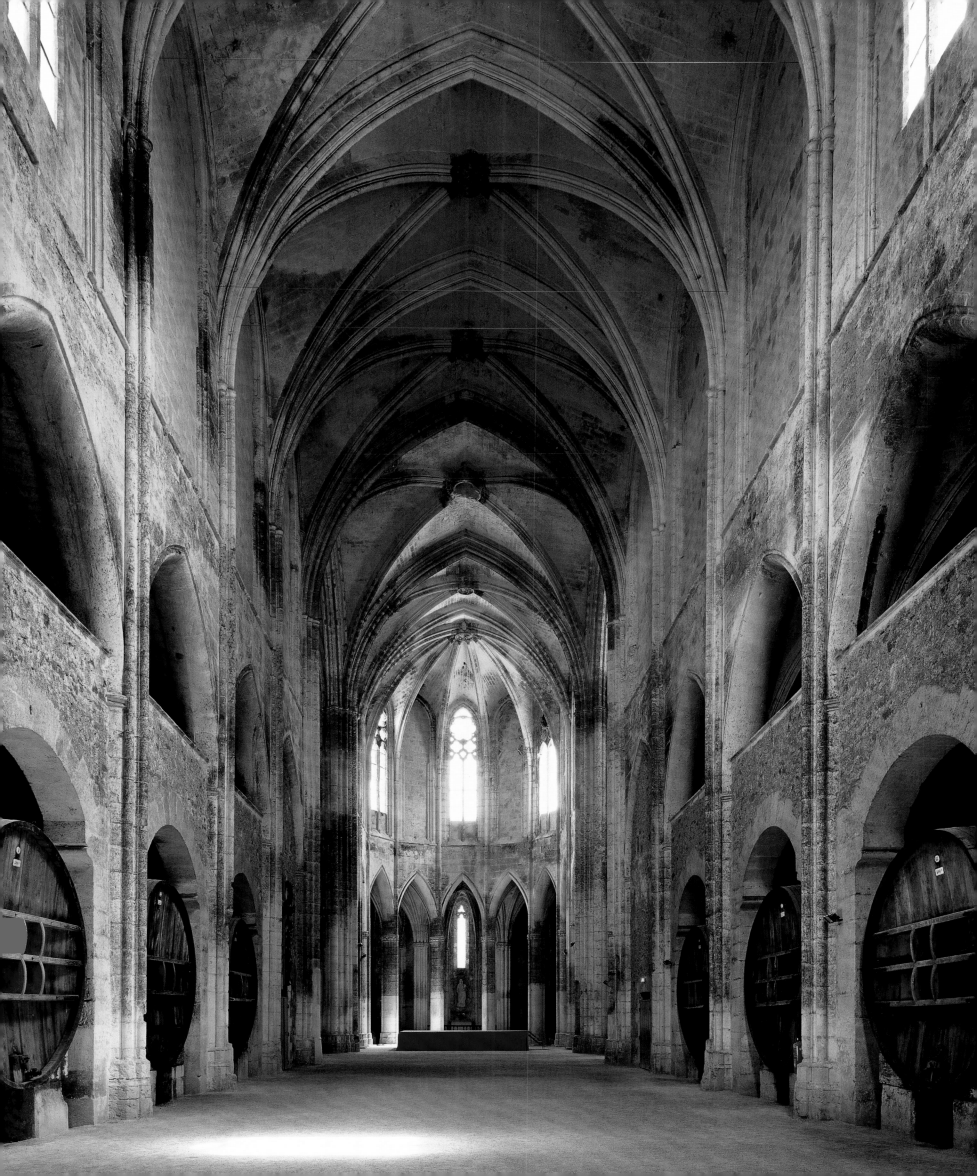

LÉRINS

THE ÎLES DE LÉRINS, OFF THE COAST OF CANNES, known as the "islands of the saints," may be included, along with Tours and Montecassino, among the birthplaces of Western monasticism. Honoratus, a Roman probably born in Trèves (Trier), who was a boyhood friend of Emperor Gratian, withdrew in the early fifth century to the smaller and more distant of the two islands, which, lacking water, was not really habitable. Honoratus had experienced early anchorite monasticism in Egypt and Syria and wanted to find God on his own path. Other Christians soon followed him to the island, and so around 410 Honoratus founded a monastery for this young community, in which he sought to combine the hermitic ideal with the cenobitic. The rule that Honoratus gave his order was the earliest monastic rule in Gaul. It is known only from a later version, known as the Rule of the Four Fathers. Lérins quickly developed into one of the most important seminaries for monasticism in southern Gaul. A few years later John Cassian founded the monastery Saint-Victor, in Marseilles, from Lérins, but he gave it a rule he composed himself, which was later taken over by countless newly founded monasteries. Over the course of the centuries Lérins produced forty-two saints, as recognized by the church, and more than eighty by popular count. They include Patrick, who brought Christianity from Lérins to Ireland, and Mayeul

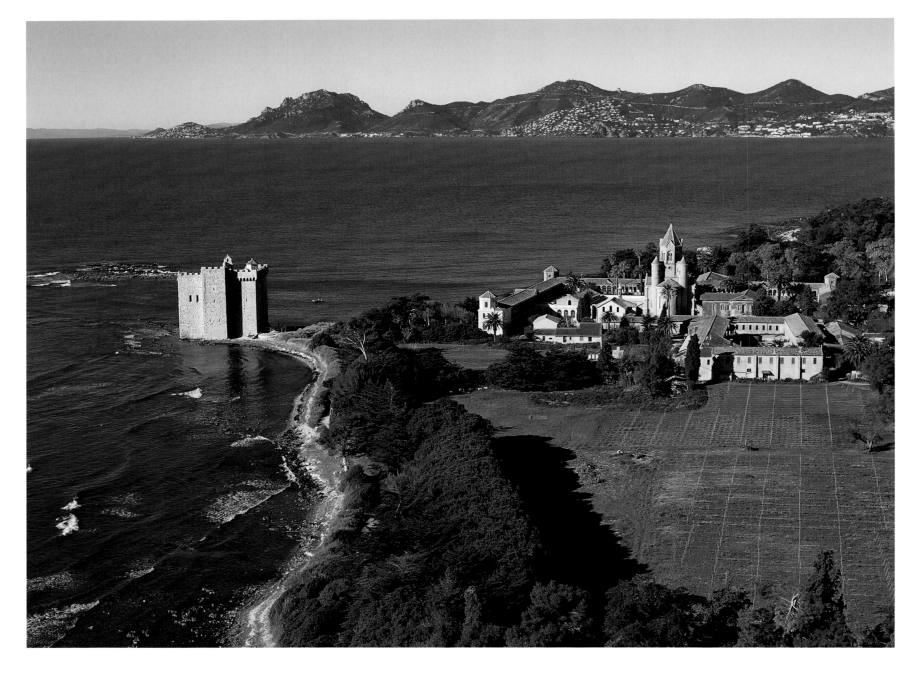

and Odilo, abbots of Cluny. Many monks and abbots from Lérins became bishops or archbishops, like its founder, Honoratus, and his first biographer, Hilary, both of whom had to accept the office of bishop of Arles against their will. In the seventh century Abbot Aigulf attempted to introduce the Benedectine rule but was killed by the monks from whom he wanted to demand greater discipline. The rule was introduced later nonetheless.

The monastery, which was said to be occupied by as many as thirty-seven hundred monks at one time, received so many lavish donations that until the time of the French Revolution it was the largest landowner on the Côte d'Azur. Its wealth frequently attracted the Saracens: in a raid in 732 they murdered five hundred monks and the abbot.

In order to protect itself against lightning raids by ships at sea, the monastery built a fortress on a rocky projection of the island to use as a keep: the "monastère fortifié," which could be reached from the island by tunnel. The first donjon was built in 1073. From the twelfth century to the end of the thirteenth this donjon was expanded and built up into a fortress, which is largely still standing. During the latter part of this construction work, the monastery could make use of the profits from the shipping rights it had been granted by Charles II of Anjou, in gratitude for three hundred pounds of silver the monastery had gener-ously provided to purchase horses for the army. As is often the case with defensive structures, the fortress's outer walls consist of carefully laid bossed ashlar, which lends a defiant, martial, rebuffing look that seems impregnable. This impression is reinforced by the projecting crenellations on top. The spaces of the interior—including the refectory, the library, and chapels—are distributed over five floors in such a way that monastic life could continue even if constricted by attacks. The core of the fortress is a small, steep, boxlike inner court, with two square floors of arcades with pointed arches—that is to say, a cloister, which was indispensable for any monastery. In general, the distri-bution of spaces and the defensive measures are so cleverly arranged that even as late as the Baroque period they were still praised as a masterpiece of well-thought-out functionality by Vauban, Louis XIV's architect for fortresses.

The only island monastery is largely destroyed. The remains were transferred to Cistercians from Sénanque in 1859, who built a new monastery, funded by the state, in 1883.

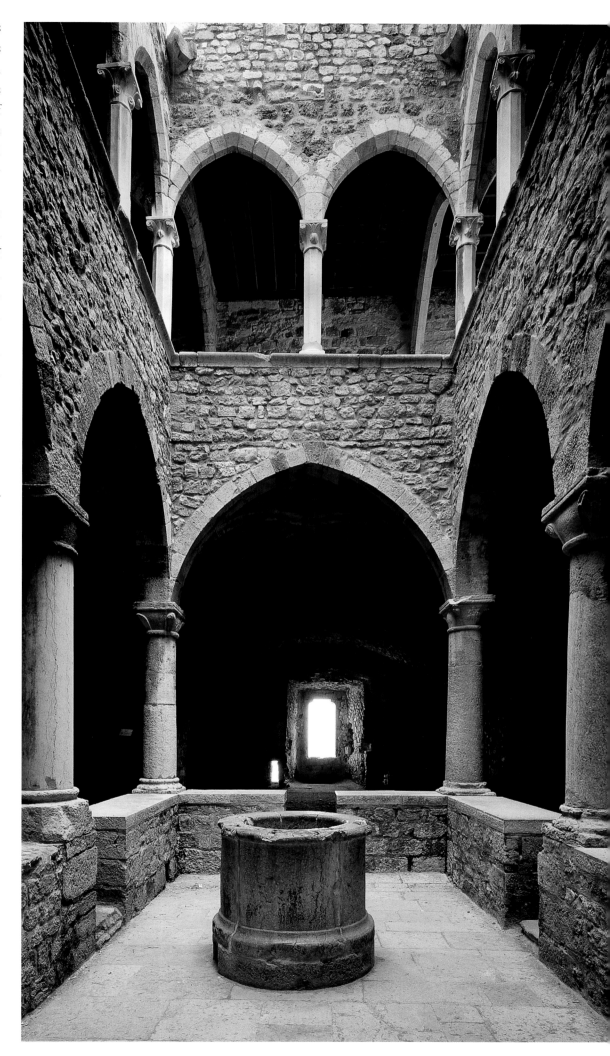

SÉNANQUE

Below:
View of monastery from the east, Sénanque

Opposite page:
Nave of the church, facing east

SÉNANQUE IS THE MOST POPULAR OF FRANCE'S Cistercian abbeys among international travelers, due in part to its excellent state of preservation and its wild, romantic location in a remote valley surrounded by cliffs—and in part to the famously picturesque field of lavender in front of the abbey, which is always blooming in photographs, and when in bloom fills the air with its pleasant, delicate scent. Sénanque is one of a group of three well-preserved Cistercian monasteries in Provence that are known as the "Provençal sisters." The other two are Silvacane and Le Thoronet. Provence originally had a dozen such monasteries.

Sénanque lies eighteen miles east of Avignon, near the Fontaine de Vaucluse, which Petrarch, who with-

drew here to live for three years, praised in many sonnets as a delightful natural wonder. Petrarch is said to have been at Sénanque as well, and to have found there inspiration for his work "De vita solitaria." The name Sénanque derived either from *sine aqua* (without water) or *sana aqua* (healthy water).

Sénanque is the youngest of the three Provençal sisters. The seigneur de Gordes, Giraud de Simiane, founded the settlement in 1148, at the initiative of Bishop Alfant of Cavaillon, in the valley of the stream Sénancole, and presented it to Cistercians from the Mazan monastery, which had been settled on a plateau near the Ardèche River as early as 1119 by monks from Bonnevaux. Bonnevaux, in turn, was the seventh daughter of Cîteaux. Sénanque, which soon had thirty monks in residence, achieved modest wealth and held about ten granges. By 1152 Sénanque was able to establish a daughter monastery in the Vivarais.

The church was built from approximately 1160 to 1175, and in any case was completed by 1178, as two inscriptions testify. The monastery buildings followed soon thereafter, probably between 1190 and 1200. They still stand; only the conversi wing was destroyed, in 1544, by plundering bands during the religious wars of

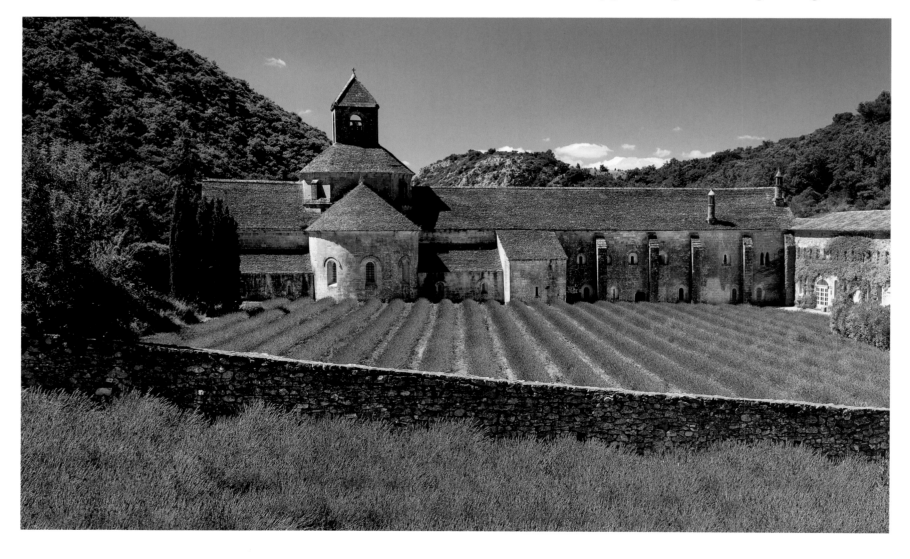

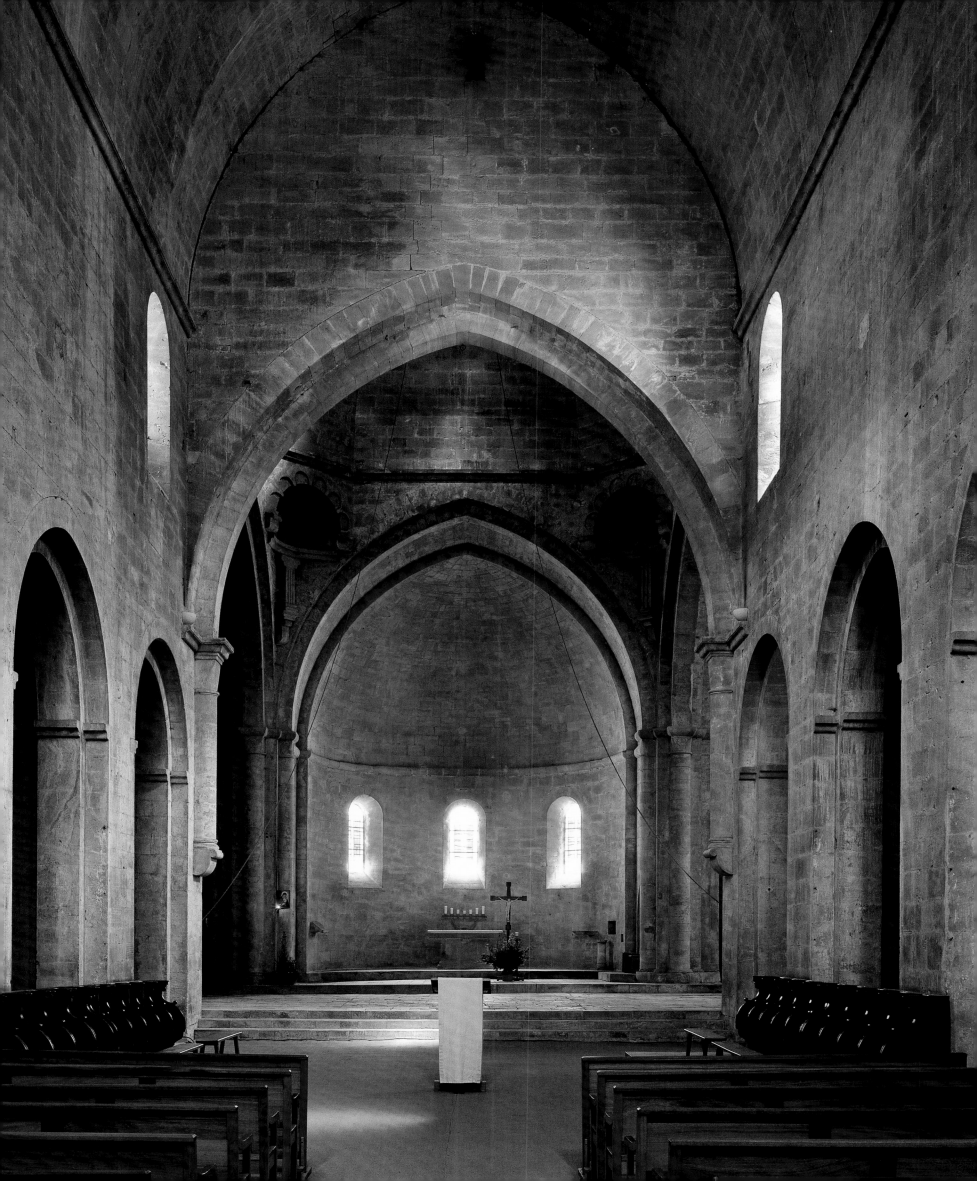

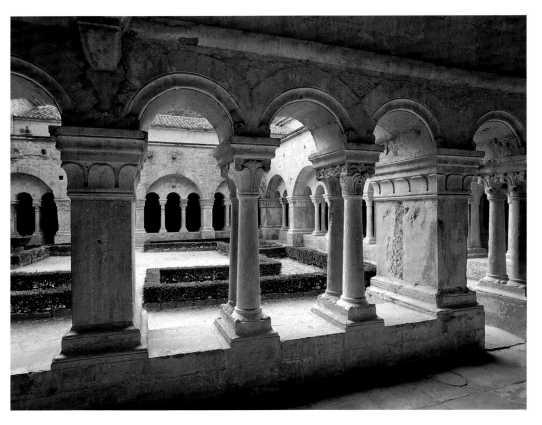

Sénanque. ABOVE: *Cloister;*
BELOW: *Monk's hall*

OPPOSITE PAGE:
Northeast corner of cloister

vaulted transept, which has two chapels on each side, in keeping with the Bernardinian plan, is very low, following an old Cistercian tradition. In front of the sanctuary, which consists almost entirely of a semicircular apse, there is a crossing with pointed arches and an octagonal dome on squinches. The nave, which also has barrel vaults, is a good deal taller than the transept arms. It has, above the nave arcades, completely unarticulated clerestory walls, with just one window on each side, in front of the crossing. The side aisles, which can barely be seen from the nave, have three-quarter barrel vaults that ascend from the outside inward and seem strangely capped at the wall on the side facing the nave—the whole thing is, as so often in Provence, a continuous abutment for the lateral thrust of the main vault. In general, the masonry, which even in the vaulting consists of ashlar, seems barren and naked; it embodies Cistercian rigor in a pure form.

The stony heaviness of the walls dominates in the monastery buildings as well. The barrel-vaulted cloister is a masterpiece of Romanesque architecture that has always been admired. On the inner side the gallery alternates in pairs between piers and double columns; on the outer side, however, the arcades consist of broadly projecting arches, grouped in threes, that rest on pier buttresses and support massive walls. The relieving arches and pier buttresses were structural necessities, as abutments for the barrel vaulting. But the architect turned them into an artful motif of great harmony. The direct model was the cloister of the Benedictine abbey Montmajour, near Arles, built around 1140.

The dormitory is also characterized by its barrel vaults: it is as bare and simple as a barn, but precisely for that reason its pure spatial volumes are extremely effective. In the monks' hall, with its low, compressed central column, the architect tried out a barrel vault in which the vaulting cells taper in, which gives the form of quadripartite groin vaults; then, in the chapter house, rib vaulting is introduced above the two quatrefoil piers, because the floor of the dormitory above called for highly compressed arch profiles. The refectory, which is so frequently the pride of Cistercian monastery buildings, has not been preserved in its original state. It was heavily damaged in 1544, then repaired, but in the nineteenth century it was converted into a chapel.

the sixteenth century, and it was never reconstructed. Following its closure, the Cistercians returned in 1854. The last of them remained until 1969, when they moved to Cîteaux. Since 1989 several Trappists have lived here, having come from the Lérins islands, near Cannes.

The monastery is fairly small; the church has a total length of only 128 feet (39 m) and a width at the transept of 89 feet (27 m). Many Cistercian churches in northern France—like Clairvaux, Pontigny, Longpont, and Royaumont—were nearly three times this size. The barrel-

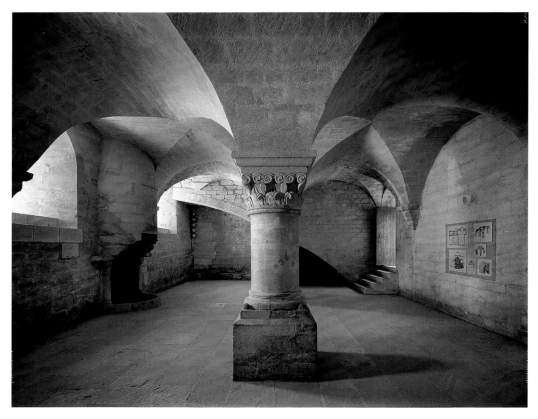

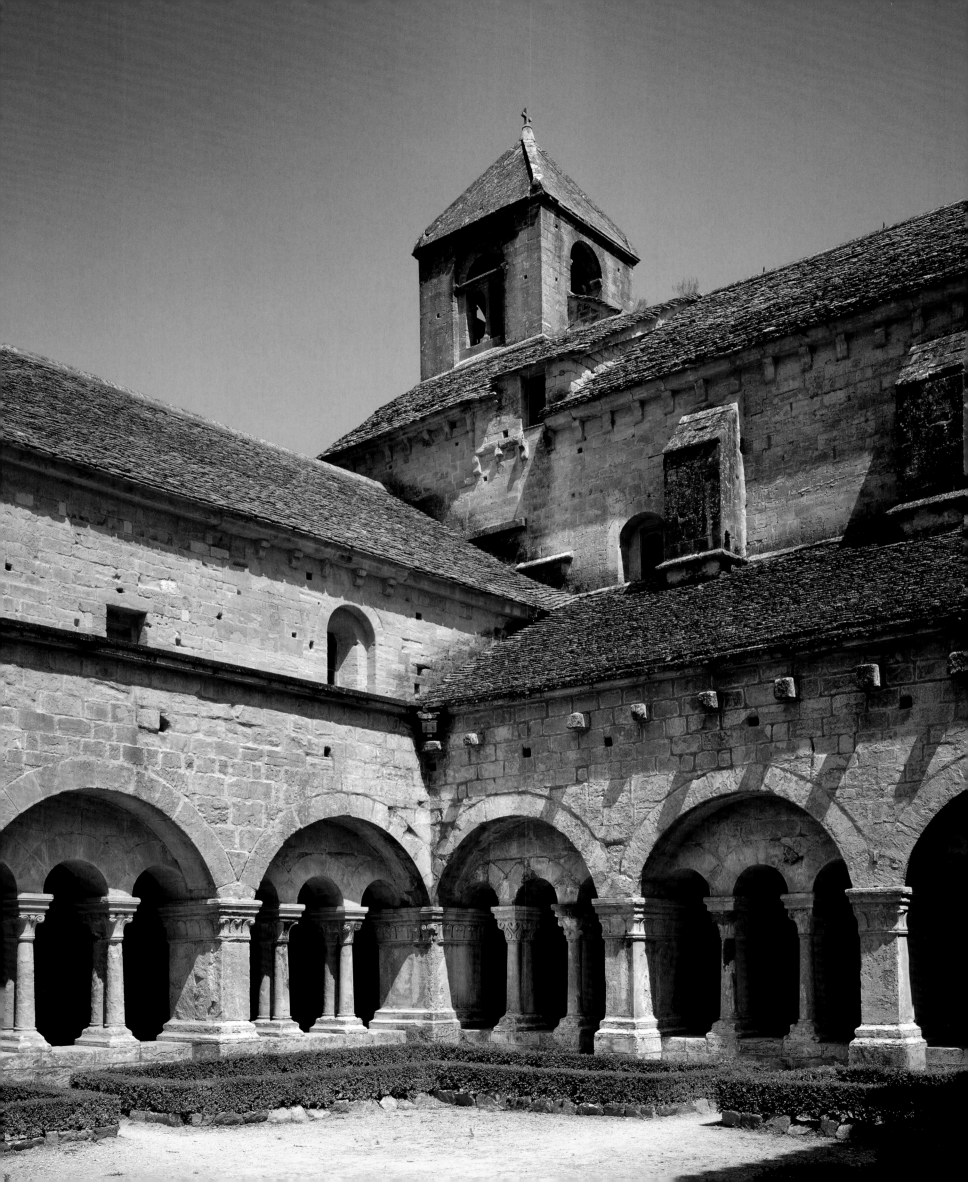

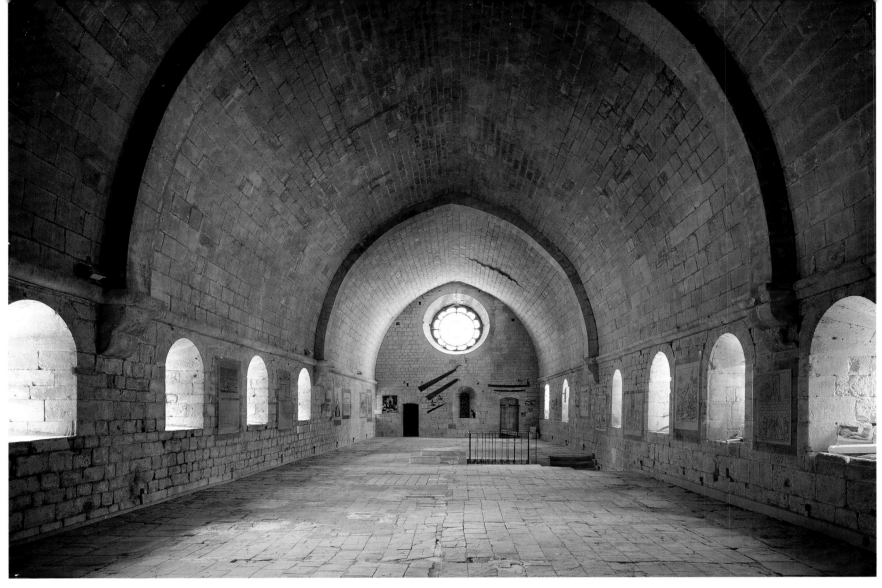

Sénanque. ABOVE: *Dormitory,* BELOW:
Chapter house

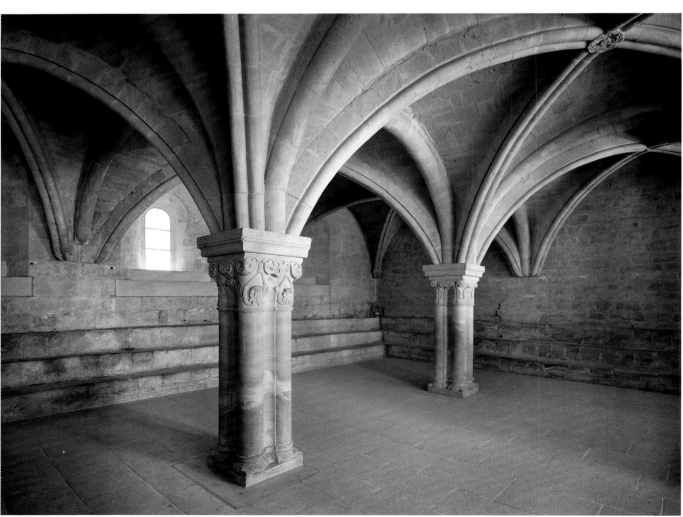

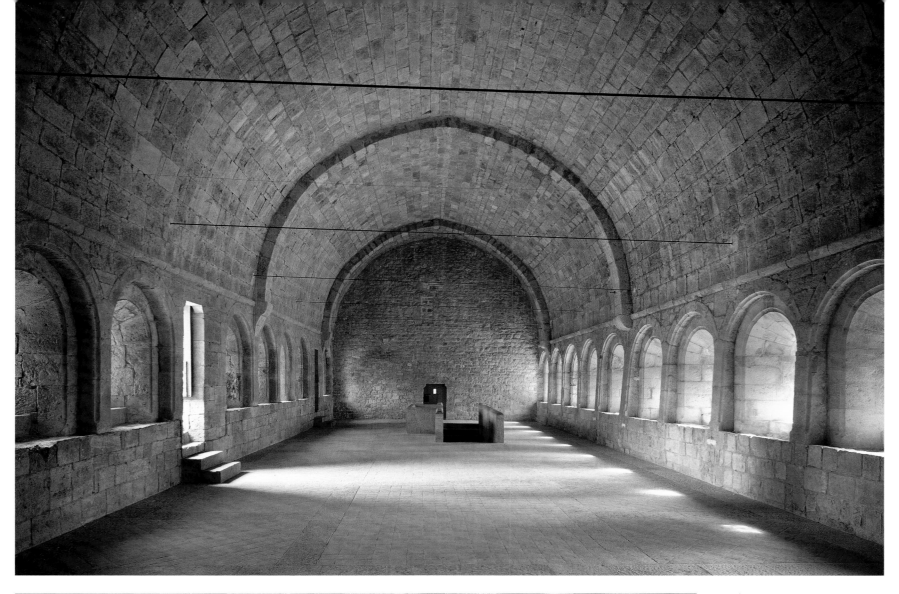

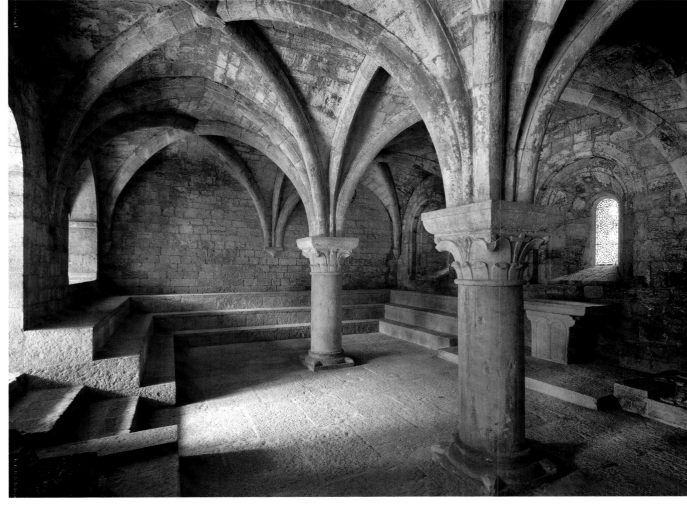

Le Thoronet. ABOVE: *Dormitory.*
BELOW: *Chapter house*

LE THORONET

BELOW:
Cloister, south and east wings,
Le Thoronet

OPPOSITE PAGE:
Southeast corner of the cloister

OF THE THREE CISTERCIAN ABBEYS IN Provence that are known as the "Provençal sisters," Le Thoronet is the oldest. The monastery lies between Fréjus and Saint-Maximin-la-Sainte-Baume, in a valley that is still surrounded by forest. The founder was Raymond Bérenguer, count of Provence. In 1136 he created a settlement near the town of Tourtour with monks from the Cistercian abbey Mazan, which lies on a plateau near the Ardèche River,

and, through its mother monastery, Bonnevaux, belonged to the filiation of Cîteaux. The new monastery was named Floreya or Florège, after the river on which it lay. Around 1160, the monks abandoned their settlement, which became a grange, and founded Le Thoronet about twelve miles further south, at a bend of a stream. There seems to have been a settlement there already. Once again it was Raymond who provided the land to the monks. In 1196 King Alfonso II of Aragon, who was also count of Provence, confirmed this grant. In the period that followed the counts of Provence transferred other lands and real estate to the monastery, but the abbey never grew rich. The modern age, with abbots *in commendam,* was one of constant decline. After the Revolution the monastery became the property of the community. At the time the structure was in a very poor to ruinous state, until the writer Prosper Mérimée, France's first preservationist, managed

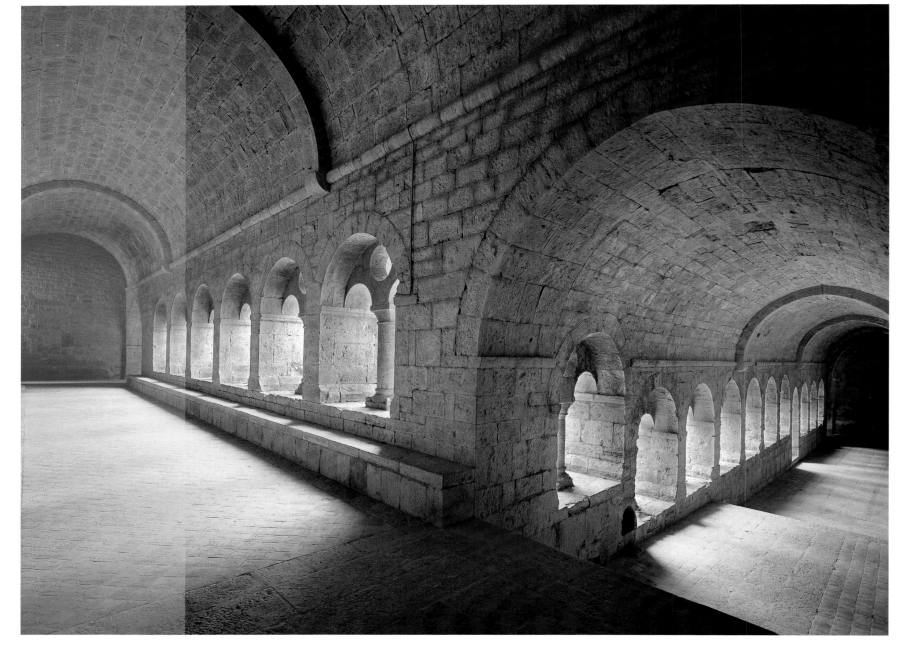

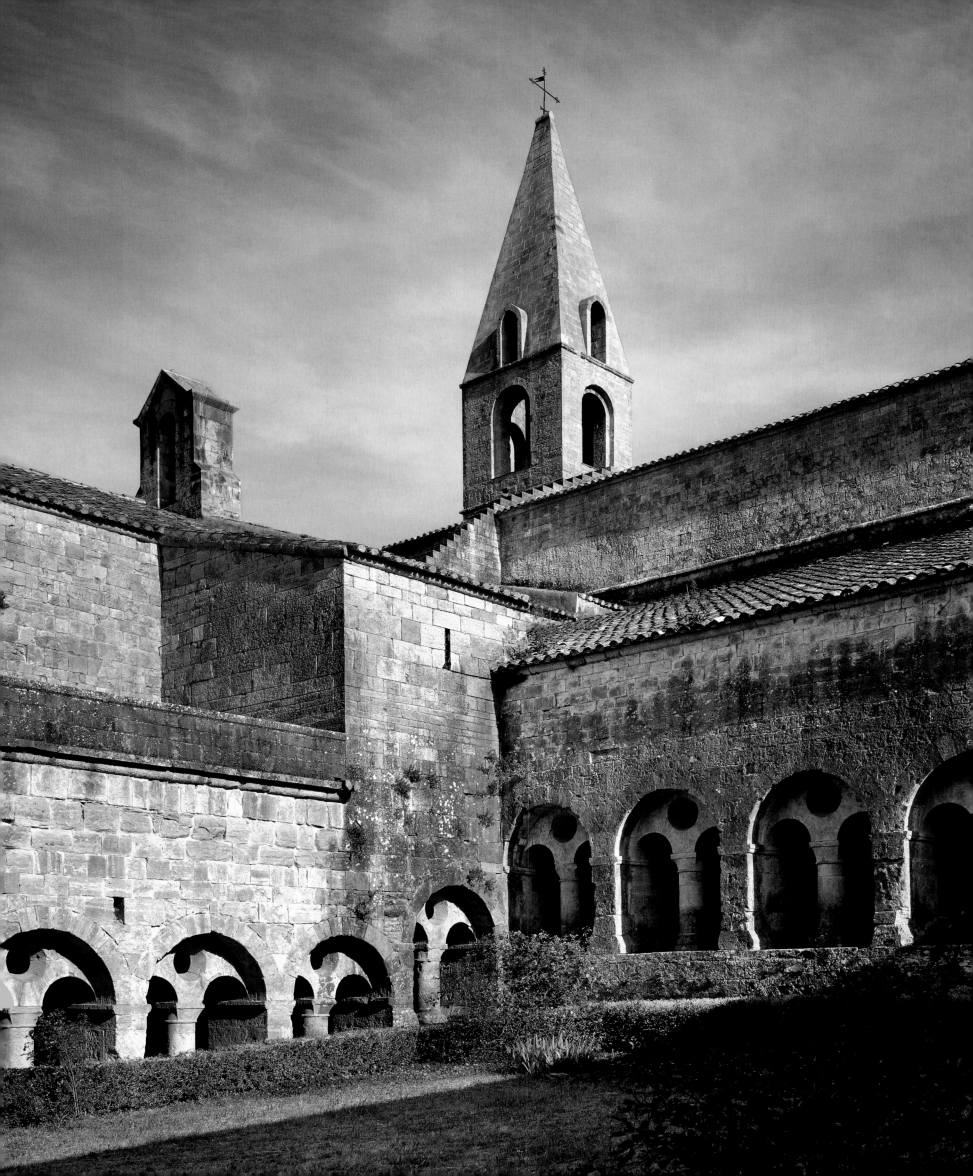

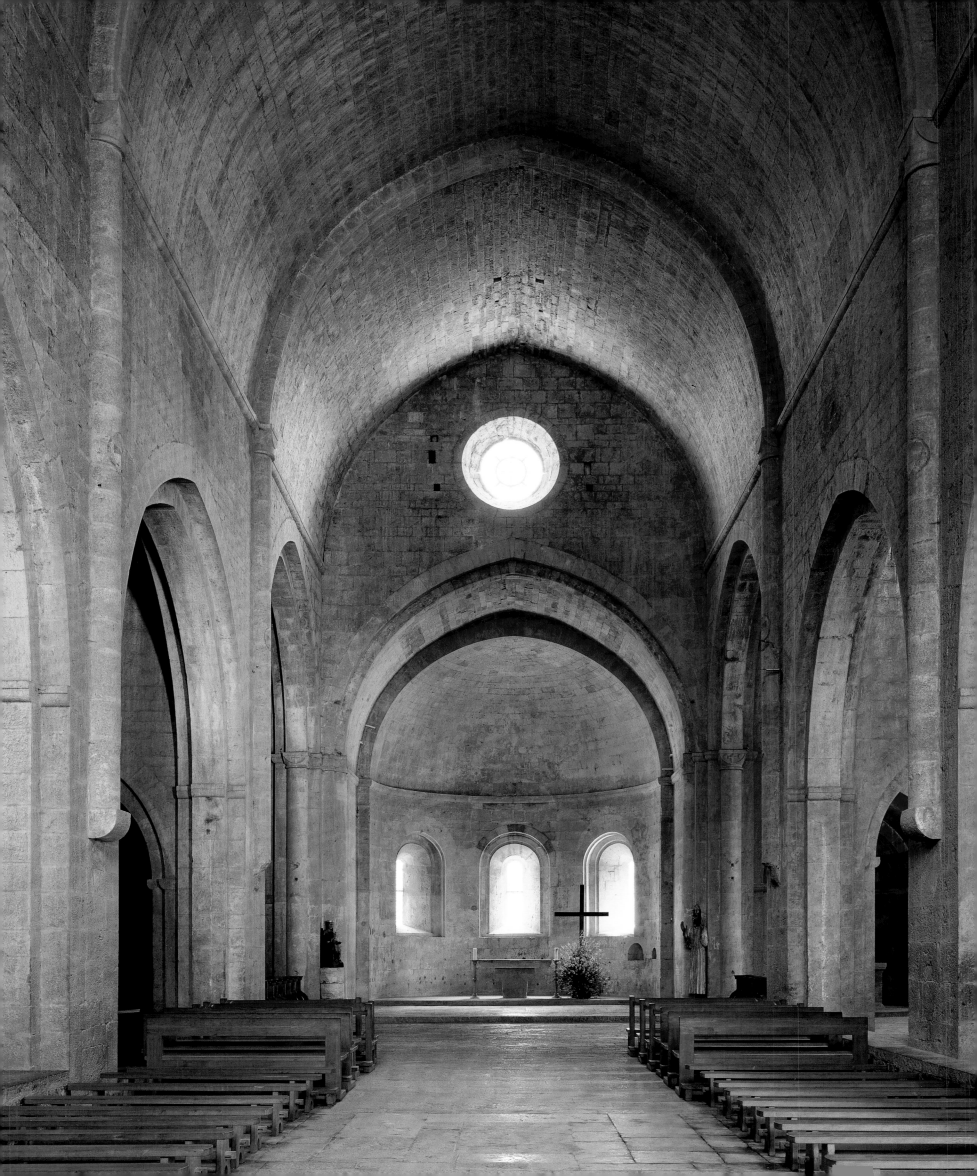

to arrange for its repair. Le Corbusier was another admirer of the monastery's architecture. In 1964 the architect Fernand Pouillon published the novel *Les Pierre sauvages (The Stones of the Abbey)*, which became quite popular in France: an imaginary diary of life on the construction site of Le Thoronet and an homage to the exquisite stonemasonry achieved there.

The church was probably begun immediately after 1160, when the convention settled once and for all at its present location, and was completed about twenty years later. At a length of 135 feet (41 m), width of 28 feet (8.5 m) in the nave, and a height at the crown of 52 feet (16 m), it belongs in the smallest category of Cistercian buildings, as do the churches of its sisters, Sénanque and Silvacane. It also embodies the same type they do: an east end according to the Bernardinian plan, with two chapels in each end of the transept, a short three-nave main block with pointed vaults in the nave, and rampant half vaults in the side aisles. The short sanctuary, which like the one at Sénanque terminates in an apse, and the transept arms are low and feel compressed. The nave is much taller. It runs through, with no crossing, to the sanctuary, above whose entry arch there is a tall wall, a field that is ideally suited to putting an oculus on stage, like a great eye that nothing can escape. The eye is all the more transfixing as the space lies in semidarkness so that the round form is seen as a radiant circle of light. The whole church, inside and out, is of the plainest sparseness and of an almost spartan severity. What speaks here is a hard-edged and smooth-surfaced ashlar structure with which the monks have walled themselves in with a solidity that is built as if for eternity. The walls have almost the joyless sobriety of prison walls, but the stonecutting is so astonishingly precise it is as if the workers wanted to compensate for the prohibition against ornamentation by carving with special meticulousness. The structure of the church's exterior would hardly differ from that of a barn or large stable if it were not also stonework of the highest quality. The plainness takes on an aspect of ascetic severity, but this merely underlines the clarity of the simple architectural forms.

The buildings for the convention are arranged to the north of the church. They are not on level ground; the site slopes down to the river. This inconvenient situation was addressed by constructing the buildings on stepped terraces. The result is that the floor levels are at different heights. This is seen most clearly in the cloister. Its south wing, next to the church, is several yards higher than the north wing opposite. The different levels are offset in the east and west wings by steps on the floor and in the arcaded galleries. The cloister, moreover, is not a square—as would have been taken for granted under normal conditions—but an irregular, oblique-angled, distorted trapezoid. Its east wing is the longest, at 121 feet (37 m).

All four wings have barrel vaults, which call for strong abutments. Therefore the walls of the galleries are enormously thick, five feet (1.5 m) across, much like

OPPOSITE PAGE:
Nave of the church, facing east, Le Thoronet

BELOW:
Right side aisle of the church, facing east

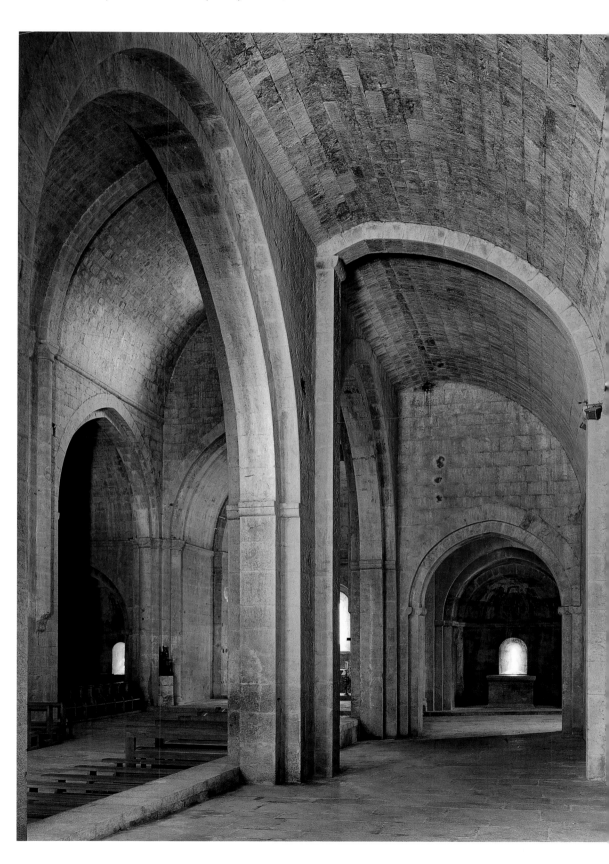

the massive forms of ancient Roman architecture, which could still be seen in many places in Provence. In each of the wide jambs of the openings a pair of arches was placed, with a short, stocky central column and an oculus in the arch bay. Numerous variants of this widespread motif would later be used in other buildings—for example, the cloister of Noirlac (see pp. 171–73)—ever more developed and refined, until the advent of Gothic tracery. At Le Thoronet one encounters the *Ur-*form, whose bulky power, paired with primitive simplicity, has something archaic to it. The hexagonal, heavily restored well house, with a basin that was reconstructed on the basis of findings, has a similar archaic effect. The dome's negative groins have box ribs resting on consoles. There are also ribbed vaults in the northeast and northwest corners, where the cloister bends. The ribs make it clear that this architecture is by no means as old as it seems. Given the time of its construction, from about 1175 onward, when the early Gothic had long since dominated elsewhere in France, it is remarkably old-fashioned, but no less impressive.

Of the adjacent buildings the east wing, with its chapter house, and the west wing, with the storerooms, have survived. The chapter house is, as is often the case, the most elaborate of all the rooms: a two-nave hall with two thick, short columns and cross rib vaults whose cross sections are shaped like pointed bulges. The stepped stone benches around the room are reproductions. The room opens onto the cloister, which is several steps higher, through tripartite double-columned arcades that have a refined elegance in comparison to the primitive arcades of the cloister. The dormitory on the upper floor consists of short, thick walls with narrow rows of low window niches or blind niches and a slightly pointed barrel vault. The latter, in its pure, stereometric large-scale form, completely determines the effect of the space, giving it a somewhat monumental feel. The same barrel vault is found in the conversi wing, which is only partly preserved. Its structure is slightly offset relative to the wing with the storerooms, and it once had arches that spanned the river, probably to house the latrines. The refectory on the north side of the cloister was reconstructed in 1992–94. Like most of the other rooms it once had barrel vaults and does not seem to have been very ambitious.

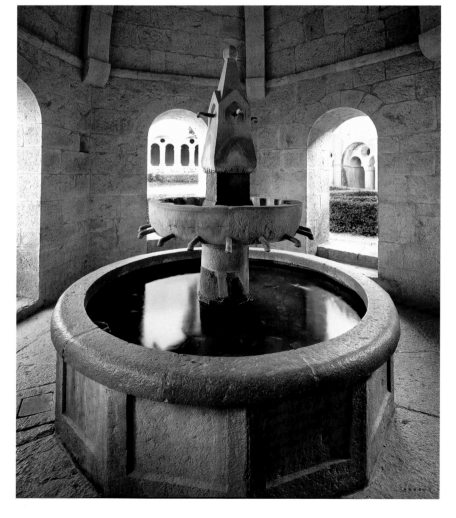

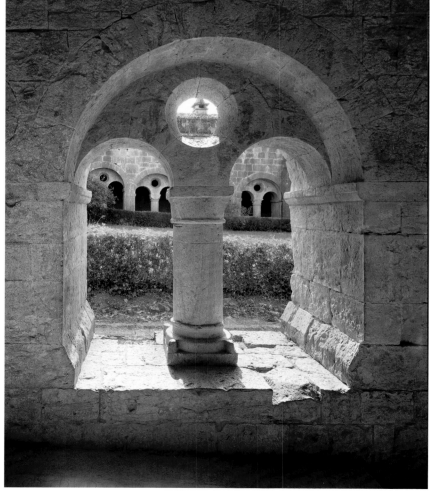

SILVACANE

SILVACANE IS THE SECOND OF THE "PROVENÇAL sisters" to be founded, after Le Thoronet but before Sénanque. The abbey lies twelve miles north of Aix-en-Provence, near the left bank of the Durance, on a terrain that was once swampland. The name Silvacane points to this, as it derives from the Latin *silva cannarum* (forest of reeds). The first convention, under Abbot Otto, who was the half-brother of the first Hohenstaufen king, Conrad III, had come all the way from the northern French primary abbey of Morimond. Initially, it seems, the monks settled further down in the valley, on a property belonging to the Saint-Victor-de-Marseille monastery, moving to their present location in 1144. Remains of a wall beneath the west wall of the cloister indicates that there must have been existing buildings, probably belonging to hermits. Raymond des Baux, seigneur de Berre, who provided the lands, is considered the monastery's founder. There were other donors, however, like Raymond Bérenguer, count of Provence, who was the founder's brother-in-law, and Guillaume de La Roque and the chapter of the cathedral of Aix. Beginning in the 1150s other noble families contributed donations as well: Lambesc, Cadenet, and Lauris. Many of the donors were buried in the monks' cemetery, which was a great distinction; the founder was even buried in the church, in 1181; such burials were permitted only after 1157. The convention grew gradually, so that Silvacane was able to establish the daughter monastery Valsainte, near Apt, in 1188; it was the only lasting filiation from a Cistercian monastery in Provence.

In 1289 the powerful Benedictine abbey Montmajour, near Arles, tried to annex Silvacane, and it went so far as to take the monks prisoner, but the king reinstated the status quo in 1291. Around 1420 Abbot Antoine de Boniface, who had a new refectory built, presided over an upturn, but by 1443, with just two monks resident there, the abbey was placed under the cathedral chapter of Aix. That was the end of its independence. In 1846 the buildings were sold to the state to save them from a scheduled demolition.

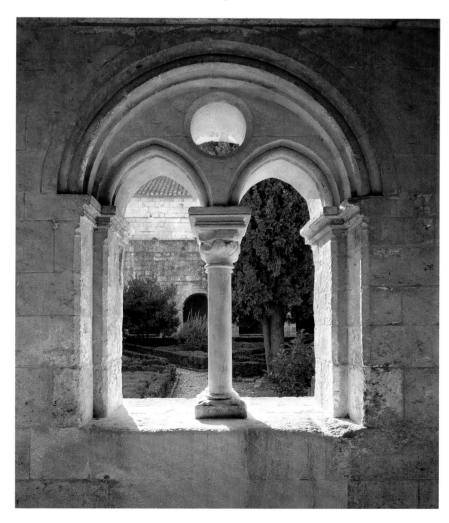

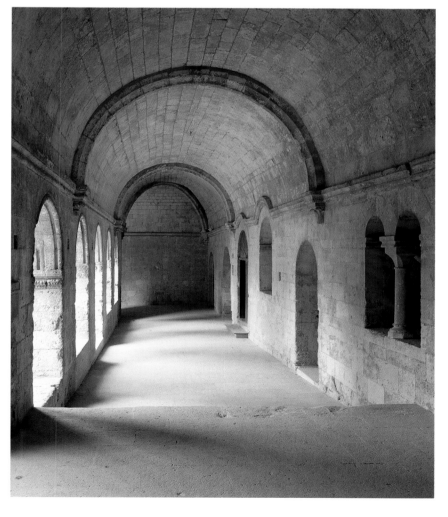

BELOW:
West facade of the church, Silvacane

OPPOSITE PAGE, TOP:
Interior of the church, facing east

BOTTOM:
Monks' hall

The construction of the present church was not begun until 1175, three decades after the founding of the monastery, and was completed in 1230. At a length of 128 feet (39 m) and a width of 95 feet (29 m) at the transept, it is very small, about the size of its sister churches. The transept, sanctuary, and chapels are arranged according to the Bernardinian plan, although here the barrel vaults of the transept arms are equal in height to the nave. The

Of the monastery buildings the cloister, like those of its sister abbeys, has barrel vaults. On the side facing the courtyard its galleries consist of arcades of thick piers with deep jambs. The fillings they once had are gone; only in one place have they been reconstructed—namely, as a two-part arcade with an oculus in the arch bay—a form that represents a more Gothic reconception of the *Ur*-form found in Le Thoronet.

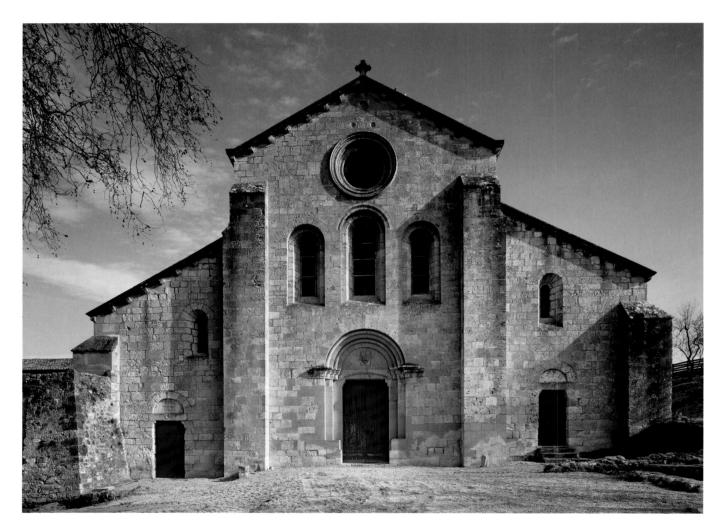

sanctuary, which, like the chapels, has a flat termination, is only a little lower. The main block has a system of vaults similar to that of its sister churches: a pointed vault with arch ribs in the nave and rampant barrel vaults, capped on the inside, as abutments in the side aisles. Cruciform piers with round projections are characteristic of the construction. The projections facing the nave rest on corbels with several steps and rounded edges—a form that is the trademark of this church. Here too the stones are worked with great precision. The western facade, articulated by pier buttresses and containing a group of windows with an oculus similar to that in the eastern wall of the sanctuary, is a typical Cistercian design; it demonstrates exemplarily the slightly terraced cross section of the church and is simple and plain.

The surviving monastic rooms are the chapter house, the monks' hall, and the dormitory (which has been divided into separate rooms), which, as in the sister abbeys, has a pointed vault. Here too the chapter house has cross rib vaults above two pillars. One of the latter has round shafts on the four edges, while the other is a spiral form, an innovative feature. The monks' hall, which also served as a calefactory, as the chimney reveals, is the usual two-nave, rib-vaulted hall; it is distinguished above all by the walls, which have a perfect system of projections using three engaged pillars. Here the Romanesque is finally liberated from the Gothic.

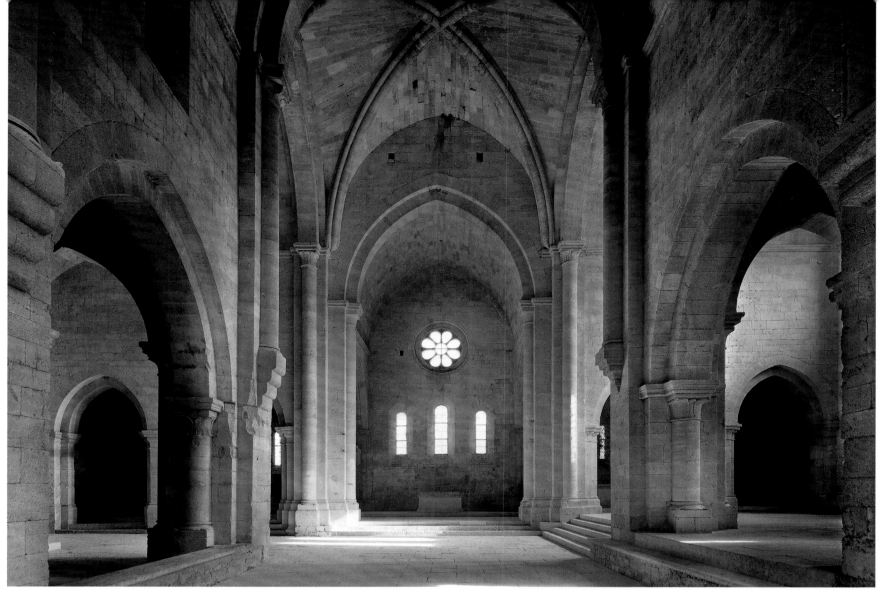

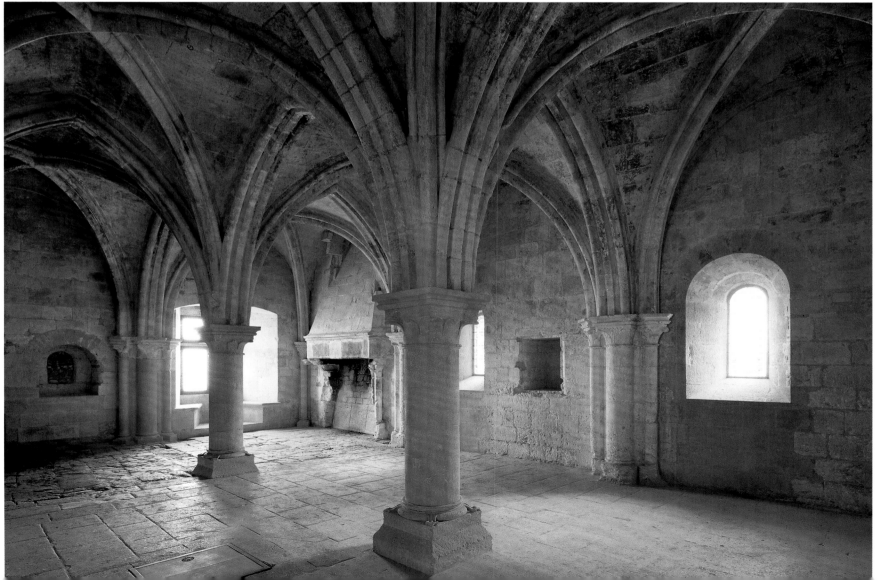

PARAY-LE-MONIAL

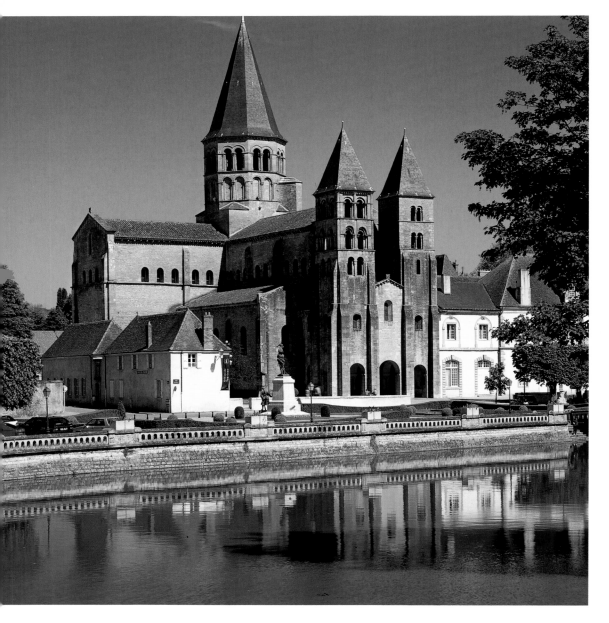

Church from the northwest, Paray-le-Monial

OPPOSITE PAGE:
View of the nave, facing east

worked two miracles in Paray. Abbot Hugh died in 1109, but it seems the church was begun shortly after that.

Paray-le-Monial, which was only a priory in the Middle Ages, seems to have achieved a high status in the Catholic religious and pilgrimage system only in the modern period, after the nun Marguerite-Marie Alacoque, in mystic contemplation, had several visions in the Couvent de la Visitation between 1671 and 1689 in which Christ pointed to his heart. The cult of the Sacred Heart of Jesus set out from there, reaching its height after the war of 1870–71, as visible above all in the Sacre-Cœur church on Montmartre in Paris. In 1875 Pope Pius IX raised the church of Paray-le-Monial to the rank of basilica of the Sacre-Cœur.

Projecting from the main block in the west is a small church with two towers, consisting of a three-nave narthex with two open round arch gates and an upper church with a barrel vault. This section of the building is clearly narrower than the main block and much shorter, so that the two towers are only slightly taller than the nave. The whole narthex is clearly part of an earlier conception for the structure that was based on smaller dimensions. The more richly articulated north tower is visibly of more recent date than the plainer south tower. The main church that adjoins the narthex to the east is strikingly small in comparison to Cluny III: its interior is just 148 feet (45 m) long from the western wall to the chancel apse, but the height of the vault reaches 72 feet (22 m). The structure is thus half as tall as it is long, which makes the spatial relationships seem even steeper. The conception for the church is based on an especially richly elaborated east end with a projecting transept, a three-nave ambulatory chancel, and three broadly projecting radial chapels that terminate in apses. Originally each of the two transverse arms had a semicircular apse as well. The southern one has been replaced by a late Gothic apse. The external appearance became very influential: a structure of staggered heights from the low chapels by way of the higher ambulatory up to the wreath of windows and the cornice of the main apse, which rises again to the chancel and the transept, finally culminating in the octagonal crossing tower, which looms above the whole and concentrates around the center. The eastern prospect of Cluny must be imagined as having been similar, but much larger and richer, which occasioned the Cluny scholar Conant's oft-cited bon mot that Paray-le-Monial was the "pocket edition" of Cluny. The structure of the pointed vaults and arch ribs of the interior also repeats the design of the mother church. Facing the ambulatory the main apse

THE TINY TOWN OF PARAY-LE-MONIAL LIES IN southern Burgundy, on the small Bourbince River, about thirty miles west of Cluny. The counts of Chalon founded a monastery here in 973, dedicated to the Virgin and John the Baptist, and in 999 they presented it to Cluny as a priory. No dates are known for the construction of the present church. Its close relationship to Cluny III, which was begun in 1088 under Hugh of Cluny, has frequently led to Paray-le-Monial's being attributed to Hugh's initiative, especially since he was related to the founding family and is said to have

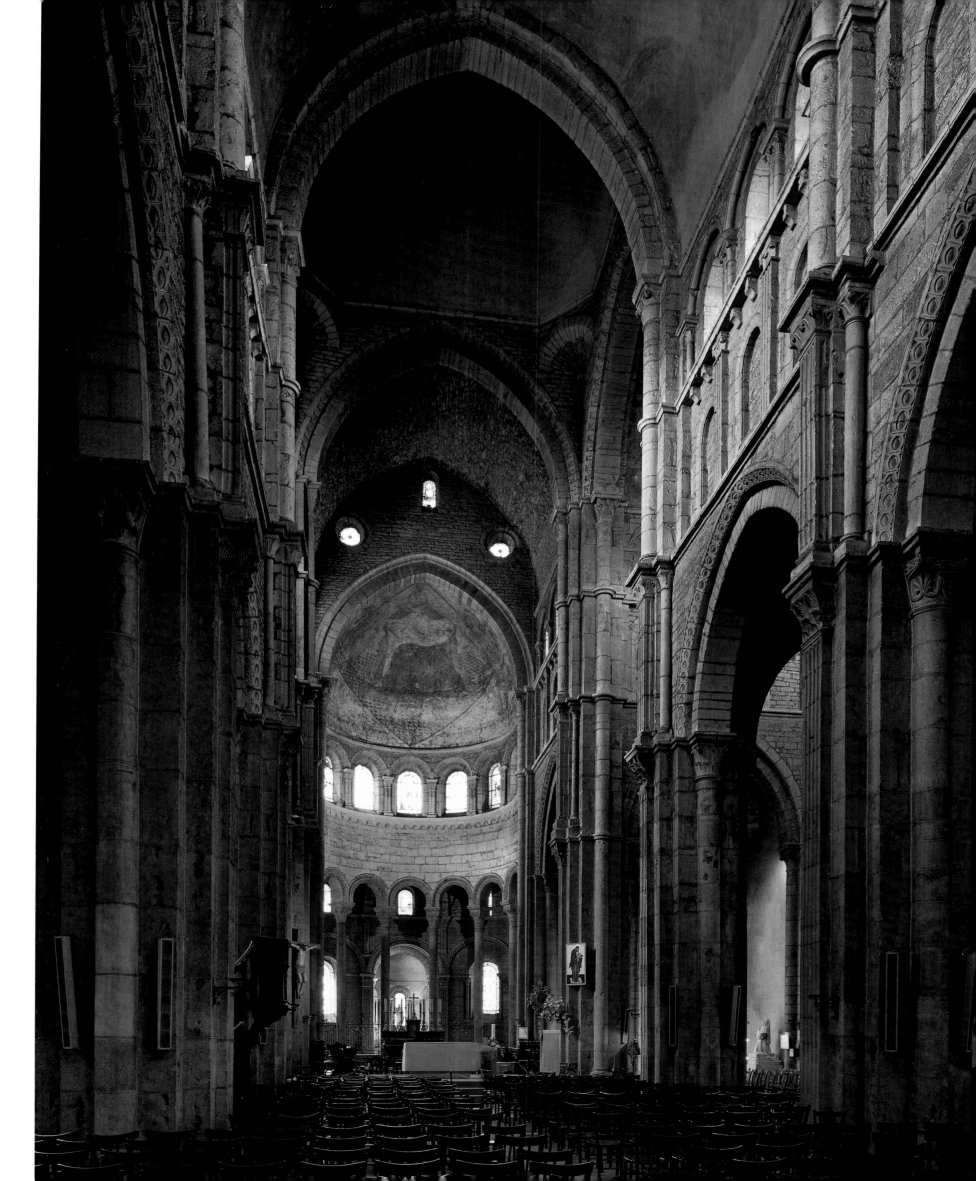

has a wreath of arcades with similarly tall columns, whose slenderness makes them seem fragile. The walls of the chancel, the transept, and the nave show the same three-story construction with virtually the same proportions: the nave arcades have pointed arches and are slightly more than half the total height of the room, whereas the triforia and clerestory are very short and subdivided into three sections. The mural relief, with several registers, is also influenced by Cluny, as is the magnificent elaboration expressed in the alternation of semicircular projections and fluted ancient pilasters. The resemblance to the mother church is expressed clearly by the narrowness and steepness of the space. Thus the small collegiate church Paray-le-Monial is now the most faithful architectural testimony to the ambition of Cluny when it was a world power.

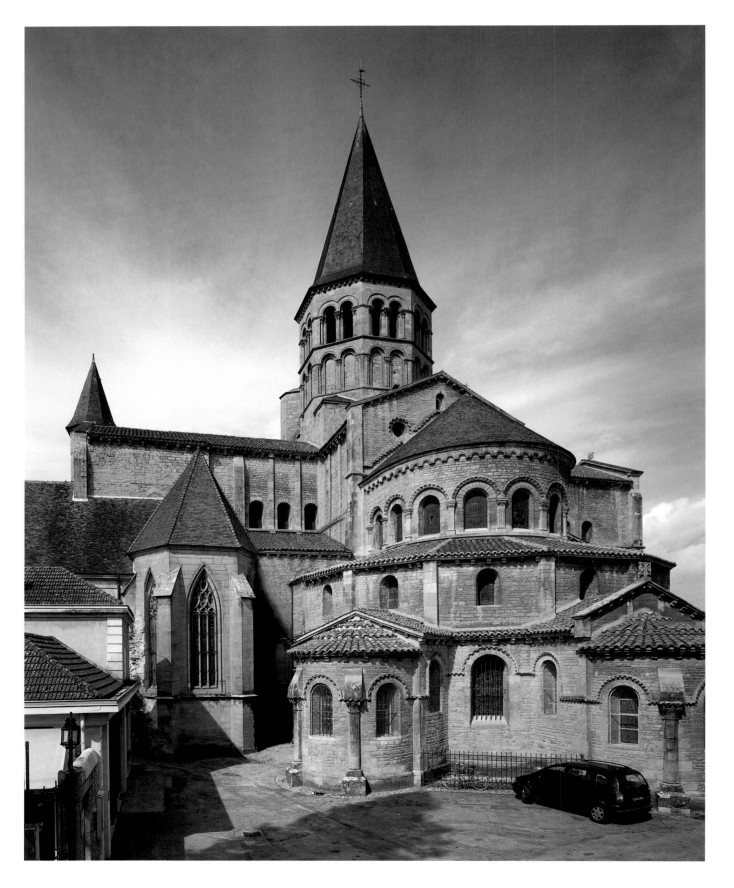

THE FORMER BENEDICTINE ABBEY CONQUES, now one of the favorite destinations in France for artistically minded tourists, is surrounded by a small medieval city in a remote landscape on a mountain slope that lies to the southwest of the central massif. Toward the end of the eighth century the hermit Dadon or Datus took up residence here near a small chapel and founded a monastic community in honor of the Savior. Louis the Pious visited the monastery, and by decree in 819 made it a royal abbey and placed it under the Benedictine rule. In 838, at the initiative of King Pépin of Aquitaine, Conques founded the daughter monastery Figeac, which then spent more than two centuries using every available means to fight for its independence, until it was finally granted at the councils of Clermont (1095) and Nîmes (1097). What Conques lacked was prominent relics, so a commando of monks tried to steal the bones of Saint Vincent in Valencia, without success. Around 863 or 883 the monks had better luck in Agen, where they stole the relics of Saint Fides (Foy) and brought them to Conques. She was the patron saint for the blind and imprisoned, and soon there were pilgrimages to her grave. The church's patron was changed accordingly, from the Savior to Fides. The place of worship was marked by a gold cult statue that shows the saint in a strictly frontal, seated posture, one of the earliest surviving cult statues of this type, dating from the late ninth or early tenth century. Conques soon flourished thanks to the stream of pilgrims heading to Santiago de Compostela. The monastery lay on one of the major routes and became an intermediate stop on the journey. In 1094 relics of Saint Fides reached Sélestat in Alsace, where a provost church was built in her honor in the twelfth century and placed under the abbey of Conques. Thus Fides also became the patron saint of Alsace.

The present-day church in Conques, which had a Carolingian predecessor that was expanded in the tenth century, was, according to the chronicle of the monastery, largely completed under Abbot Odolric ("basilicam ex maxima parte consummavit"). Odolric, who was ultimately responsible for bringing the bones of their patron saint to the new church, ruled from 1031 to 1065. Excavations of the structure have shown, however, that only the east end could have been built at that time: namely, the ambulatory chancel and its three radial chapels and the east side of the transept with two staggered chapels at each end. The ground plan of the ambulatory and the transept chapels suggest the original plan was a one-nave transept in the style of the Romanesque churches of neighboring Auvergne. What was executed, however,

CONQUES

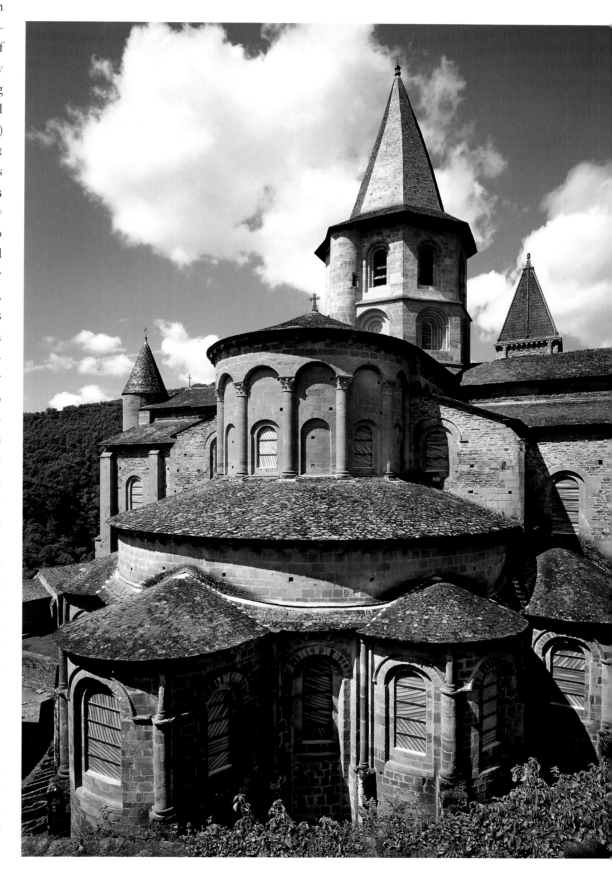

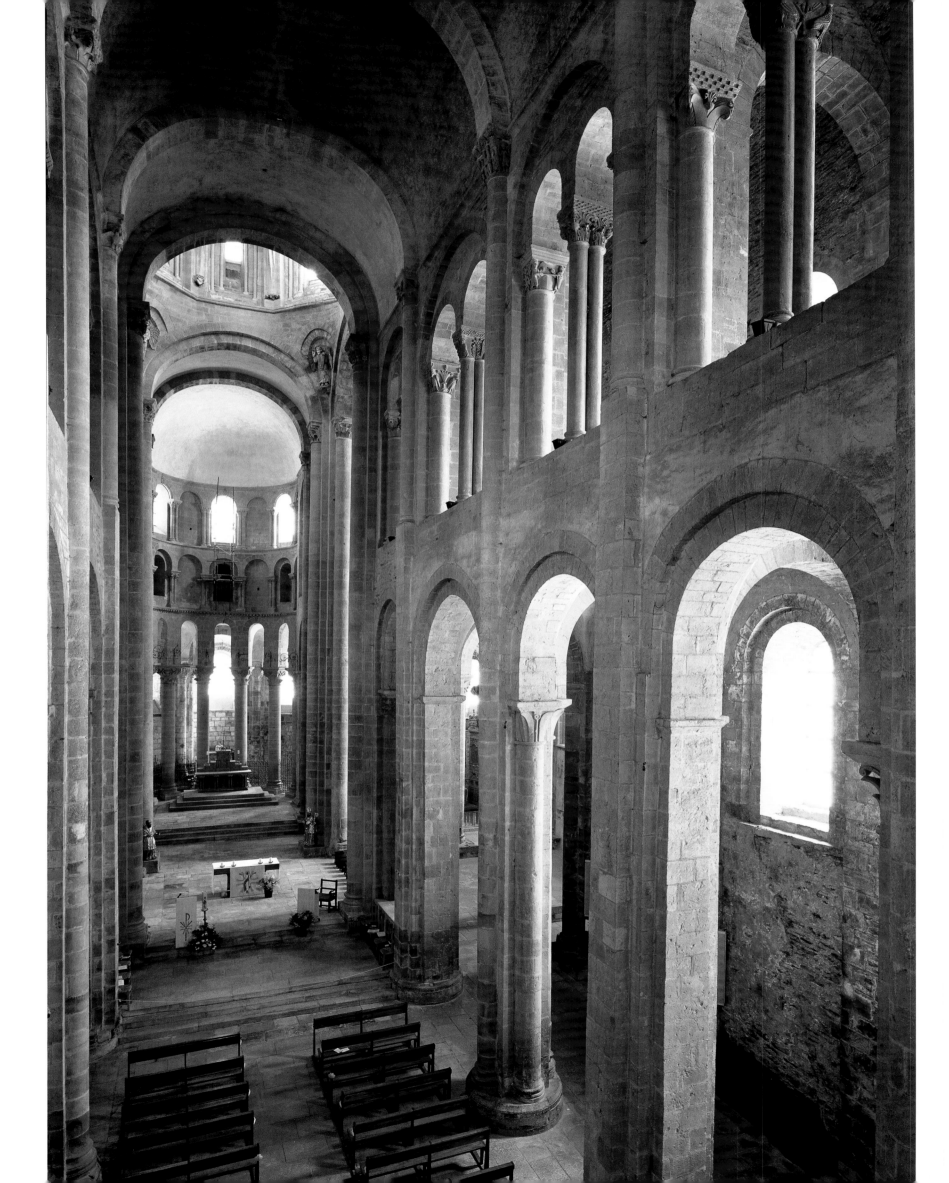

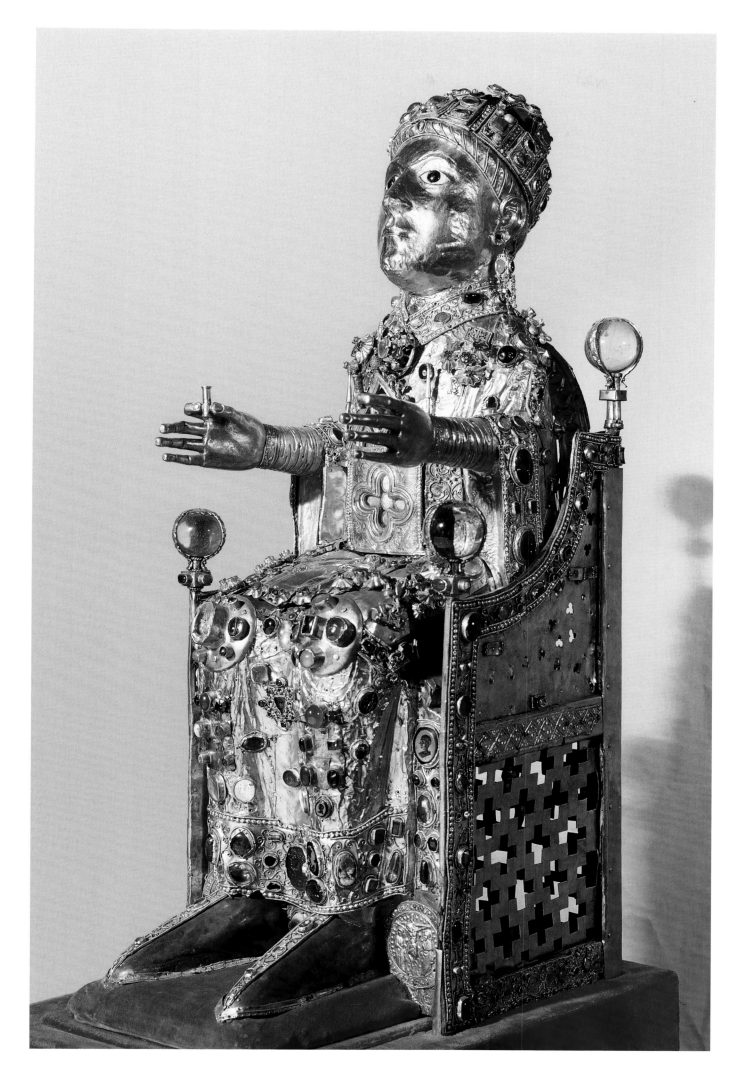

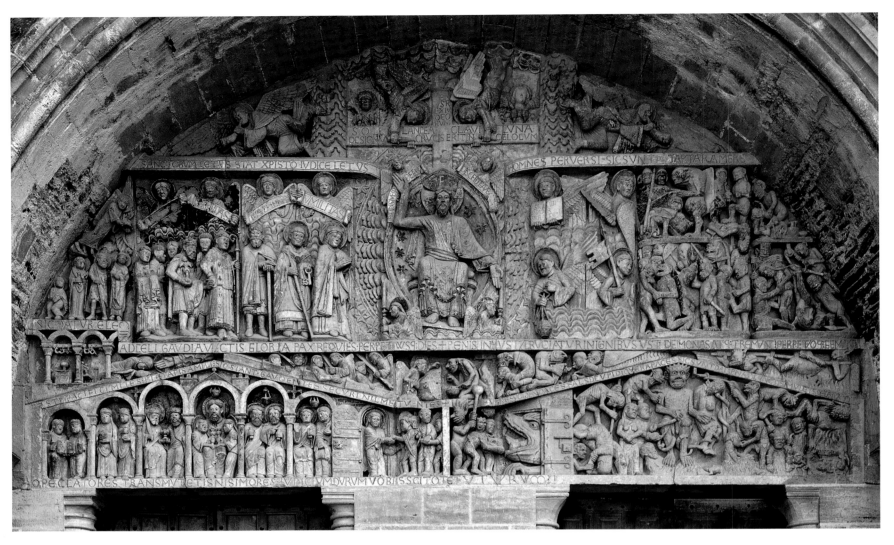

Tympanum relief with the Last Judgment, west facade, Conques

was a three-nave transept that belongs to an architectural type found along the pilgrimage route to Santiago: at Santiago, at Saint-Sernin in Toulouse (see pp. 124–26), and, before its destruction, at Saint-Martial in Limoges. The type is known as the pilgrimage church. Its structure is distinguished by the main block's having side galleries but no clerestory and the longitudinal barrel vaults of the nave being abutted by rampant half vaults in the galleries. The side aisles and galleries continue in the transepts and along the long sides of the chancel up to where the ambulatory begins; in Santiago and Toulouse it also continues in a U-shape around the facing walls of the transept. At Conques, however, there was no room for this, owing to the mountain slope, which also set limits on the length. At 184 feet (56 m) the church is only half as long as the other pilgrimage churches, but it is about the same height. This makes the space seem even steeper and more towering. Everything here is cramped and tall: the nave arcades and their strikingly thin piers, the openings in the galleries in the form of biforia with slender double columns and, not least, the octagonal crossing dome on squinches.

Conques is famous not only for its architecture but also for its sculpture, including several reliefs in the inte-

rior and numerous capitals. The major work is the large Last Judgment on the west facade. Recent stylistic analyses suggest it was probably executed before 1107, not around the middle of the twelfth century, as previously thought. The tympanum is divided into several registers by banderoles with the words of the judging Christ, in leonine verses, to the chosen and the damned. The banderoles of the jambs form two shallow gables that extend over the city of heaven on the left and hell on the right, like the roofs of two houses. The city of heaven, with its columned arcades, in which the blessed surround Abraham in pairs, is structured much like a Romanesque cloister. At far left on the gable's slope lies the patron saint, Fides, in front of the arcades, holding the iron clamps from which she has liberated the imprisoned. In hell, by contrast, the evil knight Rainon d'Aubin, under whose persecutions the monastery suffered, is falling from his horse just behind the gate. In the upper register one sees, to Christ's left, angels as allegories of virtue and the chosen, led by Mary and Peter, and on his right, angels and the damned. The apostles are not present in their role as associate judges. As so often, the depiction of hell shows an imaginative narrative pleasure, while the "good" side is ceremonial and stiff.

T HE BENEDICTINE MONASTERY VÉZELAY, WHICH lies on a mountain high above the broad, hilly Burgundian landscape, was one of Europe's great cultural centers in the Middle Ages. It evolved from a modest nunnery that had been founded at the foot of the mountain in 860 but was destroyed by the Normans in 873. It was relocated to a fortress on the mountain for protection and occupied by monks. Its

VÉZELAY

meteoric rise began around 1050, with the newly rising cult around Mary Magdalene, whose bones, according to the *Legenda aurea,* had been brought from Aix-en-Provence to Burgundy in the ninth century and were now kept in Vézelay. In no time at all Vézelay was one of Europe's most frequently visited pilgrimage sites, as well as a gathering point for pilgrims to Santiago de Compostela. In 1096 Abbot Artaud began construction of a new church to accommodate the masses of visitors. Eight years later, in 1104, the chancel and crossing could be consecrated. An interruption in construction followed when the abbot was murdered by the citizens of the town in 1106. The conflict continued for decades. The murdered abbot's successor, Renaud of Semur, began new construction of the main block in 1120. The occasion for this was a large fire in the old church that

had killed more than a thousand pilgrims. Twenty years later the main block was completed, and work on the narthex in the west was begun. In 1146, in the presence of Louis VII and his wife, Eleanor of Aquitaine, Bernard of Clairvaux called for a crusade in this new church, and in 1190 the English and French under Richard the Lionhearted and Philippe Auguste assembled here for the Third Crusade. Construction of the new early Gothic chancel had begun shortly before that, in 1085, and was completed around 1215. In the thirteenth century Vézelay's importance declined to almost nothing, when the bones of Mary Magdalene were discovered in 1270 in Provence and Pope Boniface VIII, as a favor to Charles II of Anjou, the new seigneur of Provence, declared them genuine and placed them in the custody of the Dominicans.

ABOVE:
Capitals in the main block, Vézelay

PAGE 160:
West portal and narthex

PAGE 161:
Nave, facing east

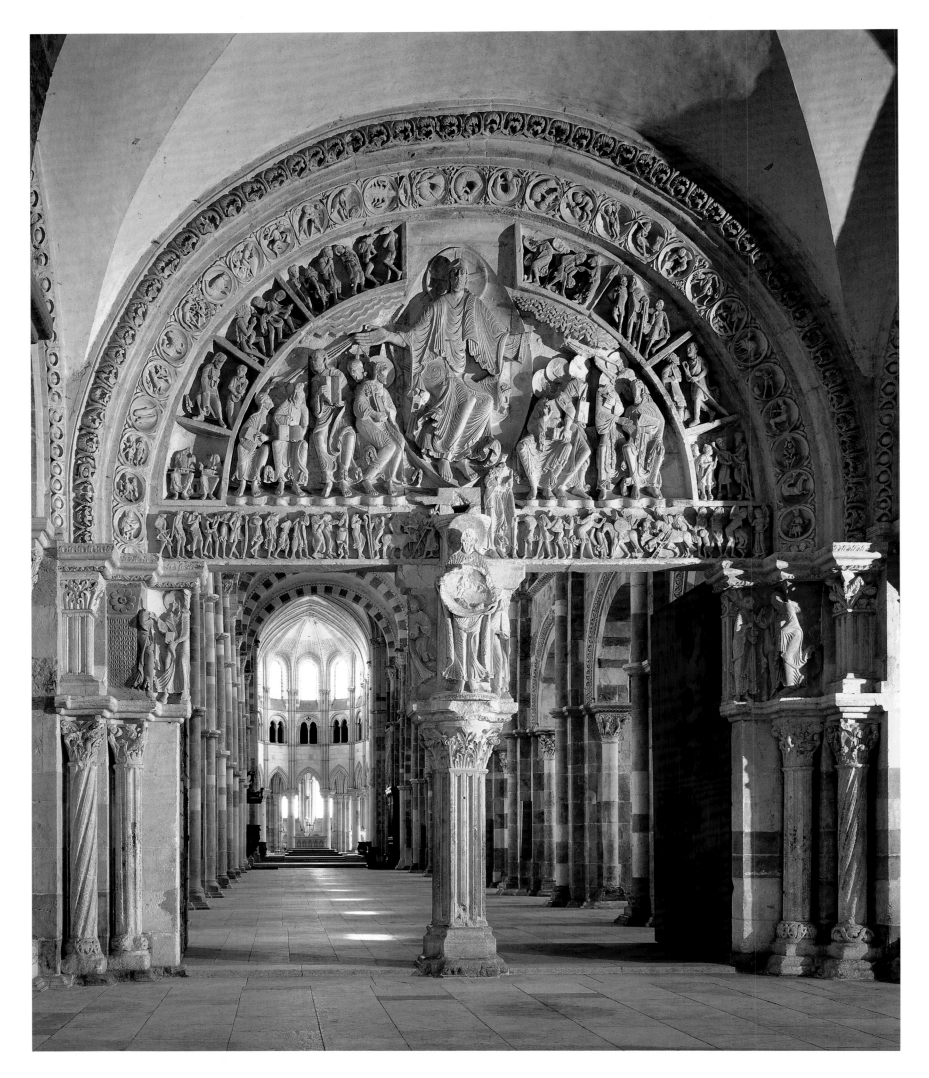

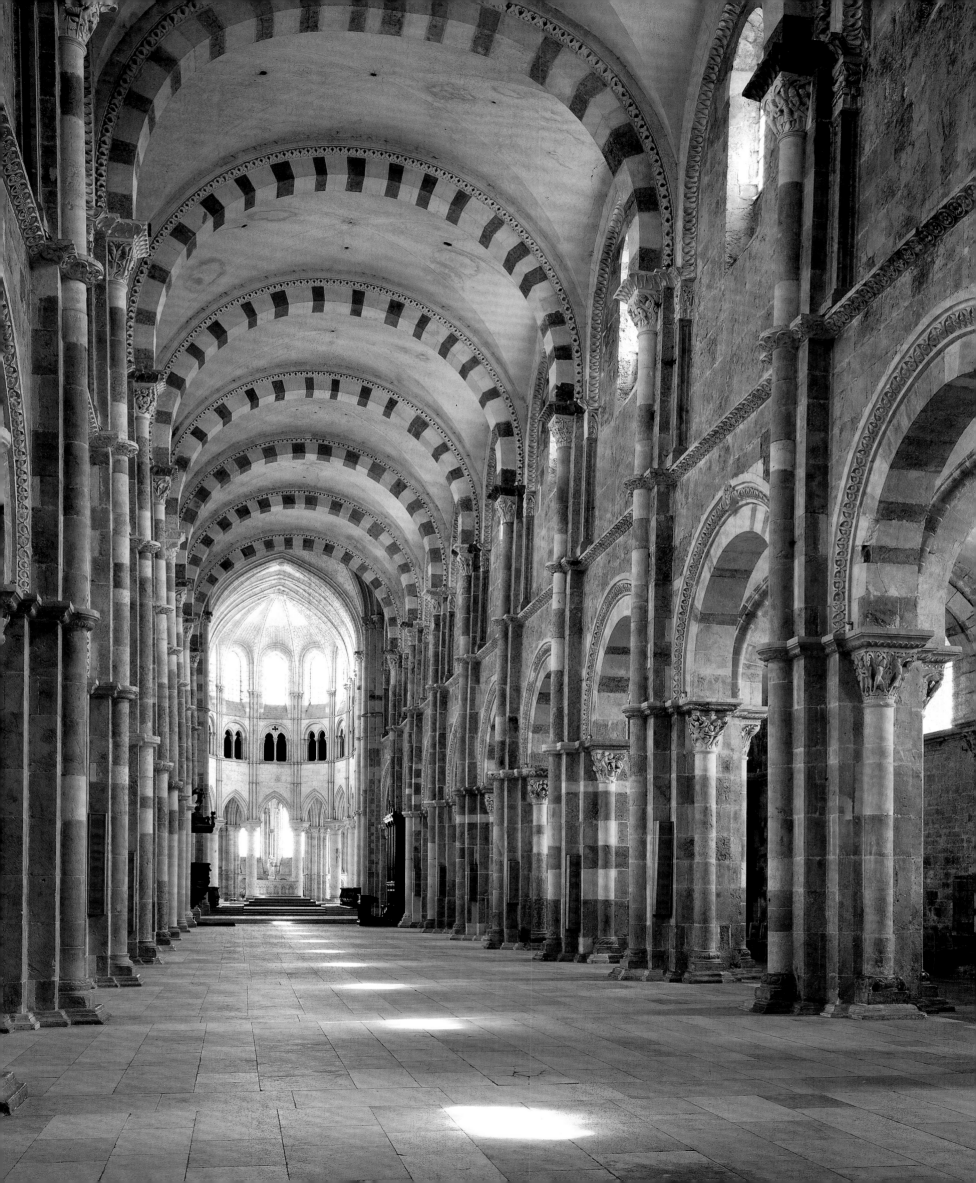

Although Vézelay belonged to the association of Cluny's order until 1162, the serene, harmoniously balanced proportions of its church are the very opposite of the narrow, exaggerated spatial canyons of Cluny III. The structure of the crosswise, rectangular bays in the nave, with their quadripartite groin vaults, rather than the longitudinal barrel vaults of Cluny, has only two stories, with a clerestory that provides sufficient light. The characteristic motif consists of arch ribs that alternate light and dark stone. Together with the projections, the bands form a sequence of large arcades that span the space, which is one of the most beautiful of the European Romanesque. The narthex has one of the greatest French figurative portals. Its focus is the tympanum, which features Christ ruling the world, just as his apostles communicate it to the peoples of the earth. The apostles are seen on the door lintel and in the coffers of the arch. The whole tympanum is an excited, visionary image of the spirit that has entered the people like the "sound from heaven" described in Acts.

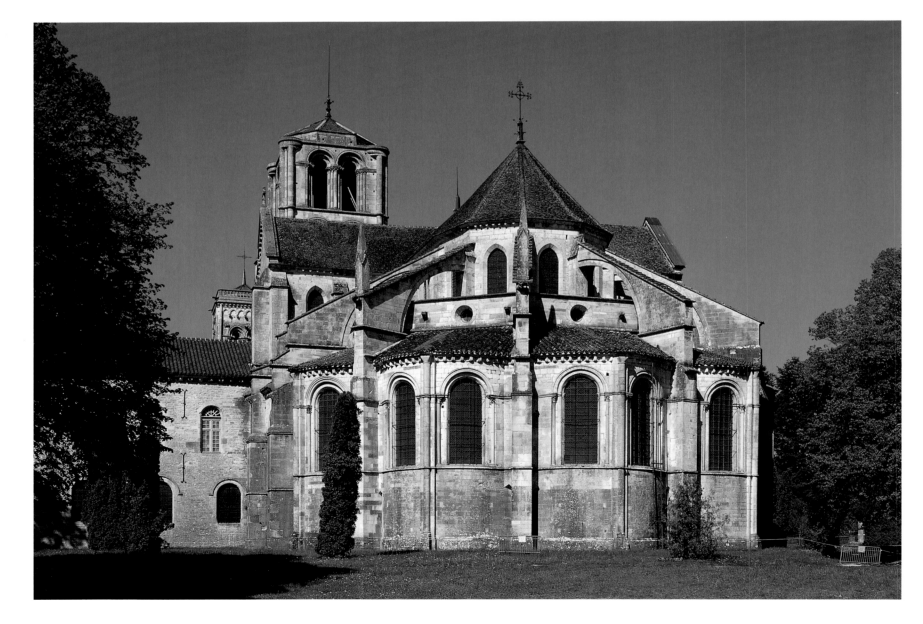

One of the Christian religious sites in Burgundy is Tournus, on the Saône River, not far from Cluny. Saint Valerian was martyred here around 177. A monastery had already been erected on the site of his grave in Merovingian times. In 875, by order of Charles the Bald, it became the home of a convention of monks who lived in the monastery Noirmoûtier, on an island off the Atlantic coast, which had to be abandoned in the face of Norman raids. The great treasure of these monks was the bones of Saint Philibert, the founder of Noirmoûtier.

In 937 the Magyars destroyed the monastery. The present church is not uniform in its overall layout or structure, and the history of its construction is equally unclear. The sources provide the skeletal framework of dates. In 979, when Abbot Étienne had Saint Valerian's bones transferred to the crypt, the east end, at least, seems to have been usable. In 1008 a fire devastated the monastery. There was a consecration in 1019, evidently for the reconstructed parts. In 1056 the southern side aisle must have been standing, as that was the year

Abbot Ardain was buried in the wing of the cloister that adjoins that aisle. Another consecration is known to have taken place in 1120.

The phase of construction after the fire of 1008 must have included the narthex in the west, which is bricked up with small, roughly squared quarry stone, and the exterior is articulated in the Lombard style with pilaster strips and arched moldings. It is a three-nave, two-story construction with a two-tower facade that is one of the oldest of its kind. The northern tower was built up in the late Romanesque period. The interior is an experiment in the art of vaulting, which was again beginning to be

BELOW:
Tournus, the church seen from the south

PAGE 164:
Tournus. TOP: *West end, upper church;*
BOTTOM: *West end, lower church*

PAGE 165:
Nave, facing east

TOURNUS

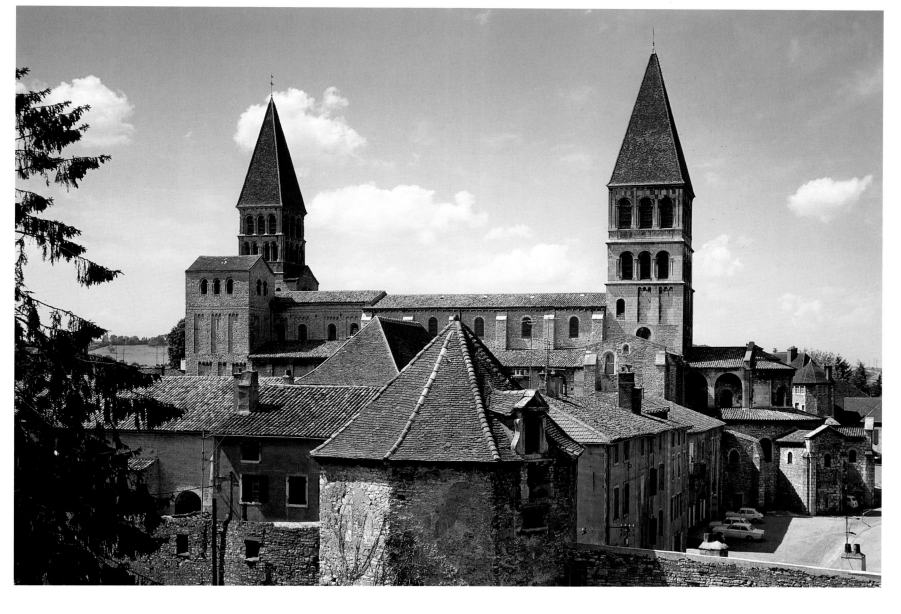

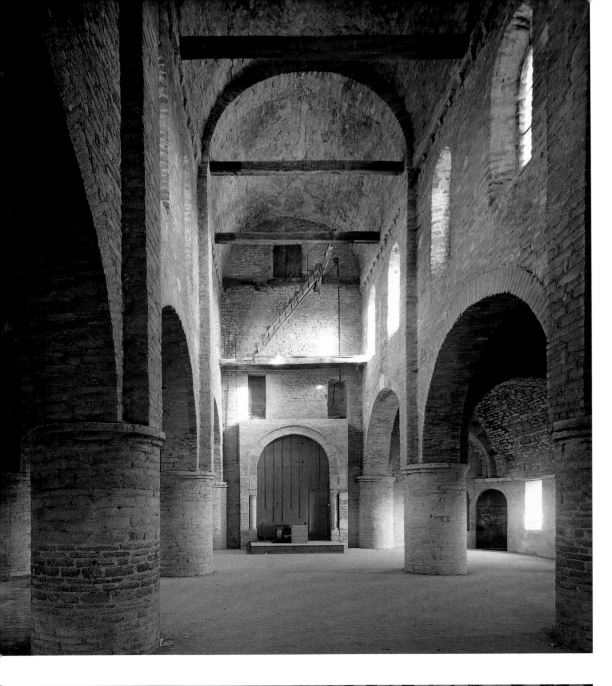

understood. In the lower church, which is low and has stocky, round piers, the nave has quadripartite groin vaults, and each compartment in the side aisles has a transverse vault of equal height. The upper church is laid out like a basilica. The nave has a clerestory and longitudinal vaults with bands, whereas the very low side aisles have rampant half vaults of ill-defined form. They are not sufficient abutment for the vault of the nave, because they are too low, which is why wooden tension members have been added in the nave for stability. The main block, which is considerably wider than the narthex, seems to have been built soon after it. The colossal piers are towering cylinders of small stones—like those of a hall church. The side aisles have quadripartite groin vaults of equal height—a common form. For the nave, however, a new vault construction was invented: transverse vaults were placed, bay by bay, on powerful, stepped diaphragm arches that cross the space. These vaults had two advantages: first, they permitted clerestory windows; second, as is the case with a bridge across a river, each side relieved the horizontal shearing force of the other. Hence only the lateral thrust of the diaphragm arches needed to be abutted. In terms of statics, this original construction was preferable to a longitudinal vault, but it was not imitated, except in the church at Mont-Saint-Vincent. This is probably because the monumental unified form of a longitudinal vault was considered more desirable in terms of aesthetics. Excavation evidence shows that the nave originally had a flat roof and was vaulted only later.

The history of the construction of the east end is particularly problematic. Though heavily restored, its current state—with an ambulatory chancel, longitudinal rectangular radial chapels, transept, octagonal crossing dome, and a tall crossing tower—can probably be associated with the consecration in 1120. The crypt, however, conceals masonry that is clearly older. It is a three-nave hall crypt with tall columns and cast quadripartite groin vaults with no bands, on which the marks from the boards used as forms are still visible. Outside the crypt, separated by thick walls, there is an ambulatory with radial chapels. The crypt determined the ground plan and type of the chancel above it. The original form of the crypt, which has been repaired and modernized several times, might date back to 979, making it the oldest example of an ambulatory chancel with radial chapels—that is, for a chancel type that would characterize French architecture of the Middle Ages right through to the Gothic cathedrals. It is more probable, however, that it was laid out after the fire of 1008.

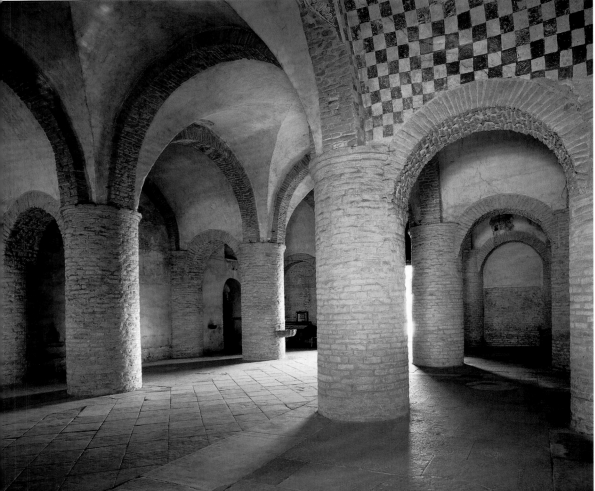

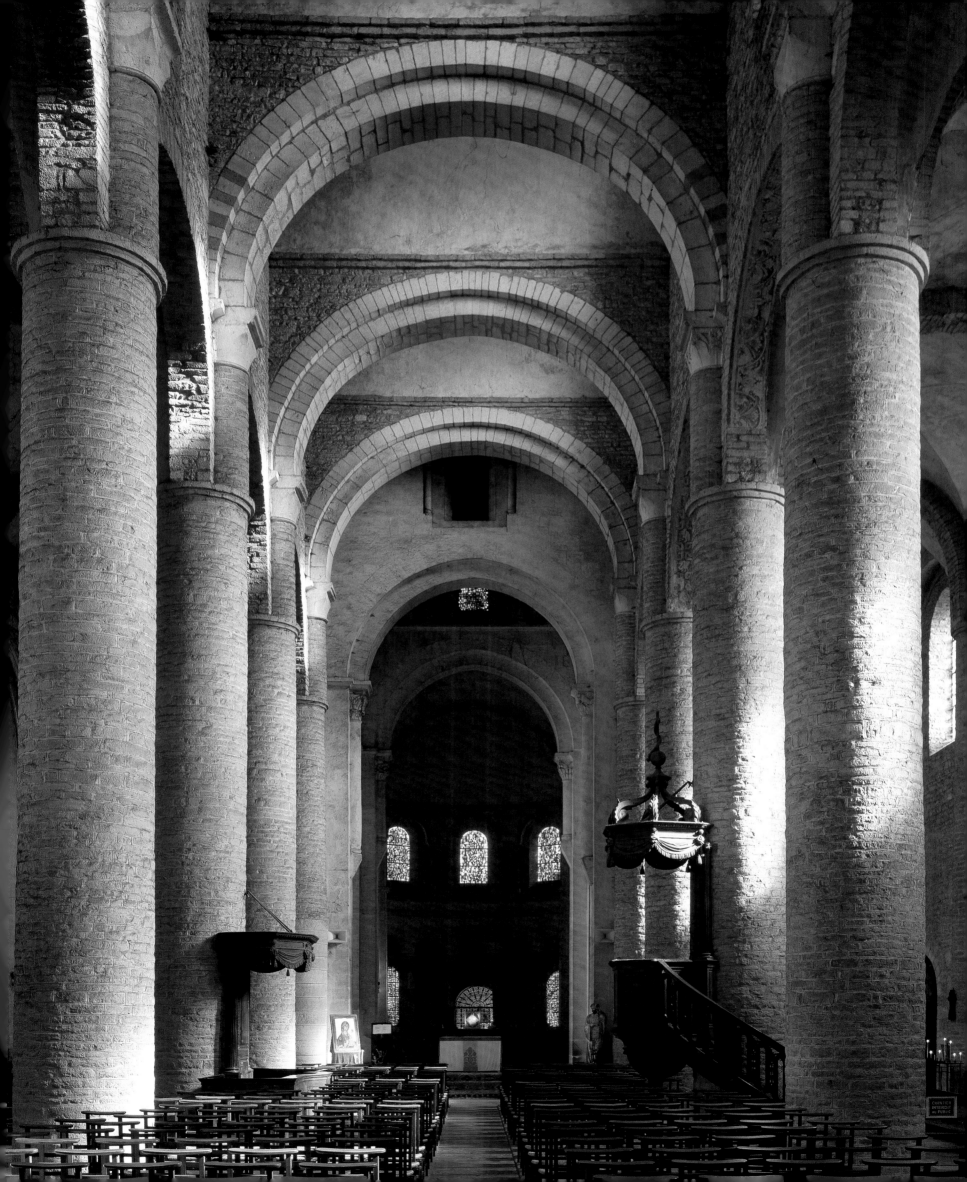

FONTENAY

TOP RIGHT:
Fontenay, west facade of the church

BOTTOM LEFT: *Church from the
southeast;* BOTTOM RIGHT:
Monastery forge

OPPOSITE PAGE:
Southeast corner of cloister

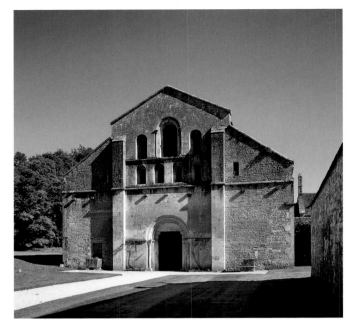

THE FORMER CISTERCIAN MONASTERY FONTENAY, located in Burgundy between Montbard and Châtillon-sur-Sein, still represents the ideal image of a Cistercian monastery of the early period: in a remote valley in the middle of large forests. The monastery was Clairvaux's second filiation. Bernard himself devoted much care to it, and he placed its direction in the hands of relatives. In 1118 or 1119 he founded this settlement on the site of a hermitage that had been provided by the Molesme monastery. Bernard's uncle Raynard de Montbard donated the surrounding lands that made it habitable. Bernard appointed another uncle, Godefroy de Rochetaillee, to be its first abbot. When Godefroy gave up his office in 1132 to become bishop of Langres, Bernard's nephew Guillaume de Spiriaco succeeded him. In 1130 rising membership necessitated that the monastery be moved to its present site, which was more favorably located. The church appears to have been begun soon thereafter. It was a stroke of luck for the construction work that in 1145 the bishop of Norwich, Everard of Arundel, withdrew to Fontenay and used his money to help finance the construction of a church. He died there a year later. Pope Eugenius III, who had been a monk at Clairvaux and was

Bernard's pupil, performed a consecration in 1147 when he passed through on his way to Auxerre from the general chapter in Cîteaux. As is often the case with consecrations that took place when a pope was passing through, it is not clear whether the church was finished at the time. In the following periods it was the burial site for many Burgundian noble families, including that of the ducal house. The abbey was an economic power in Burgundy. Its granges produced wool fabrics, and iron goods were produced in the monastery itself.

In 1359, during the Hundred Years' War, Fontenay was plundered by the English, but they left the buildings standing. When it became a monastery *in commendam* in 1557, the refectory gradually fell into disrepair; a residential building now stands in its place. The conversi wing has disappeared entirely. That the other wings, the cloister, and the church survived closure is thanks to

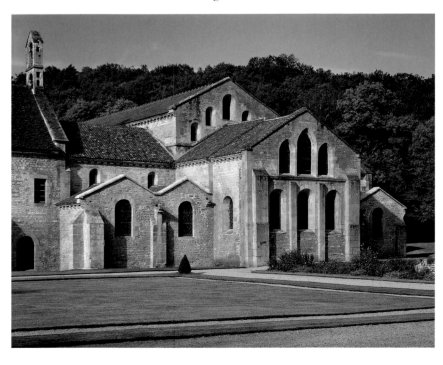

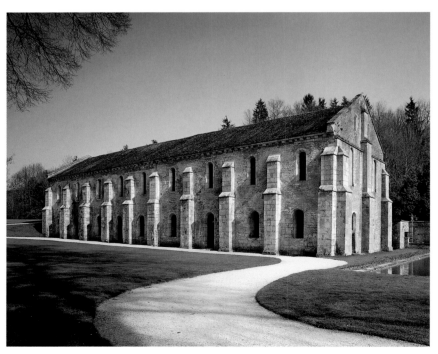

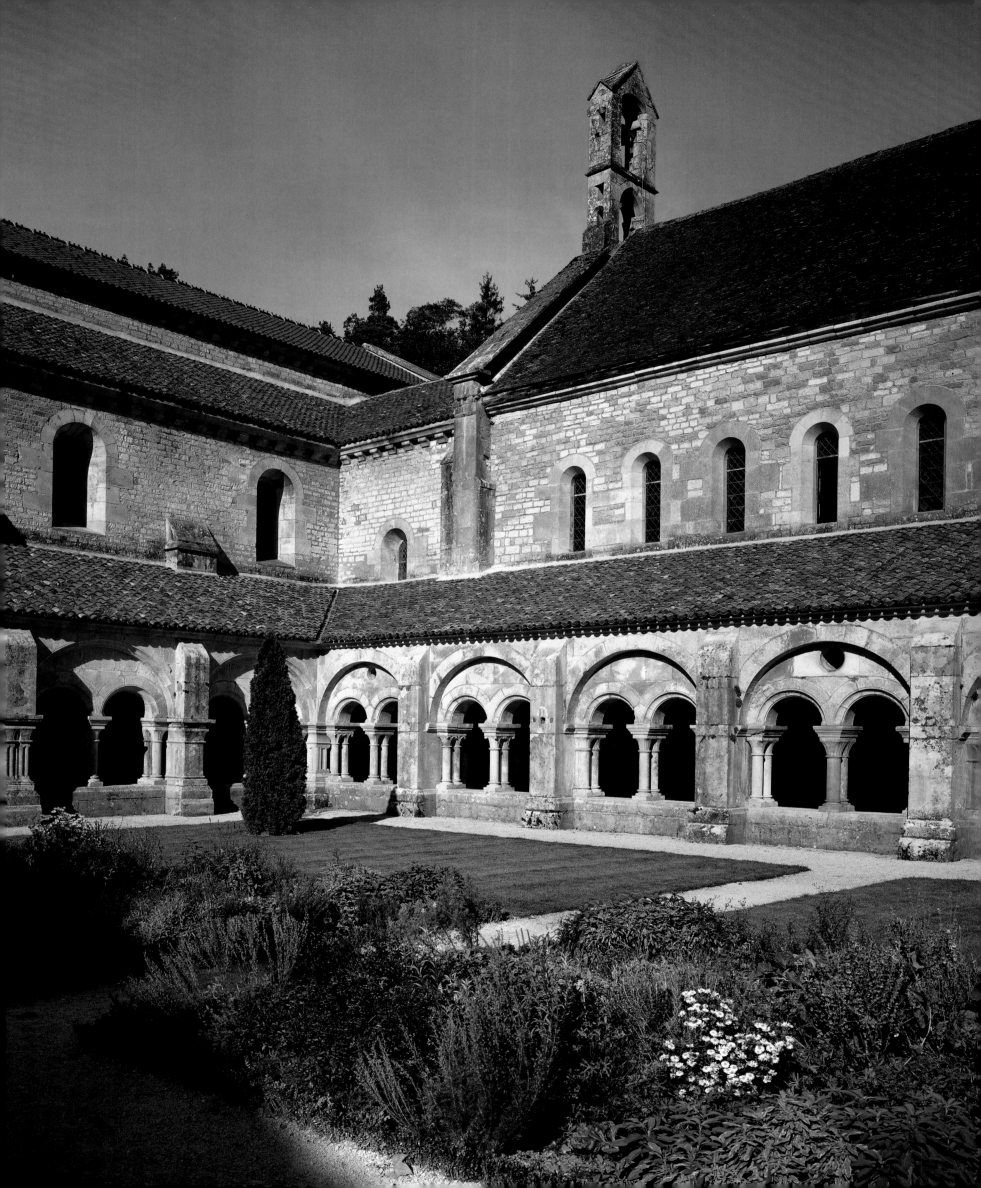

the owners, who did not use the building as a quarry, as was usually the case, but as a paper factory. Their descendants in the twentieth century have painstakingly restored the site. Today Fontenay is on UNESCO's World Heritage List and is one of the most popular destinations for tourists in Burgundy.

Fontenay is the best surviving example of early Cistercian church architecture. The eastern structure is laid out according to the Bernardinian plan, with a box-like sanctuary and two transept chapels with flat terminations on either side. The sanctuary and the transept are clearly lower than the nave. There is no distinctive crossing: the nave runs through to the sanctuary. It has a pointed vault with underlying arch ribs that spring from vault shafts. The nave arcades, whose pointed vaults are terraced, reach up almost to the baseline of

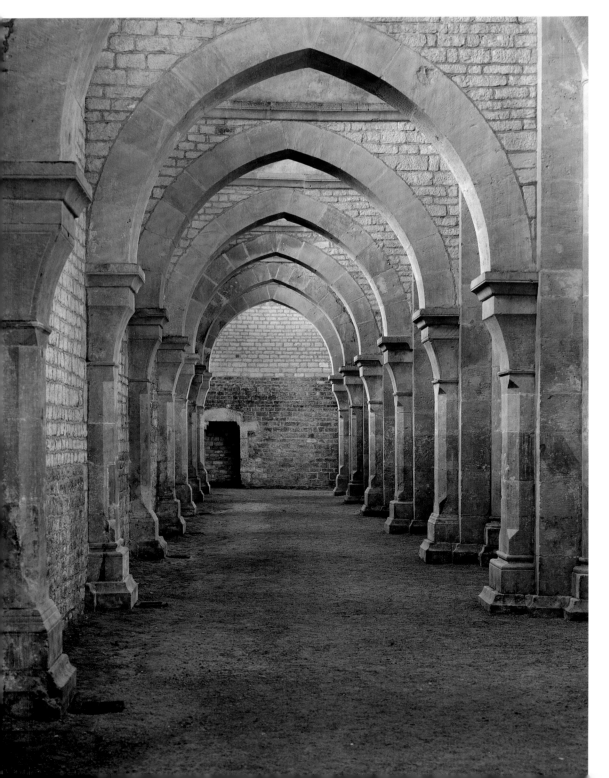

the vault. A stretch of wall remains, but there is not enough space for a windowed clerestory.

It is characteristic of the overall structure of the main block that the bays of the side aisles form a sequence, each of which has a transverse vault that stands at a right angle to the nave and connects to the nave arcade. The construction using transverse vaults provides a good abutment for the lateral thrust of the vault in the nave. The transverse walls of these bays are opened by low arches, so that looking down along the sequence of arches gives the effect of a side aisle. Because there is no clerestory in the nave, it is lighted only indirectly, by windows in the side aisles, so it remains in dim semidarkness. This gives the church's target, the group of six large windows in the east wall of the sanctuary, all the more effect: they combine optically with the five rampant windows in the wall above the arch leading into the sanctuary to form a prospect of bright planes of light. The western wall also has a group of windows; it lights the nave from behind. The beginning and end of the space of the church are thus marked by light, which has a feeling of promise for the people in the semidarkness of the nave.

The exterior, where monopitch roofs on the side establish a small step up to the low saddle roof of the nave, seems low and compressed when viewed from the east or west, especially on the facade, which reveals the cross section of the church. Compared to the towering churches of the Cluniacs, the exterior has an almost profane effect, like that of a barn, which was doubtless the intention of its builders.

Within the area of the enclosure, it is the northeast corner of the cloister in particular—towered over by the church and the dormitory—that gives a sense of monastic isolation. All four wings of the cloister are preserved; only the well house, which was once a quadratic structure, is missing. The arcaded galleries consist of thick piers—the ones at the four corners are truly massive—and two-part arcades with relieving arches and powerful, low pairs of columns. Columns of the same cross section also project from the piers. The overall impression is of a stocky solidity, which is reinforced by the projecting pier buttresses. The construction had to be so stocky and solid, at the cost of the elegance that distinguishes other cloisters, because the covered walks were vaulted, specifically with longitudinal vaults that cut into the vaulting cells on the side. The monks' workroom, which has also been described as a novitiate, has a similar stockiness: a two-nave hall with short columns and rib vaults. Equally low, but more elegant

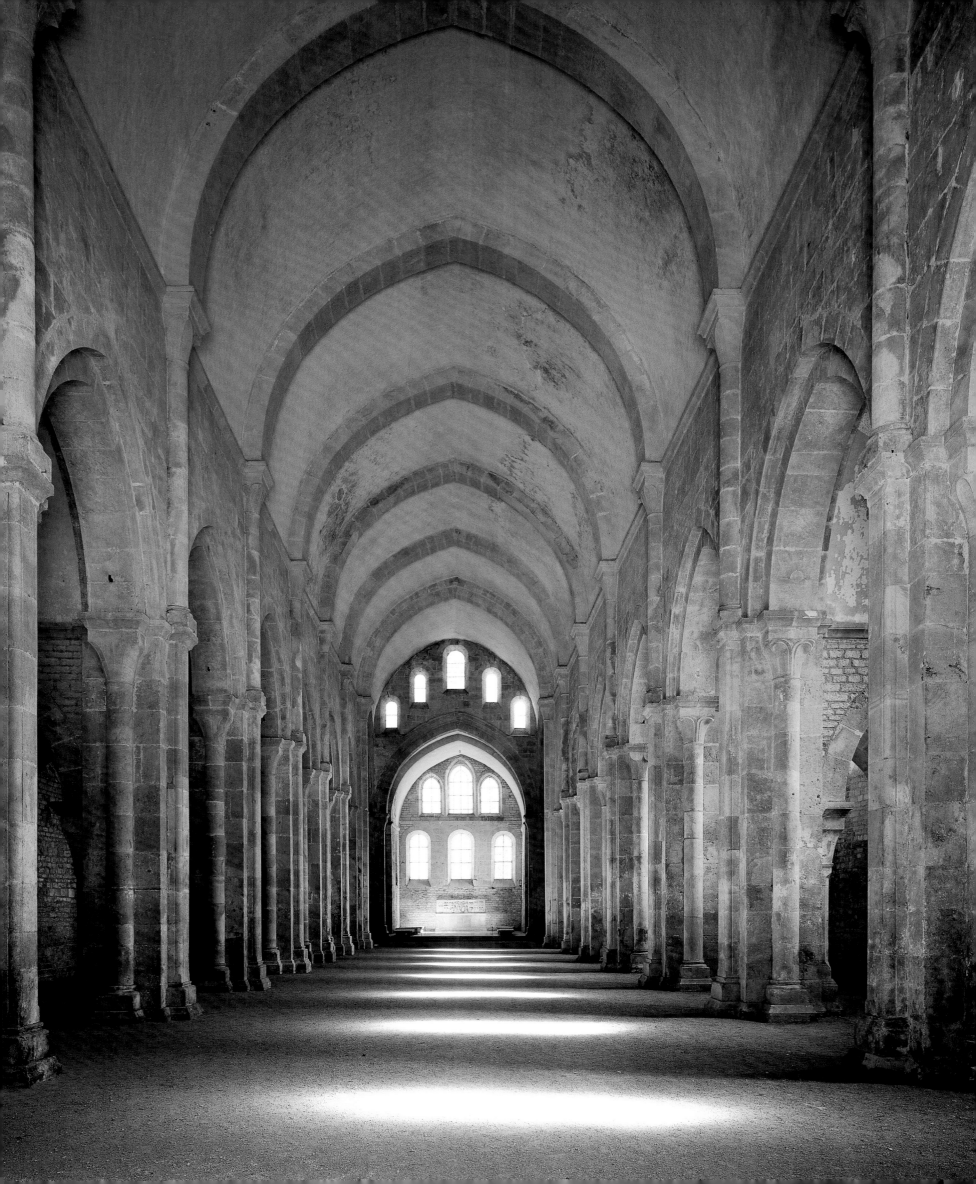

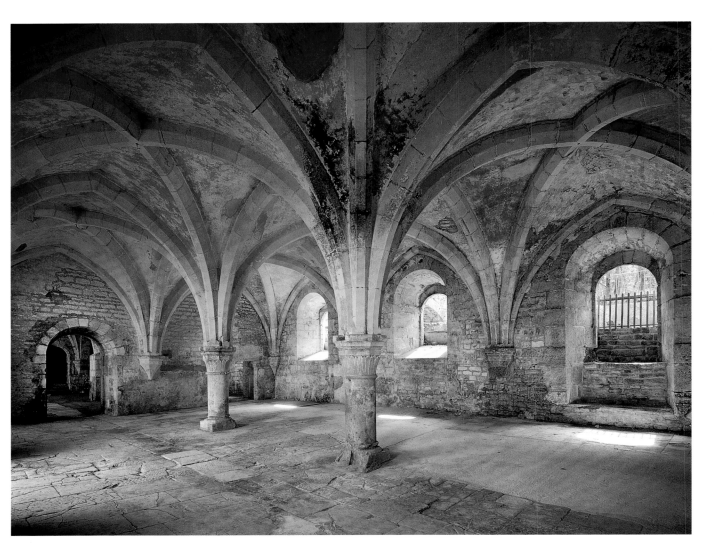

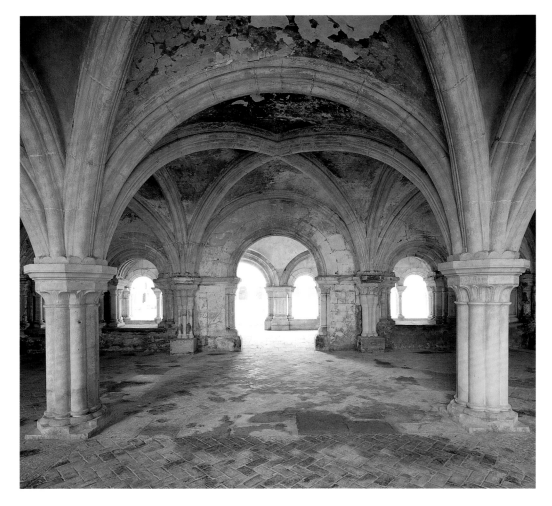

and articulated in its structure, is the chapter house from about 1150; originally it was one of the typical four-column rooms, but now only two columns remain, as the eastern section was later broken off. Here the piers have eight bundled projections, and the ribs have a robustly modeled round profile. The dormitory on the upper floor of the east wing of the enclosure is 184 feet (56 m) long, just 33 feet (10 m) shorter than the church, and it is a simple boxlike space with windows on both sides and a wooden vault, whose present form dates from the second half of the fifteenth century.

Of the functional buildings, the forge, the basis of the monastery's wealth, is famous. It is a two-nave structure, 174 feet (53 m) in length, to the south of the enclosure; the ore from a nearby mountain was processed here. The forge hammers and bellows of the smelting furnaces were driven by water from a stream that was diverted by a canal. The forge was a factory, but its architecture barely differed at all from Cistercian monks' halls.

NOIRLAC

NOIRLAC, LOCATED IN THE CHER VALLEY, twenty-five miles south of Bourges, near Saint-Amand-Montrond, is one of the best-preserved Cistercian abbeys in France, though it is not half as famous as Fontenay, for example. The abbey was originally known as Maison-Dieu-sur-Cher. Only in the fourteenth century did it acquire the name Noirlac (Black lake), which was actually the name of a meadow that derived from a pond on a stagnant backwater arm of the Cher and was also used for the nearby quarry. The monastery was built in 1136, with no noble donor to provide the legal and material basis, but it was founded by Bernard of Clairvaux, who sent the first convention into the wilderness under the direction of his nephew Robert. They were probably preceded by a small settlement of hermetic clerics; in any case, older remains of walls were found during an excavation beneath the chapter house. The site selected for the new monastery was a cheerless, swampy wasteland surrounded by forest, and it was occasionally flooded by the Cher and, more rarely, overrun by ice drifts. The initial difficulties were so great that in 1149 Bernard felt compelled to ask Abbot Suger of Saint-Denis, who was then regent of the kingdom, for donations of grain from the royal granaries for the monks. A year later, the seigneur of the region, Ebbo V of Charenton, from the powerful family of the Déols, issued the corporate charter, but he presented it not to the monastery itself, which was not yet a legally recognized body, but to its mother monastery, Clairvaux. In the charter Ebbo ceded to the monastery Maison-Dieu all of the rights of fiefdom for the site and donated several lands and farms that were necessary for survival. These gifts, supplemented by other legal determinations, were supposed to make it possible to build the monastery ("ad abbatiam faciendam").

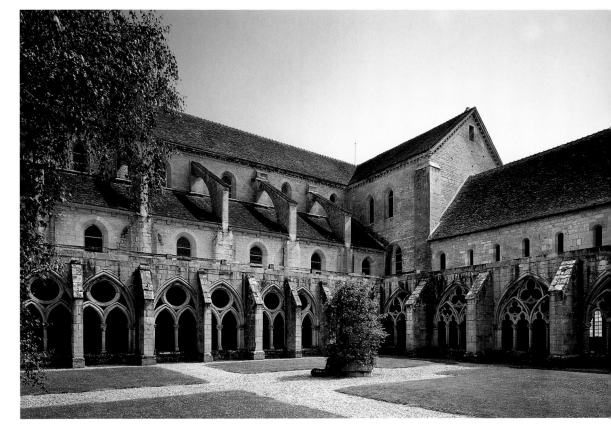

Only once the economic and legal bases had been established, could the abbey develop, and by the end of the twelfth century it had achieved affluence. With the arrival of the *commendam* system, however, decline set in here as well. Following the closure of the abbey in 1822, a porcelain factory was set up in the monastery buildings and the church, which is how the structural fabric of the buildings managed to survive. After World War II there were two restoration campaigns to return the buildings to their original condition.

The church, which was probably begun soon after the donations were received in 1150, has an east end arranged according to the Bernardinian plan, with a boxlike sanctuary and two chapels with flat terminations on either end of the transept. The oldest parts of

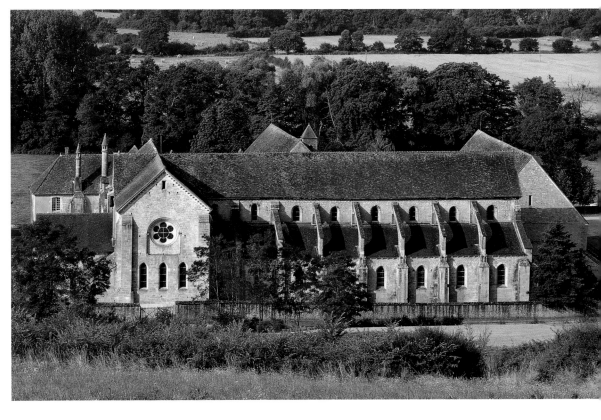

TOP RIGHT:
Refectory, Noirlac

BOTTOM LEFT:
South nave arcade of the church

OPPOSITE PAGE:
Nave the church, facing west

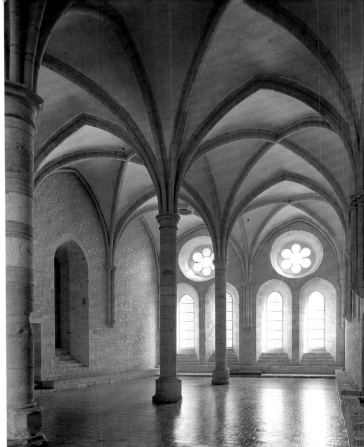

the building are of an extremely bare simplicity. The sanctuary has a pointed vault and is distinguished architecturally only by a group of three windows and an oculus above them; like the one in Fontenay, it is extremely low. The transept arms were originally designed with similarly low barrel vaults, but in the end they were brought to the same height as the nave and provided with cross rib vaults. Because work proceeded very slowly, the early Gothic style caught up with it. The main block was begun with cruciform piers, although the projection facing the main vessel was abandoned, to account for the choir stalls. Higher up, in the area of the nave arcades, there was a clear change in plan: another system with Gothic wall projections for longitudinal rectangular rib vaults. Here too everything is simple and plain in the Cistercian manner.

Although work continued into the first half of the thirteenth century, the formal language remained consistent. Outside, exposed buttresses that had not been planned originally had to be added.

From the monastery buildings it is evident that the abbey enjoyed a gradual economic upturn. The chapter house from the late twelfth century—the second one to be built there, as an excavation has shown—does not have the usual four supports but just two. Their shafts are slightly fluted, like columns—a typical example of Cistercian inventiveness. The two-nave refectory, built in the thirteenth century, is one of the great achievements of the architecture of orders: a harmoniously balanced space with tall round piers, light cross rib vaults, and the distinctive, space-defining motif of a pair of windows crowned by an oculus with six-lobe tracery. The motif of the oculus, which was widespread among the Cistercians, seems to have been especially beloved at Noirlac, for it is found in the sanctuary, the northern transept, and finally in the western facade. When the north and west wings of the cloister were rebuilt in the second half of the thirteenth century, the openings were given the same form of a pair of windows plus an oculus that is found in the refectory, although here it took the form of openwork with tracery. Only with the east and south wings of the cloister, added in the fourteenth century, did the openings begin to make use of tracery filling, and it was of remarkable refinement, ranking with the best of the period.

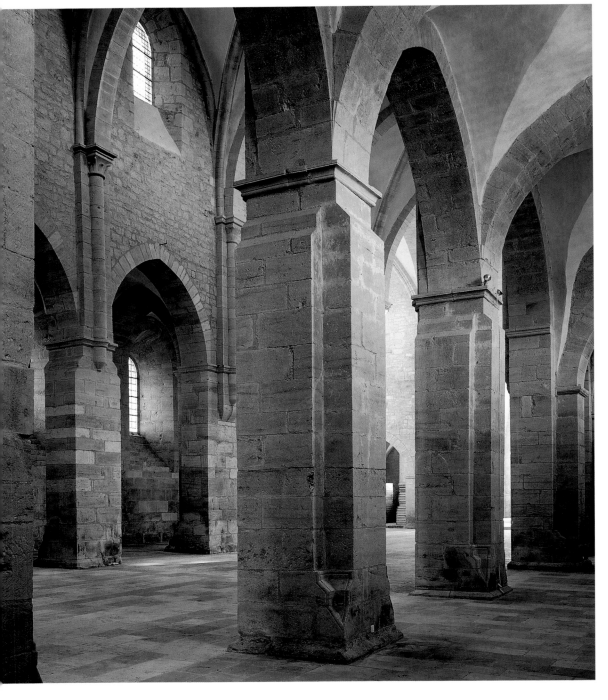

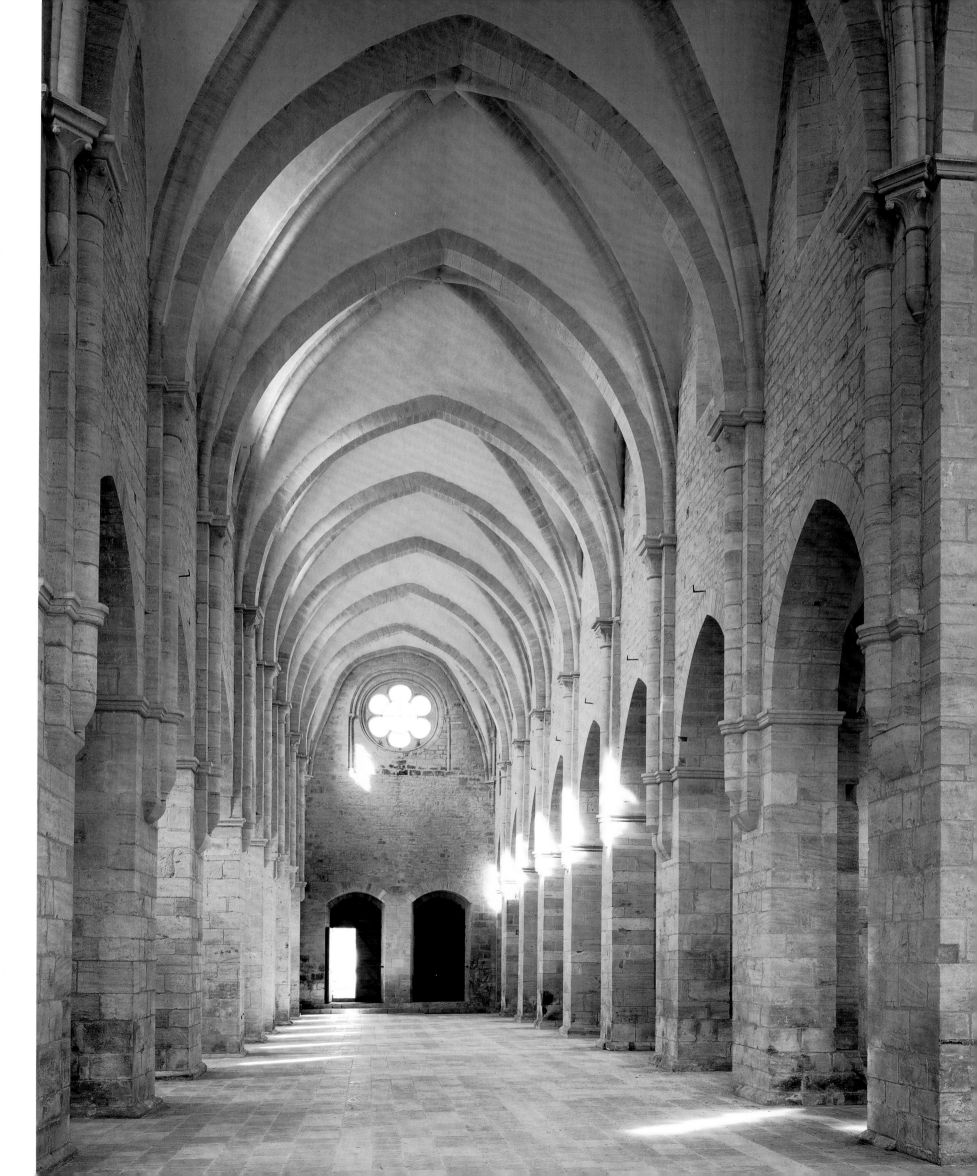

PONTIGNY

THE FORMER CISTERCIAN ABBEY PONTIGNY LIES in the valley of a stream, the Serein, twelve miles northeast of the episcopal city of Auxerre, near Burgundy's borders with the Champagne and with the Île-de-France. The founder was a hermit living here, who was joined by a convention of monks from Cîteaux in 1114. The essential lands were donated by the counts of Auxerre. Pontigny was Cîteaux's second daughter monastery and was thus one of the primary abbeys of the order. Its wealth, however, was always limited, which is why buildings probably had to be financed largely with money from donors. Its proximity to the Champagne proved a blessing in that respect.

The first abbot, Hugh of Mâcon, was widely respected. Nevertheless, the convention remained quite small at first, and so a singular rectangular chapel proved sufficient for two decades. It was still standing in the eighteenth century. Hugh of Mâcon was elected bishop of Auxerre in 1136. Under his successor at Pontigny,

Guichard, who had been a monk in Cîteaux, the convention grew to include fifty priests by 1157 and many more lay brothers. At some point that cannot be specified, perhaps toward the end of Hugh's rule as abbot, a new, large church was begun, financed by the powerful and politically influential Count Thibault II of Champagne, who was William the Conqueror's grandson and had, at one time, good prospects as a candidate for the English throne. He was a friend of Bernard of Clairvaux. In 1151 the former abbot, Hugh, was buried in the church, but the west facade and narthex of the church were probably not completed until around 1170. A little later, around 1180–85, a new sanctuary was begun, which was consecrated in 1205. Immediately thereafter the general chapter reprimanded the abbot for the uncalled-for splendor of the floor, which violated the oath of poverty, and so it had to be replaced. The sanctuary was financed by Count Thibault III of Champagne and his daughter, Queen Adèle, the widow of Louis VII. The count was buried in the sanctuary in 1201; the widow, in 1206.

In the twelfth and thirteenth centuries Pontigny had close connections to England. For example, King Richard the Lionhearted (1199) paid for lead roofing for the church and monastery buildings, after his father, Henry II, had done the same for Clairvaux. Three times Pontigny offered exile to archbishops of Canterbury who were persecuted by kings: Thomas Becket (1164–66), then Stephen Langton (1208–14), and finally Edmund of

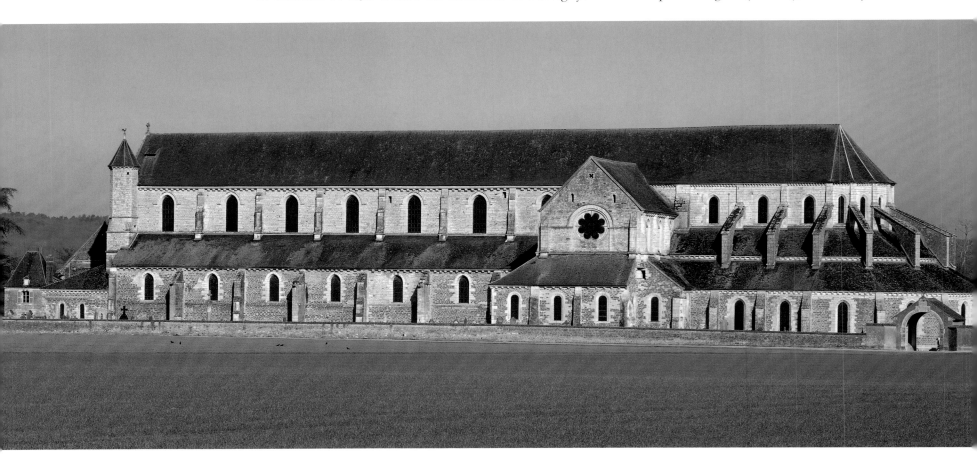

Abingdon, mistakenly known as Edmund Rich (1240), who died that year and was canonized in 1246. His grave in Pontigny received great veneration and attracted large crowds of pilgrims, among them King Henry III of England. In the late Middle Ages Pontigny's significance declined. In 1366 there were only sixteen choir monks living at the abbey, and it is a sign of how badly things were going that shortly before that it was forced to borrow money from Clairvaux. Following the Revolution, the monastery buildings were largely destroyed. The church was preserved, however, in consideration of the grave of Saint Edmund. It found new life in 1904 when the philosopher Paul Desjardins began to organize ten-day summer meetings there of writers, which took place annually until the outbreak of World War I. Participants included André Gide, André Malraux, François Mauriac, Paul Valéry, Thomas Mann, and T. S. Eliot.

In constructing the church the traditional Bernardinian plan was significantly expanded by adding, in the southern and northern transept arms, along with the three chapels of the east side, two more each on the facing wall and two on the west side. This brought the number of chapels to fourteen—an indication that there were many choir monks in Pontigny at this time. The sanctuary, which has flat terminations, was originally as tall as the transept arms. The latter are laid out according to the bay system, with longitudinal, rectangular bays and cross rib vaults, which made it possible to have a windowed clerestory, unlike barrel-vaulted structures such as Fontenay, which was about two decades older. The nave and the crossing are slightly taller than the transept arms, giving them steeper proportions. The structural system of cruciform piers and round projections, which in the nave are supported by corbels, is simple and plain in the Cistercian style. In lieu of the band vaults that had originally been planned, and as they were executed in the side aisles, the plan for the nave was altered in favor of a more modern cross rib vault.

In expanding the sanctuary, during a second phase of building, the goal was clearly to increase the number of chapels yet again. Hence the main space was extended and, following the model of Clairvaux, an ambulatory was added around the apse, with a wreath of chapels. The ground plan here is based on seven sides of a fourteen-sided polygon—a form whose effect approaches that of a semicircle. In the apse the sections of wall are necessarily quite narrow, and the round piers had to be placed so close together that the arches were stilted. The effect of the whole is that of a Cistercian parallel to the Gothic cathedral chancels of this period.

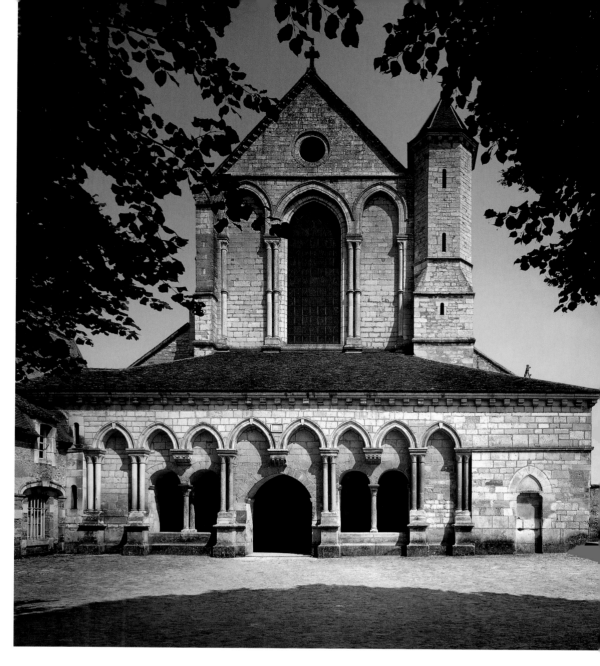

Thirteen new chapels were created in all. Together with the existing chapels in the transept, this brought the total to twenty-five, more than in any cathedral.

The second phase of building brought the church to a length of 384 feet (117 m). Because its height is so limited, however, the towerless building seems so stretched out and flat that it is almost as if it were ducking into the landscape. The wreath of chapels that produces seven apses in the interior feels more like a single large form on the exterior, since the apses are given straight cladding and combine to form a single low, broad, immense polygon. The unity of the structure is disturbed only by exposed flying buttresses that are found only on the north side of the main block, facing the monastery, not on the south side. The exterior is very plain and scarcely articulated at all. Only the west facade, where the narthex has survived, presents a richer appearance, thanks to the blind arcade. Even so, the effect of the whole is strangely asymmetrical, because the entry is displaced to the left of the central axis, and only the right side has a terraced tower.

West facade and narthex of the church

PAGE 176:
View from side aisle into nave

PAGE 177:
Nave, facing east

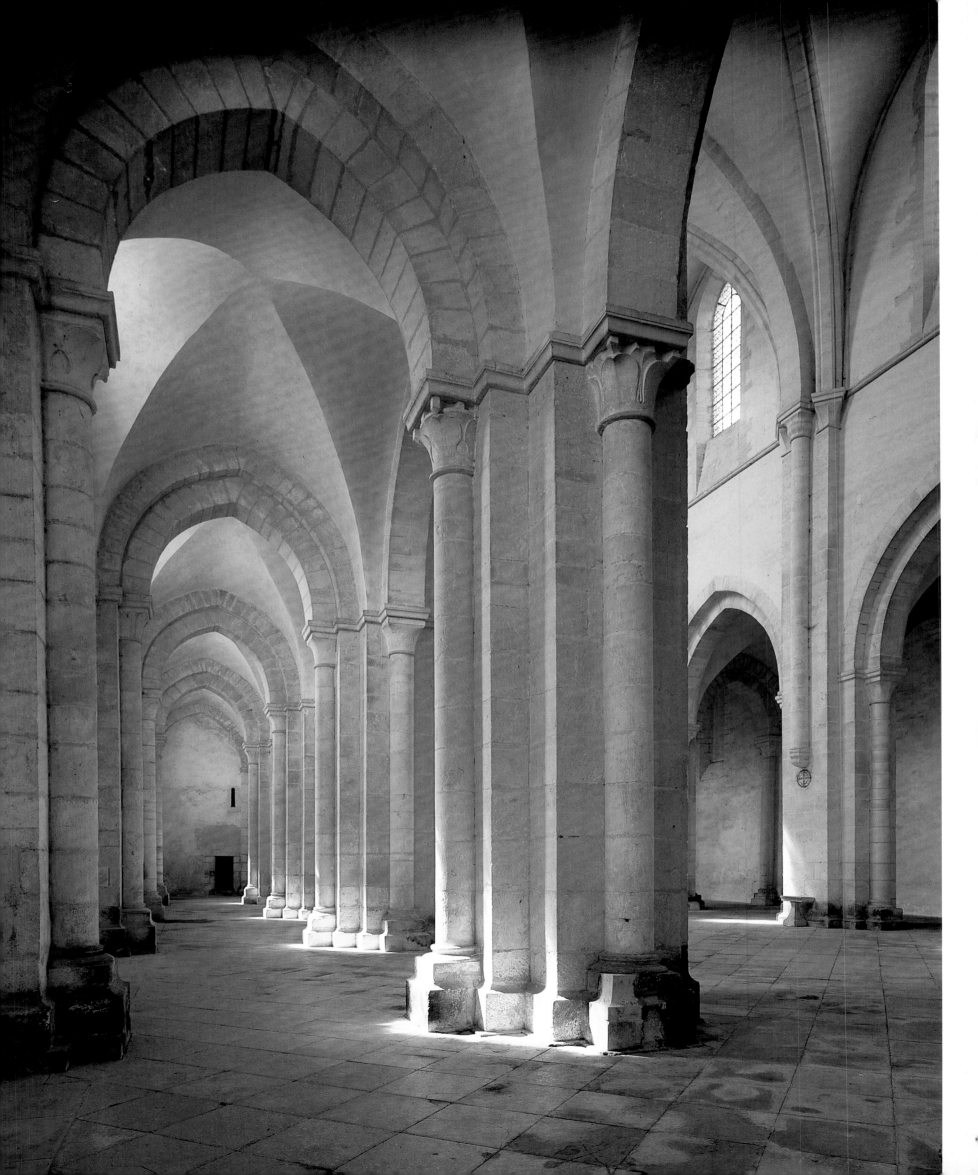

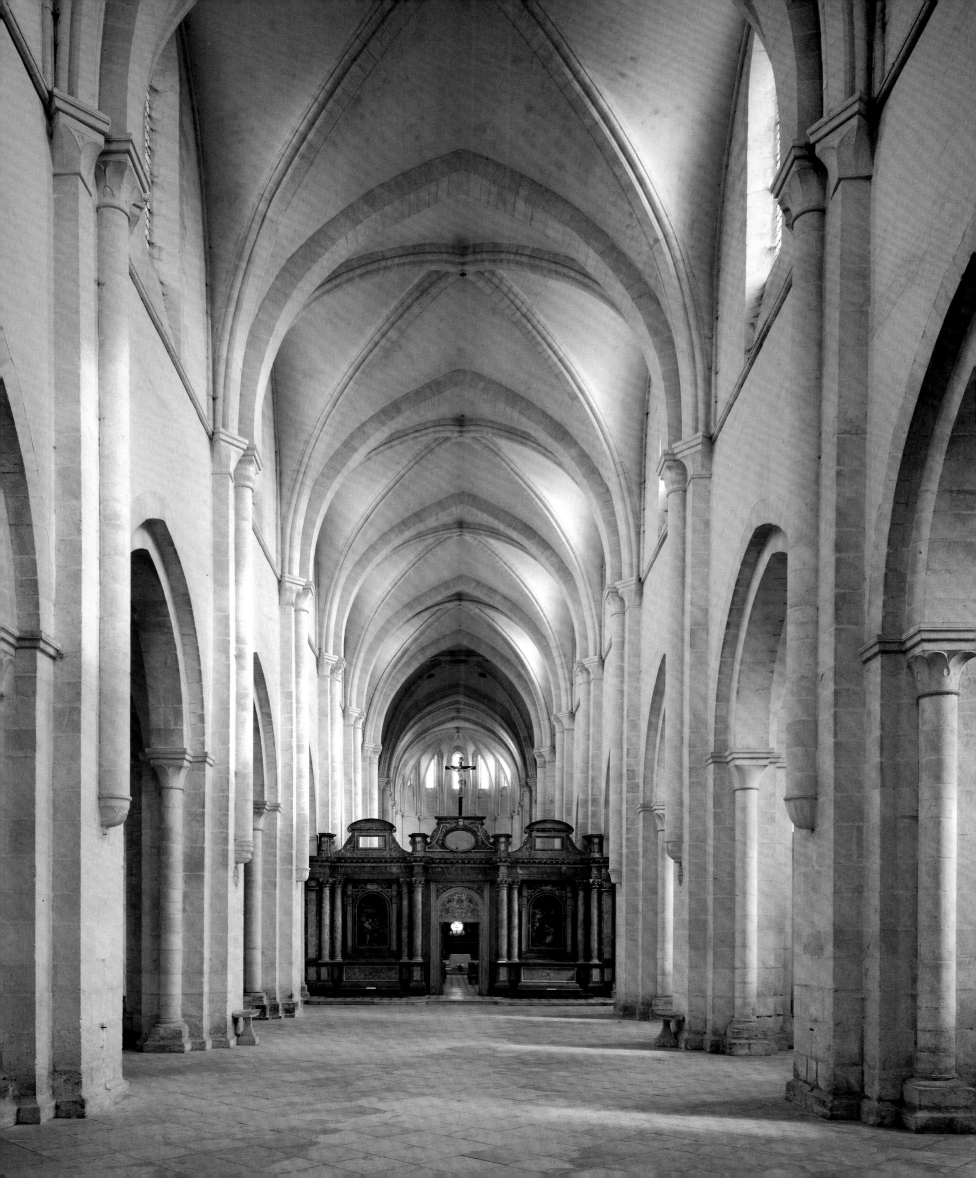

SAINT-BENOÎT-
SUR-LOIRE

TOP RIGHT:
*West tower, church of Saint-Benoît-
sur-Loire*

BOTTOM LEFT:
Church from the east

OPPOSITE PAGE:
Interior of the chancel

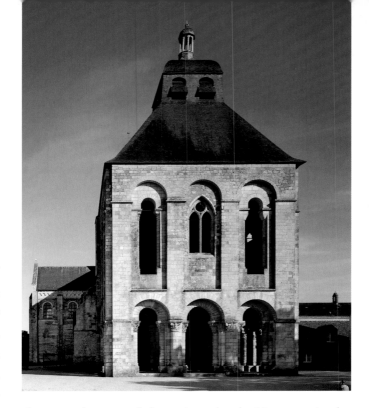

THIS MONASTERY, ORIGINALLY KNOWN AS FLEURY (Floriacum) and dedicated to Peter and Mary, was one of the most powerful in Gaul in the Merovingian and Carolingian periods. It was founded in 651 at the crossroads of the trade routes from Neustria, Burgundy, and Aquitaine. Around 672–74 monks from Fleury brought the bones of Saint Benedict from Montecassino, which had been destroyed by the Lombards, and he became its patron saint. The name Fleury gradually transformed first into Saint-Benoît-de-Fleury and then to its present name. The abbey flourished for a time but then was devastated three times by the Normans in the ninth century. Then, between 930 and 943, Abbot Odo of Cluny carried out a reform there. The monastery thrived under the abbots Abbo (1004) and Gauzlin (1020), with connections throughout Europe, but in particular to Abbot Oliba of Ripoll in Spain.

The monastery was laid out in a triangle, with a church at each of the corners; the largest of these was dedicated to the Virgin. Here Gauzlin began construction on a west tower that he declared would set an example for all of Gaul, but in 1026 the church was destroyed by a large fire. The present west tower was built under Abbot Guillaume, who ruled from 1067 to 1080. It seems to have been based on Gauzlin's tower. The two-story structure, which may have had two additional stories, and thus would have been roughly twice its current size, is a massive square that is open to the outside. Inside it has a narthex, with a gallery very high above it—both in the form of a four-column room with richly articulated pillars. The tower was one of the most impressive achievements of European architecture in its day. Guillaume began construction on the east end at the same time, and it was probably largely completed by the time the altar was consecrated in 1108. It consists of a broadly projecting transept, an unusually long sanctuary with barrel vaults, a crypt, an ambulatory, and just two radial chapels. On the whole it is influenced by Cluny III, but the interior in particular—with its massive arcades of round piers, its slight blind arcade, and the wreath of windows in the apse—has its own individual character. In the main block, which was added beginning around 1150 and consecrated in 1218, the Gothic can already be seen. But it does not approach the high quality of the east and west ends.

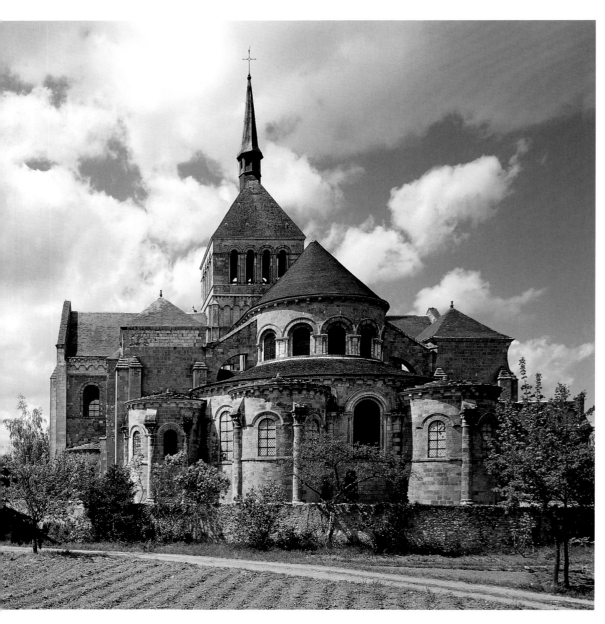

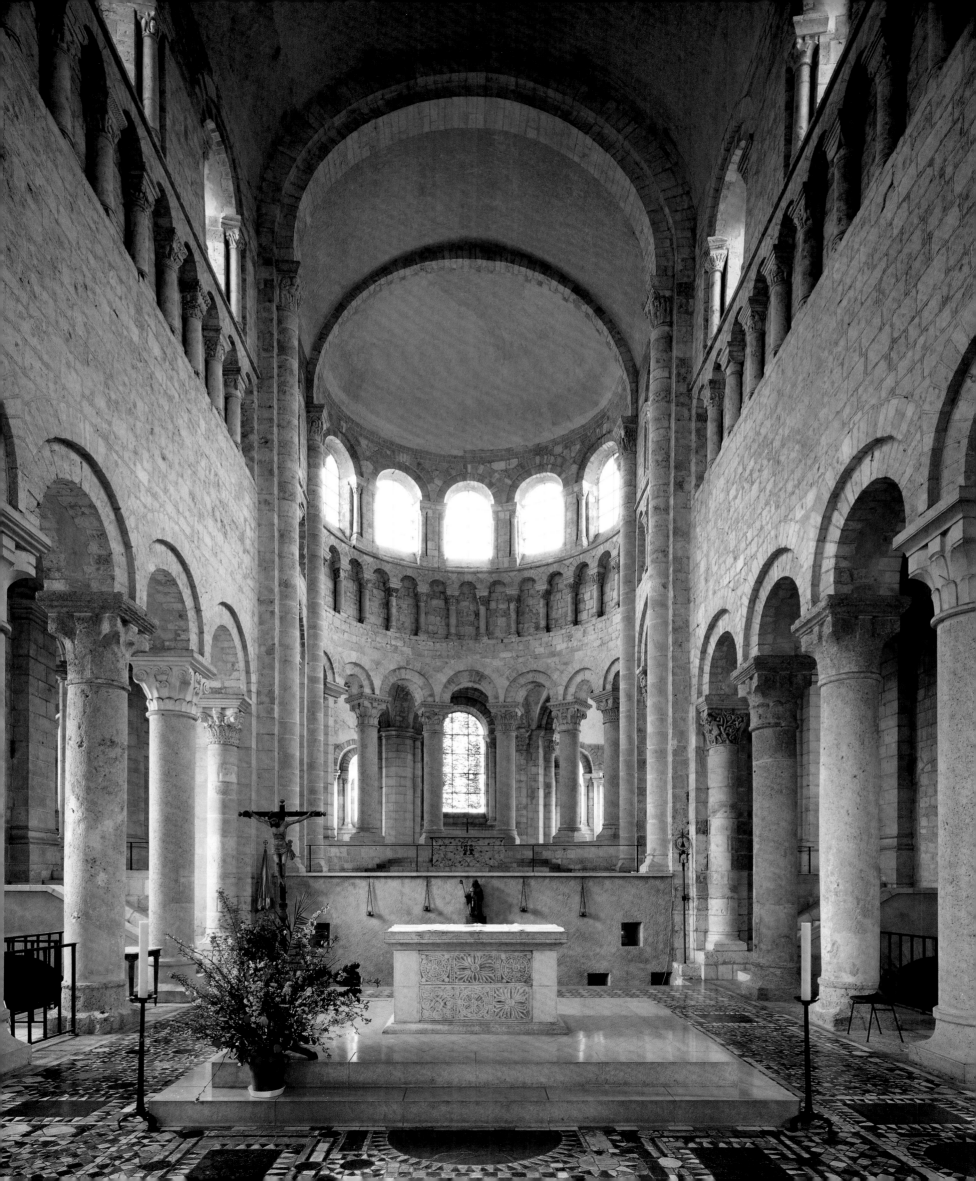

FONTEVRAULT

BELOW:
Tombs of Richard the Lionhearted, Isabelle of Angoulême, Henry II Plantagenet, and Eleanor of Aquitaine, now located in the nave, Fontevrault

OPPOSITE PAGE:
Nave, facing east

PAGE 182:
Two views of the monastery kitchen at Fontevrault. TOP: Looking up into the vault; BOTTOM: Exterior view

PAGE 183:
Chancel of the church, seen from the east

NEAR THE LOIRE VALLEY, BETWEEN SAUMUR and Chinon, lies the once famous royal abbey Fontevrault (Fontevraud), which was one of the most distinguished in France. It dates back to an itinerant preacher from Brittany, Robert d'Arbrissel, a charismatic man who campaigned on behalf of Pope Urban II for the First Crusade and soon had hundreds of male and female followers. In 1100 the Council of Poitiers chose Fontevrault, in the middle of the forest, as a fixed abode for these people. Robert gave this community a charter that resembled an order, and it was confirmed by the pope in 1106. The community was unique in that it was headed by an abbess from 1115 onward, to whom the men, even the priests, were entirely subordinate. This repeatedly led to rebellions. It was also unusual that Robert accepted social outcasts, like repentant prostitutes and lepers, who were accommodated in two buildings separate from the main monastery: the lepers in Saint-Lazare and the "pénitentes" in Sainte-Madeleine. The community began immediately to attract many new followers and

new priories had to be founded. By the end of the twelfth century there were more than one hundred in France, ranging from Picardy to the Pyrenees. Under the leadership of Fontevrault they formed a congregation, known as the Fontevrists, which had offshoots in England and Spain as well. As a rule the nuns came from the nobility; the abbesses, from royal houses. The male conventuals were simply minor brothers (*fratres*). The abbesses had unlimited authority; in spiritual matters they were subject only to the pope; in worldly matters, to the king.

The abbey received important support from the house of Anjou-Plantagenet, which, as a result of Henry Plantagenet's marriage in 1152 to Eleanor of Aquitaine, the divorced wife of King Louis VII, ruled the whole of western France, from Normandy to Gascony and the county of Toulouse. Henry's aunt, Matilda of Anjou, was abbess of Fontevrault at the time. In 1154 he became Henry II of England by matrilineal succession in 1154, becoming the founder of a dynasty that ruled England until 1399 (and by collateral lines until 1485). After Henry II chose Fontevrault as his burial site in 1189, the year of his death, his widow, Eleanor, who was a nun here in her old age, and his son and successor, Richard the Lionhearted, were also buried in the abbey church. All three had tomb monuments with a polychromed stone recumbent figure. A fourth one, in wood, was added when Henry III had the corpse of his mother, Isabelle of Angoulême, transferred in 1254 from the cemetery for the nuns, in which she had been buried, to

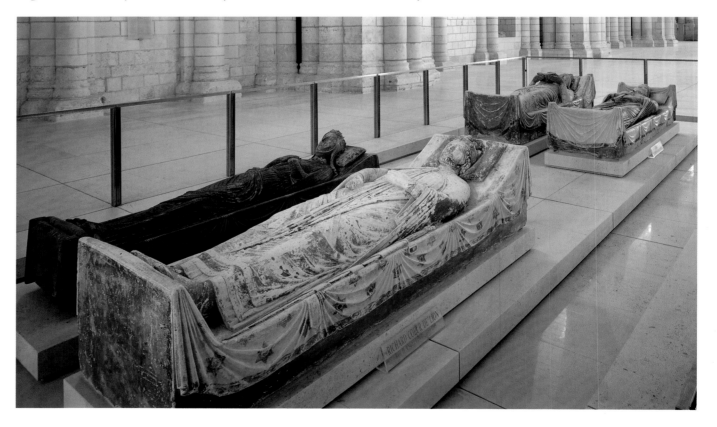

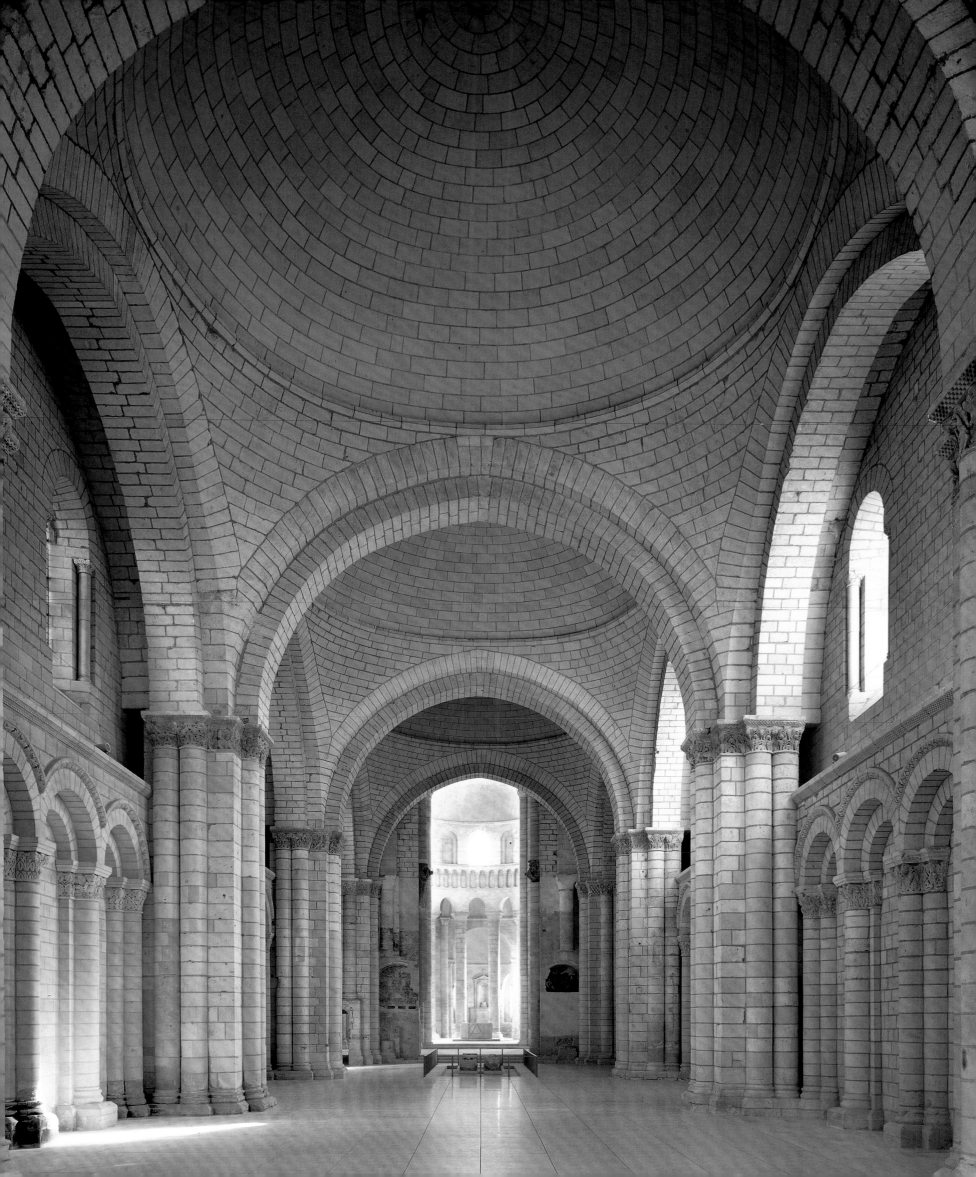

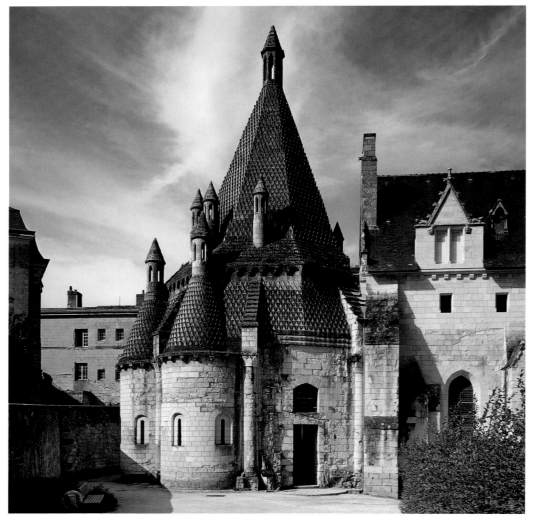

the royal burial site. Two additional tomb effigies, which showed them kneeling and praying, were destroyed in the Revolution. These were the monuments for Henry II's daughter Joan, widow of the Norman king William II of Sicily, and for her son from her second marriage, to Count Raymond VII of Toulouse. The hearts of John Lackland and Henry III were also buried in Fontevrault. Three of the tomb slabs show the deceased with closed eyes, laid out on the sheets of their deathbeds. Only Eleanor has open eyes; she is holding an open book in her hands, probably the prayers for the dead. The original location of the tombs was in a crypt under the crossing, and these slabs lay on the tomb lids. During the Revolution the graves were filled in and the slabs were placed at the northwest pier of the crossing. Their present placement, in the east end of the main block, is modern.

The chancel of the church, begun in 1001, was consecrated by Pope Calixtus around 1119. The church was completed in 1150. It consists of two clearly distinct parts: the chancel with the transept and the main block. The chancel is a typical French ambulatory chancel with three radial chapels. The architecture of the chancel's interior, with slender, extremely tall pier arcades, is narrow and steep, as is that of the crossing, which seems absolutely choked between its massive piers. The main block is a completely different world in comparison. It has a single nave and is not only wider than the chancel but also lower. Its four bays create self-contained quadratic spatial units consisting of four arches and a pendentive dome, framed on two sides by a recessed windowed wall with a blind arcade and a walkway. The whole space looks like a series of baldachins and stands clearly within the tradition of dome churches in southern France.

The monastery buildings are essentially from the Gothic and Renaissance periods, with the exception of the Romanesque auxiliary church of Saint-Lazare and the famous, eighty-nine-foot- (27-m-) tall Romanesque kitchen with its strange, squamous helmets on the roof and its many lantern-shaped chimneys. Its structure is extremely complex: an octagon surrounded by a wreath of low conchae. It conceals inside a quadratic core structure with a frame consisting of four arches. Superimposed on the latter, on squinches, is an octagonal dome that is rotated a half turn relative to the octagon of the substructure—the whole structure is an utterly unique invention of extremely imaginative design.

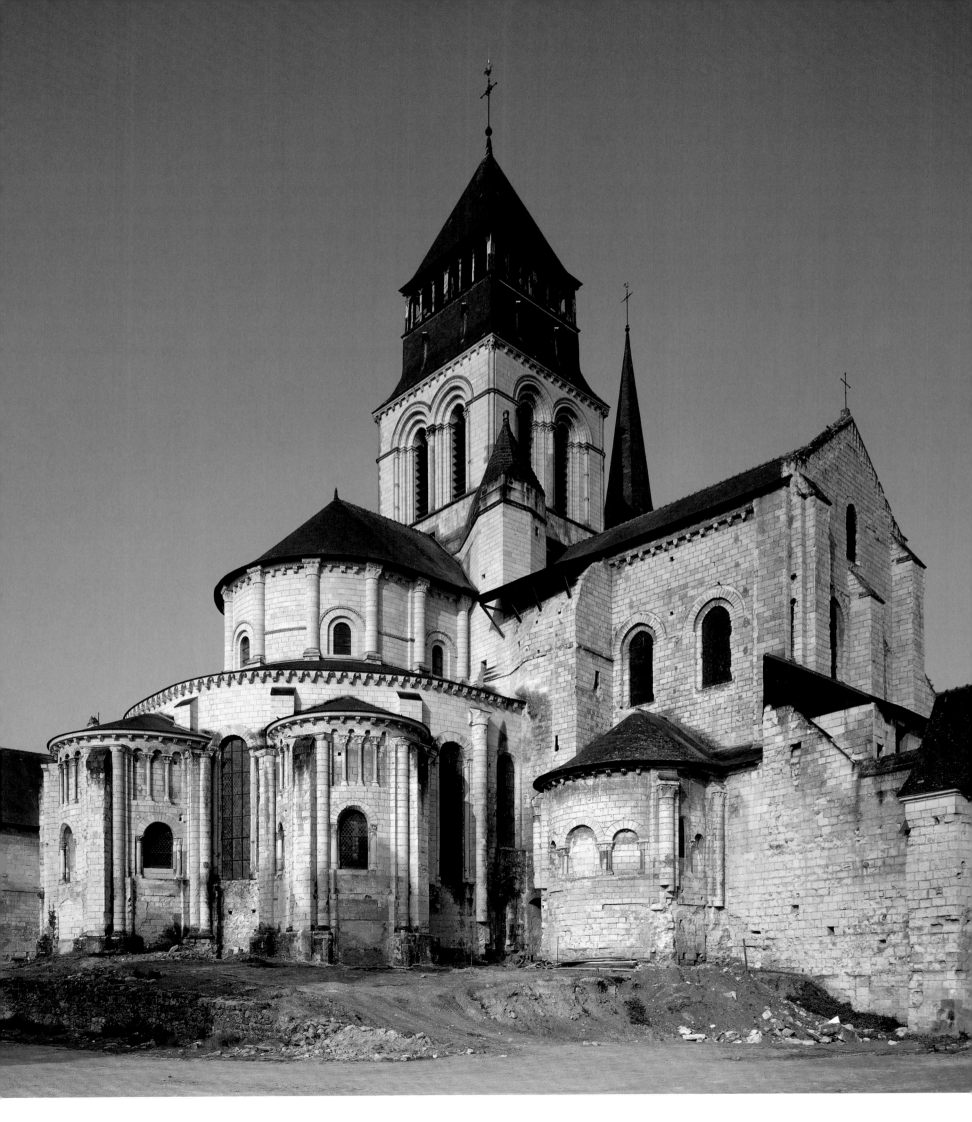

SAINT-SAVIN

East end of the church at Saint-Savin, facing the Gartempe River

THE FORMER BENEDICTINE ABBEY SAINT-SAVIN-sur-Gartempe lies twenty-five miles east of Poitiers, on the Gartempe River, where a medieval bridge provided the abbey with income from tolls. The abbey was founded in the ninth century to honor Saints Savinus and Cyprian, two brothers from Brixia (Brescia) who were martyred on the Gartempe around the middle of the fifth century. Their bones were found there around 800. Immediately thereafter Baidilus, the abbot of the Marmoutier monastery outside Tours and court chaplain to Charlemagne, had a

church built, whose clergy then formed a monastery. It stood under the protection of the Carolingian ruling house. Louis the Pious sent no one less than the reformer Benedict of Aniane, who appointed twenty Benedictine monks and Abbot Dodon, who ruled for three decades, until 853. The abbey survived the assaults of the Normans because it was under the protection of a fortified post established by Charlemagne. In the period that followed the monks were active in the reform of several monasteries in Burgundy, including Baume-les-Messieurs, which produced Berno, the founding abbot of Cluny.

In 1010 Aumode, countess of Poitou and duchess of Aquitaine, made a large donation to the abbey, which provided the basis for beginning construction of the present church; according to a later tradition it was begun under the great Abbot Odon, who ruled until 1040–50.

Excavations of the structure indicate that the church was built in two phases: the first included the chancel, transept, and, a little later, the west end of the main block; the second produced the east end of the main block. The oldest section comprises the transept, a crossing with open square tower, ambulatory chancel, and five radial chapels—a classic example of this architectural type, which was widespread in France. The polygonal division of the apse is striking—even astonishing, given its early date. The narrow arcades, with their immense, towering round piers and the windowed clerestory immediately above them, have an unusually monumental effect. The main block is one of the founding buildings of the Romanesque hall church style that will later be typical of Pitou: a barrel-vaulted nave with side aisles that are nearly equal to it in height. At Saint-Savin the side aisles are quadripartite groin vaults with no bands in a form that can be understood as the penetration of a longitudinal vault by several transverse vaults. The main vault sits directly on the nave arcades. The vault abutments in the side aisles are lower than the ones in the nave, which lends a terraced effect to the structure, but the heights are as close to each other as possible. The defining impression is that of a hall church. The three western sections of the nave—which are adjoined externally on the front wall by a campanile with an entry hall—have square piers with vaulting shafts that serve as the springing for the arch ribs in the nave that articulate the vault. In the six eastern sections, however, the nave arcades have only bare round piers, and the vaulting is completely smooth. The structure used in the western part was

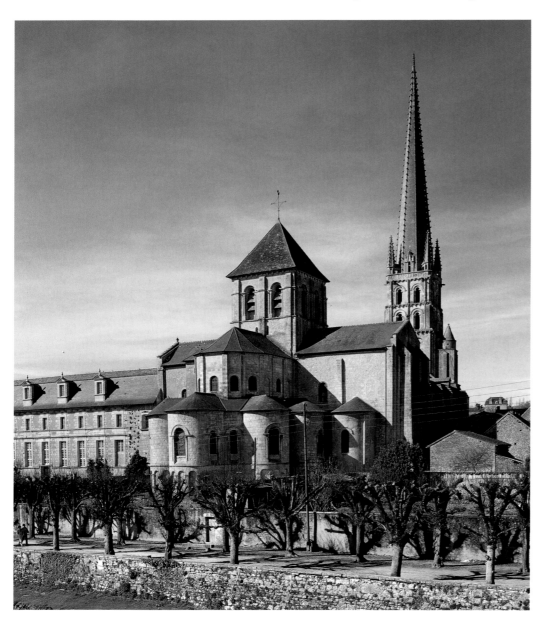

clearly abandoned in order to provide a surface unbroken by bands for ceiling frescoes.

The frescoes are largely preserved; they have brought Saint-Savin worldwide fame. They were painted toward the end of the eleventh century or the beginning of the twelfth in the fresco technique, in which the pigments are bound in lime and applied to wet plaster; sometimes, using *semifresco* and *secco,* the painting was reworked with partly dry or dry plaster. Paintings were included in the narthex, the gallery of the tower, the crypt beneath the chancel, the vaults of the nave, and perhaps on the walls of the side aisles, though they have not been preserved there. The barrel vaulting, which is divided up by a frame, has two registers on each side, totaling forty-five hundred square feet (413 sq. m), that depict a self-contained cycle of Old Testament stories from Genesis and Exodus, from the creation of the stars to the history of Joseph in Egypt. It is the most comprehensive cycle of frescoes that survives from the period. In 1835 it was discovered by Prosper Mérimée, who, as the son of a painter, immediately recognized its value and arranged for the church to be protected as a historical monument. The paintings are characterized by their warm palette, dominated by ocher, against a light background. The painters were able to tell their stories in a vigorous and easily intelligible way, using articulate poses, clothing, and gestures: for example, in the scene of the workers building the

Tower of Babel, although its style seems to be moving closer to the Gothic. One of the most famous is of Noah's Ark: a long ship with three decks, in whose arcades one sees the animals and Noah's family as if through windows, while Noah and a companion verify that the roof is dry. Just at that moment the dove arrives with the olive branch, signifying that the danger has passed.

ABOVE:
Fresco with scene of building the Tower of Babel, Saint-Savin

BELOW:
Fresco with scene of Noah's Ark

PAGE 186:
Interior of the chancel

PAGE 187:
Main block, facing east

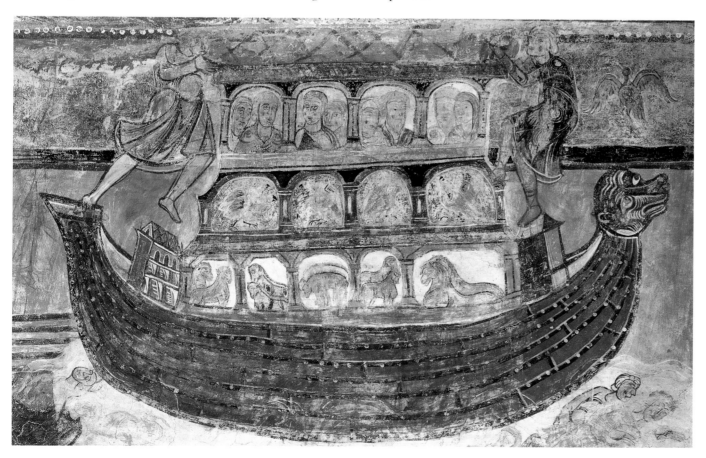

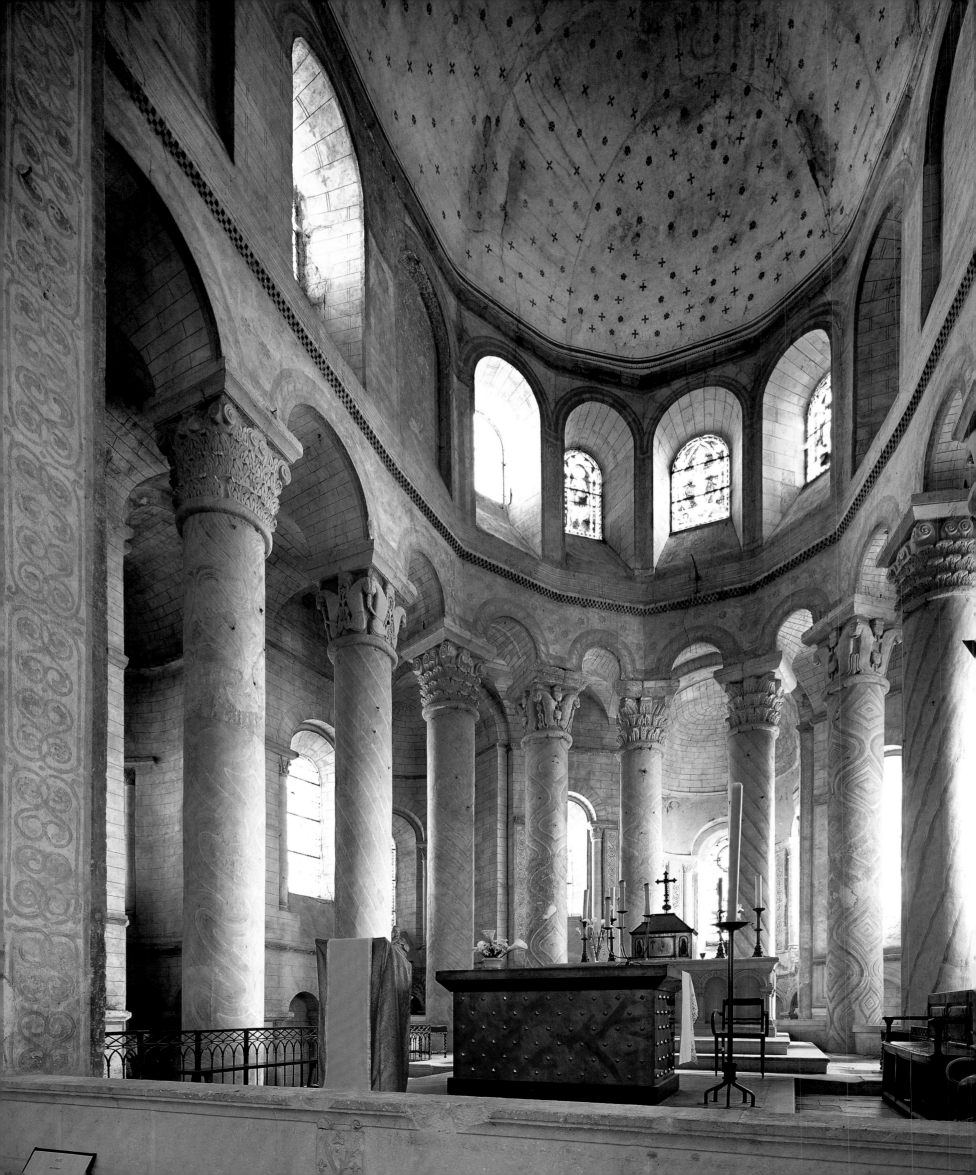

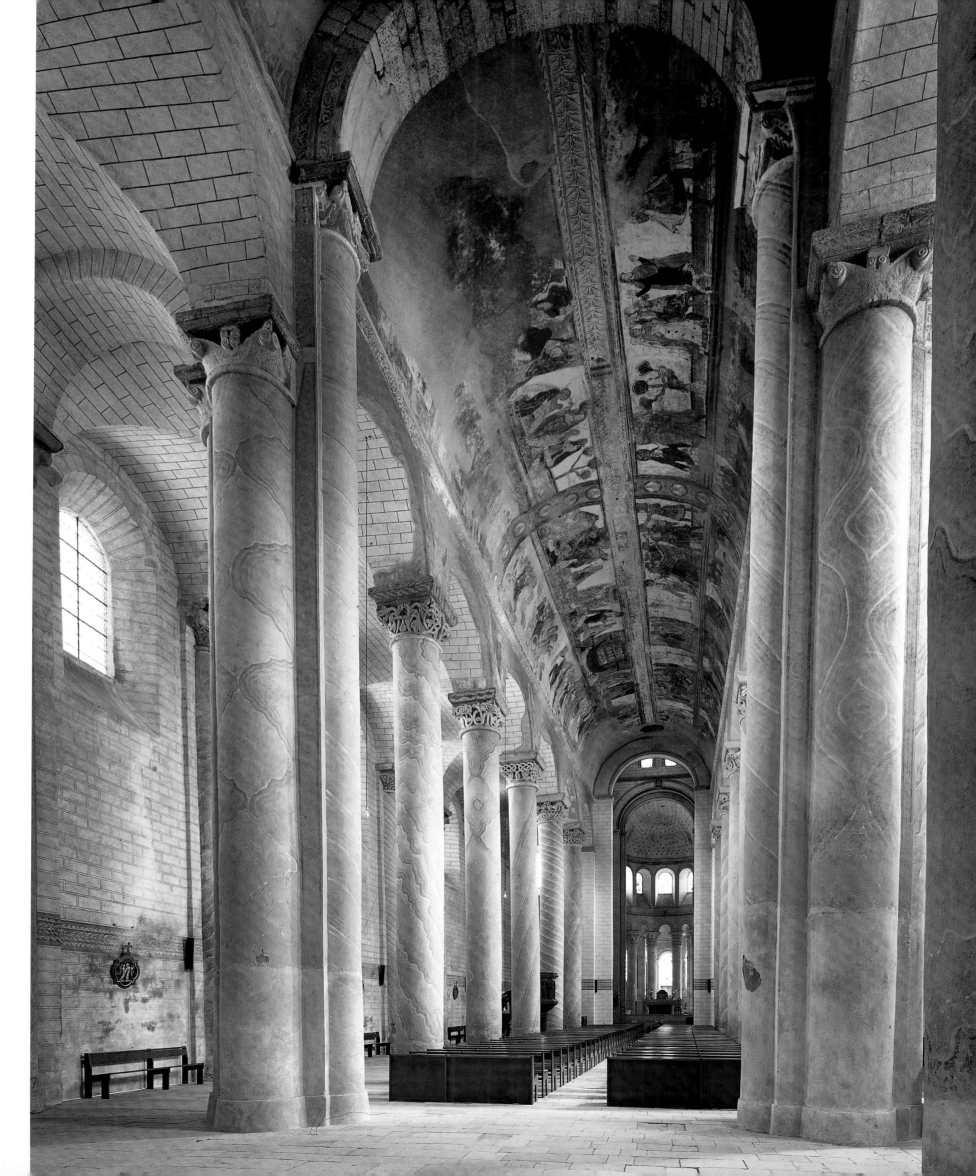

ROYAUMONT

BELOW:
*Bird's-eye view of Royaumont,
from the south*

OPPOSITE PAGE:
TOP: *Southeast corner of the cloister;*
BOTTOM: *Refectory*

THE FORMER CISTERCIAN ABBEY ROYAUMONT, twenty-two miles north of Paris, near Chantilly, was, as the name indicates, founded by the king. Shortly before his death in 1226 Louis VIII founded the abbey by stipulating in his will that his son and successor, Louis IX, who would later be canonized, had to build a monastery in Cuimont that would be called Royaumont. It was intended for one hundred monks and just ten *conversi.* The royal castle Asnières-sur-Oise was nearby. In 1228 young Louis IX—who was assisted by his mother, Blanche of Castile, because he was only fourteen—began construction on the church and monastery. The convention came directly from Cîteaux. Royaumont was the 599th founding of the Cistercian order. After just eight years of construction the church, which was 345 feet (105 m) long, was consecrated in 1236;

the monastery buildings were completed a little later. It is said that the king and his brothers helped with the construction—which proceeded in secrecy and without pause—and even carried stones. Later he would often retreat to Royaumont, where he would participate in the prayers, services, and meals as a monk. He chose the church as the burial site for family members who were barred from royal burial at Saint-Denis. One of his brothers and three of his children were buried at Royaumont. As a result of the Revolution the sarcophagi and their recumbent effigies were transferred to Saint-Denis. After the reign of Saint Louis the importance of the monastery gradually declined. Mazarin and, later, the princes of Lorraine were abbots *in commendam* here. After the closure of the monastery in 1791 a cotton spinning mill was set up in the buildings, with three hundred workers, most of whom were English. The new owner used the church as a quarry to build housing for the workers, so only the monastery buildings survived.

The church was a basilica with an ambulatory, a wreath of chapels, and a three-nave transept; all that is still standing is the south wall of the side aisle, with oculus windows and a single pier buttress, and the lofty terraced tower that stands like the stump of a tooth. The wall structure consisted of three stories. Exposed buttresses extended outward. In terms of its size, vertical section, and ground plan for the eastern termination as seven sides of a dodecagon, the church was second to none of its contemporary episcopal cathedrals; all it lacked, in keeping with the statutes of the order, was a two-tower facade. To do justice to its ambition, the building might be characterized as a royal Cistercian cathedral.

On the whole, the church and monastery buildings truly have the character of an ideal monastery, one that was not built in several phases but sketched on a drawing board as a complete unity. The four-column room of the kitchen and especially the noble two-nave refectory, with its narrow columns, seem like expansive royal halls. Even the 98-foot- (30-m-) long vaulted latrine, with a stream flowing through its center passageway, has something elegant about it. The cloister, which at 130 feet (40 m) long is one of the largest among Cistercian monasteries in France, is distinguished by its piers, whose cores are elaborately encircled by eleven thin, monolithic columns. Unfortunately, there is no tracery in the arcade openings, which can be reconstructed as quadripartite arcades with three roundels.

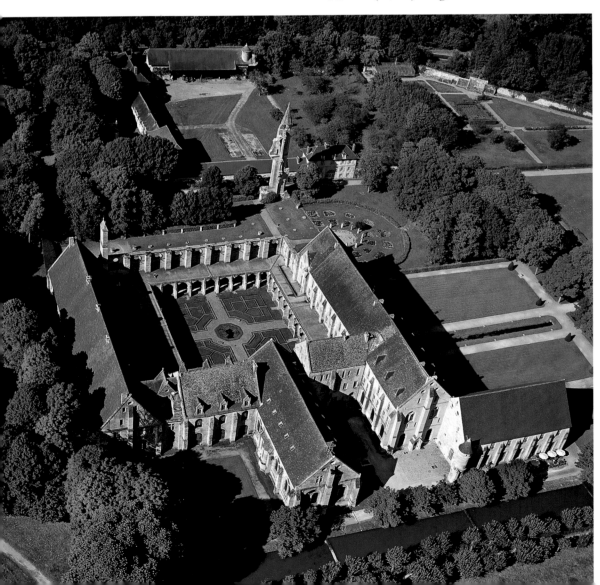

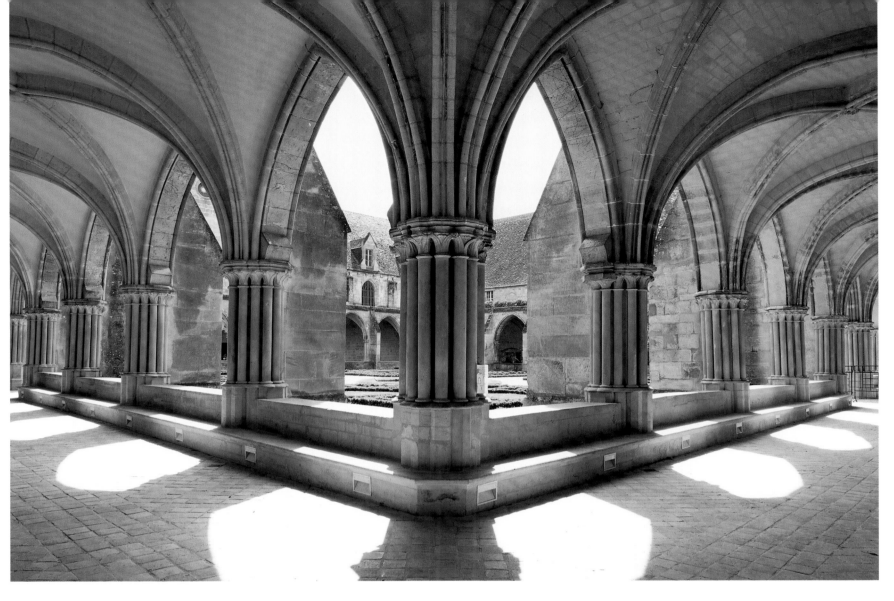
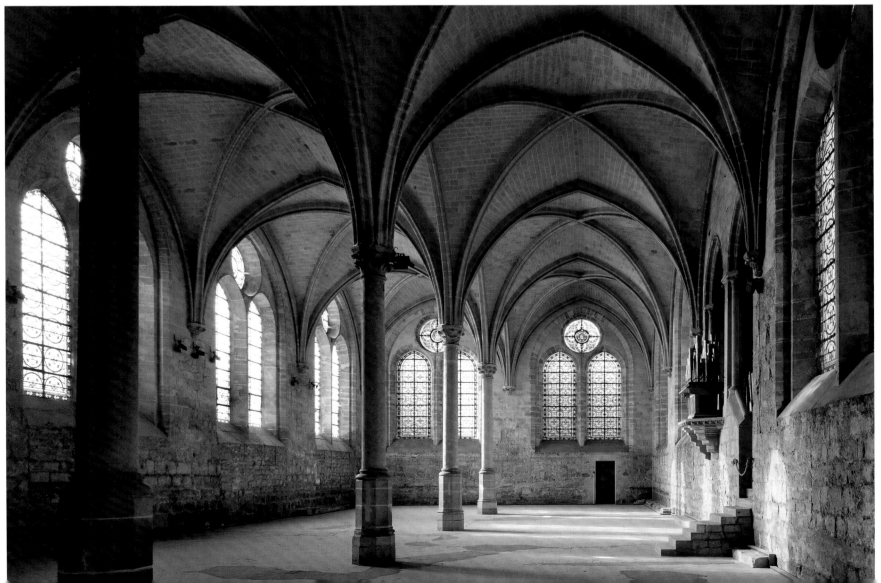

OURSCAMP

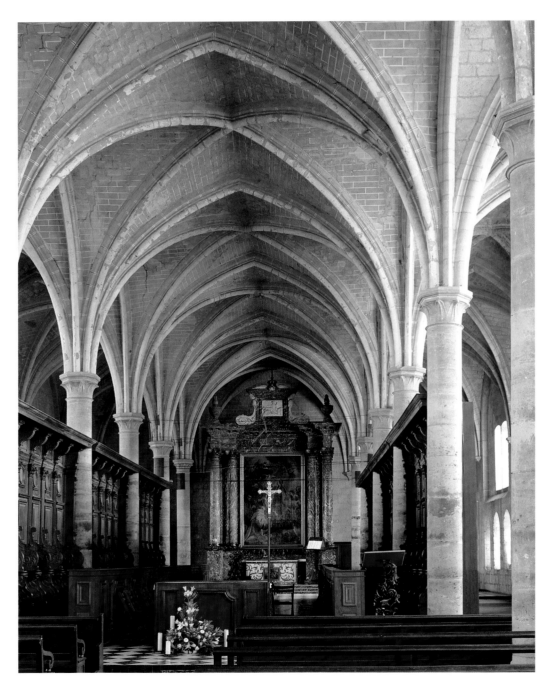

Former hospital, Ourscamp

ABOUT THREE MILES SOUTH OF THE EPISCOPAL city of Noyon, in a forested area near the Oise River, lie the remains of the former Cistercian abbey Ourscamp (from the Latin *ursi campus,* or bear field). It was founded in 1129 by Simon de Vermandois, bishop of Noyon and a cousin of King Louis VI. In the years that followed the abbey was the preferred burial site for the bishops of Noyon, and it seems to have been founded primarily for that purpose. The convention, under Abbot Waléran de Baudemont, came from Clairvaux. Its first church, which cannot have been very large, was consecrated by the archbishop of Reims in 1134. The second church was begun in 1154 and consecrated in 1201. In the thirteenth century, when the number of monks had increased to about five hundred, it became necessary to add the east end and its many chapels; it was begun after 1240 and completed around 1255.

Later, in the seventeenth and eighteenth centuries, the west end of the monastery was converted into a broad Baroque château whose wings picked up the facade of the church, which now looked more like the facade of a château, symmetrical at the center. After the Revolution the monastery served as a hospital for the Armée du Nord. The owner after 1804, Radix de Sainte-Foy, was a great enthusiast of romantic ruins, and he was responsible for the current disastrous state of the east end. To improve the view from the château, he had the main block torn down to a ruin. The act was barbaric, but the result was impressive: the church, which together with the chancel was 335 feet (102 m) long, does not look destroyed but unfinished. In its original state, the thirteenth-century east end embodied the type of a five-nave cathedral chancel with ambulatory and wreath of radial chapels, with the apse and ambulatory constructed as five sides of a decagon. The supports in the sanctuary are bare round piers with three vaulting shafts that rise up to the spring line; by contrast, between the side aisles there are more elaborate bundle piers. The whole chancel is based on the one at Saint-Denis, the most modern architecture of its day (see pp. 198–201), but it lacks the light transmitted through the triforium, and the tracery of the two-course clerestory windows has no filling in the roundel. These simplifications can be seen as deliberate, in keeping with Cistercian plainness. Only in the blind windows of the transept's eastern wall do we find an almost literal correspondence to Saint-Denis's four-course tracery with inscribed multifoils. This makes it clear that the builders were familiar with Saint-Denis.

Ourscamp is primarily famous for its beautifully preserved hospital, built to the southeast of the church around 1220. It is a wing 151 feet (46 m) long and 52 feet (16 m) wide, articulated on the exterior by blind arcades. Inside it is a spacious, three-nave hall with cross rib vaults and tall round piers and it has traces of old polychromy. The sick were given a room in the style of a large refectory. Today the hall serves as a church, with a Baroque choir stall taken from a charterhouse.

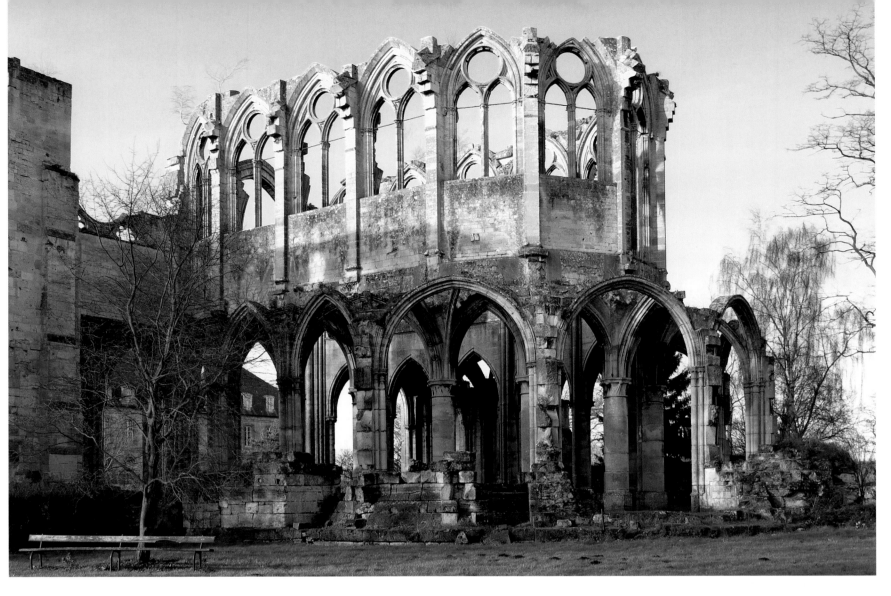
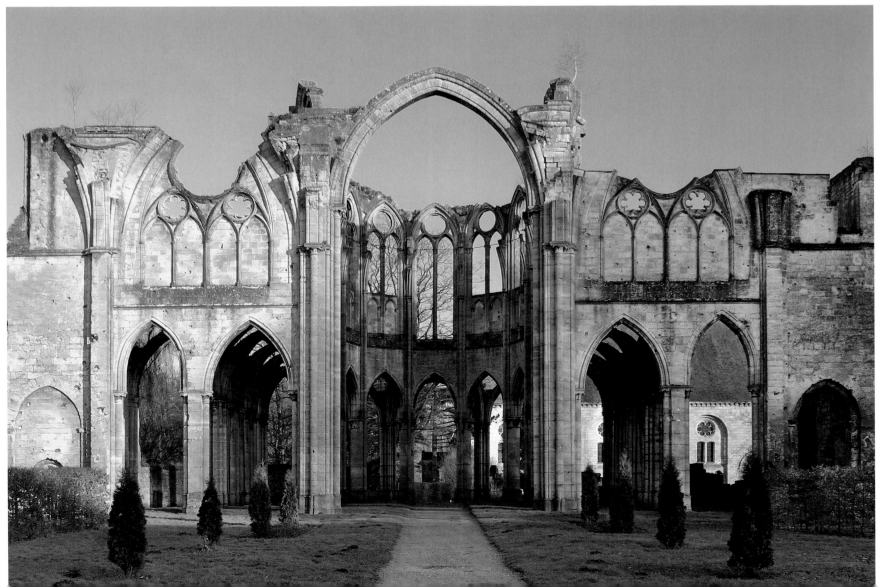

LONGPONT

TOP RIGHT:
Monastery gate, Longpont

BOTTOM LEFT:
Former church

OPPOSITE PAGE:
Ruins of the main block, facing west

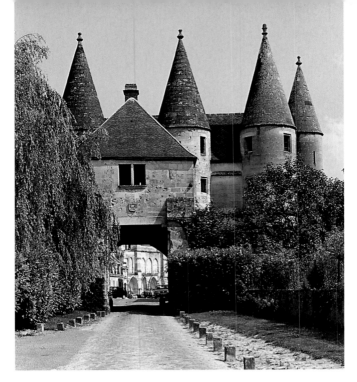

ABOUT NINE MILES SOUTHWEST OF THE EPISCOPAL city of Soissons, in the valley of the Savière River, lies the former Cistercian abbey Longpont, which was once—with eleven granges, several town houses, wine cellars, mills, forests, and fish ponds—one of the richest of the order. It was founded in 1135 by Bernard of Clairvaux at the request of the bishop of Soissons, Josselin de Vierzy. The land was donated by Gérard de Chérizy. The abbey received ample donations from the beginning. The monastery buildings from the twelfth century have not survived. In 1192 the abbot was expressly informed by the general chapter in Cîteaux that he had violated the order's principle of simplicity. Somewhat later a new church was begun. In 1227 thirteen-year-old Louis IX, later Saint Louis, traveled with his mother, Blanche of Castile, to its consecration. The young king found ideas for the construction of the abbey Royaumont that he would establish a year later (see pp. 188–89). Longpont's church was used as a quarry from the time of the Revolution to 1831 and is only a ruin today. At a length of 344 feet (105 m) and a height at the nave of 92 feet (28 m), it was just 26 feet (8 m) shorter and 16 feet (5 m) lower than the cathedral of Soissons, which had been begun a little earlier. The surviving parts of Longpont include the church facade, with gable and a wheel window 33 feet (10 m) in diameter; the southern wall and its buttresses up to the transept; and the west bay of the main block, including some of its vaults and buttresses. Traces of the parts that were carried off can be found on the ground: stumps of piers and fragments of walls.

The Cistercian dictate of plainness was overstepped by this church in particular, since, apart from the lack of a two-tower facade, it represented a second version of the cathedral of Soissons, simplified a little but in certain aspects even more elaborate. The overall layout—a three-nave transept and five-nave east end whose apse, ambulatory, and wreath of chapels formed seven sides of a dodecagon—was entirely in keeping with cathedral architecture. So were the double pier buttresses of the exterior and the three-story construction of the walls in the interior, with nave arcades, triforium (though here it was only a blind triforium), and a tall clerestory. It was, so to speak, a Cistercian cathedral, and it would have successors in Royaumont and elsewhere.

Of the monastery buildings only the kitchen, which has also been described as a calefactory, is well preserved. It is a room with a high chimney on four stocky, round piers, which support long horizontal stone beams—so-called straight arches. They are constructed like window lintels, using an arch brick course of individual hewn stones that interlock and interdigitate on the vertical joints in three rackings. Relieving arches were also introduced above this. This chimney construction is unique in medieval French architecture. Also noteworthy among the buildings at Longpont is the fourteenth-century monastery gate with four round towers that combine to form a small fortification.

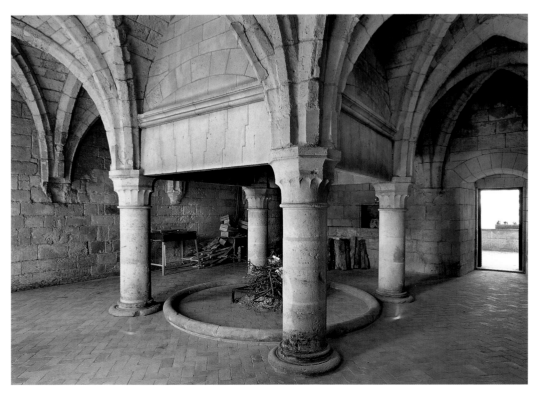

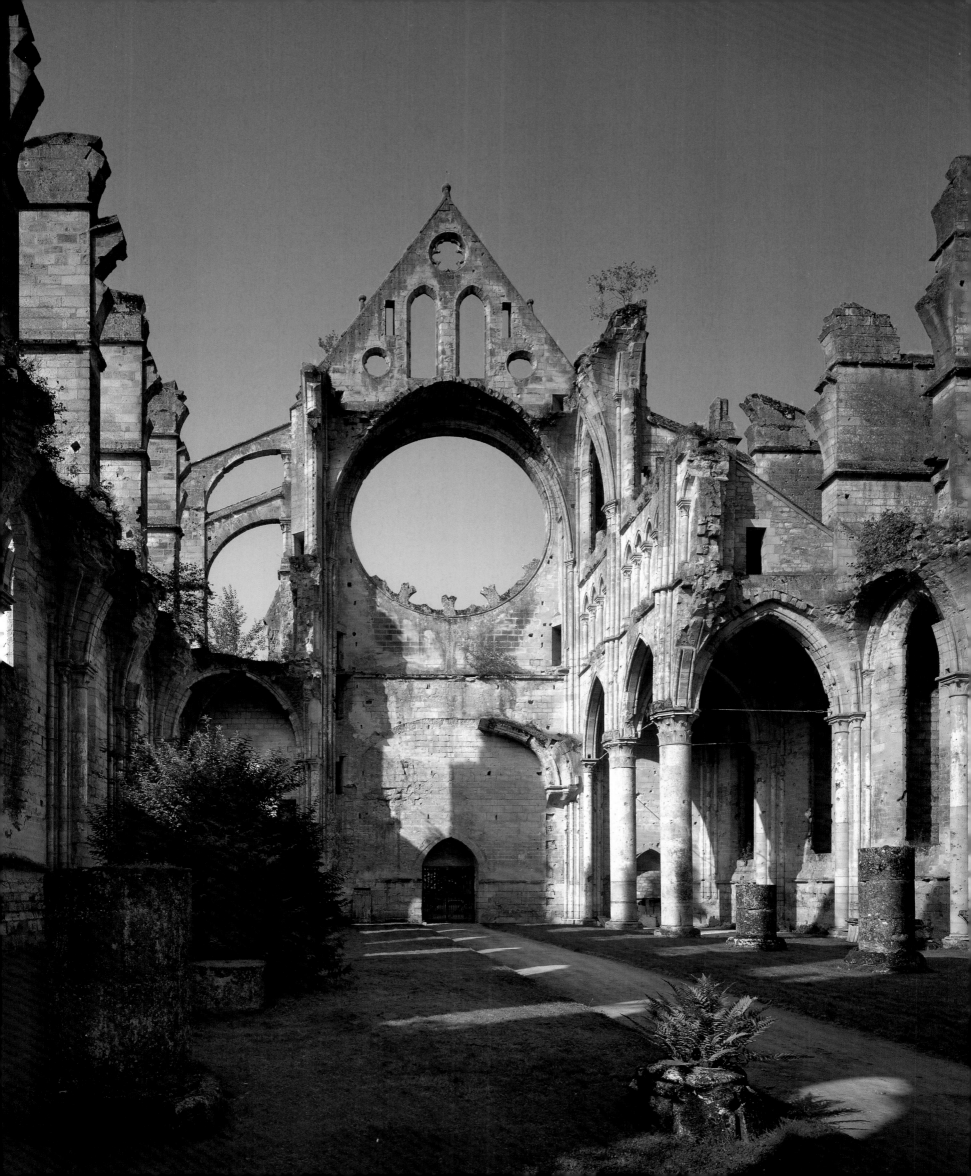

PARIS
ST-MARTIN-DES-CHAMPS,
ST-GERMAIN-DES-PRÉS

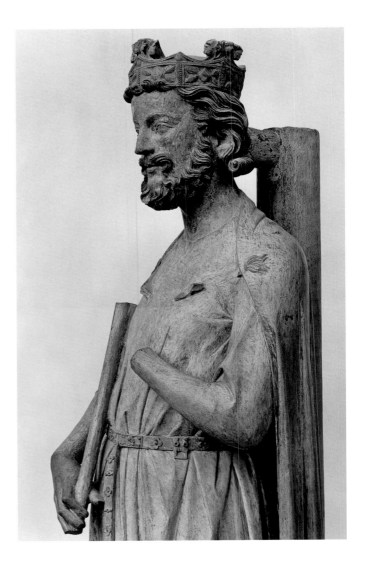

THE FRENCH CAPITAL, WHICH IS MENTIONED FOR the first time in the third century—specifically, as an *oppidum* (town) on the Île-de-Seine by the name of Lutetia—was declared the capital of the Merovingian empire around the end of the fifth century by King Clovis. Thereafter the Merovingians promoted the city; less so the Carolingians. Even in the early period numerous monasteries sprang up on its periphery, including, above all, Sainte-Geneviève, where Clovis was buried, Saint-Germain-des-Prés, Saint-Germain-l'Auxerrois, Saint-Martin-des-Champs, Saint-Gervais, and Saint-Marcel. In the middle of the ninth century it is said there were seventeen monasteries in and around Paris—by comparison, this was one more than in Ravenna and nine more than in Tours, Milan, or Cologne. Small settlements, known as *burgi*, formed around the monasteries on the outskirts of Paris. After

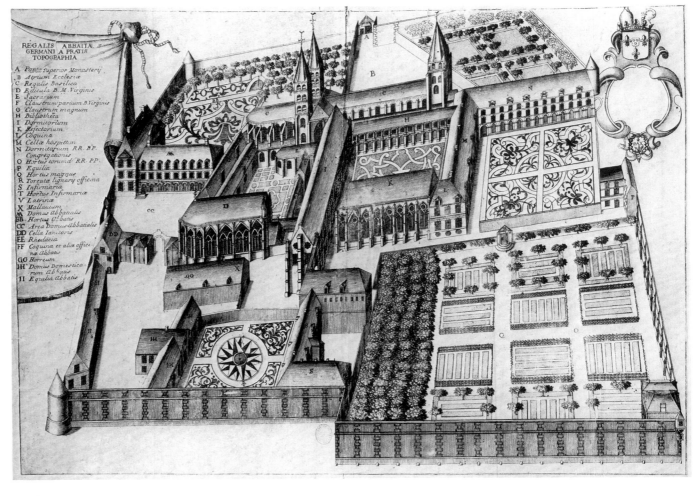

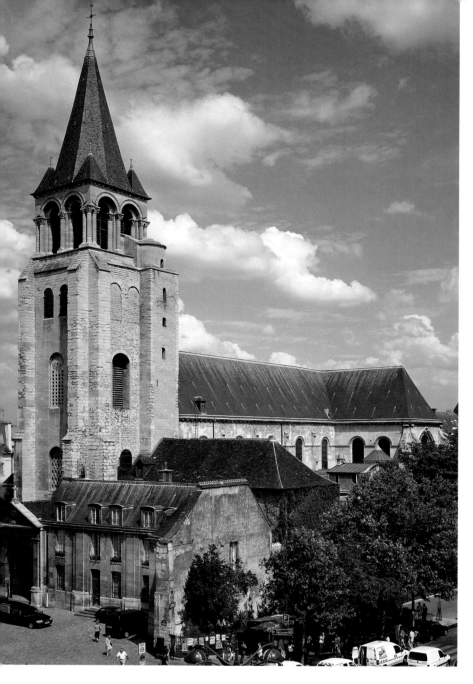

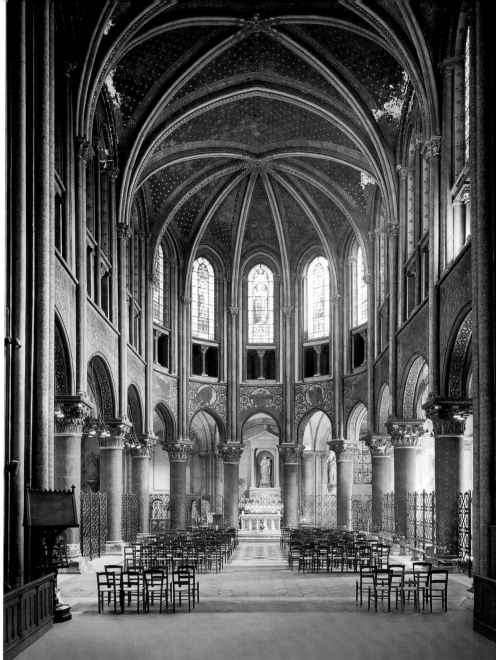

the Capetian kings made Paris the permanent royal residence and the population continued to grow constantly, the city and the *burgi* increasingly grew into one entity.

Saint-Germain-des-Prés was the most important abbey after Sainte-Geneviève. It was founded between 543 and 558 by King Childebert at the instigation of Germain, bishop of Paris, as a royal burial site, and its first patrons were Saint Vincent and the Holy Cross. Only toward the end of the eighth century did its founder, Germain, who had since been canonized, become its patron saint.

Saint-Martin-des-Champs, first mentioned in 710, was probably a more recent founding. It is not known where exactly the monastery was located, since it was destroyed completely by the Normans. It was founded again in 1060 by King Henry I and occupied by canon regulars. Philip I, however, soon transformed the association into a priory of Cluny. It achieved a leading position within the Cluniac association, as it governed twenty-nine other priories and had no fewer than sixty parishes

to appoint. Saint-Martin-des-Champs, which was not incorporated into the city until the late Middle Ages, also had a hospital and a guesthouse.

The church of Saint-Martin-des-Champs was given a new chancel under Prior Hugh (1130–42), shortly before Abbot Suger began construction of the chancel at nearby Saint-Denis. Like Saint-Denis, Saint-Martin-des-Champs also tried out a design with an ambulatory chancel and a wreath of chapels but here bundle piers were used instead of round columns. The geometry of the ground plan of the ambulatory bays is not based on the trapezoidal forms that had long been determinative for Romanesque architecture, but instead made use of triangles and rectangles, which were, moreover, unusually oblique. Nevertheless, the chancel, especially the spacious axial chapel with its highly original cloverleaf-shaped termination, was an important design achievement.

The same is true of the chancel of Saint-Germain-des-Prés. Still standing from the earlier construction

ABOVE LEFT:
West tower, Saint-Germain-des-Prés

ABOVE RIGHT:
View of the chancel, Saint-Germain-des-Prés

phases of this church are the imposing west tower with thick pier buttresses at its corners, dating from around 1000, and the main block, from the second half of the eleventh century but not vaulted until the seventeenth century. The early Gothic chancel was visibly designed in competition with Saint-Denis. It was begun around 1150, when the latter's chancel was already finished. It was consecrated by Pope Alexander III in 1163, the same year that construction of Notre-Dame cathedral began. The chancel of Saint-Germain is also an ambulatory chancel with a radial wreath of chapels, but the architect defiantly ignored Abbot Suger's pathbreaking work and instead oriented his work around the cathedrals of Noyon and Sens: the ambulatory and chapels are related to Noyon; the three-story structure with mock gallery, the paired windows in the clerestory, and the buttresses, to Sens.

Around 1230 a refectory was added to the monastery of Saint-Martin-des-Champs that is unrivaled anywhere; today it serves as a reading room for the library of the Conservatoire des Arts et Métiers. It is, as usual, a two-nave structure with rib vaults and columns, but the columns are so tall and fragile looking that surely every observer asks in astonishment, and rightly so, how these thin columns can support such a vault. Saint-Germain-des-Prés followed suit a little later and had Pierre de Montreuil, who was also active at Saint-Denis and in the transept at Notre-Dame, to construct a new refectory. Here the goal was rich tracery. Beginning around 1245 the same architect also created a Lady chapel parallel to the chancel of the church and east of the cloister. Like Sainte-Chapelle, built soon thereafter, it had a single nave and the construction of the walls consisted of a filigree-thin tracery gallery below and tracery windows above; the whole appearance is of one great glass house with a slightly protruding polygonal apse and two six-part vaults. These two buildings—the major works of the rayonnant style, which can still be seen on seventeenth-century engravings—were torn down when the monastery was closed. Remains of the Lady chapel have been placed in the green space near the west tower (although incorrectly reconstructed), and the portal is now found in the Musée de Cluny.

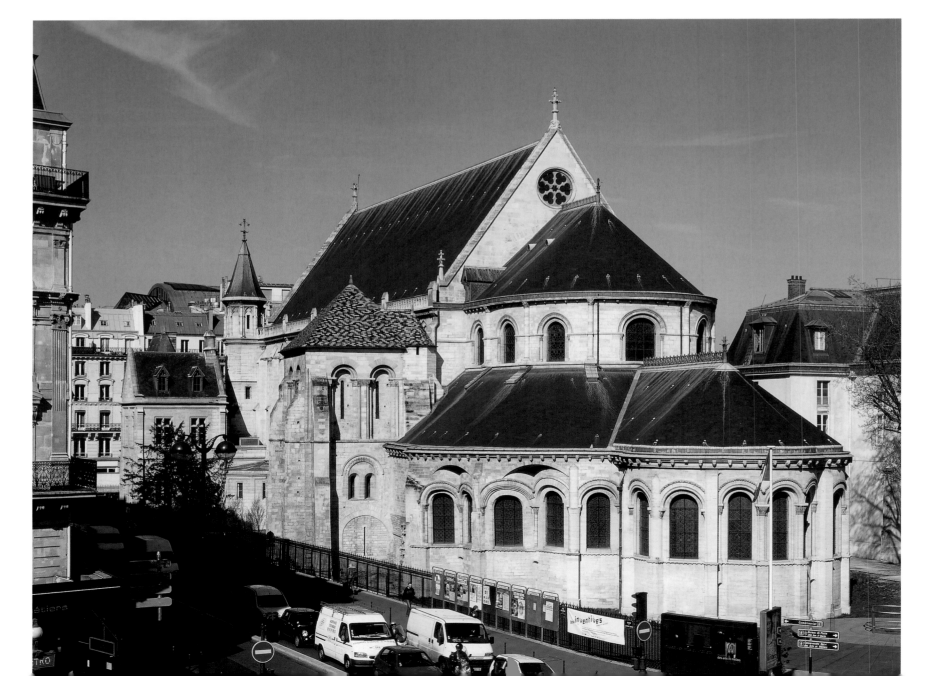

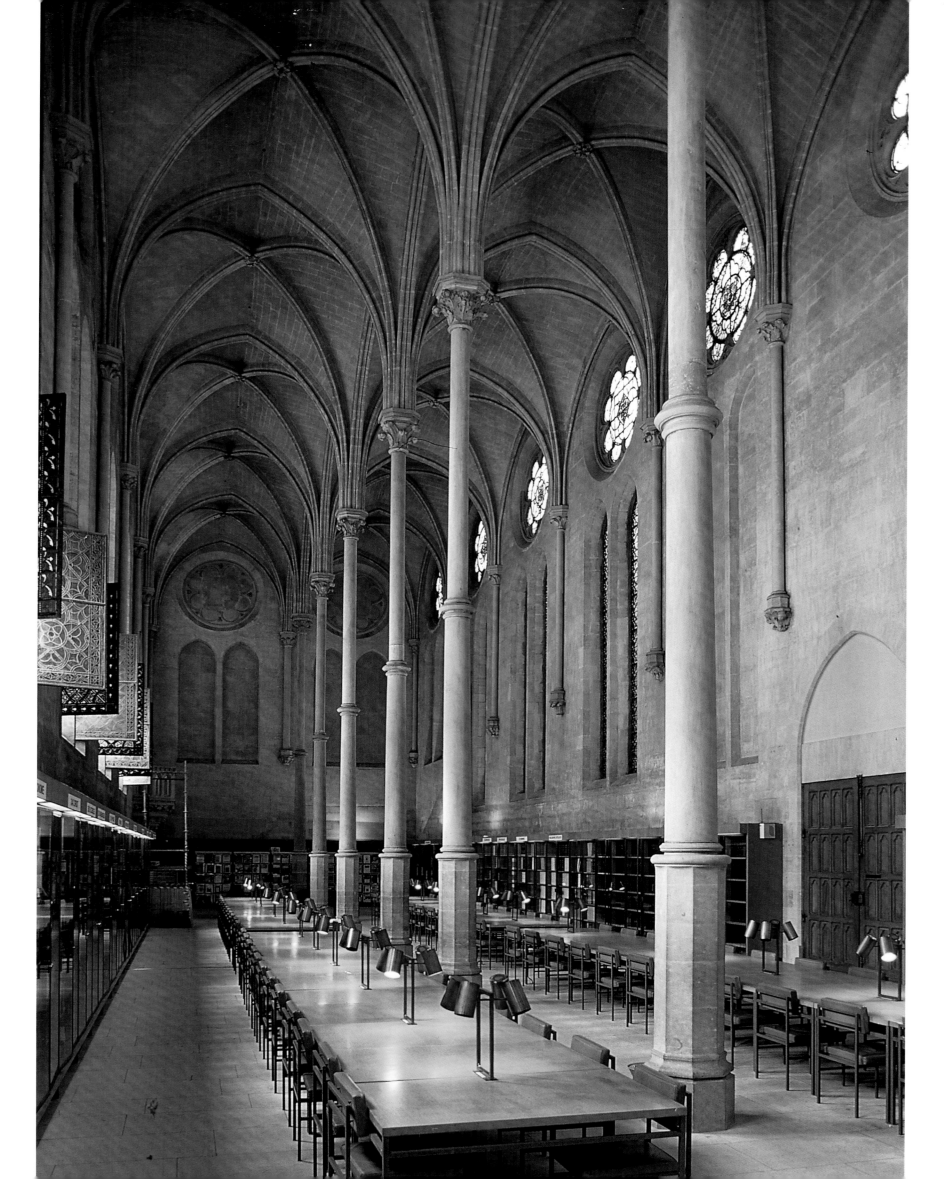

SAINT-DENIS

TOP RIGHT:
West façade, Saint-Denis

BOTTOM LEFT:
Tombs of Philip the Bold and Philip the Fair

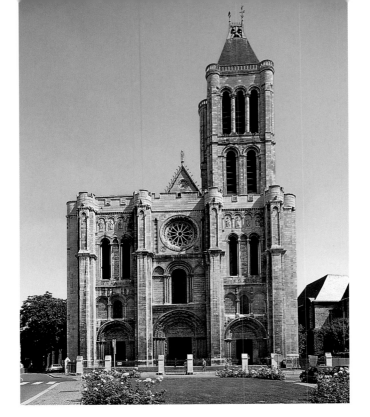

THE BENEDICTINE ABBEY SAINT-DENIS, NORTH of the gates of Paris, was one of France's holiest shrines, as the burial site of Saint Denis (Dionysius), who had been bishop of Paris and died as a martyr, and as the place where the royal insignia were kept. According to later legend, Denis; the biblical Dionysius the Areopagite, a pupil of Paul; and a Syrian philosopher of the fifth and sixth centuries named Dionysius were one and the same person. A first church was built around the grave of Dionysius around 475, which then became the burial site of the Merovingian rulers, including King Dagobert I (639). Around the middle of the seventh century a monastic community, which enjoyed the privilege of immunity, formed there. In the eighth century, under Abbot Fulrad, who was also court chaplain, Saint-Denis became the privileged monastery of the Carolingian dynasty, after Pope Stephen II consecrated Pépin III and his sons, Carloman and Charlemagne, kings, which marked the final supersession of the Merovingian dynasty by the Carolingian. Fulrad built a basilica with a transept and an eastern ring crypt for the patron saint, Denis. The consecration took place in 775. According to later legend King Dagobert was the architect, and Christ himself consecrated the church. King Pépin was buried in the west end; later Emperor Charles the Bald, who had been a lay abbot at Saint-Denis, was buried in the chancel.

The rule of Abbot Suger (1122–51) resulted in a new

flowering; he was one of the great abbots of the Middle Ages. He was even granted regency of the empire when King Louis VII took part in the Second Crusade in 1147–49. Because the church was too small for the immense crowds of pilgrims, Suger expanded it first with a two-tower west end (c. 1135–40) and then with a new chancel (1140–44). The west end includes three large-scale figurative portals that would serve as the prototype for cathedral portals to come. The north tower of the facade had to be removed in the nineteenth century. Suger's chancel is considered the founding structure of the Gothic and specifically the Gothic cathedral. All that survives is the ambulatory with its wreath of chapels. The new aspects of its conception included, first, the surrounding wreath of large stained-glass windows and, second, the transparence of the architecture, thanks to slender supports and walls that are dissolved by means of openings and the framing system. In his writings on the new building Suger emphasized the importance of the light (*lux continua*) and the windows (*sacrae vitreae*) for an understanding of God through the effect of light. The idea of reaching a higher understanding in anagogic steps by means of light is one that already permeated the ideas of the philosopher Dionysius. For Suger light was a decisive element in the construction of the church.

This was even more true a century later when, beginning in 1231, in close collaboration between Abbot Eudes Clément (Odo) and King Louis IX, a new cathedral-like building with tracery windows, windowed triforia, and large rose windows in the transept was built. It was a foundational building of the rayonnant, the "radiant" style. In 1247 Pierre de Montreuil, who was the architect of the south transept facade of Notre-Dame de Paris, is

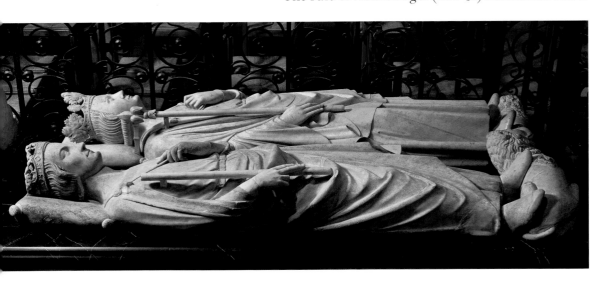

mentioned as the *cementarius* here. The plan for Saint-Denis was probably by another, unknown architect, however, who clearly also designed the cathedral of Troyes, which was built around the same time.

Saint-Denis was also one of France's holiest shrines because nearly all the French kings since the Merovingians and Carolingians were buried there. In 1264, perhaps at the instigation of Louis the Pious, the tomb reliefs of sixteen previous kings and queens were executed anew and placed in the crossing, the Carolingians in the south and the Capetians in the north. The tomb slabs for Philip the Bold (1285) and Philip the Fair (1314) are of the same type. Most of the tomb monuments

were not commissioned during the lifetimes of those depicted but later, by their successors. By the time of the French Revolution forty-six kings, thirty-two queens, sixty-three princes and princesses, and ten illustrious figures of the kingdom had been buried there. From the time of Henry IV the Bourbons were buried in the crypt without tomb monuments. In 1793 revolutionaries tossed the bones into mass graves and destroyed several monuments, such as that of Hugh Capet. The gold-chased tomb figure of Louis the Pious was destroyed in the Hundred Years' War. Seventy-two recumbent tomb figures have survived, by far the largest ensemble of royal tomb monuments in Europe.

BELOW:
Chancel ambulatory of the Suger building, Saint-Denis, with the thirteenth-century upper choir

PAGE 200:
Rose window of the south transept

PAGE 201:
Upper choir and north transept

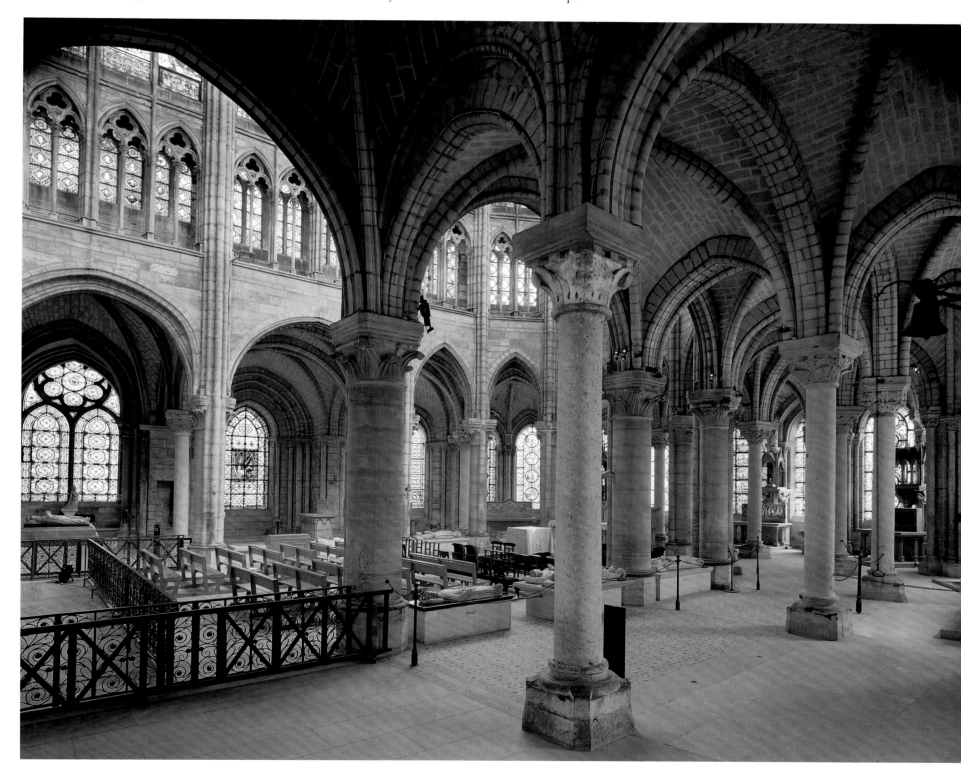

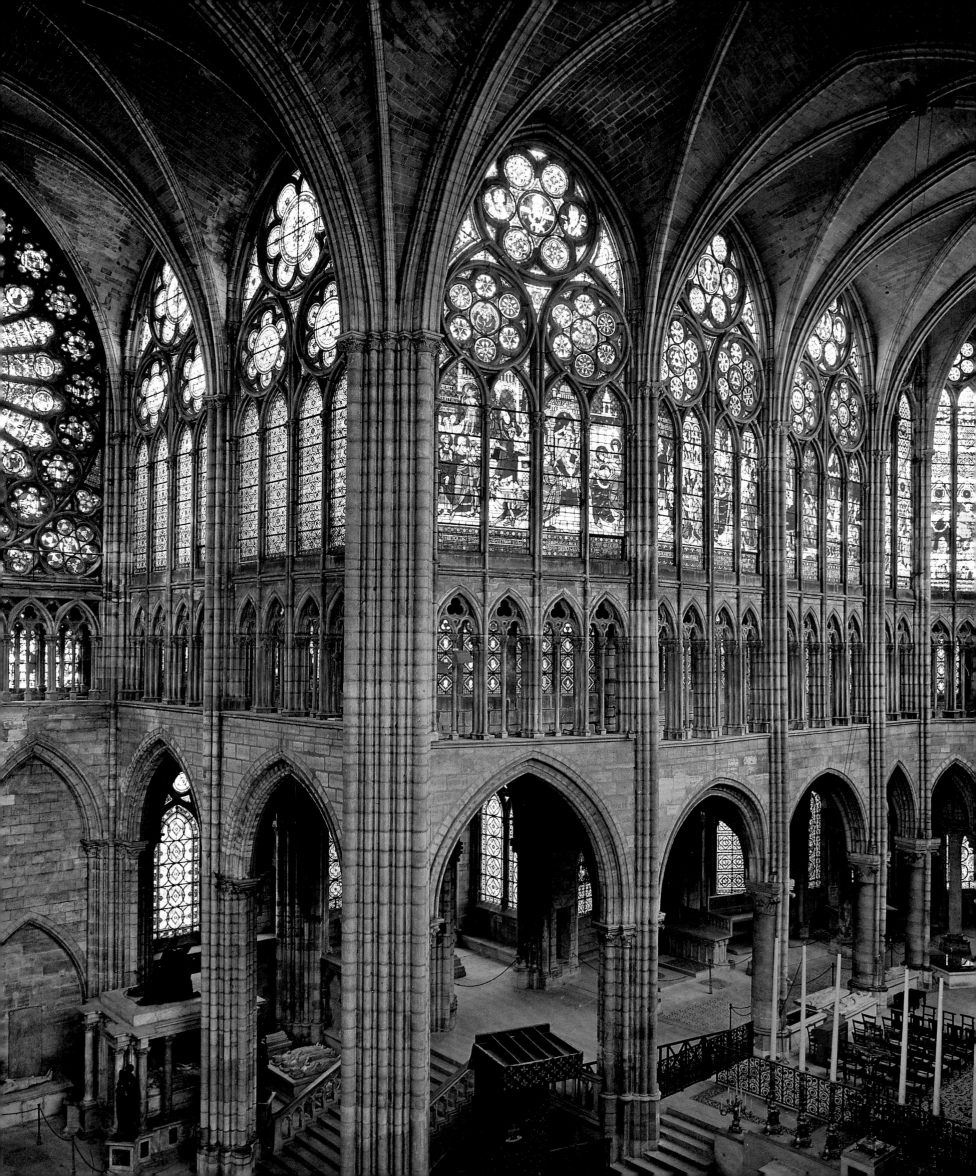

REIMS
SAINT-REMI

REIMS, SEAT OF AN ARCHBISHOP, IS THE CITY where French kings were crowned. It had two important abbeys that honored former bishops of Reims: Saint-Nicaise, demolished in 1789, and Saint-Remi, whose church is still standing. It was the burial site of Saint Remigius, who anointed Clovis, king of the Franks, and for that received an ampoule of holy anointing oil from heaven. This ampoule lent a sacramental solemnity to the anointing of later French kings.

The present church Saint-Remi was built in two separate phases: the first, from about 1007 to the consecration by Pope Leo IX in 1049, included an unusually spacious basilica with galleries, three-nave transept, and ambulatory chancel—an early example for the later widespread type of the pilgrimage church. In the second phase, from about 1165 onward, Abbot Pierre de Celles added a facade and an ambulatory chancel with a wreath of chapels—much as Abbot Suger had done shortly before at Saint-Denis. In addition, the Romanesque nave was given a vault, and the walls received a system of projections and blind pointed arches.

The chancel is a masterpiece of the early Gothic. In the interior the structure is, like that of several cathedrals from this period, composed of four stories: nave arcades, galleries, triforia, and clerestory. The ambulatory, which opens up onto the chapels through an arrangement of columns articulated in threes, offers genuine fireworks of inventive imagination in all the details. This is also true of the exterior structure, with its rhythmically terraced three-light windows of the galleries and its highly original buttresses. The high quality must have been admired, for in the church Notre-Dame-en-Vaux, in Châlons-sur-Marne, the chancel was imitated almost identically.

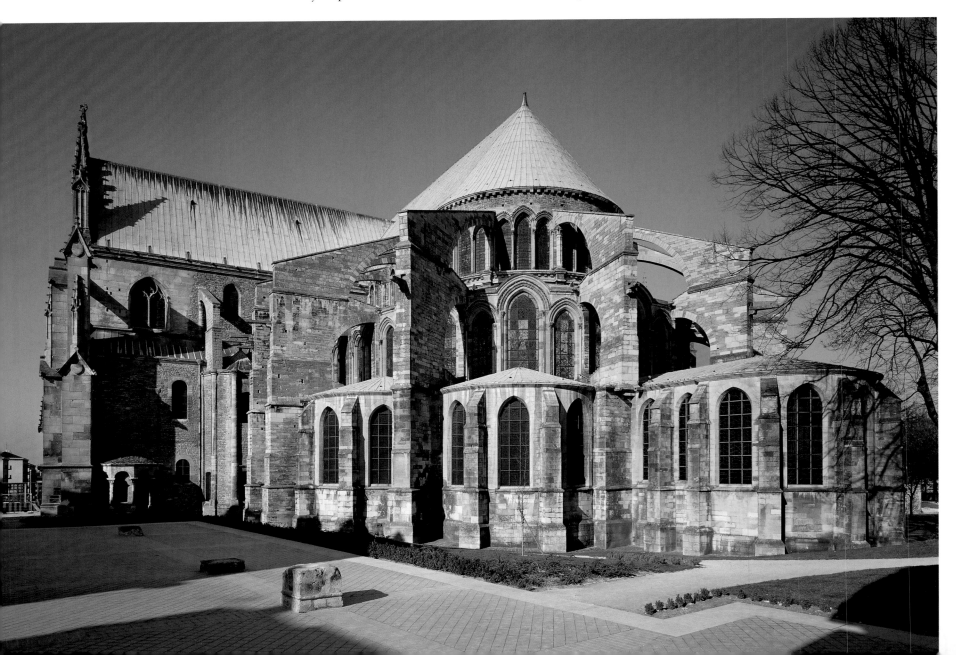

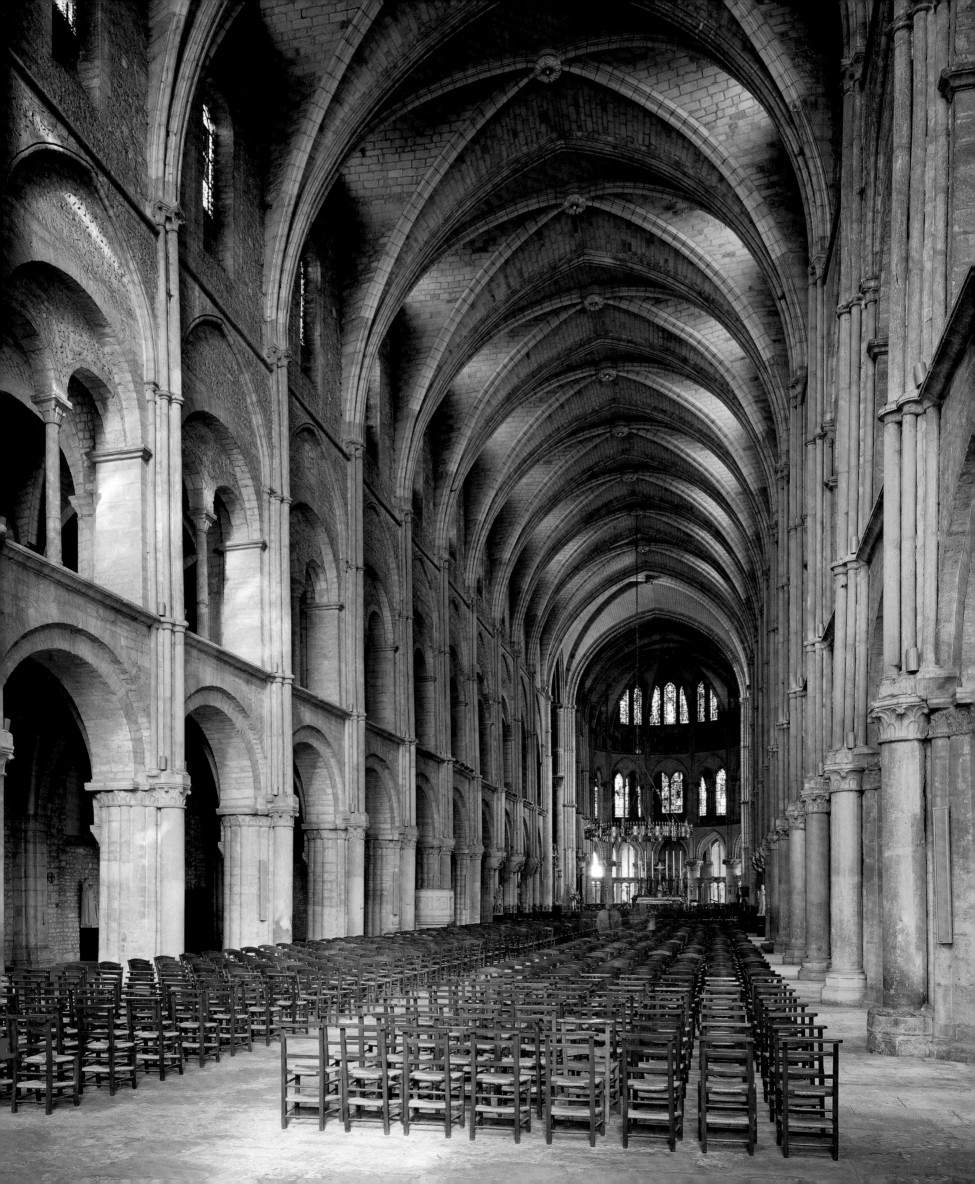

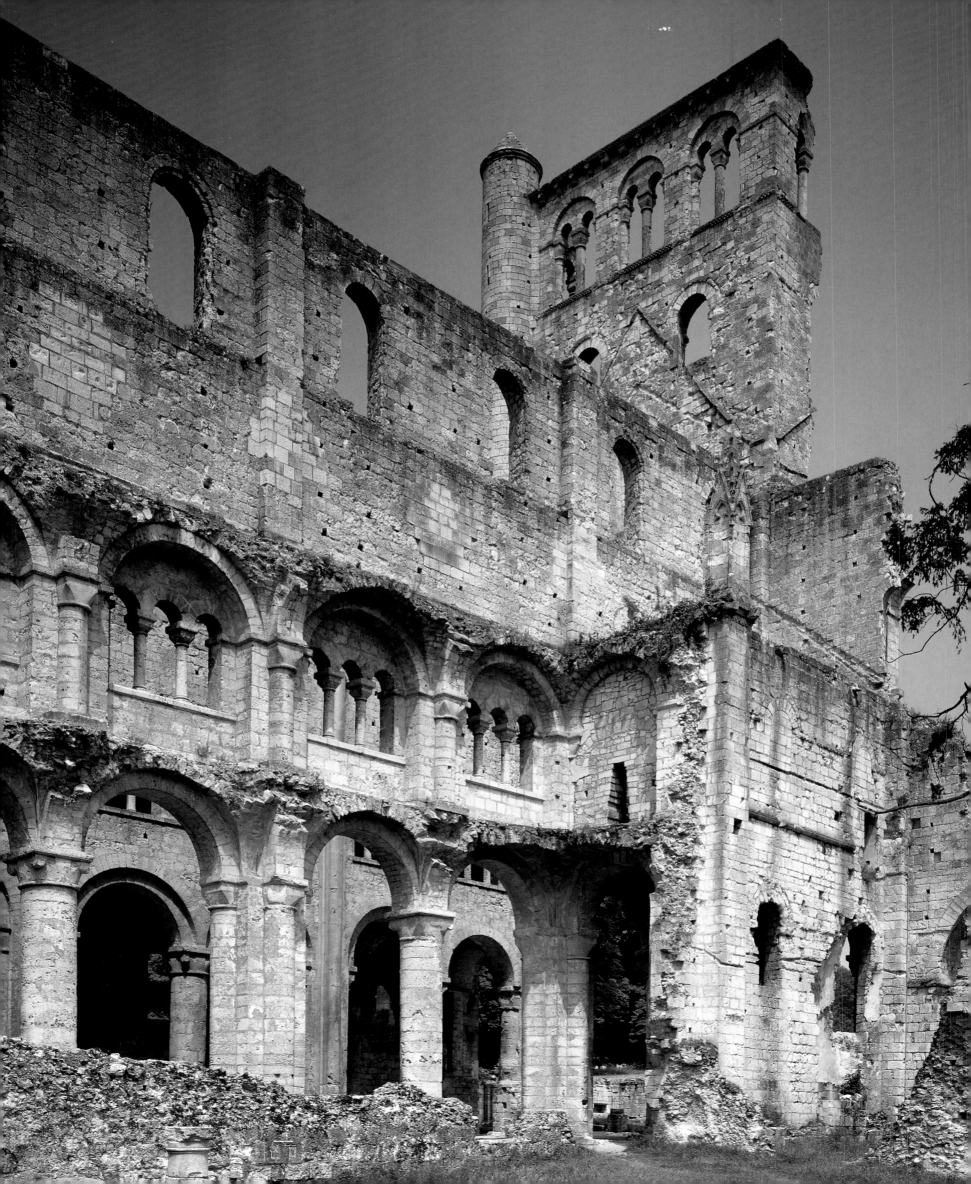

THE FORMER BENEDICTINE ABBEY JUMIÈGES, ancient Gemmeticum, dates back to Saint Philibert. He had lived at the court of the Merovingian king Dagobert and then became a monk. Together with his friend Wandrille he moved to the archdiocese of Rouen, where in 649 Wandrille founded the monastery Fontenelle, now known as Saint-Wandrille, and Philibert founded Jumièges on a loop of the Seine below Rouen in 654. Eight hundred are said to have been living there even during Philibert's lifetime; his bones were later brought to Tournus in Burgundy (see pp. 163–65). Under the Carolingian rulers Jumièges was one of the largest and most favored monasteries of the realm.

Jumièges succumbed to the Norman invasion, which began in 841, and the monks left the site. After the Normans had established their own duchy of Normandy, however, its second duke, William Longsword, reestablished the monastery around 940 and settled monks from Poitiers there. But only after the reforms of William of Volpiano, who had been called to Normandy in 1004 by Duke Richard II and had brought the *consuetudines* of Cluny, did the monastery flower again. William's pupil Thierry, abbot of Jumièges and Mont-Saint-Michel concurrently, was planning to build a new church before 1030, but its foundation was not begun until 1040, under Abbot Robert Champart. After England was conquered by the Normans in 1066 Jumièges provided the abbots for the important English abbeys of Abingdon, Ely, Malmesbury, and Westminster. By 1067 the church in Jumièges was consecrated, and William the Conqueror, now king of England, traveled there expressly for the occasion. When the monastery was closed in 1790, the church was used as a quarry; they went so far as to blast the chancel, before a new owner put a stop to the demolition in 1824.

The church, now an impressive ruin, is constructed entirely of white limestone ashlar. After the abbey churches of Bernay and Mont-Saint-Michel, which were begun twenty years earlier, it is the third largest Romanesque building in Normandy. It was originally a three-nave basilica with galleries, a transept, and an ambulatory chancel with no radial chapels. The nave had a flat roof; the side aisles and galleries had quadripartite groin vaults. In the fifteenth century the chancel was replaced by a new Gothic structure with a wreath of chapels. The entire east end has disappeared, down to its foundation. The remains still standing include the western wall of the transept, the west side of the crossing tower, the nave without its roof, and parts of the side aisles and galleries. Most of the columns are missing from the gallery

JUMIÈGES

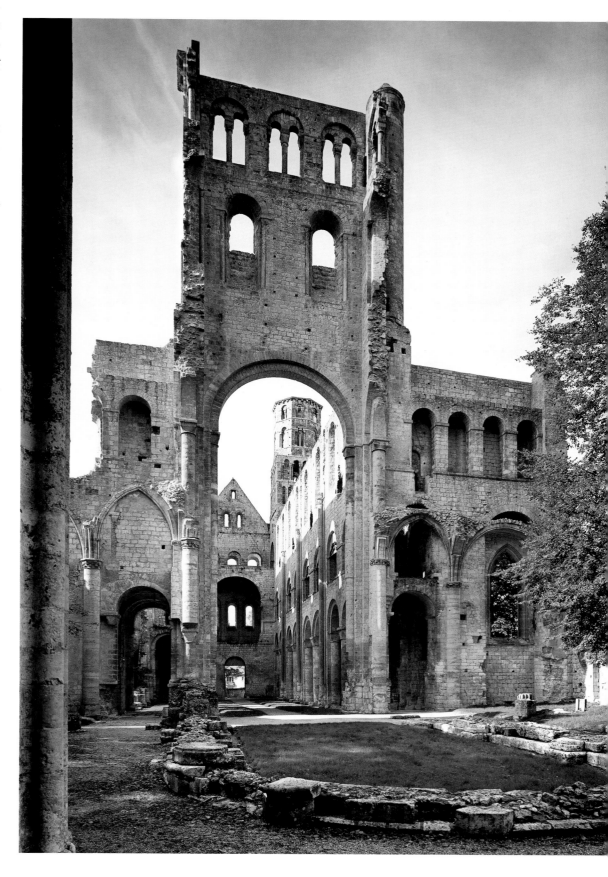

openings, which consist of a tripartite arcade within a round arch. The west facade is the best-preserved part, with a brusquely aloof, angularly protruding middle section that conceals an interior gallery and richly articulated towers that terminate in octagons.

The quadratic crossing tower was, as its remains reveal, once a steep shaft that was open to the crossing, with two stacked rows of windows, resembling a gigantic lantern. The nave, eighty-two feet (25 m) high and just thirty-six feet (11 m) wide, is the tallest, steepest, and narrowest of the Norman Romanesque. The three-story walls, whose nave arcades alternate main and intermediary piers, have strong projections on the main pillars that pair off sections of the wall—a key early stage in the evolution of the double bay of the bound system in later Romanesque vault construction.

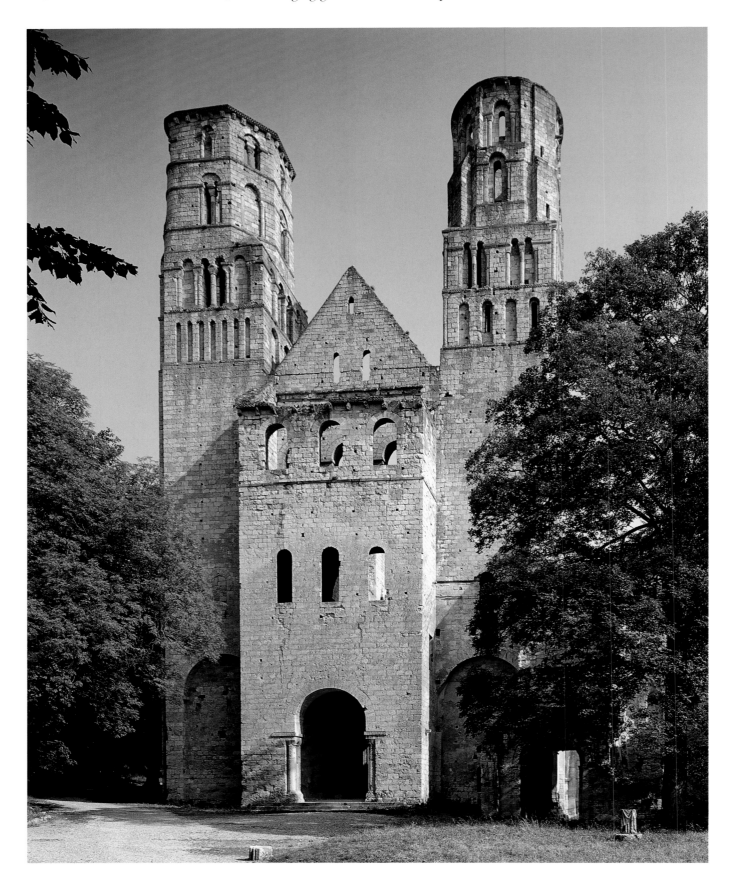

SAINT-ÉTIENNE, SAINTE-TRINITÉ

CAEN, THE FORMER CAPITAL OF NORMANDY, lies on the Orne stream, near the coast along the English Channel, not far from the much older episcopal city of Bayeaux, which dates back to Roman times. Caen, by contrast, was at first just a ducal domain under the Normans, then a market with a port and an annual fair. Duke William II finally raised its status to that of a town, before his conquest of England. He had a fortress built on the plateau above the river, before which the city was laid out: Bourg le Duc, later Bourg le Roi. William and his wife, Matilda, the daughter of the powerful count Baldwin V of Flanders, each founded an abbey before the gates of the town: William's was the monastery Abbaye-aux-Hommes Saint-Étienne and Matilda's was the convent Abbaye-aux-Dames Sainte-Trinité, just a mile and a quarter distant to the east. The occasion for this double founding was their wedding: at the Council of Reims in 1049 Pope Leo IX had prohibited their marriage for reasons of consanguinity but probably for political reasons as well. The wedding took place in 1052 nevertheless, which led to a sharp rift with Rome. Reconciliation came only in 1060 under Leo's successor, Nicholas II, but apparently with the stipulation that the ducal couple had to found two monasteries. They did so without delay and decreed that the newly founded monasteries would be their burial sites. William was buried in Saint-Étienne in 1087, and Matilda in the chancel of Sainte-Trinité in 1083. In 1063 William appointed Lanfranc abbot of Saint-Étienne; Lanfranc had been prior and director of the school at the monastery Le Bec Hellouin near Evreux. In 1070 Lanfranc left Caen to become archbishop of Canterbury.

The construction of Saint-Étienne, which probably began soon after the monastery was founded, progressed quickly, thanks to generous income from England, which William ensured after the conquest. The chancel was consecrated by 1073; in 1077 the east end of the main block followed; and in 1081 the west end. The two-tower facade was built immediately thereafter. Together with the crossing tower, which collapsed in 1566, the church had three towers. The east end was originally a tripartite staggered choir, comparable to that of the church Saint-Nicolas in Caen, built by the same architects. The crossing tower, a quadratic shaft like the one at Jumièges, is open toward the church. These towers became the models for numerous similar towers in England. The main block introduced the innovation over the gallery church of Jumiège, built two decades earlier, that the galleries were now considerably more important, with arcades opening onto the

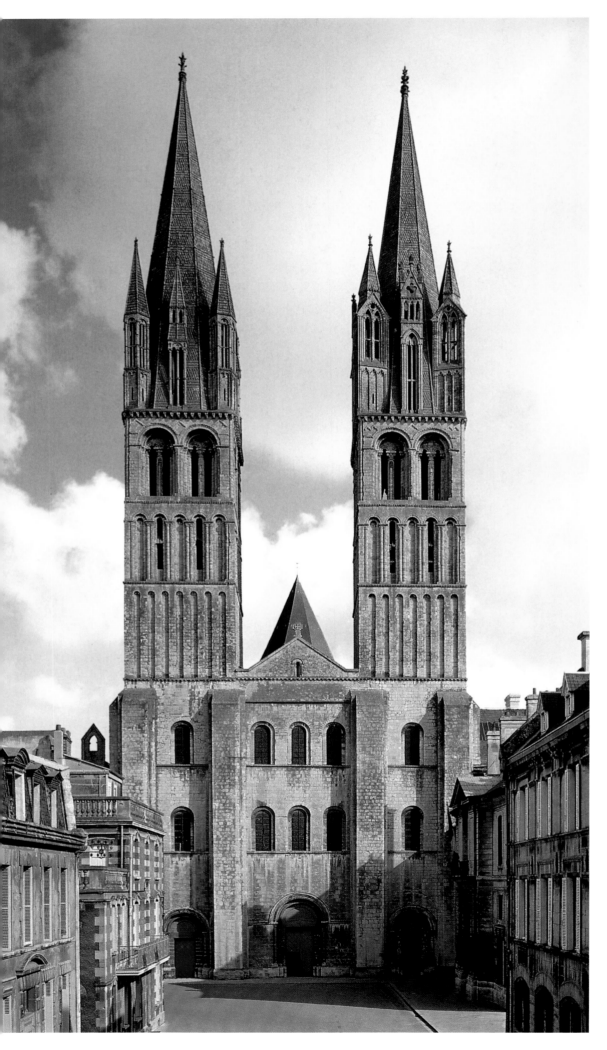

nave that were the same height and similar in form to the nave arcades. At Jumièges the galleries had been much smaller and the openings were screened by tripartite arcades. The walls of Saint-Étienne's nave resemble a two-story aqueduct, topped by a clerestory; in front of the window wall in the clerestory there was a narrow walkway with a quadripartite arcade in front of it. By means of wall projections, as at Jumièges, each pair of bays was grouped to form a double bay. Although the side aisles and galleries had vaults, the nave had a flat ceiling. This design, with large galleries and a walkway in the clerestory, would soon be very influential in England and be increasingly elaborated. Thus Saint-Étienne became the founding building of the large-scale Norman architecture there.

Around 1120 the main block was significantly altered: rampant barrel vaults were added in the galleries, and the present six-bay rib vault replaced the flat ceiling in the nave. The model for the vaults was the Norman cathedral of Durham, in northern England, where, from about 1193 to 1100, in an almost unprecedented pioneering achievement, the vaults of the upper choir were separated by ribs into six bays. The engaged pillar system of the walls had earlier been given two quadripartite rib vaults over each double bay. The vaults of the upper choir of Durham, which within about a century were so dilapidated that they had to be replaced by the vaults that survive today, were the earliest large-scale rib vaults in Europe. In England they found no followers, but they did in Caen on the continent. From the vaults there it is possible to imagine what those at Durham must originally have looked like.

The west end of Saint-Étienne was also very important, as it is one of the earliest two-tower facades in which the whole focus is on a pair of high-soaring towers. Articulated below only by pier buttresses that reveal on the exterior the width of the interior aisles, by molding, and by windows, the richness of the facade's articulation increases as one moves up the three stories of the towers to the open arcades. The two steeples, each with its own style of corner tabernacles, were not added until the early thirteenth century. The three portals carry virtually no weight at all within the overall facade.

Quite the reverse is true of the facade of Sainte-Trinité, which was built a little later. There the three portals are so large that they establish their own theme within the facade. At Saint-Denis somewhat later, and especially in the Gothic cathedrals of the subsequent period, the portals would become a major theme. That development begins here. Today, the towers of Sainte-

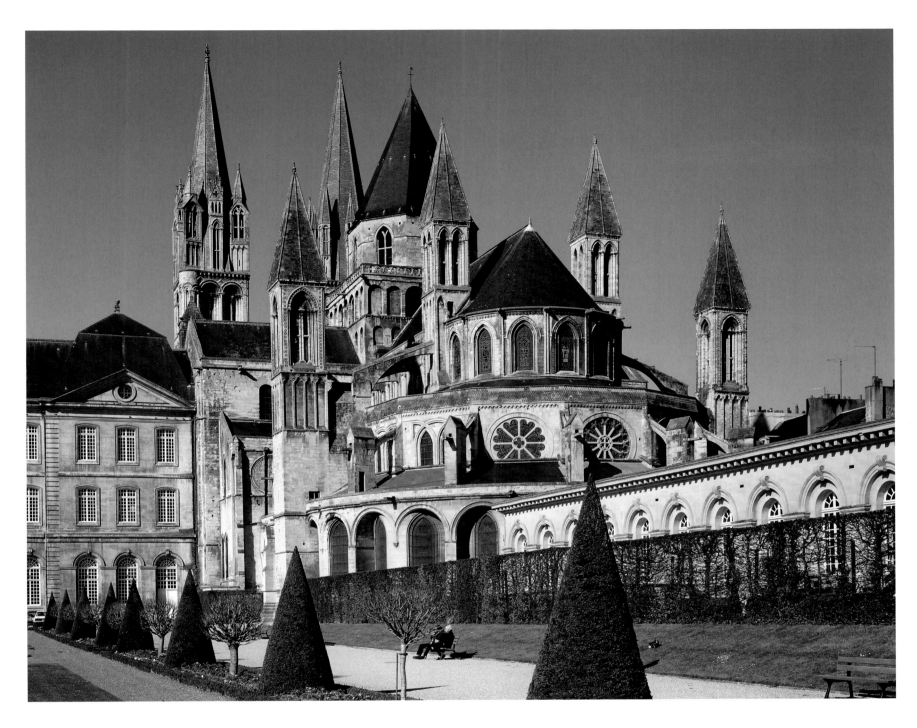

Trinité have terminations built in the eighteenth century. Originally they had an additional story and steeples. It was thus much more closely related to Saint-Étienne, and from a distance the two churches looked like a pair when they were founded.

The only original parts of the interior of Sainte-Trinité are the chancel, to which a new apse with two-story arcades was added in the early twelfth century, and the nave arcades in the main block. The upper structure, with a blind triforium and staggered tripartite arcades in the clerestory, was not built until 1120 or 1130, and it was designed from the start to have six-bay rib vaulting. Despite the number of ribs, however, the vaults have not six crowns but four, because in the middle of the span the transversal rib supports not the vault, but a vertical suspended wall that leads up to the crown. This is strangely illogical, but it does nothing to weaken the powerful impression this architecture creates.

Probably beginning in the late twelfth century (dates have not been recorded) Saint-Étienne received a new ambulatory chancel with galleries and a wreath of chapels that is one of the great achievements of the early French Gothic. The exterior, with four slender towers, wheel windows in the galleries, and an arcade on the ground floor that integrates the chapels into a large semicircle, offers one of the greatest chancel prospects of the Gothic, and the effect is heightened by the western towers and the crossing tower, which was supplemented in the seventeenth century, though it was once much taller. The architect of the chancel was honored with burial in the apse, where an inscription memorializes his name, Guillelmus, and his achievement.

OPPOSITE PAGE:
West facade, Saint-Étienne

ABOVE:
Exterior of early Gothic chancel

PAGE 210:
Interior of the chancel

PAGE 211:
Nave, facing east

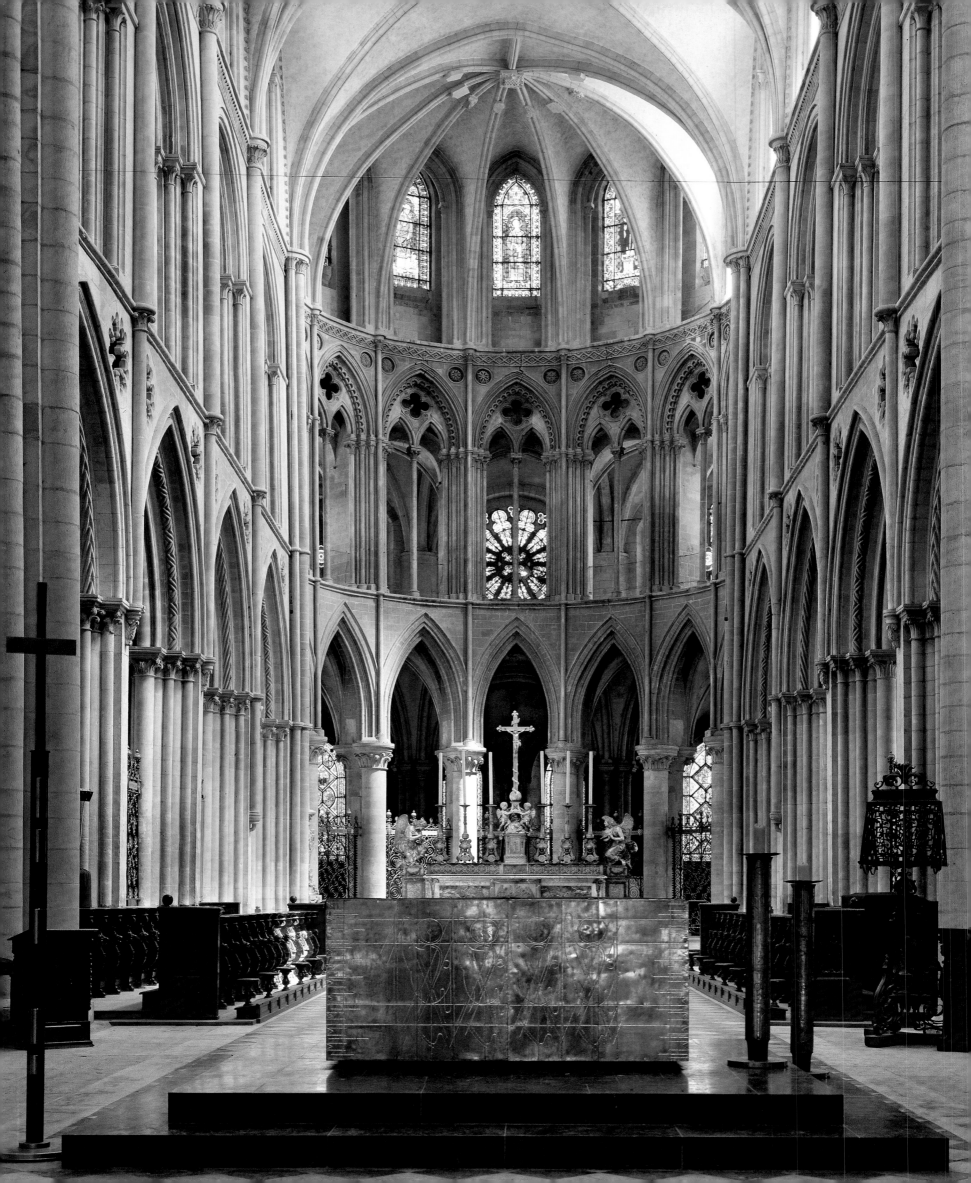

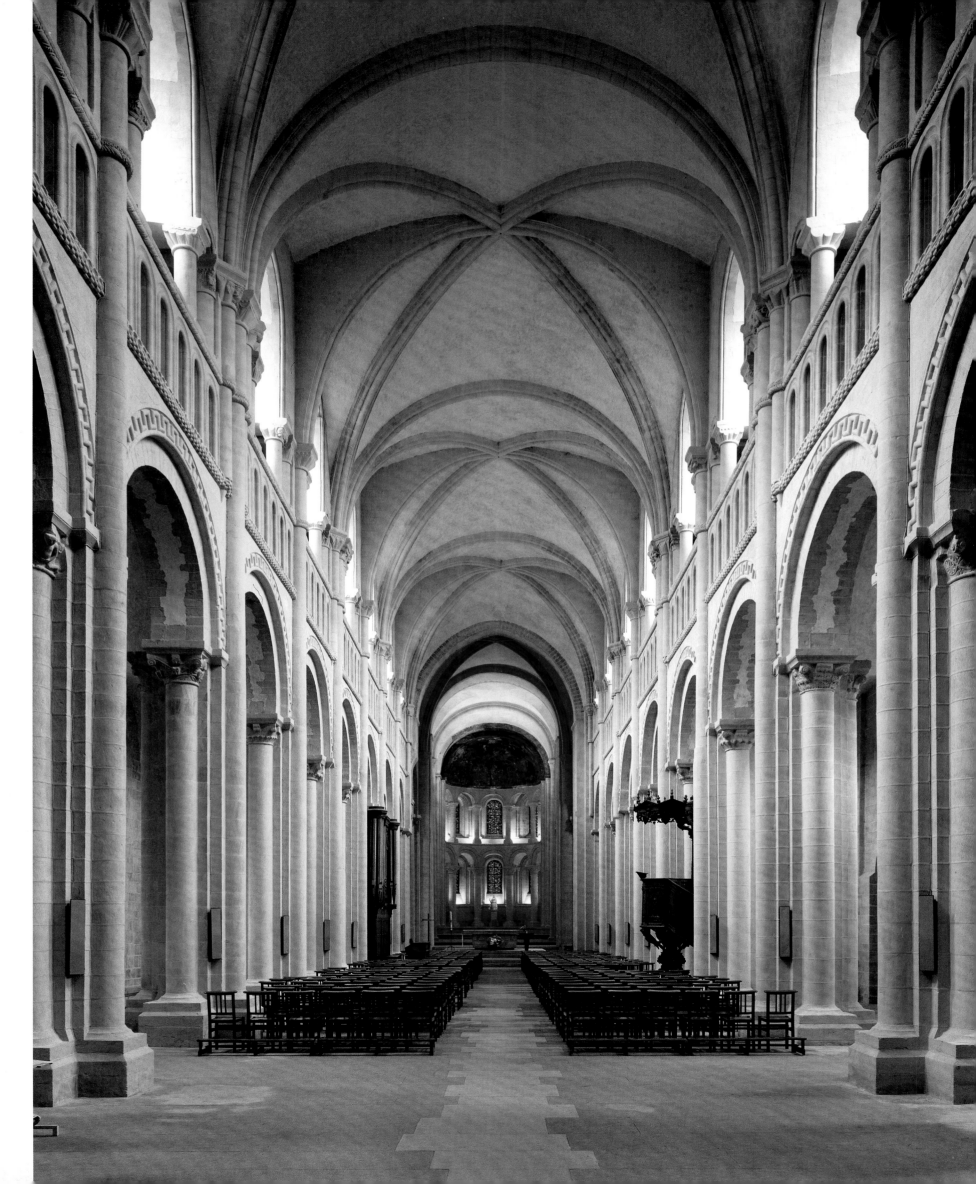

MONT-SAINT-MICHEL

Europe's greatest fortress monastery, praised by many as one of the world's wonders, is Mont-Saint-Michel, on the Atlantic coast, on the border between Normandy and Brittany. The mountain is a conical formation of granite about 260 feet (80 m) high. It was once surrounded by forest, but in the early Middle Ages a violent storm's flood transformed the land into a mud flat with treacherous quicksand. On the craggy mountain, which was an ancient Celtic burial site, Bishop Aubert of Avranches placed a shrine to the Archangel Michael in 708, for which he had relics brought from Monte Gargano in Apulia, the center of Michael's cult. At that time twelve canons were also settled on the mountain. But in 966 Richard I, duke of Normandy, replaced the canons with a Benedictine convention from the monastery Saint-Wandrille, under Abbot Maynard. Then began the systematic conversion of the mountain into a fortress monastery and stronghold. Soon there were pilgrimages to Mont-Saint-Michel that brought the monastery income. From the time Duke William II conquered England in 1066, Normandy, which was actually a fief of the French crown, effectively belonged to England. When the French king

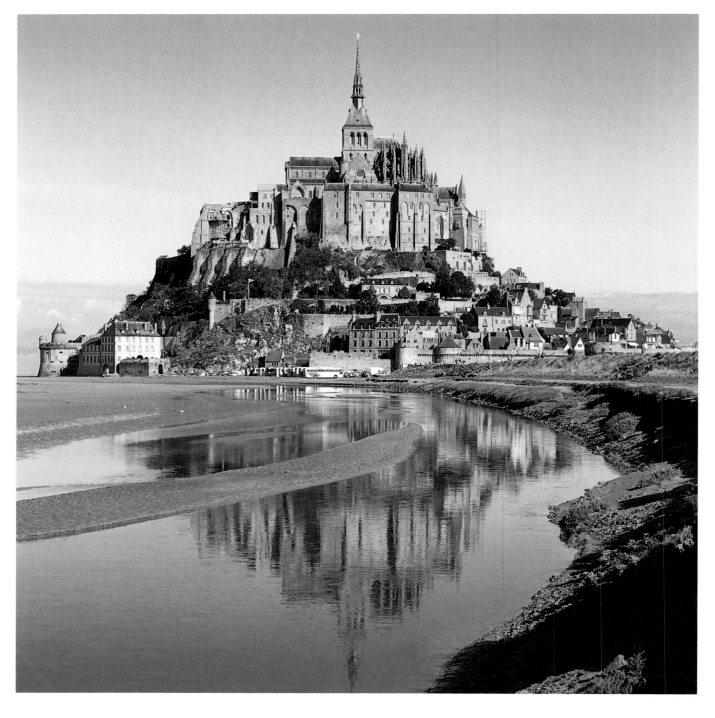

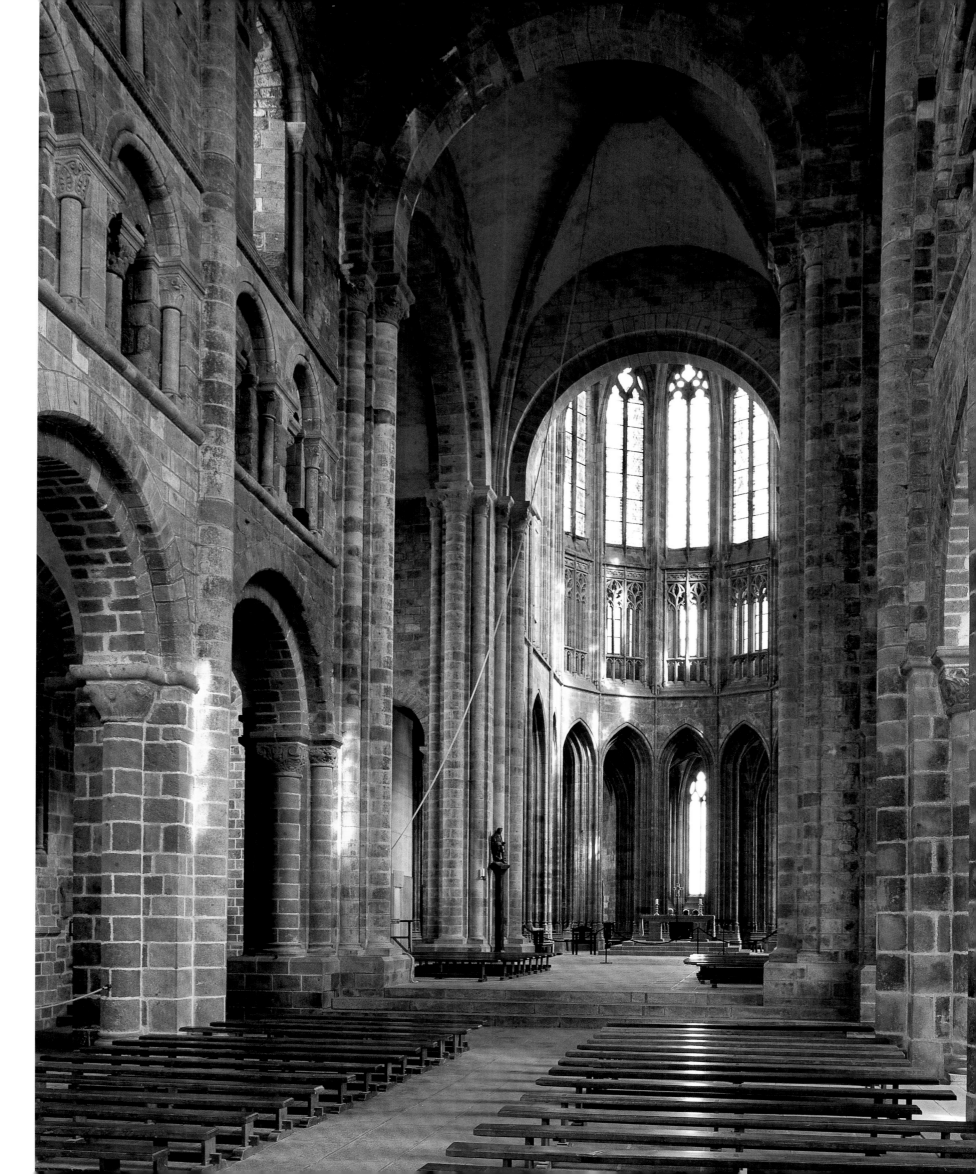

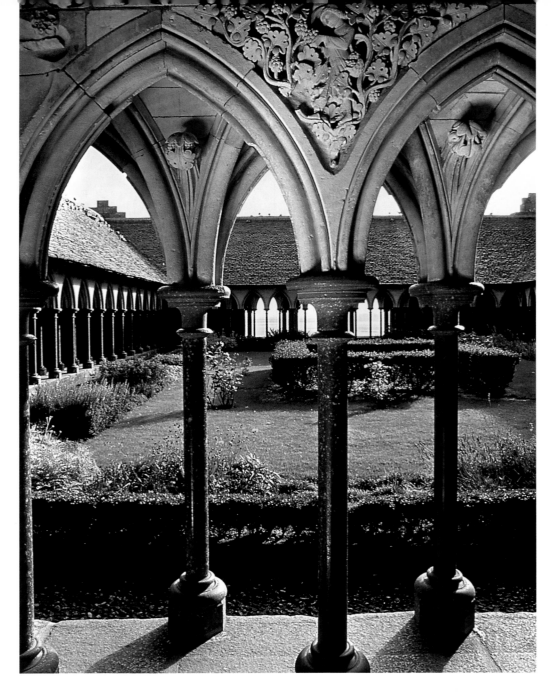

managed to hold the fortress and even captured two heavy cannons in a sortie. Only in 1450 did the English withdraw and abandon their base on Tombelaine.

The history of the construction of Mont-Saint-Michel is extraordinarily complicated. The site was repeatedly altered and expanded into the late Gothic era. Because the natural area was not large enough, it became necessary to build up enormous substructures from below, which provided space on several floors for the requisite rooms and halls. Parts of buildings collapsed many times, because walls slipped down or because the construction of the substructures had been too daring. The building material is granite almost throughout.

In the course of the reform of the monasteries that Duke Richard II carried out with William of Volpiano, Abbot Hildebert of the Norman monastery Fécamp began a large Romanesque church with transept and ambulatory chancel. The main block covered the older church, which thus became a lower church that is now known as Notre-Dame-sous-Terre. Under the transept arms there were also two rooms for rites: the Martin crypt to the north and the Chapelle des Trente Cierges (Chapel of thirty candles) to the south. The main block is one of the greatest achievements of early Norman architecture. The three-story structure of the walls in the nave is united axis by axis by means of blind arcades that stretch over the nave arcades, the openings of the galleries, and the clerestory windows like an enormous order—a solution that gives the walls a powerful relief and that is related to the contemporaneous nave of the cathedral in Speyer. The main block, which now comprises just four bays, was originally three bays longer. In 1184 a two-tower facade was added. This west end was torn down after a fire in 1776, in favor of the present terrace. Hence the crossing tower was the only one left on the church. In its present form the crossing tower dates from the late nineteenth century, but there was a crossing tower in the Middle Ages that was repeatedly struck by lightning and had to be repaired.

The buildings for the convention were constructed to the north of the main block in the eleventh and twelfth centuries. Instead of a true cloister, for which room could not have been found anywhere, there was a two-nave ambulatory hall next to and on the same level as the lower church, Notre-Dame-sous-Terre. Only under Philip Augustus did it become possible to build in a grander style, following the siege of 1203 and the reconquest of Normandy. The buildings on the north side had been badly damaged by fire. From 1212 to

Philip Augustus went to battle against John Lackland of England to reconquer Normandy, Mont-Saint-Michel sided with England and in 1203 successfully defended itself against a siege by the French under Guy de Thouars. The following year Philip Augustus brought his campaign to a successful conclusion, driving the English out of Normandy. In an act of royal magnanimity he donated significant sums to Mont-Saint-Michel to reconstruct the damaged buildings. In the Hundred Years' War the fortress monastery, now further reinforced, resisted the English, who took the neighboring island Tombelaine. Abbot Jolivet carefully readied the monastery's defense, but in 1420, thinking the cause was lost, he surprisingly sided with the English even before the battles had begun. Under Jolivet's direction the English established a solid cordon ring in 1424. A year later, however, the monastery's defenders succeeded in breaking through the ring. The English continued to attack, using artillery as well from 1434 onward, but 119 French knights under the leadership of Louis d'Estouteville

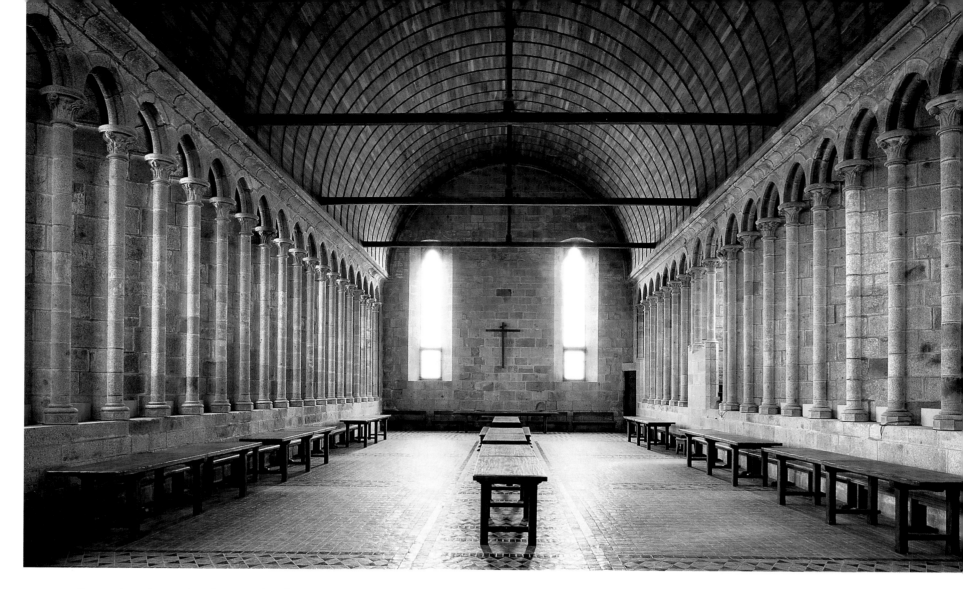

1228 a tall, soaring, imposing longitudinal wing was built there, which has rightly been called the Merveille (Wonder). The exterior side, facing the sea, is articulated by pier buttresses into narrow courses that shoot up vertically. The interior structure has three floors and is composed of two separate halves with different functions. In the eastern half, above the Romanesque two-nave hall for the distribution of alms, which has survived, they built a guest hall on the second floor: a tall two-nave hall whose slender columns and elegant quadripartite rib vaults would bring honor to any king's castle. Above that, on the third floor, was the monks' refectory. It is a one-nave hall with side walls, each of which consists, very monotonously, of thirty-one narrow window niches; the whole is covered by a wooden barrel vault.

On the second floor of the western half, above a cellar, there is a spacious three-nave hall (even four naves in places) with circular windows and robust columns: the monks' workroom. Since the eighteenth century this hall has been called the Salle des Chevaliers (Knight's hall), after the Order of Knights of Saint Michael, which King Louis XI founded in Château Ambroise in 1469, although it seems they never met at Mont-Saint-Michel. The halls of the Merveille recall

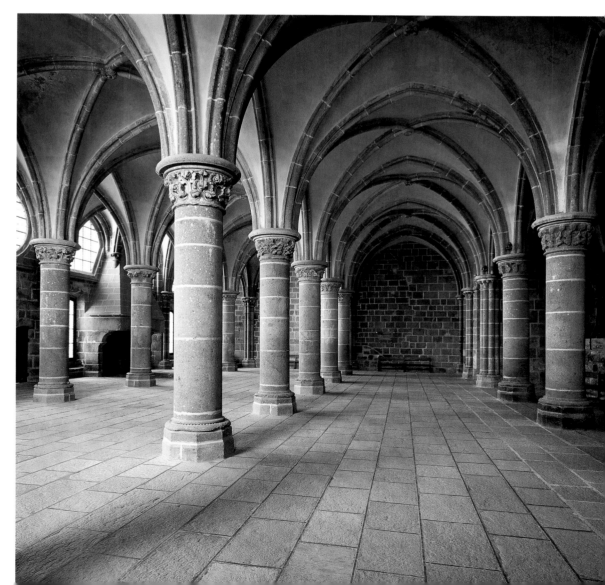

similar halls of Cistercian architecture and are of the same high quality. The cloister, which lies above the workroom, is a delicate, stunning masterpiece. The arcades of pointed arches and slender columns form two parallel, close-set rows on all four sides that are connected by miniature vaults. A special pleasure for the eyes results from the fact that the two rows are shifted with respect to each other, so that the columns of the farther row stand in the gaps of the nearer one. This results in visual overlappings that change constantly as one moves about. The high point, however, is in the west: the view through the arcature from the courtyard and through another arcature beyond into the sea.

On the south side of the mountain, toward the shore, additional buildings were constructed gradually and in a haphazard arrangement, including, around the middle of the thirteenth century, a wing for the abbot's residence and a new entrance to the monastery. At the foot of the southern slope a small settlement arose, with defensive walls and round bastions. The state of the monastery mountain around 1400 can be seen in a miniature in the famous book of hours painted by the Limbourg brothers: *Les Très Riches Heures du Duc de Berry* (see p. 2). The present state had almost

been reached by that time. The church shows two towers of the west facade, then still standing; the crossing tower; the transept; and the original Romanesque ambulatory chancel.

The chancel collapsed in 1421, perhaps because a large cistern had been added at the ambulatory shortly before, in 1417. In 1448 Abbot Guillaume d'Estouteville, who in his role as cardinal was responsible for the rehabilitation of Joan of Arc at this same time, began the construction of a new chancel, with ambulatory and radial chapels; a lower church, with the same ground plan as the upper church, was built as a substructure: La Crypte des Gros Piliers. It has round pillars with a diameter of sixteen feet (5 m). The chancel was not completed until 1513 or 1521. It towers twenty-six feet (8 m) above the nave; with its apse, which forms seven sides of a dodecagon, and its three-story structure, which has windows throughout in the triforium and clerestory, it looks like a cathedral chancel. Equally elaborate is the exposed buttressing, with pointed segmentation, of the exterior, which can also stand comparison to cathedrals. No cathedral, however, has the incomparable location of Mont-Saint-Michel, which makes the chancel soar toward heaven all the more steeply and proudly.

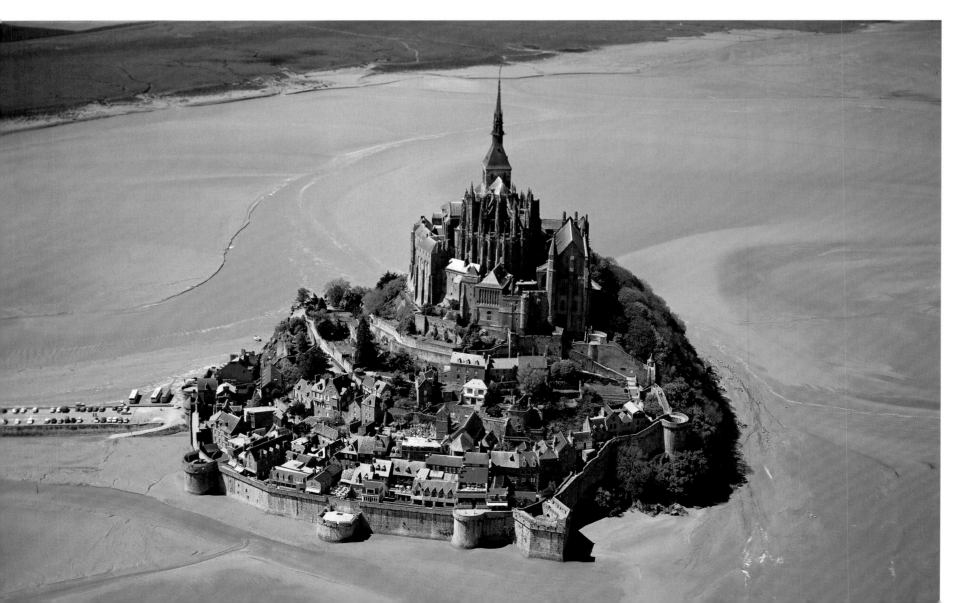

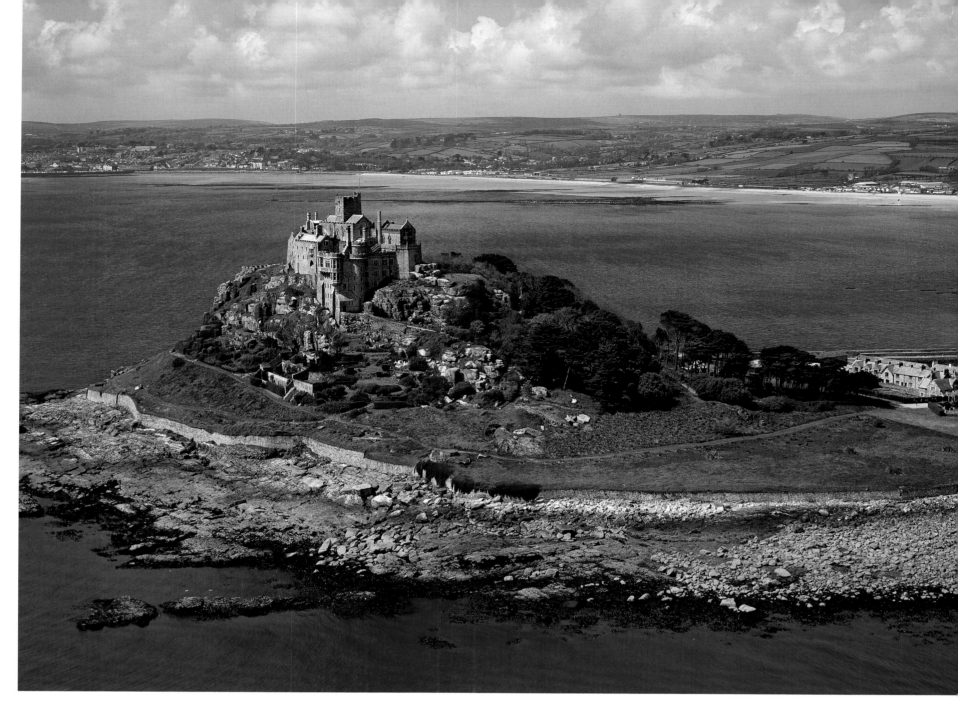

The English counterpart to Mont-Saint-Michel is the former Benedictine fortress monastery Saint Michael's Mount, at the southeastern tip of Cornwall. It stands just off the coast, on a granite crag of an island in the bay between Lizard Point and Land's End. The correspondence of their respective geographic situations is amazing, and the islands could be mistaken for each other, at least from a distance.

According to a report by the Greek historian Diodorus Siculus on the inhabitants of Belerion, present-day Land's End, Cornwall was already famous in the first century B.C. and sought after for its tin deposits. The island off its coast, then called Ictis, was a stop for the cassiterite mined in Cornwall.

In 1044 Edward the Confessor founded a chapel on the mountain, and he is said to have donated it to the Benedictine abbey Mont-Saint-Michel. The authenticity of the document of donation that is preserved in Mont-Saint-Michel has been disputed. It has even been char-

acterized as a forgery that served only to reinforce the monks' claim on their properties in Cornwall. What is certain, however, is that from the time of his youth, much of which had been spent in Normandy, King Edward was fascinated by the similarity between the two islands. After the Norman conquest of England, Robert, whom William the Conqueror named earl of Cornwall, officially donated the mountain to the monastery Mont-Saint-Michel. Its abbot, Bernard, established a priory there in 1135.

At the end of the twelfth century the mountain was built up into a stronghold by supporters of John Lackland while his brother, King Richard the Lion-hearted, was on a crusade. The present fortress dates from the fourteenth and nineteenth centuries. It was used as a stronghold during the Wars of the Roses in the fifteenth century, during Cornwall's rebellion against Edward VI, and as recently as 1646, during the civil war.

Saint Michael's Mount, Cornwall

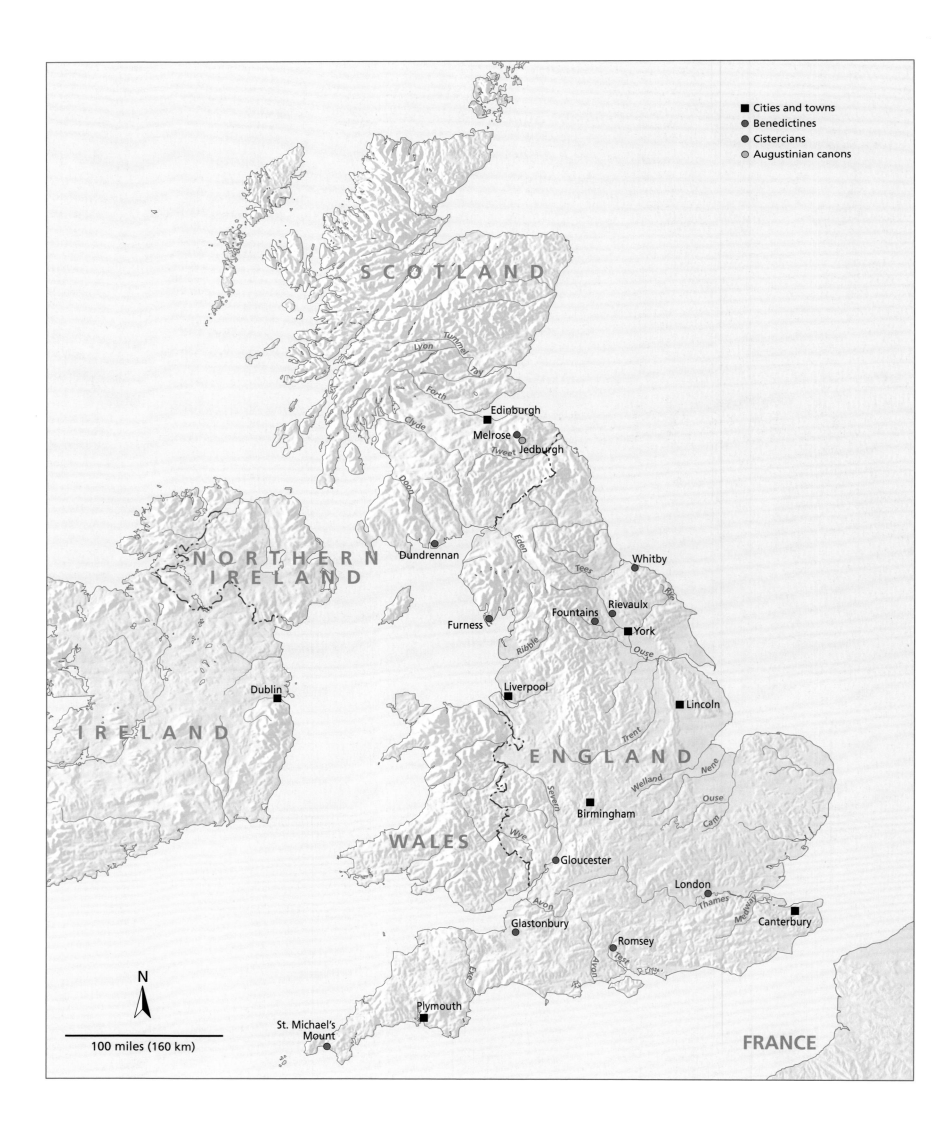

Cities and towns
Benedictines
Cistercians
Augustinian canons

SCOTLAND

NORTHERN IRELAND

IRELAND

WALES

ENGLAND

FRANCE

Lyon
Tummel
Tay
Forth
Clyde
Doon
Edinburgh
Melrose
Jedburgh
Tweet
Dundrennan
Eden
Tees
Whitby
Rye
Fountains
Rievaulx
York
Furness
Ribble
Ouse
Liverpool
Lincoln
Dublin
Trent
Welland
Nene
Birmingham
Severn
Ouse
Cam
Wye
Gloucester
Avon
London
Thames
Medway
Canterbury
Glastonbury
Romsey
Avon
Test
Exe
Plymouth
St. Michael's Mount

N

100 miles (160 km)

GREAT BRITAIN
ENGLAND · SCOTLAND

LONDON
WESTMINSTER ABBEY

TOP RIGHT:
North transept, Westminster Abbey

BOTTOM LEFT:
Aerial photograph from the southwest

OPPOSITE PAGE:
View from the monks' chancel to the west

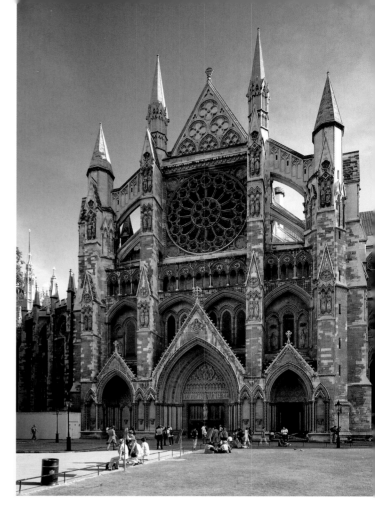

ENGLAND'S MOST IMPORTANT SHRINE IS WESTminster Abbey, the coronation site of its kings and the mausoleum for many kings, queens, and other members of the royal house, as well as for outstanding statesmen, writers, scientists, artists, and scholars. According to legend, Sebert, king of the East Saxons (d. 616), founded the abbey, at the insistence of London's first bishop, Mellitus. For later monks the legend became truth, for they established a tomb monument for King Sebert in 1308. What is certain is that King Edward the Confessor had a large Benedictine monastery built on an island in the Thames, once known as Thorneye Island but now called Westminster Eyot, and he built a royal palace beside it. Their immediate proximity pointed to the unity of church and state. For five hundred years Westminster remained the royal residence and then became the Houses of Parliament. The consecration of the monastery church took place on December 28, 1065. Eight days later King Edward died and, as the Bayeux Tapestry shows, was transferred to the church. Soon thereafter his successor, Harold, was crowned here. On Christmas of that year, 1066, William the Conqueror had himself crowned in Westminster as well, which was a pointed act of legitimation. Although that church was built before the Norman Conquest, it had nothing whatsoever to do with the traditional, rather modest Anglo-Saxon architecture; in terms of size, ambition, and form it was a pure Norman building, similar to Jumièges, near Rouen, in Normandy (see pp. 204–6), where the bishop of London, Robert Champart, had been abbot before he took his episcopal office in 1044.

The donor of the present church, begun in 1246, was King Henry III, the son of John Lackland; the barons and clergy, under the leadership of Stephen Langton, archbishop of Canterbury, had forced John to sign the Magna Carta in 1215. Like symbols of their new freedom, the nobility had their coats of arms placed in the spandrels of the nave arcades, packed closely together, beginning with the donor and Edward the Confessor. Henry was the brother-in-law of both the Hohenstaufen emperor, Frederick II, and the French king, Louis IX the Pious, whom he emulated.

The church belongs not to the local early English tradition but to that of the French cathedrals, with a

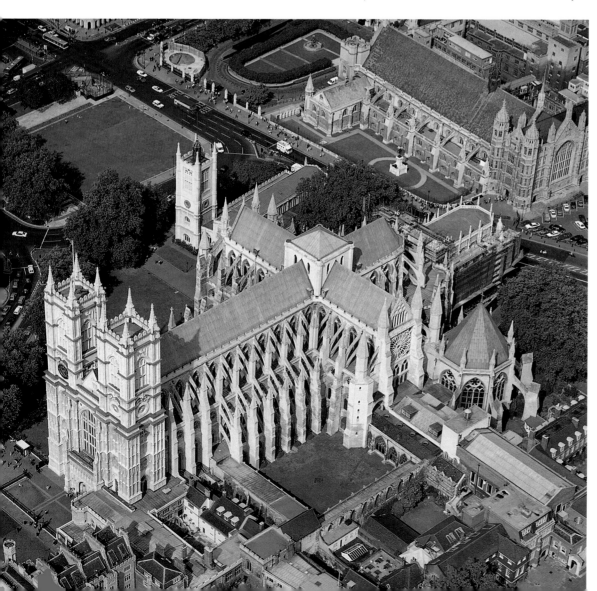

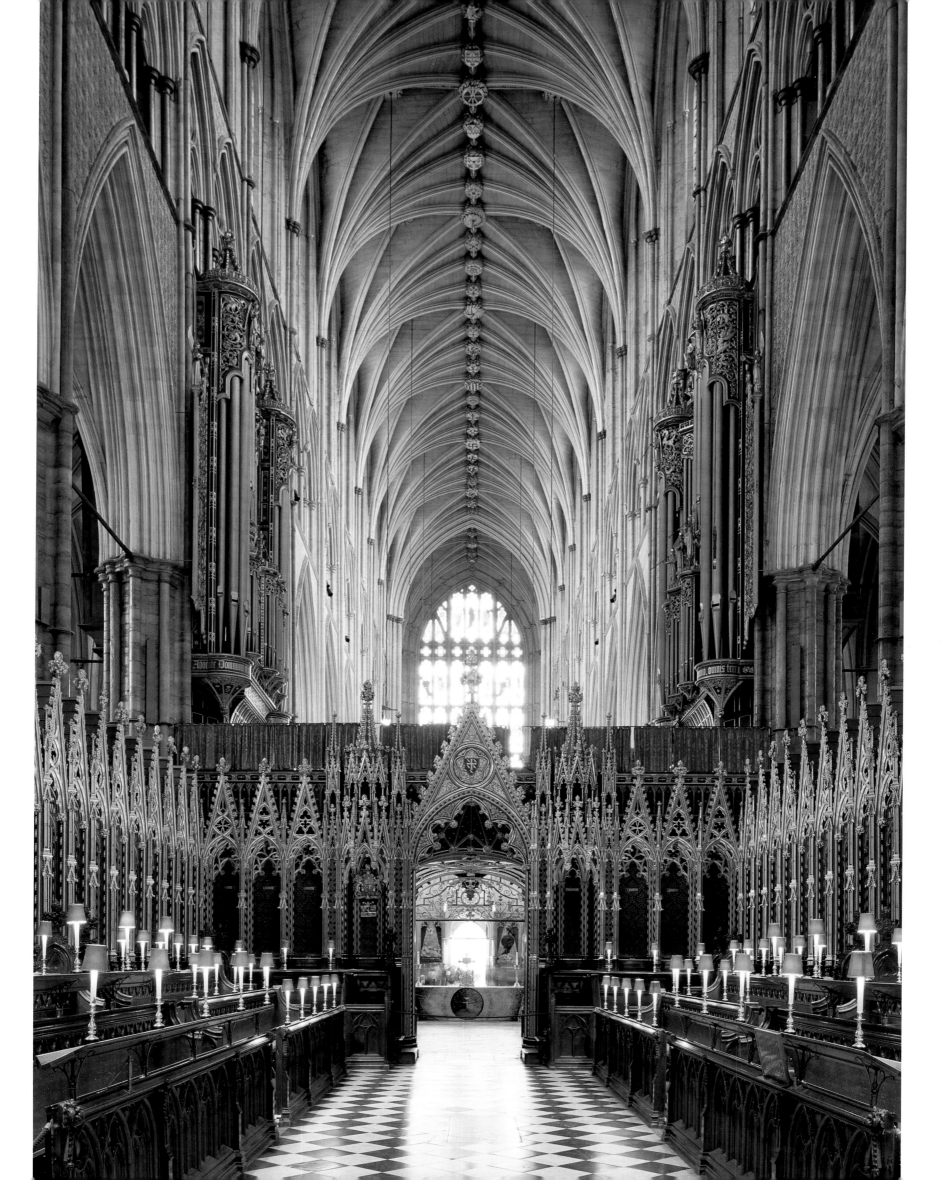

three-nave transept, an ambulatory chancel, and a wreath of radial chapels. The galleries that were typical in England have been retained, but in terms of the size of the openings they have been reduced to the format of French triforia. Conversely, the clerestory is significantly taller, since—for the first time in England—the imposts of the vaults reach well into the area of the windows. All of this results in a purely French structure, in

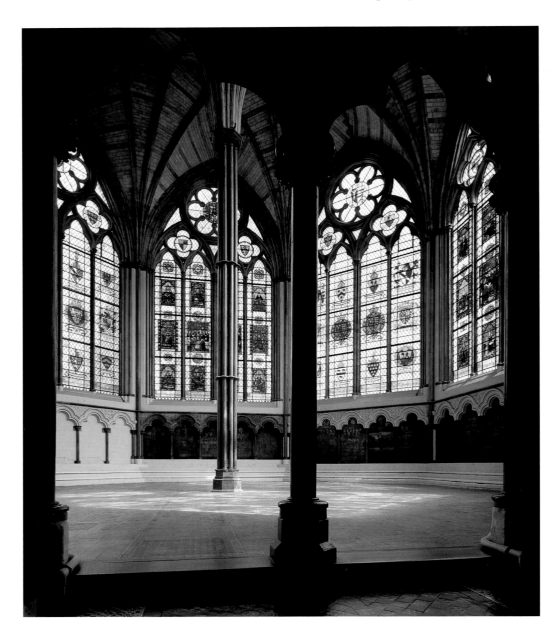

which the clerestory is equal in height to the nave arcades. It also results in much steeper proportions for the space than were common in the early English style. Not least among the imports from France is the tracery of the windows and galleries, which, also an innovation for England, completely replaced the older lancet forms. On the exterior, the north transept facade, though heavily restored and partially reconstructed, shows French influence in its three portals and its large rose window as well as in the exposed buttressing with

one arch above the other. The English tradition is expressed primarily in individual forms—for example, in the ridge rib in the transept and main block, the pointed shape and profiling of the arches, and in the multistory arcaded galleries of the inner side walls of the transept. The language of the architecture is French but with a heavy English accent.

Records indicate that Henry of Reyns was the architect of this extremely expensive building—the total cost, 42,000 pounds, was 1.2 times the average annual income of the crown. His name might indicate that he was from Reims, but a number of peculiarities in the geometry of the ground plan of the chancel ambulatory, not found in the work of any French architect, make it doubtful that Henry received rigorous schooling in a French mason's lodge. He may have come from Raynes in Exeter and thus would have been a native Englishman. He was succeeded by John of Gloucester and Robert of Beverley. The craftsmen were certainly English. By the time of Henry III's death in 1272 the construction of the chancel, transept, and five spans of the main block had been completed—that is, the area extending as far to the west as the monks' chancel in the nave. The remaining parts of the main block came later, although the original concept was followed, with the towers not being added until the eighteenth century.

From 1503 to 1509 Henry VII, the first English king from the House of Tudor, had the old Lady chapel on the chancel ambulatory replaced with a new one. It is the last highlight of the virtuoso art of late English Gothic vaulting, with traceried fan vaults, which in places seem to hang from the ceiling like lamps and overcome the laws of gravity to such an extent that the engineer becomes a magician. The banners that hang into the room, blocking the view, were added in the eighteenth century as symbols of the Knights Grand Cross of the Order of the Bath. Behind the altar lies the tomb of Henry VII and his wife, Elizabeth of York, with recumbent figures by the Italian Renaissance artist Pietro Torrigiani.

The surviving parts of the monastery include the cloister and especially the octagonal chapter house, which even at the time was praised as incomparable: with a central column, sixteen radiating ribs, and splendid tracery windows, it is a building in which a French adherence to rules and an English imagination have become one. An inscription made the comparison: *Ut rosa flos florum, sic est domus ista dormorum* (As the rose is the flower of flowers, so is this the house of houses).

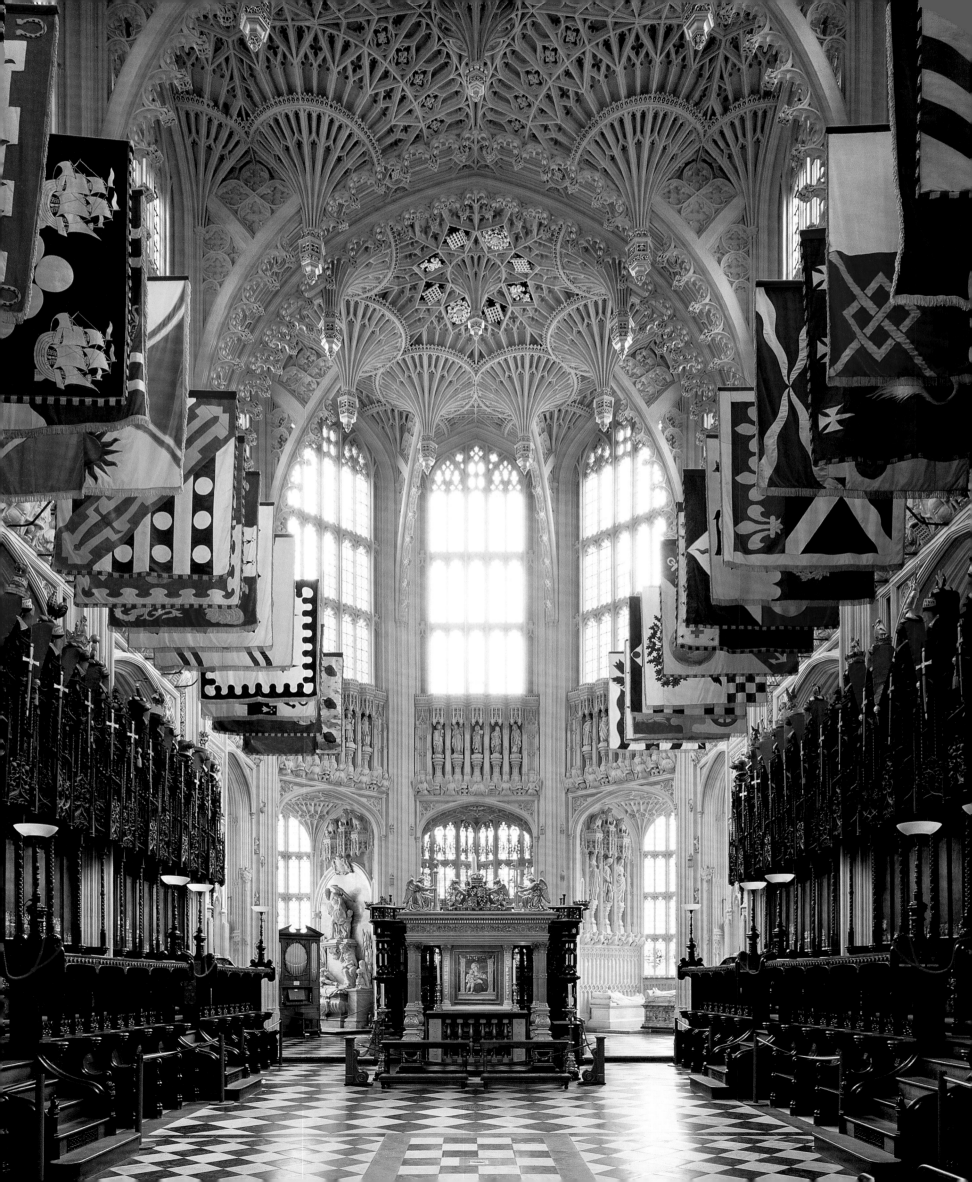

ROMSEY

Romsey, view of the church from the north

THE CITY OF ROMSEY—NEAR THE OLD EPISCOPAL city of Winchester, which was once the seat of the Anglo-Saxon kings—is now a suburb of Southampton. The abbey dates back to King Edward the Elder, the son of Alfred the Great. He founded a nunnery here in 907 and named his daughter Elflaeda its abbess. Roughly sixty years later King Edgar reorganized the monastery under the Benedictine rule. He appointed the pious Merewenna as abbess, who was followed by the equally pious Ethelflaeda. Both had reputations for saintliness. Even today the church is known as Saints Mary and Ethelflaeda. During a Danish invasion in 994 the nuns fled to Winchester, but they soon returned, and Ethelflaeda had work begun on a stone church. At the time Romsey was where the daughters of the higher nobility were educated. One of these was Edith, who was a member of the Anglo-Saxon royal house and who, under the Norman name Matilda, married King Henry I, one of William the Conqueror's sons. She died in 1118. Soon thereafter, from about 1120 to 1140, the Norman east end of the present church was built, perhaps as a memorial to Matilda that Henry sponsored. Between 1150 and 1180 the Norman west end of the main block was constructed, probably at the prompting of Abbess Mary, King Stephen's daughter, who later left the convent and married. The last three sections of the main block, now in the early English style, were only added between 1230 and 1240. When the abbey was closed under Henry VIII the citizens purchased the church for one hundred pounds and turned it into a parish church, which saved it from being used as a quarry.

The church is one of the greatest Norman buildings in England. It is a three-nave basilica with galleries, a broadly projecting transept, an open, quadratic crossing tower, and a box chancel that is surrounded by a U-shaped ambulatory, where originally there was a bipartite Lady chapel. The side aisles and the ambulatory have rib vaults, but the nave, the chancel, and the transept all have wooden barrel vaults. The side walls of the

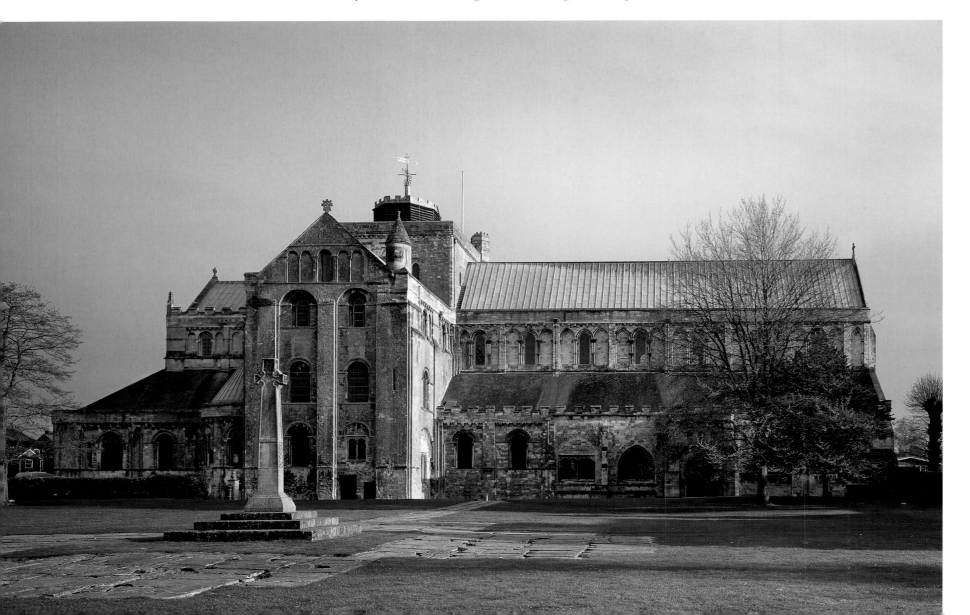

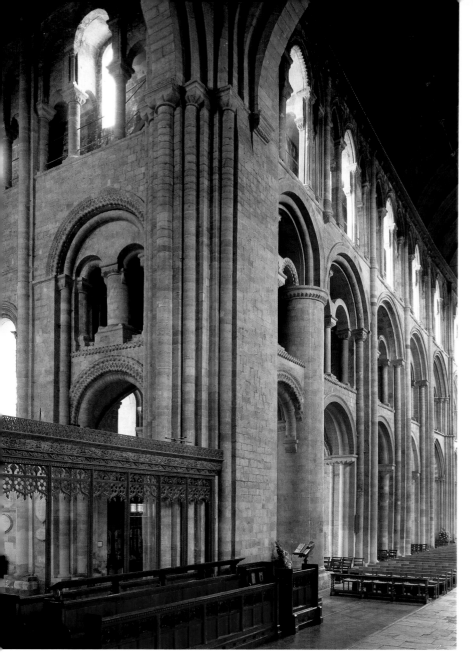

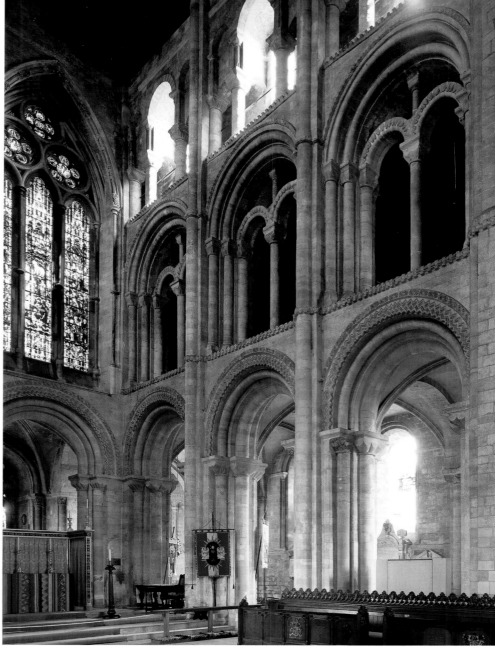

chancel—the two tracery windows in the east wall were added in the Gothic period—have three levels, as was typical in the Norman style. They consist of nave arcades with elaborate jamb contours, gallery openings, and a clerestory with two ranks of openings, where the passageway, which is recessed into the wall, opens onto the chancel area through a staggered tripartite arcade—a widespread and beloved motif of Norman architects. The galleries have the biforium motif that was used everywhere in England at the time: a double arch with a column inserted into a larger arch. Here, however, the motif is enriched in an unusual way, in that a second, smaller column stands in the middle above the open arch bay and connects directly with the relieving arch. This recalls the galleries of the imperial chapel at Aachen.

A new idea was introduced on the east side of the nave, just where it connects with the crossing. The architect, clearly influenced by the abbey churches of Gloucester and Tewkesbury, employed for support a bare, unarticulated round pier that is so tall it supports not the arch of the nave arcade but rather that of the gallery. In Gloucester there are no galleries, so these piers seem like true colossi; in Romsey they did not wish to dispense with the galleries, so they were hung directly on the piers, as at Christ Church in Oxford. Together with the arches of the gallery, these round piers create a giant arcade that encompasses two levels. When construction was continued later, this solution was found unsatisfactory, so they returned to the usual pier style with many engaged columns. What was retained from the original concept for the main block, however, was the idea of a giant arcade, but now this was realized in a different way by means of a single engaged column that ran all the way up. This resulted in an arcade wall in which the two lower floors are rigidly reined together by a large form, one that is unified in all its parts, without the rigidities of the solution using round piers. This solution had a predecessor, in certain respects, in the church at Mont-Saint-Michel, in Normandy, but it was developed in Romsey independently of that, as a consequence of the piers that had been introduced shortly before in Gloucester.

LEFT:
View into the south transept and the nave

RIGHT:
South wall of chancel

GLOUCESTER

Aerial photograph of the cathedral of Gloucester, from the southwest

THE CATHEDRAL OF GLOUCESTER, A CITY ON the River Severn, near the Welsh border in southwest England, is one of the most famous examples of English architecture, although originally it was a monastery church—like, for example, Peterborough, Ely, and Saint-Alban's. It was only promoted to an episcopal seat under Henry VIII, as part of England's ecclesiastical reorganization. The abbey was one of England's oldest, dating back to 681, when King Aethelred granted permission for its founding. The monastery was closed in 1022, during the Danish king Canute the Great's brief reign over England, but the bishop of Worcester refounded it immediately thereafter. William the Conqueror entrusted it to his chaplain, Serlo, who had been a monk at Mont-Saint-Michel, and soon the monastery—which had been unable to live and unable

to die—flourished again. By the time Serlo died in 1103, the number of monks had grown from the two who preceded his arrival to more than one hundred. The present church was begun under Serlo in 1089. It was consecrated after just eleven years of construction, which was not unusual for Norman churches. The demeanor communicated by the structure of the main block, with its completely unarticulated round piers—which are truly colossal stone cylinders—is that of undisguised power. In its naked impact the architecture is an expressive message from the new Norman rulers that reads: Anyone who builds like this is not to be fooled around with. The Gothic vaults that were added later, however, take away much of the brutal effect of its original.

The Norman east end, with transept, ambulatory chancel, and three radial chapels, was thoroughly redesigned in the fourteenth century by adding facing of delicate tracery, an enormous east window, and fine-mesh tracery vaults. The occasion for this was the outrageous murder of King Edward II in Berkeley Castle in 1327, carried out on the orders of Queen Isabella and her lover, Roger Mortimer. His corpse was buried in Gloucester, since none of the other abbeys in this region were prepared to accept it. Soon Edward's tomb, over

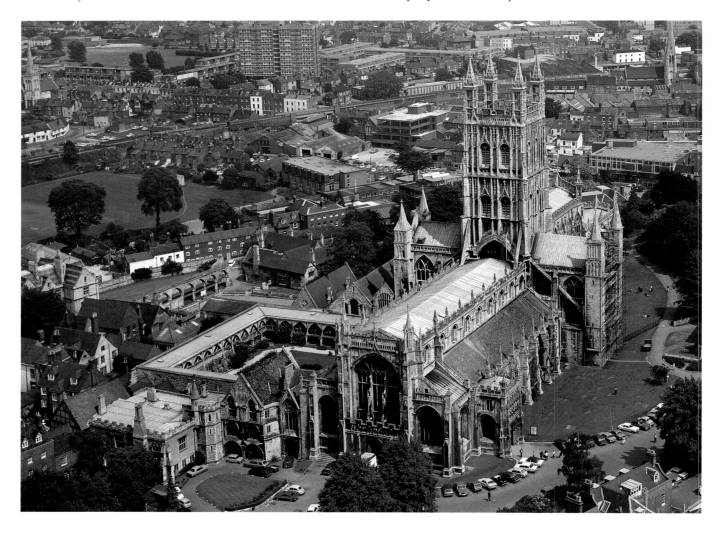

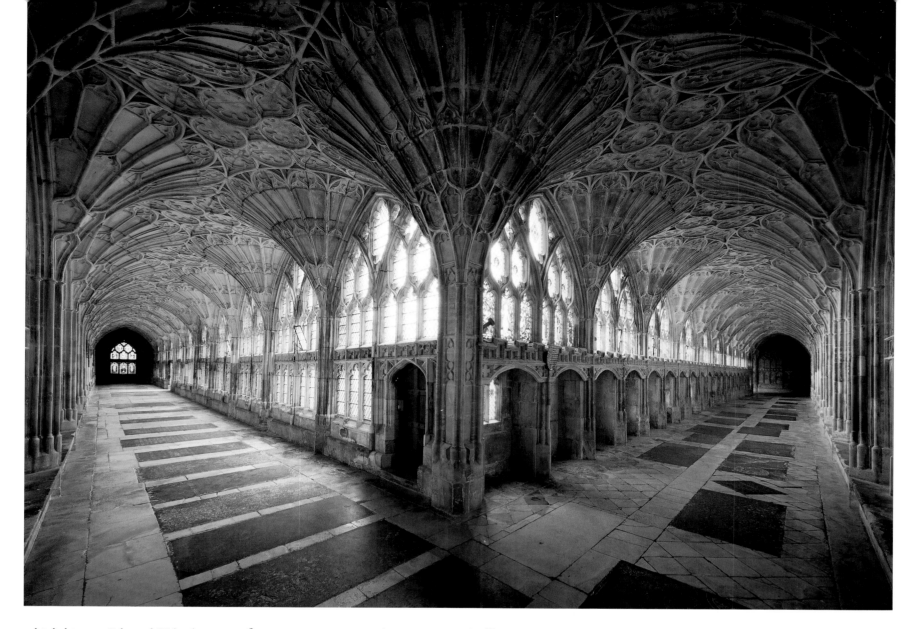

which his son Edward III had a magnificent monument built, was revered by countless pilgrims like the tomb of a saint. Their donations, along with gifts from the royal house, enabled the abbey to redesign the east end into an architectonic tracery shrine for the unfortunate king. The slim dowels of the wall facing and of the east window—which at a height of eighty-two feet (25 m) and width of nearly forty feet (12 m) is the largest tracery window in England—founded a new phase in the evolution of English architecture: the perpendicular style. The architect may have been William of Ramsey, who had built the chapter house of Old Saint Paul's Cathedral in London shortly before.

The perpendicular style achieved its ultimate perfection at Gloucester with two other architectural elements in the abbey church: the 226-foot- (69-m-) tall crossing tower, built from about 1450 onward, the openwork upper crenellation of which is exquisitely delicate, and the Lady chapel in the east, built shortly thereafter, around 1460–70. This precious work of virtuoso stonemasonry has walls entirely of tracery and glass. Facing the chancel, above a bridge arch that spans the room, there is a see-through tracery panel that provides the

charming visual effect of overlappings that constantly transform as one walks around. The refinement of this architecture is diametrically opposed to the brusque primitiveness of the Norman main block.

In Gloucester the cloister, which was begun in 1372, is another major work of the late English Gothic. It is the earliest fully developed example of that fascinating vault style that exists in this form only in England and that truly accounts for the fame of the late Gothic architecture in that country: the tracery vault. It consists of a series of half funnels on both sides of the passageway that are lined with tracery except for a rectangle with concave sides at the crown of each vault that contains small rosettes. Later large spaces were also given such vaults, such as the abbey church in Bath or King's College in Cambridge. The cloister in Gloucester is also unique for its washhouse in the north wing and the twenty small reading niches in the south wing, all of which once had a wooden lectern for studying. Work on the cloister lasted four decades, until about 1410, as a consequence of the unrest toward the end of Edward III's reign and the early years of that of Richard II.

East and south wings of the cloister

PAGE 228:
Wall of the nave in the main block

PAGE 229:
Lady chapel, view to the west toward the chancel

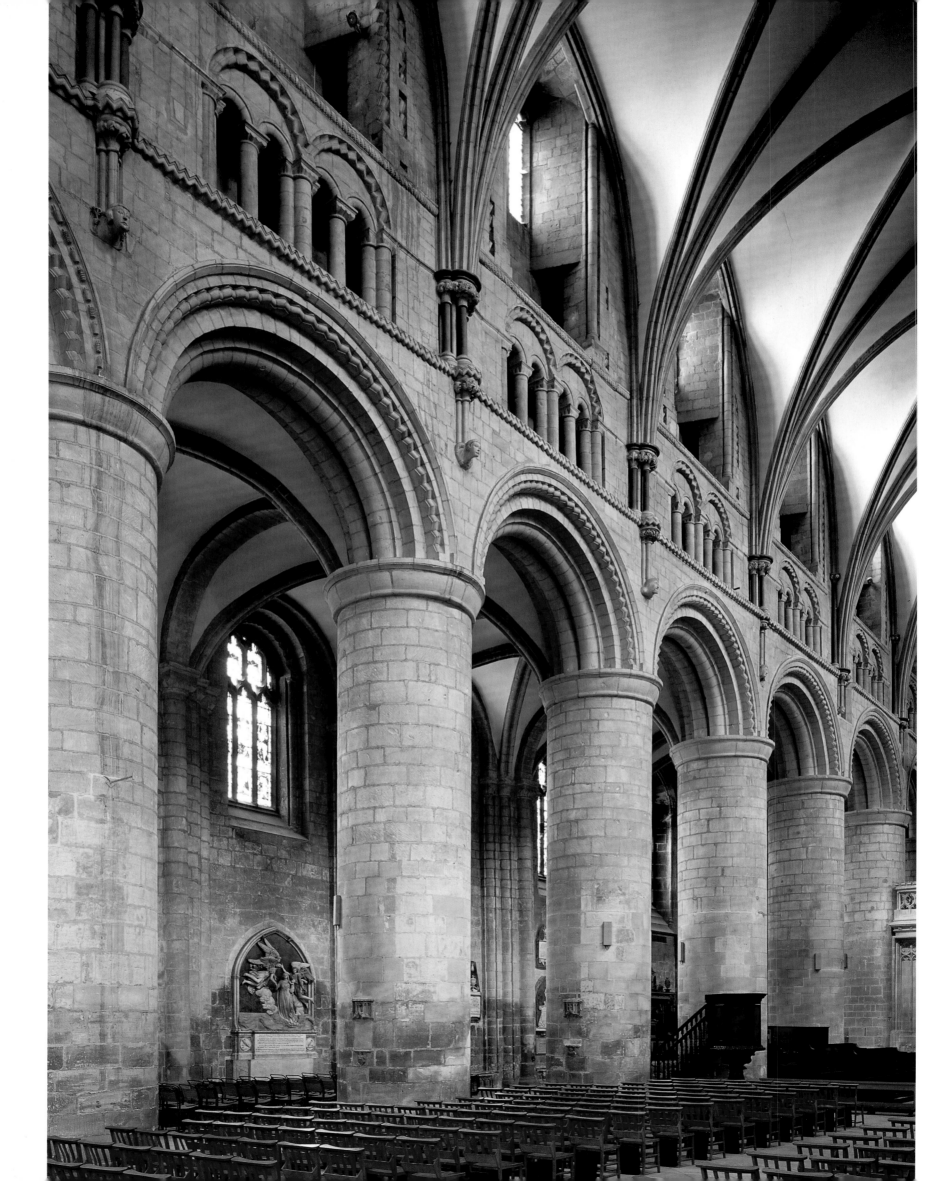

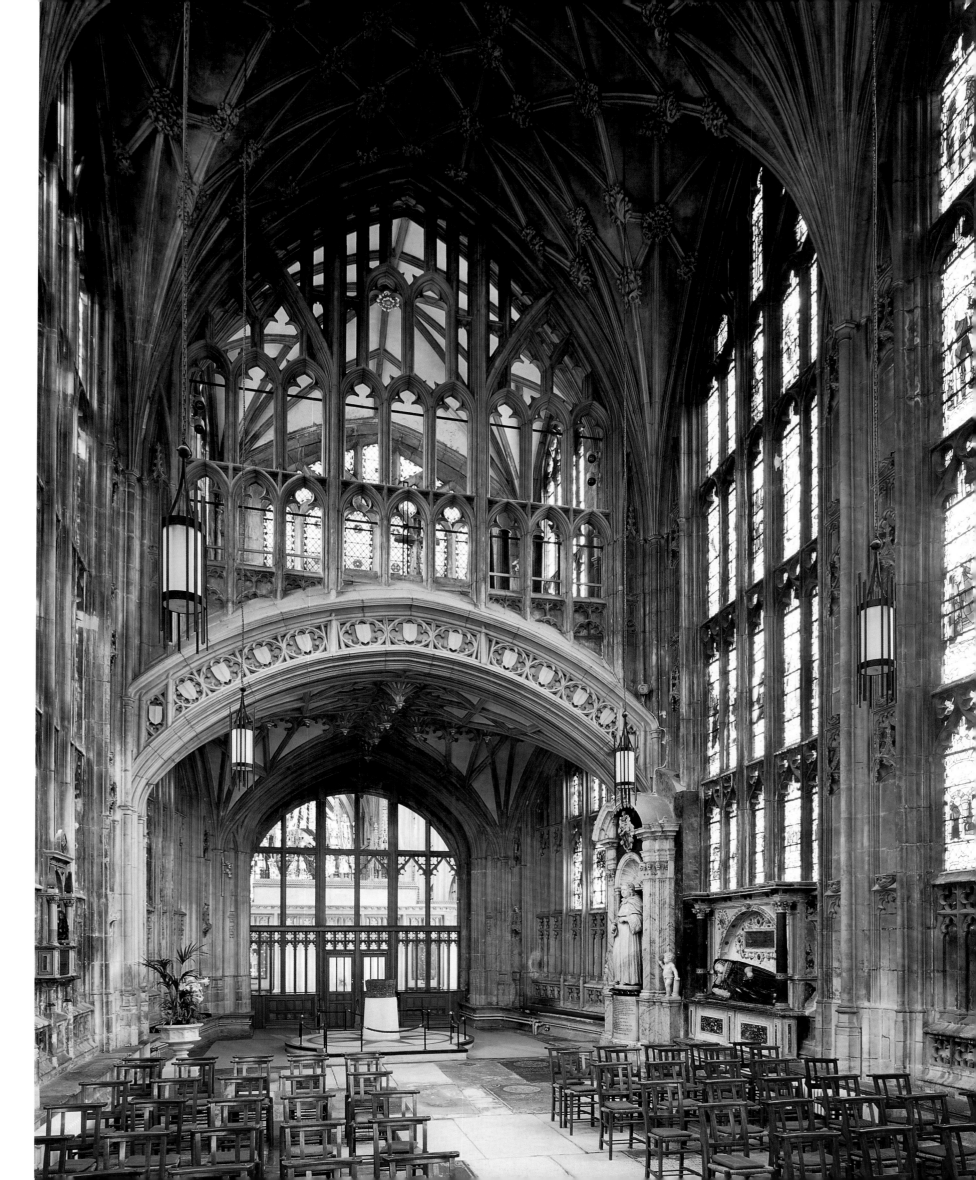

GLASTONBURY

THE FORMER BENEDICTINE ABBEY, WHICH IS ONE of the oldest in England, if not the oldest, lies in Somerset, south of Bristol, near the episcopal city of Wells. Built in the fifth or sixth century on the site of a Celtic holy site and burial ground that was shrouded in the saga of the Isle of Avalon, the abbey was refounded by King Ine of Wessex in 705. He had a stone church built that was later the burial place of many Anglo-Saxon kings. Under Abbot Dunstan, who was appointed by King Edmund around 940 and became archbishop of Canterbury in 959 or 960, Glastonbury developed into one of the leading Benedictine reform monasteries in England, and architecturally too it became a model, with an impressively large cloister (180 × 120 feet [55 × 36.5 m]). Soon the abbey was one of the richest in the country. In 1184 the church and monastery were destroyed by a fire. Thereafter the monks, probably hoping to attract pilgrims, spread the tale that they had found the graves of the legendary King Arthur and his wife, Guinevere, in the cemetery and identified it by means of an inscription on a lead cross. Later a shrine was built for the bones, and in 1278 it was placed before the high altar in the chancel of the new church in the presence of King Edward I.

After the fire of 1184 the Lady chapel was reconstructed to the west of the church, on the site of a "vetusta ecclesia" (ancient church): a one-nave, box-shaped building with rib vaults and elaborate late Romanesque articulations and sculptural decoration. It was consecrated in 1186, just two years after the fire. Apart from the vaults, the Lady chapel is well preserved. Of the church, however, which was completed only in the fourteenth century, all that stands are parts of the entry hall, including the portal, and the eastern piers of the crossing together with adjoining fragments of the transept. To judge from these remains, the structure was defined by large arcades that stretched up over the floor to unite the nave arcades and the triforium. Higher up, in the area of the vaults, was a clerestory with staggered tripartite windows. The whole was a typical example for the phase in England between late Norman architecture and the Gothic that is known as the transitional style.

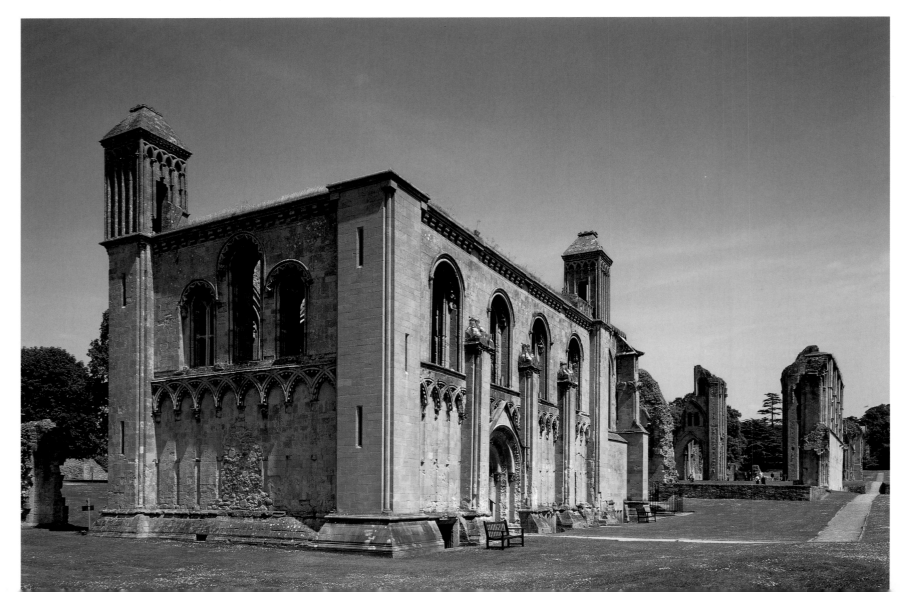

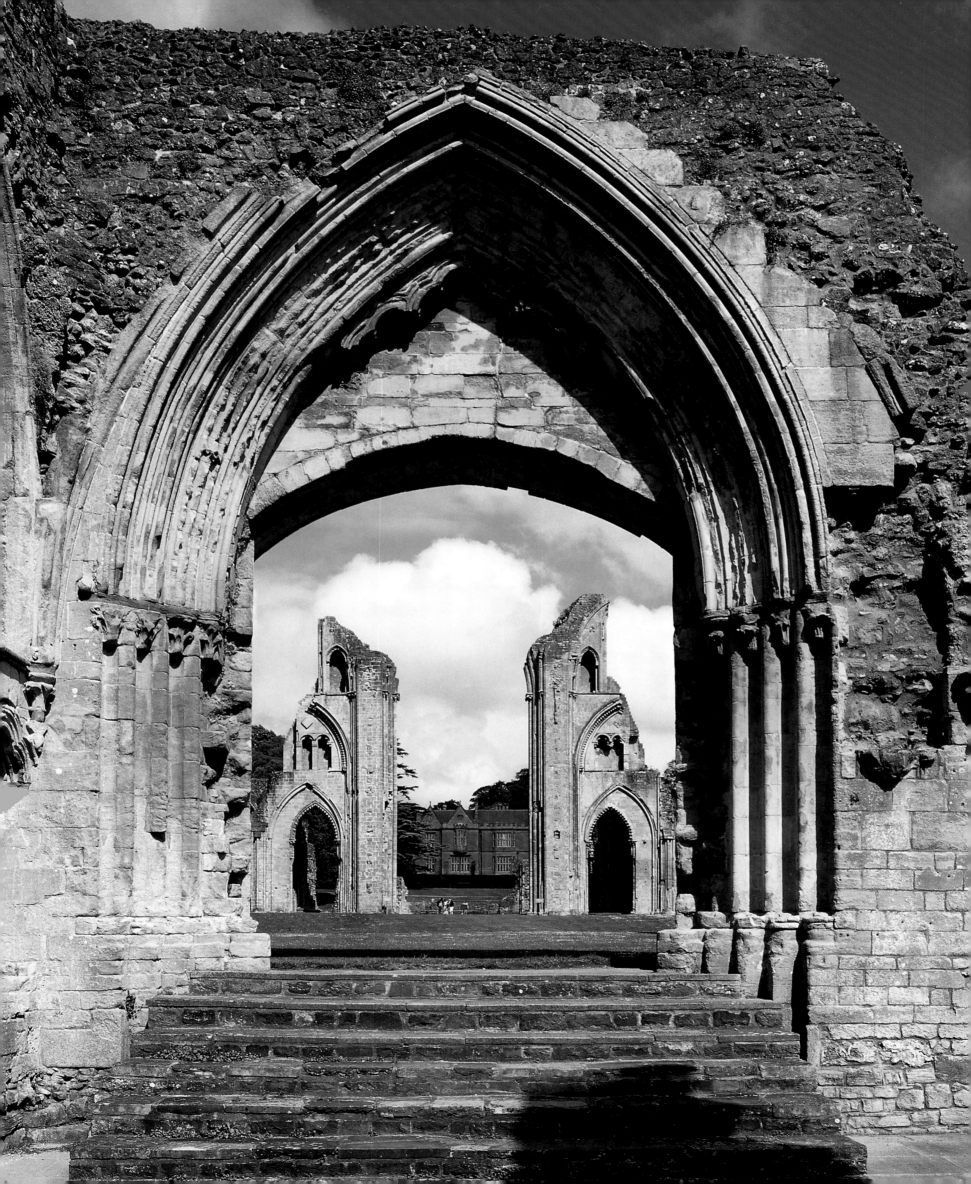

FOUNTAINS

this account, in 1132 Prior Richard of Saint Mary's, the leader of a radical group of monks, called for the return to strict adherence to the Benedictine rule; he was probably inspired by the group of Cistercians from Clairvaux that had just passed through York that year on its way to found Rievaulx. After a rebellion lasting several days had broken out in the monastery—which led to the thirteen rebellious monks being locked into

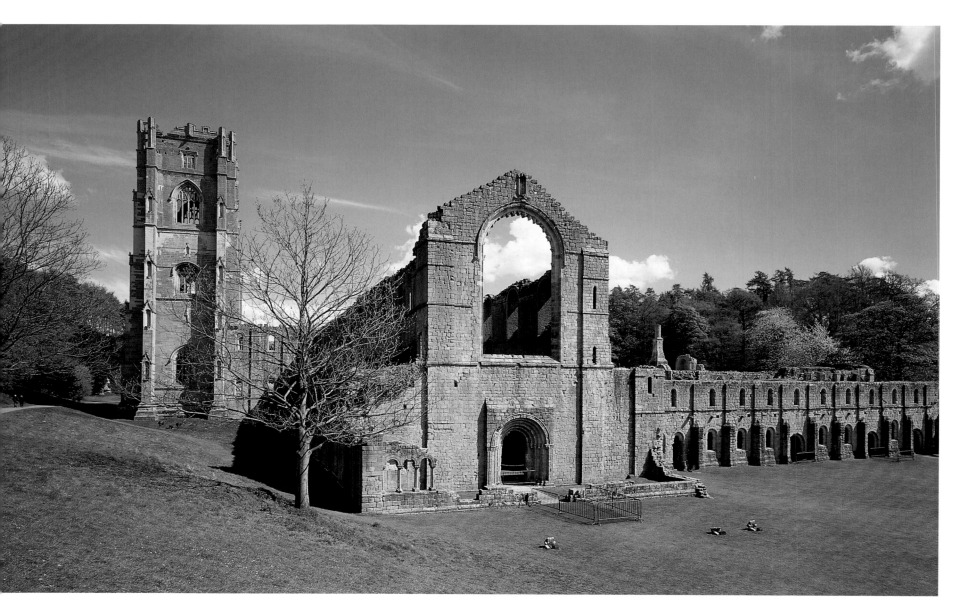

Church and conversi wing from the northwest, Fountains

IN NORTHERN YORKSHIRE THE RUINS OF FOUR GREAT former Cistercian abbeys are found in close proximity to one another: Jervaulx, Rievaulx, Byland, and Fountains, the last of which is very close to the ancient Benedictine abbey Ripon. Fountains, the oldest and richest of the medieval Cistercian monasteries in England, dates back to a revolt in the Benedictine monastery Saint Mary's, in York, which had been founded from Whitby in 1088–89. An account of these dramatic events was provided around 1205 by a very elderly Cistercian monk, Serlo of Kirkstall, who had witnessed the events himself as a youth. According to

the church with Archbishop Thurstan of York, the group had to leave the monastery. The archbishop took them in and offered them a place to found a monastery, together with a little property, in the rough wilderness in the valley of the River Skell. Prior Richard was chosen to be its first abbot. The settlement proved not to be viable, however, so in 1133 the monks turned to Bernard of Clairvaux for help. He sent the experienced monk Geoffroi d'Alaine from Clairvaux as an instructor, and the first buildings were constructed following his advice, by *carpentarii* (carpenters) and *operarii* (artisans), whose activity the following year is

documented. The monastery was named Fountains after the six springs here that, along with the river, provided plenty of water. The convention suffered from such hunger, however, that in 1135 they were tempted to give up and relocate to Burgundy. A little later, several high-ranking clergy from York arrived, whose considerable income fell to the community. This finally provided the basis for a functioning economy and

thereafter, but it was closed in 1539. Its last abbot and monks received a pension, though the abbot's predecessor had been executed for opposing the church policies of Henry VIII.

The first stone church was very small, with a single nave and a transept with two staggered chapels on each side. After supporters of the deposed abbot William set fire to the monastery in 1146 or 1147, a new church,

BELOW:
Church and monastery from the southeast

PAGE 234:
View into the main block of the north wall of the nave

PAGE 235:
View from the south through the east end (Chapel of the Nine Altars)

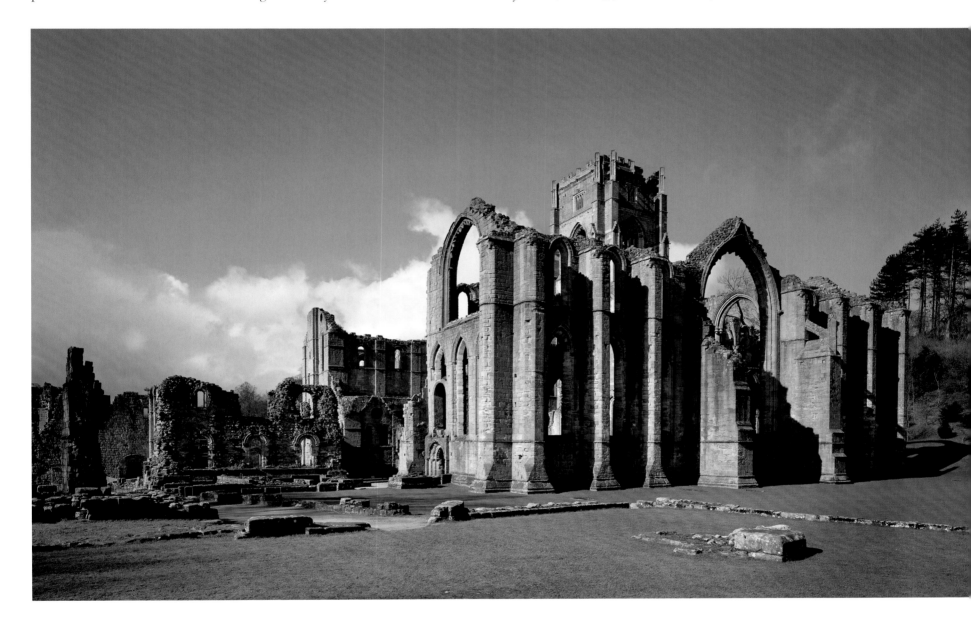

resulted in a meteoric upturn. By 1138 Fountains had founded three daughter monasteries and a total of eight by 1150. The main source of income was provided by enormous herds of sheep, which grazed as far away as the Lake District and whose wool was sold to traders from Flanders and Italy. In addition, there was income from lead mines, ironworks, quarries, cattle breeding, and other smaller industries. Around the middle of the thirteenth century Fountains was one of England's richest abbeys, and its abbots served as members of Parliament. The monastery survived an economic decline in the fourteenth century and recovered somewhat

nearly twice as large, was begun, with a transept that had three chapels on each side. The main block originally had just one nave; not until around 1155–60 was it expanded to three naves, with the side aisles vaulted with a series of transverse barrel vaults. The nave, which once had a flat ceiling, has an extremely bare architecture with circular piers and nave arcades with slightly pointed arches.

Half a century later, around 1203, Abbot John of York built a new three-nave longitudinal chancel with a T-shaped transverse building that held nine altars. The chancel, which brought the church to a length of 328

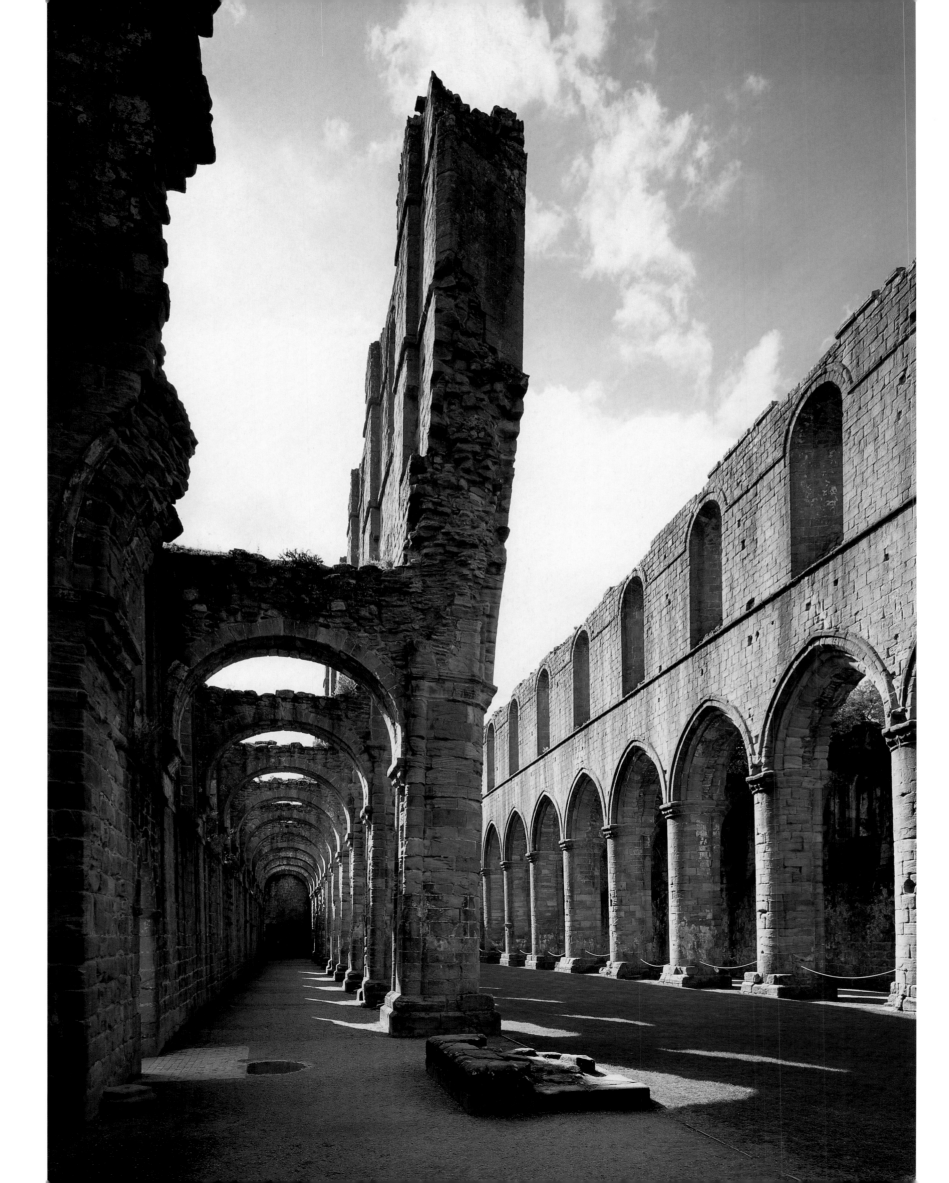

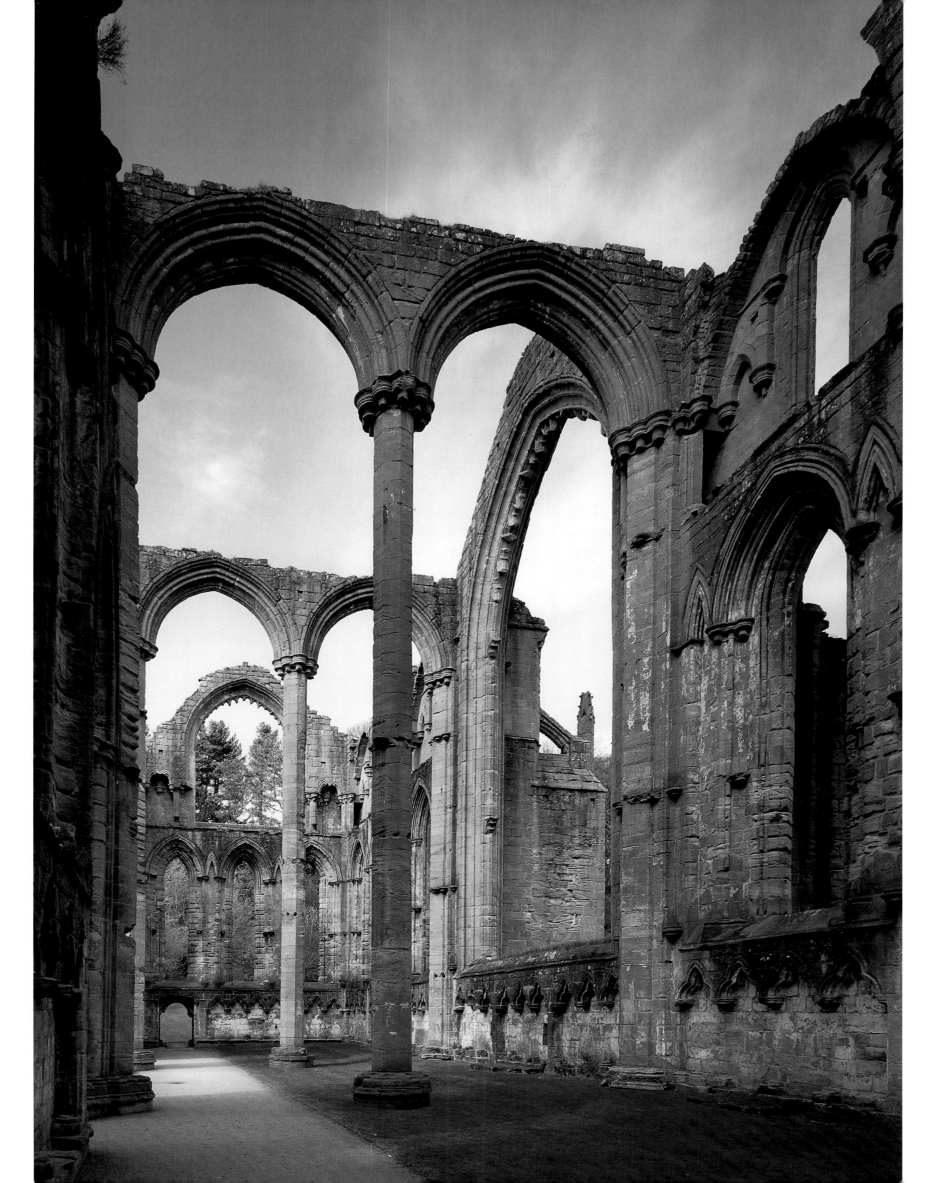

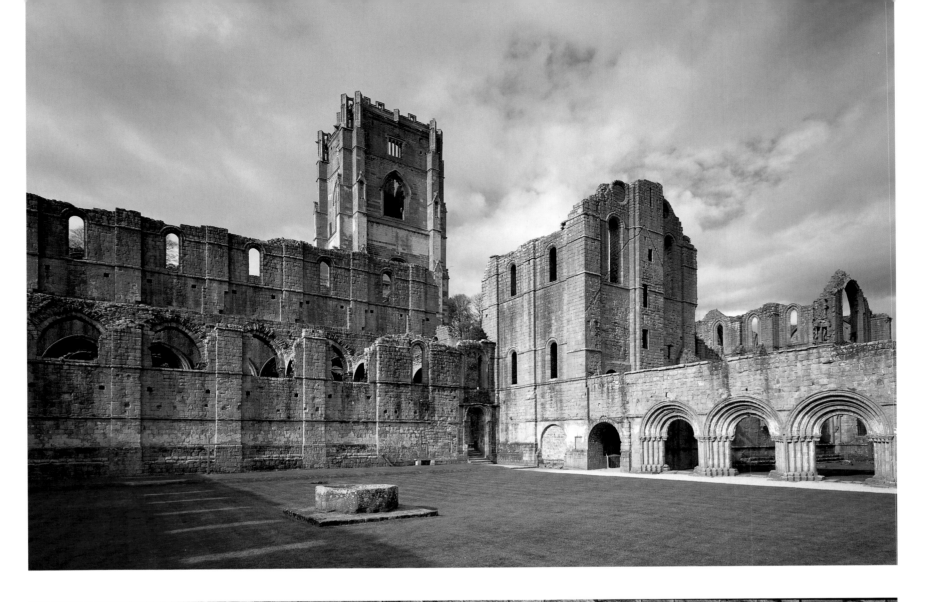

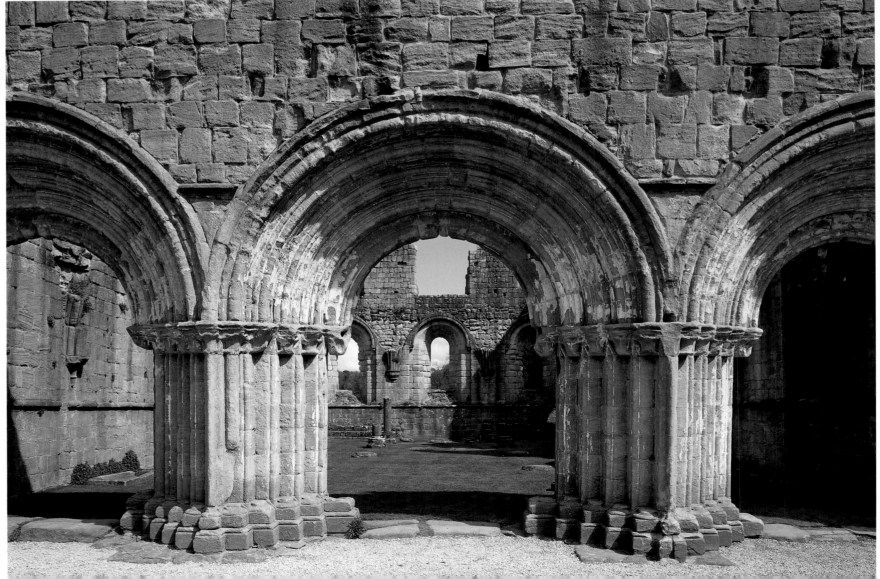

feet (100 m), was completed under Abbot John of Kent around 1247. The transverse building is a famous example of the early English style. Originally the entire structure was ornamented with countless colonettes of the local Nidderdale marble, as were the slender, dizzyingly tall octagonal piers of the double arcades that separate the middle section of the transverse building from the wings. When the piers and arcade jambs still had

however, was the vaulting. In the transverse building it caused such problems that Abbot Darnton had it replaced by a wooden ceiling in 1483. He was also responsible for the giant window in the middle of the east wall, which has been robbed of its tracery. Darnton's successor, Marmaduke Huby, ignored the Cistercian prohibition against stone towers and had a massive colossus of a tower built on the north transept during

OPPOSITE PAGE:
TOP: *Church and east wing of the monastery with the area where the cloister once stood;* BOTTOM: *Entrance to the chapter house*

BELOW:
Lay refectory and storeroom

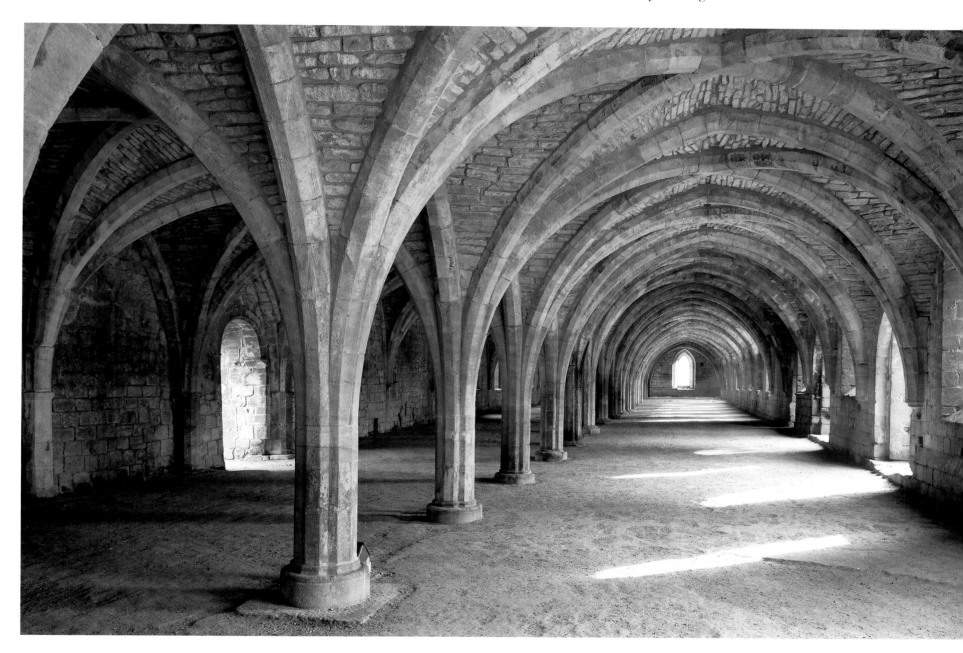

these colonettes at their corners on several levels, they must have been truly splendid, and this splendor was sustained by the windows and the pointed lancets of the exterior walls. Even today, when all the colonettes have disappeared, one can sense the former wealth of Fountains here, whereas the appearance of the exterior, with its mighty pier buttresses, conveys more an image of the abbey's power. The transverse building had such an effect even then that it was imitated for the cathedral of Durham, from 1242 onward. The weakness in Fountains,

the reign of Henry VIII. Of the abbey buildings, the exterior walls of the monks' refectory and the chapter house, with its three magnificent terraced portals, are still standing. The two-nave, rib-vaulted hall on the ground floor of the conversi wing has survived as a whole. It is 328 feet (100 m) long, exactly the size of the church. Originally the hall—which gives an idea of the convention's size—did not run all the way through as it does today, but was subdivided into a lay refectory and a storeroom.

RIEVAULX

BELOW:
View of the southwest of the chancel, with remains of abbot's palace and hospital, Rievaulx

OPPOSITE PAGE:
Chancel and transept from the south

PAGE 240:
TOP: *Monks' refectory;* BOTTOM: *Entrance to the monks' refectory*

PAGE 241:
View through the chancel

ENGLAND'S EARLIEST CISTERCIAN ABBEY, WAVERLY, which was founded in Surrey in 1128, was followed in 1151, with the support of Archbishop Thurstan of York, by the first abbey in the north: Rievaulx in Yorkshire. Bernard of Clairvaux was personally involved in its founding, which was to provide the order with a base in the north, and he chose his former secretary, William, an Englishman native to the region, to be abbot of the convention. The land on the left bank of the Rye was donated by Walter l'Espec. The river formed the border between Walter's domain and that of his neighbor Roger de Mowbray. In 1142

Mowbray also founded a monastery in the river valley, and entrusted it to a congregation from Savigny, which joined the Cistercian order in 1147. Since then the valley has had two Cistercian abbeys that were so close together that each disrupted the other with its bells. That is why the second settlement was relocated, first in 1156 and then definitively in 1177, to its present location, Byland, where it flourished and developed into an important monastery. Under Aelred, Rievaulx's third abbot (1147–67), who had a reputation in England similar to that of Bernard in France, the abbey is said to have had 140 monks and 500 conversi. It founded nineteen daughter monasteries in all: eight in England and eleven in Scotland. Beginning in the thirteenth century its significance declined steadily, so that by 1380 there were only fifteen monks and three conversi still living there. After its closure in 1538 the buildings fell into disrepair, and in 1758 they were incorporated into nearby Duncombe Park as a romantic ruin.

The abbey's beginnings were modest; in 1132 the monks were still living in simple huts (*casae*). The

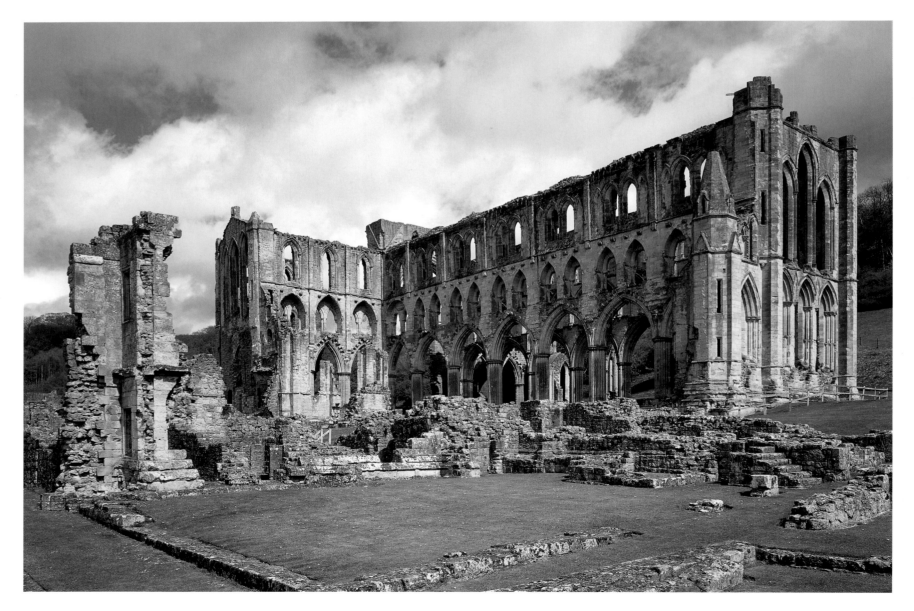

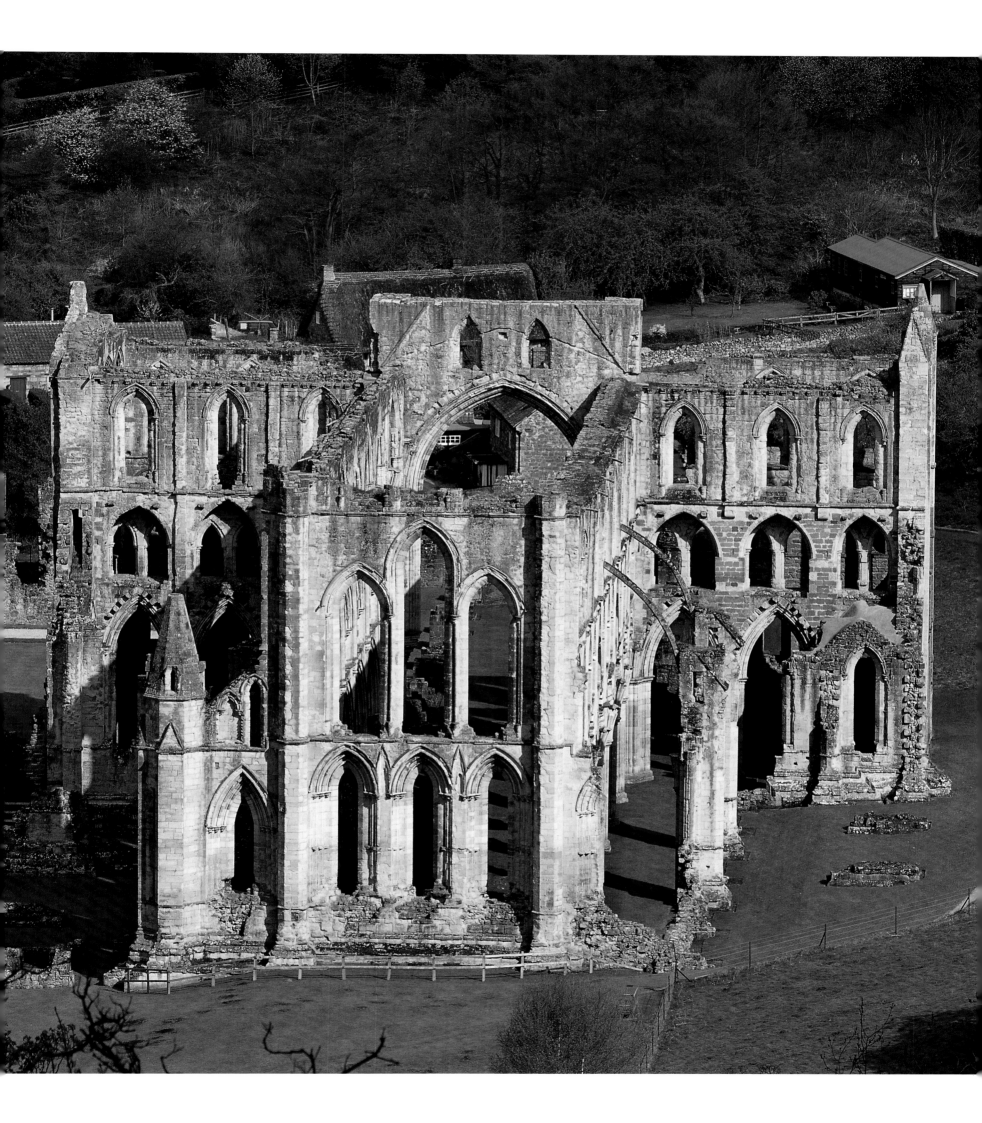

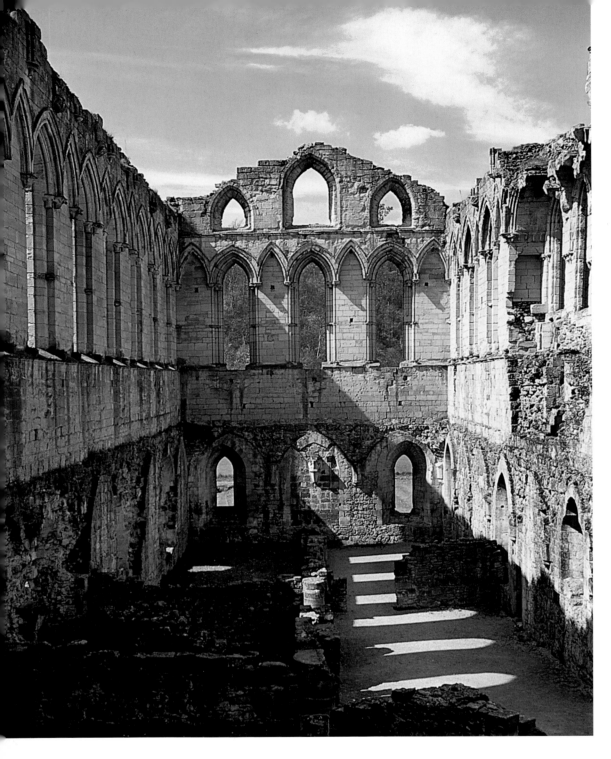

church, which faced south rather than east, because of the terrain, was probably begun only around 1150. The main block, which has been worn down to its foundation walls today, was a three-nave basilica with wood longitudinal barrel vaults in the nave and simple square piers; in the side aisles, much like Fountains, it had a series of transverse barrel vaults. The south end consisted of the transept arms, with three chapels each, and the sanctuary. Of this the exterior walls on the north, east and west, which were built up in the thirteenth century, are still standing. From about 1215–20 onward a new chancel was built to hold the choir stalls and several altars, bringing the church to a total length of 341 feet (104 m): a three-nave basilica of seven spans with a flat terminating wall that had five altars in front of it. The chancel is well preserved; only the side aisles, the vaults, and the roofs are missing. The structure of the wall has the three levels typical of the early English style. As was usual in England it consisted of nave arcades with bundle piers and elaborate arch profiles, round arch openings in the galleries into which double arcades of pointed arches have been set, and on top a clerestory with two ranks of openings with a walkway recessed into the wall in front of closely set pairs of windows. The two tiers of tripartite windows in the terminating wall are also characteristic of the early English style. The quality and lavishness of this Cistercian chancel are quite comparable to contemporary cathedral architecture in England, and correspondingly the crossing had a stone tower, although this was actually prohibited by the order.

The ruins of the monastery buildings at Rievaulx are also impressive. The chapter house, of which only the foundation walls survive today, represented a singular invention for the period around 1150. It was a three-nave basilica structure with a clerestory and an apse with an ambulatory, very much as in a church. The hall may have been designed in the form of a church—that is, as a building for rites—in anticipation of the canonization of the first abbot, William, who is buried here along with a number of his successors. The refectory, whose exterior walls are well preserved, was an enormous structure. It was on the second floor and was a hall 125 by 39 feet (38 × 12 m) in size, surrounded by the rhythmic blind arcades of the early English style. Another astonishing layout was the hospital from around 1150, with its own arcaded cloister and a hall for the sick that was 144 feet (44 m) long and 33 feet (10 m) wide. It is the earliest surviving example of such a hall in Cistercian architecture.

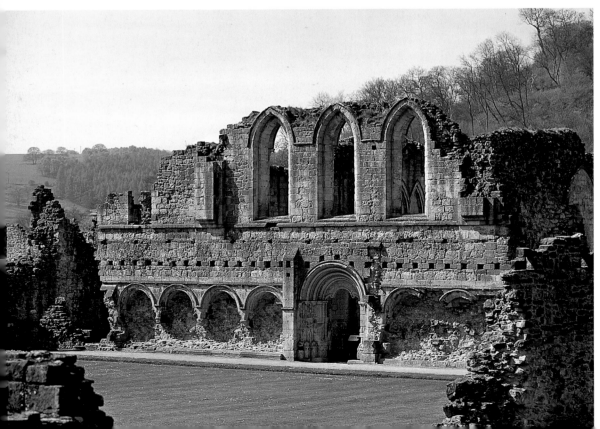

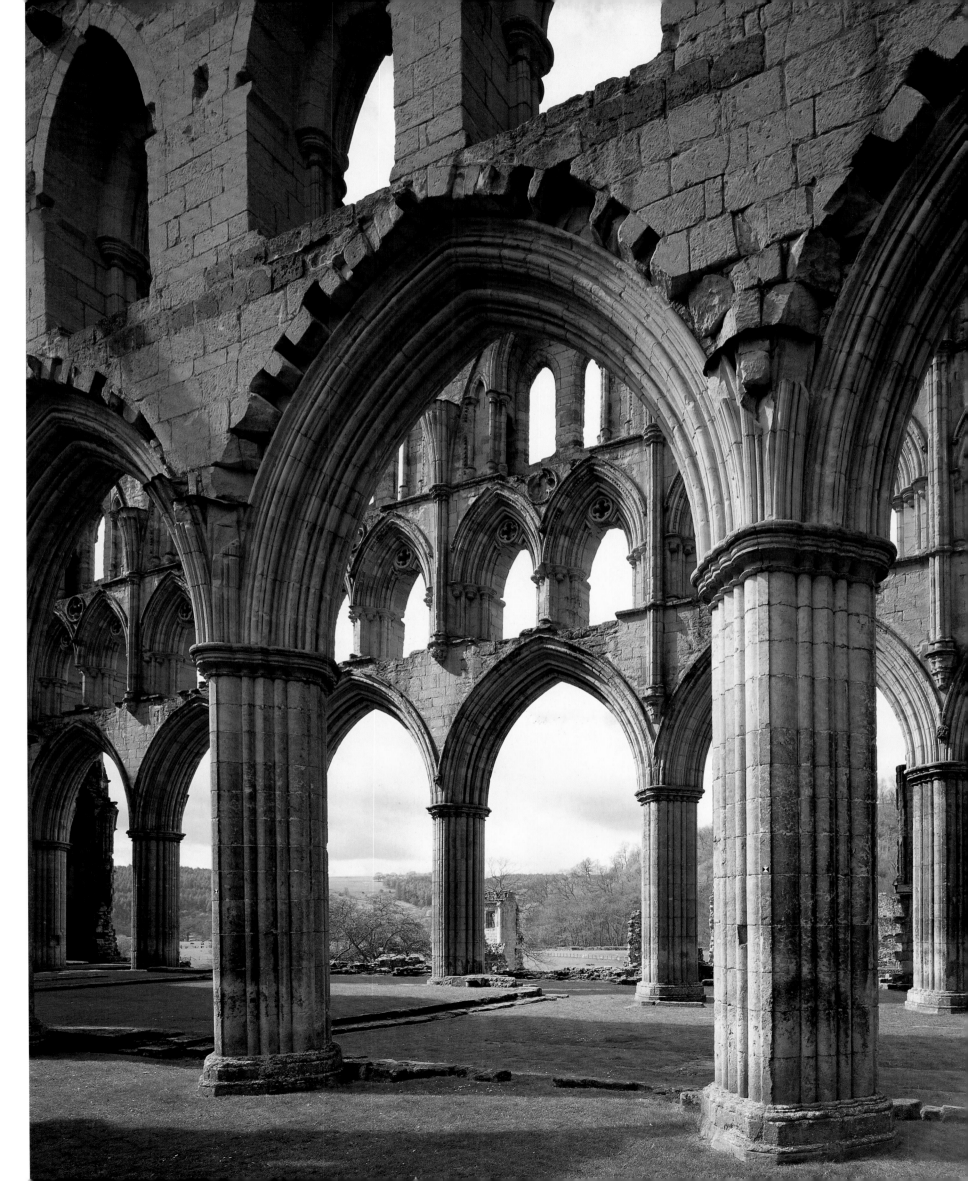

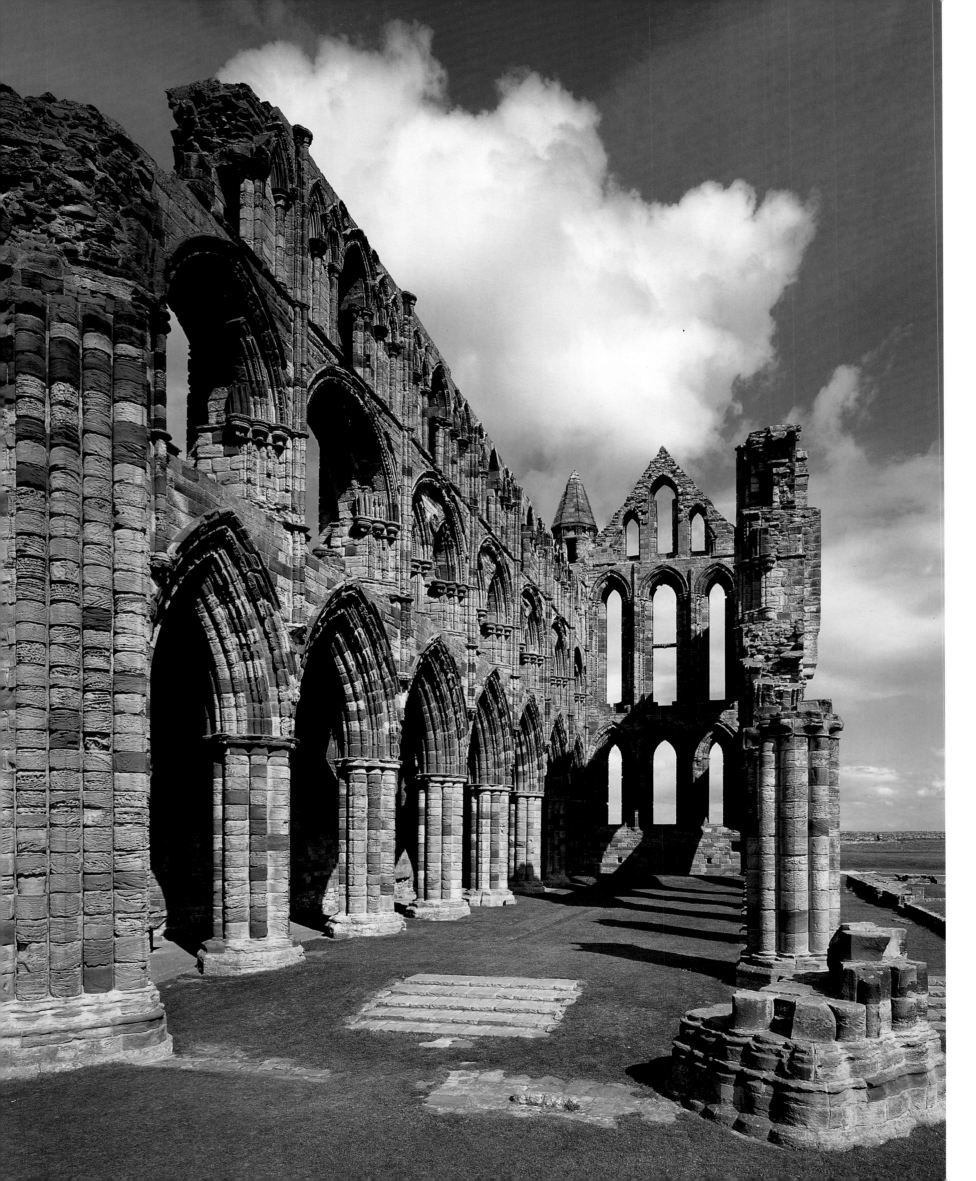

WHITBY

Whitby Abbey is one of the most beautifully located church ruins in England, lying directly above the cliffs of the North Sea coast of Northumbria, in present-day northern Yorkshire. Whitby was founded in 657 by King Oswiu of Northumbria for a community of nuns and monks under Abbess Hilda. In 664 it was the site of the famous synod at which the Roman ecclesiastical rule was introduced for all of England in lieu of the Irish rule. The monastery, of which both Oswiu's widow, Enflaeda, and his daughter Elflaeda were abbesses, was the burial site for the royal house of Northumbria.

In 867 the Danes destroyed the monastery. Not until the eleventh century, under Norman rule, was it refounded by Reinfrid, one of William the Conqueror's knights. Beginning around 1220, as part of the growing cult around the many saints of Whitby, particularly Hilda, a new Gothic building was begun, 328 feet (100 m) long; its chancel and transept are partially preserved and they are splendid examples of the early English style. Among the typical features of that style are, in the interior, the three-level structure with elaborate pier and arch profiles, and, on the exterior, the squat gable walls of the chancel and the north transept. Only small fragments of walls and stumps of piers survive from the main block and the south transept; nothing at all remains of the monastery buildings.

OPPOSITE PAGE:
Interior of the chancel, Whitby

BELOW:
Chancel from the southeast

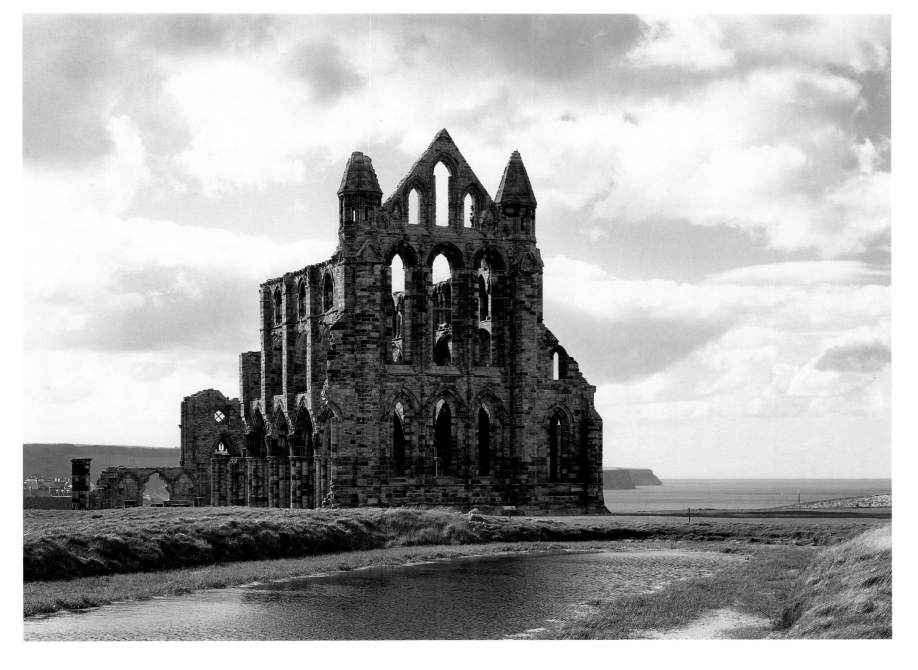

FURNESS

BELOW:
View of the transept from the northwest,
Furness

OPPOSITE PAGE:
TOP: *Chapter house*
BOTTOM: *Entrance to the chapter house*

ABOUT TWENTY-FIVE MILES NORTH OF BLACK-pool, in a rocky wooded valley on the penin-sula Barrow-in-Furness, near the coast of the Irish Sea, lies the former Cistercian abbey Furness. In 1124 Count Stephen of Boulogne, who would become king of England eleven years later, founded a Benedic-tine abbey in Tulketh, near Preston, and thus quite a bit further south. It belonged to the Norman congregation of Savigny, which had been established in 1112 by the hermit and itinerant preacher Vitalis. In 1127, just three years after it was founded, it was relocated to the totally isolated peninsula of Furness. Two decades later, in 1147, the entire congregation of Savigny joined the Cistercian order in Clairvaux's filiation. The abbot of Furness put up bitter resistance, but in vain. The monastery devel-oped into one of the wealthiest in England and was, after Fountains, the largest Cistercian abbey on the island; its estates extended to the Scottish border. From 1264 onward its abbot was a member of parliament, as one of twenty Cistercian abbots.

The church originally had an east end with a transept and five staggered apses, similar to Vaux-de-Cernay, a monastery near Paris that was also part of the congrega-tion of Savigny. In Furness, beginning around 1160–70, the Cistercians replaced the existing church with a new building that had a longer transept, each end of which had three chapels with flat terminations, and an extended sanctuary in box form. The chapels were sepa-rated only by low partitions. Ruins of the east end of the red sandstone church have survived, and the early Gothic is evident in the projections and arches, but the basic Nor-man character has not been abandoned entirely.

There are also remains of the chapter house, which was of extraordinary quality, with its three magnificent entrances through richly profiled round arches and its exterior walls in the finest early English style. Here it is evident how wealthy the monastery was.

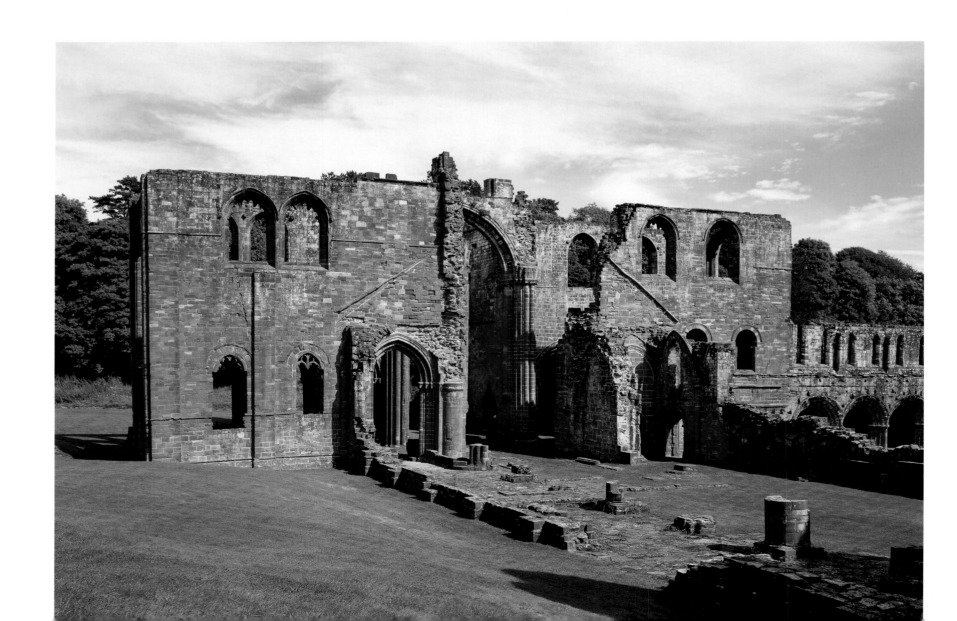

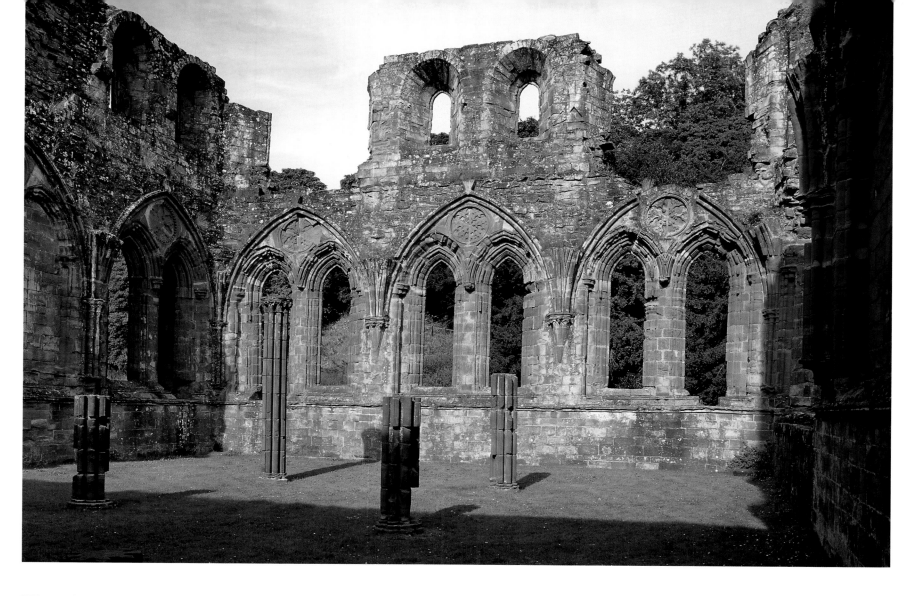

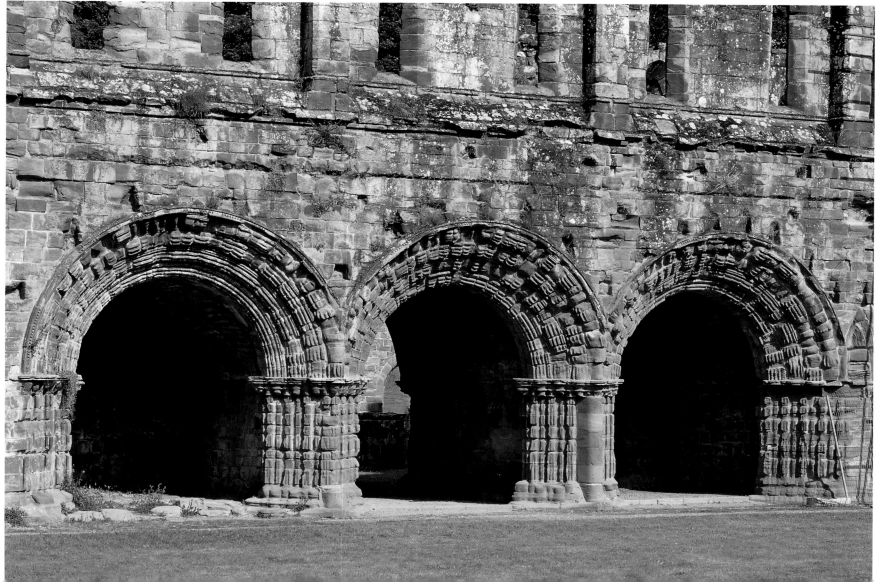

DUNDRENNAN

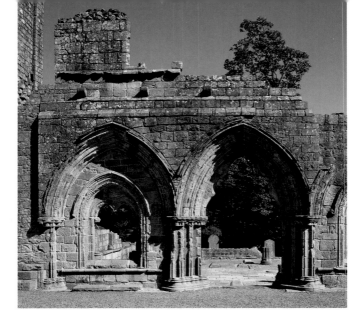

Above right:
Entrance to the chapter house,
Dundrennan

Below:
East end of the church from the west

Opposite page:
East wall of the south transept with the
north side wall of the sanctuary

THE RUINS OF THE MONASTERY DUNDRENNAN ("thorn hill"), a former Cistercian abbey on the Scottish border, lie near the coast of the Irish Sea at the entry to Solway Firth, which leads to Carlisle. About twenty miles further east on the same coast one finds the next Cistercian abbey, Sweetheart. Dundrennan was founded by King David I, probably in 1142, and settled with monks from Rievaulx; Sweetheart was not settled until 1273, as the last Scottish Cistercian abbey, by Devorguilla, the mother of the future King John Balliol. Dundrennan, where Mary Stuart spent her last night on Scottish soil on her 1568 flight to England, was closed by her son, James I, in 1591. All that still stands of the church are the whole of the north transept and the east wall of the south one, as well as the side walls of the sanctuary. The east end was arranged according to the Bernardinian plan, with three chapels in each end of the transept.

The sanctuary is a massive, barely articulated example of Norman architecture with thick walls. It appears the transept arms were entirely rebuilt around 1180. Oddly, the clerestory, with its heavy Norman forms, is the oldest section in stylistic terms. The blind triforium below it belongs to the transitional style. By contrast, the supporting arcades at the bottom, which once opened on to the chapels, are finest early English style, with bundle piers, highly pointed arches, and rich jamb profiles. Paradoxically, it is as if it had been built from top to bottom. It is possible that older material was simply reused for the clerestory. Apart from the three Gothic arches between the cloister and the chapter house, virtually nothing has survived of the monastery buildings.

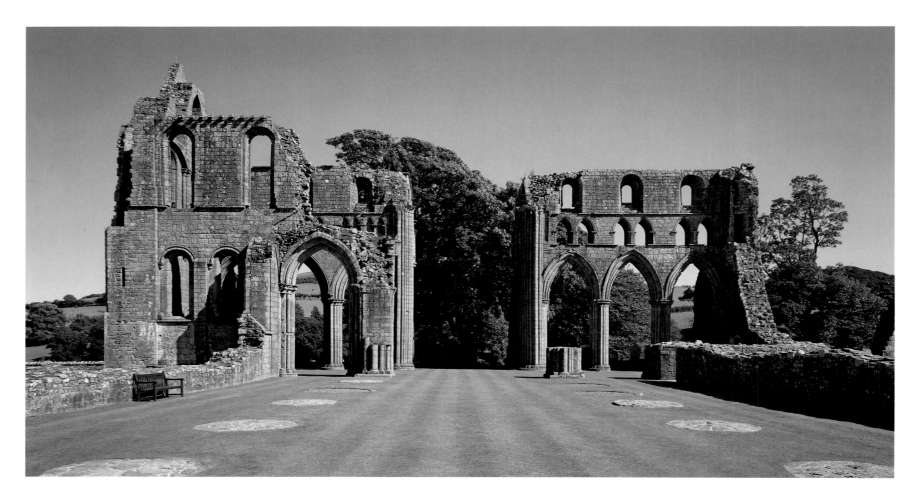

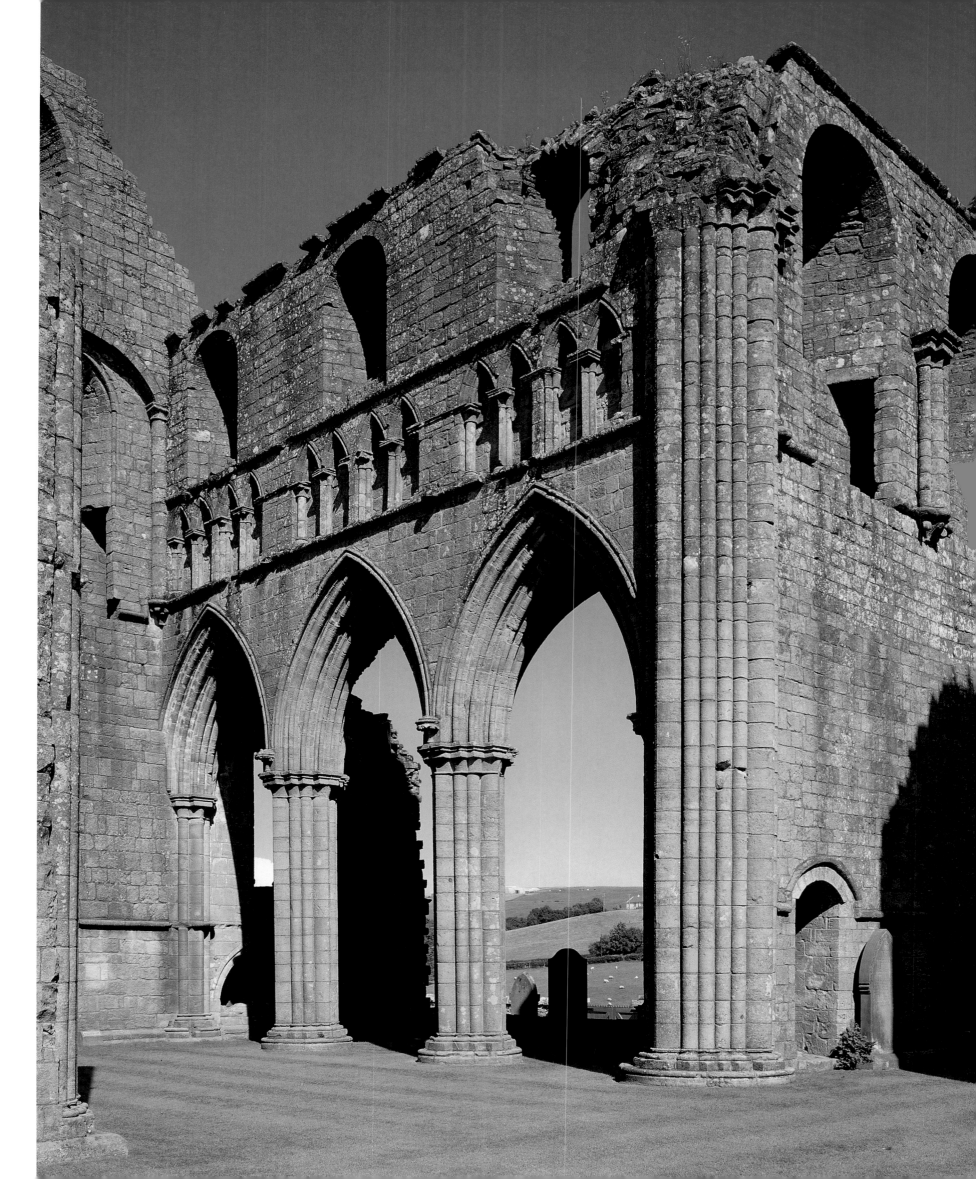

MELROSE

Below:
*Main block and transept from the
southwest, Melrose*

Opposite page:
Top: *The church from the east*
Bottom: *View from the main block
into the east end*

ABOUT THIRTY MILES SOUTH OF EDINBURGH, near the Scottish border with England, four different orders settled within close proximity: the Benedictines, at Kelso; the Augustinian canons, at Jedburgh; the Premonstratensians, at Dryburgh; and, just a slight distance away, the Cistercians, at Melrose. This abbey in the Tweed Valley had a predecessor settled from Lindisfarne in the seventh century that was destroyed repeatedly until the Scottish king David I refounded the monastery in 1136 farther up the River Tweed and entrusted it to the Cistercians of Rievaulx in Yorkshire, from the filiation of Clairvaux. Melrose was the first Cistercian abbey in Scotland. Because it was near the military road, it was destroyed several times in the English-Scottish wars: in 1322 by Edward II, in 1385 by Richard II, and then finally in 1545 by the earl of Hert-ford. After 1385 the church was completely rebuilt in late Gothic forms, for which Richard II donated funds in 1389.

The surviving ruins include the chancel, the transept, and parts of the main block, including some vaulting and exposed buttresses and large buttress pinnacles on the exterior. The chancel and its large window in the east side wall belong to the English perpendicular style, with its penchant for vertical posts and rectangular tracery patterns. The windows of the south transept and the side aisle, however, have curvilinear tracery, which had long been out of fashion in England at this time but was still used on the continent until the late Gothic. One of the architects, John Morow, immortalized his name in engraved verses on the monastery wall, with the comment that he was from Paris and had been active in Glasgow and at other monasteries. The parts of the building with curvilinear tracery can be attributed to him.

Melrose, which was sketched by J.M.W. Turner and used as the setting of Walter Scott's novel *The Monastery* of 1820, is also famous as the epitome of the romanticism of ruins. Scott recommended visiting only in the moonlight, since daylight and the sun were not suitable for ruins.

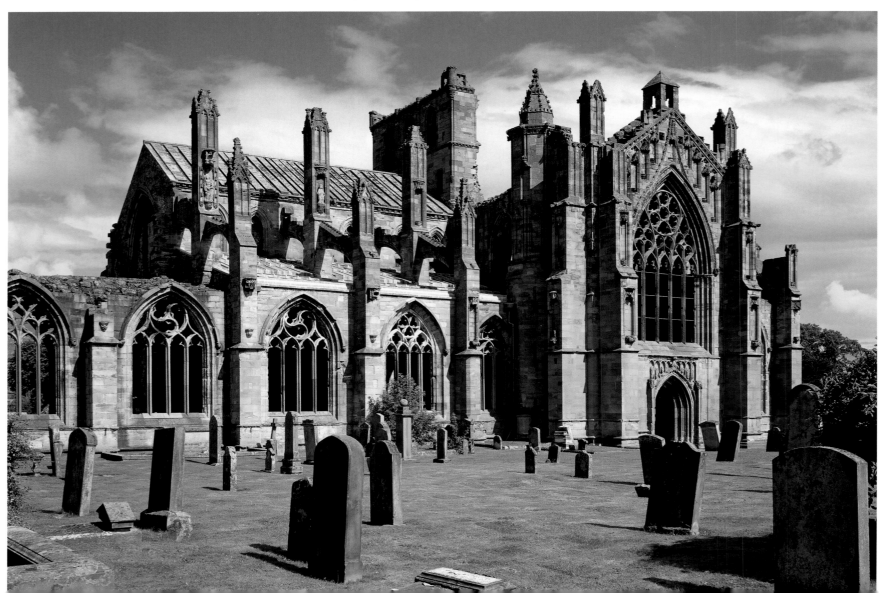

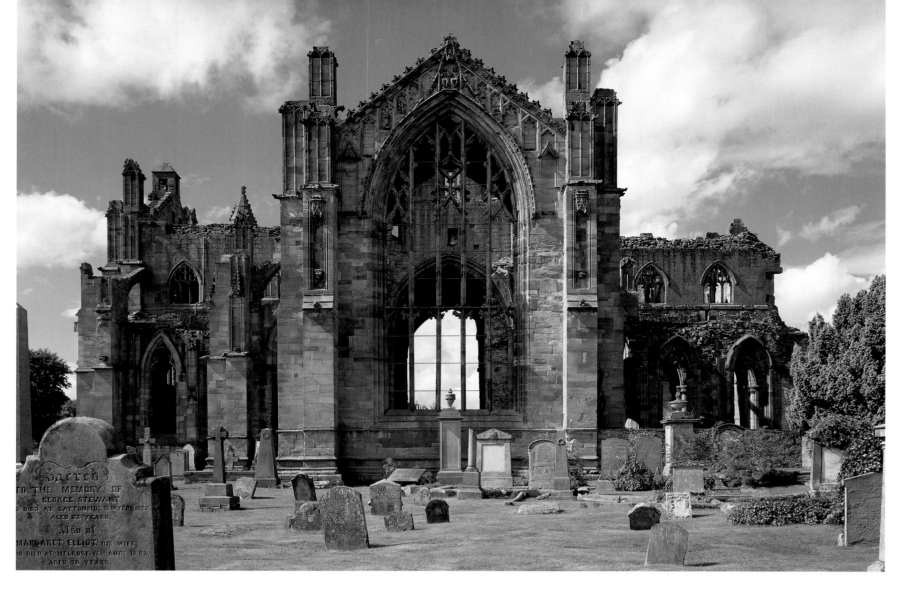

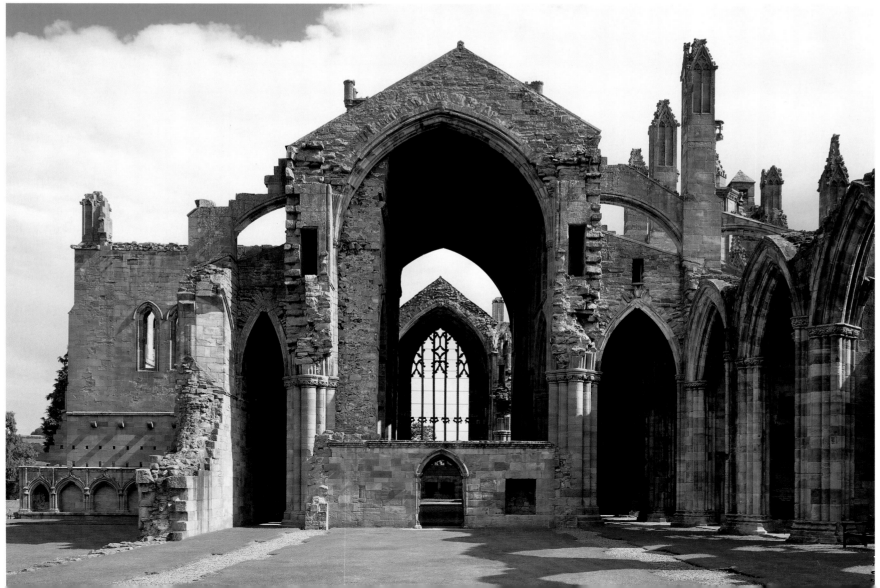

JEDBURGH

Norman side wall of the chancel, Jedburgh

OPPOSITE PAGE:
View of the nave, looking toward the east

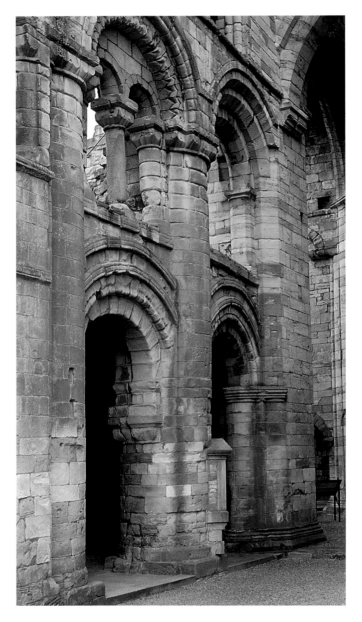

Beauvais, France. In 1544–45 the monastery was destroyed during the English invasion under the earl of Hertford and then closed in 1559. Ownership fell to the crown for a time, then to various private owners. The church remained reasonably well preserved, because the nave was used for a time as a parish church after the monastery was closed.

The chancel, which dates to the mid–twelfth century, is a powerful example of Norman architecture, with the peculiarity that there is a tall round pier in the middle of each side wall that reaches up to the gallery arches and thus, together with the neighboring piers, forms a giant arcade that spans the floor. The nave arcades are supported by round piers without projections. This structure was taken over directly from the main block of the southern English abbey church Romsey, where it had been tried somewhat earlier but then immediately abandoned (see pp. 224–25). In Jedburgh the piers and arches were translated into a plainly denser formal language and the volumes of the walls became almost unsurpassably massive; this heightens the impression of Norman power, but it also diminishes a bit the shapeliness of the round arch arcades. Jedburgh's founder, King David, had personal connections to Romsey: his aunt Christina lived there as a nun, and his sister, Matilda, who later married King Henry I of England, was raised there by Christina.

The main block, of which only the enclosing walls of the nave and the west facade with its distinctive rose window survive, dates from the early thirteenth century and belongs to the early English style. The structure consists of an arcade wall, in which the three levels, which lack projections, are placed horizontally one above the other like an aqueduct. On the lowest level there are pointed nave arches with bundle piers, the central column of which is surrounded by eight round projections that touch. Above that there is a gallery with large round arches into which paired pointed arches have been inserted. On the highest level runs a delicately arcaded gallery with small bundled columns. Here four arches are grouped together in each section of the wall, but despite this rhythm the fundamental impression is of a continuous, monotonous row. The concept of giving equal weight to round and pointed arches was concerned only with providing rich variety in the construction of the floors, and not the system of vaults, since the main block had wood ceilings. Here the old Norman construction system with three-level arcade walls lived on, though superficially modernized by means of individual Gothic motifs.

A BOUT FORTY MILES SOUTH OF EDINBURGH LIES Jedburgh, a former Augustinian canon monastery that was one of a group of four monasteries in close proximity near the Scottish border, along with the Benedictines, at Kelso; the Premonstratensians, at Dryburgh; and the Cistercians, at Melrose. Around 1138 King David I (who was also responsible for Kelso and Melrose) and Bishop John of Glasgow provided Jedburgh with an adequate monastery. David, then still earl of Cumbria, had already established a priory here in 1118, with canons from Saint-Quentin in

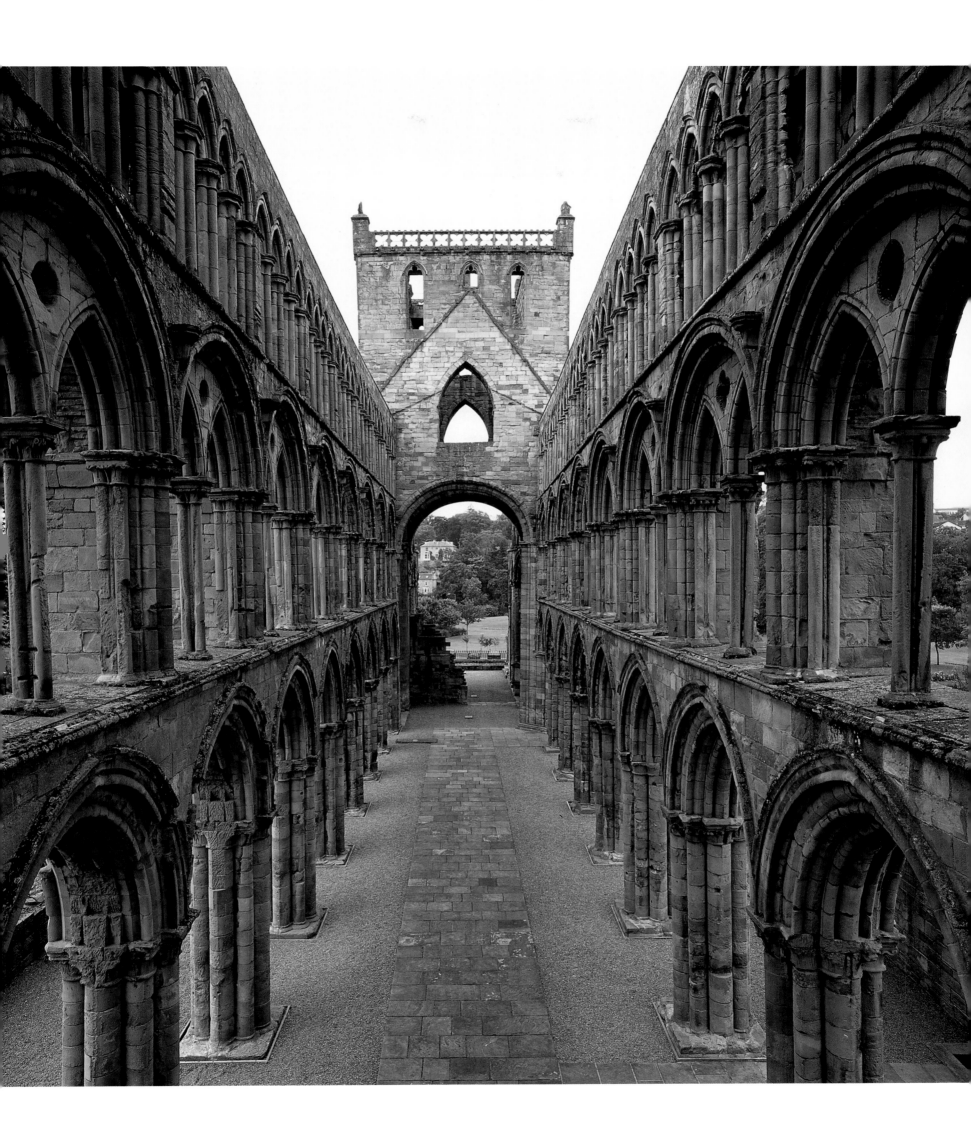

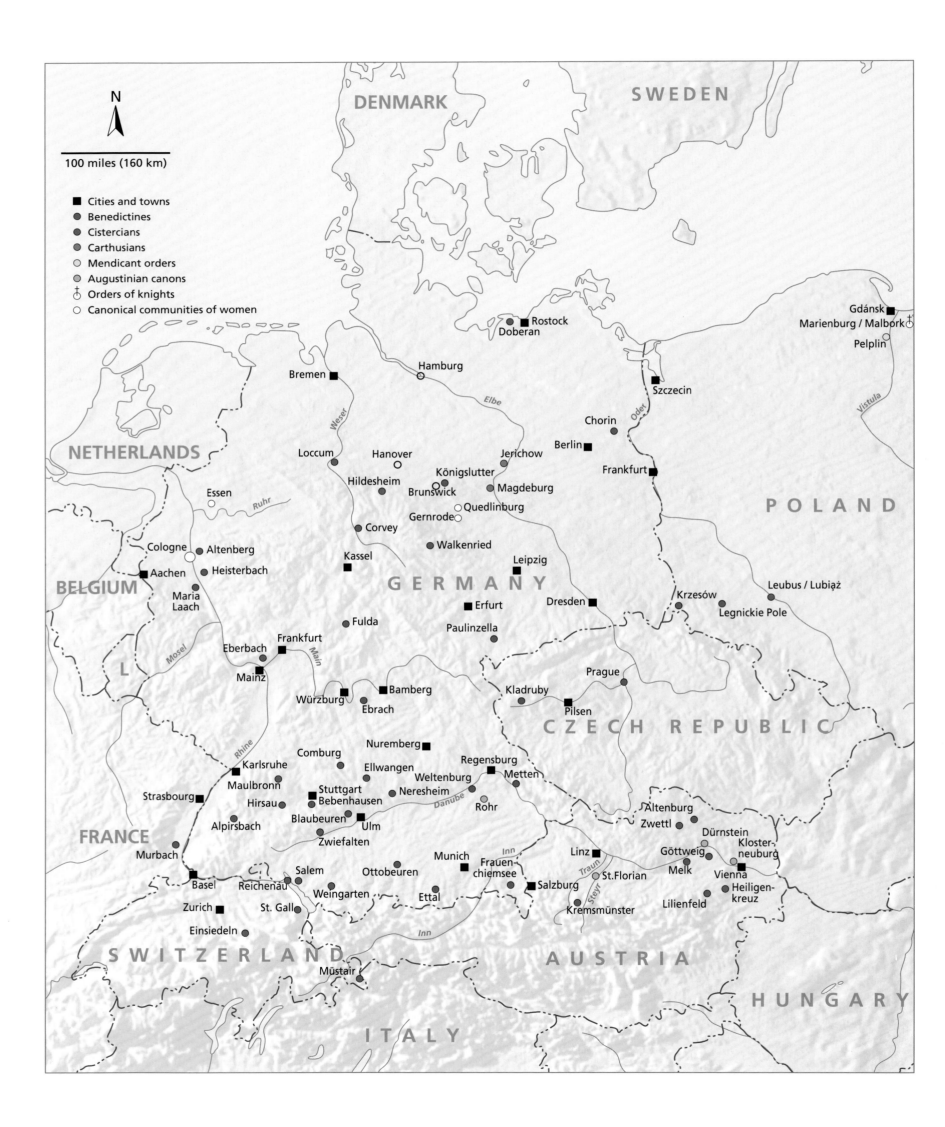

N

100 miles (160 km)

■ Cities and towns
● Benedictines
● Cistercians
● Carthusians
○ Mendicant orders
● Augustinian canons
⚔ Orders of knights
○ Canonical communities of women

SWEDEN

DENMARK

NETHERLANDS

BELGIUM

FRANCE

SWITZERLAND

GERMANY

POLAND

CZECH REPUBLIC

AUSTRIA

HUNGARY

ITALY

Rostock
Doberan

Hamburg

Bremen

Loccum

Hanover

Hildesheim
Brunswick
Königslutter
Jerichow
Magdeburg
Berlin
Chorin
Frankfurt
Szczecin

Gdánsk
Marienburg / Malbork
Pelplin

Gernrode
Quedlinburg

Corvey

Walkenried

Leipzig

Essen

Cologne
Altenberg
Aachen
Heisterbach
Maria
Laach

Kassel

Fulda

Erfurt

Dresden

Krzesów

Leubus / Lubiąż

Legnickie Pole

Paulinzella

Prague

Eberbach
Frankfurt
Mainz

Würzburg
Ebrach
Bamberg

Kladruby
Pilsen

Nuremberg

Comburg
Karlsruhe
Ellwangen
Regensburg
Metten

Maulbronn
Stuttgart
Bebenhausen
Neresheim
Weltenburg
Rohr

Hirsau
Alpirsbach
Blaubeuren
Ulm
Zwiefalten

Danube

Munich

Frauen-
chiemsee

Altenburg
Zwettl
Dürnstein
Klosterneuburg
Göttweig
Melk
Vienna

Linz
St.Florian

Heiligen-
kreuz
Lilienfeld

Murbach

Basel
Reichenau
Salem
Ottobeuren
Ettal
Salzburg
Kremsmünster

Zurich
St. Gall
Weingarten

Einsiedeln

Müstair

CENTRAL EUROPE
POLAND · GERMANY · SWITZERLAND · AUSTRIA CZECH REPUBLIC

MALBORK
(MARIENBURG)

ONE OF THE GREATEST FORTRESS AND monastery sites in Europe is Marienburg (now known by the Polish, Malbork), in former Pomerania in West Prussia (now Poland). It lies thirty-two miles (52 km) southeast of Danzig (Gdańsk) on the right bank of the Nogat, a tributary of the Vistula. This was the intersection of the trade route from Pomerania to Novgorod and the amber route from Samland to the south. The fortress is a brick building surrounded on all sides by moats and walls with defensive towers. The total dimensions, including the front castle, is approximately two thousand feet long by sixteen hundred feet wide (600 × 500 m).

Marienburg was the main seat of the Teutonic Order, known in Poland as the Knights of the Cross. In 1230 Duke Conrad of Masovia had the order brought into the area to secure his border against the pagan Prussians, and for numerous military campaigns it conquered its own state, which comprised West and East Prussia as well as present-day Latvia and Estonia. Construction of the fortress began in 1274, and by 1280 a chapter of knights under a commander was able to occupy it. In 1309 the grand master transferred his seat here from Venice; that same year the order annexed Pomerelia along with Danzig, the land bridge from West Prussia to the German Reich. Work on the enormous complex continued into the middle of the fifteenth century. By that time the order had already been defeated by the Polish-Lithuanian army in the Battle of Tannenberg (also known as the Battle of Grunwald) in 1410. In 1457 it had to surrender the fortress to Poland. In 1772 the whole region

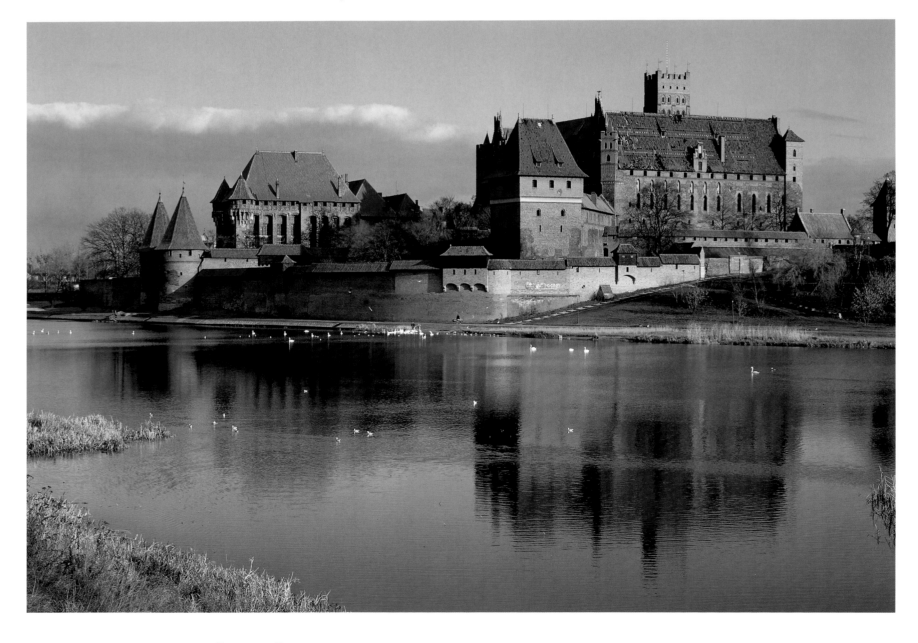

fell to the kingdom of Prussia in the first division of Poland. The Poles managed to maintain the fortress in a reasonable architectural state for more than three centuries, but in just thirty years the Prussians made a ruin of it through barbaric use and destruction. Not until 1803 did an impassioned article by Max von Schenkendorf, a student from Königsberg who would later become famous as a patriotic poet, convince the public that the fortress should be preserved. Eventually, Marienburg become a German national monument on a par with the Cologne cathedral. This was soon followed by the first romantic restoration, which Karl Friedrich Schinkel championed, inspired by drawings that the young Friedrich Gilly had been making of the fortress since 1794. An extensive renovation was carried out between 1882 and 1939. Its fate seemed doubtful, however, when the Germans pronounced the fortress a stronghold toward the end of World War II and defended it for days against the Red Army. At that time eighty percent of the building's structure was destroyed by artillery fire. After the war's end the Poles carried out an impeccable reconstruction between 1961 and 1978 and thus saved for posterity one of the most important architectural monuments of its former archenemy.

The fortress consists of three separate parts: the upper castle, the middle castle, and the front castle with the farm buildings. The upper castle, where the monastery is located, is laid out in four wings, with a two-story cloister in the inner court and several magnificent gables, framed by small towers, on the exterior. It is in fact a separate fortress, like a castellum, as was typical for the fortifications of the Teutonic Order. After 1330 a broadly projecting two-story chapel with a polygonal apse was added on the side facing land, with the burial site of the grand masters below and the church of Saint Mary above. The middle castle, which has a large, two-nave *Remter* (refectory) with star vaults, was built between 1310 and 1330. The high point is the grand master's palace. It was added to the west wing between 1380 and 1400, and it opens up directly onto the Nogat. It offers an impressive facade toward the river, with octagonal crenellated turrets extending far out from the corners. Inside it contains two stately late Gothic rooms: the winter *Remter,* with floor heating; and the summer *Remter,* with large rectangular windows on three sides. Both are square, stately rooms with a central pillar of granite from which the thin ribs of the star vault radiate like palm leaves. In the grand master's palace the heavily fortified bastion becomes a magnificent castle that impresses us not by its fortification but by its lightness and elegance.

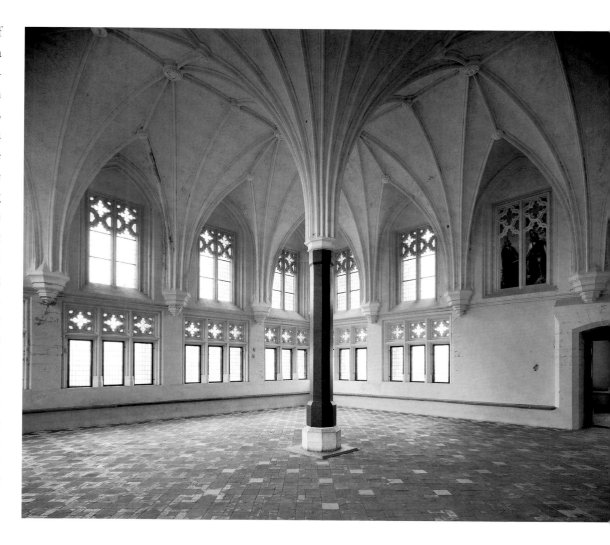

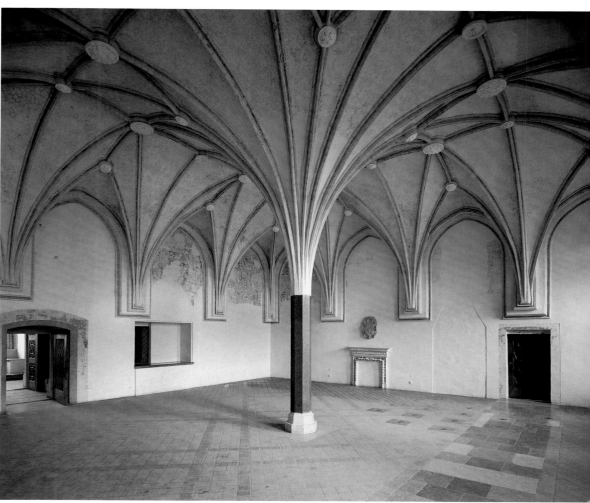

PELPLIN

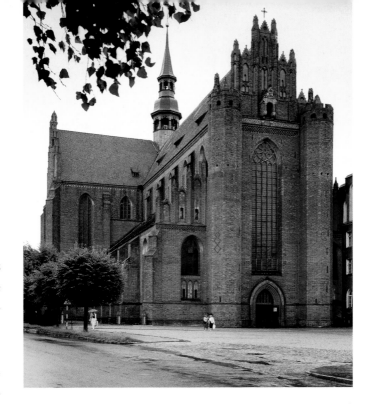

THE FORMER CISTERCIAN ABBEY OF PELPLIN LIES in Pomerelia, south of the lower course of the Vistula near Starogard Grańsk (formerly Prussian Stargard). It is thirty miles (50 km) from Gdańsk, fifteen (25 km) from Malbork (Marienburg).

The monastery was founded in 1258 in Pogutken (Pogódki) by Duke Sambor II of Lübschau and settled with monks from Doberan, in Mecklenburg. In 1276 Duke Mestwin (Mszczuj) II of Pomerania, with the approval of Duke Sambor, moved the monastery to its present location. A little later, in 1282, the land fell to the Teutonic Order; from 1466 to 1772 it was ruled by Poland, then by Prussia, and after World War I, by Poland again. In 1823 the monastery was closed, but the church was promoted to being the cathedral for the Kulm diocese.

The cornerstone for the church was laid sometime before 1295. Construction was largely completed by 1348, including the monastery. Later there were several phases of reconstruction, particularly with the vaulting: the five western spans in the middle vessel, which collapsed in 1399, had to be replaced, and in 1557 the Danzig mason Anton Schultes added an elaborate tracery vault in the transept arms. The church, a brick building with a total external length of about three hundred feet (90 m), is a three-nave basilica with a flat termination on the east side and a broad transept approximately in the center. The external appearance of the imposingly large building is simple, yet the upper level—with four staggered gables, blind tracery ornaments, and piers that loom up like pointed lances—displays the great variety characteristic of Gothic brick architecture in the Baltic region. The narrow, towering west facade, drawn tightly together by polygonal terraced towers, is also momentous in its effect. The interior, with a tall, steeply rising middle vessel and sanctuary, is marked by the contrast of magnificent star vaults and bare, undressed nave walls, on which thick projections run up, extending from the low octagonal piers of the nave arcades. The north and south transept arms represent a special innovation: they have two naves and open through an immense double arch onto the middle vessel. The effect, however, is almost that of a quadratic central-plan building with a massive octagonal middle column, above which the tracery vault spreads with an almost weightless buoyancy. The cloister encroaches on the ground floor of the south transept arm. The idea of two naves in the transept was borrowed from its mother monastery, Doberan (see pp. 258–59). The monastery buildings are largely preserved. In terms of architectural achievement, however, they are far inferior to the church.

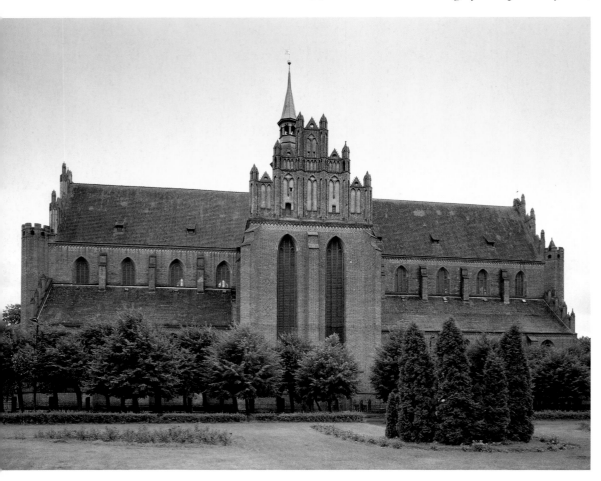

DOBERAN

Mecklenburg, was the Slavic prince Obodriten Pribislaw, who had converted to Christianity, and whose father, Niclot, had been defeated by the Saxon duke Henry the Lion in 1160. In 1171 the first monks arrived from the monastery Amelungsborn, near the Upper Weser, which belonged to its mother monastery, Altenkamp, on the Lower Rhine, as part of the filiation of Morimond. Eight years later, however, the convention, which had grown

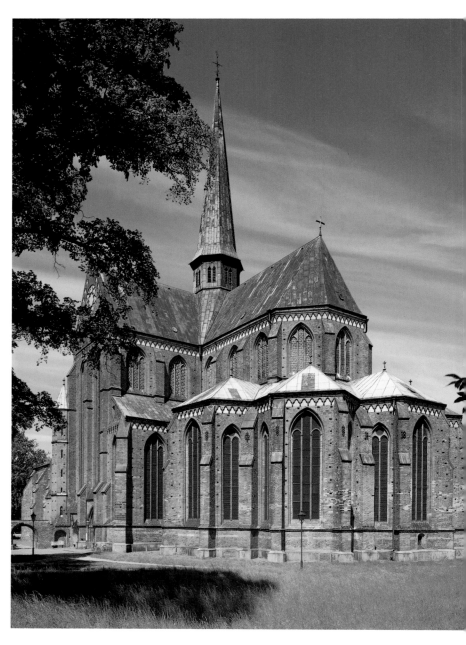

ABOVE LEFT:
The church of Doberan, seen from the northwest

ABOVE RIGHT:
East end of the church showing the ambulatory and wreath of chapels

THE FORMER CISTERCIAN MONASTERY DOBERAN, one of the richest in northern Germany, lies in Mecklenburg, near the Baltic coast. It presided over the income from about forty villages and estates, as well as from profitable salt pans in Lüneburg and even from its own fleet of ships. When the region became Protestant and the monastery was closed in 1552, the property fell to the dukes of Mecklenburg, who had used the church as their burial site since the Middle Ages. The founder of the monastery, the oldest in

to seventy-eight residents, was killed in the war over Pribislaw's successor, and the monastery was destroyed. Amelungsborn sent a new convention in 1186. At the same time the monastery was relocated about two miles (3 km) away, at its present location, which was better protected. With the help of farmers from Westphalia and Lower Saxony who had been coming into the area since 1218 with the permission of the prince, the monastery soon rose to become a regional economic power.

The first church, a late Romanesque building, was

consecrated in 1232. After a fire caused by lightning seriously damaged the monastery buildings and church in 1291, the abbot, Johann von Dalen (1294–1299), had the old wooden church, which was to be replaced by a new structure anyway, torn down and began work on the present brick church. The generous sum of eleven thousand Lübschau marks (roughly fifty hundredweights of silver), was available for this purpose. The east end was

Sankt Marien, in Lübeck, and Rostock and Sankt Nikolai, in Stralsund—but also the cathedral in Schwerin, the seat of the diocese to which Doberan belonged. In the interior the nave arcades are very tall; by contrast, the clerestory windows, located in the vault bays, are short. The strip of wall below them is turned into a triforium by means of painted arcatures, a trademark of this church. The second trademark is the transept arms,

BELOW LEFT:
Interior of the church facing east

BELOW RIGHT:
Looking into the vaults of the south transept arm

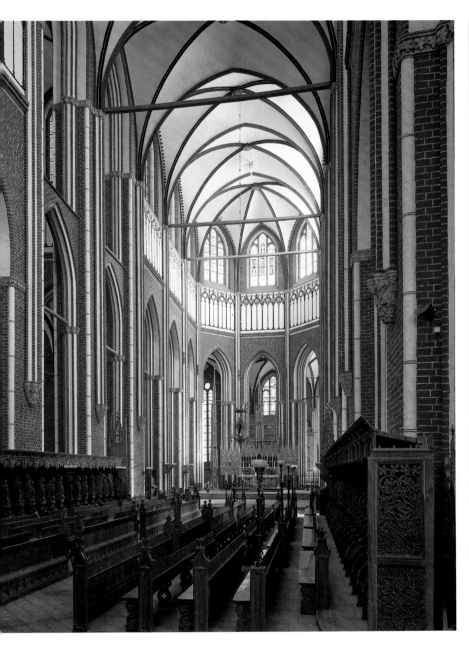

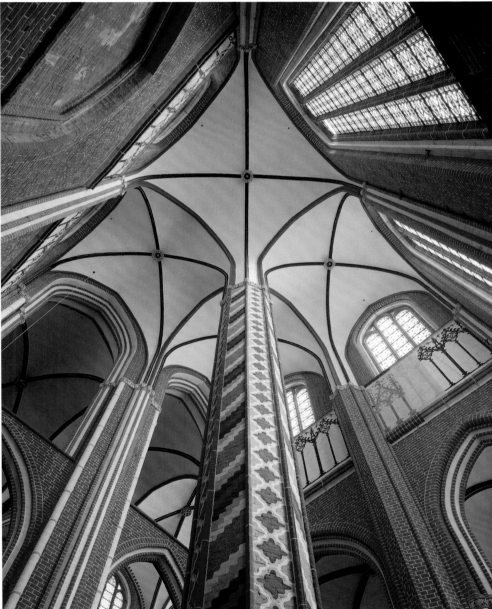

completed around 1310, when the high altar was erected, and the final consecration followed in 1368. The church is a typical Cistercian "cathedral," with a transept, ambulatory, and a radial wreath of chapels—a counterpart in the brick-church region to Altenberg, near Cologne (see pp. 288–89), or Marienstatt, in the Westerwald. The models for the east end, in which the chapels are grouped together with the trapezoidal bays of the ambulatory by means of the vaulting, were the large churches of the Hanseatic cities on the Baltic—

each of which is a central-plan room with a pier in the middle and two levels of arcades that open onto the nave. The decorations from the fourteenth century are almost totally preserved, including the high altar, which has one of the oldest polyptych altarpieces and has elaborate tracery; the wooden sacrament house; the choir stalls for the monks and the conversi; the remains of the glass windows; and the altar for the laity. The building and its decorations form a completely homogenous unity to an extent that is unusual for this period.

CHORIN

IN THE MARK BRANDENBURG THAT SURROUNDS
Berlin, the margraves from the house of the Ascani-
ans founded several Cistercian monasteries and
chose them as their burial sites, beginning in 1183 with
Lehnin, near Brandenburg, which settled three more
monasteries in the Mark in the period that followed.
The most important of these was Chorin, northeast of
Berlin, near Barnim. When the Ascanians split their
domain into two lines in 1258, Margrave Johann wanted
a monastery for his line and for its burial site, and so
he established a Cistercian monastery called Mariensee
on an island in Lake Parstein. Construction of a large

church was begun there immediately. But in 1273 the
margraves moved the monastery to its present location
and called it Chorin. By the time the Ascanian line died
out in 1319, the monastery was already the largest prop-
erty owner in the region. It did not exist long, however;
in 1542 it was secularized and became the state property
of the electoral princes.

The church was built after the refounding in 1273,
and the monastery buildings were constructed over a
period of about sixty years, built entirely of brick and as
a unified complex of Gothic buildings. After the Thirty
Years' War it declined gradually until Karl Friedrich
Schinkel began in the early nineteenth century to cam-
paign for the preservation of romantic ruins, and won
over the Prussian crown prince (later King Fredrick
William IV), to the cause. The site is reasonably well pre-
served on the whole, despite a few gaps. The south side
aisle of the church, the chapter house, the well house,
the north and south wings of the cloister, and the
monks' refectory are all missing. The overall look is dis-
tinguished by numerous gables with rich, constantly

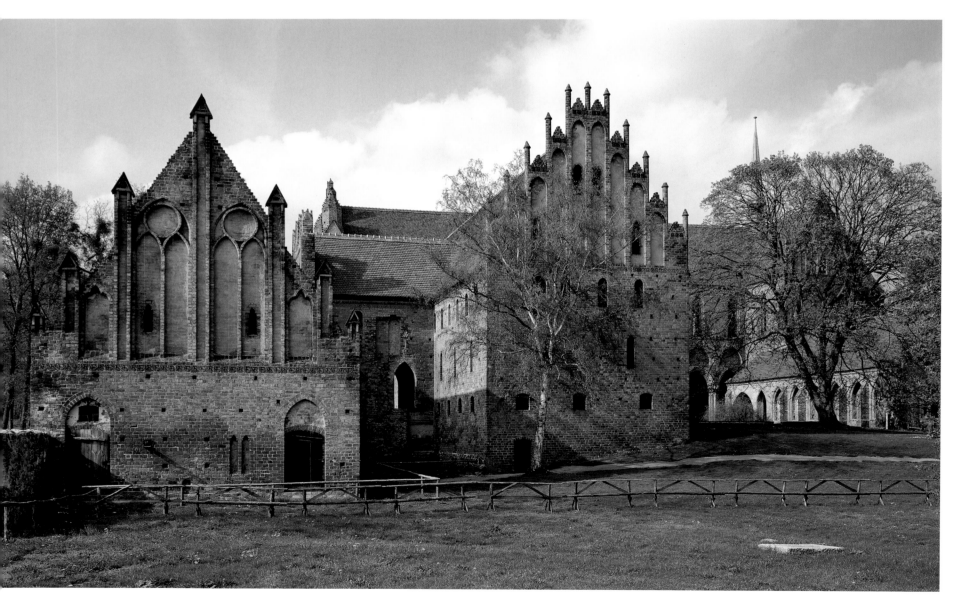

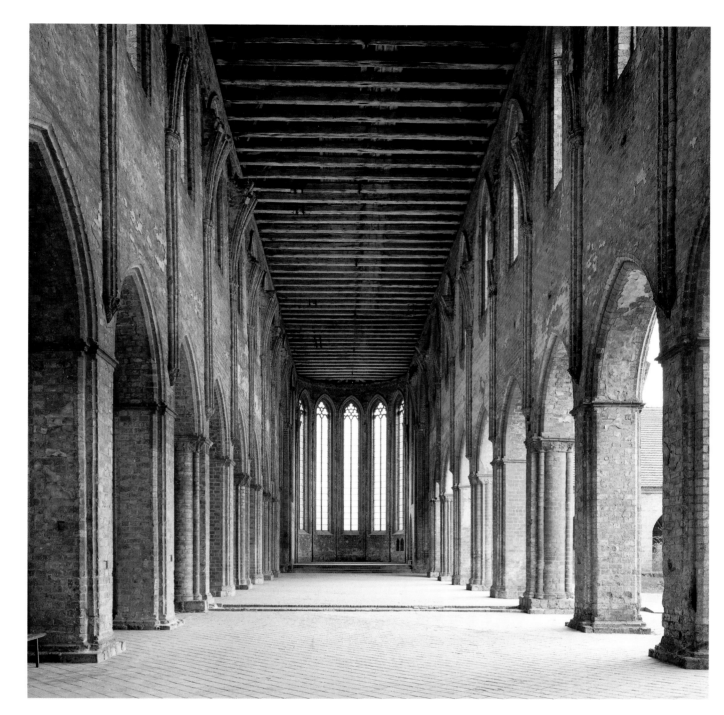

varying blind articulations, as is characteristic of brick Gothic buildings.

The vaults in the church have collapsed, as have those of most of the monastery buildings, because the roofing tiles were removed in 1661 for other uses, and the vaults were left exposed to the weather. The church is a bare, cruciform pier basilica, 226 feet (69 m) in length. The sanctuary in the east does not have a flat termination, as is often the case with Cistercian churches, but a polygonal apse, elaborately constructed within the seven sides of a dodecagon. The tall, slender windows are fitted with tracery filling. The wreath of light from the windows makes the apse into a very effective focus within the space.

Chorin's fame is due to the west facade of the church. While even the end walls of the transept are turned into showpieces by the splendid gables, the west facade as a whole is truly magnificent—not so much for its rich decor, however, as for its comprehensive articulation. Vertically, the facade is graduated in three parts; thus each of the three naves has its own facade. The center dominates. Framed by pierlike turrets it presents a rhythmically articulated group of three tracery windows with a rosette above them. The whole is capped with a series of small pointed gables and helm roofs that form a jagged horizontal silhouette. What is most remarkable about this display wall, which demonstrates the design possibilities of brick, is the balance of proportions. Gone is any sign of Cistercian simplicity. Rather, the splendor of the architecture makes it seem as if the order wanted to create a monument to their Ascanian sovereigns.

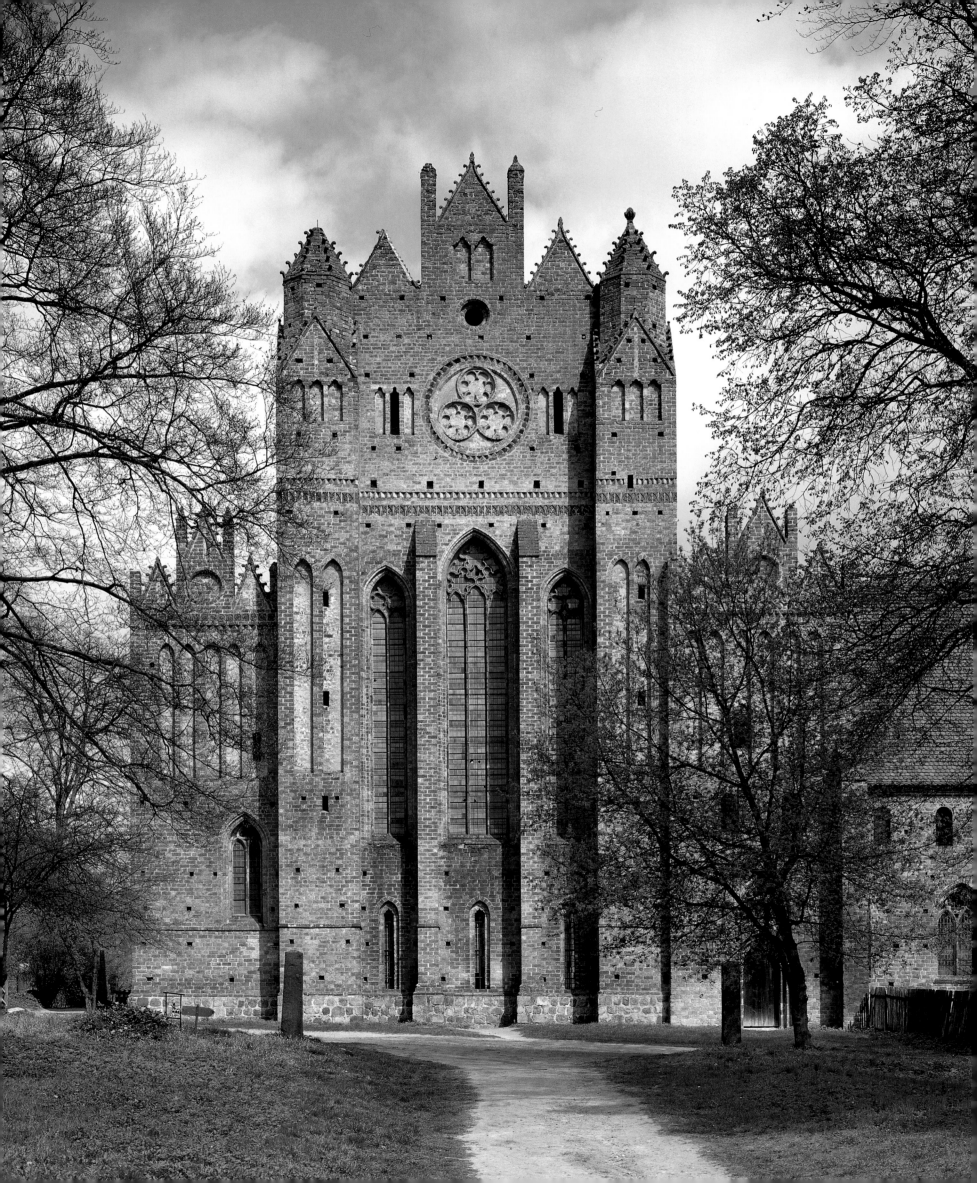

JERICHOW, IN THE ELBE-HAVEL REGION FAR FROM any larger towns, is famous for having the best preserved all-brick Romanesque monastery in Germany, which is an architectural masterpiece of the Premonstratensian order. The monastery was founded by the margraves of Stade, after the reigning margrave, Rudolf, died in a battle against Dithmarschen in 1144 without leaving an heir. His brother Hartwig, then provost of the cathedral in Bremen and later archbishop there, arranged for the founding of the monastery that year. The convention arrived in 1145 from the Liebfrauenkloster in Magdeburg. The market in Jerichow proved too loud for chancel offices, however, so the monastery was moved to its present location, about half a mile away (1 km), in 1148.

The church and monastery buildings were built thereafter. The church was begun in ashlar, but after just a few courses brick was introduced. At the time no one had any experience with brick in the north, so Jerichow was a pioneering building, and it achieved astonishing precision. The architect was immediately able to obtain original architectural effects with the unfamiliar material.

The church is a three-nave, flat-ceilinged pier basilica with a two-tower facade, transept, and tripartite chancel in the east, which terminates in three parallel apses. The exterior view from the east in particular, with its groups of barely articulated cubic blocks of buildings and semicircular projecting apses, presents an image of a fully developed, stylistically pure Romanesque. The smooth brick surfaces are trimmed with perforated friezes of round arches—a very simple ornamental motif that is typical of Romanesque brick architecture. A brusque two-tower facade, with a boxlike projection in the middle, looms loftily and steeply in the west. It was begun in the thirteenth century and not completed until the fifteenth; the upper stories of the towers are in a Gothic style, but the architecture's old Romanesque defiance survived until the end.

The interior breathes an austere monastic severity, although thanks to the warm red brick hues it is not harsh, but filled with a very individual, lively atmosphere that ashlar never achieves. All of the forms are reduced to the simplicity of the elemental: not only the completely smooth walls with windows inset without any profiles, but also the nave arcades. The architect turned the column arcades he saw in the cathedral and the Liebfrauenkirche in Magdeburg into pier arcades with circular shafts made of brick. The capitals are also masonry. Their form goes back to the widely used type

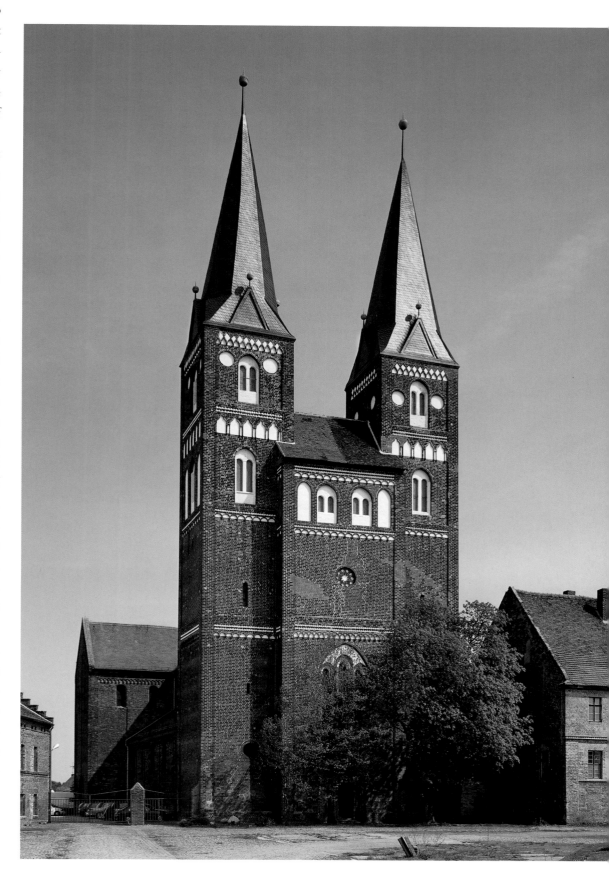

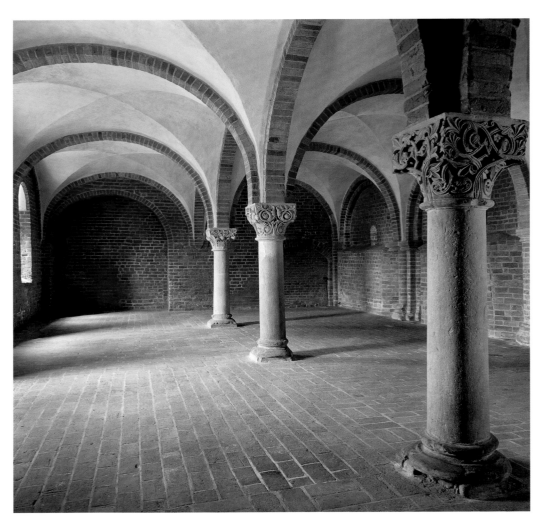

of the block capital, but the semicircular shields of that design have been transformed into simpler trapezoids that are better suited to brick. In the arches of the arcades brick provided a simple means to stagger the profile of the facing. On the whole, the result is a variant on the traditional column basilica that is defined by the material. A two-nave crypt, extending from the apse to underneath the crossing and opening onto the middle vessel through two arches, was added later, toward the end of the twelfth century. Here ashlar columns with monolithic shafts were used, one of which was clearly taken from Otto the Great's cathedral in Magdeburg, having been imported in turn from an ancient building in Italy.

The monastery, which adjoins to the south, consists of a very simple vaulted Romanesque cloister surrounded by three late Romanesque two-nave rooms in a style similar to the crypt: the chapter house, the summer refectory with its magnificent bell-block capitals on the columns, and the winter refectory, which was heated. Later additions to the monastery site have since been removed, for the most part, and several missing parts have been reconstructed. Now Jerichow reveals more or less the original state of the Premonstratensians' living quarters.

PAGE 263:
West façade of the church, Jerichow

ABOVE:
Summer refectory

RIGHT:
Crypt of the church

OPPOSITE PAGE:
Middle vessel of the church, facing east

PAGE 266:
East end of the church

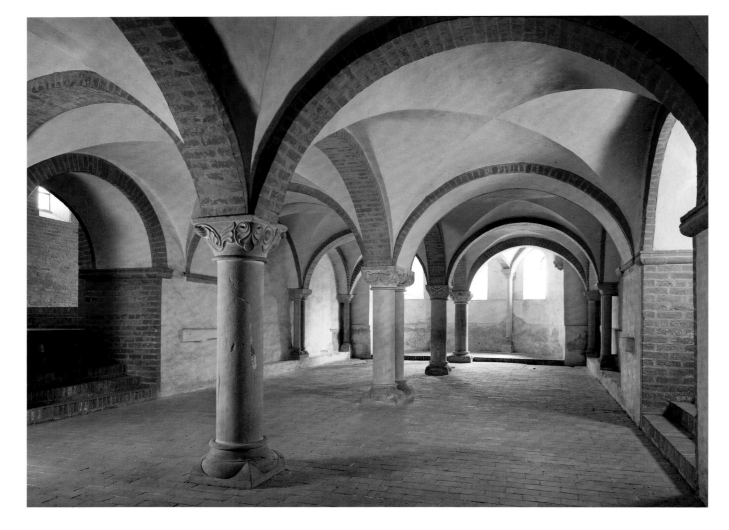

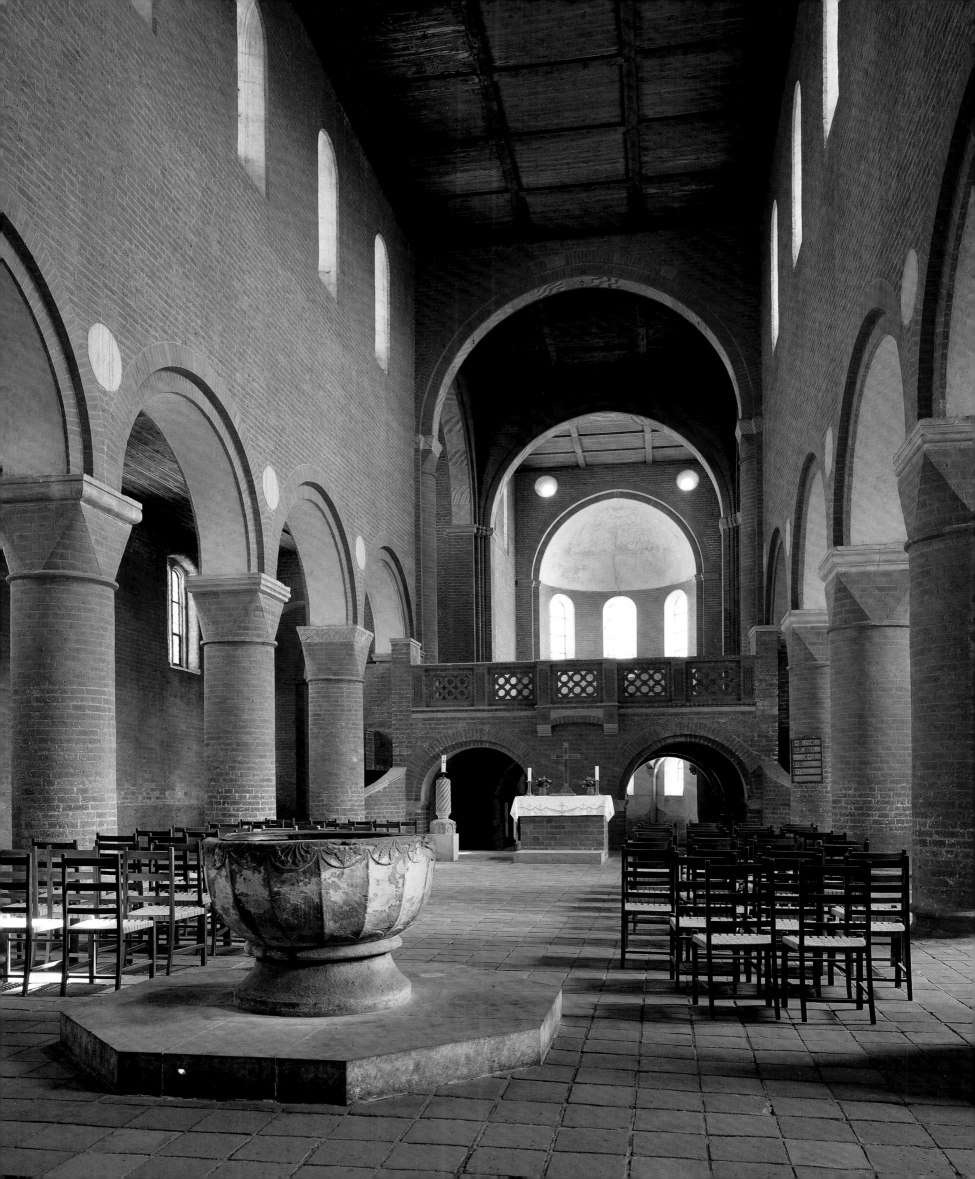

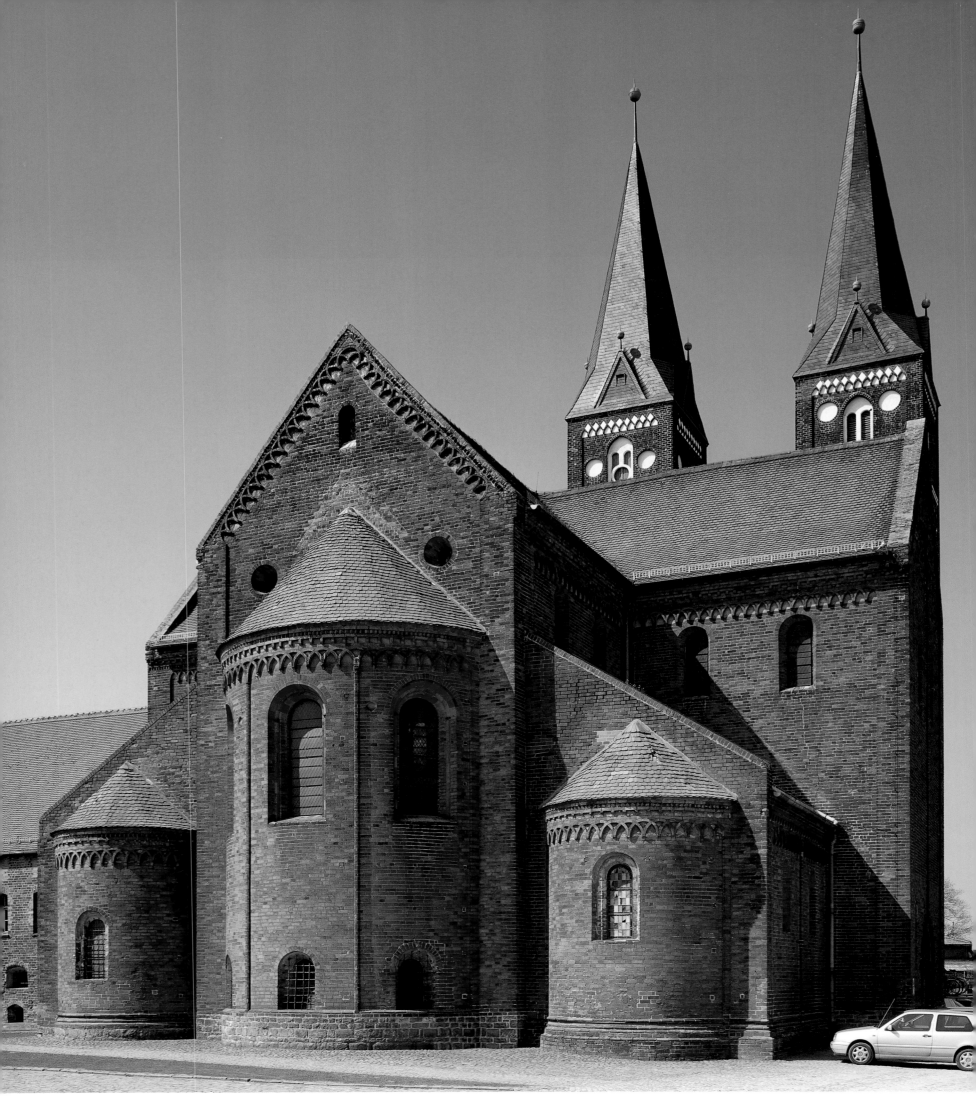

THE FORMER BENEDICTINE MONASTERY CHURCH Königslutter, east of Brunswick on the Elm mountain range, dates back to Lothair II, emperor of Supplinburg, who was elected king of Germany in 1125, after the death of Henry V, and crowned emperor in 1133. Just before he died in 1137, he invested his son-in-law, the Bavarian duke Henry the Proud, from the house of the Guelphs, with the duchy of Saxony. Königslutter was intended to become the monastery for a new Saxon-Guelph dynasty. This union produced Henry the Lion, the son of Henry the Proud and Lothair's daughter Gertrude. The emperor and his wife, Richenza, the heir of the landed Count Henry of Northeim, were buried in the church, as was Henry the Proud, who died in 1139. Their tomb monument in the main block dates from 1708; it replaces a Gothic tomb relief that was destroyed when the ceiling collapsed in 1690.

In 1135, two years after his coronation as emperor, Lothair transformed an existing Augustinian canonical community in Lutter on the Elm into a Benedictine abbey, settling it with monks from the Hirsau reform church Berge, near Magdeburg. That same year the foundation stone for the church was laid in the presence of the emperor and empress. Neither Lothair nor his wife, who died in 1141, lived to see its completion around 1170 or 1180. The west end, an angular, steep cross bar, lacks a tower even today. Königslutter is the oldest Romanesque church in northern Germany in which large-scale vaults were attempted, though only in the east end. The layout—with a transept, side chancels, and apses—is in the Hirsau style, but the walls are so thick that they can absorb the thrust of the cross rib vaults without additional bracing. The exterior of the east end is an ideal image of high Romanesque forcefulness: groups of angular blocks and projecting apses, the stone-heavy structure of the ashlar walls, and the power of the whole ensemble. The frieze above the lower round arches of the main apse has a cycle of reliefs with depictions of hunting, with the climax in the middle showing the hares having defeated and tied up the hunter. The sculptor was apparently the same Niccolò whose activity is documented at San Zeno in Verona (see pp. 416–19), as well as Ferrara, Modena, and elsewhere in northern Italy. He was one of the most skilled workmen of his day, and the emperor probably brought him along from Italy. The master signed the hunting frieze not with his name but with an encoded enigmatic inscription in mirror writing.

The interior of the east end, which was painted in the nineteenth century with religious scenes of poor

KÖNIGSLUTTER

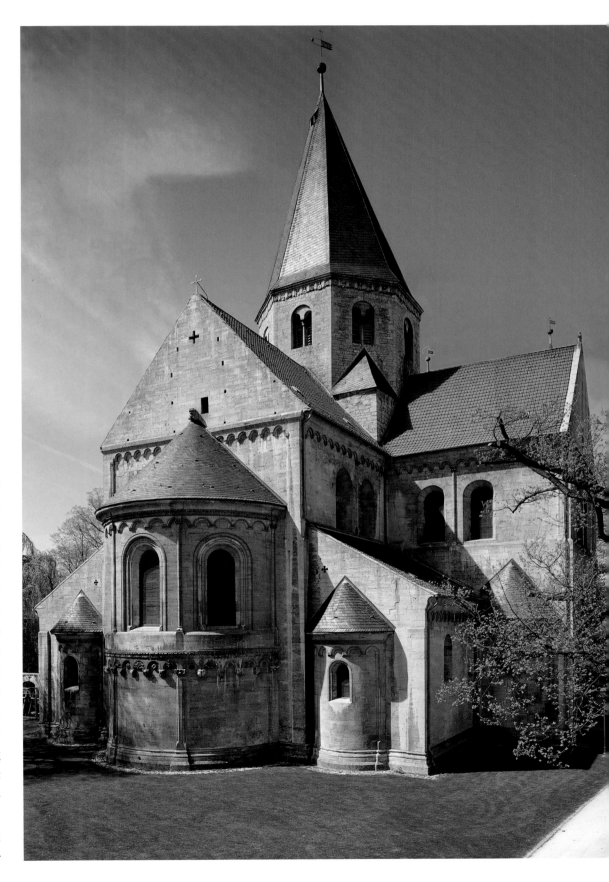

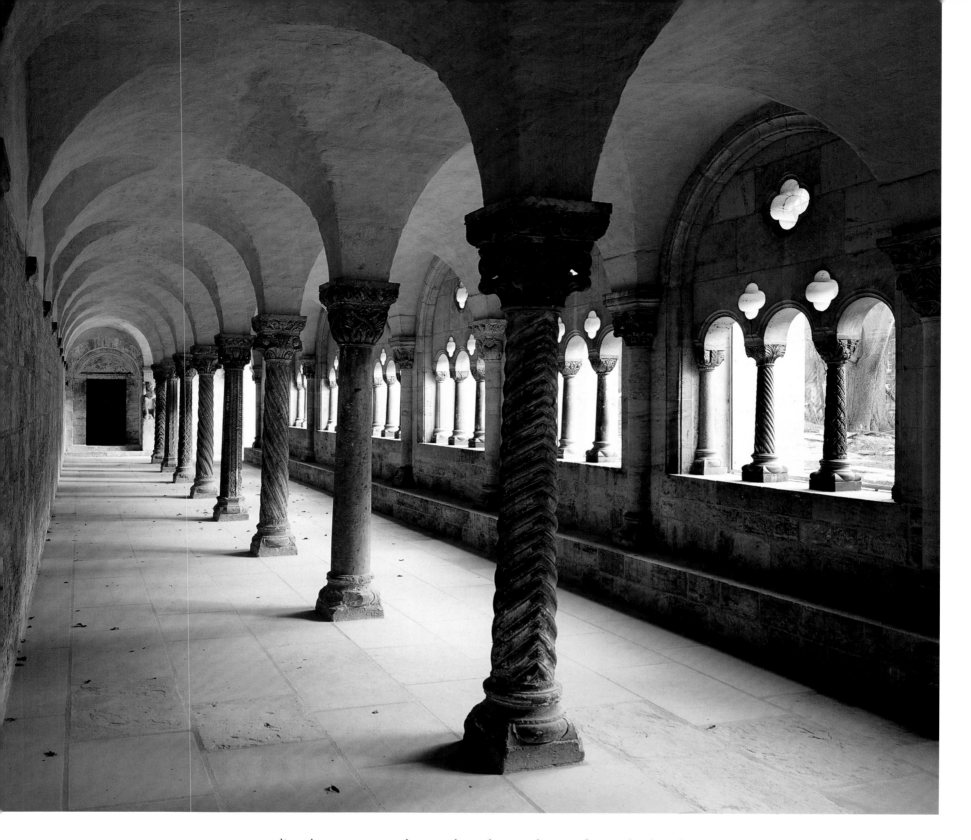

quality, does not come close to the rich articulation of the Rhenish imperial cathedrals. The walls, piers, and arches are simple and seem unusually massive. The high quality of this architecture lies in its spatial proportions: expansive gravity and vertical steepness combine into an image of majestic repose. In its severity the interior is a monastic ritual space, but its majesty elevates it into the sphere of securely established sovereign power. The monastic and the imperial become one here, and this gives the space a rank of its own. The main block—a simple pier basilica that originally had a flat ceiling—

is clearly inferior to the east end. The old theory—that it was once intended to have vaults as well but was left unfinished when the emperor died—has since proven to be unfounded. Of the monastery buildings the north and east wings of the Romanesque cloister have survived. The north wing is a two-nave hall with opulent decoration on the column shafts and capitals. The whole thing is a unique piece of stately architecture whose sculptures were clearly produced by Master Niccolò's Italian stonemasons. The arcature of the exterior wall was reconstructed in the nineteenth century.

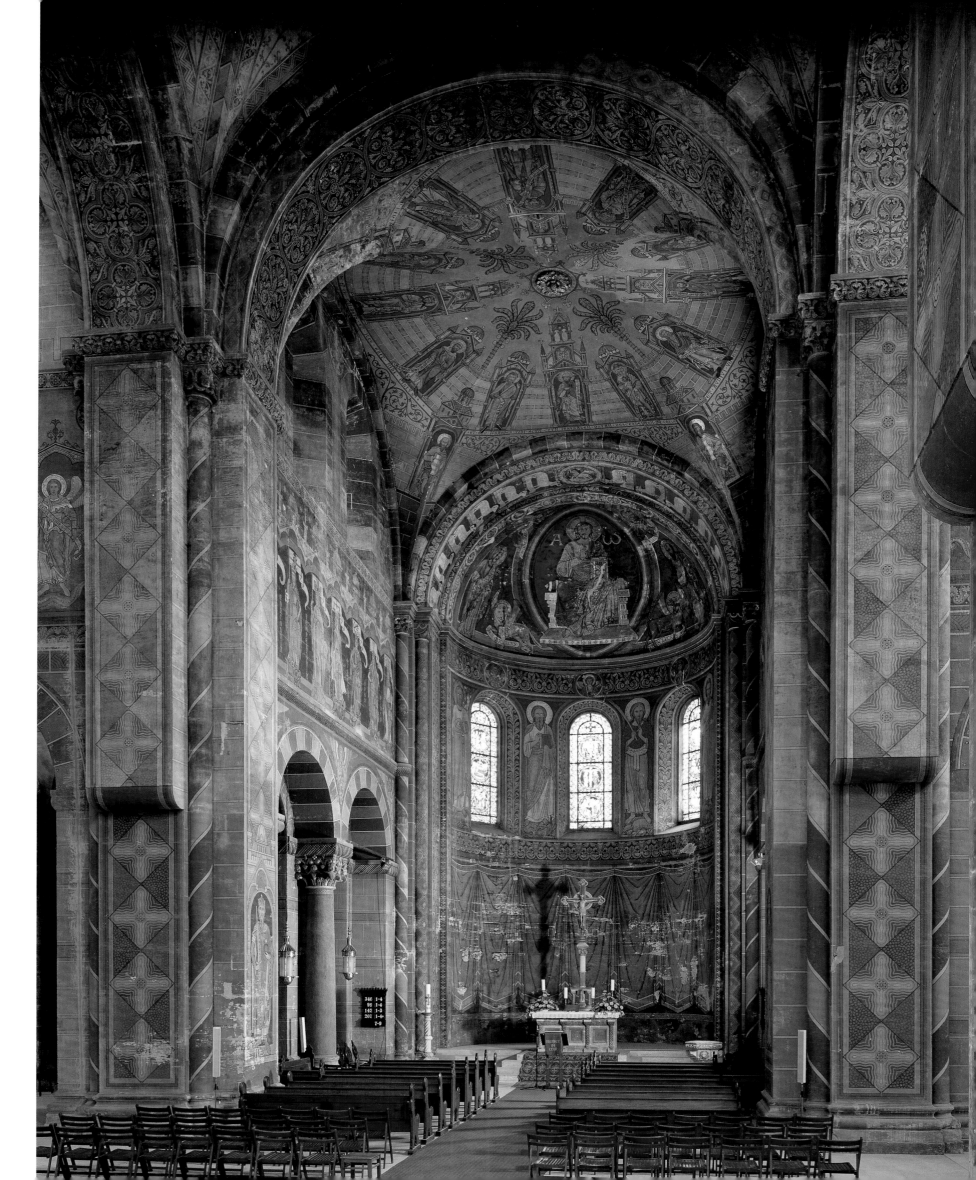

MAGDEBURG
LIEBFRAUENKLOSTER

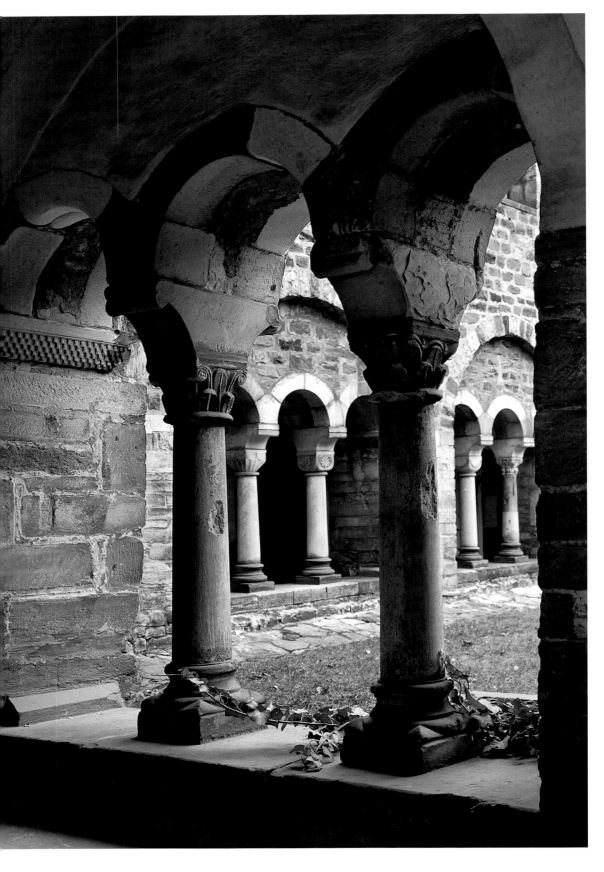

THE CITY OF MAGDEBURG, LOCATED ON THE Elbe, once a border stronghold against the pagan Slavs living east of the Elbe, was the favorite residence of Emperor Otto the Great. The emperor, who raised the town to the rank of city, founded the archdiocese Magdeburg in 968 for missionary work among the Slavs, and had the first cathedral built, where he would be buried. On the border of the northern cathedral precinct, Archbishop Gero founded the monastery Unser Lieben Frau around 1015 and provided it with generous donations. Only under Archbishop Werner (1063–1078), however, was an adequate church built: a column basilica that is still concealed within the core of the present building. Werner was a brother of Anno, the powerful archbishop of Cologne who ruled the empire for a time as the guardian to King Henry IV, when he was still underage.

A new era began for the Liebfrauenkloster when Norbert of Xanten, the founder of the Premonstratensian order, became archbishop of Magdeburg in 1126. He entrusted the monastery to the Premonstratensians in 1129, and he was buried there in 1134. With support from the archbishop the monastery managed to free itself from the sovereignty of the French mother monastery, Prémontré, and to found fifteen of its own daughter monasteries. Thus the Liebfrauenkloster became the Premonstratensian order's center in the Saxon province. The importance this monastery had for northern Germany may be seen from the fact that Premonstratensians were named bishops in Havelberg, Brandenburg, and Ratzeburg.

Soon after the Premonstratensians took over, construction began on the monastery buildings. Until World War II it was one of the best-preserved and most beautiful Romanesque monasteries in Germany, and after the war it was reconstructed for the most part. The two-story vaulted cloister, with its tripartite arcades inserted into larger pier arcades, is a classic example of the harmony of Romanesque round arches and arcades. On the east side of the cloister stands the round two-story well house, a singular building with massive pier buttresses, a stone pointed spire, and richly designed tripartite arcades grouped by round arches. The refectory gives an idea of the convention's size at the time: it is a simple box structure nearly 150 feet (45 m) long; the dormitory was also very large, but it was demolished in 1631.

THE FORMER IMPERIAL ABBEY WALKENRIED, ON the southern border of the Harz region, was one of the oldest and wealthiest Cistercian monasteries in northern Germany. It was founded in 1127 by a certain Adelheid, who had originally intended her donation for the Benedictines of Huysburg, but entrusted it in the end to the Cistercians in 1129.

The first convention came from Kamp (Altenkamp) on the Lower Rhine. Walkenried's daughter monasteries were Sittichenbach, near Querfurt, and Pforte (Schulpforte), near Naumburg. Sittichenbach's filiation included the Brandenburg monasteries Lehnin and Chorin; Pforte's included the large Silesian monasteries Lubiąż (Leubus), Henryków (Heinrichau), and Krzeszów (Grüssau).

The monks of Walkenried made broad regions arable, including parts of the Goldene Aue (Golden pasture) in Thuringia. Its constantly increasing wealth was due largely to Emperor Frederick Barbarossa as well, who donated to the monastery in 1157 a quarter of the silver mining at Rammelsberg, near Goslar, northern Germany's largest silver deposit. During the late Middle Ages and early modern era the importance of the abbey diminished. Following the ravages of the Peasants' War in 1546, the few monks remaining here converted to Protestantism, but the monastery continued to exist for a century before it was closed in 1648. The church fell into disrepair and was used as a quarry. Only a few fragments remain today, and these threaten to decay still further, as a result of the poor foundation. The building, begun around 1207–9 and consecrated in 1290, is one of the largest Cistercian churches in Germany, with an exterior length of 302 feet (92 m). The east end originally had a sanctuary with a flat termination around which a U-shaped ambulatory with fourteen rectangular chapels was arranged, similar to the later design of Riddagshausen, near Brunswick; however, here the ambulatory and chapels are not staggered in height but are on the same level, forming two-nave halls comparable to the ambulatory of the Cistercian church Lilienfeld, in Austria (see pp. 372–73).

The buildings of the enclosure, including the cloister, a three-nave chapter house, a well house, and a monks' hall, are largely preserved. They date from the fourteenth century and are in the tracery Gothic style. The north wing of the cloister is a two-nave hall whose cross rib vaults rest on round piers with foliage capitals. This wing, which was preceded by a Romanesque two-nave hall, is one of the most beautiful rooms in Cistercian architecture.

WALKENRIED

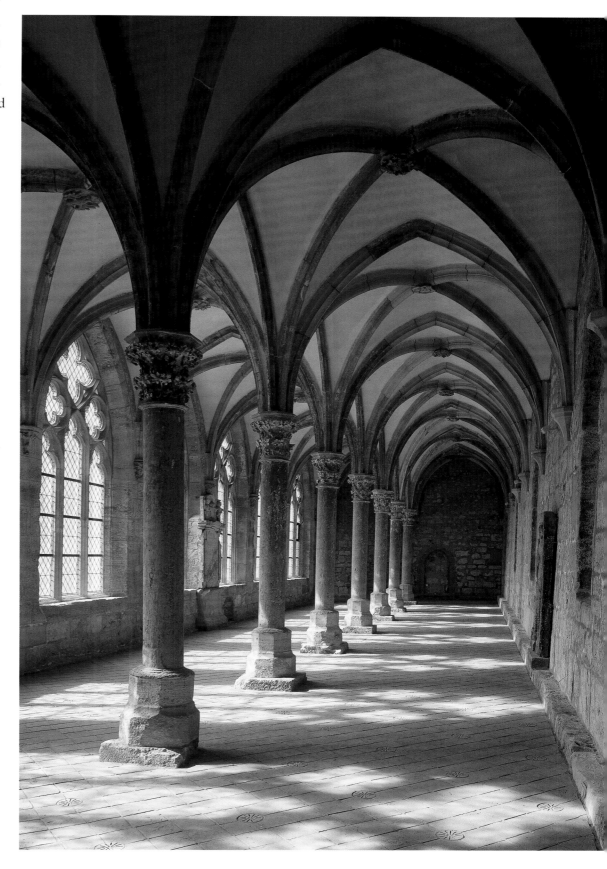

GERNRODE

BELOW:
View from the south of the two-story cloister wing, Gernrode

OPPOSITE PAGE:
Interior of the church, facing east

PAGE 274:
West end of the church

OF THE MANY MONASTERIES IN THE HARZ region, the hereditary lands of the Ottonian-Saxon emperors, the two most important are right next to each other on the northern border of the eastern Harz: Quedlinburg and Gernrode. Gernrode's founder was Margrave Gero, who was of gigantic proportions and a successful military man, to whom Otto I had entrusted the protection of the Ostmark in 937. When his last son died in 959 Gero decided to establish a canonical community of women with twenty-four members, so-called canonesses, with Hathui (Hedwig), the childless widow of his son, as their abbess. As the daughter of Margrave Hermann Billung and the niece of Queen Mathilda, Hathui was also from the upper aristocracy and was related to the Ottonian dynasty. She headed the convent until her death in 1014. Margrave Gero, who died in 965, saw to it that Gernrode was the most distinguished canonical community of women of this period—which included Quedlinburg,

Gandersheim, and Essen. Under the protection of Otto I, it was granted *Reichsunmittelbarkeit* (immunity), making it subordinate only to the emperor. Gero gave the convent the valuable relic of Saint Cyriacus's arm, which Gero had personally brought from Rome.

The church was probably completed by the end of Hathui's office in 1014. It is the only Ottonian church from this period that has survived nearly intact. The west end was altered around 1130: originally it was a three-tower westwork with round side towers and a dominant square in the center that had a gallery inside, as at Quedlinburg. The round side towers were retained but the westwork was remodeled by removing the galleries inside, adding a crypt, including a bulging apse. The round towers were heightened, and the square was converted into a cross bar. The blind gallery on the apse today dates only from the nineteenth century.

The east end—with longitudinal chancel, crypt, transept, and crossing—seems to have been built during Gero's lifetime. The quarry stone masonry, particularly in the crypt, has the primitiveness of a distant early age. The crossing, with its cruciform piers and diaphragm arches, is an early example (partially reconstructed) of the "marked off" crossing type that only became common around 1000, although here the four arches have imposts at different heights and varying sizes.

The main block, which strangely is askew to the east end, is another world. The middle vessel is unusually short and seems wider for that reason. The wall structure is centered on a pier, with room for a pair of arches on either side. The most striking aspect of the middle vessel is the side galleries. Their arcades are divided by the central pier, forming groups of six arches, with each pair further articulated by an arch above them. There are twenty-four columned arches in all, corresponding to the number of canonesses. In its original state, when the west wall also had gallery openings, the middle vessel seemed less like a nave than a broader, more festive and noble galleried hall. This idea was purely Byzantine, and it had nothing to do with Saxon architecture. This suggests that Empress Theophano, Otto II's wife, who was from Byzantium, may have influenced the building design.

An impression of the convent buildings can best be obtained from the cloister wing on the south end of the church, which was built around 1170 and reconstructed in 1867 using original material. It has two floors and together with the gallery and clerestory of the main block, it forms a staggered, four-tier structure.

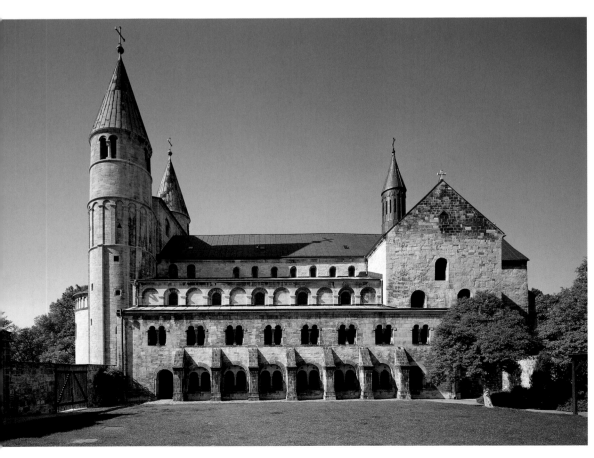

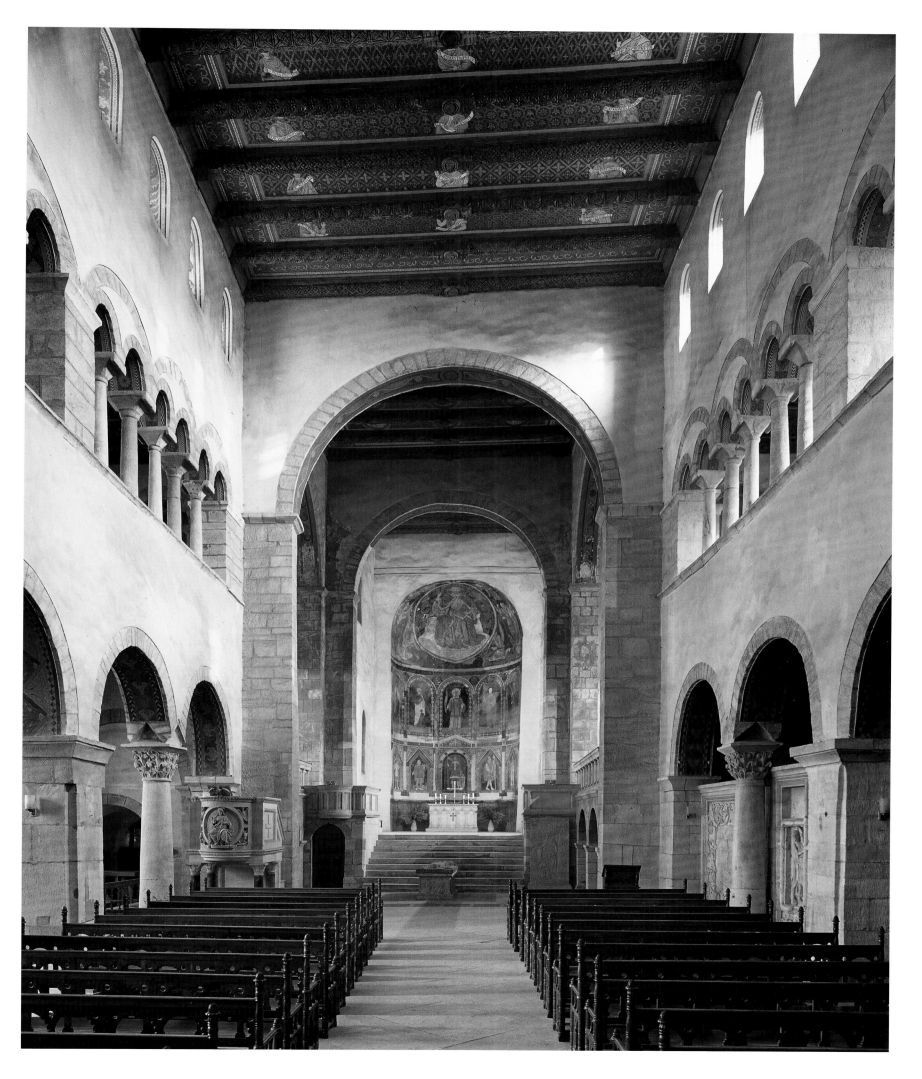

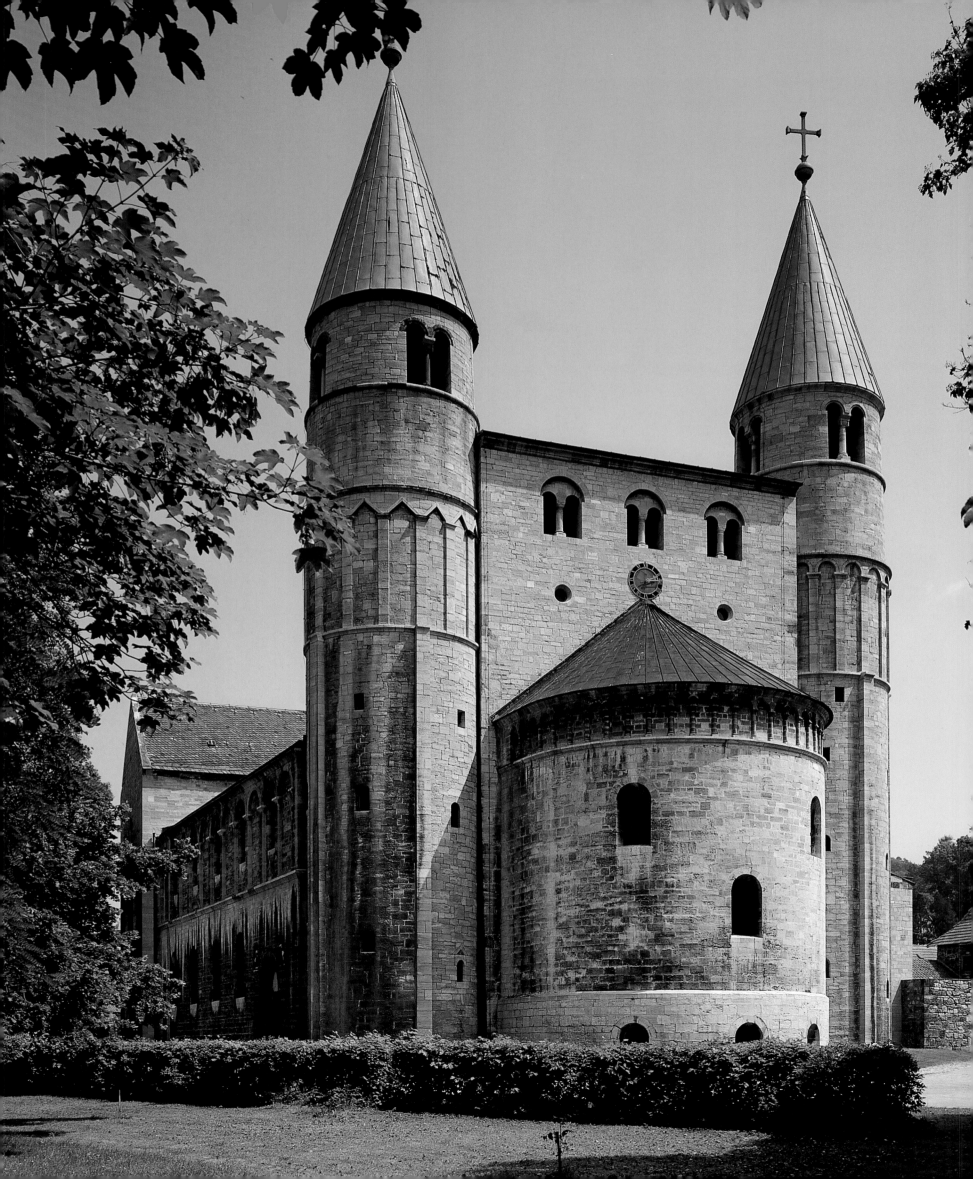

QUEDLINBURG

Quedlinburg, which lies on the northern border of the eastern Harz region, was the most distinguished of the aristocratic canonical communities of women of the early and high Middle Ages. For a long time it was closely connected to the ruling imperial house. It was established in a fortress that had been converted into a royal palace by Henry I, the first king from the Saxon house and the progenitor of the Ottonian emperors. Under Ottonian rule this palace, which lies high on a sandstone cliff, became the center of the empire. Here Otto I married Edith, the daughter of the Anglo-Saxon king; many imperial diets and synods were held here; and members of the ruling house, such as the empresses Adelaide and Theophano, were here for such frequent and extended periods that Quedlinburg can be considered the residence of the Ottonian rulers.

Henry I was buried here in 936. His widow, Mathilda, established a canonical community of women on the fortress mountain, which she led until her death in 968, although without being abbess. From Maastricht the community received a rich treasury of relics, including the bones of Saint Servatius, to whom the church was then dedicated. Mathilda was buried next to her husband.

Otto I, Henry and Mathilda's son, donated extensive lands to the community and raised it to an imperial abbey under the protection of the king. In 966 Otto's daughter, whose name was also Mathilda, was consecrated as its first abbess in the presence of all the great men and woman and all the archbishops of the empire. Abbess Mathilda, sister of Otto II, was responsible for governing Saxony and the rest of Germany from 997 to 999, when her nephew Otto III was on his second Italian campaign. Mathilda died in 999 and was buried at her parents' heads.

Mathilda's successor, Otto II's daughter Adelaide, was also from the imperial house. When Adelaide died in 1044, emperors' daughters from the Salic dynasty, Beatrix I and Adelaide II, succeeded her as abbess. The abbesses of later periods were not from nobility of this rank. With the Reformation, the convent continued from 1539 on as a free Protestant lay community, and until it was completely secularized in 1803 it provided for the daughters of the nobility. After the Reformation the convent buildings were remodeled into a residential Renaissance castle with ornamental gables.

The present church had several successors from the time of Henry I onward, beginning with the small palace chapel in which Henry was buried, then the small church for the canonical community that his widow,

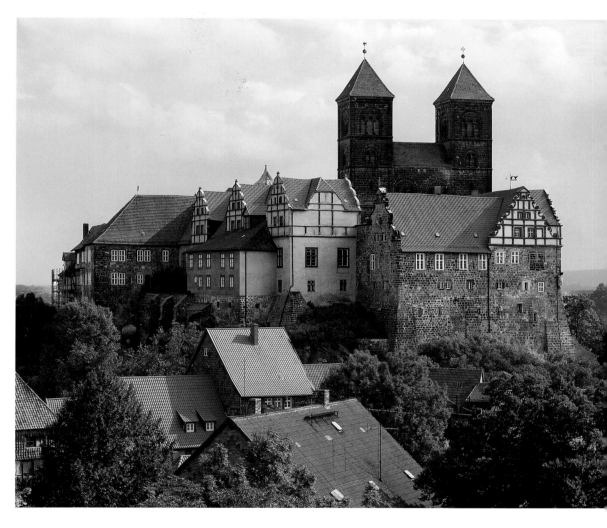

Mathilda, had built. Here, behind Henry's grave under the high altar, was a semicircular *confessio* with elaborate stucco ornaments, which was evidently intended as the site for the relics from Maastricht, whose "paradisiacal splendor" was praised at the time. The second community church, of a "more advanced and elevated architectural style," was built under Abbess Mathilda. The final consecration took place in 1021, in the presence of Emperor Henry II. This church was destroyed, apart from a few remains, by a fire in 1070. Abbess Adelaide II arranged for it to be reconstructed, but it was not consecrated until 1129, in the presence of King Lothair of Supplinburg, who would later become emperor. This third community church is the present one, a flat-ceilinged three-nave basilica with a transept, crossing, large crypt, and two towers on the west end. It stands on the founda-

Above:
Castle mountain from the northwest, Quedlinburg

Page 276:
Middle vessel of the church, facing west

Page 277:
Top right: *Middle vessel of the church, facing east;* Bottom:
View of the crypt showing the tomb slabs of the abbesses

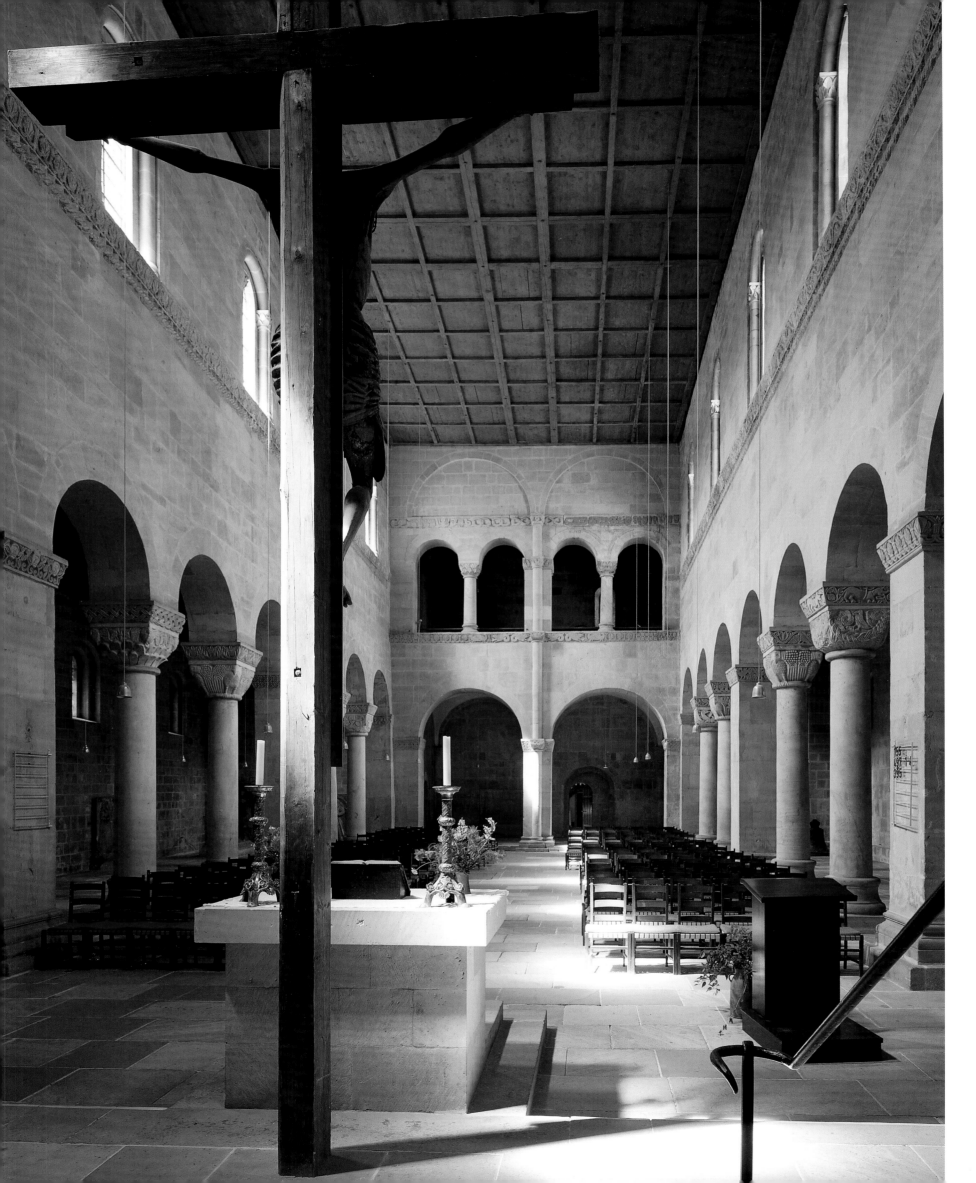

tions of the second church and seems to replicate its essential structure.

Its high ambition is evident above all in the carefully worked ashlar, inside and out, which was still quite rare at the time. It appears that Adelaide's brother, Emperor Henry IV, had a troupe of northern Italian artisans brought from the construction site of the Speyer cathedral; they also created exquisite capital ornaments. The nave arcades alternate two columns with piers, in the Saxon style, with distinct harmony.

The middle vessel is a wide hall that recalls a royal throne room. Accordingly, the west gallery is a dramatically staged sovereign loge. One senses a proud, well-founded restraint in this architecture, which is notable not for its size but because it absolutely gives the impression that a ruling house once dwelled here. If Speyer is the expression of the imperial power of the Salic dynasty, then Quedlinburg is the expression of the Salic royal dignity. This dignity is the striking feature of this church, and is found not least in the stucco tomb slabs of the abbesses, which were once lined up in the middle vessel, in front of the cross altar, but are now found in the crypt. The figurative representations of the abbesses depict their high office, not their personalities.

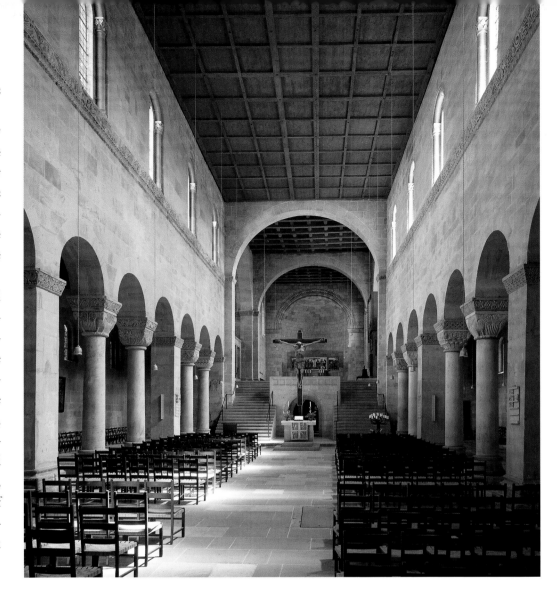

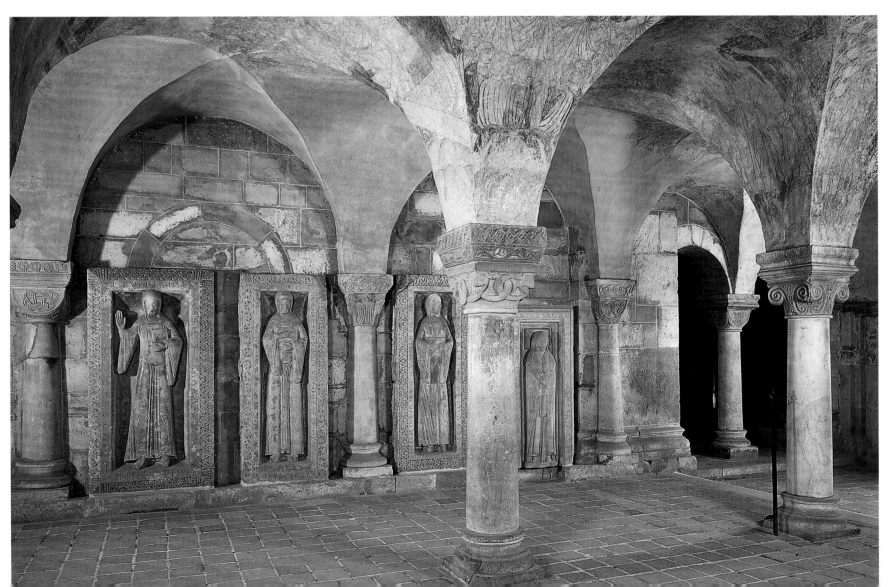

PAULINZELLA

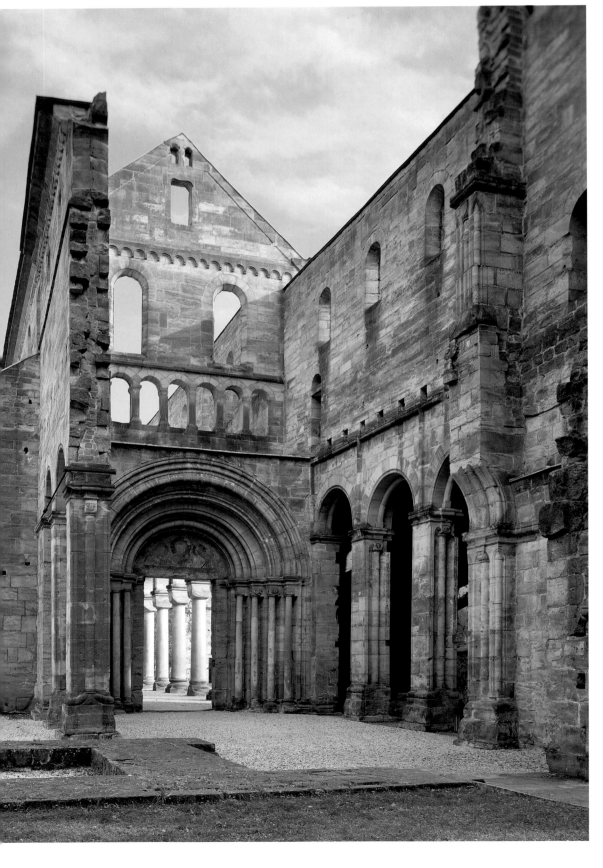

ONE OF THE MOST IMPORTANT BUILDINGS OF the Hirsau reform is the monastery church Paulinzella, which has survived only as a ruin. It lies in an idyllic spot in a small river valley on a northern offshoot of the Thuringian Forest, not far from Weimar, between Ilmenau and Rudolstadt. The sylvan seclusion of these ruins has always attracted poets, including Schiller and Goethe, and thus stimulated the historical imagination. It was founded as a double monastery for monks and nuns around 1105 by Paulina, a pious woman from the Saxon aristocracy who made pilgrimages to Santiago de Compostela once and to Rome three times. She had particularly close relationships with the reform monasteries of the Black Forest: Saint Blasien visited her, and her father entered Hirsau as a monk. In 1107 she traveled to Hirsau, where she arranged for six monks under Abbot Gerung to be sent to found her monastery. She died in Schwarzach monastery on the Main River on her return journey. Thereafter the monastery she had founded was renamed Paulinzella, and her body was brought there. Her son Werner entered the monastery as a lay brother, and he was employed by Abbot Gerung as a courier to Hirsau. During his lifetime Gerung saw to it that his successor as abbot would also come from Hirsau. His name was Ulrich, and he brought experienced artisans, *cementarii,* along with him. The church was consecrated in 1124. Paulina was buried in the sanctuary, east of the crossing, where her sarcophagus was found in the Romantic period, and her son Werner *in medio ecclesiae,* that is, in or in front of the crossing. Between its consecration and about 1150 the building was expanded by the addition of a three-nave antechurch with a two-tower facade. The monastery was closed in 1534, during the Reformation, and the property fell to the counts of Schwarzburg. From that point, the church served as a quarry and was gradually carried off—the entire east end, the southern side aisle, and the northern tower disappeared. Further demolition was stopped only by the Romantic enthusiasm for ruins.

When construction was begun around 1105 Abbot Gerung had not yet arrived from Hirsau. Nevertheless, the eastern parts were laid out according to the Hirsau scheme, although the three aisles did not have the flat terminations of Hirsau but rather apses—a solution gradually adopted by other churches as well, for example, in Königslutter (see pp. 267–69). The crossing, whose west side is still standing, was precisely marked off with cruciform piers and diaphragm arches. The entire main block is executed in unplastered ashlar and, along with

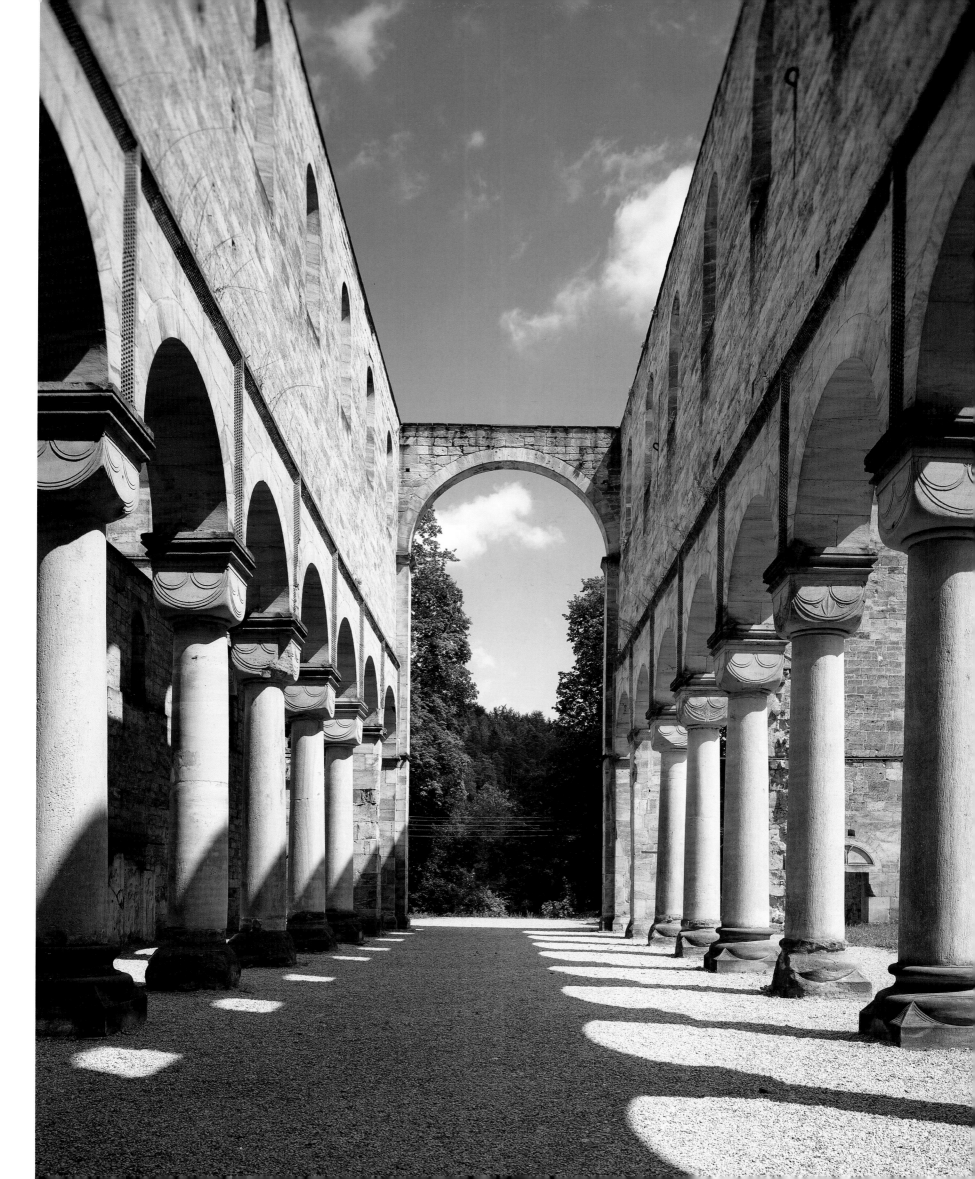

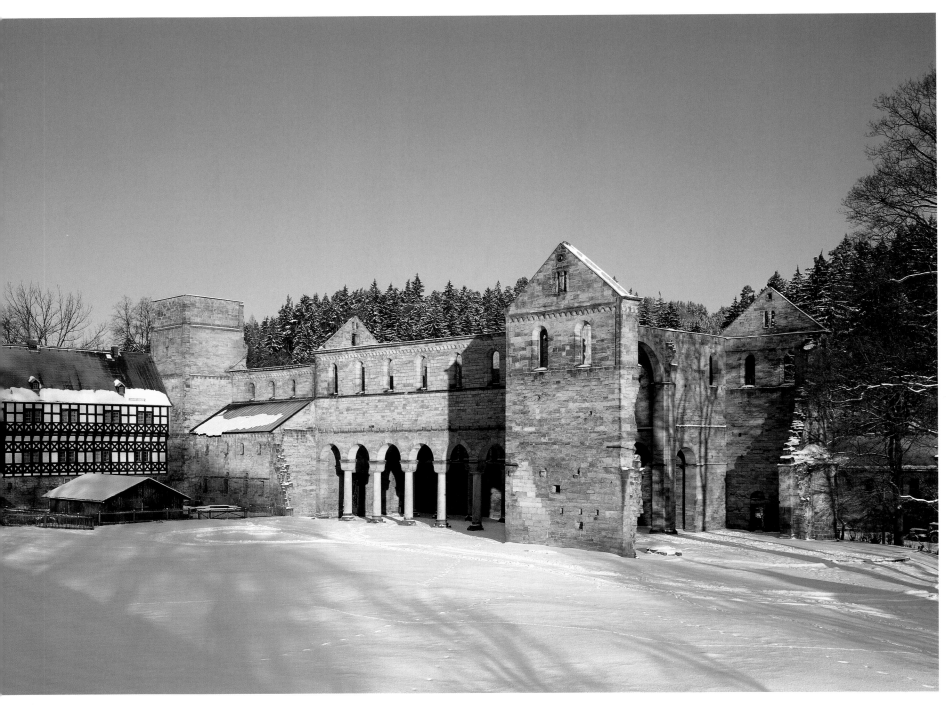

Alpirsbach in the Black Forest, may be considered one of the ideal examples of Hirsau architecture: a pier basilica whose middle vessel has the same steepness and oppressive narrowness, the same tendencies to rigidity, and the same ascetic hardness that Alpirsbach does. The only difference is that here everything seems even a degree harder, in part because of the fair-faced masonry. Here too it starts with a *chorus minor* with a cruciform pier. The block capitals, with the typical "Hirsau cusps," are blocky and tower powerfully over the slender column shafts. The shields on the capitals now come in threes. Above the nave arcades one finds the same rectangular frames that are found in Hirsau as well.

The antechurch offers a very different image. Here the columns are replaced by piers with small columns and torus inset into the jambs of the arcade. The model

for this was Saints Peter and Paul in Erfurt, the most important Hirsau church in Thuringia. The middle vessel of the antechurch, which replaced the original *galilaea,* or forecourt, leads to the main entrance: a magnificent portal with terraced walls, columns in front, and archivolts richly profiled with astragals. It is a second version, on a smaller scale, of the west portal of Cluny III, which so impressed Abbot Gerung, who was in Cluny twice, that he immediately had it copied.

As the beam holes above the nave arcades reveal, the middle vessel of the antechurch once had a wooden deck, evidently for a gallery where the nuns could witness the services through the seven openings of the arcature above the portal. The middle vessel and the portal must have been very poorly lit, which would have certainly obscured the interior of the church.

ALPIRSBACH

THE REGIONS OF THE BLACK FOREST AND THE Upper Rhine were the hereditary lands of the far-reaching Benedictine reform that began at Cluny, in Burgundy, and then was adopted by the Black Forest monasteries Hirsau and Sankt Blasien. The reform monasteries included Schaffhausen on the Rhine and Alpirsbach and Gengenbach in the valley of the Kinzig, a small river in the Black Forest. Gengenbach is said to have been founded in 725 by the Frankish duke Ruthard and placed under the Benedictine rule by Saint Pirmin around 750. Alpirsbach was not founded until 1095, by a group of Swabian nobles opposed to Emperor Henry IV, who wished to establish their burial site there. The convention came from Sankt Blasien. The present church was completed around 1130, roughly at the same time as Gengenbach. Both these churches adopted and refined certain architectural practices developed in Hirsau. This group of Hirsau buildings also included the somewhat older monastery church of Schaffhausen and, as a straggler in the early thirteenth century, the monastery church Schwarzach on the Upper Rhine.

Alpirsbach is the best preserved of all of these. The church is a three-nave column basilica with a flat termination, a transept, and a marked-off crossing (that is, marked off by piers and diaphragm arches). Typical features from Hirsau are the slender columns crowned by block capitals, so tall that the zone of the nave arcades, including its decorative cornice band, occupies half the height of the middle vessel. The square piers placed in front of the cruciform piers of the crossing, in lieu of columns, are also typical. As was often the case with Hirsau churches, they once marked the border between the *chorus minor* and the area of the lay brothers, while the *chorus maior* had its place in the crossing.

The spatial ratio of 1:2.2 is striking. It turns the middle vessel into an extremely steep canyon between arcades and looming walls. The space is so oppressive in its strangling constriction that we feel closed in and surely uncomfortable. The prescribed monastic animosity toward the body becomes a real animosity toward space here. In this oppressive severity, rarely taken as seriously as here in Alpirsbach, the space becomes not only superhuman but antihuman. At the same time, it is characterized by a pattern of severity that ties not only the arcades but also the enclosing walls into a whole, governed by discipline. Consequently, Alpirsbach can be considered the epitome of a Hirsau monastery church, fulfilling an ideal of ascetic austerity.

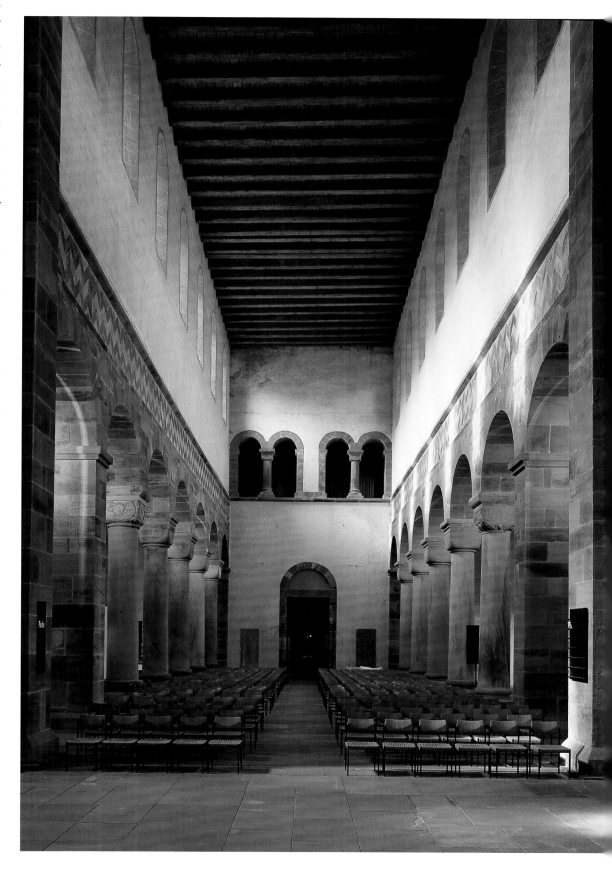

CORVEY

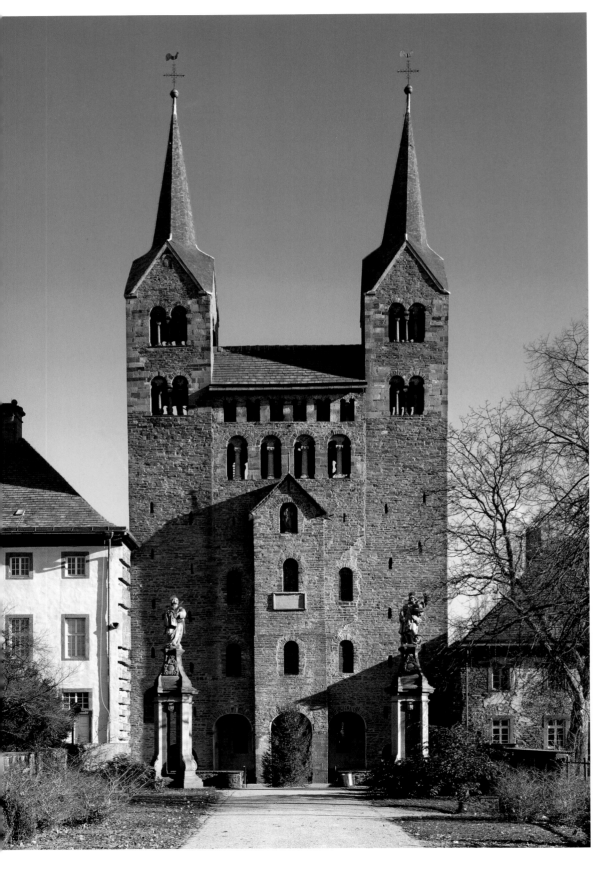

Of the churches dating from the early period of the Holy Roman Empire, Corvey, which lies directly on the upper course of the Weser, right on the river, is one of the most important. It was built during the Saxon wars of Charlemagne, as a missionary monastery for Saxony. After a first attempt to found a monastery in the forests of Solling in 815, the monks were given a count's court in the Weser valley in 822, with the approval of Emperor Louis the Pious. The site was advantageous, as two trade routes intersected nearby at a ford of the Weser: Hellweg, from the west; and the old military and trade route through the valleys of the Diemel and the Weser.

The monastery was founded by two of Charlemagne's cousins, the brothers Adalhard and Wala, both of whom had lived at the Corbie monastery in northern France, where Adalhard had been an abbot. The new monastery was named Nova Corbeia after Corbie. Adalhard became its first abbot, and he simultaneously ran its mother monastery, Corbie, in a personal union. By 833 Corvey received the rights to have a market and to issue coins, and in 836 the bones of Saint Vitus were brought here from Saint-Denis. As an imperial abbey Corvey had to feed kings and emperors who passed through, as well as their armies and attendants. Because it lay on a military route, this occurred frequently. The monastery had its final flowering under its highly educated abbot Wibald of Stablo, who was a diplomat and adviser to King Conrad III. This was followed by continuous economic decline, yet the abbey managed to be raised to a principality subordinate only to the emperor, and in 1793 it even became a prince-bishopric. That lasted only ten years, however, until secularization in 1803.

The former monastery is a princely Baroque castle with turrets, and the church was rebuilt, following a fire in 1667, as a modest Baroque building that replaced the earlier Carolingian church. By fortunate coincidence, however, the most important part of the Carolingian church survived—the westwork. All of the other westworks from this period have been lost; they are known only from written sources and excavations. Corvey always served as the model for reconstructions.

The westwork, built between 873 and 885, was added decades after the Carolingian church was consecrated in 844. There is explicit evidence that it had three towers (*fundmenta trium turrium posita*), of which only two survive. Abbot Wibald of Stablo had the thick, square middle tower torn down in 1146 and added to the two remaining towers, which were joined by a transverse belfry.

Thus only the lower part of the facade, which once had a two-story atrium in front of it, is Carolingian; the entire upper termination is by Abbot Wibald. In the interior the abbot had the upper area redesigned, but here the interventions in the Carolingian structure were so minimal that it was possible to return the space to its original state as part of renovations after World War II and to carry out the necessary replacements according to evidence from excavations.

The entire structure of the westwork is unusually complicated. The core forms a square, surrounded on all sides by rectangular rooms. Above that stood the tower that Wibald demolished. The interior of the square has two floors. Its enclosing walls are tripartite pier arcades that open onto the adjoining rooms. The ground floor of the square resembles a crypt in that it is a vaulted four-column room. Its capitals are quite precise imitations of antique Corinthian capitals, but most went without the finishing touches to their bosses.

In the upper church this square has a tall, boxy, flat-ceilinged room framed by pier arcades and galleries. The west gallery has a particularly large opening in the center, behind which one finds the beam holes for a wooden platform, which presumably held a throne for

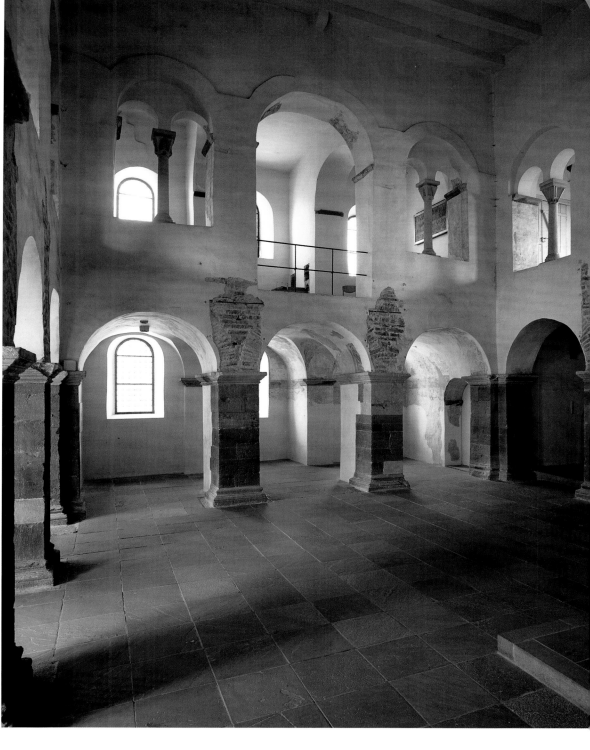

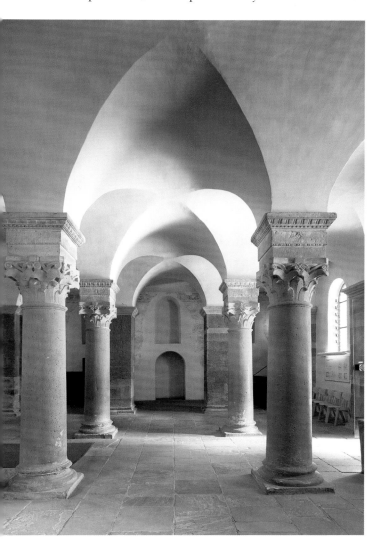

imperial visits. This would suggest that the original purpose of the westwork was to provide a separate imperial church. It opened onto the middle vessel of the monks' church through a three-level pier arcade but was at the same time barricaded by a grille. The throne in the west gallery demonstrated that the emperor was there in spirit at all times, even when he was elsewhere *in persona*. The whole effect is a pure architecture of power: defiantly off-putting on the exterior, like a fortress, and highly distinguished inside, like an imperial palace.

OPPOSITE PAGE:
West facade of the church

TOP RIGHT:
Westwork, upper church with view of the west gallery

BOTTOM LEFT:
Westwork, lower church

HILDESHEIM
SANKT MICHAEL

BELOW LEFT:
Middle vessel, facing west

BELOW RIGHT:
Galleries in the southeast transept arm

THE BENEDICTINE CHURCH OF SANKT MICHAEL in Hildesheim is one of the most significant buildings in the history of medieval architecture in Germany. It is the work of the politically influential and artistically discerning Bishop Bernward of Hildesheim, one of the teachers of the future emperor Otto III. Bernward chose the church as his own burial site, and he was interred in the crypt in 1022. He had founded the monastery west of the city, on a hill that was then still in the wilderness. The laying of the foundation stone is documented in 1010; according to another, less certain tradition, the church was begun in 1001. In 1015 the crypt was consecrated, followed by the whole church in 1033. It is claimed that Bernward himself was the architect. A more likely possibility is the first abbot of the monastery, Goderamnus, former provost of Sankt Pantaleon in Cologne, who possessed Charlemagne's manuscript of Vitruvius and made marginal notes in it. He must therefore have been knowledgeable about architecture. Goderamnus was named abbot in 1022, but he is supposed to have arrived in Hildesheim as early as 996. That he was indeed the architect is indicated by the many correspondences with earlier architecture in Cologne—for example, with Sankt Pantaleon but also with the Ottonian additions to the cathedral. The church's appearance today is in part a reconstruction based on seventeenth-century drawings; this includes the entire eastern termination and the two angular crossing towers. It was heavily damaged during World War II, and the decision was made to restore the exterior to its original Ottonian appearance rather than to its state before the war.

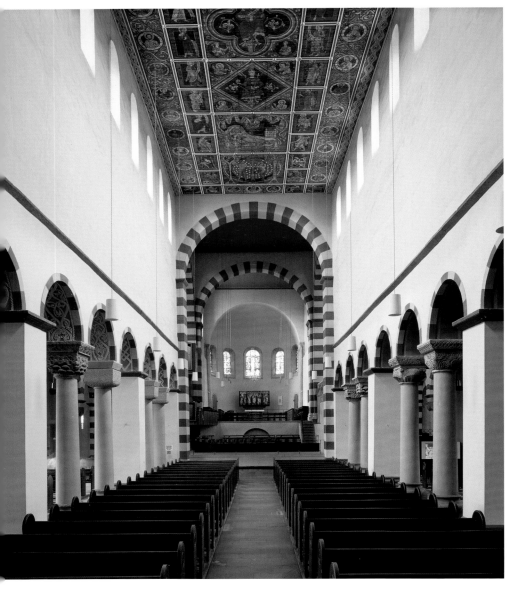

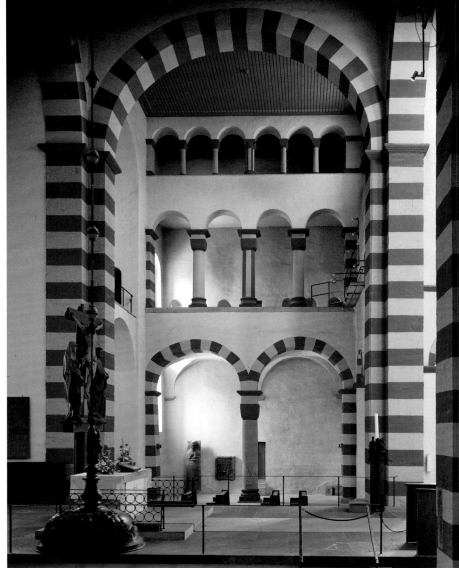

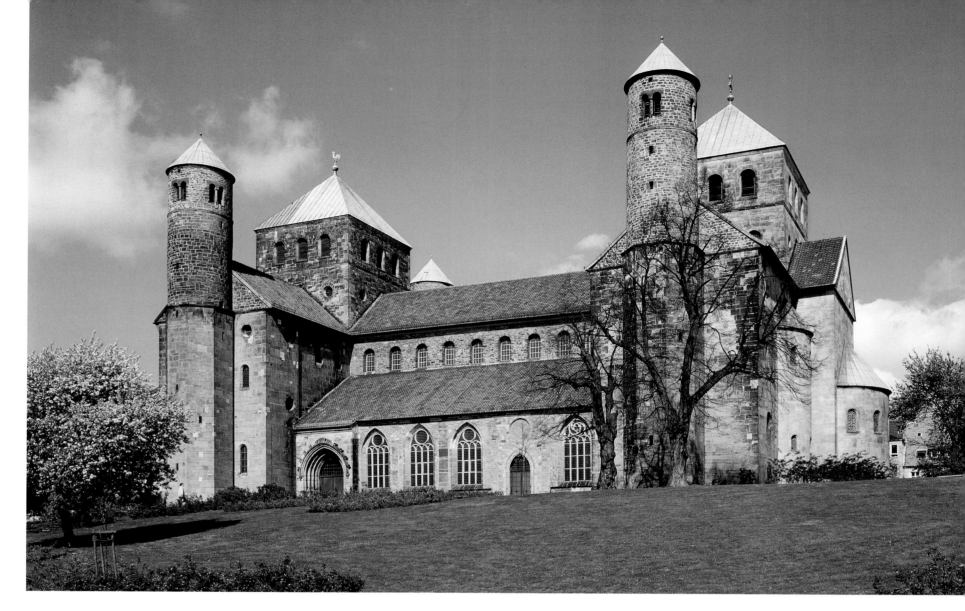

The church of Sankt Michael, which has two chancels, reformulated in fundamental ways the old theme of the basilica. It was provided with two transepts and two square crossings that are exemplarily marked off from the adjoining spaces by means of cruciform piers and diaphragm arches, reinforced by the striped alternations between white and red. The middle vessel is based on three times the square of the crossing. This schema, which works systematically with exactly measured squares, results in a structure with square piers that mark the corners of these squares with two stocky columns between them. The capitals originally had a simple block form. Following a fire in 1162 most of the columns were replaced by others with slender shafts and stately late Romanesque capitals. The basic concept of Sankt Michael, with its double transept and two crossings, was modeled on the church of the Ottonian imperial palace Memleben, on the Unstrut, which at 270 feet (82 m) in length was about twenty-six feet (8 m) longer than Sankt Michael. The palace church has survived only in ruins. Bernward, who cultivated a profound worship of angels, was particularly concerned with the two-story galleries in all four transept arms. They were sacred shrines to the nine choirs of angels, distinguished by a three-level arcade wall with two, four, and six arches grouped optically by the piers and the arch of the crossing. The architecture, a high point of the Romanesque in its beautiful harmony, is comparable to the arcade walls of Carolingian westworks, like that of Corvey, not far away (see pp. 282–83). On the exterior side walls of the transepts there are towers with staircases accessing the galleries. Together with the crossing towers they present an image of a defiant, six-tower fortress of God.

Bernward also saw to it that the church was suitably decorated, including famous bronze doors, each side of which was cast as a single piece. In 1015, according to the inscription, they were installed in the facade of the angel's church—that is, that of Saint Michael—in his memory. Bernward's successor, Godehard, relocated them to the cathedral, where they remain today. The cathedral has Bernward's bronze columns, which also originally stood in Sankt Michael's. After Bernward was canonized in 1193, the church was given a new painted wooden ceiling (around 1230–40), on which the root of Jesse is depicted along the entire length of the middle vessel in a frame divided into panels—a unique and artistically superior work whose only possible parallel is the ceiling in Zillis, Switzerland, on the via Mala.

LOCCUM

LOCCUM LIES BETWEEN THE WESER AND STEIN-huder Meer, on the edge of the north German lowland. Here, in an area that was then quite inhospitable, in 1163 Count Wulbrand of Hallermund founded a Cistercian monastery intended for the nobility. It was settled by monks from Volkerode, in Thuringia, near Mühlhausen. Its heyday was the thirteenth and

fourteenth centuries, then toward the end of the Thirty Years' War the monastery became Protestant and broke from the Cistercian order. From that point on it played an important role in the Lutheran regional church of Hanover. A seminary was established in Loccum and later a Protestant academy. The Protestant regional bishop was also the abbot of Loccum.

The monastery site has been largely preserved, including the farm buildings on its perimeter, the Romanesque chapter house, and the Gothic cloister, which is braced by massive flying buttresses. The chapter house is a typical four-support room; the columns have block capitals that support cross rib vaults with no bands. The space seems like a crypt. Given that it was built in the thirteenth century, it seems remarkably antiquated.

The church is one of the most impressive Cistercian churches in Germany. It was begun around 1230–40 by the monastery architect Bodo or Bardo and was completed around 1280, without having altered the basic concept. It is 230 feet (70 m) long, making it a medium-sized Cistercian church. Cistercian architectural practices such as the Bernardinian chancel, the bare simplicity, and the supported vault projections combine with the late Romanesque style of Westphalia. For example, the wide and low proportions, the solid, thick walls, and above all the looming rib vaults are related to the cathedral in Münster, as are the ornamental disks and the form of these supported projections. The church is very conservative for its time; despite the pointed arches its basic approach is Romanesque.

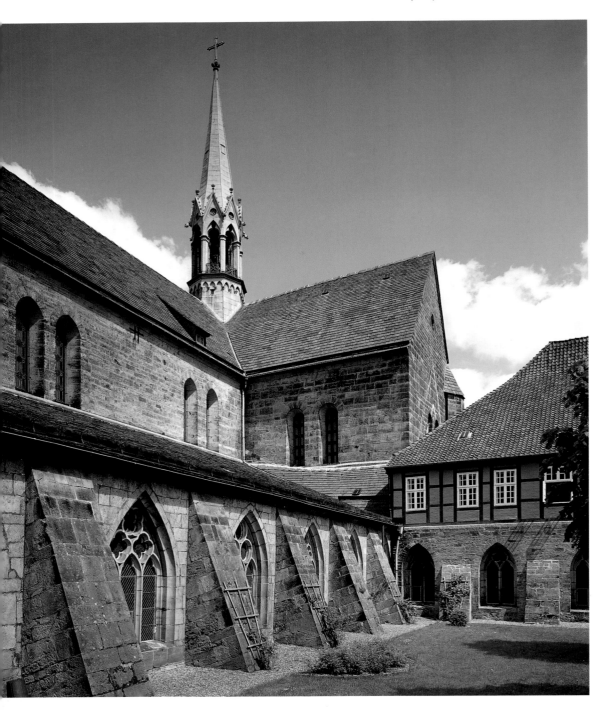

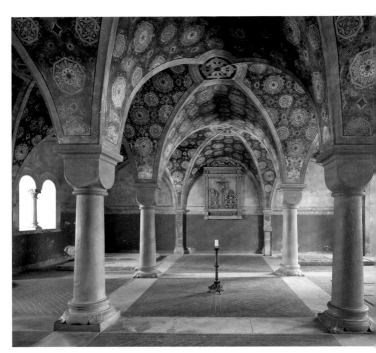

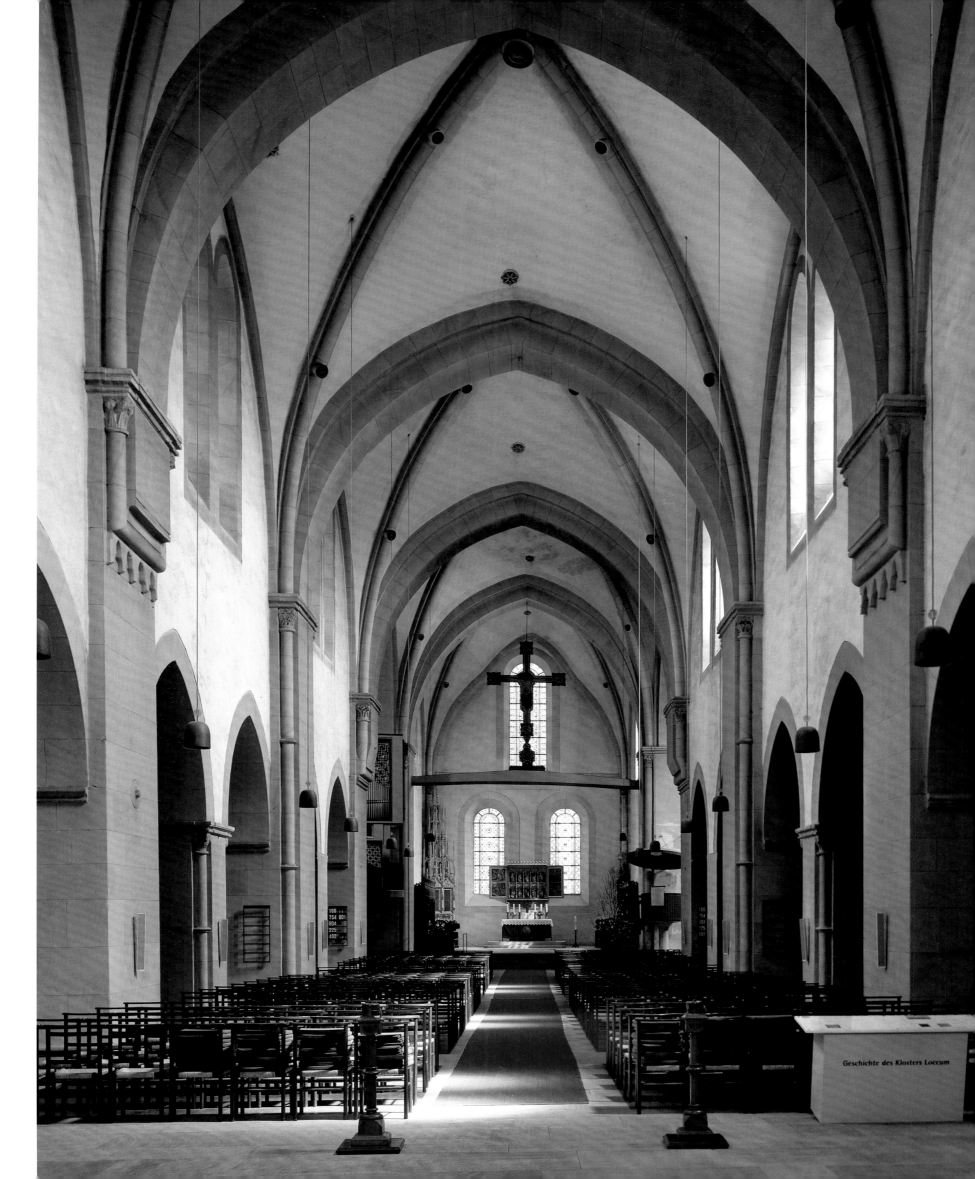

HEISTERBACH, ALTENBERG

BELOW LEFT:
Ruins of the apse, Heisterbach

BELOW RIGHT:
Ambulatory around the apse, Heisterbach

IN THE REGION AROUND COLOGNE AND BONN to the east of the Rhine there are two extremely important Cistercian monasteries: Heisterbach, in the forests of the Siebengebirge, and Altenberg, in the valley of the Dhün River, which is in the middle of the Bergisches Land. In Altenberg the entire medieval monastery church survives, although parts of it are a nineteenth-century reconstruction; in Heisterbach, we have only the apse of the church and its ambulatory. Heisterbach was founded in 1189 by the archbishop of Cologne and settled from Himmerod in the Eifel. The church is 289 feet (88 m) long, making it, after Walkenried, the largest Cistercian church in northwest Germany. It was built in an astonishingly short time, between 1202 and its final consecration in 1237. After secularization the well-preserved building was sold in 1809 to be used as a quarry, but Sulpiz Boisserée, who advocated the continuation of construction on the Cologne cathedral, made scale architectural drawings before everything disappeared. It is fortunate that the apse, the most important part of the church architecturally, has survived. It is surrounded by an ambulatory with niche chapels and its own clerestory and has umbrella vaults. The apse is a double-width, two-level structure with narrow column arcades with a wreath of closely arranged round arch openings behind it in the upper level of the window wall. The entire parachute vault of the apse is supported on delicate columns. There is a second rank of columns behind, which seem to be balanced on short columns; they support not only the

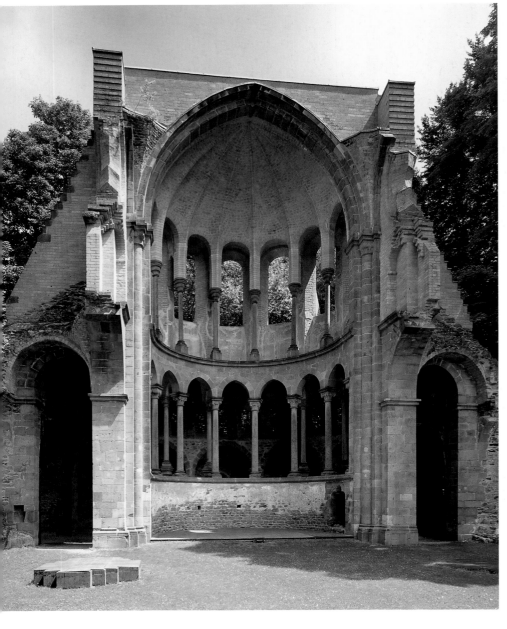

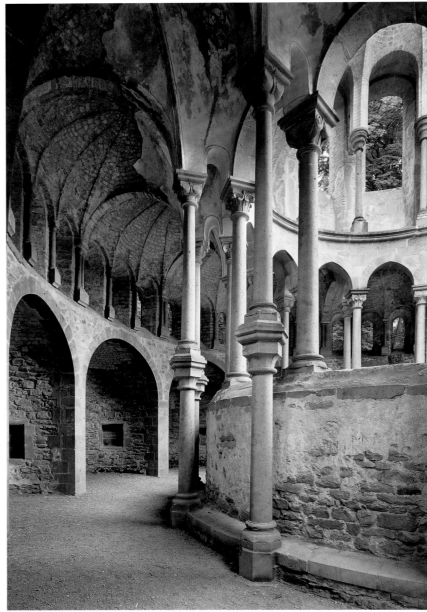

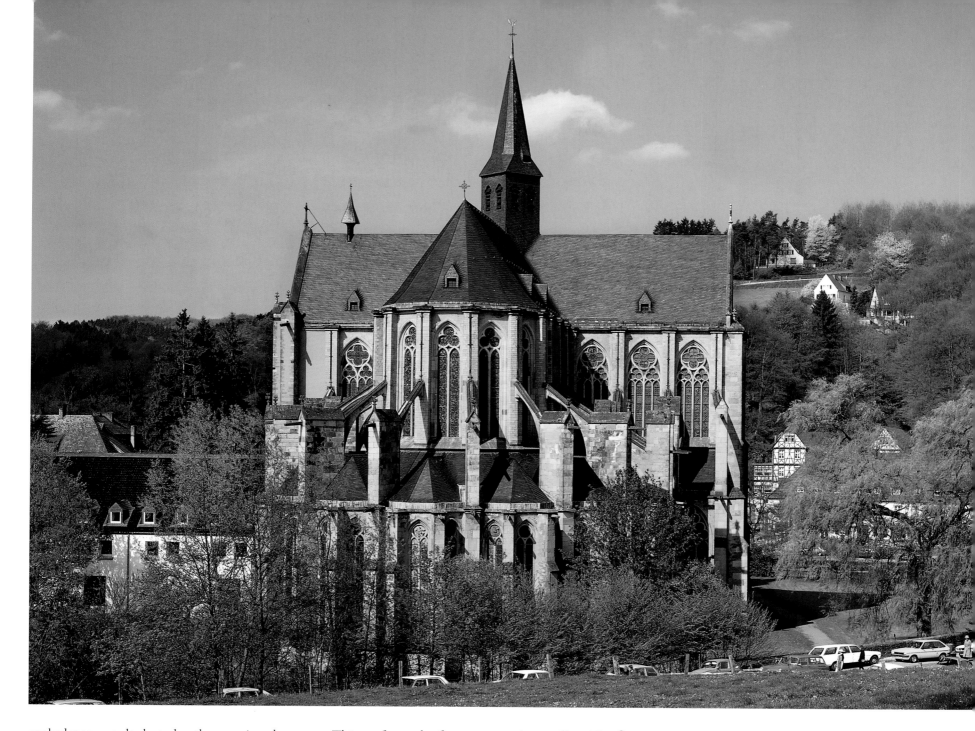

ambulatory vaults but also the massive clerestory. This unstably balanced structure is one of the boldest and most original designs that the highly inventive Cistercian architects ever produced, inspired by comparably bold constructions of the late Romanesque in Cologne, such as Gross Sankt Martin.

Altenberg's founder was Count Adolf of Berg, the most important territorial lord in the region. His brother Eberhard had been living as a monk in the French primary abbey Morimond since 1129. Adolf had just built a new fortress on the Wupper, and now he donated his former residence on the "old mountain," Altenberg, to the Cistercians to found a monastery that would serve as a burial site for the house of Berg. The counts of Berg and later the dukes of Jülich and Berg were buried in the monastery church into the sixteenth century. The new foundation was settled in 1133 under Abbot Berno by monks from Morimond, but soon they were relocated

from the fortress to a river valley. The first monastery church, consecrated in 1160, was replaced by the present Gothic structure between 1259 and 1410, which was consecrated in an unfinished state in 1379. The church, which is often called the "cathedral of the Bergisches Land," is a Cistercian counterpart to the cathedral in Cologne, which had been begun eleven years earlier; at 262 feet (80 m) in length, however, it is only half its size. The east end consists of a three-nave transept, a five-nave sanctuary, an apse with seven sides of a dodecagon, an ambulatory, and a wreath of radial chapels. As in Cologne, it has all the features of a cathedral, but its overall disposition resembles the Cologne cathedral less than the royal French Cistercian church Royaumont (see pp. 188–89); it repeats not only the latter's polygonal construction, including the ambulatory and chapels, but also its three-story structure with round piers in the nave arcades, a triforium, and a clerestory.

ABOVE:
View of the monastery church of Altenberg, from the east

COLOGNE

SANKT APOSTELN, GROSS SANKT MARTIN, SANKT MARIA IM KAPITOL

BELOW LEFT:
View of the east end, Sankt Aposteln

BELOW RIGHT:
View of the east end, Gross Sankt Martin

OPPOSITE PAGE:
Wood doors with reliefs of the life of Christ, Sankt Maria im Kapitol

No city has as many ROMANESQUE CHURCHES as Cologne. The Roman city Colonia Agrippinensis had been reduced to rubble and ashes during the Germanic migrations, but out of the wreckage arose the new, holy Cologne—Sancta Colonia Agrippina, as it was called on coins as early as the tenth century. In addition to the cathedral, other religious and architectural centers were built for associations and as monasteries; several of these were founded on graveyards on the outskirts, others within the Roman city walls. Beginning around 1200 all of the monastery sites were located within the new Hohenstaufen city walls, with the exception of Deutz, east of the Rhine. The tenth to the thirteenth centuries was a singularly prolific time for church construction, with Sankt Pantaleon, Sankt Severin, Sankt Georg, Sankt Maria im Kapitol, Sankt Aposteln, Sankt Cäcilien, Gross Sankt Martin, Sankt Gereon, Sankt Andreas, Sankt Ursula, and Sankt Kunibert. The area around Cologne also had the religious associations and monasteries of Deutz, Bonn, Knechtsteden, Brauweiler, Neuss, and Xanten. Nearly all of these churches have an important role in the history of architecture, some of them an extremely important one. The Cologne churches of the Romanesque period were largely destroyed during World

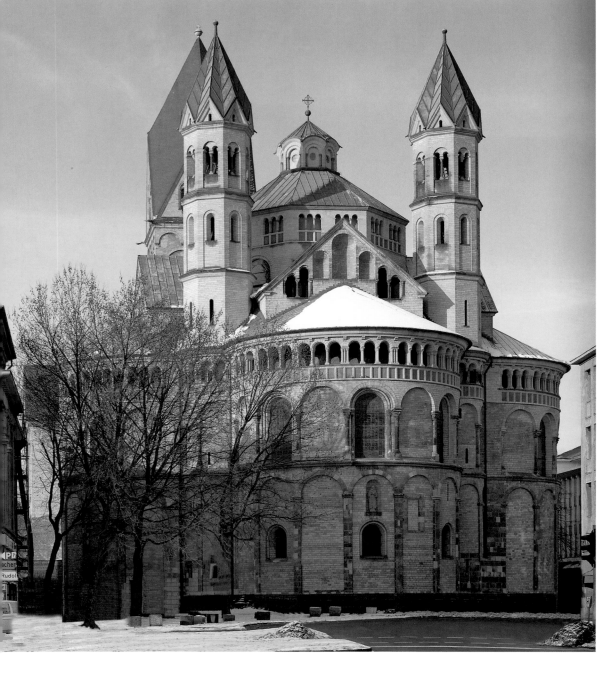

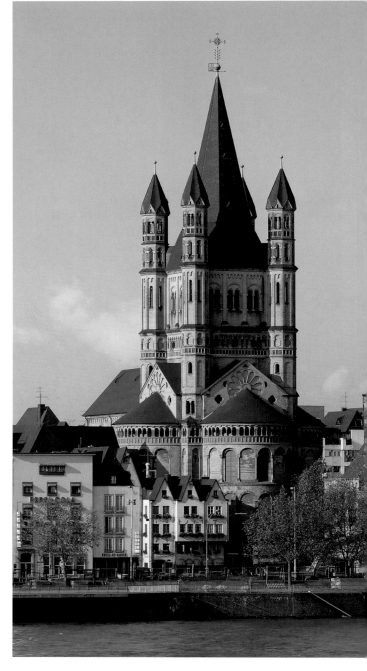

War II, then reconstructed in tedious detail over decades—then ultimately, through the addition of modern religious interior ornaments, especially stained glass, their aesthetic effect was destroyed once again.

The first one was Sankt Pantaleon, with its Ottonian westwork, in which the Empress Theophano was buried; the three wings and three towers of the exterior and the galleries of the interior characterize the building as a demonstration of the proud sovereignty of the ruling imperial house (see p. 24). The monastery church Sankt Maria im Kapitol, which was built under Abbess Ida (1015–1060), Otto II's granddaughter, had, above a Roman Capitoline temple, a layout with three conchae and ambulatories—a "clover chancel." The model for this was the Justinian three-concha layout of the church of the Nativity in Bethlehem, and even the dimensions were borrowed from there. The surviving decorations of Sankt Maria im Kapitol include the wooden doors, which date to around 1065, that have many polychrome reliefs of the life of Christ in richly ornamented frames; it is a wooden counterpart to the Romanesque bronze doors and a sign of the church's ambition. The triconch of Sankt Maria im Kapitol was taken up again in the second half of the twelfth century in the late Romanesque east ends of first Gross Sankt Martin and then Sankt Aposteln, both of which have two-level blind articulations and dwarf galleries in the conchae, very much in keeping with the Rhenish "multistory chancel." Sankt Aposteln has an octagonal cupola and two slender towers in the corners of the conchae; Gross Sankt Martin has a single massive tower with four satellite turrets on the corners. In the skyline from the Rhine the look of this tower, which forms a counterweight to the cathedral, was originally even more elaborate, as the four sides terminated in stately gables. Three of them blew down in a storm in 1434. Another triconch building in this group is the monastery church in Neuss. In all the Cologne churches of the twelfth and thirteenth centuries the Romanesque is realized in a richness of articulation by means of blind ornaments and galleries, with an increasingly ornamental style over the years. The final high points of the late Romanesque is Sankt Gereon, once a late-antique oval rotunda with a wreath of conchae but remodeled between 1219 and 1227 into a decagonal central-plan building with walls articulated as giant three-level arcades and later an early Gothic clerestory and a ribbed cupola. A little later, in 1248, the French cathedral Gothic style was used in the construction of the cathedral.

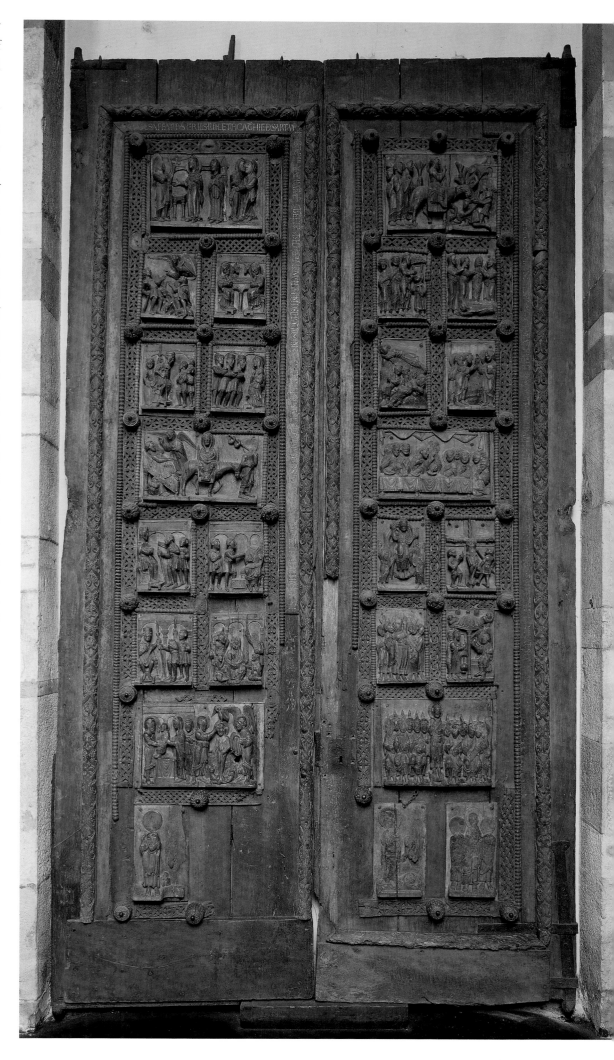

MARIA LAACH

THE BENEDICTINE ABBEY MARIA LAACH, active again since 1892, lies in a beautiful landscape on a maar in the Eifel. The church, the very epitome of perfected Romanesque form, has made the monastery world-famous among art lovers. Its founder was Count Palatine Henry II of the house of Luxemburg-Salm and his wife, Adelaide of Orlamünde, who had a castle on the east bank of the lake and founded the monastery on the opposite bank in 1093. It was settled from Sankt Maximin abbey in Trier, which had joined the reform of Gorze, but soon the new monastery adopted the *consuetudines* of Cluny.

The church was begun soon after the founding and the groundwork for the whole site was laid. In 1156 the archbishop of Trier consecrated it, but the eastern chancel and its flanking towers were not completed until 1170, after Countess Hedwig of Are, the sister of Gerhard of Are, the provost of the association in Bonn, had provided the funds. The three western towers obtained their present height and form under the reign of Abbot Albert (1199–1216), and finally Abbot Gregorius (1216–35) added a special treasure: the paradise in front of the west end.

The church is in the tradition of the Speyer cathedral as one of the first vaulted basilicas of the Rhenish Romanesque. It is a matter of debate when precisely the vaults were introduced, though clearly they were planned from the beginning. Hence the overall layout is unusual for the Rhenish region in that the main block is not laid out according to the bound system with double bays but according to the bay system with transverse oblong bays, similar to Vézelay (see pp. 159–62). The barren, plain severity of the interior presents the greatest

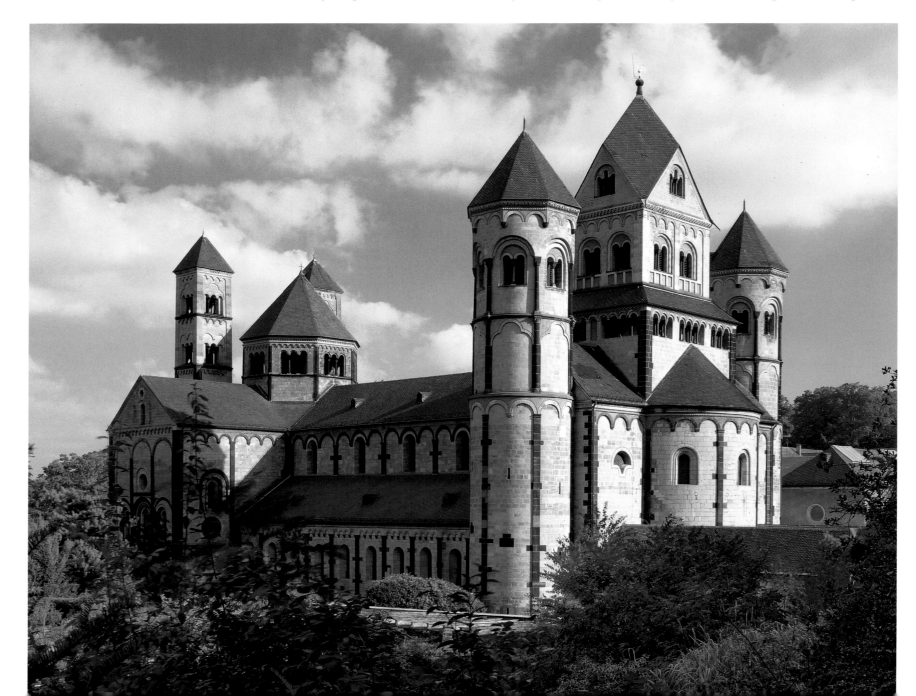

imaginable contrast to the richly articulated, six-tower exterior. The interior has something monastically ascetic about it, whereas the exterior tends to display the abbey's power. Two three-tower groups of buildings, divided by the main block, are juxtaposed: on one side, the east end with a projecting transept, a square chancel, three apses, an octagonal crossing tower, and two square turrets on the corners; on the other side, the west end with a cross bar flanked by round towers, a bulging apse, and a square tower in the center. The tower is sitting on a broader lower story as if on a pedestal, which seems to raise it to a commanding height. The round towers are subordinated to it; they are like paladins flanking a ruler sitting solidly and confidently on a throne. In this elevated sphere the articulations, with blind ornaments, frames, and all kinds of arcade openings, unfold with a rigidly ordered abundance. In its overall appearance the exterior achieves such perfect symmetry of proportions that it could be called classical. Where else in the German Romanesque is there such a well-balanced equilibrium between simplicity and splendor, round and angular forms, powerful order and lavish abundance? The classical features of this architecture are brought to completion by the noble arcades of the paradise in front—which in their lightness reveal an inner relationship to the early Renaissance—and especially the west side and its stately portal. The sculptural decoration of the paradise was the work of one of the region's finest sculptors: the so-called Master of the Samson, whose work can stand alongside the leading French sculpture from this period.

The apse of the west end makes it appear as if the church had two chancels. In fact, however, the whole of the western cross bar is taken up inside by a gallery that eclipses the apse on the ground floor with a double arcade; the round shape only makes itself felt above that level. The gallery, beneath which lies the donor's tomb, was completed in the thirteenth century, which suggests that the west end was conceived in the tradition of older westworks, as an architecture of power. This is precisely what the architectural forms express so articulately on the exterior as well.

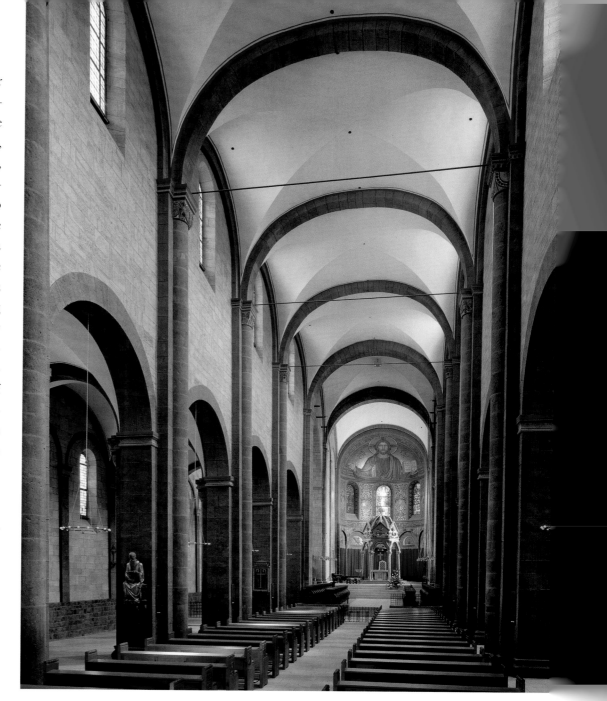

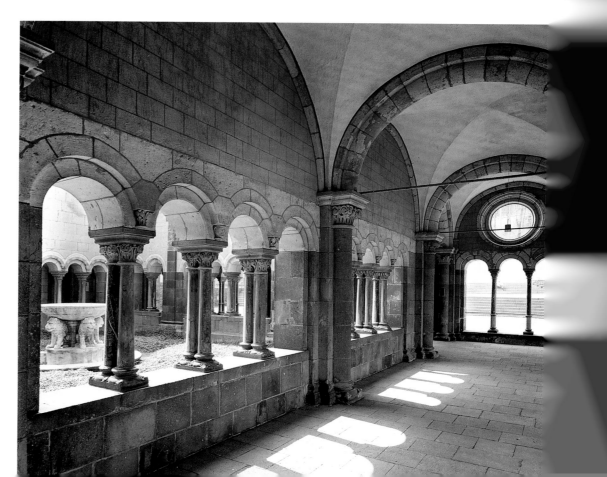

EBERBACH

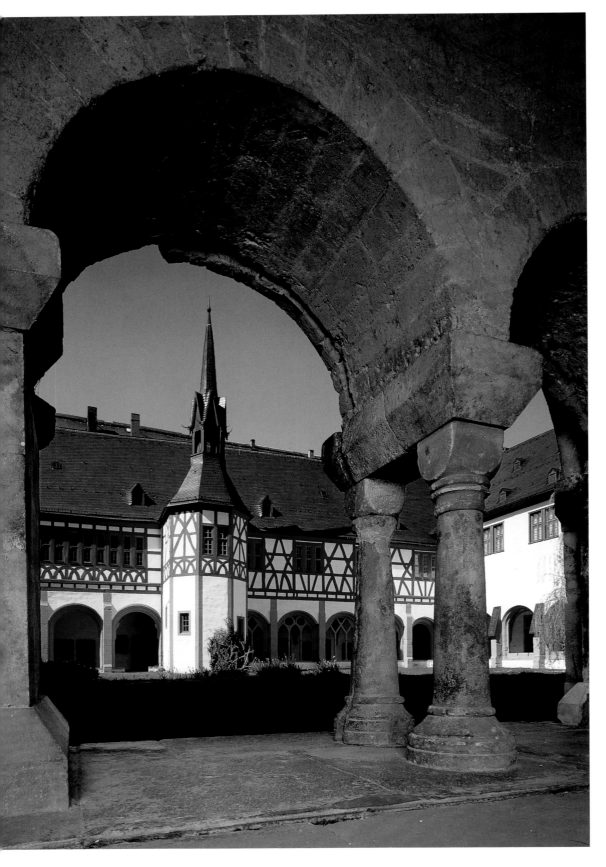

EBERBACH IS ONE OF THE BEST-PRESERVED Cistercian monasteries in Germany. Not far from the large cities of Mainz and Wiesbaden, it lies in a valley at the foot of the Taunus range, where the vineyard hills of the Rheingau begin—a typical Cistercian site. The site had in fact already been settled by Augustinian canons around 1116 and by Benedictines in 1131, although neither community really thrived, so in 1136 Archbishop Adalbert I of Mainz had Cistercians brought directly from Clairvaux, one of the order's five primary abbeys. The monastery, whose economic basis was viniculture, quickly flourished and was soon one of the largest Cistercian abbeys in Germany. In the twelfth and thirteenth centuries the convention probably consisted of about 150 choir monks and as many as 400 or more conversi. The monks' halls of the site are correspondingly large.

The church was begun around 1145 as a square building very much according to the model of the early French Cistercian churches based on the Bernardinian plan. At the time the plan was for barrel vaults with underlying arch ribs like those at Fontenay, for example (see pp. 166–70). At that point, however, construction halted, as the monastery ran afoul of the conflicts between Emperor Frederick Barbarossa and Pope Alexander III, and the second abbot was forced to flee to Rome. Only around 1170 was construction resumed on a new, thoroughly altered plan, which was then carried out in a consistent way until the consecration in 1186. The time-consuming ashlar technique was replaced by quarry stone masonry covered with plaster.

The church is a barren, plain-vaulted construction according to the bound system, with five immense double bays in the middle vessel. All the bays of the vaulting consist of cross rib vaults with arch ribs whose rectangular responds are supported by typically Cistercian corbels. The room imparts a sense of calm balance, like that of the cathedral in nearby Mainz; it is like a version of the Mainz cathedral in severe, ascetic Cistercian garb. There is scarcely another church that achieves such perfect beauty by means of simplicity. In this respect the Romanesque period was superior to all others, and Eberbach was in the vanguard.

The monastery site is a good example of the strict separation of the enclosure from the areas for the conversi by means of a monastery alley between them. The largest wing, dating from around 1200, is the Romanesque structure for the conversi, on the west end of the site. In the interior it has several two-nave rooms on two stories: on the ground floor, the lay refectory—which

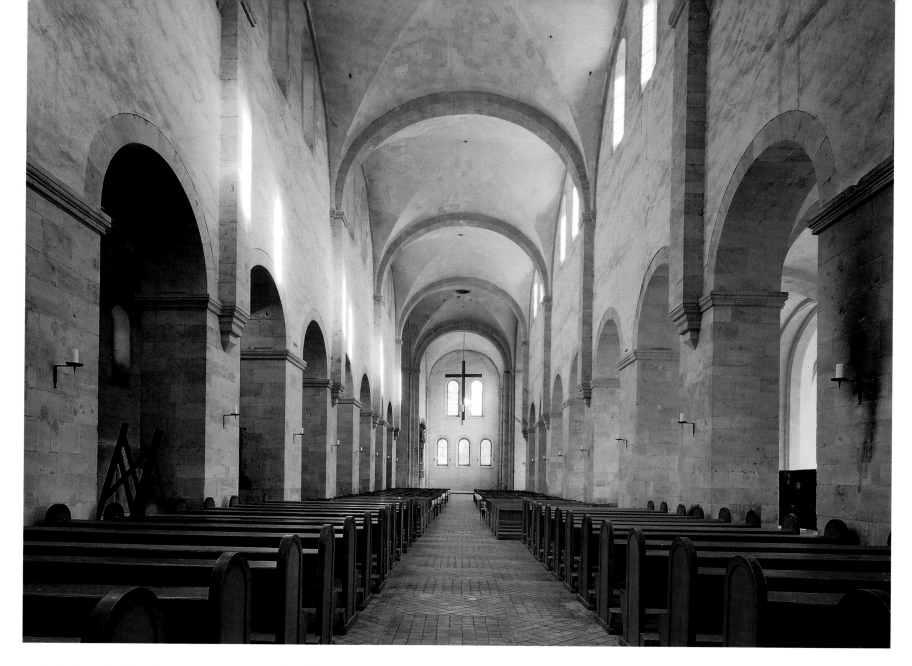

today is the primitive-looking storage area for old wine presses—and the cellars; on the top floor, the lay dormitory. At 272 feet (83 m) in length, the latter is the largest medieval room of a nonreligious purpose in Germany.

Less well preserved is the area of the enclosure around the cloister. Two of the cloister wings are missing, as are the old refectory and the well house, although for the latter a stairwell on the west end, built later with a half-timber crown, provides a reasonably satisfying visual substitute.

On the east wing of the enclosure, extending quite a distance to the north, is the two-nave, late Romanesque frater—once the workroom for the monks but now a wine cellar that resembles a cold, windowless crypt. The chapter house in the east wing seems that much more elegant and light. Originally it was a Romanesque four-support room. The arcades that opened onto the cloister have survived. Around 1345 a new rib vault, with an inscribed eight-pointed star, was built within the old square enclosure with a single central pier as support; it consists of eight bands and eight forklike figures with three radiating arms. This produces the fascinating effect of sixteen thin ribs radiating out in all directions from the middle column, as if from a fountain; it is analogous to the vault figurations in the chapter houses of English monasteries and cathedrals, which specialized in effects such as these.

No less impressive and justly famous is the upper story of the east wing of the monks' dormitory, which is also a two-nave hall, but at only 236 feet (72 m) in length it is not quite as large as the Romanesque lay dormitory. It is an early Gothic structure from around 1250–70, with the southern part dating from around 1340. In a seemingly endless sequence, bay after bay of broad cross rib vaults line up on stocky columns that are so short that the room seems to consist solely of vaults. In a monotonous unity the room stretches back into the depths, but gives an idea of the size of a Cistercian convention of monks and illustrates its principle that all monks were equal.

OPPOSITE PAGE:
View from the chapter house toward the west wing of the cloister

ABOVE:
View down the nave, facing east

PAGE 296:
TOP: *Monks' dormitory;*
BOTTOM: *Lay dormitory*

PAGE 297:
Chapter house

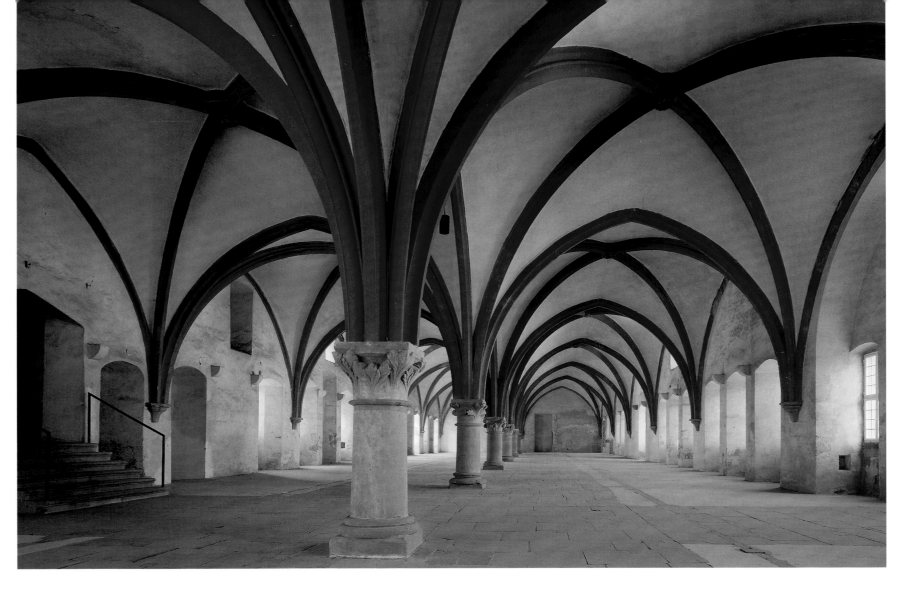
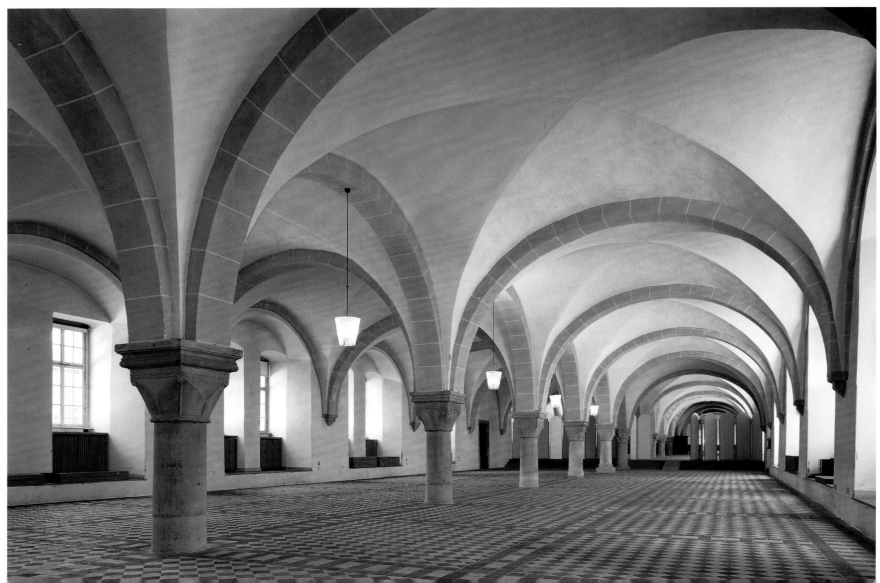

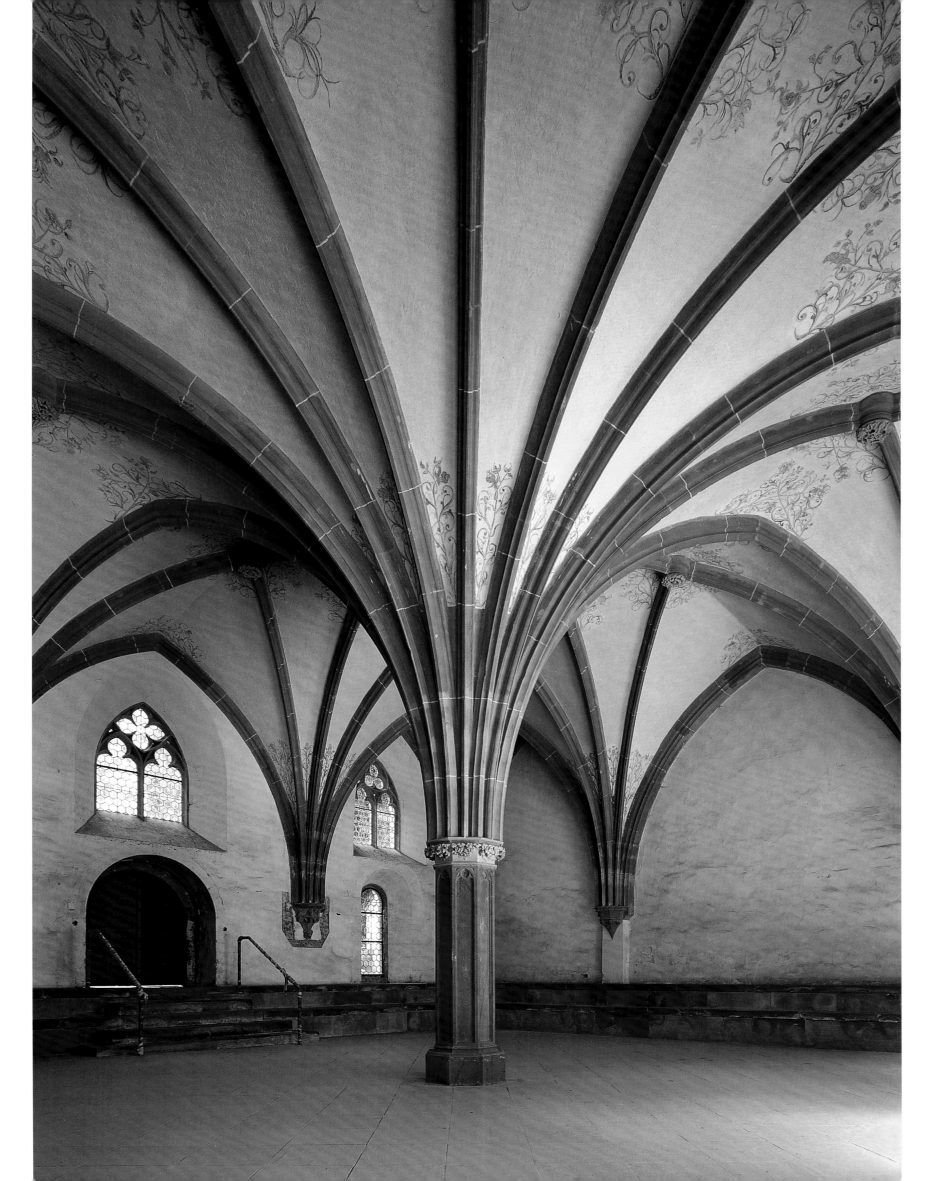

BEBENHAUSEN

BELOW:
Aerial view, from the northwest

OPPOSITE PAGE:
TOP: *Summer refectory (monks' refectory)* BOTTOM: *Chapter house*

EBENHAUSEN IS, AFTER MAULBRONN, THE best-preserved medieval Cistercian monastery in southern Germany. It lies in the immediate vicinity of the university city of Tübingen of the Württemberg dukes, in a river valley on the edge of the Schönbuch forest. Here Count Palatine Rudolph of Tübingen founded a Premonstratensian monastery around 1185, soon after his father had founded an abbey of that order in the Obermarchtal, on the Danube. As early as 1190, however, Cistercians had moved into Bebenhausen. They came from the Schönau monastery, near Heidelberg, which was part of the filiation of Clairvaux through Eberbach, in the Rheingau. The monastery was closed in 1535, after Duke Ulrich introduced the Reformation to the region.

Today the defensive walls and their towers are largely still standing, and the monastery, with its church, enclosure, and half-timber utility buildings looks like a miniature city. The church was consecrated in 1228. Its west end was demolished after the Reformation, but its east end is a late Romanesque structure based on the Bernardinian plan and ornamented with round arch friezes. The eight-sectioned window on the east side, with its stately, eye-catching tracery, was added around 1335–40, based on the transept window at Salem. Even more striking is the stone spire above the crossing, which resolves entirely into tracery and delicate pinnacles. It is a prized example of Gothic stonemasonry, of the sort that was actually prohibited by the Cistercian order. The lay brother Georg of Salem created the work in 1407–9 at the behest of Abbot Peter of Gomaringen. A mural inside the church shows the donor presenting the spire to the Virgin.

The enclosure buildings around the late Gothic cloister, which was built between 1475 and 1500 on the site of an older structure and includes a well house with an elegant star vault of sweeping ribs, still stand in their entirety, though parts of them are reconstructed. The surviving parts of the late Romanesque buildings include the four-support rooms of the chapter house and the locutorium as well as the three-nave hall of the

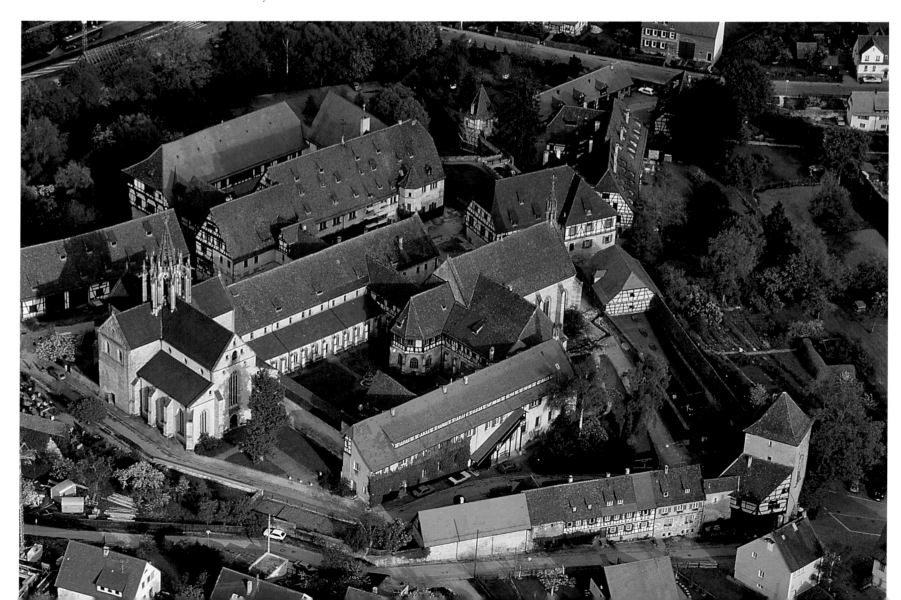

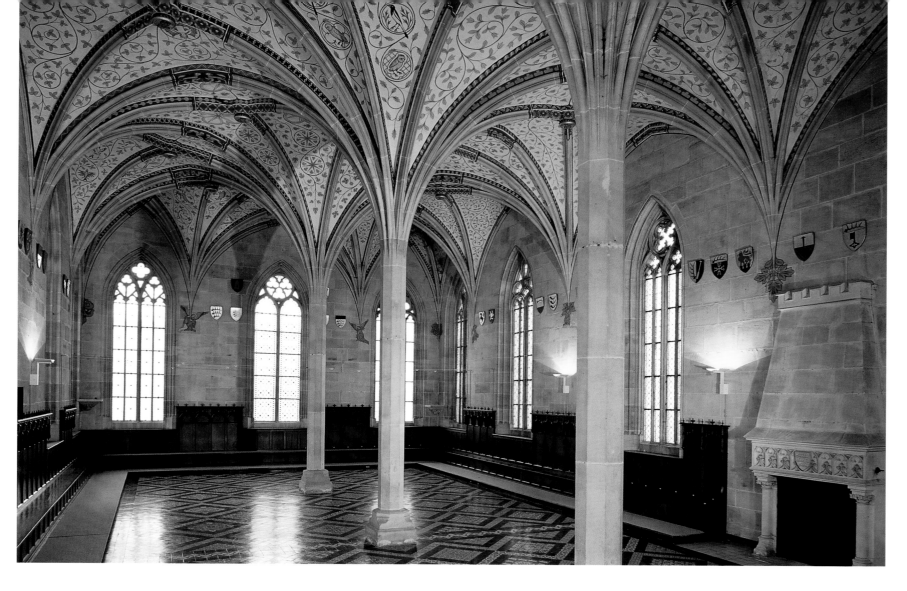
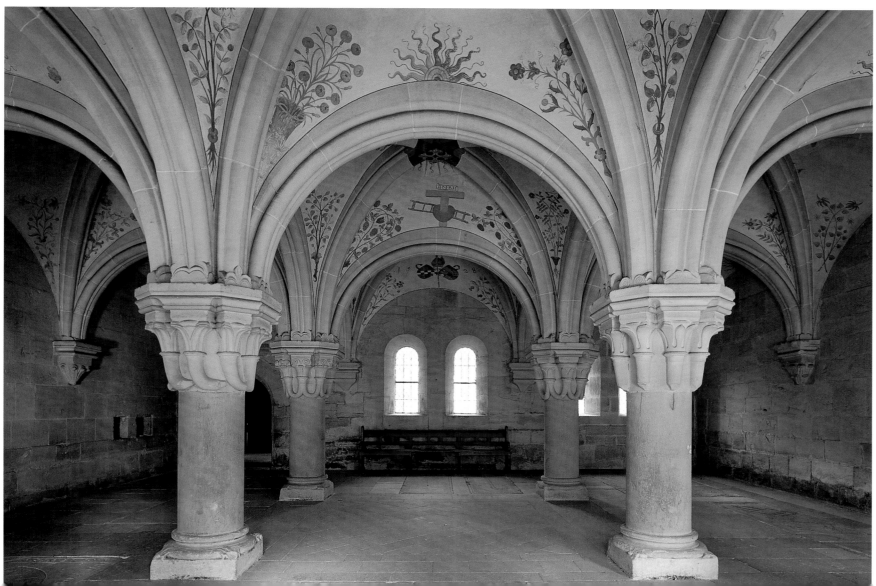

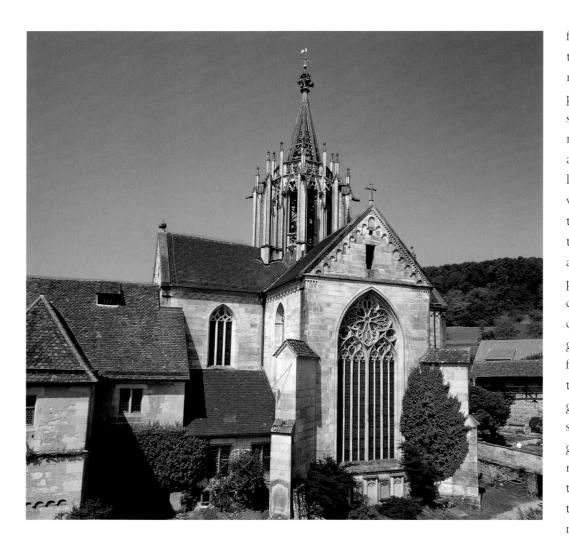

frater, all in the east wing, whose ceiling was built in 1217, to judge from the date the wood was felled. All these rooms have vaults whose cross ribs have weighty torus profiles and feature Bebenhausen's trademark low, stocky round columns with engaged pillars that terminate in short stubs just under their capitals, where they are either capped or deflected. As late as 1530, when the lay refectory was built, shortly before the monastery was closed, the formal language was still based on these three Romanesque rooms. The Gothic monks' refectory forms a stark contrast. It is a two-nave hall built around 1335 to replace an older refectory of the same plan that was destroyed by fire. The airy, spacious hall is distinguished by three thick octagonal piers without capitals, from which the ribs of the star vaults seem to grow like the branches of a tree. The points of the stars from field to field are constructed as the usual Y-shaped three rays. The spatial effect of the refectory is an elegant lightness, while the older Romanesque rooms seem oppressive and as heavy as earth and even a little gloomy. This makes it all the more surprising that they returned to the older forms when building the lay refectory, as if they considered the old and unfashionable style to be good enough for the conversi, and reserved the new for the monks.

ABOVE:
View of roof spire and tracery window, east end of the church of Bebenhausen

BOTTOM RIGHT:
Cloister, main block, and south transept

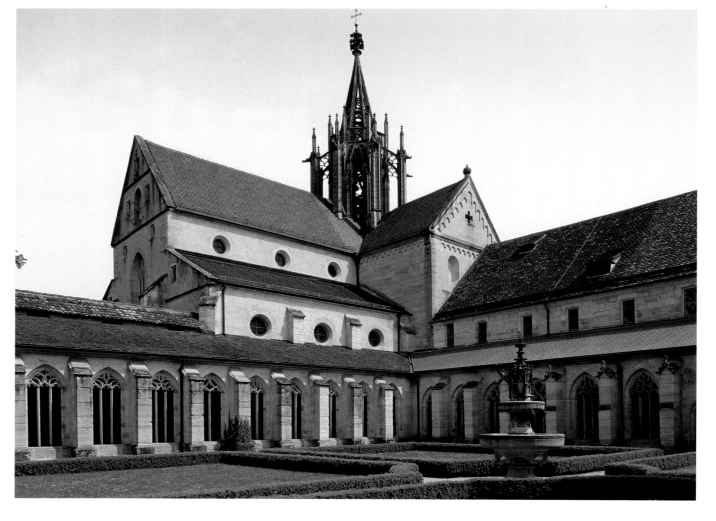

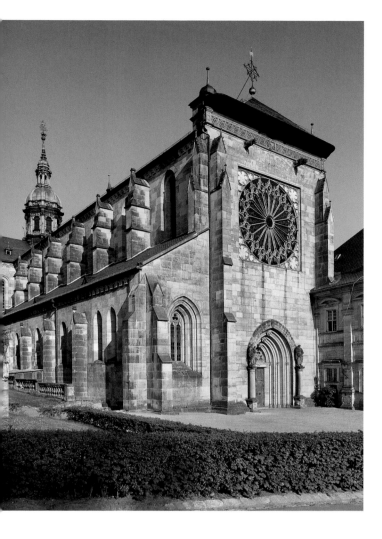

EBRACH

THE LARGEST AND MOST IMPORTANT CISTERCIAN abbey in Franconia was Ebrach, in the woodland regions of the Steigerwald between Würzburg and Bamberg. It was the third largest Cistercian monastery in the German Reich, after Kamp, on the Lower Rhine, and Lützel, in Alsace. Founded in 1127 by the free nobleman Berno, who later entered the monastery himself as a converso, the first convent came from Morimond under Abbot Adam. Ebrach itself founded six daughter monasteries, as far away as Bohemia and Styria. The abbey received support from the first Hohenstaufen king, Conrad III, whose wife, Gertrude, and their son, Hermann, duke of Swabia, were buried in the church. The later history is marked by the long, ultimately futile battle over its status of *Reichsunmittelbarkeit* (immunity) half granted by Emperor Charles IV, which

LEFT:
Gothic rose window on the west facade of the church, Ebrach

BELOW:
East end of the church, with Sankt Michael chapel on the right

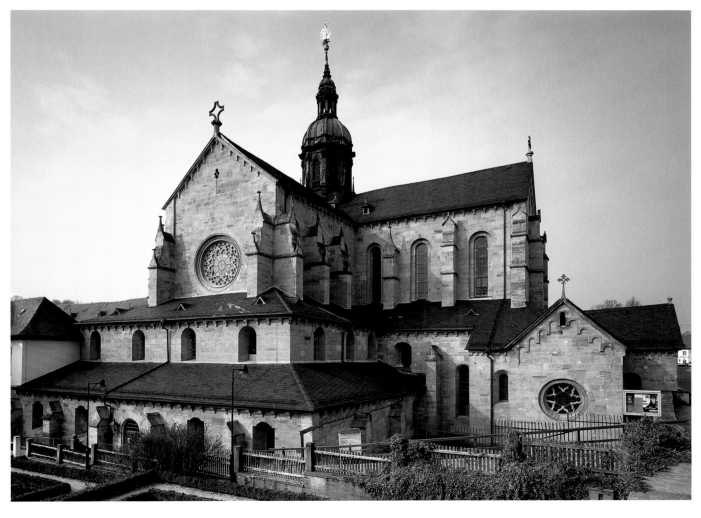

RIGHT:
*Interior of the chapel of Sankt Michael,
Ebrach*

BELOW LEFT:
Baroque staircase

OPPOSITE PAGE:
*View down the nave of Ebrach,
facing east*

would have made it subordinate only to the emperor,
but which was never acknowledged by the prince-
bishops of Würzburg. The abbey was extraordinarily rich
in the modern era, as is evident not only from the
Baroque monastery buildings but also by the many
regional curia for the officers, each of which—like Burg-
windheim, for example—is an impressive castle.

The monastery church, begun in 1200 and conse-
crated in 1285, is an early Gothic ashlar building of 289 feet
(88 m) in length, making it one of the largest Cistercian
churches in Germany. The east end, with a U-shaped
ambulatory and low chapels, corresponds to the Cîteaux
type. The main block, closely related to Pontigny but also
to the group of Italian buildings around Fossanova (see
pp. 449–53), is in the Cistercian international Gothic style,
but the effect of the interior was totally altered by the
plastering work done in 1778–91 by Materno Bossi, the
plasterer of the Würzburg court. Of the exterior, which
in the west bays retains the early Gothic formal language,

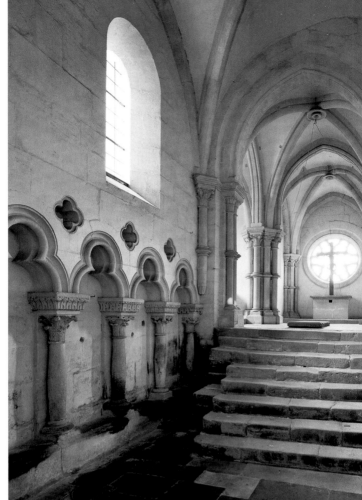

the reconstructed rose window in the west (the original
was used for the Bayerisches Nationalmuseum in
Munich) is a response to the rose window of the cathe-
dral of Strasbourg, which had been planned around 1285
but not yet executed. All that has survived of the original
construction from 1200 onward is Sankt Michael's chapel
at the north transept: a small, cruciform building whose
tiny crypt can only have been a tomb. The east end, with
its engaged pillars, annulets, and ribs, is flawless early
Gothic imported by French artisans. It was imitated in
the west end, but evidently by native workers who were
not quite as practiced.

The Baroque monastery buildings, which include
several interior courtyards, were built beginning in 1688
according to plans by the then still unknown Johann
Leonhard Dientzenhofer, who later became architect to
the court at Bamberg. His plans were altered, however,
by the addition of a open honor court in the west like
those found in princely residences, which turned the
abbey buildings into a monastery castle. The high point
of the Baroque structures at Ebrach is the wing and stair-
case designed in 1715 by the Würzburg architect Joseph
Greissing. Outside and inside it represents a simplified
revision of the grandiose staircase of the nearby castle
Pommersfelden, which the Bamberg prince-bishop
Lothar Franz von Schönborn had built according to
plans by the architect to the imperial court, Johann
Lukas von Hildebrandt.

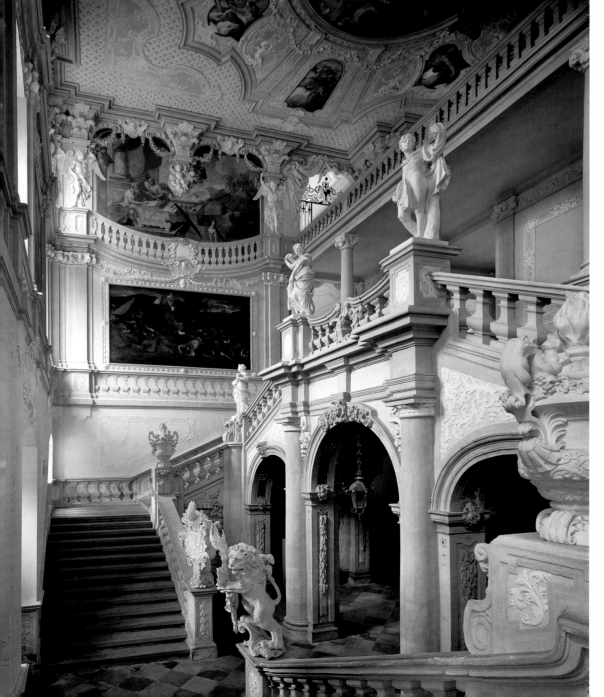

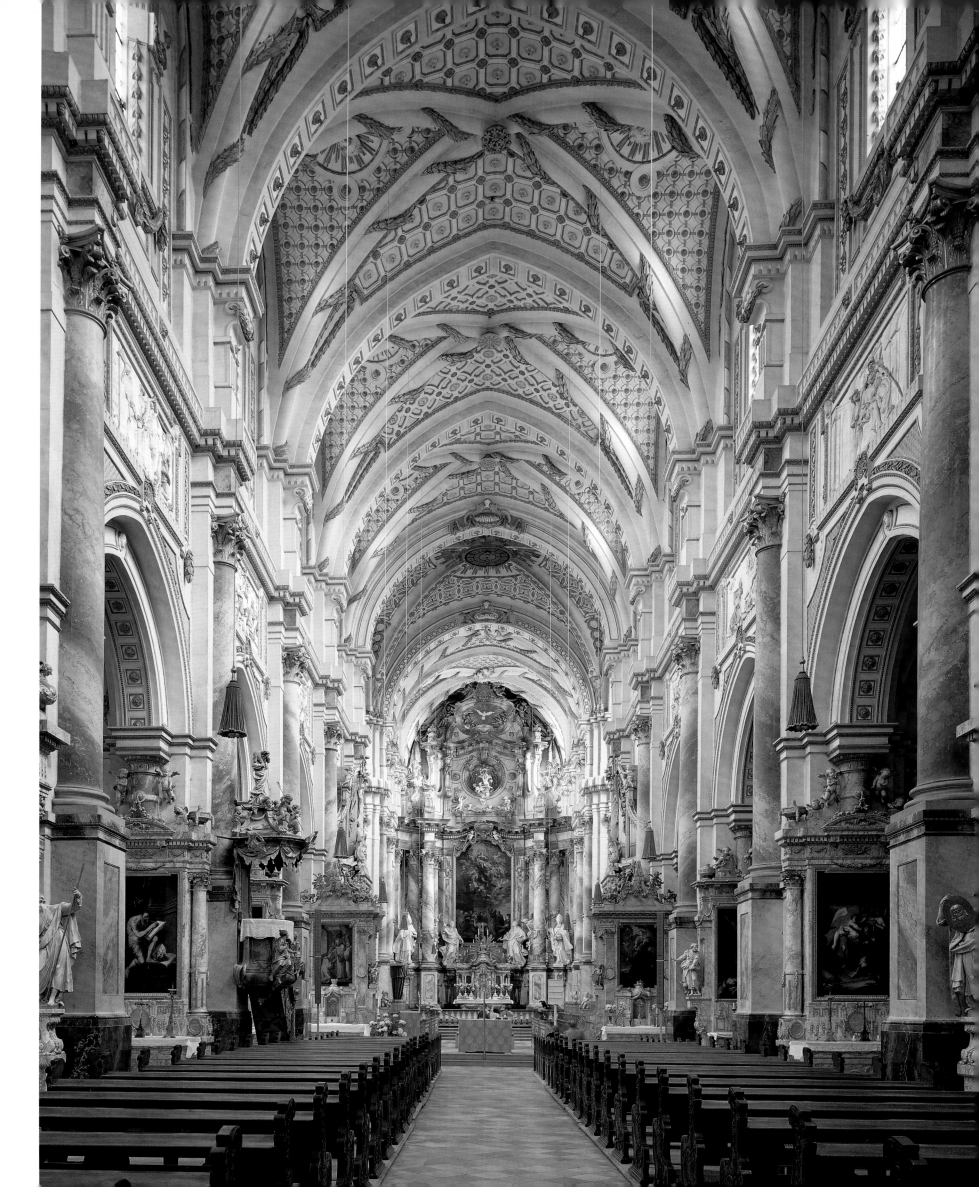

COMBURG

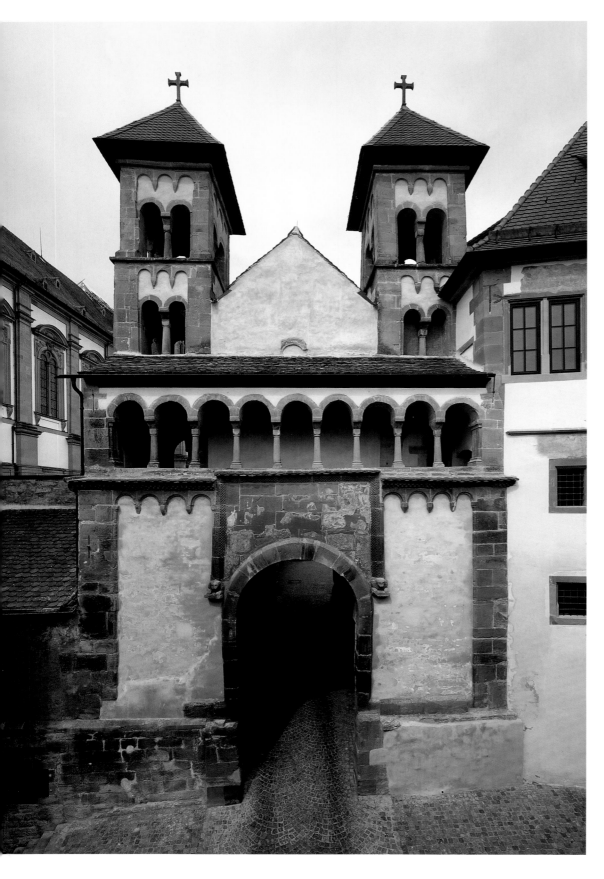

OMBURG, ALSO CALLED GROSSCOMBURG (Large Comburg) to distinguish it from neighboring Kleincomburg (Small Comburg), is a monastery fortress with buildings from the Middle Ages, the Renaissance, and the Baroque. It lies near the old imperial city Schwäbisch Hall, on a mountain above the Kocher river. Surrounded by a well-preserved ring wall built around 1560–70, which was reinforced by many low tower bastions, the monastery, with its three-tower church that seems to dominate everything, presents an image of a proudly towering fortress of God. The site and the overall appearance are unique in Germany.

This site was originally occupied by a fortress belonging to the Frankish counts of the Kochergau, who could control the salt sources in Hall from here. In 1078 Count Burkhard, who was crippled by bone disease and thus unable to serve in the military, converted the fortress into a Benedictine monastery, which he then later entered as a monk. Immediately after its founding, work began on a two-chancel stately basilica with a transept on the west end. Shortly before it was consecrated, the monastery joined the reform movement of Hirsau and took its abbot from there.

The monastery church was soon followed by a second church on the opposite slope, just half the size of the first, Kleincomburg, which is very well preserved. Count Heinrich, the last count of his dynasty, established a provostry there in 1108, which is probably when that church was built. Its function is unclear (perhaps it was a nunnery or a church with stations for processions). Standing in this room gives an almost unadulterated experience of the simple plainness and monastic severity typical of the Hirsau reform monasteries. The church is a flat-ceilinged column basilica with a crossing that is marked-off in exemplary fashion by means of four arches and cruciform piers. One trademark of Hirsau monastic architecture is that the engaged columns elsewhere in the middle vessel of the church are replaced by square piers next to the crossing, where they serve to mark the border to the *chorus minor*.

Another unique building survives from the period around 1100 or perhaps later: the monastery gate. On the first floor it is disconcerting, like an ominous fortress gate; above that, however, it transforms into a two-tower church facade with the distinctive motif of a gallery with a column arcade running across. The two recessed square turrets are open like bell towers with two levels of paired arches. The whole is an impressive example of the pure Romanesque style.

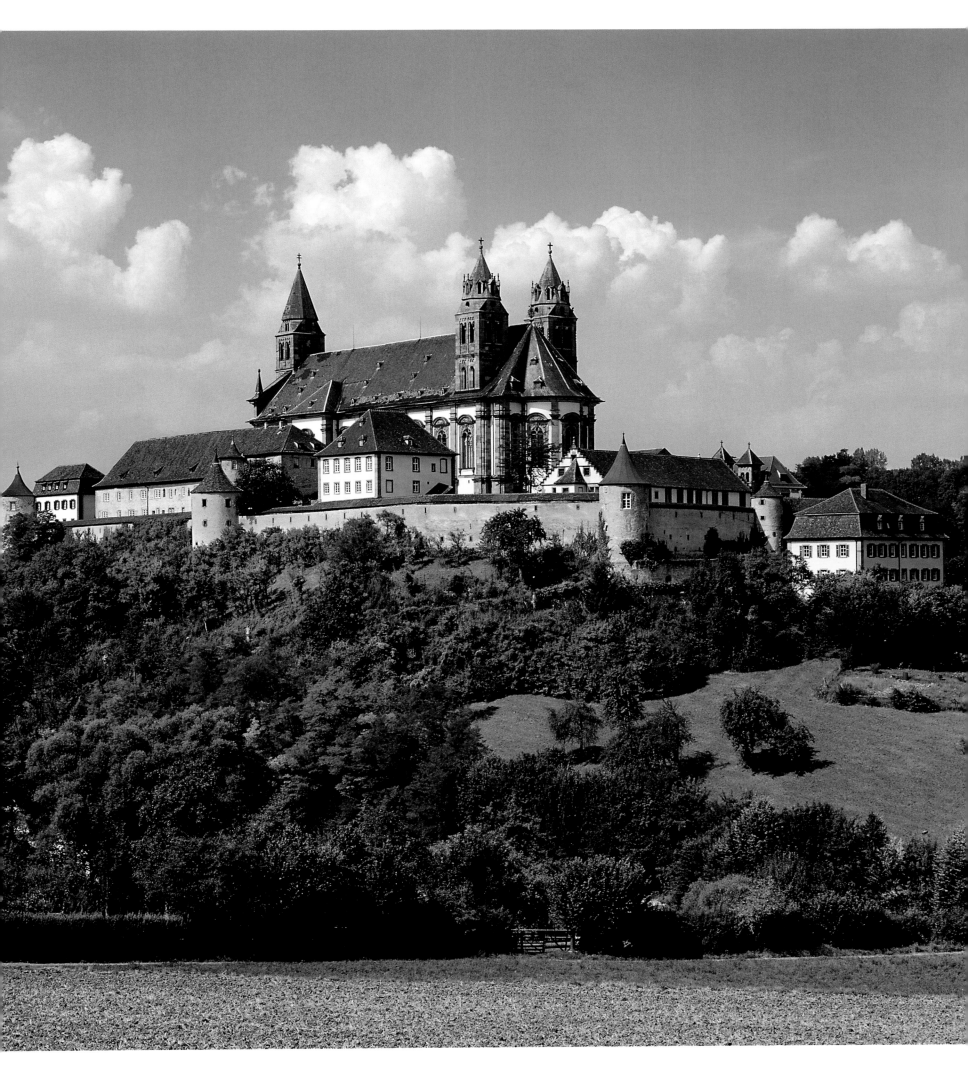

Comburg flourished under Hartwig (Hertwig), the monastery's third abbot. He reigned between 1109 and 1138 and lavishly ornamented the church. During this period the administration of the monastery was the responsibility of Conrad, the Hohenstaufen duke of Swabia, who became king of Germany in 1138 as Conrad III.

During the first half of the thirteenth century a new east end was added to the church, with the chancel flanked by two towers in lavish late Romanesque forms, crowned by stone spires. The existing west tower was built up using similar forms. The view from a distance of these three towers is the unmistakable pride of Comburg.

In 1488 the monastery was transformed into an aristocratic canonical association (knights' association), which survived until secularization in 1802. It maintained close relations with Würzburg and the Swabian association Ellwangen (see p. 309). The canons had their own residences, so-called curia, built around the church, but the medieval monastery buildings, some of which still had the substance of the Romanesque structure, remained largely preserved, including a late Romanesque hexagonal chapel north of the church, which had a dwarf gallery on the exterior and a central supporting column in the interior.

Although the canonical association was considered poor, in 1706 its dean, von Guttenberg, under the direction of the provost, von Stadion, had the old church torn down, leaving its towers, and a year later construction of the present Baroque church was begun on a new, longer foundation. Its consecration followed in 1715. The workers and artists came from Würzburg, and its

architect, Joseph Greissing, was the municipal carpenter of Würzburg. From Vorarlberg, he was also a building contractor. He built a hall church with three naves of equal height and freestanding piers. At that time, from 1707 onward, a comparable hall church was being built not far away, at the Cistercian monastery Schöntal, on the Jagst River. The hall church was no longer as fashionable a style as it was in the Gothic period.

The hall in Comburg gets its look from the piers of hewn stone. They are cruciform, with pilasters on all sides. The true defining motif of this architecture, however, sits above the capitals: an impost block in the form of a complete, tripartite entablature consisting of architrave, frieze, and cornice. Particularly characteristic of Comburg is the extremely wide projection of the cornice, which resembles the wall-pier churches of Greissing's fellow architects in Vorarlberg. The entablature concentrates the structure vertically. On the exterior Greissing wanted to redo the old-fashioned Romanesque towers in a Baroque style, augmenting them significantly, to compensate for the height of the new church's roof. This was not carried out, however, with the result that the Baroque structure is enhanced by the contrast with the older Romanesque architecture as if by monuments to the monastery's own history.

Two outstanding works in metal have survived from the medieval decorations: an altar antependium and a wheel candelabrum. According to an inscription the candelabrum was donated by Abbot Hartwig, so it must have been made in the early decades of the twelfth century. The same abbot is thought to have donated the antependium. Surviving documents indicate that he

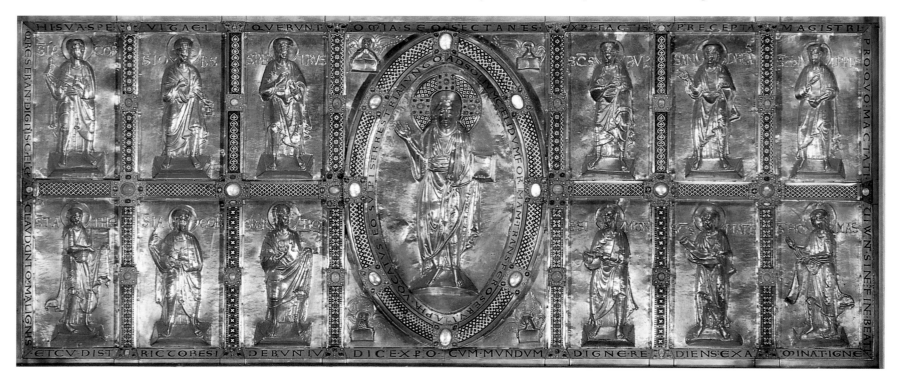

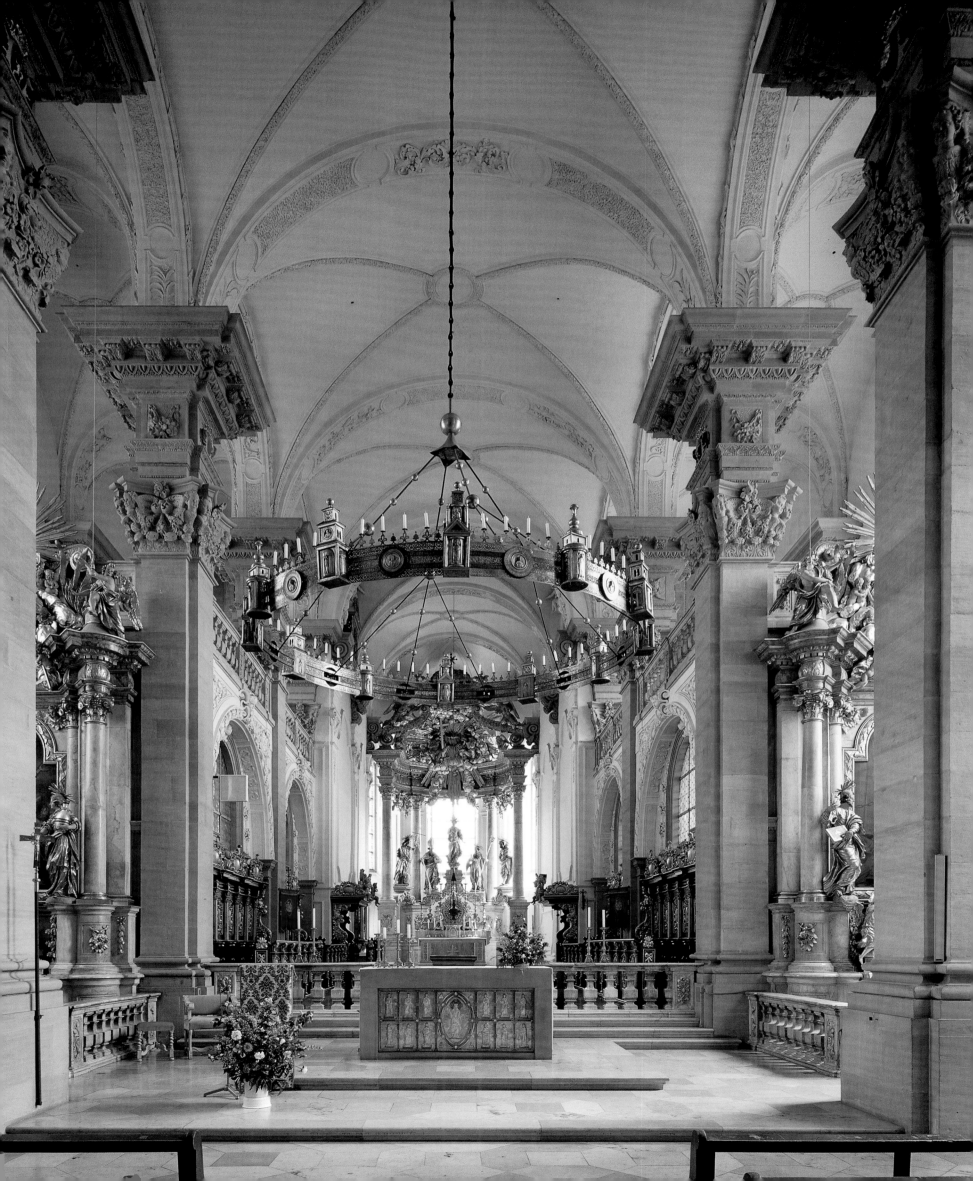

BELOW:
Interior of the church, Kleincomburg

OPPOSITE PAGE:
*View of the east end of Ellwangen,
from the southeast*

donated two other works that have been lost: a gem-encrusted gold cross and a somewhat smaller antependium for Kleincomburg portraying the same themes as the one that survived. The quantity of works in metal suggests that the workshops were located in Comburg itself.

The antependium, which is 31 by 74 inches (78 × 188 cm), is made of chased gilded copper over a wood core.

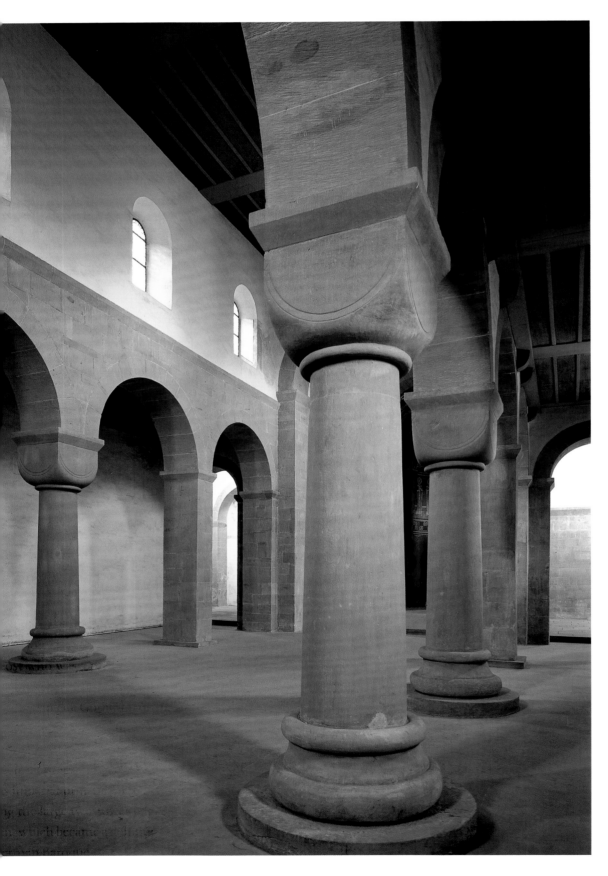

Its frame is decorated with colored enamel cloisonné stripes and with precious stones in filigree settings. The panel, which again decorates the front of the altar today, depicts at the center Christ in a mandorla, pointing to a book with his left hand and with his right hand raised in a gesture of teaching or judging. He is surrounded by two registers of the symbols of the evangelists and twelve apostles, each standing on plinths against a gold backdrop and turned toward Christ. Their names are emphasized in large letters, and the long inscription that runs around the antependium points out that the apostles, who relinquished themselves and everything worldly in order to serve their master, will sit alongside the strict judge at the Second Coming.

Although their heads are turned, the apostles are depicted with solemnly rigorous frontality and their poses are nearly static. This lends them a touch of the hieratic, a sense that they are distant and untouchable. Their forms, and especially that of Christ, give expression to a spiritual existence beyond the world, time, and space. They are presented to the viewer in the golden radiance of heaven, as if they themselves were that radiance. No epoch was better than the Romanesque at making such messages clear through art.

The wheel candelabrum, about sixteen feet (5 m) in diameter, consists of two iron wheels and incised copper covered in gold and silver and painted with brown varnish. It has no fewer than 412 figurative depictions. Its hanging rods extend from a sphere on which there is a bust of Christ. This portrait has the inscription *Ego sum lux mundi* (I am the light of the world). The long inscription that runs around the candelabrum explains that it is a depiction of the Heavenly Jerusalem. According to the inscription the twelve small towers allude to the apostles; the twelve columns (i.e., the medallions), to the prophets; the golden radiance, to faith; the silver, to the value of the Word; the hard iron, to the patience of endurance; the flames, to charity; and the chains that point upward, to hope. There are two other wheel candelabra similar to the one in Comburg: an earlier one, which Bishop Hezilo donated to the cathedral in Hildesheim, which is more than three feet (1 m) larger, and the Barbarossa candelabrum in the imperial chapel in Aachen. In Comburg the candelabrum is hung over the tomb reliefs of the donors, thus they rest beneath the promise "Ego sum lux mundi."

ELLWANGEN IS THE OLDEST AND MOST DISTIN-
guished of the medieval Benedictine abbeys in
southern Germany. It was founded in 764 by the
Frankish noblemen Erlolf (who was then bishop of Lan-
gres) and Hariolf, who became the first abbot of the
monastery he had helped found. He succeeded in obtain-
ing the bodies of no fewer than sixteen Roman
martyrs—a considerable collection of relics, which at the
time was considered of greater value than treasures of
gold, silver, and gems. The monastery was reserved for
the aristocracy. As early as 817, just after Reichenau and
Sankt Gallen, it was made an imperial abbey, and from
979 onward it reported directly to the papal see.

The present church is the monastery's third. A fire
in 1182 was the occasion for a completely new building,
which was consecrated in 1233. Its driving force was
Abbot Kuno, who took office in 1188. As a close confidant
of the Hohenstaufens he was also a politically ambitious
man, and in 1215 he was raised to the rank of an imperial
prince in his role as abbot. In 1218 he took over the abbey
at Fulda, Germany's highest-ranking abbey, and contin-
ued to administer Ellwangen from there.

The elaborate ashlar building stands directly in the
tradition of the Rhenish imperial cathedrals, but at 250
feet (76 m) in length, it did not reach that scale. It is a pier
basilica based on the bound system, with double bays
and domed cross rib vaults. Because the interior has
been adapted to the Baroque style, the Romanesque
structure is barely recognizable. Only the east end of the
exterior reveals the ambitions of an imperial abbey in the
age of the Hohenstaufens.

A group of elaborately staggered structures are in
front of the cross bar of the transept: high chancel, side
chancels, three apses, and two square towers in the cor-
ners between the high chancel and the transept arms.
This ensemble is articulated by pilaster strips, blind orna-
ments, and round-arched corbel tables—a Hohen-
staufen counterpart to the French ambulatory chancel.

In 1460, at its request, the abbey was transformed
into a canonical association subordinate only to the
emperor, with a provost who was a prince and twelve
aristocratic canons. The monastery buildings, including
the cloister, were redesigned in late Gothic forms. In the
seventeenth and eighteenth centuries the provosts, who
often came from the aristocracy, built a fortified resi-
dential castle above the monastery site that was in keep-
ing with their status as imperial princes. They were also
responsible for building the large two-tower pilgrimage
church near Ellwangen, which became a defining build-
ing of the southern German Baroque.

ELLWANGEN

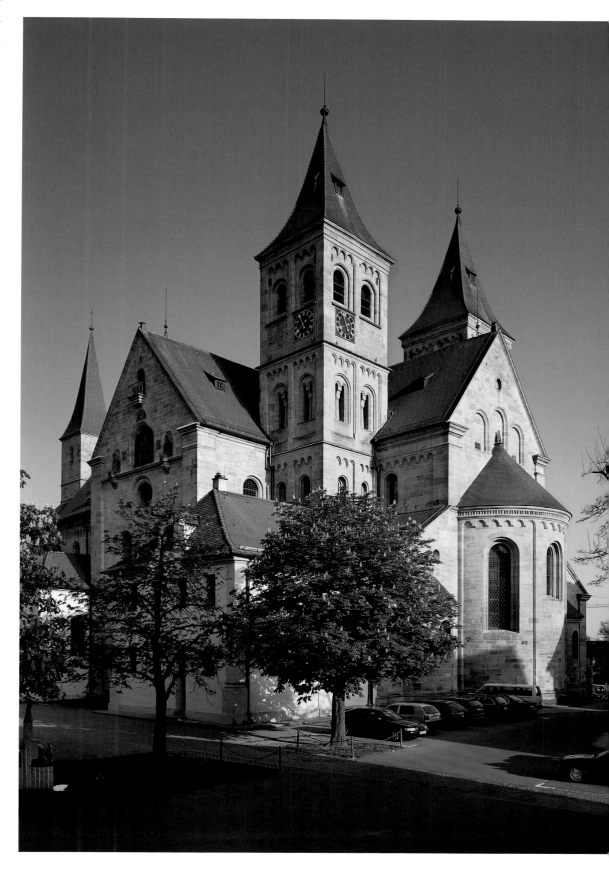

MAULBRONN

MAULBRONN, WHICH LIES NOT FAR FROM Pforzheim in the valley of the Salzach River, is the best-preserved of all the German Cistercian monasteries. At the same time, the individual building elements are of such architectural quality that in Germany Maulbronn is not unjustly considered the epitome of a Cistercian monastery. In 1138 it was founded at a different, less favorable site by the free nobleman Walter von Lomersheim, who then entered the monastery himself as a lay brother. The first convention, under Abbot Dieter, came from Neuburg, in Alsace. At first the monastery could neither live nor die. In 1146, however, Bernard of Clairvaux made an appeal in Speyer for a crusade, and Abbot Dieter had soon decided to sign up, whereupon in 1147 Bishop Günther of Speyer offered the convention a more favorable site in a remote forest on property belonging to Speyer. The bishop also made donations to Maulbronn that became the basis of its rich real estate holdings. From that point onward the convention grew so rapidly that Maulbronn was able to settle Bronnbach, in the Tauber valley, in 1151 and Schöntal, on the Jagst River, in 1157. Maulbronn was under the protection of the empire until Emperor Charles IV transferred its administration to the Electorate of the Palatinate. At that point the monastery was converted into a fortress. Duke Ulrich of Württemberg nevertheless managed to capture it after a seven-day siege in 1504 and introduced the Reformation in 1534. Maulbronn was returned to the Cistercian order in 1548, but then it was closed for good in 1556 and converted into a Protestant monastery school.

The overall layout is that of an expanded, walled monastery city. The defensive walls and the towers—parts of which have rustic ashlar work, as is typical of defensive structures of the Hohenstaufen period—date back to the thirteenth century and were later expanded and built up several times. The western farmyard contains, even today, the cooperage, fruit and grain storage, bakery, mill, smithy, and wheelwright's shop. Together with other functional buildings they form a picturesque ensemble of half-timber buildings that resembles a small city, dating mainly from the late Middle Ages. The termination of the farm area to the east is the closed facade of the church and the conversi building.

The church was probably begun soon after the monastery was resettled in 1147. A consecration in 1178 is documented. The structure is precisely executed ashlar with round-arch corbel tables on the exterior; on the outside it still looks as if the scaffolding has just been removed. The east end is built according to the Bernardinian plan: a sanctuary with a flat termination and three chapels in each end of the transept. The only difference is that the chapels are not added to the transept on the exterior, as was commonly the case, but built into the interior—an extremely unusual solution that results in an oddly oppressive, cramped space. The eastern parts of the church have cross rib vaults with primitive box ribs. Only in the sanctuary, which seems to have been vaulted subsequently, is there a more advanced rib vault with circular responds in the corners.

The main block, 161 feet (49 m) long, is a basilica with elaborately designed pier arcades whose arches have rectangular frames, in keeping with the Hirsau

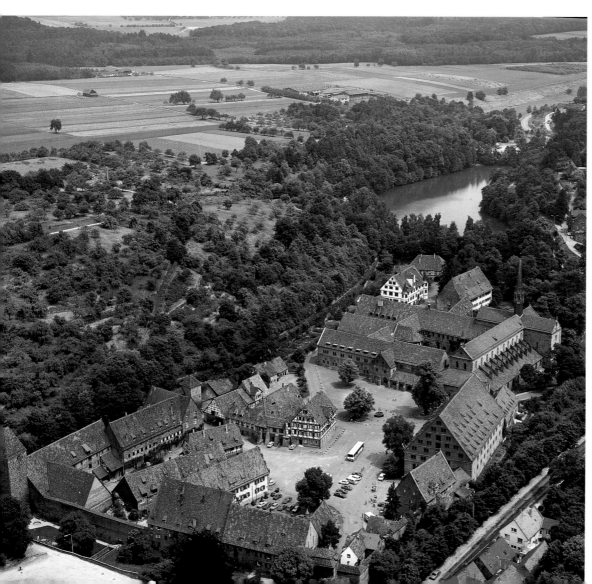

school of architecture. In addition, the jambs of the arcades have a sill in each arch and piers with semicircular column projections—similar to the cathedral in Würzburg. Cistercian plainness is found, by contrast, in the completely smooth, towering clerestory; it gives an extraordinarily steep profile to the room, which originally had a flat ceiling. This steepness is no longer as stark as it originally was because in 1424 the lay brother Master Berthold inserted a diamond frieze in the crown of the late Gothic, typically Swabian tracery vault.

The church is one of the few Cistercian churches in which the barrier in the middle vessel that separates the monks' chancel from the area for the conversi has survived. It does not divide the nave into two equal halves, but gives the conversi a third more room, which surely reflected the number of members at the time. The monks' chancel still has the late Gothic choir stall from around 1450, with ninety-two seats and elaborately carved sides. The area that is demarcated by the choir stall and the barrier clearly demonstrates that in Cistercian churches the monks' choir was found in the middle vessel, not in the east end.

After the church was completed, the early Gothic came to Maulbronn around 1210–20. An architect schooled in France, one of the best in his field, began the

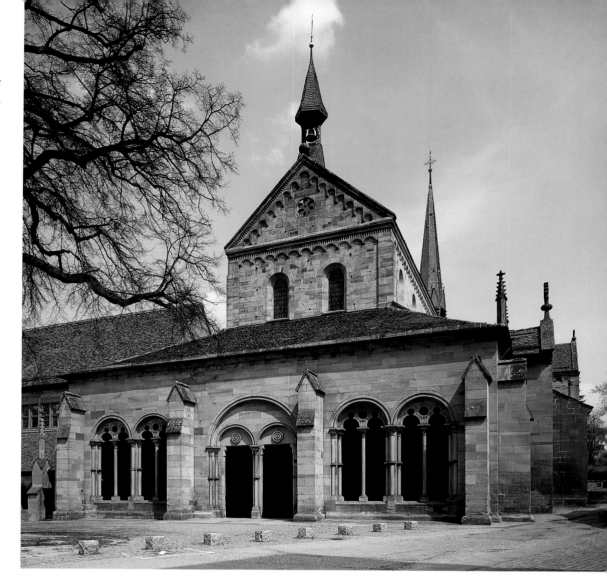

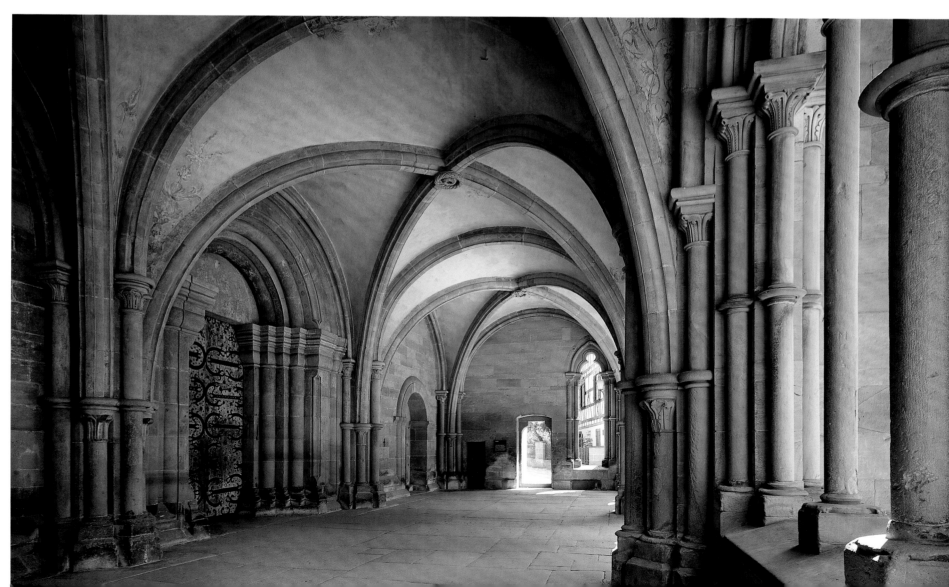

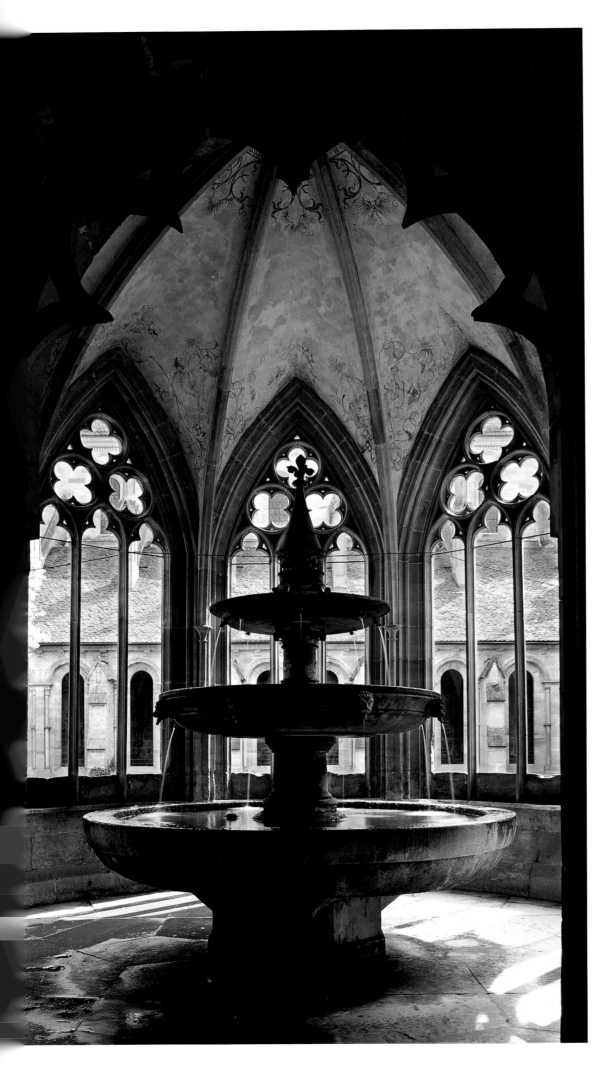

cloister and constructed the west entry to the church and the monks' refectory. In addition, he added vaults on double columns in the lay refectory—probably rib vaults, but they have not survived (in 1869–70 they were replaced with groin vaults, and with the wrong profile at that). This master placed a half-moon, like an artist's signature, on all the parts of the building for which he was responsible. This symbol is also found elsewhere—for example, at Walkenried and Ebrach, but above all on the bishop's passageway in the Magdeburg cathedral. This suggests that members of the building crew could be active simultaneously in different guilds. The half-moon may suggest that the master was a member of the aristocratic family von Magenheim from the Heilbronn region, as a half-moon was part of their coat of arms, and they were among the sponsors of Maulbronn.

For the church entry, which was referred to as the "paradise" as early as the thirteenth century, the master placed in front of the Romanesque terraced portal a vaulted structure with three bays whose ribs have semicircular profiles, as do the western windows with their punctuated forms. Because the radius of the diagonal ribs is larger than that of the other arches, and the crown height is the same everywhere, the imposts of the diagonal ribs are necessarily quite a bit lower than those of the neighboring imposts. This style results in "jumping" imposts. This could easily have been avoided through the use of pointed arches, but the master recognized that these imposts had a distinctive aesthetic charm—as did the round arch profiles of the ribs, which were already old-fashioned by that time—that he clearly savored. With vaults of light elegance the master managed to achieve an effect of taut tension. On the responds he used the tubelike astragals that were typical of the early Gothic. He inserted them into the racking of the wall as finished pieces *en délit*, that is, not bonded into the masonry. The astragals are supported and held in place solely by shaft rings fixed in the ashlar. The many imposts and ribs result in an architecture of a loosely arranged, articulated structure composed of many forms, and lend the edifice a high degree of sculptural power, even though the astragals are very slender.

The master's plan also made use of the usual Gothic vaulting techniques: pointed arches for the wall and arch ribs and round arches for the diagonal ribs, as is evident in the parts of the cloister that he built: the south wing and the adjacent bays of the east and west wings. Here he used six-part rib vaults that are supported by sculptural imposts inserted *en délit*, like those of the paradise. On the garden side the imposts extend down to the ground,

while on the inside they are supported by corbels at half-height. The remaining parts of the cloister and its richly figured tracery windows were added during the high Gothic period, as were the chapter house, with its star vaults, and the well house. In the interior of the well house—which is unparalleled and surely practices its quiet, almost paradisiacal magic on every visitor—Gothic tracery is fulfilled in perfect harmony.

The monastery's most famous space, however, is the refectory of the choir monks. In Maulbronn it was distinguished from the lay refectory by calling it the "Herrenrefektorium" (refectory of lords), which also suits its appearance. Both rooms are two-nave halls. But whereas the extended lay refectory seems low, compressed, and barren, the much shorter and wider Herrenrefektorium has a tall and proud orientation, as if to demonstrate the intellectual superiority of the choir monks to the working conversi. The alternating robust and slender round piers of the Herrenrefektorium are truly sculptures in architectural form. They support six-bay vaults—with seven bays in the corner vaults—that have ribs with strong profiles. The ribs rest on engaged bundle pillars that are short, almost stubby, and on corbels, so that the exterior walls with their tall windows remain free and smooth. This space would be worthy of a king. But kings rarely had rooms of such majesty.

OPPOSITE PAGE:
The well house

BELOW:
View from in the cloister, showing the well house

PAGE 314:
Monks' chancel with choir stall, looking west

PAGE 315:
The Herrenrefektorium (refectory of lords)

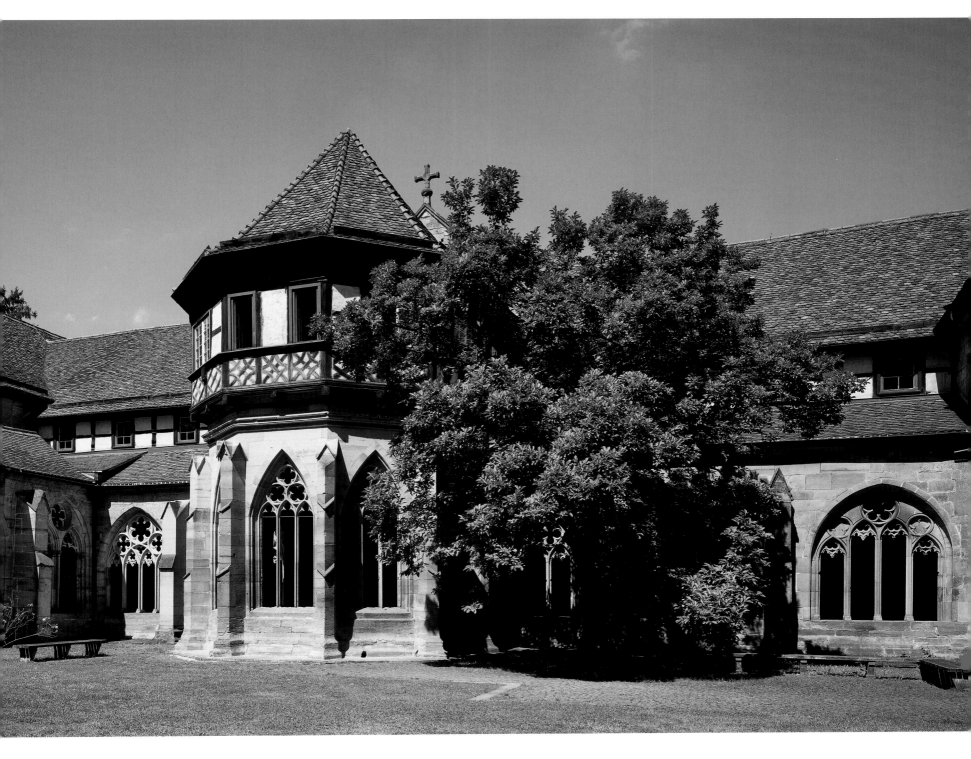

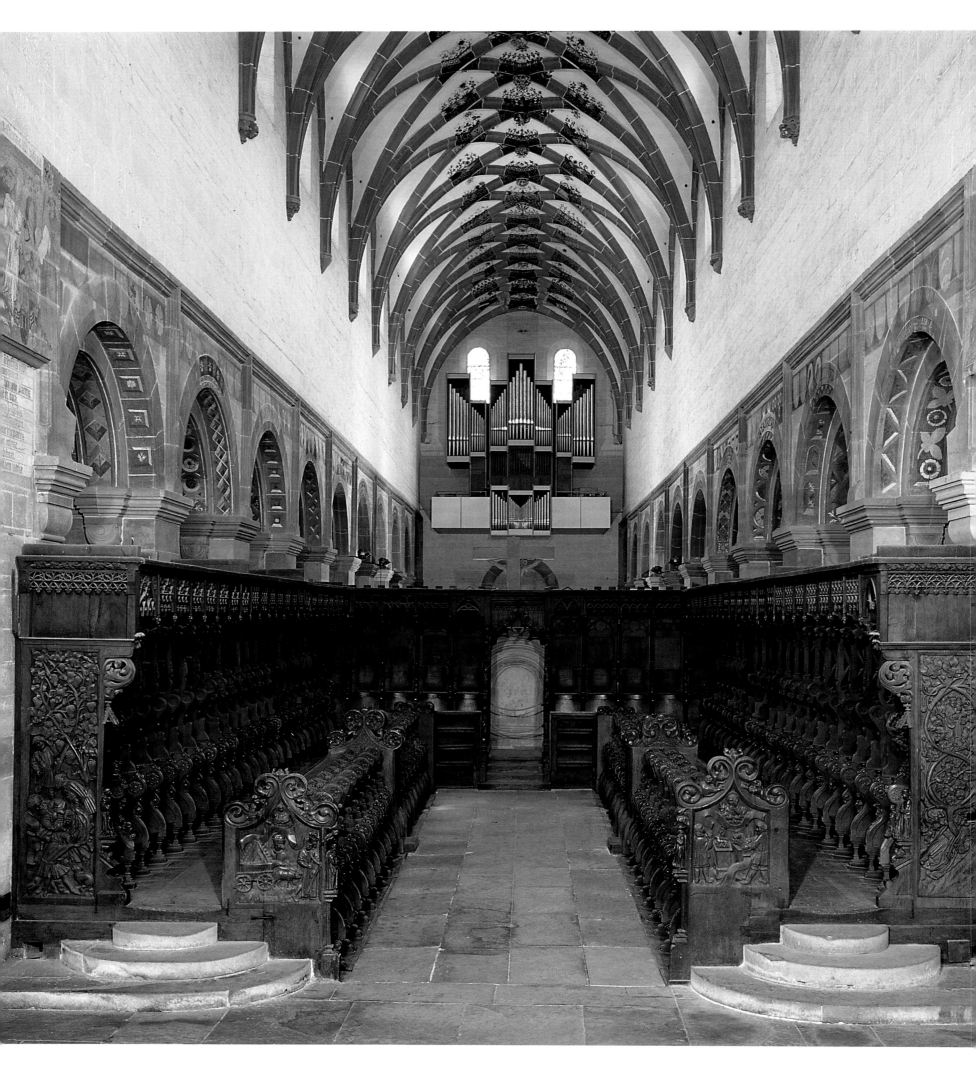

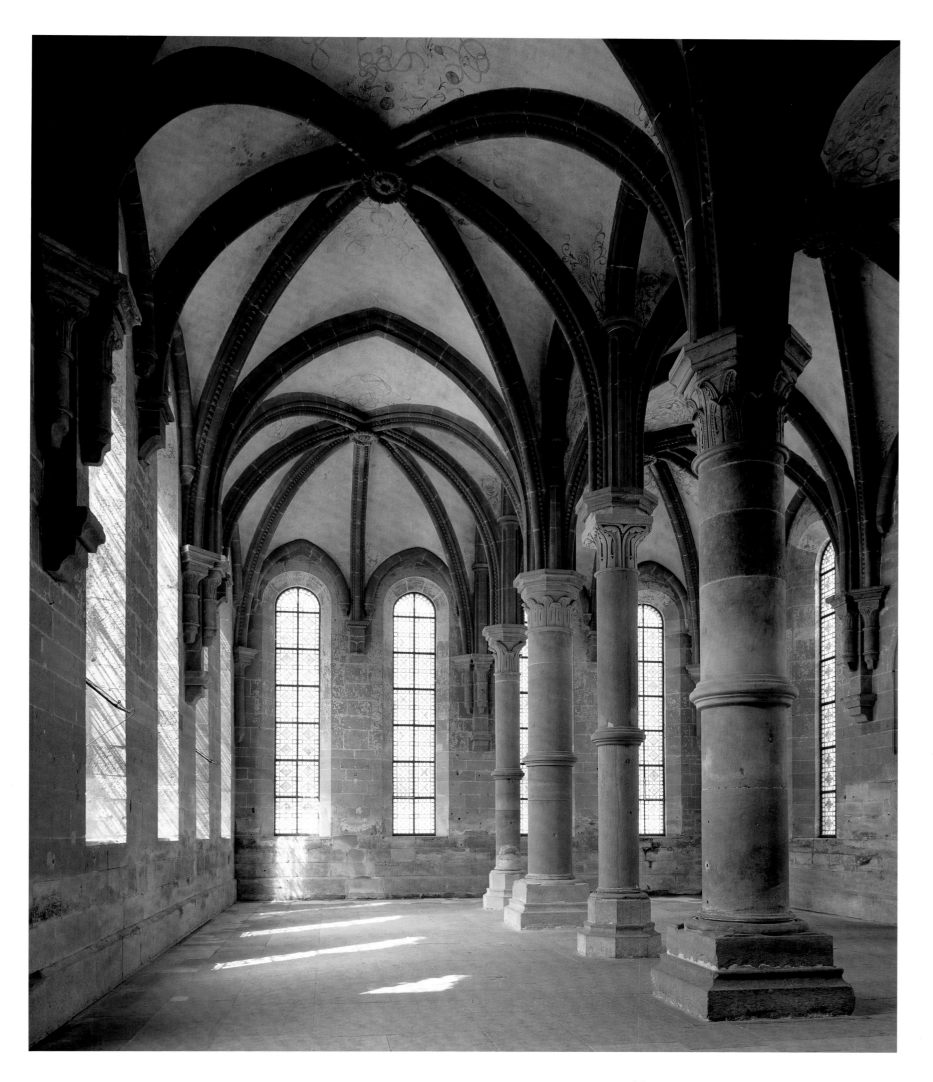

BLAUBEUREN

THE FORMER BENEDICTINE ABBEY BLAUBEUREN, near Ulm, is a quite well preserved site from the late Gothic. It lies directly on the legendary Blautopf, a deep and unusually large river source that rises out of white karstic Jurassic stone and varies in color from deep blue to a dark turquoise as a result of the refraction of light; the church is reflected in the water. Founded by the count palatines of Tübingen, the monastery was moved here in 1085 from the dry plateau of Schwäbische Alb and settled by monks from Hirsau. Its heyday came after it joined the Melk reform (see pp. 362–65) in 1451. The entire site was rebuilt at that time, but soon thereafter, in 1536, the Reformation led to the monastery's closure and transformation into a Protestant school (now a theological seminary). Once the monastery buildings were finished and tracery vaults were added in the cloister in 1482, the construction of a new church began. It consists of a one-nave main block with wall pier chapels and a long monks' chancel. The two parts are separated by a tower substructure that stands in the middle. The master workman Peter von Koblenz added a tracery vault in the chancel in 1491, and immediately thereafter the room was given exquisite decorations, nearly all of which survive today—a rare stroke of luck. This decoration includes the oak choir stall with sixty-six seats that was provided in 1493 by Jörg Syrlin the Younger, a businessman from the nearby imperial city of Ulm. The most important piece, however, was the famous high altar, which was nearly finished that same year. It is collaborative work by several artists, primarily from Ulm, and it is attributed to the woodcarver Michel Erhart and his son Gregor and the painters Bartholmäus Zeitblom and Bernhard Strigel. It is a portable altarpiece with two folding wings. Its splendid gilded middle panel depicts the Virgin surrounded by four saints, all in a tender, elegiacally pensive sentiment and contemplative silence. Particularly in its original location, it demonstrates the magical power with which such a shrine can present the sacred. The shrine is one of the outstanding achievements of the late Gothic in Germany, and the chancel is a worthy home for it.

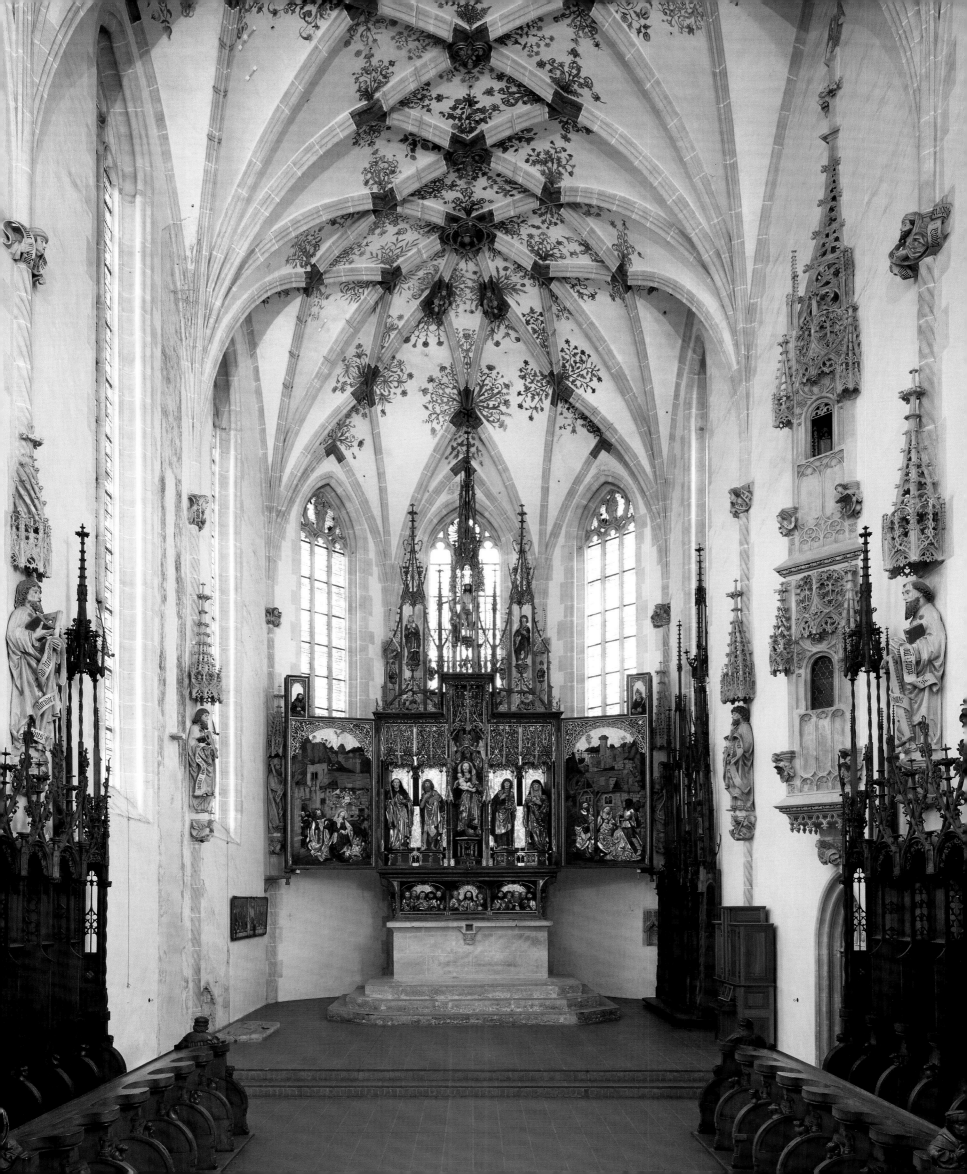

SALEM

The Cistercian abbey Salem, north of Lake Constance, in the Linzgau, was one of the largest, wealthiest, and politically most important abbeys in southern Germany until its secularization in 1803–4. It owes its founding to the forceful eloquence of Bernard of Clairvaux. In 1134 the knight Guntram von Adelsreute decided, after hearing Bernard preach in the cathedral in Constance, to found a Cistercian monastery on his estate, Salmannsweiler. Three years later the convention arrived from Lützel, in Alsace, which at the time was the closest monastery of that order and which belonged through Bellevaux to the filiation of Morimond, one of the five primary abbeys of the Cistercians. Thus this new founding had a good lineage, and the monastery quickly flourished. Its first abbot was Frowin, who had been active in Bernard's immediate circle. He called the new monastery Salem, probably as an allusion to Jerusalem (*salem* is related to the Hebrew word for "peace" or "salvation"). The Hohenstaufen king Conrad III made it a royal monastery in 1142. It was supported in particular by Archbishop Eberhard I of Salzburg, who had become friends with the abbot on a diplomatic journey to Rome in 1201. He placed the monastery under Salzburg's protection and donated a profitable saltworks near Hallein. Since then the archbishop has been considered Salem's second founder.

By 1300 Salem had long since diminished the standing of the old and famous Benedictine abbeys around Lake Constance. There were only seven monks still living on Reichenau Island and five at Sankt Gallen. Salem, by contrast, had three hundred members in its convention, counting both choir monks and lay brothers. In accordance with its significance, in 1348 Salem was raised by the later Emperor Charles IV to the rank of an imperial abbey whose abbot was a prince. During the Baroque period the abbey headed the so-called Schwäbisch-Reichsprälatisches Kollegium (Swabian imperial prelate committee). This was a coalition of twenty-three abbeys in Upper Swabia that were subordinate only to the emperor. With Salem as its chair, the abbeys had seats and voting rights at the Perpetual Diet in Regensburg, although they had only a single shared vote and even that was on the very low ninety-seventh rank.

The present church, begun in 1299, is a Gothic building 217 feet (66 m) in length. Its final consecration was in 1414 by the archbishop of Salzburg during the opening of the Council of Constance. The basic layout of the church was designed for the ritual needs of a large convention. The architect placed a two-nave U-shaped ambulatory

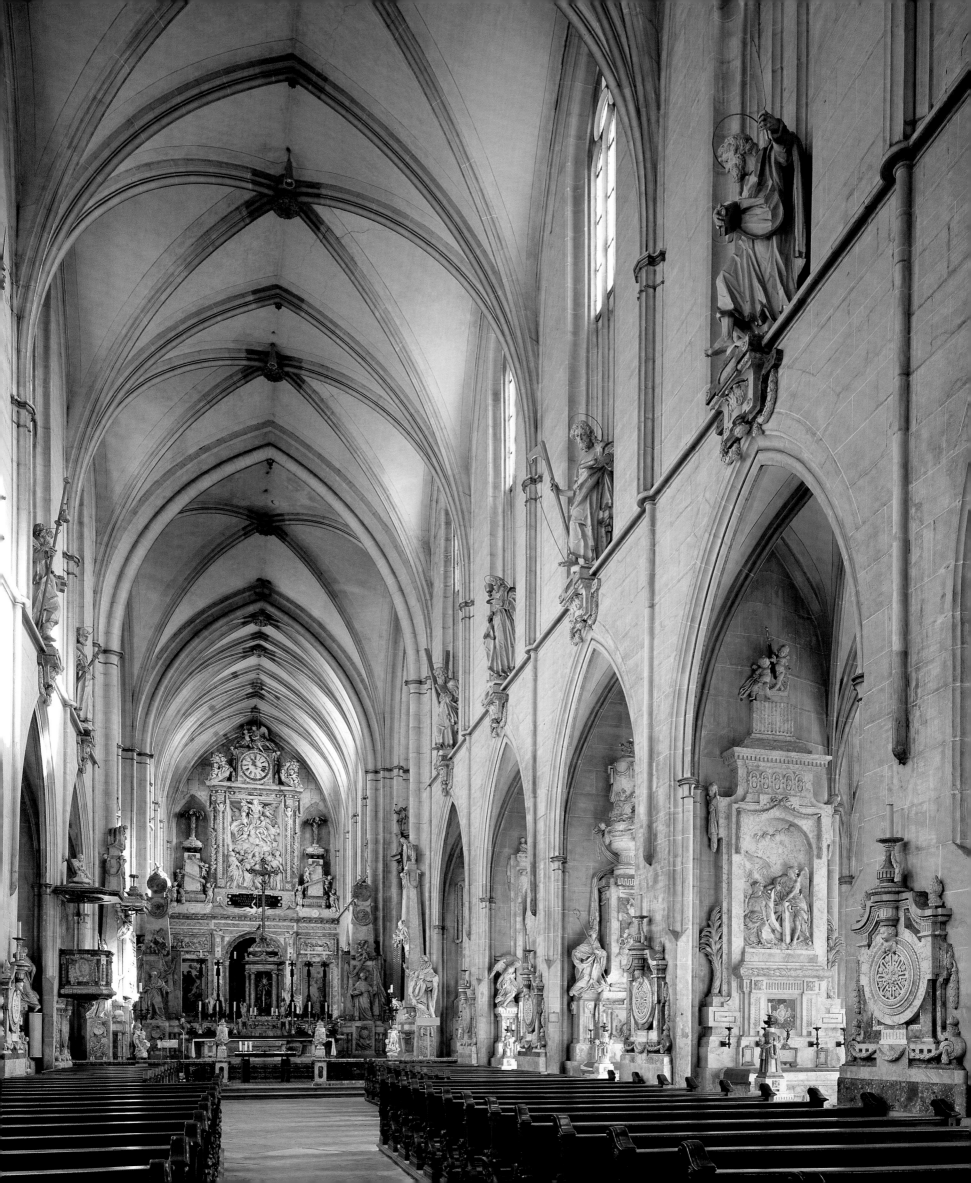

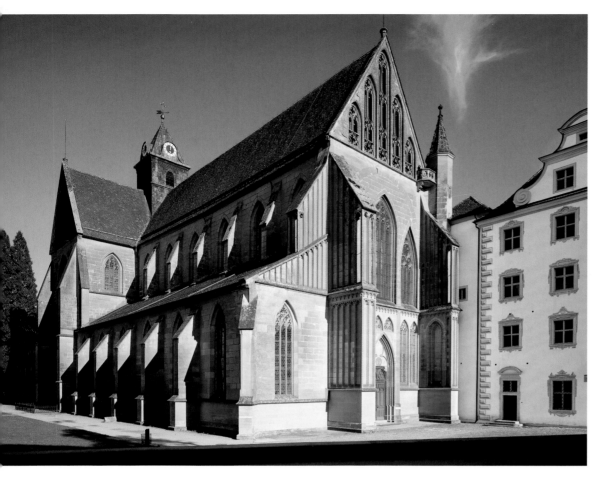

The interior of the church was remodeled in 1750 by the architect of the Order of Teutonic Knights, Caspar Bagnato, who moved the monks' chancel to the sanctuary and dismantled the eastern ambulatory and its chapels, including the Lady chapel on the upper story. In the late eighteenth century the church was redecorated with twenty-seven altars by Johann Dirr in the style of Louis XVI. The monument to Death, which records the names of forty abbots of Salem, was part of this as well. The plaque has room for twelve more names, but there were only two more abbots before secularization.

The monastery buildings were lost in a large fire in 1697. Immediately thereafter, even though the abbey was deeply in debt, the abbot had the Vorarlberg architect Franz Beer begin work on the present building: a monastery castle 558 feet (170 m) long, articulated by blocklike pavilions. The cost of this structure, which was lavishly decorated inside, was correspondingly high: 350,000 gulden.

Salem also managed the pilgrimage site Birnau on the bank of Lake Constance, and beginning in 1746 it had a church built there based on plans by the Vorarlberg architect Peter Thumb; it was exquisitely ornamented in the Rococo style and consecrated in 1750. Both inside and out Birnau contrasts entirely with the austere appearance of the monastery church at Salem. The interior is a broad hall that presents itself to the viewer like a spatial picture. It is the epitome of a magnificently laid out, staggered visual prospect. The projecting gallery that runs around it imparts something of the feeling of a profane festive hall, whereas the basket-handle arch of the entry to the chancel recalls the proscenium arch of a theater, and the chancel and its high altar present a sacred stage. Taken together, it is a brightly buoyant, light-filled *theatrum sacrum,* a perpetual feast for the senses.

PAGE 318:
Monument to Death on the southwest crossing pier of the church, Salem

PAGE 319:
View down the nave, facing east

ABOVE:
Church from the northwest

BOTTOM RIGHT:
Eighteenth-century engraving of the Baroque monastery grounds

OPPOSITE PAGE:
Pilgrimage church of Birnau, on Lake Constance. TOP: *Exterior;* BOTTOM: *Interior*

to the east of the sanctuary—a solution similar to that of the Cistercian churches at Lilienfeld, in Austria (see pp. 372–73) and of the original plan for Walkenried, in the Harz region. The individual bays of the ambulatory's outer nave, of which there were fifteen in all, served as chapels, while the inner nave could be converted into a corridor and provided access to the chapels. Thus fifteen monks could read their mass simultaneously in the chapels. Above the eastern ambulatory there was a Lady chapel that was closed off from the sanctuary by means of an apse with openwork tracery; it survived into the eighteenth century. Other places for altars were located between the piers in the main block. The piers are reinforced with flying buttresses shaped like pointed wedges turned inward, reminiscent of ice breakers—an original solution. The church had a total of twenty-seven places for altars, including the main altar. Another trademark is the four tracery gables of the exterior, so that the building was ornamented in every direction.

The Salem masons' guild was widely respected. It produced Master Michael, who around 1353 took over the biggest building project in the empire—the Cologne cathedral—and directed its extension until at least 1387. He came from a family of master workers with the name "von Savoyen" (that is, Salem). They were related by marriage to the Parlers in Prague and on the Upper Rhine.

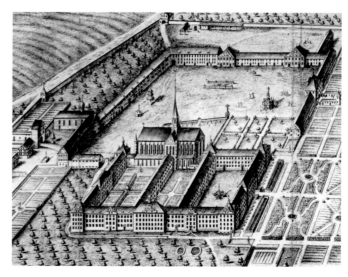

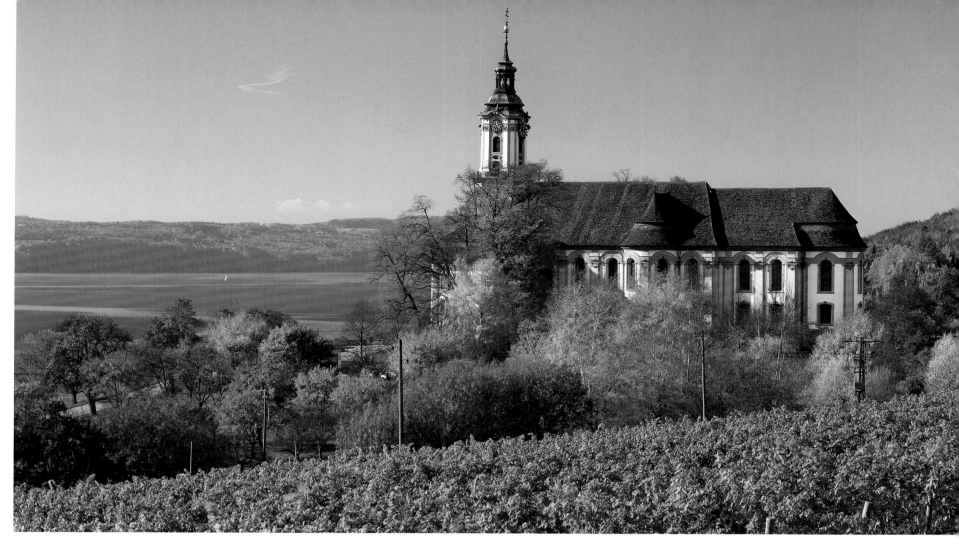

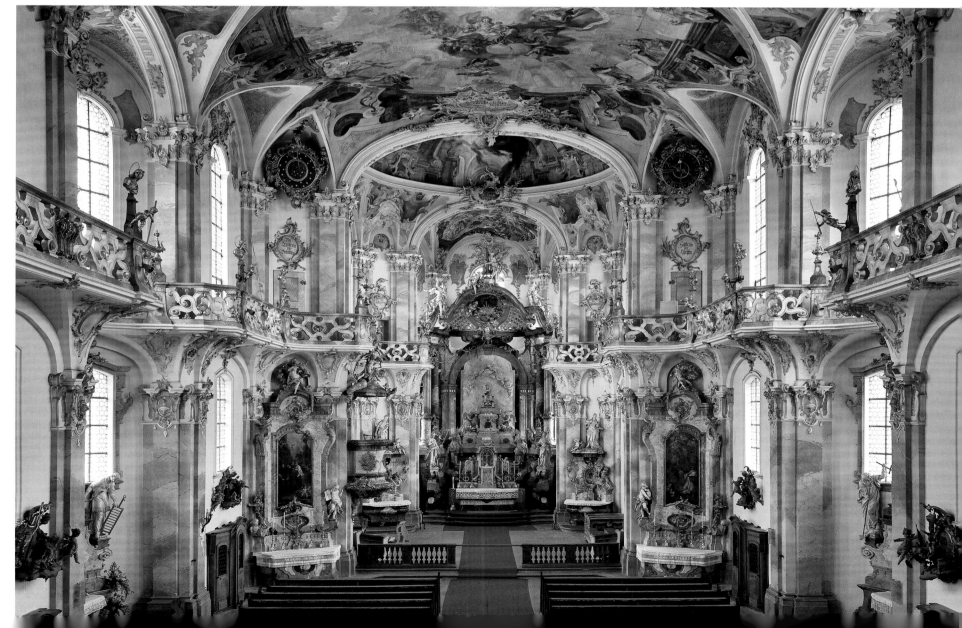

REICHENAU

RIGHT:
The west tower, Mittelzell, Reichenau

BELOW LEFT:
Panel painting, dated 1624, in the Mittelzell, Reichenau, showing Reichenau Island with the three monastery churches and the Pirmin Landing

OPPOSITE PAGE:
TOP: *View from the south of Oberzell*

BOTTOM: *View from the north of Mittelzell*

ONE OF THE MOST IMPORTANT CULTURAL CENters of Western monasticism during the early Middle Ages was Reichenau Island in Lake Constance, near the episcopal city of Constance. The abbot and bishop Pirmin, whose origin is uncertain (perhaps Irish or Visigoth), is said to have been sent to the island in 724 by the Frankish mayor of the palace Charles Martel, at the suggestion of the Alemannic dukes, in order to found a monastery. Just three years later he left the island again. At some unknown point after his departure the Benedictine rule was introduced.

From the late eighth century onward Augia Dives, as Reichenau was called, had a series of outstanding abbots, who not only fostered the monastic life, literature, and the sciences but were frequently active in the politics of the empire. Waldo (786–806) and Haito I (806–23) were close confidants of Charlemagne. In 806 Charlemagne made Waldo abbot of Saint-Denis. His successor, Haito, had been the director of the monastery school and in 802 had become bishop of Basel, an office he continued to hold after he was named abbot. In 811 he led a legation to Byzantium on behalf of Charlemagne. Haito had the now-famous monastery plan drawn up for Abbot Gozbert at Sankt Gallen, which records the ideal layout for a monastery (see p. 22). In 823 Haito resigned all his offices and continued to live on the island as a simple monk until his death in 836.

The strict, ascetic Abbot Erlebald (823–38) was followed by Walahfrid Strabo, a highly talented literary monk who had been called to Louis the Pious's court in Aachen in 829 to teach Prince Charles, the future Emperor Charles the Bald, before being named abbot of Reichenau in 842. In 849, at the age of forty, he drowned in the Loire River on a peace mission that would have brought him to his former student, Charles. Haito III (888–913), also known as Hatto I, was a politically important abbot. From 892 onward he also served as archbishop of Mainz, which also made him archchancellor of the empire. Haito accompanied King Arnulf of Kärnten—the successor to Emperor Charles the Fat, who was buried in the monastery church in 888—to his imperial coronation in Rome in 896, and he returned with the valuable relic of the head of Saint George, which Pope Formosus had given him. Following Arnulf's death in 899, Haito acted as guardian and regent for Arnulf's son, Louis the Child, the last of the Carolingian emperors, and became involved in high levels of imperial politics in the matter of Louis's successor, which was decided by the election of Conrad I.

During the Ottonian period Reichenau increasingly became the empire's center of manuscript illustration, producing magnificent codices for the imperial house, as purveyors to the court, as it were. Abbot Witigowo (985–997) had a particular fondness for pomp and encouraged artistic activity, but he was deposed by his monks for profligacy in architectural matters. The last of the great

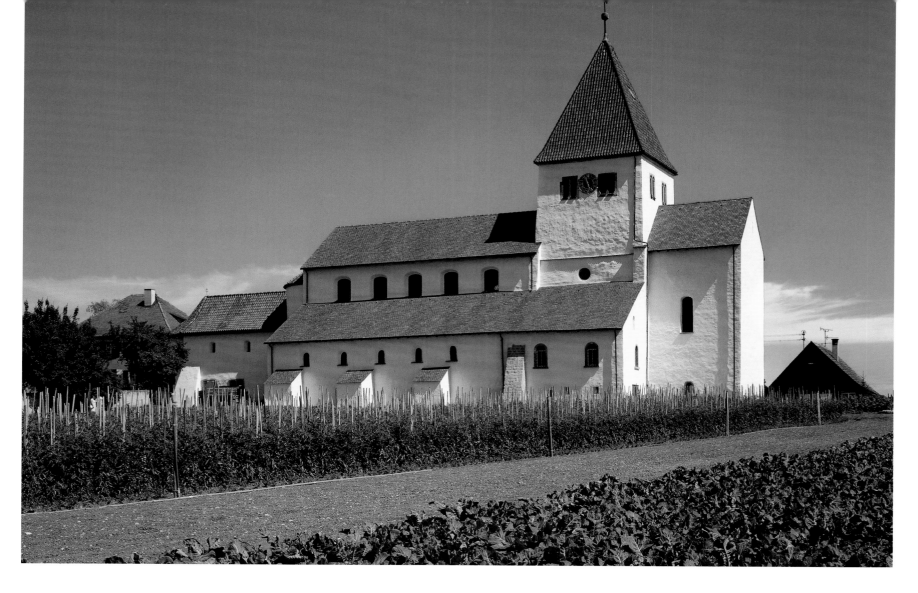

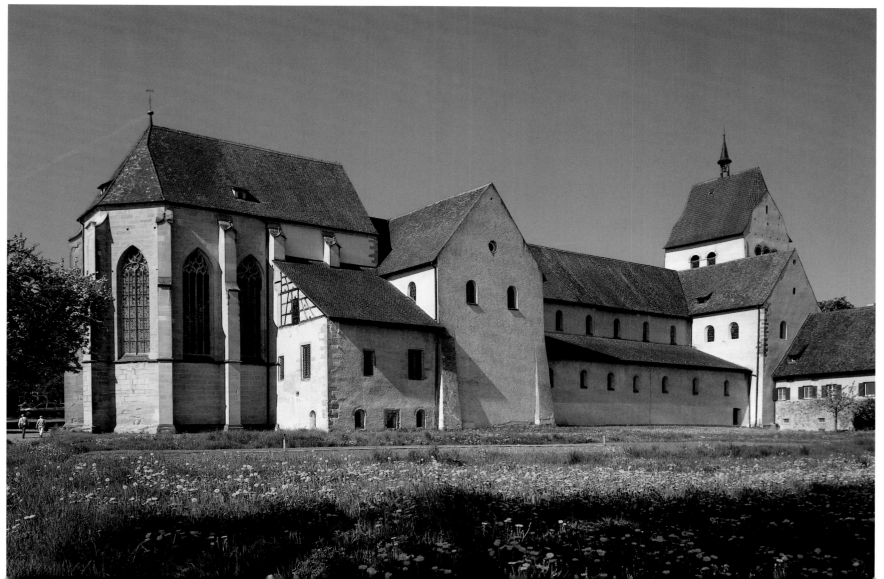

RIGHT:
Resurrection of the Youth from
Nain, c. 980, from the Ottonian fresco
cycle of the Miracles of Christ. Oberzell,
Reichenau

OPPOSITE PAGE:
View of the interior, facing west, Oberzell

abbots was Berno (1008–1048), who maintained an active correspondence with the great figures of the empire. During his rule one of the greatest scholars and scientists of the day was active in the monastery, Herman the Lame, praised as "the miracle of our century." He was a historian, theologian, astronomer, mathematician, composer and musician, poet, clockmaker, instrument maker, researcher of the calendar—in short, a universal genius.

Following Berno's death, Reichenau declined slowly but surely. Because only sons of the aristocracy were then permitted to enter, the number of members were reduced from between 90 and 120 in its heyday to two in 1414. From 1540 onward the monastery was merely a priory of Constance.

The island has no fewer than three surviving monastery churches: Mittelzell, the main church, Oberzell, and Niederzell. The overall arrangement can be seen on a panel painting from 1624 that memorializes the ninth centennial of its founding, showing Pirmin arriving on the island, while the snakes and frogs leave in a panic from the other side of the island.

The Mittelzell church was rebuilt five times between the early ninth century and the eleventh century. The first large building (consecrated in 816) was built during the reign of Abbot Haito I. Its cruciform east end still stands; it has a marked-off crossing that is the oldest surviving example of its kind. The present west

end, with a transept, a crossing, and a chunky crossing tower that contains the imperial loge (consecrated in 1048) was built under Abbot Berno. The church of the Oberzell was constructed by Haito III for the relic of Saint George he brought from Rome in 896. The building is a column basilica with a square chancel tower and an apse at the western entrance, which is extended outward by a rectangular forebuilding.

The well-preserved, if somewhat faded, fresco cycle in the middle vessel of the church dedicated to Saint George, is wonderful. It has been dated around 980. The theme of the eight-part cycle, which is framed by a perspectival meander frieze, is Christ's miracles, in particular the healings and resurrections, including the resurrection of the youth of Nain. The paintings are closely related to the style of the illuminated manuscripts of Reichenau, such as the Codex Egberti. Christ, followed by a tightly packed group of apostles, is always a large, gesturing figure whose raised right hand has such power that it can work miracles. The backdrop for the figures, which also reinforces their significance, is made up of small perspectivally rendered buildings that divide the scene of the youth of Nain's resurrection into two poles, creating a field of tension between them. The lapidary urgency of the narrative is typical of art from Reichenau. The double nature of Christ as God and man is made visible in rare fashion.

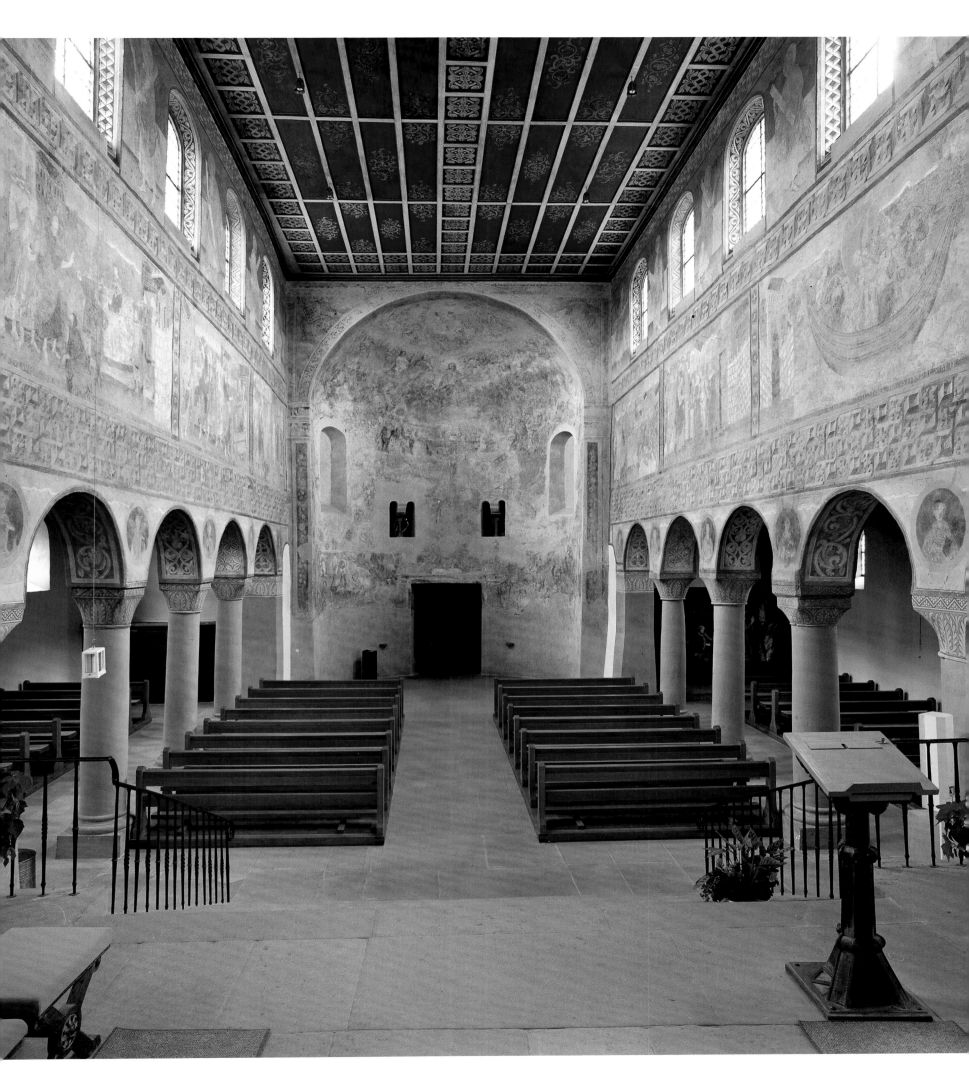

SANKT GALLEN

Library, Sankt Gallen

Sankt Gallen, which lies in Switzerland, southwest of Lake Constance, has been the canton capital since 1803. It was an exemplary incubator of monastic culture in the early Middle Ages, just like the monastery on nearby Reichenau Island (see pp. 322–25). The history of the site begins in 612, when Gall, one of the companions of the Irish itinerant monk and missionary Columban (see pp. 17–18), separated from the group that was continuing on to Italy and built himself a cell and a stone oratory in the high valley of the Steinach River. In 719 the priest Otmar founded a Benedictine monastery there and became its first abbot. The first monastery church was built at that time.

Thanks to generous donations the newly founded monastery was soon thriving. In 818 it freed itself from its dependence on the diocese of Constance and became an imperial abbey. The monastic school, extolled as "Alemannia's educator," was soon one of the leading centers of science and scholarship. It produced, among others, the learned writer and historiographer Notker Balbulus (the Stutterer), one of the most famous of the late Carolingian literati. The large library was renowned; by the ninth century its catalog

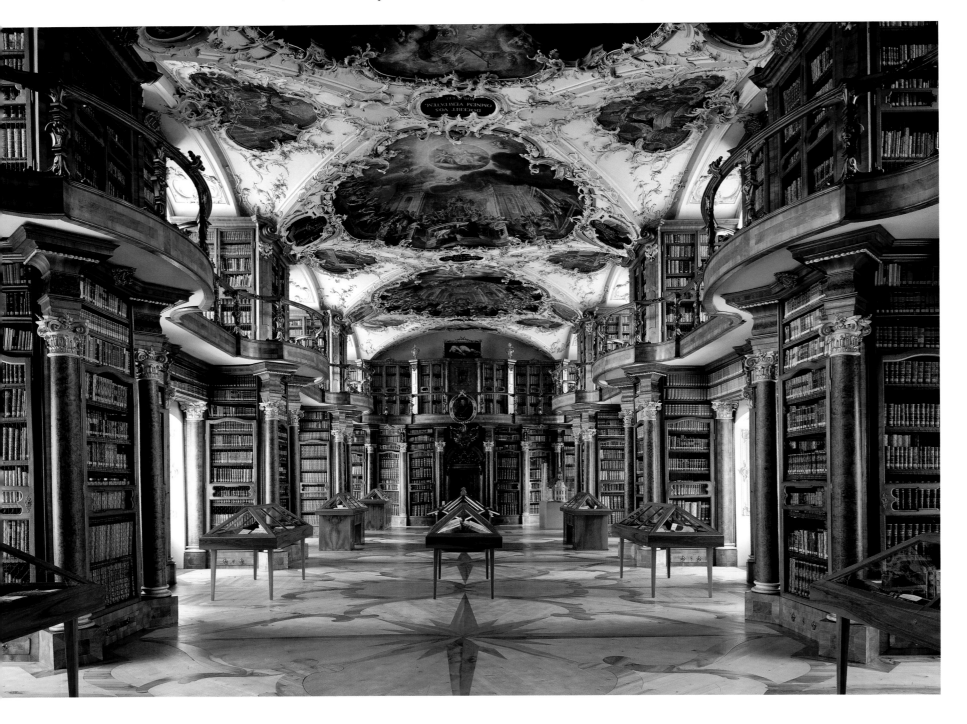

included four hundred manuscripts. Some of these were insular and Anglo-Frankish illuminated codices from the pre-Carolingian period, which were then imitated and refined in its own scriptorium.

When Abbot Gozbert (816–37) was considering new buildings for the church and monastery, his colleague Abbot Haito I of Reichenau sent him the now famous unique Sankt Gallen monastery plan, which is now preserved at the monastery (see pp. 21–24). This is a large-format ideal plan sketched on parchment, with guidelines for the church and monastery buildings based on the contemporaneous Benedictine monastery reform of Benedict of Aniane. Gozbert's church, the construction of which was directed by three monks, Winihart, Isenrich, and Ratgar, consisted of three separate buildings arranged one behind the next: the

church of Sankt Gallen in the east (consecrated in 837), the church of Sankt Otmar in the west, and an antehall between them, with the chapel dedicated to Saint Michael in its upper story. The antehall and the church of Sankt Otmar were consecrated together in 867. Both churches had crypts. Sankt Otmar's crypt, a small four-support room with primitive Ionic columns, is one of the oldest surviving crypts.

During a half-century of construction, beginning in 1439, the church of Sankt Gallen was given a spacious new chancel in the form of a three-nave hall church with tracery vaults. The church of Sankt Otmar was rebuilt in 1623; the antehall with the chapel of Sankt Michael was demolished, and the main block of the church of Sankt Gallen was extended into this space.

In the eighteenth century the monastery, whose

Middle octagon of the church

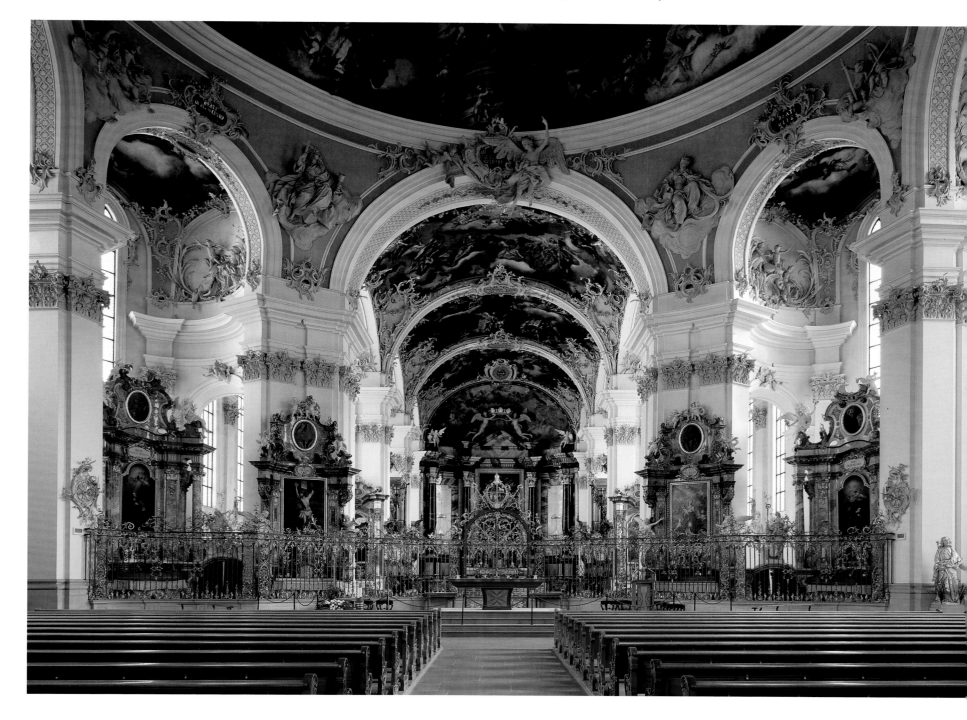

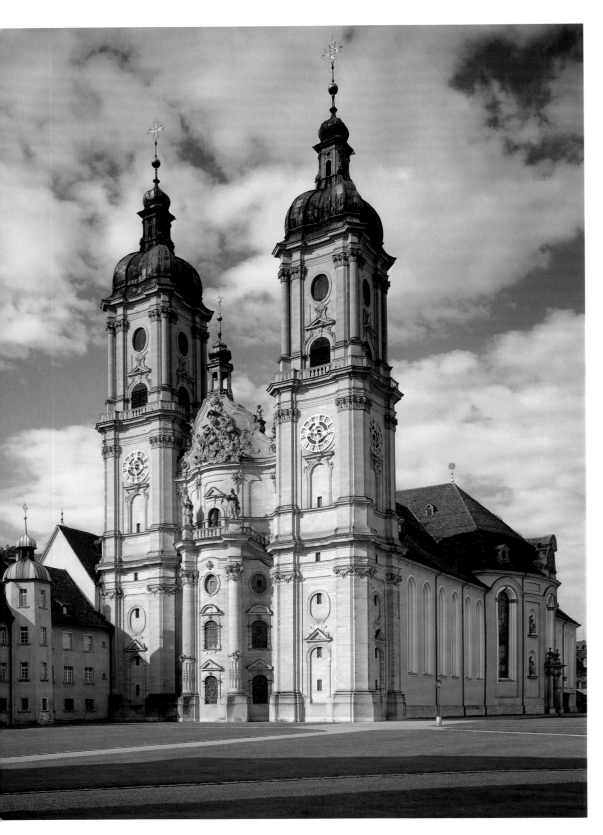

East facade of the church, Sankt Gallen

this into account from the beginning. The octagon, which extends roughly to the middle of the whole, became the crossing octagon, similar to the crossing rotundas in churches by Balthasar Neumann.

Because the Baroque church was built on the space occupied by both medieval churches and the antehall, it had to be unusually long, about 345 feet (105 m). Just the central octagon, which has the effect of a rotunda, owing to the circular, shallow dome, has an interior diameter of 98 feet (30 m)—an enormous size. In the main block and chancel Thumb overcame these dimensions using the traditional Vorarlberg style with wall piers, massive pier capitals, and deep, rectangular lateral vaults, but the arcades open up the material of the wall piers to such an extent that the views through the building resemble those of a hall church. He did not use the usual barrel vaults with groins but instead had a shallow dome above each section that fit onto a frame of four arches. This resulted in a series of vault baldachins. The octagon, a space framed by eight arches, is surrounded by aisles that take the form of conchae, making the space, in any case very wide and quite low, seem even wider.

The eastern termination of the church is a lavishly articulated two-tower facade with a slightly protruding center—something that might be expected on a west end, not a chancel. The architect of the Order of Teutonic Knights, Johann Caspar Bagnato, had wanted to place the towers in the corners, but Johann Michael Beer von Bildstein, the architect who executed the project and thus made the final alterations to the plans, gave them a frontal arrangement, which was more traditional. The result is one of the most opulent two-tower facades of the Baroque, worthy of the rank of a prince-abbey.

The fame of the Baroque church of Sankt Gallen, however, is its library, built from 1758 to 1767. It was the final work of Peter Thumb. As so often in monastery libraries of the eighteenth century, such as at Schussenried or Wiblingen (see p. 9), the look of the space derives from the gallery set on columns. Its balustrade defines a gently protruding curve around three projecting wall piers holding books, and it sets the whole room into an elegant, oscillating motion. This stately room is not meant for reading; rather, it is a festive hall for books. The full, sumptuous ornamentation, which has a warm overall tone from the dark brown wood, wraps itself around the ordered scholarship arranged behind book spines and thereby celebrates it. Thus Sankt Gallen in particular is also an abbey celebrating itself.

abbots were now also princes, flourished anew. Prince-Abbot Cölestin Gugger von Staudach pushed through the construction of a new church, and only the Gothic chancel was to remain. After a long period of planning, in which various architects took part, in 1755–57 the Vorarlberg architect Peter Thumb constructed a new main block to replace the church of Sankt Otmar and added an octagon in the east. Only then was the decision made to demolish the Gothic chancel as well and build a new monks' chancel. Thumb's plan had taken

EINSIEDELN is one of the largest and most revered religious sites in Switzerland. The monastery evolved from a hermitage established by Saint Meinrad, who had been a monk on Reichenau Island and in 835 moved to a forested area that was then still wild. In 934 the cathedral provost Eberhard of Strasbourg founded a Benedictine community near Meinrad's cell and became its first abbot. A strict reform monastery, it received land from the Ottonian emperors and Emperor Henry II.

The church, which was rebuilt several times during the Middle Ages, consisted of two separate parts: the Unteres Münster (lower cathedral) for the common people and the Oberes Münster (upper cathedral) for the monks, separated by two Romanesque towers. The center of ritual in the people's church was the hermit chapel, which became the most important pilgrimage site in Switzerland when, with the addition of a miraculous painting of the Black Virgin, the patron saint was changed in the thirteenth century.

From 1674 to 1676 the architect Hans Georg Kuen of Bregenz added a new chancel in the Oberes Münster: a wall pier structure of the sort typical of Vorarlberg

EINSIEDELN

West facade of the church

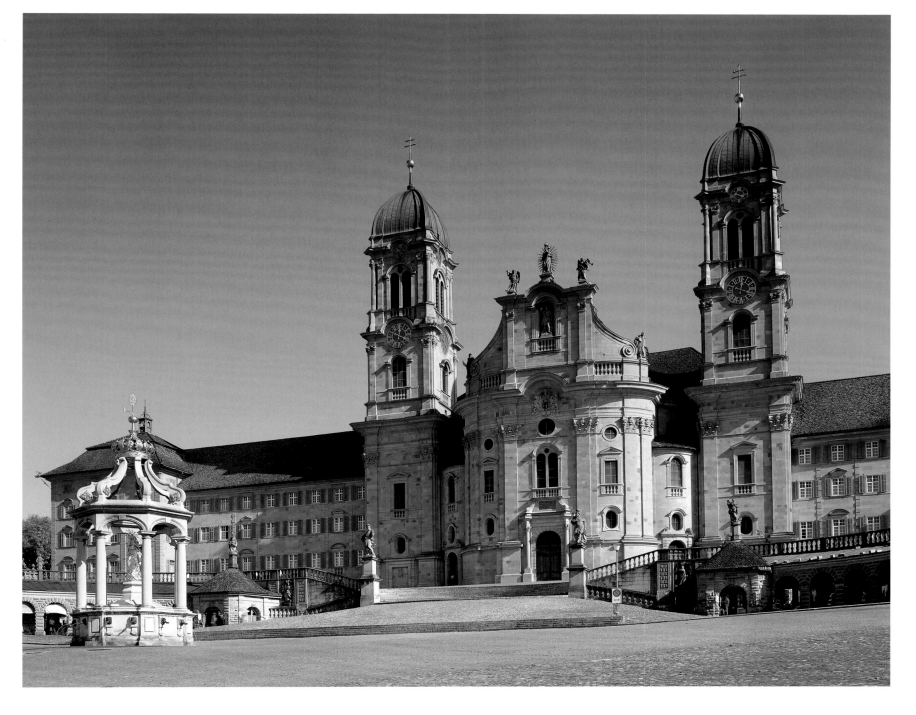

BELOW:
*View facing west, from the sermon room
of the church, showing the octagon with
the chapel of Mercy*

OPPOSITE PAGE:
*View facing east showing the sermon
room, dome room, and monks' chancel*

architecture. In 1702 Abbot Maurus and the convention decided to rebuild the monastery "in order to conserve discipline." The brother Kaspar Moosbrugger, who was resident at Einsiedeln, presented a plan for a completely regular site that was symmetrically framed by square pavilions in the corners, with the church in the middle. The whole layout was similar to that of Weingarten abbey (see pp. 338–42). The monastery buildings were

completed in 1718. Moosbrugger was also working on the plans for the church. The abbot did not make the decision to rebuild the church until 1719; construction began in 1721, and the consecration took place in 1735.

Moosbrugger, who was obliged to take into account the advice of a "famous architect" from Milan who was consulted in 1705, kept the newly completed chancel and subdivided the remaining area into three separate sections: in front of the chancel he placed a dome with lateral vaults. He designed the dome itself as a tall Italian dome on a drum, but out of consideration for the raw mountain climate it was replaced with a shallow dome. Adjacent to this was the sermon room for the people, expanded on the sides by deep lateral vaults. He surrounded the chapel of Mercy, the destination of the pilgrimage, with an immense octagon whose diagonals extend about a hundred feet (30 m). In order to vault a room this wide, Moosbrugger placed a supporting structure in the middle, behind the chapel of Mercy, that takes the form of a bay with piers whose molding is arched slightly in such a way that it forms a gate that looms freely in the space. The two piers are connected with the eight corners of the room by means of vault ribs that extend out radially nearly forty feet (12 m). The octagon is also extended by means of lateral vaults.

There is no perspective from which this multipart sequence of rooms, which extends 328 feet (100 m) to the high altar, can be seen in its entirety. The rooms expand into the lateral vaults and offer new vistas. The climax is the octagon, and its effect is made monumental by the immense size of the piers and arches. Light also shapes the space, entering the room powerfully and turning this dim sacred space into a dramatic chiaroscuro. The stucco and fresco decorations by the brothers Egid Quirin and Cosmas Damian Asam of Munich complement this effect. The dense ornamentation they created in the vaults adds a powerful element of color to the chiaroscuro. The architecture, the light, and the decoration make one feel that this is a sacred place. There is scarcely another example of Baroque architecture that dramatizes a place of mercy with equally affecting pathos and strength.

The prelude to this is Moosbrugger's exterior, behind the wide square that rises slightly as one approaches, with its receding towers and the middle that bends outward like a shield, which offers a preview of the gate of the octagon. The facade is related to Johann Bernhard Fischer von Erlach's collegiate church in Salzburg—that is, the church of the Benedictine university there, to which Einsiedeln had close connections.

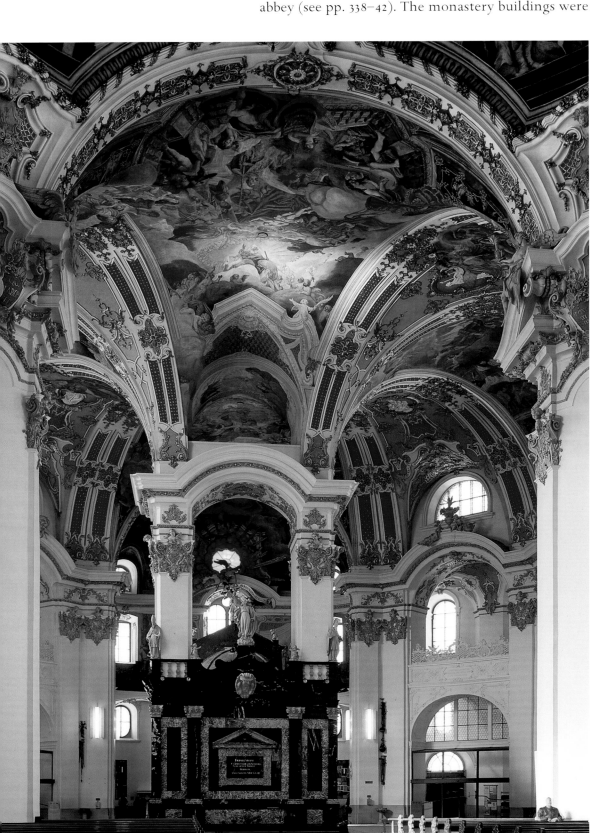

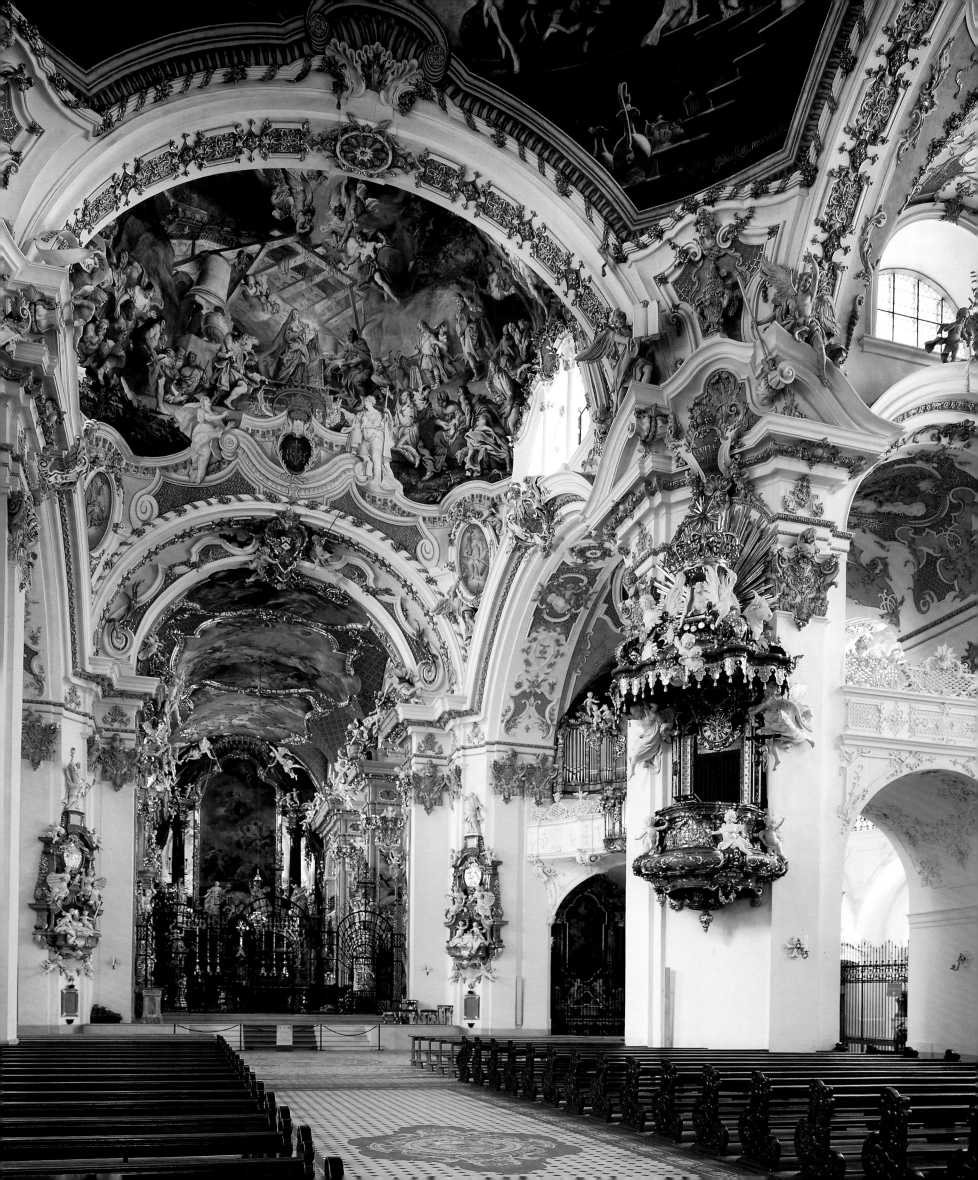

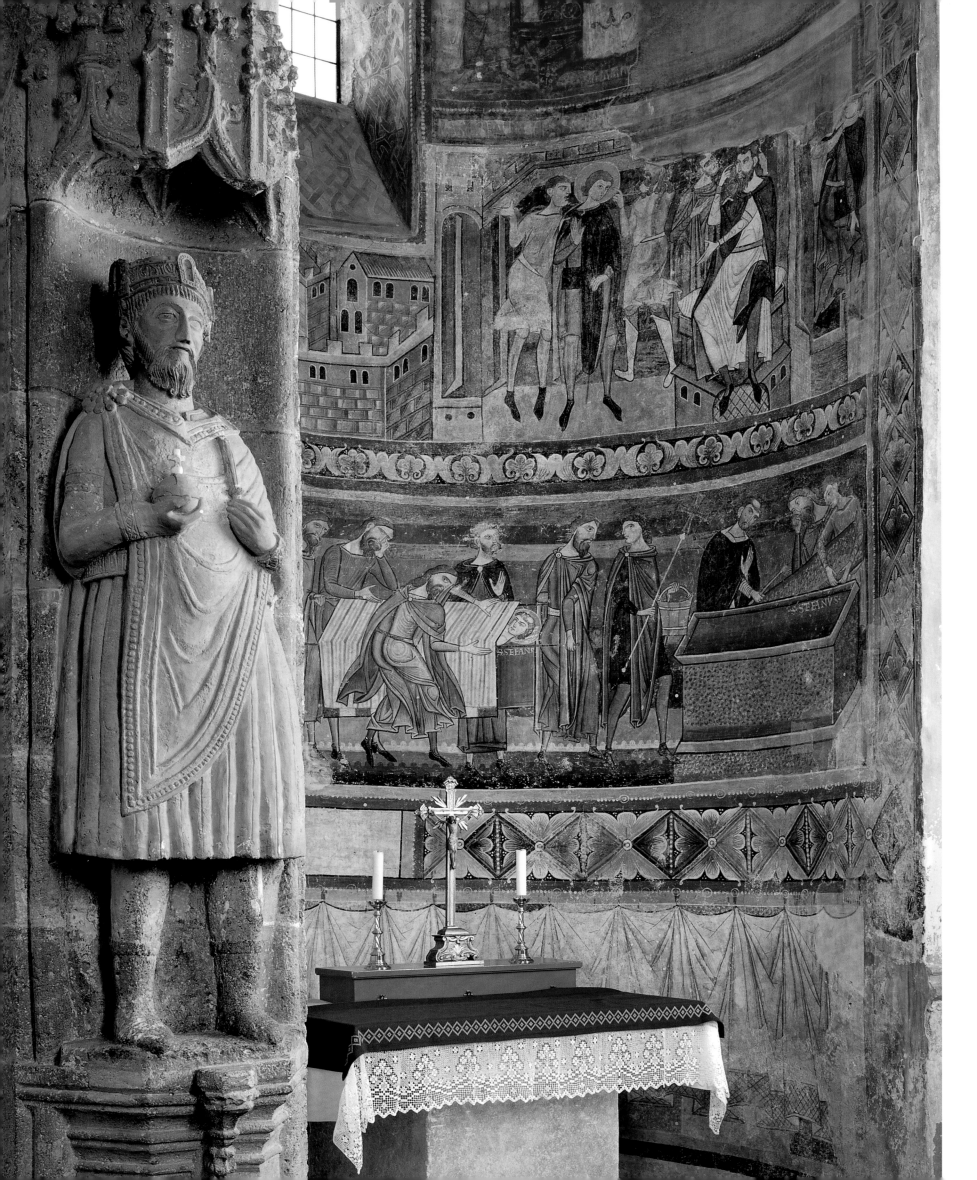

MÜSTAIR

THE SANKT JOHANN MONASTERY IN MÜSTAIR, which is on UNESCO's World Heritage List, lies in Switzerland near the border to Vintschgau in southern Tyrol, at an exit from the Ofenpass, at an altitude of 4,100 feet (1,250 m). It is just a few miles from the neighboring monastery Malbork (see p. 11). Müstair was founded in the late eighth century by the bishop of Chur, Constantius, or by his successor, Remedius. Constantius was appointed *praeses,* or provincial governor, of Chur by Charlemagne, who wanted to secure the Alpine passes of this region for his campaign in Lombardy (772–74). Remedius also held this secular administrative office. Vintschgau then belonged to Chur-Rhaetia, and the monastery, an episcopal proprietary monastery, was an important way station before the route through the pass. Müstair—the name derives from *monasterium,* monastery—was originally an abbey of Benedictine monks, but it was converted to a convent of that order in

the first half of twelfth century, and it remains so today, with twelve nuns. The monastery complex lies in an Alpine valley and forms a picturesque ensemble of widely varying buildings that have grown together over time. The most striking of them is a stocky residential tower on the north side, adjacent to the church, with a monopitch roof and diagonally rising crenellations: the Planta tower, named after Abbess Angelina Planta, under whose reign it took its present form in the late fifteenth

OPPOSITE PAGE:
View of the statue of Charlemagne and the southern apse of the church, Müstair

BELOW:
View of the monastery site from the northeast

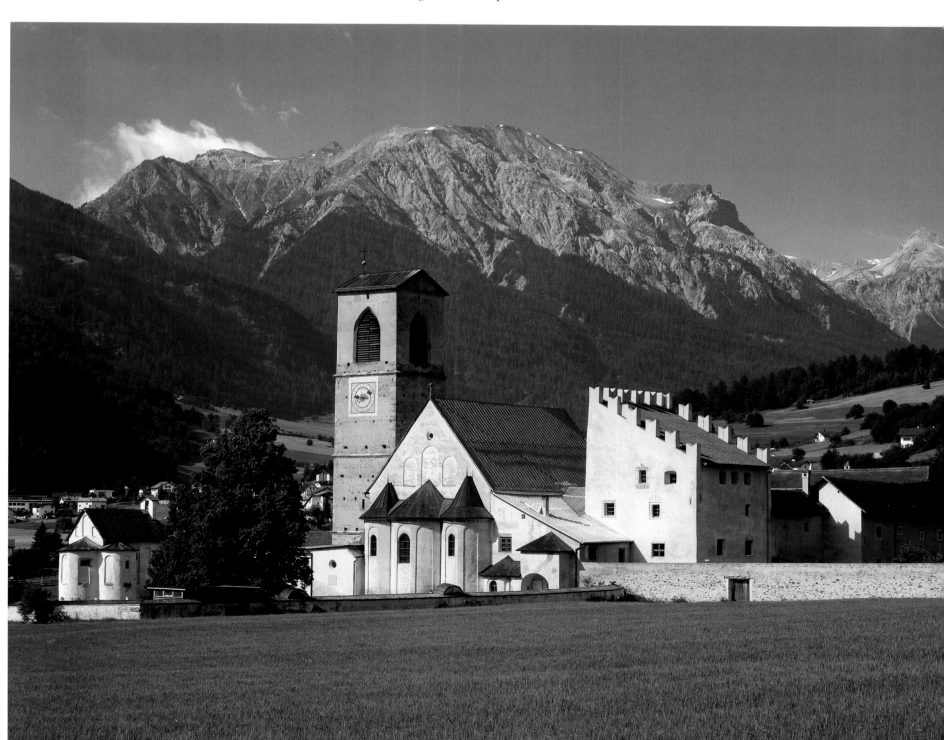

BELOW:
Interior of the church

OPPOSITE PAGE:
Frescoes. TOP: The Beheading of John the Baptist and Herod's Feast, *late Romanesque fresco in the main apse;* BOTTOM: Healing of the Deaf Mutes, *Carolingian fresco on the long northern wall*

century. The interior of the complex also has a residence for the bishop of Chur with a double chapel. At a slight distance to the south stands the eleventh-century Sacred Cross chapel: a two-story building in the form of a tri-conch with a rectangular main block.

The church dates from shortly after its founding in the Carolingian period. It was originally a simple flat-ceilinged hall structure about forty feet wide by eighty feet long (12 × 14 m), with three parallel apses of equal height but different widths—a style of eastern origin, many examples of which can be found in Switzerland during this period, and which survived in a modified form at Mistail, near Chur. In Müstair these three apses

were supplemented by another low apse on each side, but only the northern one has survived; the southern was sacrificed to the later tower and its adjoining building. On the exterior the church essentially retains its original Carolingian appearance, with articulation in the form of shallow blind arcades—a motif that dates from late antiquity. The interior, however, was remodeled between 1489 and 1492 under Abbess Planta into a three-nave hall church with three round piers on either side and tracery vaults. The enclosing walls are Carolingian, but the entire interior is late Gothic. The Carolingian flat ceiling was about three feet (1 m) taller than the crown of the present vaults; the space was thus taller and steeper.

At the end of the nineteenth century remains of figurative paintings were found on all four enclosing walls above the vaults. When the whitewash was removed from the interior walls 1947–50, Carolingian frescoes were uncovered everywhere, even in the window jambs; it proved to be the largest surviving early medieval fresco cycle in Europe. The long walls originally contained no fewer than eighty-two scenes in five superimposed registers within a grid of simple rectangular frames. Fifty of these depict the life of Christ; twenty the story of David, as an ancestor of Christ; the rest perhaps showed the martyrdoms of the apostles. The paintings—such as the healing of the deaf mutes—are in reddish-brown earth tones, supplemented by gray and white, and narrate the events in a reserved style by the gazes of the subjects' broadly outlined eyes and their spare gestures. The painters' origins and their possible models remain uncertain, as is their date (perhaps around 810–20). The closest parallels are the frescoes in San Salvatore in Brescia (see pp. 412–15). The three apses and the west wall also have frescoes; the latter depicts the Last Judgment. In the late twelfth century the interior walls of the three apses were replastered and frescoed, but when the Carolingian paintings were revealed, this layer was removed, leaving only its best-preserved sections in place, such as Herod's feast with the dance of Salome in the middle apse and the story of Deacon Stephen in the southern one—paintings of a decidedly courtly nature. Between these two apses a life-size sculpture of Charlemagne stands like a statue of Knight Roland. According to later records, it is supposed to have been donated to the monastery in 801. The figure is executed in plaster, showing the emperor with fibula crown, imperial orb, and scepter, and was probably executed during Barbarossa's reign, when Charlemagne was canonized by the antipope in 1166 at Barbarossa's instigation.

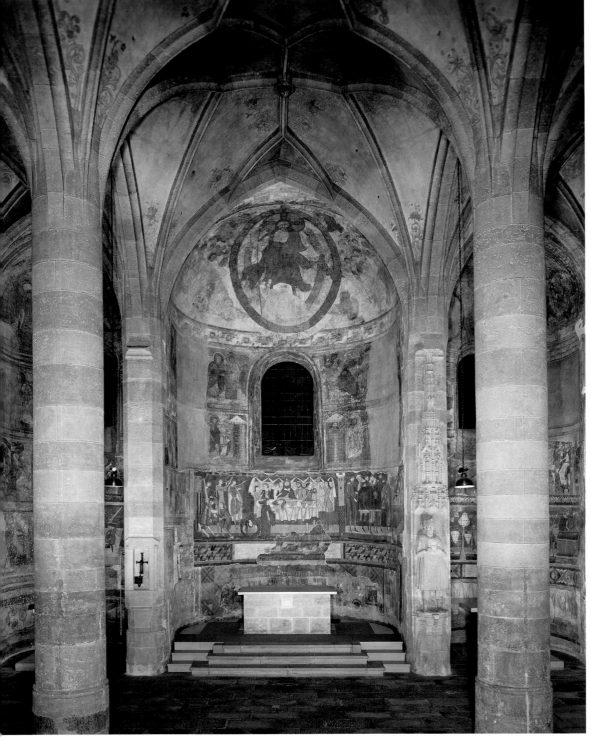

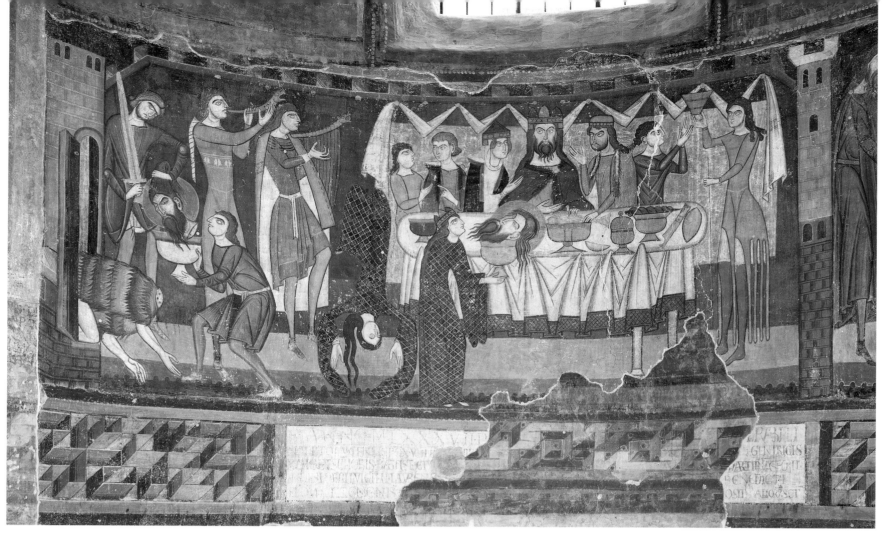

ETTAL

Monastery of Ettal, located in an Alpine valley

ETTAL MONASTERY LIES AT AN ALTITUDE OF ABOUT 3,000 feet (900 m) in a high valley of the Ammergau Alps. Emperor Louis the Bavarian founded this highly unusual settlement in 1330, a Benedictine monastery with a convention of male and female knights. This association of knights did not last long, however, and for many years the monastery remained insignificant as well. It had an upturn in the late fifteenth century with the start of a pilgrimage to a painting of the Virgin that Emperor Louis had brought with him from Italy, and its heyday was in the eighteenth century. Abbot Placidus Seitz, who had been professor at the Benedictine university in Salzburg, and its prorector for a time, founded an academy of knights in Ettal in 1710 to educate young aristocrats and prepare them for state service. The academy existed until 1744, when a large fire severely damaged the monastery buildings.

The church is unique among southern German monastery churches. A dodecagonal central-plan building with an interior width of eighty-three feet (25.3 m) and a two-story outer ambulatory, it was begun soon after the founding. In the late fifteenth century a vault supported by a central pillar was added.

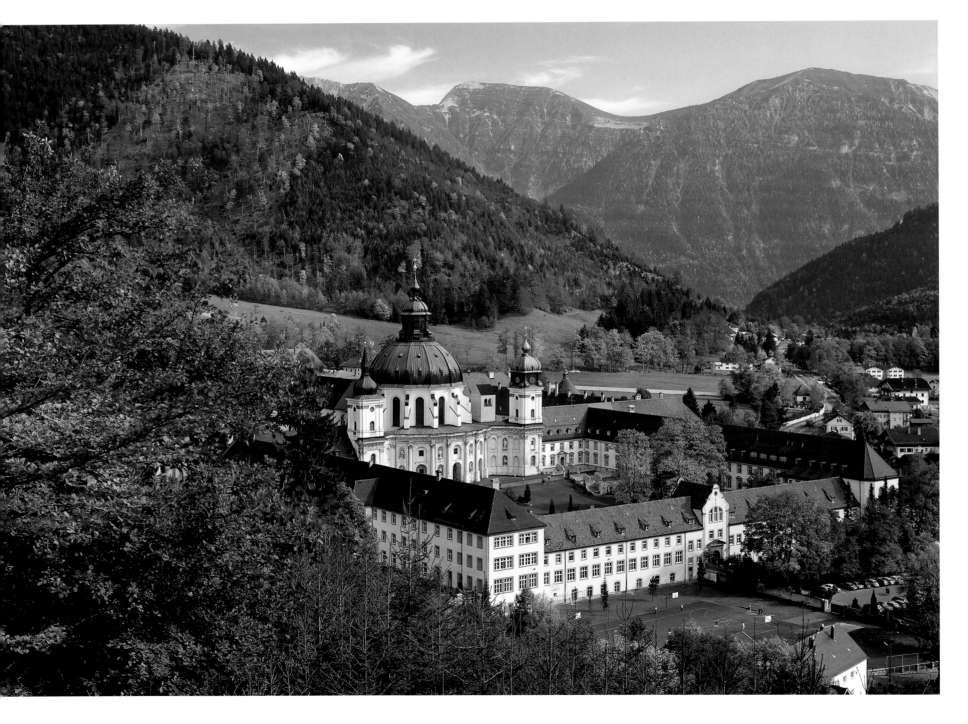

The monastery and church were rebuilt just after the academy of knights was founded. The buildings around the courtyard in front of the church were intended for the academy, and the wings around the church for the convention. The architect of the court at Munich, Henrico Zuccalli, was engaged as architect; he was essentially unemployed at the time, as his lord, Electoral Prince Max Emanuel of Bavaria, was in exile.

Zuccalli was enthralled by the buildings and projects of Gianlorenzo Bernini. In planning the facade for the church at Ettal, for example, he based his work on Bernini's first project for the Louvre in Paris, applying the design for the facade of the château to his church. In front of the convex Gothic central-plan building he placed bays with columns in a rhythmic polygonal arpeggio. On the left and right he added con-cave rounded wings that establish a connection to the far-flung, frontally arranged towers. The wings, which are articulated by pilasters rather than columns, frame the central-plan building like outspread arms. This sequence of concave-convex-concave corresponds to Bernini's project for the Louvre, but the grouping of two towers around a central dome corresponds to Sant' Agnese in the Piazza Navona in Rome. The facade was not completed until the nineteenth century, when the missing right tower was added.

After the fire of 1744, the architect, Joseph Schmutzer, raised the exterior walls and the pier buttresses considerably, vaulted the interior without the use of the central pier, and added a dome roof on the exterior that gives the church, whose core is still Gothic, a decidedly Baroque look.

WEINGARTEN

BELOW:
Father Beda Stattmüller, ideal view of Weingarten, 1723

OPPOSITE PAGE:
Interior of the church, facing east

WEINGARTEN WAS ONE OF THE MOST IMPORtant of the many Baroque imperial abbeys in Upper Swabia. It lies near the old imperial city of Ravensburg, dominating the landscape above the Schussen valley. The monastery, which was originally called Altdorf, was founded in 935 by the Welfs, a dynasty of counts and dukes that had its ancestral seat in the valley below and founded a convent here to be used for its burial site. In 1056 Welf IV transferred the convent to its present location on the mountain. At the same time he had a convention of monks brought from the Welf monastery Altomünster, where the nuns were resettled in an exchange. Weingarten's most important possession was and is a relic of the Sacred Blood, which was brought to the monastery in 1094. Every spring there is still a great procession in its honor, the Weingarten Ride

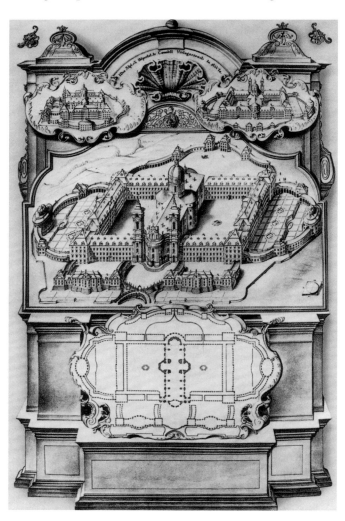

of the Sacred Blood, with some three thousand riders (once more than seven thousand).

In the twelfth century a flat-ceilinged column basilica with a transept and a two-tower facade on the west end was built in the monastery. The burial site of the Welfs was located in a chapel between the two towers. At a total length of 269 feet (82 m) the church is one of the largest Romanesque column basilicas anywhere; in the Lake Constance region it forms a counterpart to the episcopal cathedral in Constance. The administrators of the monastery were first the Welfs and, beginning in 1191, the Hohenstaufens. After an interregnum, however, the monastery managed to become directly subordinate to the emperor, although to do so it had to fight hard against the house of the Habsburgs, which laid claim to administration over it. Weingarten was always an incubator for the arts and sciences. During the seventeenth and eighteenth centuries many of its fathers taught as professors at the Benedictine university in Salzburg.

As early as the Thirty Years' War the abbey wanted to modernize the church to reflect its high rank, and so after the war there were negotiations with several renowned architects regarding a new building: the Vorarlbergers Michael Thumb and Kaspar Moosbrugger and the Munich court architect, Henrico Zuccalli. After 1700 the very active Vorarlberg architect Franz Beer, Johann Jakob Herkommer, who was active in the Sankt Mang monastery in Füssen, and the Wessobrunn architect Joseph Schmutzer also submitted plans. Finally, the architect of Ludwigsburg castle, Donato Frisoni, also entered the field when the church was already under construction. It is unclear even today who was responsible for the design of the church. It is generally considered to be the work of Franz Beer, but its quality makes Kaspar Moosbrugger, the architect of Einsiedeln (see pp. 329–32), the more likely candidate. The new church was begun in 1715 and by 1724 it was consecrated, with nearly all the decoration completed, including the frescoes by Cosmas Damian Asam. The costs ran to 227,000 guldens—a very high sum, but the church was able to pay it without taking on debt.

Next came the monastery buildings. Construction was delayed by an endless legal dispute that resulted because parts of the buildings would have been on Austrian soil, and thus outside of the monastery's own country. The site was never completed in full. The ideal plan of 1723 shows a completely symmetrical monastery castle with the church in the center and block buildings in the corners; everything is enclosed within a wreath of

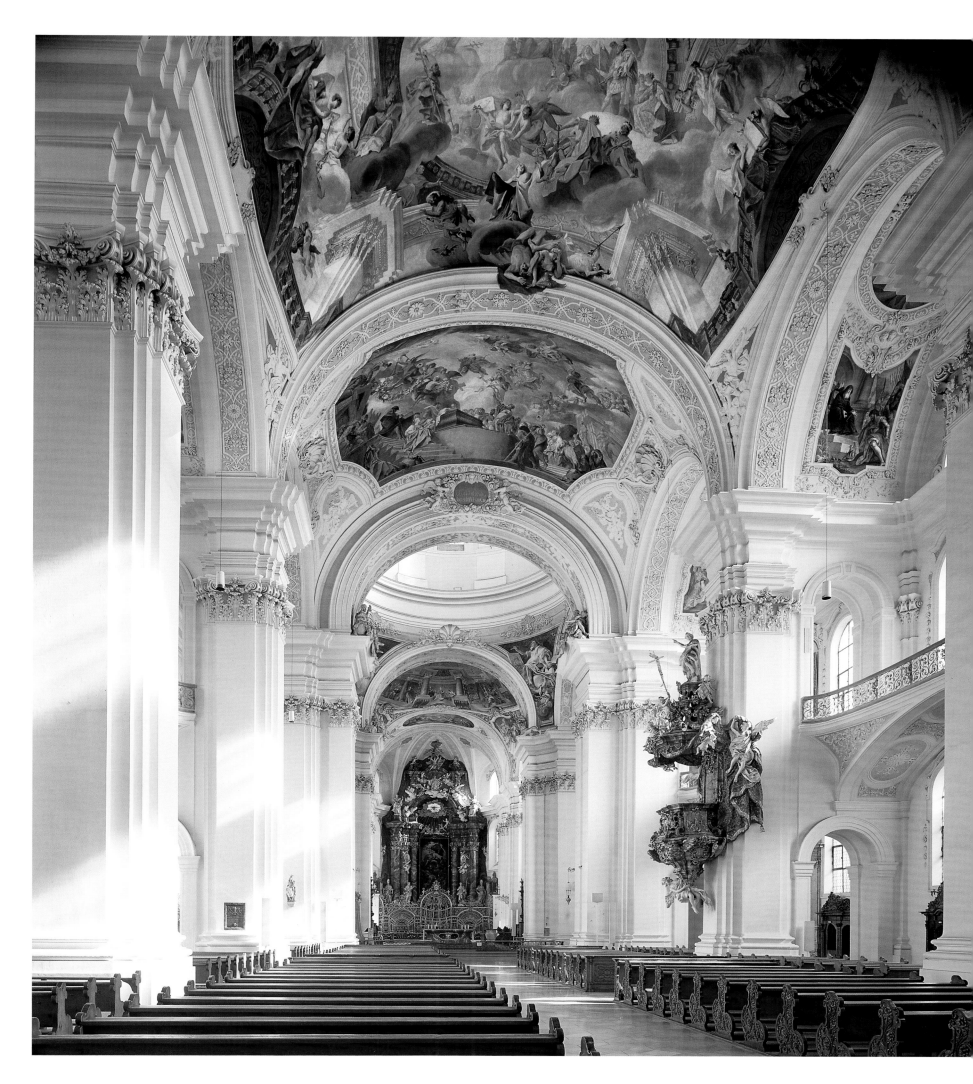

RIGHT:

View of the main organ, by Joseph
Gabler, on the west side of the church

OPPOSITE PAGE:

Cosmas Damian Asam, Chancel fresco
with the Pentecostal miracle

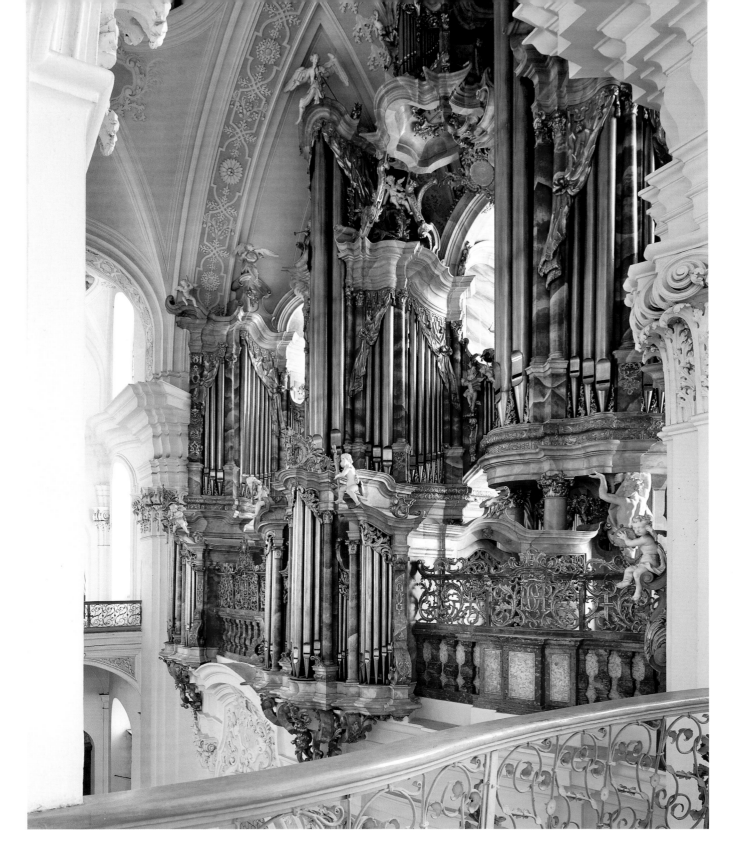

outward curving galleries and pavilions in the style of
princely pleasure palaces.

At 335 feet (102 m) long, the church is the largest
German Baroque church. Everything is conceived gen-
erously in architectural terms as well: the crossing, over
which looms, on immense piers and arches, an Italian
dome on a drum that is unique in this region; the
extended monks' chancel; and finally the broad, light-
filled hall of the main block, with its broad and deep lat-
eral vaults and shallow domelike vaults. In this room
size communicates not only measurable dimensions but
even more, the power of the monumental.

Large-scale architecture is also a theme in Asam's
frescoes, as in the chancel fresco with the Pentecostal
miracle beneath a column rotunda with a dome, all
painted with virtuosic perspectival foreshortening from
below. Asam was inspired by a construction by the great
Italian master of perspective, Andrea Pozzo. The choir
stall by Joseph Anton Feuchtmayer and the large organ
are also distinguished. The latter was built by Joseph
Gabler over a period of thirteen years beginning in 1737,
for a fee of 26,895 guldens. With the light entering from
the six western windows, the organ offers a prospect
that intoxicates the senses. Surely it is the greatest of all

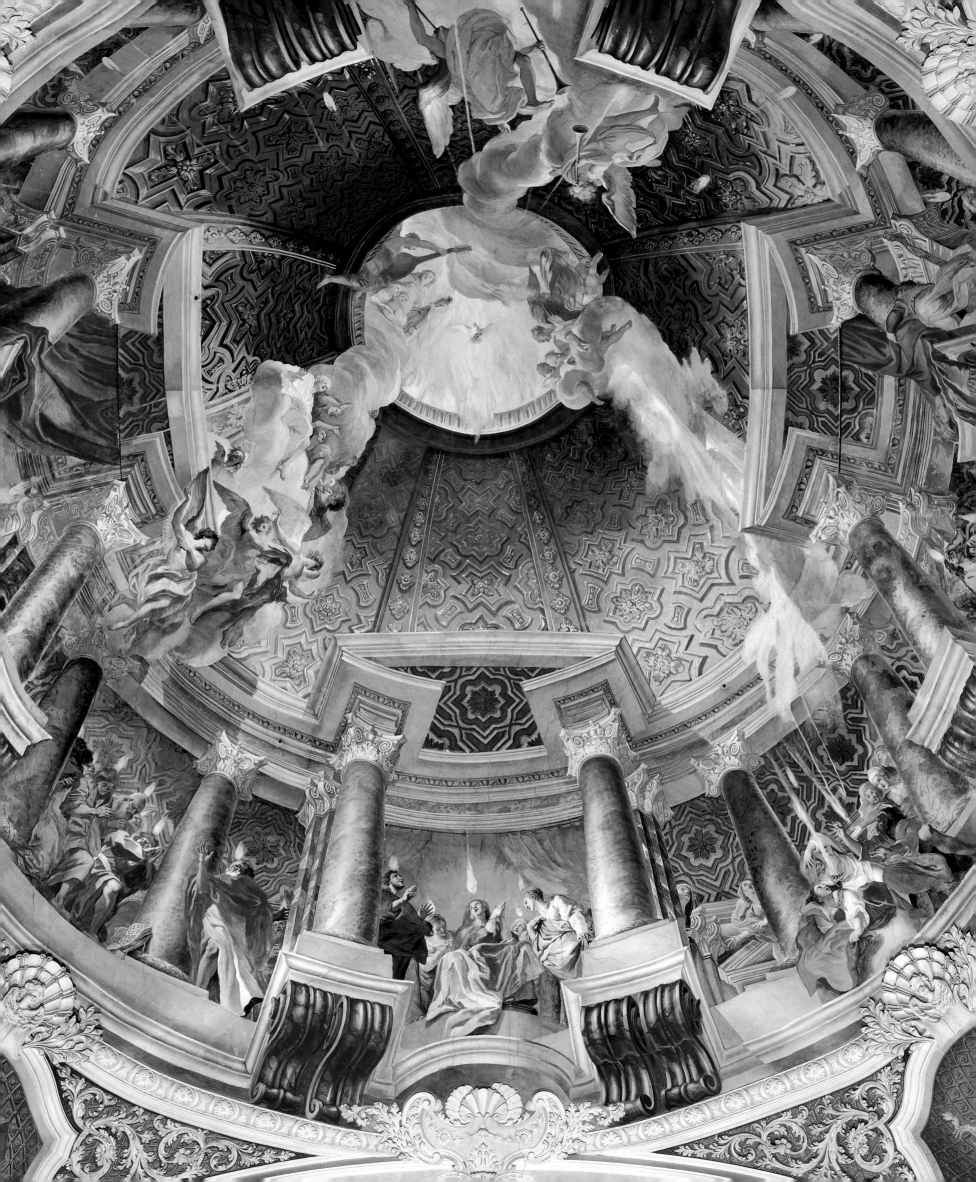

Baroque organs; at best the one in Neresheim could compete with it.

The facade is also ambitiously conceived. Framed by two far-flung towers, the center projects toward the valley in a powerful oblong oval shape. The architect was responding here to the facade of Fischer von Erlach's Salzburg collegiate church, but he toned down the pathos that dominates there and instead gave it a rock-solid gravitas, simplicity, and the timeless calm of the monumental. For the articulation he employed colossal pilasters on pedestals and a uniform two-tiered row of round arch windows that runs all the way across. The over-ornamented frontispiece that Frisoni added over the middle does not match the lower structure, admittedly. The facade announces to a visitor even from afar that this church is part of an imperial abbey.

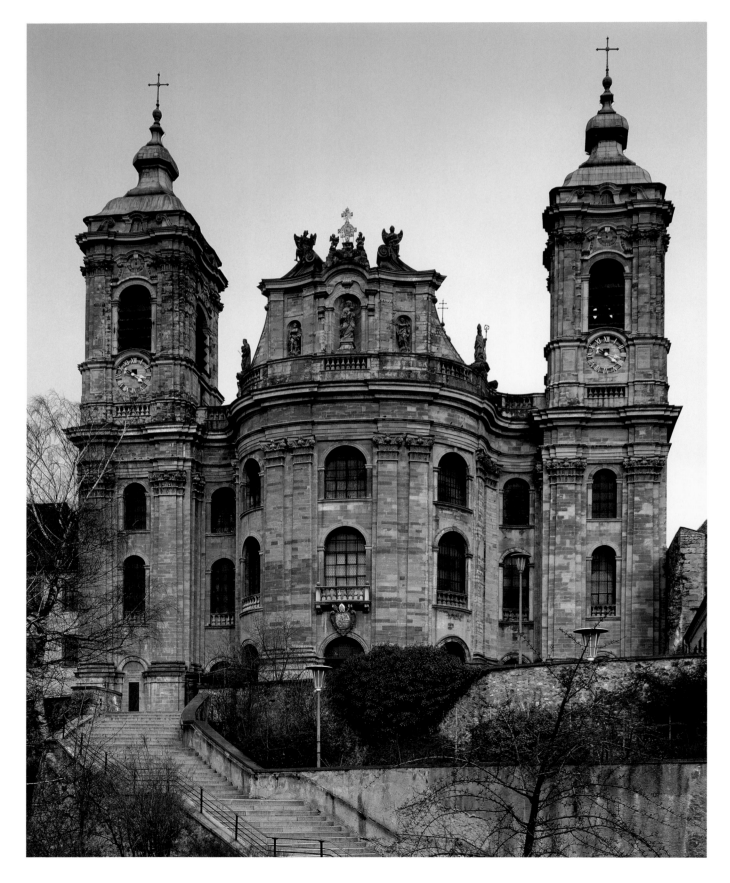

OTTOBEUREN IS OFTEN PRAISED AS SWABIA'S Escorial. It is indeed the largest and most splendid of the Swabian monastery castles. It is thought to have been built in 764, which makes it one of the oldest monasteries in southern Germany. It was supported by gifts from Charlemagne and his wife, Hildegard. In 973 Emperor Otto I raised it to the rank of imperial abbey with the free election of abbot—a privilege that Emperor Frederick Barbarossa confirmed in 1171. In the late eleventh century the abbey joined the Hirsau reform.

Ottobeuren's status, especially the question of protective administration, was fiercely debated for centuries. In 1212 the abbey arranged for its administration, which had until then been in the hands of counts, to be taken over by the future emperor Frederick II. In 1268 it finally became subordinate to the emperor alone, but in 1356 Emperor Charles IV pledged its administration to the Hochstift Augsburg. The empire never redeemed this pledge, however. In the years that followed its administration was repeatedly contested and taken to court, until the abbey took matters into its own hands in 1624 and purchased from Augsburg the land and tax sovereignty over its own territory in exchange for payment of the enormous sum of 100,000 guldens. From that point onward, Ottobeuren was once again considered an imperial abbey, but not until 1710 was it made subordinate only to the emperor in all respects, when its newly elected abbot, Rupert Ness, purchased the rights of administration from Augsburg for another 30,000 guldens.

Ottobeuren was an incubator of the arts and sciences comparable to Weingarten. In connection with the intense study of the humanities pursued there, one of the earliest monastic printing presses was installed in 1509. In 1541 a public school for Oriental languages was established, and two years later a university for Swabian Benedictines, though the latter was short-lived. In 1612 another university was founded in Ottobeuren, but shortly thereafter it became part of the Benedictine university in Salzburg, which was founded in 1622. The abbot of Ottobeuren became the first president of that university and a father its first rector. Fathers from both Ottobeuren and Weingarten were frequently active there as professors. The monastery maintained a secondary school, which had two hundred pupils in 1790. An especially impressive indication of how lively the abbey's cultural life was, is that they were able to stage Haydn's large-scale oratorio *The Creation* with their own performers. In 1802 the abbey was closed, but by 1834 it was reestablished as a priory by King Louis I of Bavaria, as part

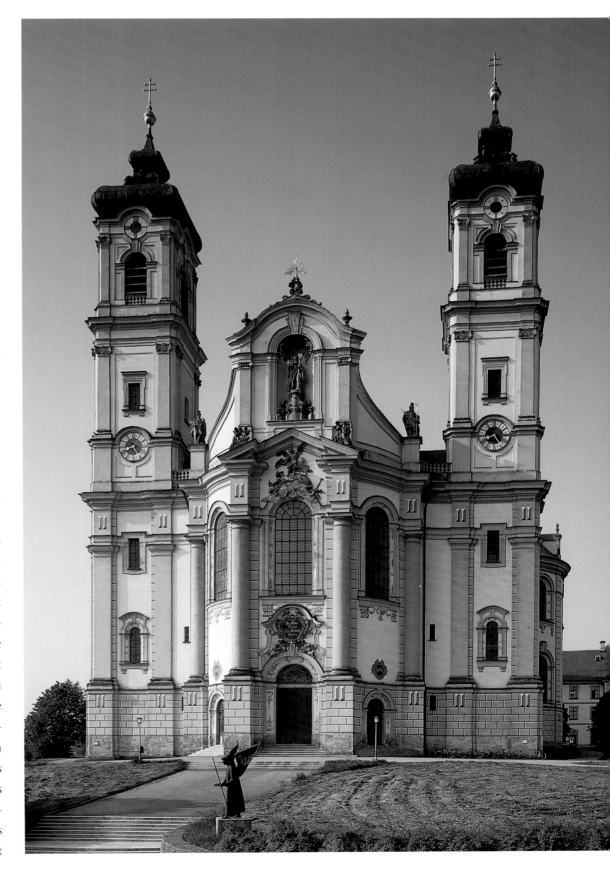

PAGE 343:
Facade of the church

BELOW:
Aerial view, from the southwest

OPPOSITE PAGE:
Interior of the church, facing south

of his counter-secularization, and finally made an abbey again by Pope Benedict XV in 1918.

The present Baroque church is indebted to the initiative of Abbot Rupert Ness, who reigned for a thirty-year period beginning in 1710. In 1718 the confederation of the University of Salzburg unanimously elected him its *praeses*.

During his first year in office the abbot began reconstruction of the entire monastery based on plans by Christoph Vogt, a resident father, and on a scale that exceeded that of the old monastery by several times. In the end the distance from the church to the furthest service building totaled 1,575 feet (480 m). In 1731, approximately twenty years later, the square of the monastery buildings and the guest wings were complete, including their lavish decoration. This encompasses a rectangle of 466 by 420 feet (142 × 128 m). In rebuilding the monastery the abbot was concerned with reflecting status, as Ottobeuren had become a full-fledged imperial abbey again. Hence this square is, like many other abbeys, a monastery castle and has the usual block structures in the corners and an elaborate entrance in the middle. The showpieces of the interior include the library, with a gallery running around the top floor on a lavish colonnade, and the theater. In the flourishing Benedictine Baroque theater,

varied works were performed written by the fathers, which were intended for the education and edification of the secondary school pupils. The most important of the prestige spaces was the emperors' hall—a stately room with columns and opulent stucco decor, with sixteen statues of Habsburg rulers, from Rudolf I to the then current Charles IV, and a depiction of Charlemagne's imperial coronation on the ceiling, which marked the beginning of the Holy Roman Empire. The entire hall is an expression of the idea of empire and the continuity of imperial rule; it is a direct allusion to Ottobeuren's rank as an imperial abbey. The hall was used to receive guests, to perform acts of sovereignty before imperial subjects, and to celebrate festivities.

The church was begun only after the monastery buildings were complete. The abbot wanted a new building that would reflect the abbey's status and stand free of the monastery. To achieve this, its axis had to be rotated ninety degrees relative to that of its predecessor. Long before construction began the abbot collected proposals from a wide range of architects, including Dominikus Zimmermann and Joseph Schmutzer. More than a hundred architectural drawings have survived. Early on, in 1718, P. Christoph Vogt proposed a literal imitation of the

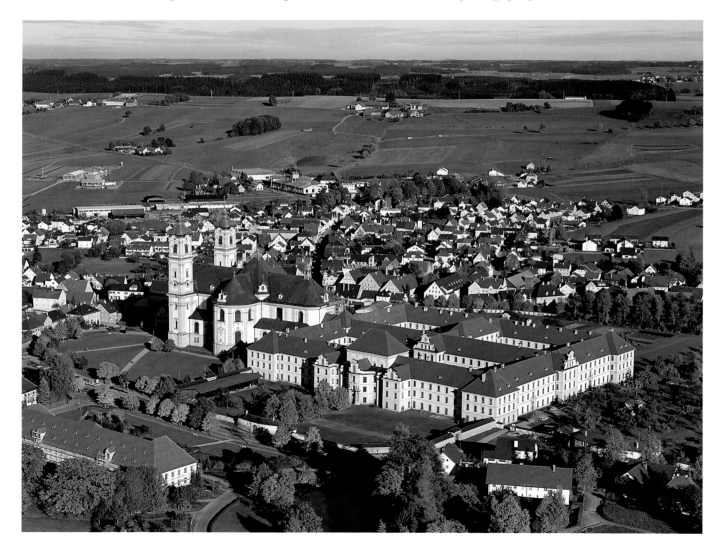

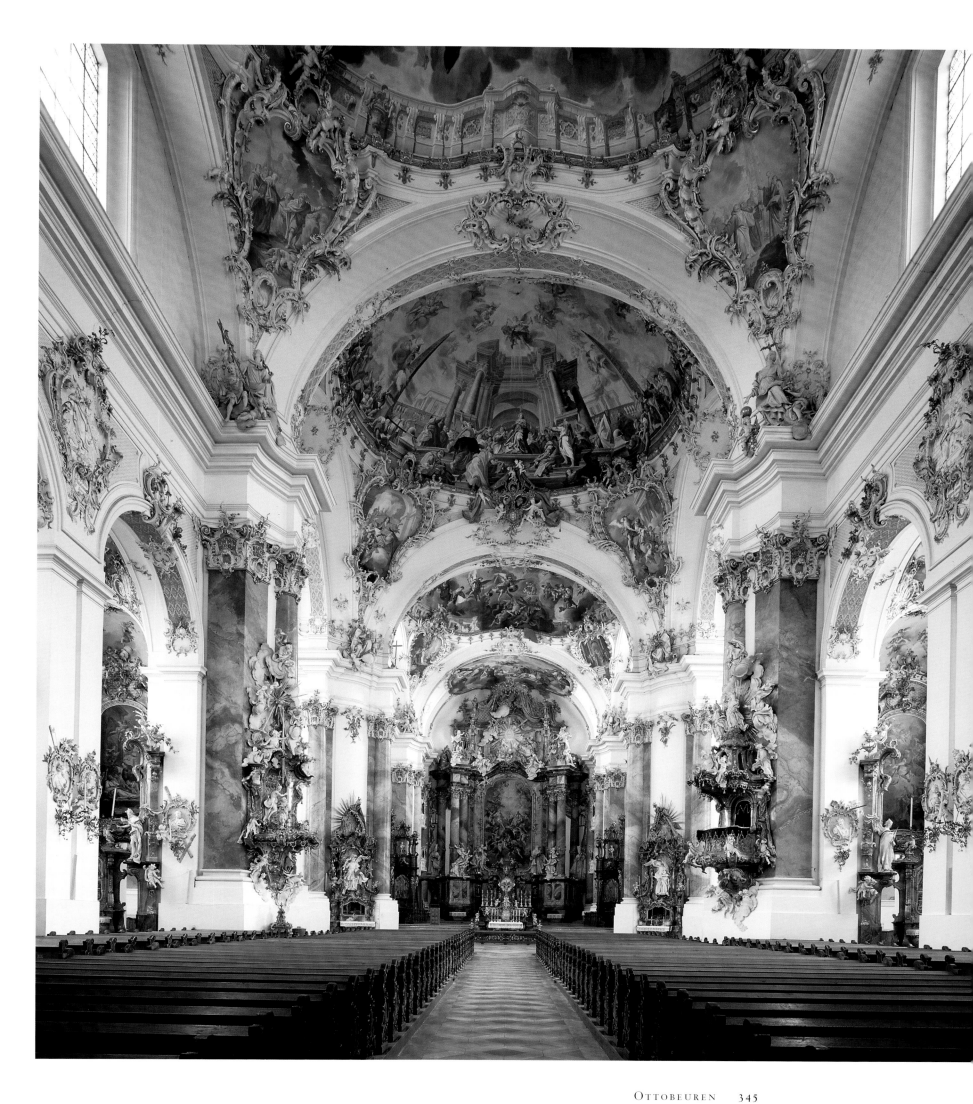

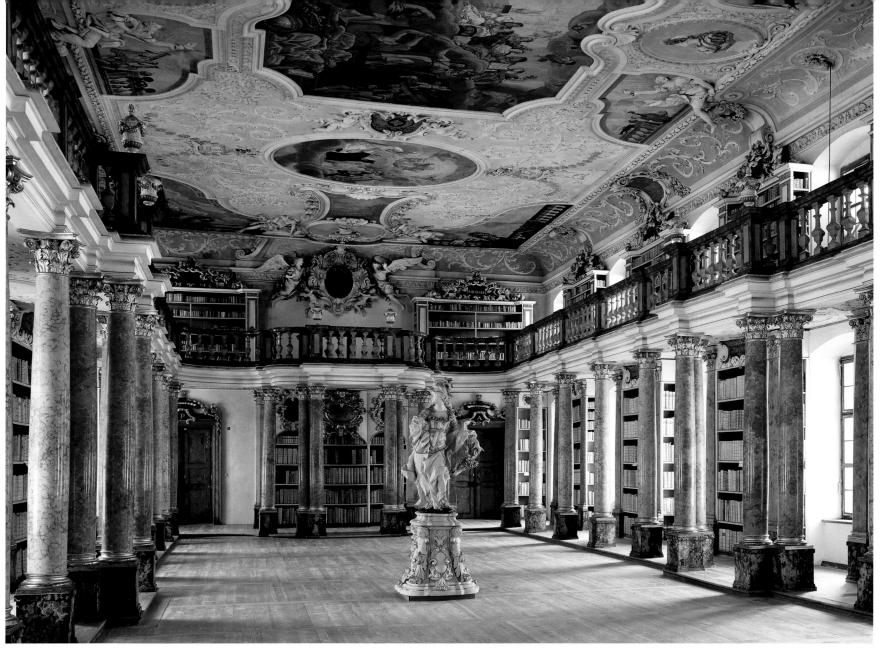

church of the Benedictine university in Salzburg, that is, Fischer von Erlach's collegiate church. Eighteen years later, in 1736, the abbot noted in his diary that he had many plans in hand and was taking something from each of them in order to select the best. On this basis he commissioned the architect Simpert Kramer with the final plan and the preparation of a model. Construction began in 1737. The majority of the foundation was laid under Kramer's direction, but Abbot Rupert's successor, Abbot Anselm Erb, dissociated himself from Kramer and brought architects from Munich: first Joseph Effner in 1744 and finally the leading church architect in Bavaria, Johann Michael Fischer, in 1748. In a first-rank feat of design Fischer was able to take the existing concept and turn it into something completely different, adding curves to the piers and beams to make something Baroque, as it were, of Kramer's rigid, straight lines. This is particularly evident in the massive piers of the crossing, whose round forms curve back and forth. His redesign changed the structure so thoroughly that the architecture of the church can be considered Fischer's work, for he is the one who gave it its look. The character

of the space as a whole is also the work of the Tirol painter Johann Jakob Zeiller and the Wessobrunn plasterer Johann Michael Feichtmayr, who provided the interior with an unusually splendid, colorful Rococo ornamentation of rocaille fireworks. The resulting prospect is of a festiveness, unity, and harmony but also of a powerful grandeur in its overall appearance that is found in no other building of the Bavarian Baroque.

Martin Herman's choir stall is a true delicacy of refined taste; it has two organs by the famous Ottobeuren master Carl Riepp that are placed in the stall with a particularly fortuitous concord. This is the most perfect of all Rococo choir stalls (see p. 8).

Another masterpiece and proud expression of the imperial abbey is the two-tower facade. As at Weingarten, the center projects outward, but Fischer has exploited this effect for another theme. The convex shape pushes forward its own planar motif: a giant aedicule with columns that looks like a giant gate to the church, above which loom the two tall towers and the gable crown that curves up and out. The inscription above the door states what this shows: "The house of God and the gates of Heaven."

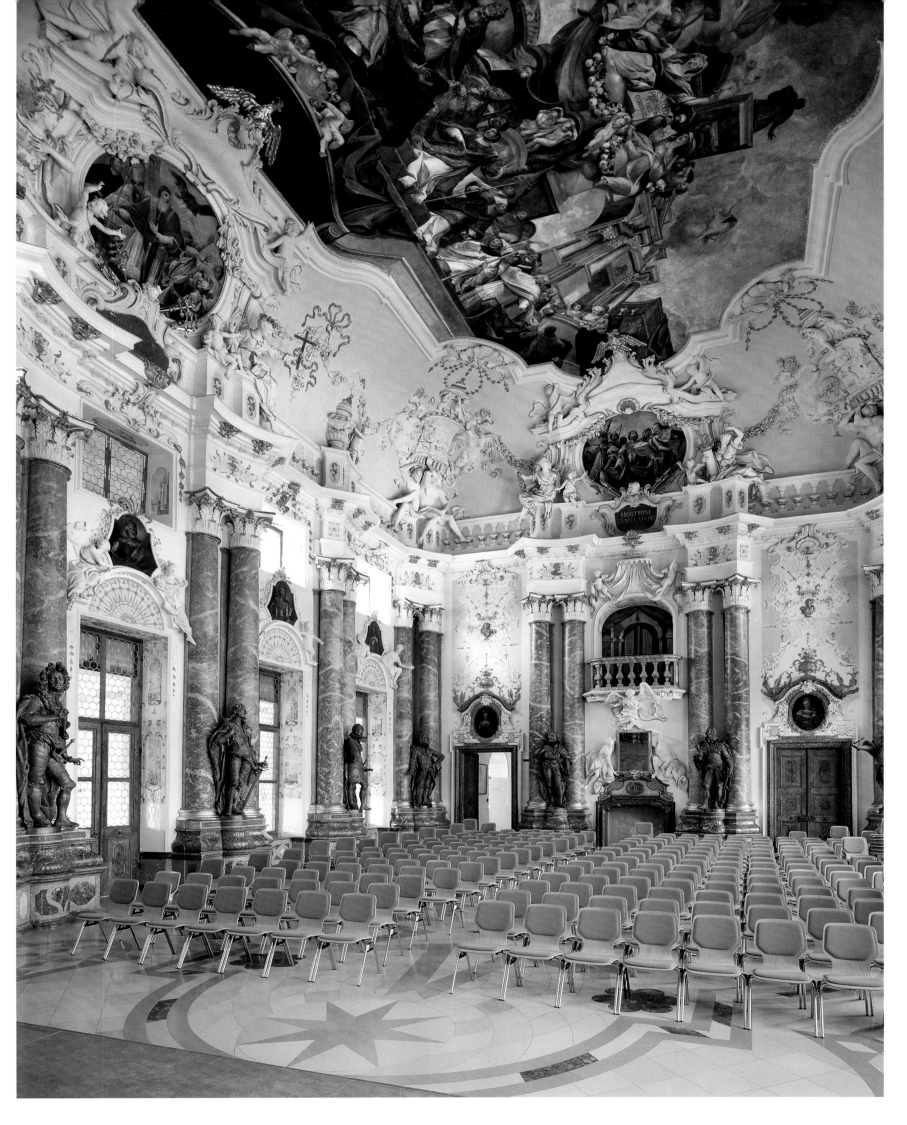

ZWIEFALTEN

ONE OF THE GREATEST ACHIEVEMENTS OF southern German Baroque and Rococo is the former Benedictine abbey Zwiefalten. It lies near the upper course of the Danube, in a valley on the southern edge of the Swabian Alps. Its founders were Count Kuno and Count Luitpold von Achalm. They sought a strict reform monastery, and so they turned to Abbot William of Hirsau in 1089, who sent the first convention. The church, consecrated in 1109, was one of the most important basilicas in the Hirsau style.

The Baroque redesign of the church began in 1688 with the new monastery buildings by artisans from Graubünden working under Tommaso Comacio. Additional construction, based on plans by the Vorarlberg architect Michael Thumb, was undertaken from 1684 onward. Around 1700 the Vorarlberg architect Franz Beer brought

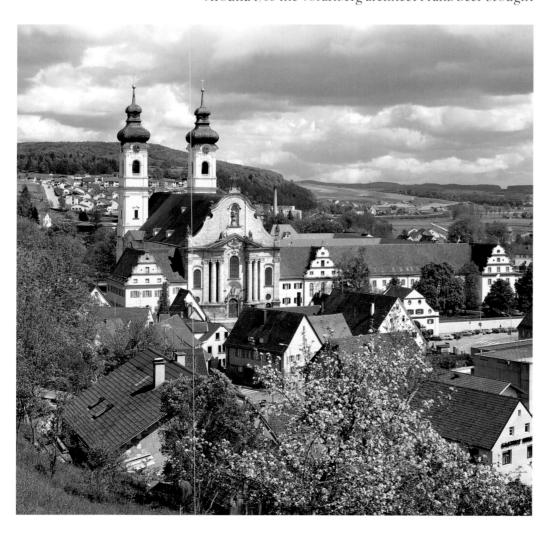

the work to a conclusion. The result was an expansive monastery castle decorated by gables with scrollwork.

In 1739 a new monastery church was begun based on plans by the monastery master masons Joseph and Martin Schneider. The task proved more than they could cope with, however, so Johann Michael Fischer of Munich, who was then Bavaria's highest authority on architecture, was entrusted with the building in 1741. Fischer presented his own plan, and among other things he took into account the towers, whose groundwork had already been laid, flanking the chancel, according to the old Swabian tradition, rather than on the west facade. The abbey, which was made subordinate directly to the emperor while construction was still under way, aimed for the highest level, and with his energetic intervention Fischer achieved it. He created a roomy, barrel-vaulted hall with wall piers and galleries, distinguishing the faces of the wall piers with the grand motif of marbled pairs of columns with immense entablature blocks that convey an impression of vertical stability. Both the balustrades of the galleries and the face arches of the barrel vaults have elegant and lithe outward curves, which give movement and elastic tension to the structure in addition to the solidity of the wall piers. Fischer was the master of the unified image of space, and here too he managed, despite its length of 315 feet (96 m), to give the room a visual prospect in which this length is optically compressed and foreshortened. When seen from the west, a broad, articulated festive hall opens up with polished, colorful pairs of columns that lend splendor to the room and make it clear that columns are the general theme of the architecture here. After this parade of columns in the main block, the theme is heightened in the crossing to become a receding triad of columns, and finally the prospect is concluded with the columns of the sanctuary and the high altar. Moreover, everything is dressed in ornate splendor with rocaille by plasterers from Wessobrunn, frescoes, and altars. The ornamentation is what truly makes the room a work of Rococo art.

On the exterior, the four square towers with sculptured caps loom to a height of 308 feet (94 m), nearly as tall as the church is long. The west facade, made of heavy, hewn gray ashlar that was originally whitewashed to match the towers, is distinguished by an immense, slightly projecting entry aedicule with double columns and an exploded gable that is surrounded by a pierced gable, which relates to the smaller gables of the monastery buildings. The motif of the aedicule is a large gate, as though it is the gate to a church of an imperial abbey.

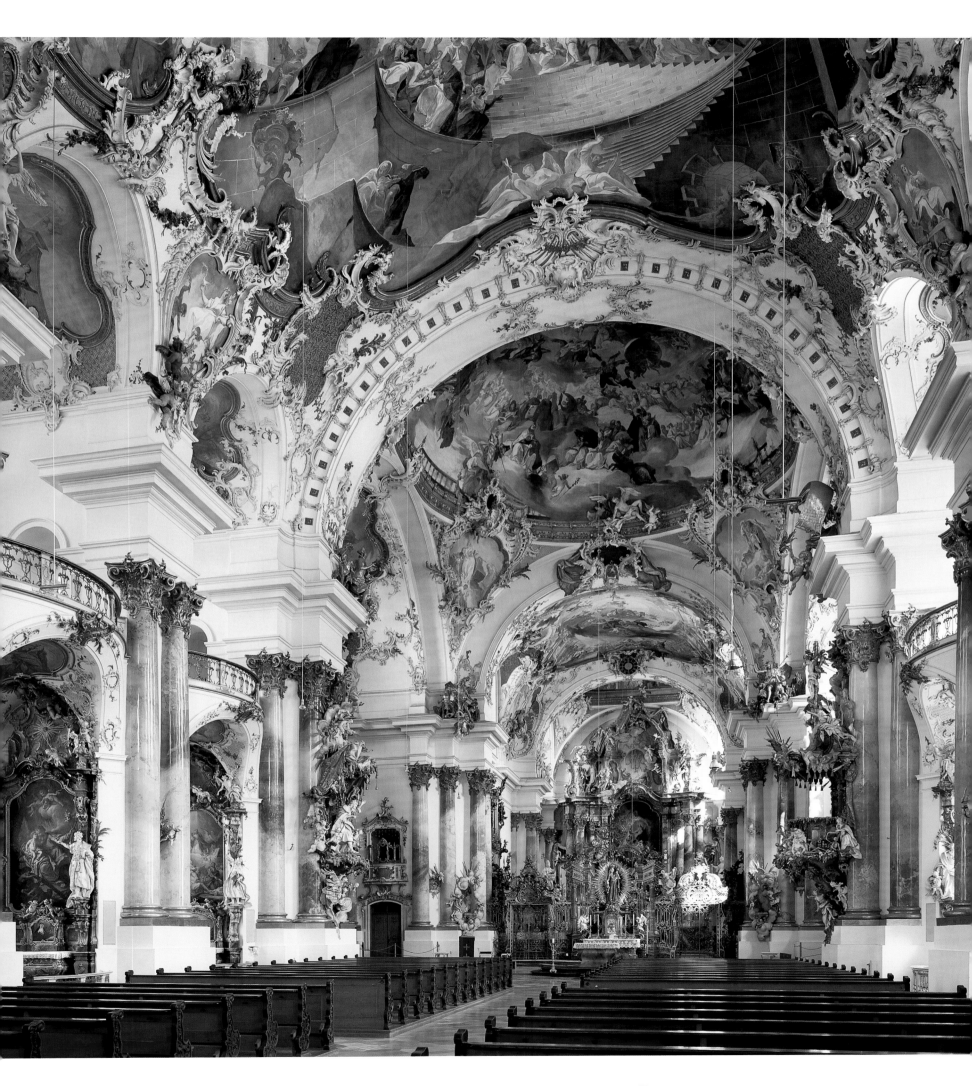

NERESHEIM

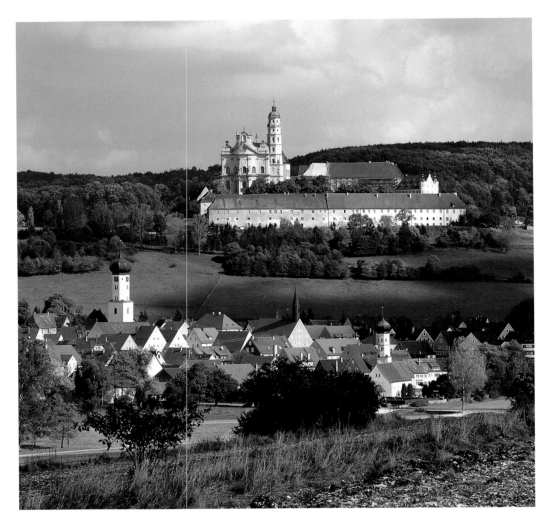

ABOVE:
View of the monastery seen above the town of Neresheim

OPPOSITE PAGE:
Interior of the church

THE BENEDICTINE ABBEY NERESHEIM, LOCATED high upon the Ulrichsberg, is the proud "queen of the Härtsfeld," the barren, stony, and climactically raw hill landscape that extends along Swabia's border between the giant crater of the Nördlinger Ries and the mountain range of the Swabian Alps. The monastery, which was founded in 1095 as a canonical association, was settled by Benedictines in 1106. They came from the Hirsau reform monastery Petershausen, near Constance. Through the history of the monastery, which is rather deprived of gleaming high points, one can trace the thread of five hundred years of conflict with the counts of Oettingen. Viewing their protective administration as oppressive, the monastery sought to free itself from them, to become instead directly subor-

dinate to the emperor. It did not succeed until 1764. The abbey paid dearly for that new status, however, handing over property, several towns, certain rights, and a sum of 40,000 guldens.

Around 1700 for roughly the same cost the abbey built a four-wing structure whose elaborate articulation with a three-tier pilaster order has the grand ambition of a princely residence. Neresheim owes its worldwide fame, however, to its church. In 1747 Abbot Aurelius Braisch engaged the most famous and best architect of the time, Balthasar Neumann of Würzburg, for the new building. Neumann was the house architect of the prince-bishops of the house of Schönborn, but at the time he had been released of his episcopal duties in Würzburg and was simply working in Ellwangen, not far from Neresheim, for one of the Schönborns—the provost Franz Georg, who simultaneously held the offices of prince-archbishop and electoral prince of Trier. Neumann would make detours to Neresheim on his journeys to Ellwangen to show the abbot his plans and consult with him. The church was not occupied by the monks until 1782, twenty-nine years after Neumann's death and twenty years before the abbey was closed during secularization. Not only were Neumann's plans executed incorrectly, but two crucial aspects were altered: the planned stone vault was replaced by a wooden one, and it was made so shallow, to reduce echoing, that its profile seemed compressed. The central dome was only half as tall as planned, and it was built without windows for light. The dome, the high point of the space, thus became far too shallow and dark.

This is one of the main examples of so-called curved architecture, a trend within the Baroque to make all walls and vault arches curved, as if they were in oscillating motion. In the precise center, in lieu of a traditional crossing, there is an elongated oval rotunda with four free-standing pairs of columns and curving main arches. This was Neumann's favorite motif—a baldachin—writ large. In this space one experiences as nowhere else the sharpness and clarity of the pure spirit as embodied in architecture—not the celebration of the senses of the Rococo style that was its immediate predecessor. The room lacks Rococo decoration, apart from Martin Knoller's ceiling frescos. In comparison to Rococo spaces like Ottobeuren (see pp. 343–47), this room boldly presents itself in the garb of the early Enlightenment, as pure architecture. It is still unquestionably the grandest example of church architecture that this period produced.

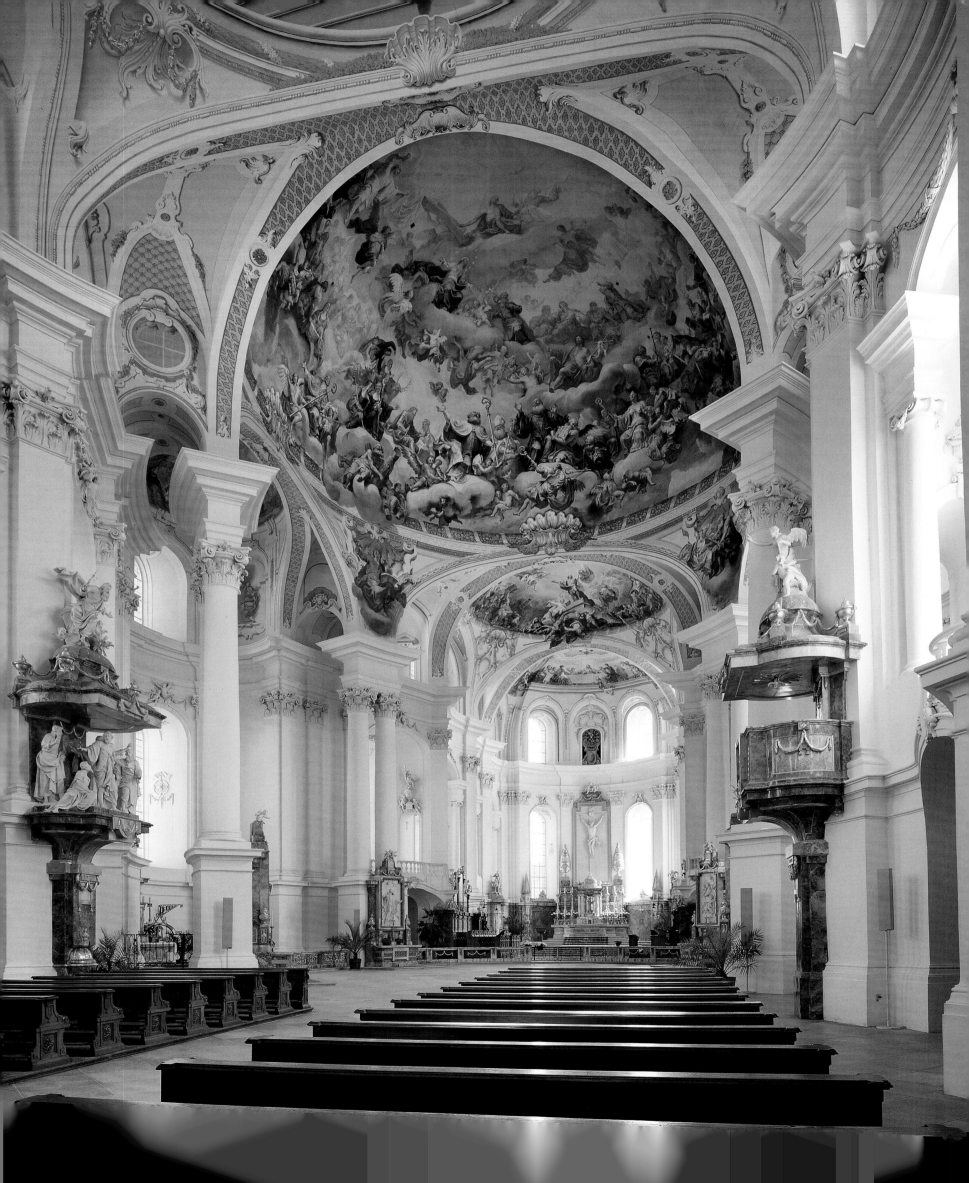

WELTENBURG, ROHR

THE BENEDICTINE ABBEY WELTENBURG LIES not far from the episcopal city of Regensburg, in a beautiful river landscape immediately in front of the wild and romantic Donau Durchbruch, where the Danube "breaks through" the white limestone cliffs of the Franconian Jura. It is thought to be Bavaria's oldest abbey. It may have been founded as early as 600, by itinerant Irish-Scottish monks from the retinue of Saint Columban, who are said to have founded a monastery here as a base for missionary work in Bavaria. Only after 763, however, did the Bavarian duke Tassilo, who would later be deposed by Charlemagne, arrange for a fixed, permanent settlement with Benedictine monks. Over the course of its history the monastery suffered repeatedly from pillaging, the flooding of the Danube, and ice drift. Around 1700 it was declared to be

in the worst condition of any monastery in Bavaria and was about to be closed. It enjoyed an upturn, thanks to Abbot Maurus Bächl, who was elected in 1713—a financial genius who achieved the miracle of bringing these desolate circumstances back to good order in no time at all. The abbot, who was able to finance the buildings using profits from the state monopoly on wheat beer, immediately began construction on the monastery buildings and followed them with the splendid church. He engaged as architect the painter Cosmas Damian Asam, who had just returned from Rome, where he had won first prize at the Accademia di San Luca. The church was begun in 1716.

A year later the nearby Augustinian canonical association Rohr—which had never achieved particular importance from the time of its founding in 1133—followed suit by building a new church, based on plans by the sculptor and plasterer Egid Quirin Asam, Cosmas Damian's brother, who was six years younger. The two buildings belong to contrasting styles, but they are related in the way they dramatize the high altar, and in this they are unique.

In the church at Weltenburg, where the decoration of the interior continued until 1735, the Asam brothers brought the high pathos of the Baroque art of Rome to

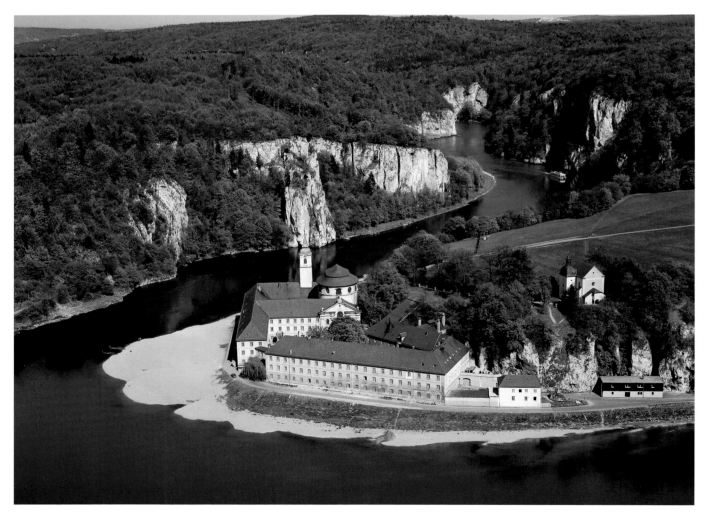

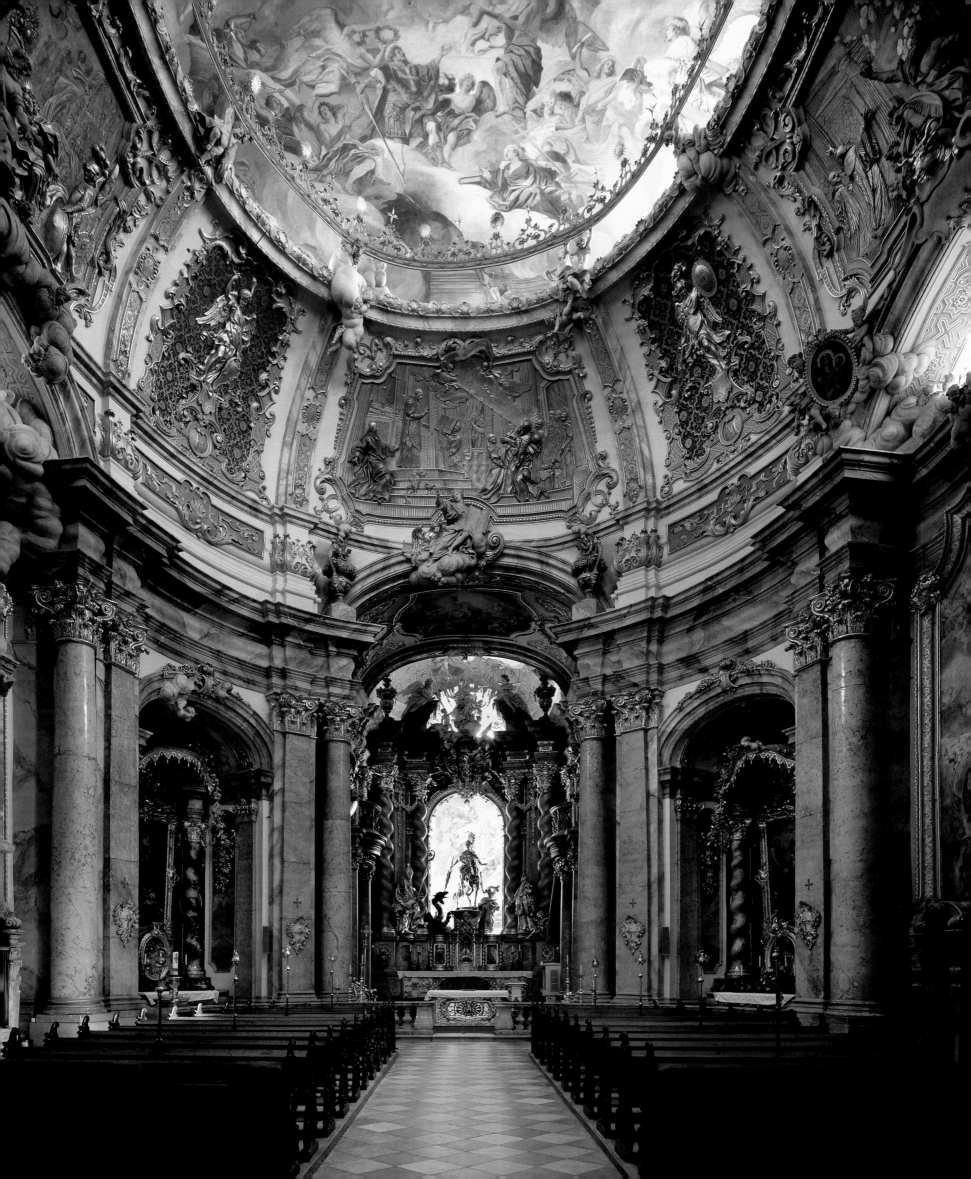

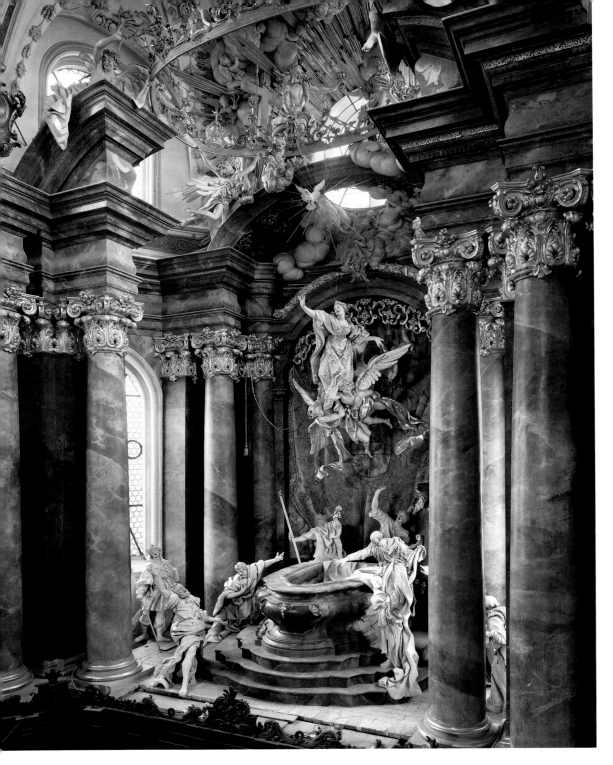

The high altar, Rohr

This visionary aspect is heightened in the chancel by means of the *theatrum sacrum* of the high alter, with an equestrian monument to Saint George that has become famous. Within the frame of the altar, set between showy spiraling columns, the rider flashes in silver against a gleaming, bright background lit by an indefinable light source, which provides a natural aureole. The saint thus becomes a light phenomenon, distanced by its elevation on a pedestal but nonetheless present, a vision of another world. Asam's goal in Weltenburg was to present the church as a sacred place, and to that end he consciously employed every conceivable theatrical device in order to make it possible to experience this—or, more broadly, to experience sacredness itself—by means of the senses. This is precisely the miracle of Weltenburg.

In this equestrian figure Asam has introduced surprising aspects into the architecture. Something surprising, something that contradicts all our visual habits, becomes here, for the first time, the defining feature of large-scale architecture. Saint George's stabbing of the dragon takes this a step further. George is not even looking as he guides his lance with the same casual ease that mere mortals hold a pencil. The princess who was in the dragon's grip has been freed, but she still conveys horrified fear. Despite the stabbing of the dragon, it is the pedestal—which derives from that of Emperor Marcus Aurelius on the Capitoline Square in Rome—that elevates Saint George to a monument. He is no heroic victor, however; rather, his friendly, naively cheerful, and chubby-cheeked face evokes a boy who has slipped into the role of dragon slayer as part of a child's game. The rider is certainly a monument, but one that makes us smile. A concealed, winking humor has been elevated to the dignity of an altar. The humor makes the saint sympathetic; it does not create distance but brings him closer.

The high altar in Rohr is the counterpart to this. The church is an elongated Roman hall structure with a transept into which the altar, elevated on a stage, presents itself like a vision. Above the semicircular choir stall one sees a theatrical arena, framed by powerful columns, that offers a performance of the Assumption of the Virgin. The apostles surrounding the elaborate empty sarcophagus are in mourning. They display pathos-filled expressions and their poses and gestures convey astonishment. Mary herself floats in midair; the rod that holds the figure in place is not visible. The Baroque theater that was flourishing at the time is captured on the altar by a single dramatic image—an idea that is like the Saint George monument at Weltenburg.

Bavaria. It is based on a comprehensive *concetto* that extends to all aspects of the architecture and the decoration. Weltenburg is the first church in Bavaria in which the space is clad in an opulent, richly colored ornamentation of marble, ceiling stucco, and large-format ceiling frescoes. The *concetto* unites two opposed trends in Roman churches: the heavy, serious gravitas that was the main trend and a subsidiary trend toward theatrical surprises and inventive, sometimes witty caprice. The room is a dark, elongated oval rotunda with powerful articulations of bays with pilasters and columns, but no windows. There is a giant oval opening in the vault. Above it, like a distant vision, a painted sky with a golden yellow dome can be seen, brightly lit by an unseen source. The light falls into the room from above. The rotunda opens up to the light of the heavens.

THE BENEDICTINE MONASTERY METTEN, on the Danube in Lower Bavaria, was founded in 766, and in the Middle Ages it was one of the most important abbeys in Bavaria. The present monastery is a Baroque structure whose showpiece is its famous, utterly unique library. The library was built in the sixteenth century, but it only obtained its present appearance thanks to the extravagant decoration of 1722–24: a collaboration between the painter Innocenz Waräthi of Sterzing in southern Tirol and the talented Upper Austrian plasterer Franz Josef Ignaz Holzinger, who moved on to Sankt Florian in 1724. The interior of the library wing is subdivided into a series of three different but related rooms. The largest of these is a low two-nave hall whose shallow cross rib vault is decorated with white reliefs against a black background and unusually colorful frescoes. This room derives its unmistakable look not from the bookcases and galleries, as is so often the case in Baroque libraries in

METTEN

southern Germany, but by the vault supports in the center. Holzinger designed them in stucco as pairs of atlantes. These figures do not, as is usually the case, press against their burden with the superhuman exertions of Herculean musclemen; instead, they carry out their task of supporting with playful legerity and tumultuously driving vehemence. They are able to do this because the weight of the vault is not on their shoulders alone but also on columns that are concealed between them.

The library, Metten

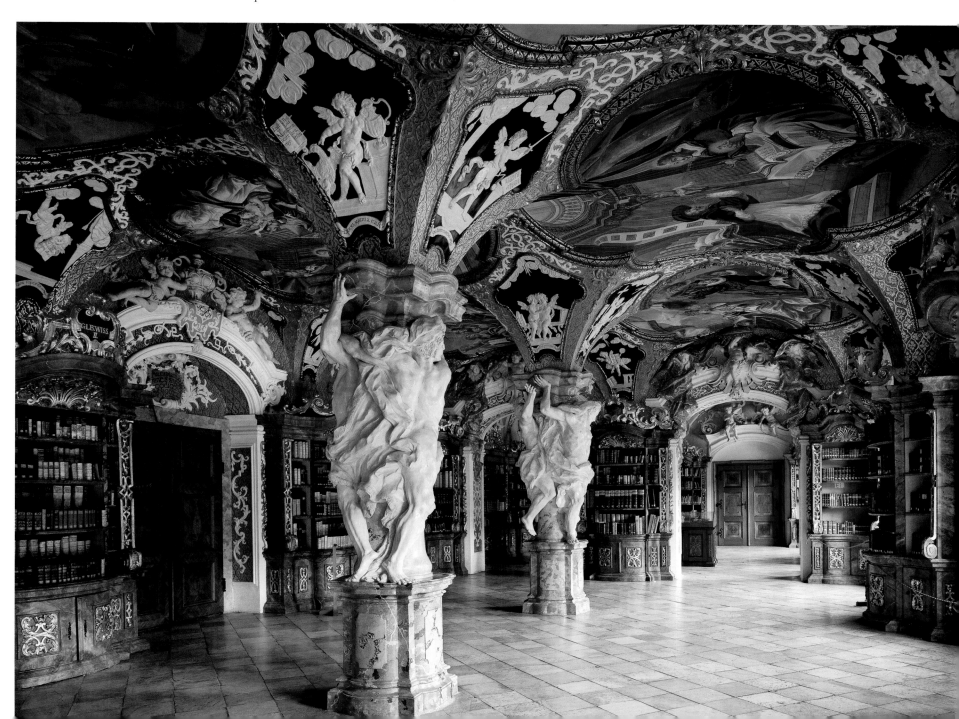

KREMSMÜNSTER

("tradidi quam potui"). According to legend it was the site where his son Gunther had been mortally wounded by a boar while hunting. Gunther was buried in the monastery church; in 1300 he was given an elevated tomb with a recumbent effigy, which now lies in the southern tower. Of the original altar decorations from the time of Tassilo, who was deposed in 788 by his cousin Charlemagne and sent to France to be held in confinement in a

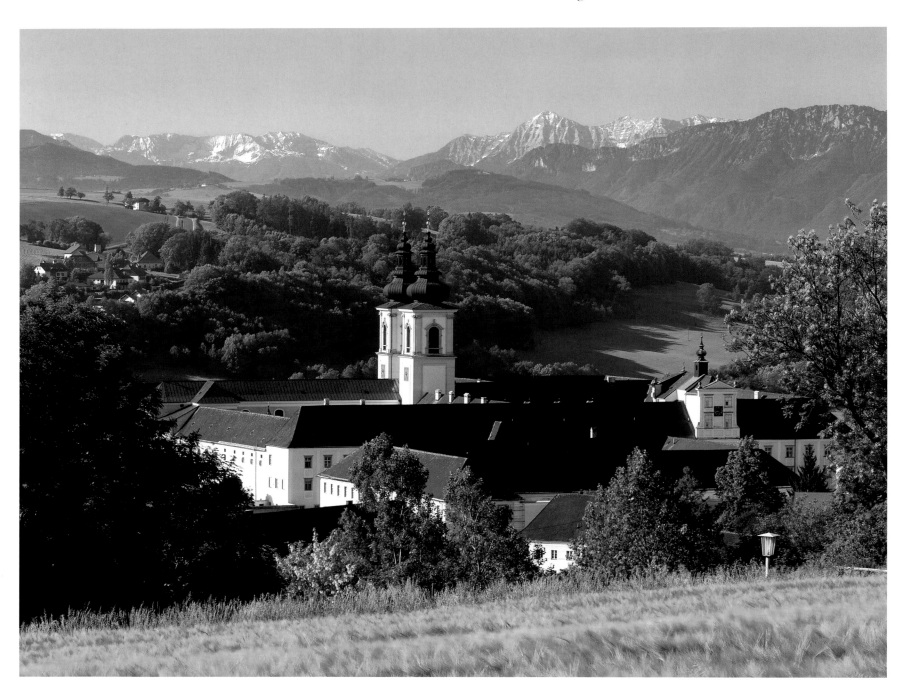

View of Kremsmünster with the Alps in the background

THE BENEDICTINE MONASTERY KREMSMÜNSTER, where some eighty monks still reside today, lies in the Alpine foothills in the charming valley of the Krems, a small tributary of the Traun that flows into the Danube near Linz. A Roman road ran through the Krems valley and over the Pyhrn Pass. The Bavarian duke Tassilo III, the lord of Traungau, founded a monastery here in 777 and decorated it as lavishly as he was able

monastery, two candleholders and a precious chalice survive. The latter is the famous Tassilo chalice, made of gilded copper and soldered-on silver plate, whose donor inscription, which names Tassilo and his wife, Liutpirc, conceals the year 781. The early furnishings of the church included a Gospel dating from around 800, the *Codex millenarius*. During the Carolingian period Kremsmünster was an imperial abbey and was later the proprietary

monastery of the bishops of Passau. Later it joined the reforms of Gorze and Cluny. In the thirteenth century a large late Romanesque basilica with transept was built, which was completely remodeled in the Baroque style in the seventeenth and eighteenth centuries, but its core still survives. The monastery school became a knights' academy in 1744, but that was closed by Joseph II as early as 1789. It survived as a secondary school with a boarding school.

monastery's natural history collections. Its interior is decorated with 240 portraits of boys that immortalize all the pupils of the knights' academy—the only gallery of its kind. The fish pond is a series of five pools for breeding carp, pike, brook trout, and trout. The pools are arranged in a charming, elongated arcaded courtyard with Tuscan columns that is divided into pools by airy intermediate galleries but offers open

Fish pond

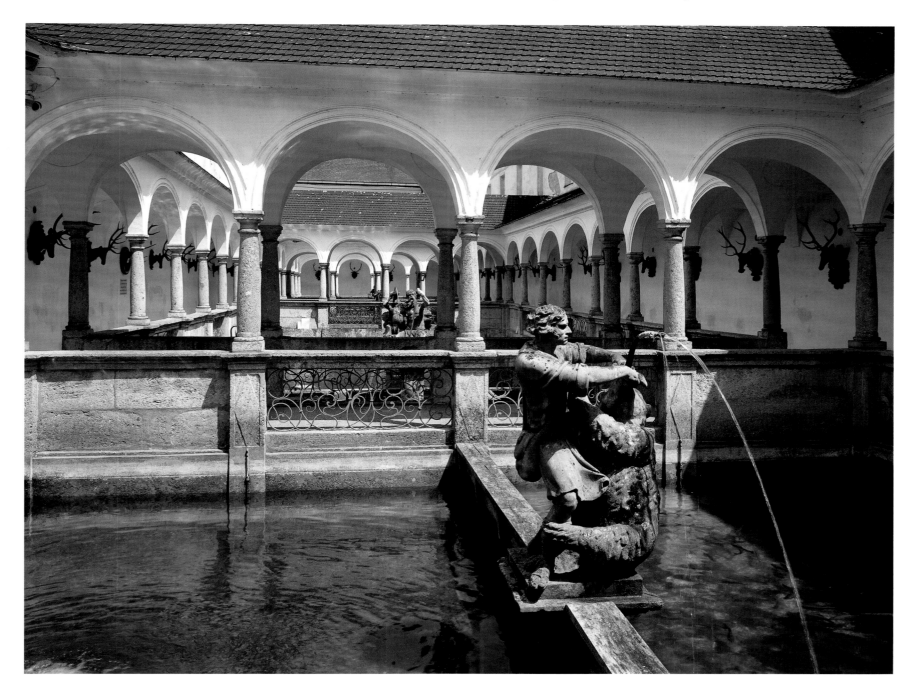

The monastery buildings are an extended Baroque site, with nine irregular courtyards that were added over time and a facade toward the valley side that is 820 feet (250 m) long. Two of the structures of this ensemble are unusual: the observatory and the fish pond. The observatory is an eight-story structure that is 164 feet (50 m) tall. It was built in 1748–58 as a "mathematical tower" for scientific use and to house the

vistas throughout. It is also cheerfully animated by wrought-iron grilles and fountain sculptures that cause the water to splash about. The ensemble forms a unique prospect of water and arcades. The first three ponds were built by Carlo Antonio Carlone, the architect of Sankt Florian, in 1690–92; the others, by Jakob Prandtauer, the architect of Melk, in the early eighteenth century.

SANKT FLORIAN

BELOW:
View of Sankt Florian from the southeast

OPPOSITE PAGE:
Interior of the church

PAGE 360:
Festive hall

PAGE 361:
TOP: *Exterior, showing the staircase;*
BOTTOM: *Upper story of the staircase*

AMONG THE BAROQUE MONASTERIES OF UPPER and Lower Austria—Wilhering, Sankt Florian, Kremsmünster, Melk, Dürnstein, Göttweig, Altenburg, and Klosterneuburg—Sankt Florian has a decidedly specific artistic character that combines monastic severity with an outward-looking, cheerful attitude toward life. The patron saint of the monastery, Saint Florian, a Roman civil administration director, was drowned in 304 in the nearby Enns River with a millstone around his neck for being a Christian; he was buried at the present site of the church. At some unknown point prior to the eighth or ninth century, a monastery was built here. It was a proprietary monastery for Passau. Bishop Altmann of Passau, a strict advocate of church reform, transformed it into an Augustinian canonical association, which it remains today. In the late Middle Ages it experienced its first flowering in a fertile period of building activity, including many of the parishes it incorporated. One artistic high point is the Albrecht Altdorfer's Saint Sebastian altar (completed in 1518), whose panels are the premier showpieces of the association's collections.

After the threat from the Turks had been eliminated once and for all in the late seventeenth century, the association was seized, like most others, by the Baroque passion for building. Provost David Fuhrmann first organized the finances and then in 1686 commissioned workers to begin on the construction of the new church and the monastery buildings to the south of it. His choice was the very active architect Carlo Antonio Carlone, an Italian from Val d'Intelvi, between Lugano and Como, a region from which many others in the building trades had come in droves over the Alps, often already organized in guilds, after the Thirty Years' War. The church, which was consecrated in 1715, is a monumental Italian hall building with aisle chapels, galleries, and a series of shallow rectangular vaults—so-called Bohemian domes, similar to the vaults in the main block of the

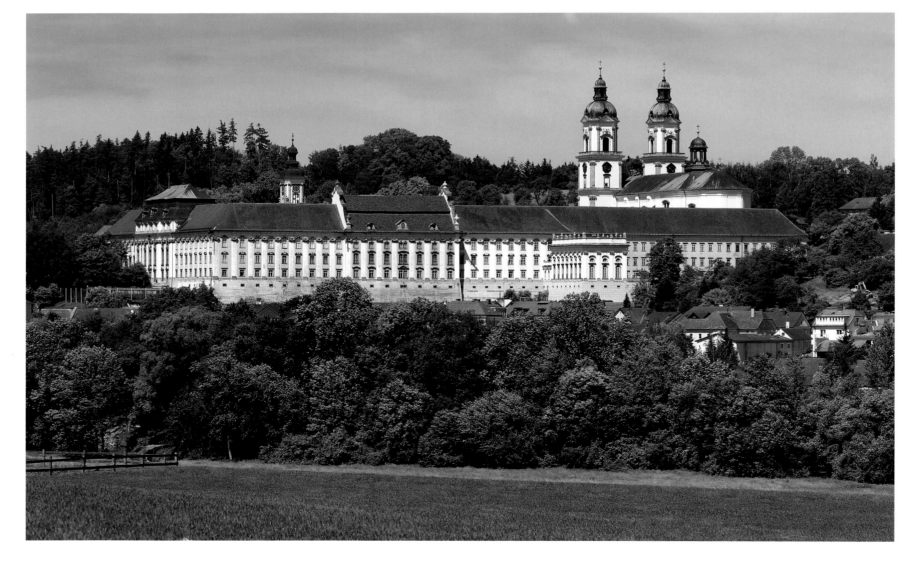

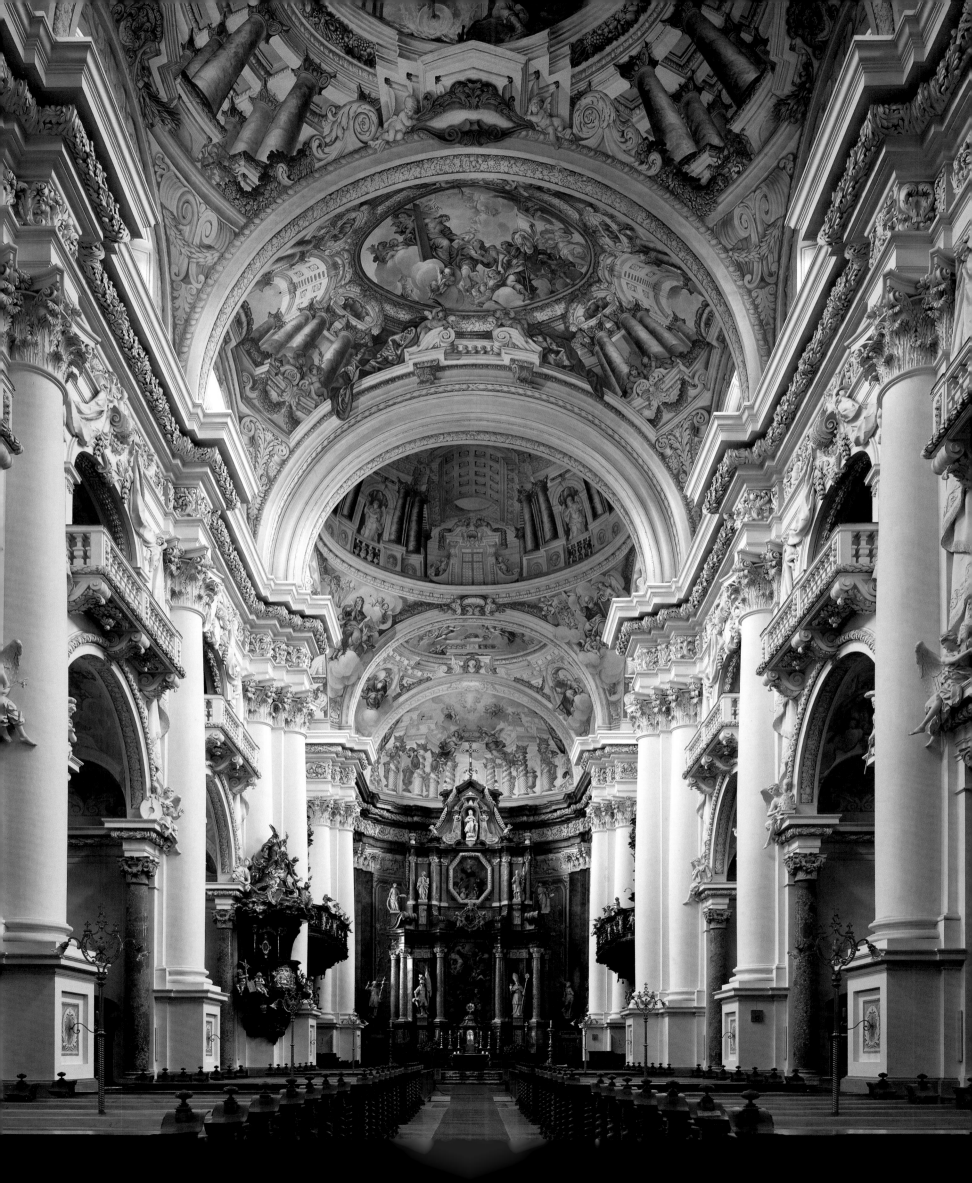

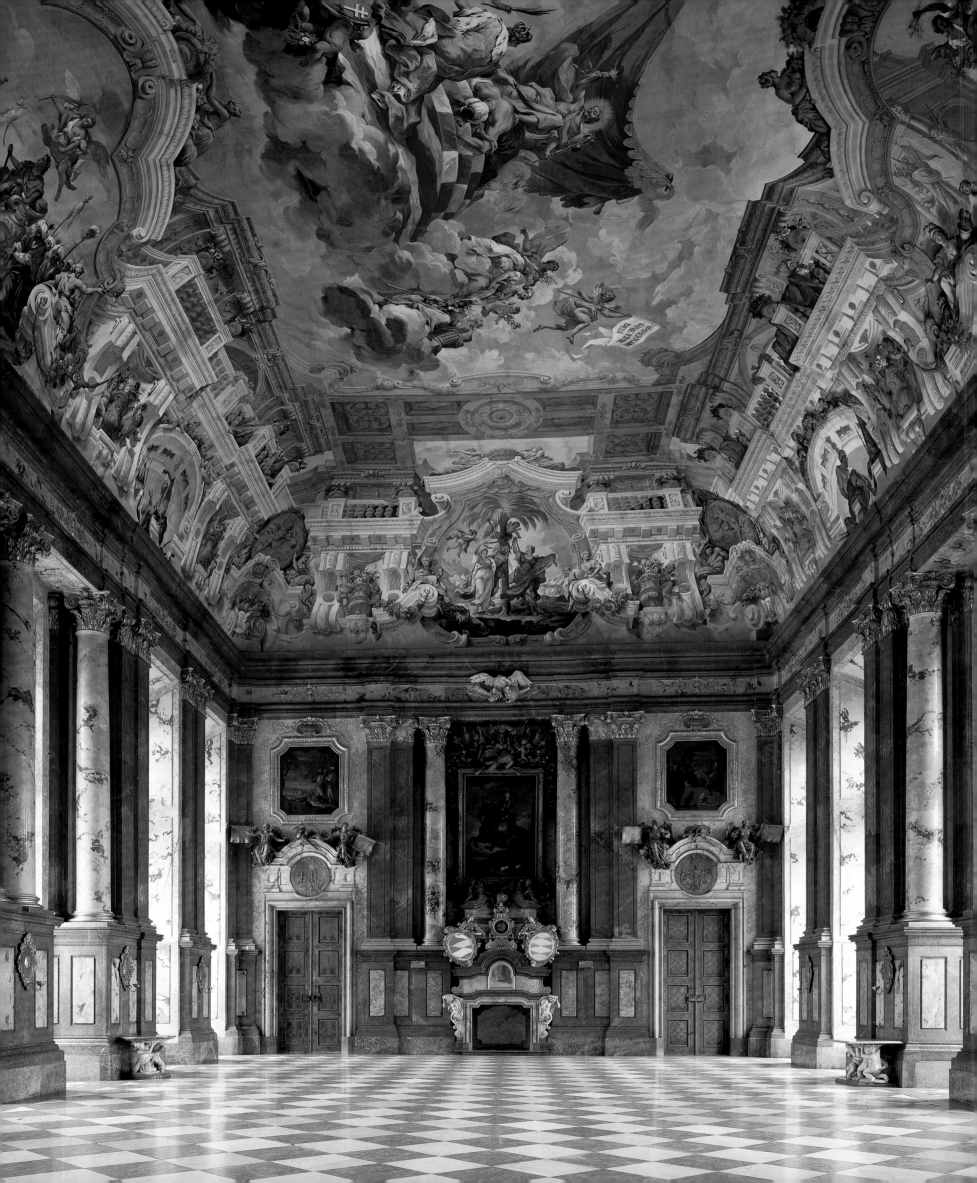

cathedral in Passau, which had been designed a little earlier by Carlone's compatriot Carlo Lurago.

The high point of the series of vaults in Sankt Florian is the pendentive dome above the chancel. The wall structure is based on an order with colossal half-columns and entablatures with molding, heightened by the projecting balconies of the galleries and the column arcades introduced in front of the chapels. The most important part of the festive, pomp-filled decoration is the organ, made famous by the composer Anton Bruckner, who was the organist there for a seven-year period beginning in 1848, and who was buried under the organ gallery in 1896.

Following Carlone's death in 1708, the architect of Melk, Jakob Prandtauer, took over as director of the construction. Carlone had already planned a spacious courtyard south of the existing monastery buildings, with U-shaped wings that would house the staircase, the library, and the festive hall. The total length from the church to the southern end was 702 feet (114 m); the inner courtyard was 312 by 256 feet (95 × 78 m). Carlone lived to complete the west wing as far as the monastery portal with its Bläserturm (wind players' tower), which is articulated by a large pilaster order that reaches across three floors. The basic idea for the stairwell, which opens onto the courtyard and has a tower above it, goes back to Carlone, but it was Prandtauer who brought it to its ultimate form, with a few very effective alterations. The flights of stairs, which run from the inside to the outside in both directions, open onto the courtyard through arcades with ornamental openwork foliage grilles, and a horizontal arcade provides a serene upper termination to the structure. The large central opening, which, like the other openings, is ennobled by an arch and columns, is triumphantly dramatized by the stairs. The uniquely artistic aspect of the architectural idea is that interior and exterior architecture, interior staircase and ramp, castle and garden architecture have all become one; the ensemble is a cheerful delicacy of southern charm.

By contrast, the central pavilion of the south wing, with its taller pilaster order, high windows, skylights, and attic are more concerned with grandeur and status. Inside it contains a festive hall, which is probably the greatest pageant hall of any castle of the Austrian monastery. It is distinguished by colonnades with columns on high pedestals and by a saturated color scheme of reddish brown, light gray, and gold. The columns, the marble, and the ceiling fresco give the room a festive dignity worthy of an emperor's castle; the whole is a unique tribute to the imperial sovereigns in whose glory the monastery also participated.

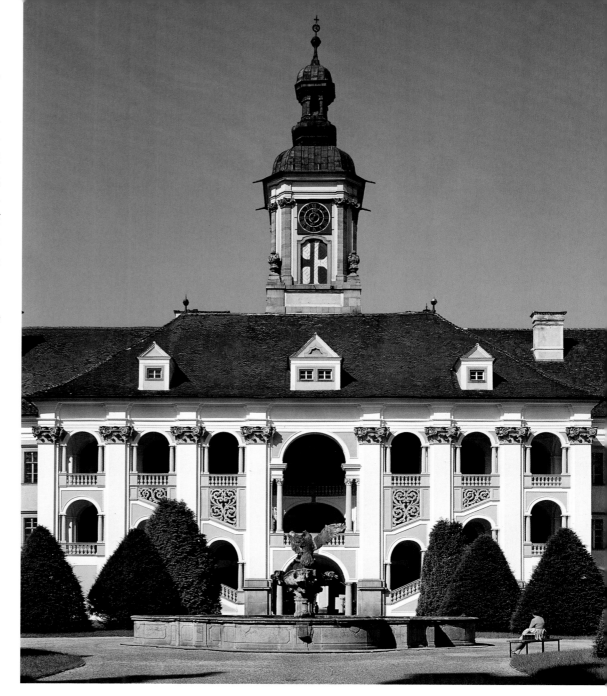

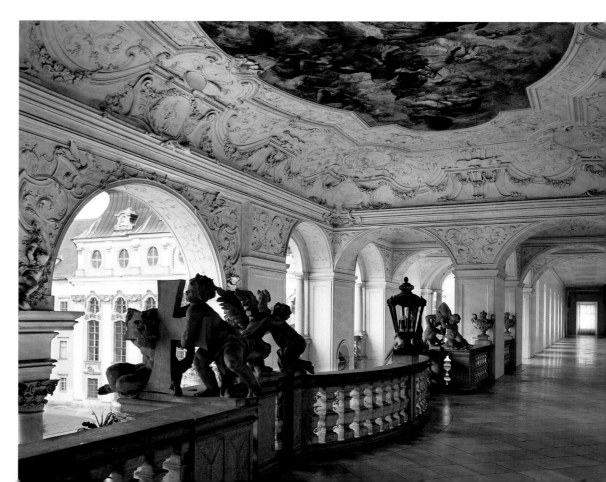

MELK

THE BENEDICTINE MONASTERY MELK, WHICH still houses a community today, is the most famous of the Baroque monasteries in Austria—first, because of its spectacular site on a rocky plateau above the Danube; second, because of the grand unity of church and monastery buildings, to which nothing else can compare. It is on the site of a fortress that served the Babenberg margrave as a palace from the tenth century onward, until Leopold III relocated his residence to Klosterneuburg in 1106. Next to the fortress there was a canonical association with secular priests, but Leopold II transformed it into a Benedictine monastery. After Leopold III abandoned his palace in Melk, he finally donated the fortress mountain to the monastery in 1113. Soon thereafter Melk was granted exemption, that is, independence of the bishop of Passau. In 1297 a fire destroyed the entire monastery. Its very existence was seriously threatened from this point up to the end of the fourteenth century, when it was completely in debt to the Jewish lender Hetel. Shortly thereafter, however, under Abbot Nikolaus Seyringer (1418–25), who had been sent here as *visitator* from the Council of Constance, the monastery became the starting point for a comprehensive reform of the Austrian Benedictine monasteries and, in combination with the University of Vienna, an intellectual and cultural center of the country. The Reformation once again brought Melk almost to the point of closure, but in the seventeenth century it managed to consolidate its economic circumstances.

The present Baroque monastery is the result of an initiative by Abbot Berthold Dietmayr, one of the great prelates of the eighteenth century, who was elected in 1700 when he was only thirty and also held the office of *rector magnificus* of the University of Vienna for a time. He immediately began preparations for a modernization of the monastery, and he found the right architect in Jakob Prandtauer of Sankt Pölten. Initially, the plan was simply to renovate in the Baroque style, then to build a new church; finally, in 1711, the decision was made to rebuild the entire site. The foundation stone for the church was laid in 1702. Prandtauer directed the work until his death in 1726, and his student Josef Munggenast brought it to a conclusion. The building had scarcely been completed when it suffered serious damage from a fire in 1738, which Abbot Dietmayr lived to witness, but he died shortly thereafter. The damage was repaired under Prandtauer's successor, von Munggenast, who also had the church's two towers rebuilt, with slight alterations to Prandtauer's plans. The church, with its lavish decoration, was consecrated in 1746.

The site extends 1,050 feet (320 m) along the ridge of a hill, and facing the town in the valley to the south its extended facade presents a seemingly endless series of fifty-window axes accentuated by three projections. This wing contains the imperial apartments and the rooms in which the court was accommodated, lined up

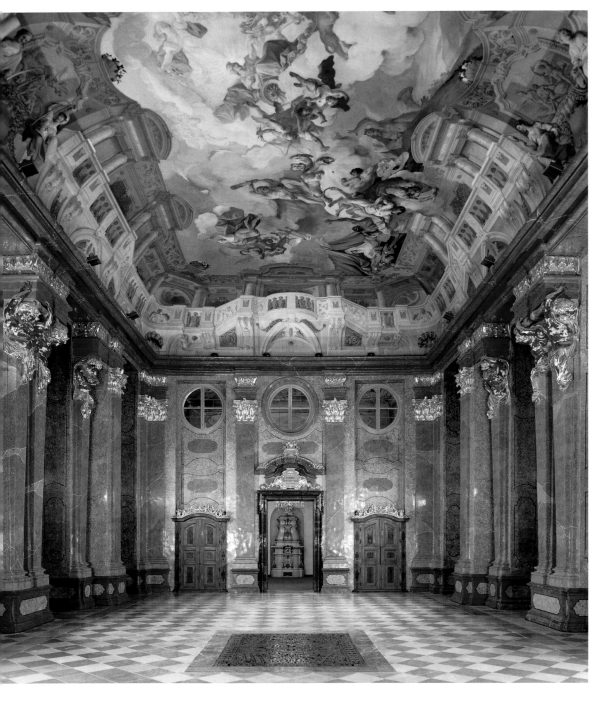

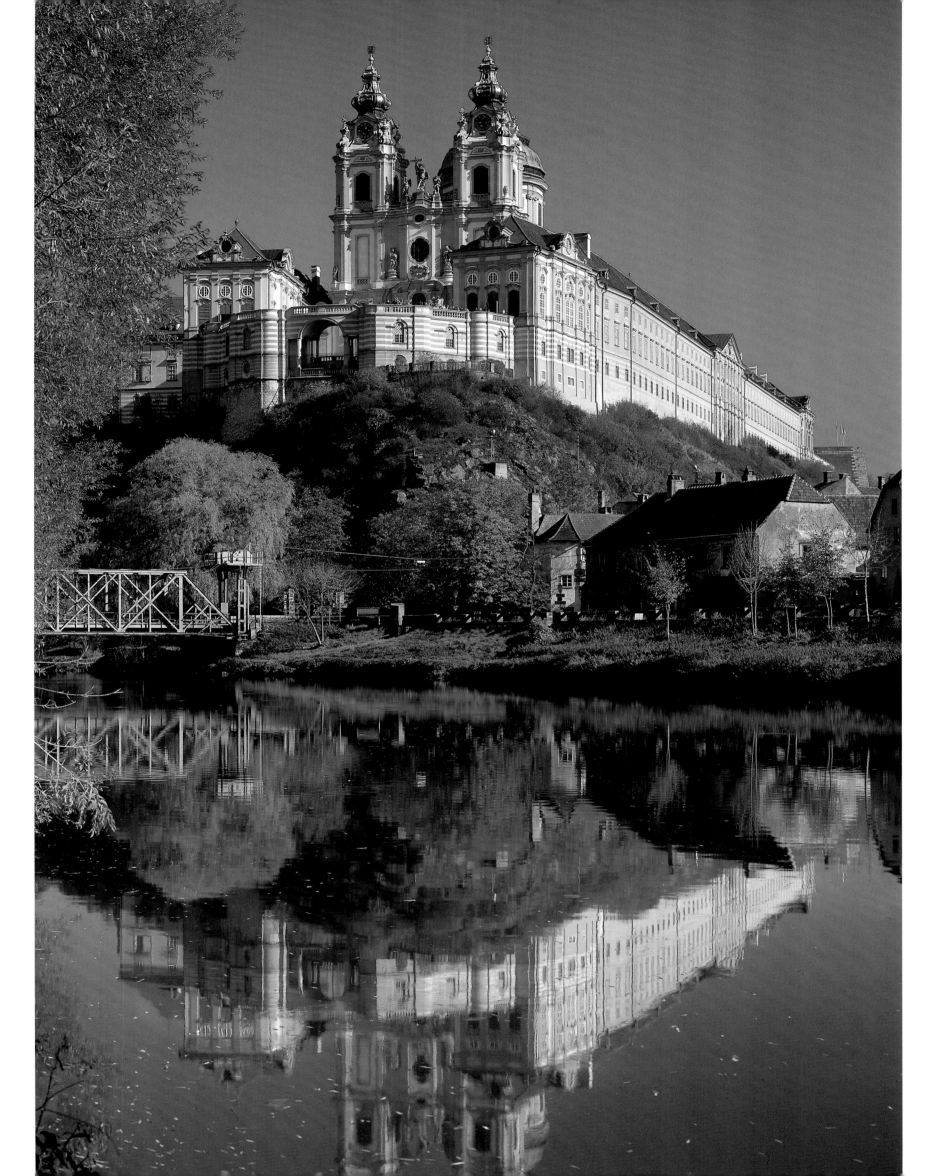

along a corridor of 643 feet (196 m). The enclosure lies on the opposite side; here the buildings project out toward the Danube valley in several terraces, and, in contrast to the town side, they are by no means regular, though the irregularity does not particularly attract attention. Access to the monastery is from the east, between two immense semicircular bastions, through which one arrives in the extensive prelate's courtyard. The display side of the monastery faces west, toward the Danube, a branch of which flows directly under the cliff.

This prospect is an incomparable invention, which has rightly become world famous. In front of the church, with its tall Italian dome on a drum and lively, sculpturally modeled two-tower facade, Prandtauer placed a small terrace that is framed on the sides by the end buildings of the long wings. These buildings are not parallel to each other but at a slight angle, giving the terrace a trapezoidal ground plan with its short side facing the Danube. Here Prandtauer placed a wall that projects outward in a semicircle and has a gallery on its crown; in the middle he left an opening in the form of a *serliana,* which gives a view of the church facade. The group of buildings are in harmony with each other, and it establishes such a fortuitous connection to the landscape that the church and monastery appear to have arisen from nature itself, crowning and dominating the landscape far and wide. It was the topographical situation that gave wing to Prandtauer's invention, a true stroke of genius. The two end buildings, which are so powerfully articulated on the exterior and stand out so distinctly from the restrained side facades, naturally contain the display rooms inside: the library to the north and the marble hall to the south, which was intended as a festive hall for guests. The walls are clad in dark marble and stucco, and above them there is a bright ceiling fresco by Paul Troger that offers a view into the realm of Pallas Athena.

The interior of the church is another luxuriously decorated display room, harmonized in shades of reddish brown and gold. This is the typical timbre of the Austrian high Baroque. The steep proportions of the hall room that is the main block are framed by three side chapels with small galleries and vaulted with shallow rectangular domes. The structure of the wall is determined by a colossal pilaster order with an immense entablature that bends concavely backward in three places. This gives a slightly undulating motion to the boundaries of the room. In contrast there are balustrades in the gallery that curve out in the opposite direction, which give a suggestion of playful, lavishly decorated theater loges to an otherwise severe structure. The theater specialists Antonio Beduzzi and Giuseppe Galli Bibiena had a hand in this. Prandtauer, however, was concerned with lending tension and motion to the tectonic heaviness of the order. The result is a space that has something majestic and powerful to it but is also filled with great pathos. The decoration gives this pathos a touch of the ecstatic, which is heightened when the other sense impressions join in, especially the booming sounds of the organ. The space culminates in the looming dome on a drum; in front of the high altar it rises to immense heights. No other monastery church in Austria is designed to the extent Melk is to overwhelm people by all the means available to architecture and the arts of decoration and to "raise them up," to phrase it in Baroque terms.

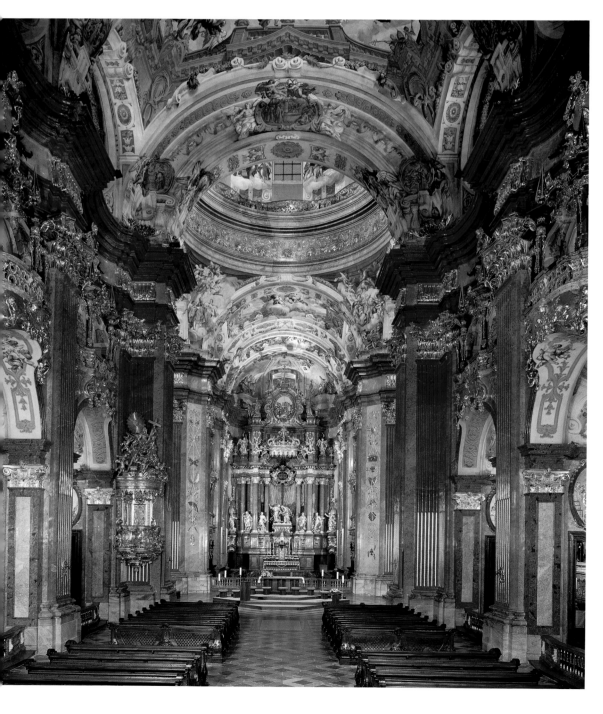

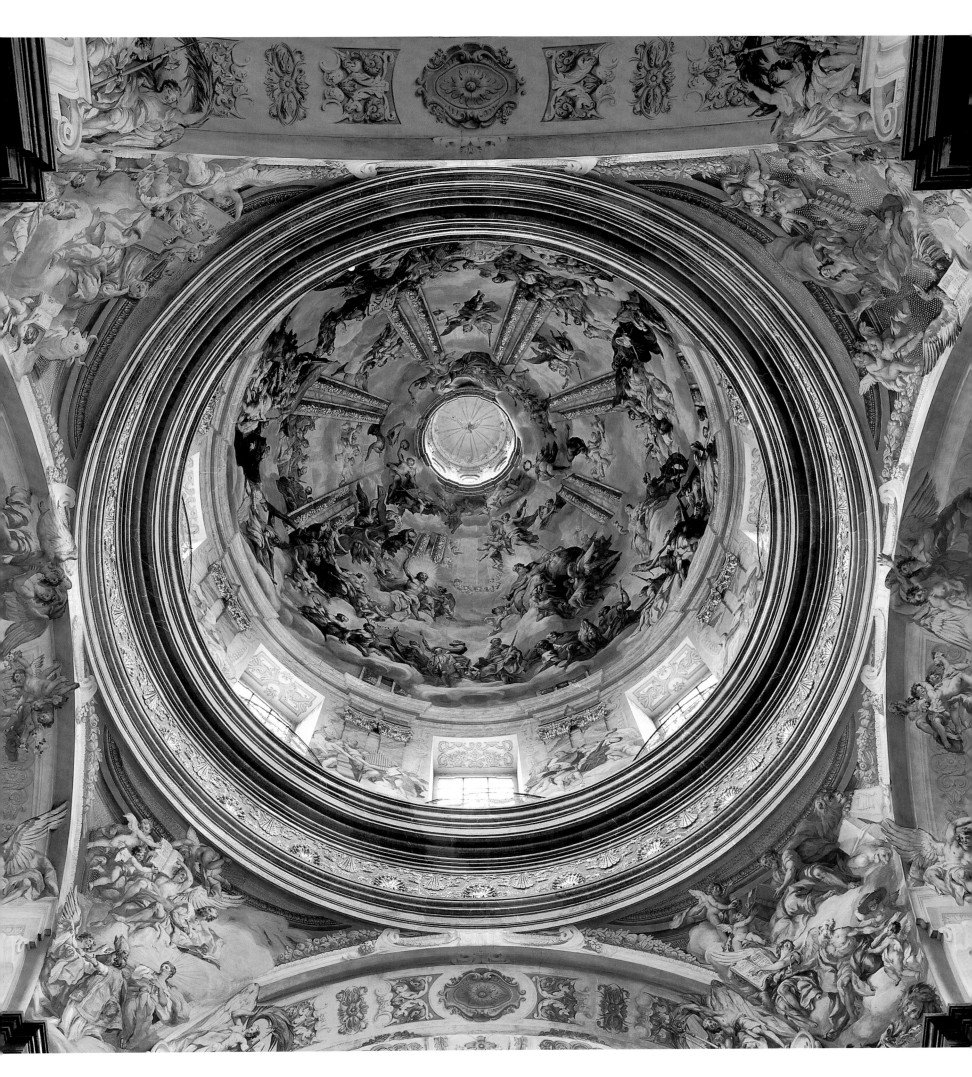

GÖTTWEIG

BELOW:

Salomon Kleiner, engraving of the monastery of Göttweig from the west, 1744–45

OPPOSITE PAGE:

Paul Troger, ceiling fresco, emperors' staircase

THE AUSTRIAN MONASTERY GÖTTWEIG, WHICH lies on a mountain across the Danube from Krems, is still a functioning Benedictine abbey. It was founded as an Augustinian canonical association in 1083 by Bishop Altmann of Passau (d. 1091). Persecuted by followers of Emperor Henry IV and driven out of Passau, he found refuge with the Babenberg margrave Leopold II and was later buried in Göttweig. He is still worshiped as a saint here, although he was never canonized. In 1094 Göttweig was transformed into a Benedictine monastery and settled with monks from Sankt Blasien monastery in the Black Forest.

Göttweig had its heyday under Abbot Gottfried Bessel, who led the monastery from 1714 to 1749. When Charles IV was crowned emperor in Frankfurt in 1711, Bessel led the religious ceremony. He remained in contact with the imperial couple thereafter, as well as with the house of Schönborn. As soon as he was elected abbot, Bessel began to consider building a new monastery. However, it was not until 1718 that a devastating arsonist's fire—which later led to rumors that it was set by the abbot himself—created the conditions for a new large-scale plan. The architect chosen was Johann Lucas von Hildebrandt of Vienna, architect to the imperial court and the favored architect of Prince Eugene and the

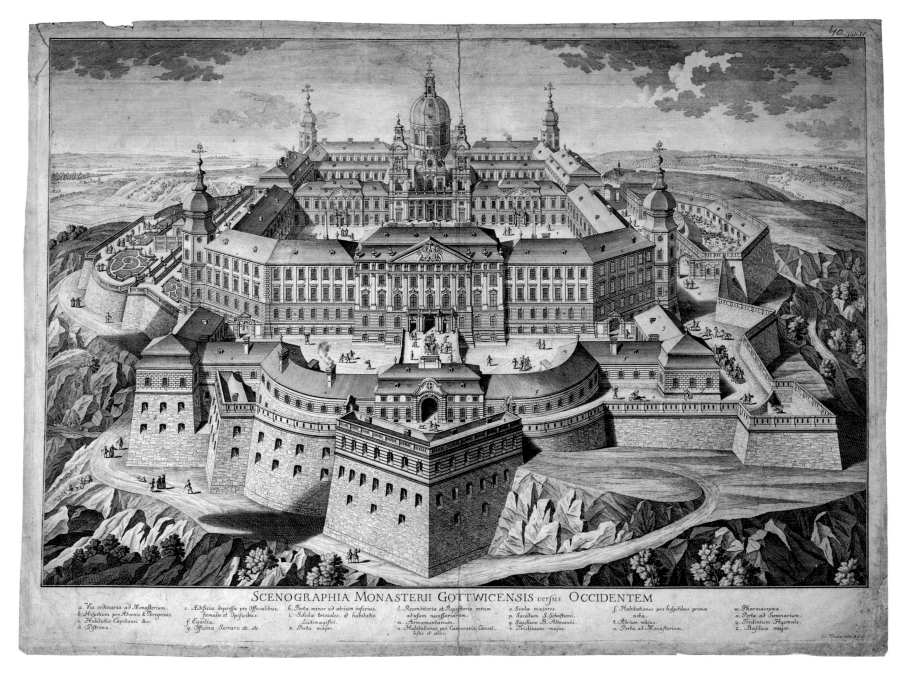

SCENOGRAPHIA MONASTERII GOTTWICENSIS *versus* OCCIDENTEM

a. *Via ordinaria ad Monasterium.*
b. *Hospitium pro Advenis & Peregrinis.*
c. *Habitatio Capitanei &c.*
d. *Pistrina.*
e. *Ædificia depressa pro Officialibus, famulis et Opificibus.*
f. *Equilia.*
g. *Officina Serrarii &c. &c.*
h. *Porta minor ad atrium inferius.*
i. *Scholæ triviales, et habitatio Ludimagistri.*
k. *Porta major.*
l. *Reconditoria et Repositoria rerum ad usum necessariarum.*
m. *Armamentarium.*
n. *Habitationes pro Camerario, Cancellistis et aliis.*
o. *Scalæ majores.*
p. *Sacellum S. Sebastiani.*
q. *Sacellum B. Altmanni.*
r. *Triclinium majus.*
s. *Habitationes pro hospitibus prima nota.*
t. *Atrium majus.*
u. *Porta ad Monasterium.*
w. *Pharmacopœa.*
x. *Porta ad Seminarium.*
y. *Triclinium Hyemale.*
z. *Basilica major.*

imperial vice chancellor, Friedrich Karl von Schönborn. The building project was intended to be ambitious if only for the reason that Charles IV was entertaining a plan to raise Vienna, the small diocese of the house of the Habsburgs, to an archdiocese—at the expense of the enormous diocese of Passau—with the monasteries Melk, Göttweig, and Klosterneuburg as its suffragans.

Hildebrandt's project—details of which were altered, in particular with respect to the stairwell, by Franz Anton Pilgram, who directed the construction after 1734—was published in 1744–45 at the behest of Abbot Bessel by the engraver to the imperial court, Salomon Kleiner of Augsburg, with fifteen engravings. Particularly striking are the immense bastions that make the monastery look like an impregnable fortress. The monastery area itself is an extended castle with a wide court of honor in front of the church's facade, which lies on the middle axis, and two smaller, enclosed courtyards to the left and right of the church. All of this is dominated by an Italian dome on a drum that looms high above the two-tower west facade. Extended wings run along all four sides. They are framed by domed turrets in the corners and accentuated by a central pavilion, which helps prevent the endless axes of windows—no fewer than thirty-three on the long sides—from seeming too monotonous. The east wing, which faces the Danube, and the north wing were the only ones completed. The old church, which had been almost entirely spared by the fire of 1718, received a facade in 1754 based on Hildebrandt's plans. Only a few parts of the fortifications were completed.

The showpiece of the festive rooms is the emperors' staircase in the diagonal wing northwest of the church, which leads one luxuriously to nowhere, since the central wing to the west, with the emperors' hall to which the staircase was intended to provide access, was never built. The staircase starts on the side with two arms that bend at right angles at a landing, meeting in the center and joining to form a single arm. The room is brightly lit by several levels of window walls on each of the long sides. The extremely shallow 2,422-square-foot (255-sq.-m) ceiling is a technological masterpiece. On this ideal ground Paul Troger painted a fresco in 1739, which lifts Charles VI into the heavens by depicting him as Helios Apollo on his sun chariot and celebrates him as god of the muses as well. It is all an allegorical tribute to the good government that sheds light on everything. An apotheosis of Saint Benedict would have been painted in the monks' staircase, which was conceived as a pendant to the emperors' staircase; it was planned for the south end of the monastery but it was never built.

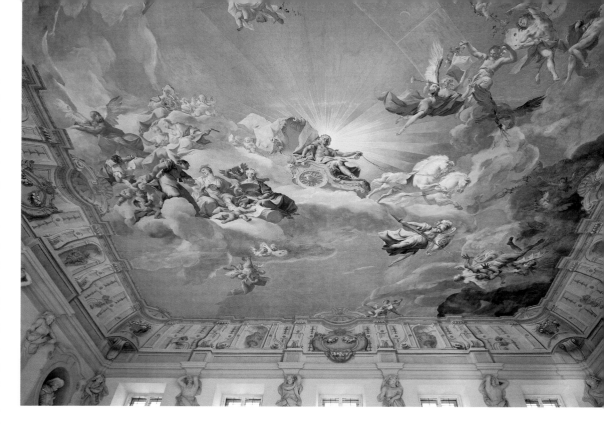

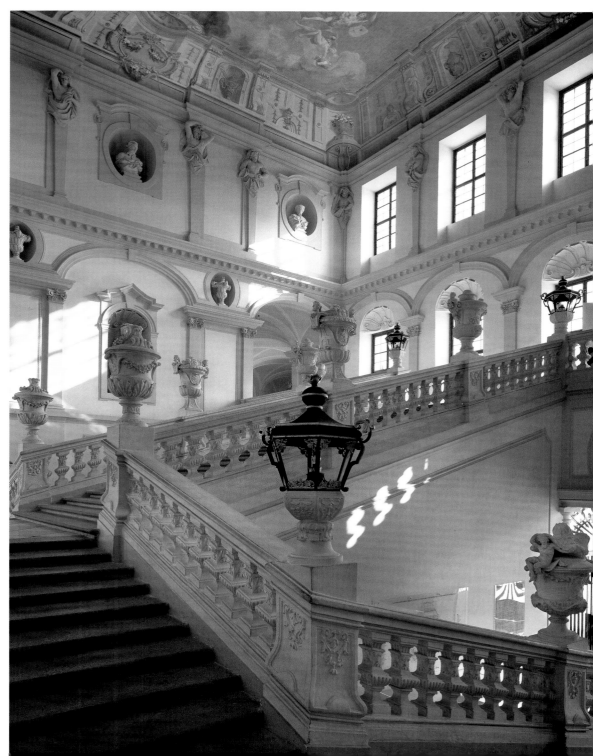

KLOSTERNEUBURG

Emperors' hall, Klosterneuburg

KLOSTERNEUBURG, WHICH IS STILL A FUNCTIONING Augustinian canonical association today, lies directly on the Danube just upriver from Vienna. Its founder was the Babenberg margrave Leopold III of Austria, known as Saint Leopold (1095–1136), who was married to Agnes, Emperor Henry V's sister. Later its foundation was embellished with a typical medieval legend, which was meant to demonstrate that

it was heaven itself that provided the impulse. It was said that once when the couple stepped out onto the balcony of their castle on the Kahlenberg, above Vienna, the margravine's precious veil was carried off by a breeze, and searches for it proved futile. Nine years later, when the margrave was out hunting, he found the veil undamaged in an elderberry bush. At that moment the Virgin Mary appeared before him and ordered him to build a church and monastery in her honor on this site, and the margrave promptly undertook to do so. This story was depicted on four panels in 1505 by the Passau painter Rueland Frueauf the Younger (Klosterneuburg, Stiftsmuseum), probably on the occasion of Leopold's canonization in 1485.

Contrary to the legend, there had been a Roman fortress on the site. The monastery, which originally housed secular canons, was probably built on the foundations of that fortress around 1100. Margrave Leopold had a stately palace built immediately adjacent to it. Only after 1113, when the monastery came into his sole possession, did he decorate it lavishly and entrust it to the Order of Augustinian Canons in 1130. In 1114 work on the church had begun: a three-nave basilica with transept, square chancel, three apses, and an octagonal crossing tower—but not west towers; the present towers were added later. This church, which was consecrated in 1136, is the core of the existing one. The Romanesque structure, whose exterior was restored too drastically in the nineteenth century, was completely redone in the Baroque style during the seventeenth and eighteenth centuries.

The surviving medieval monastery buildings include the cloister, which is lavishly articulated by slender columns and vaulted with six-bay rib vaults; its south and east wings, built in the thirteenth century, are closely related to Cistercian cloisters in Austria from this period. The most important Gothic building at Klosterneuburg was the sensational Capella Speciosa, which was consecrated in 1222. It stood in the palace building that Leopold VI, the Glorious, had built to replace the old palace, after he moved the seat of his government to Klosterneuburg in 1198. The chapel had a two-tier wall structure and was finished in very costly yellow, red, and white marble. The workers must have come directly from France, either from Reims or Burgundy. In 1799 the chapel, only drawings of which survive, was demolished.

In the eighteenth century Charles VI, who had been the Habsburg pretender to the Spanish throne before he was elected emperor in 1711, wanted to build an Austrian

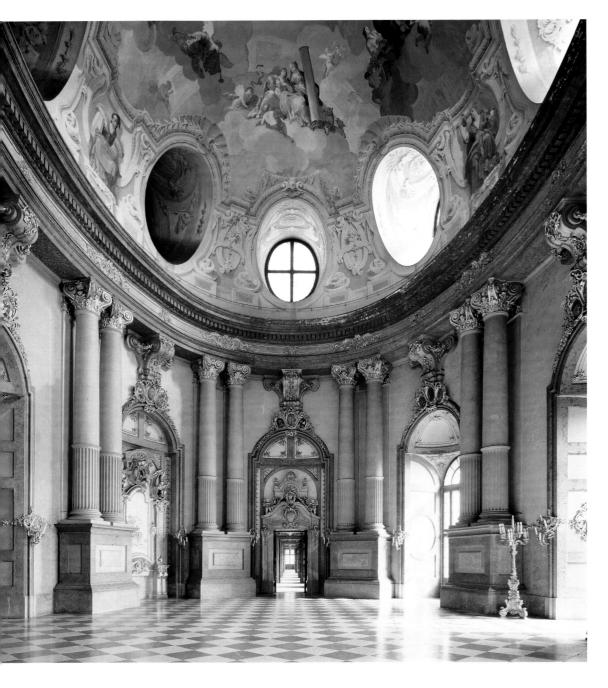

Escorial near the imperial city of Vienna, a monastery castle with an imperial residence. He chose Klosterneuburg for this purpose, which, after all, had been a ruler's palace associated with a monastery as early as the Middle Ages and was the burial site of Saint Leopold, who had been made the patron saint of the area on either side of the Enns in 1663. In addition, the Austrian archduke's hat was kept here. The fortifications engineer Donato Felice d'Allio was appointed architect. His plans were reworked by Joseph Emanuel Fischer von Erlach, however, the favorite architect of the director of architecture to the court, Gundacker Graf Althan. The most revealing impression of the project, for which many plans have survived, is provided by a bird's-eye view that is held at Klosterneuburg and can be dated to 1774 based on a chronogram in the legend. This view was made long after work on the project had been stopped.

They were begun in 1730, but just ten years later the project came to an end with the death of Charles VI in 1740. Not until 1836–46 did Joseph Kornhäusel at least complete, in a simplified form, the courtyard on the northeast side.

As the bird's-eye view shows, the original plan had been for four courtyards: two next to the church, which was to be completely redone in the Baroque style, with a new two-tower facade and a dome, and two next to the stately stairwell, crowned with a tall dome on a drum. The wings were to be articulated by the corner and middle pavilions that were common at the time. Each has a dome or a domelike roof, so the site would have had no fewer than nine domes in addition to the spires of the two church towers. On the east side, facing Vienna, the central pavilion bulges outward as a domed rotunda; the emperors' hall was located here, and the

Joseph Knapp, ideal view of the monastery palace of Klosterneuburg, 1744. Ink drawing with watercolor

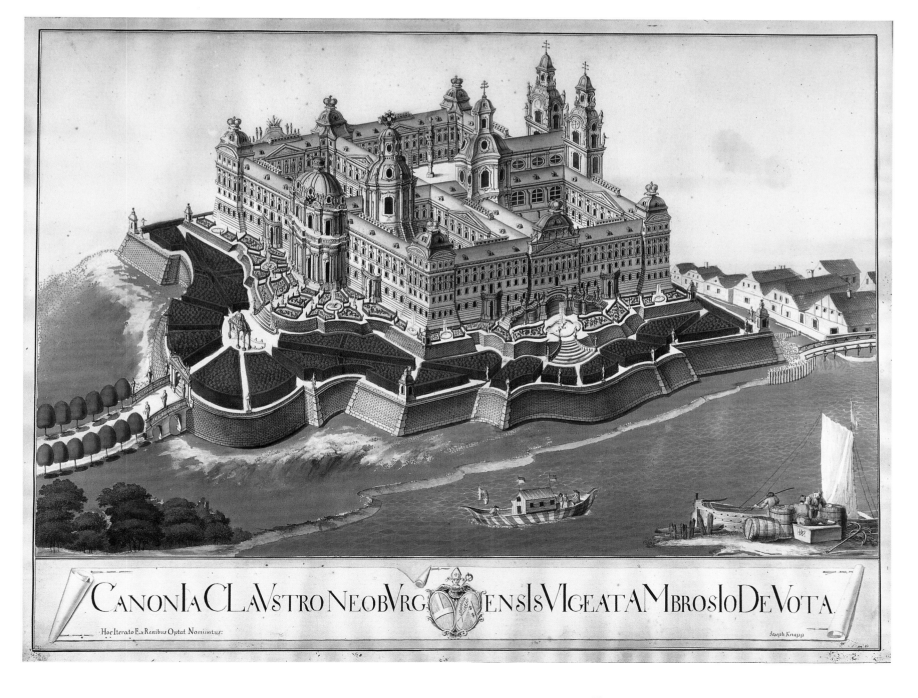

CANONIA CLAVSTRO NEOBVRGENSIS VIGEAT AMBROSIO DEVOTA

Hoc Iterato Ex Renibus Optat Nominatus:

Joseph Knapp

Rueland Frueauf the Younger,
The Legend of the Founding of
Klosterneuburg, *1505. Panel
paintings (Klosterneuburg, Stiftsmuseum)*

OPPOSITE PAGE:
Detail of the Verdun altar, 1181

stately stairwell led to it. To make it clear even from a distance that this was a monastery castle of the house of Habsburg and of the emperor, the dome over the emperor's hall was a large-format copy of the medieval emperor's crown and that of the corner pavilion facing the Danube, a copy of the archduke's hat.

The emperors' hall also announced the grandeur of the house of Habsburg. It is an oval rotunda clad in marble, with a double-column colonnade and an entablature with no molding that holds the room together like a solid hoop. Oval lunettes with deep jambs are cut into the dome—truly channels of light, which give an impression of the enormous thickness of the walls. The heightened pomp of the overall effect make it seem a somewhat empty repetition of Johann Bernhard Fischer von Erlach's halls, like the ancestors' hall at Frain castle, on the Thaya River, or the central hall of the Vienna Court Library, which were also expressions of the newly won greatness of the Habsburg monarchy. Accordingly, Daniel Gran's dome fresco at Klosterneuburg is an allegory of the fame of the house of Habsburg.

In artistic terms, however, it is not the gigantic imperial project that constitutes Klosterneuburg's

fame, but one of its decorations: the Verdun altar. Today it is in the former chapter house, where Saint Leopold is buried, and serves as his tomb altar. As an attribution in the inscription indicates, it was executed by Nikolaus von Verdun, who would later execute large parts of the Dreikönigenschrein (Three Kings Shrine) in the Cologne cathedral. The altar is one of the most important medieval works in metal and enamel. It was produced in 1181 as a cladding for the chancel, and in 1331 it was redesigned for use as a winged altar. The theme is three stages in the history of salvation: the middle zone depicts the New Testament covenant *sub gratia,* that is, under Christ's grace; above that is the Old Testament era *ante legem,* that is, before Moses presented the tablets of the Law; and below it is the era after the Law, *sub lege.* Thematically related events from each of these three areas are related to one another, making it clear that the Old Testament is fulfilled in the New Testament. This way of visualizing in types and antitypes, known as typology, was characteristic of medieval thought. In artistic terms the work represents a great renaissance of antique forms that is seen in the art of the Maasland during this period.

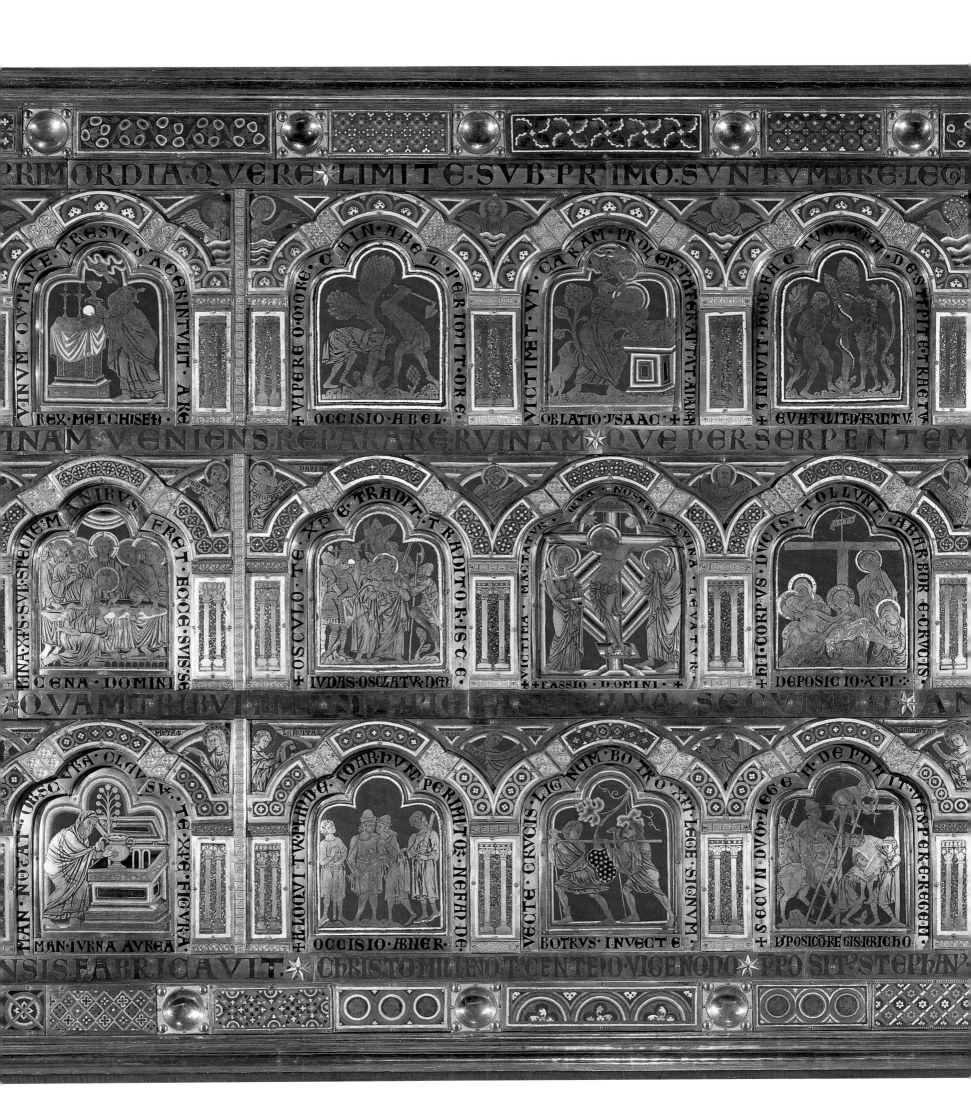

PRIMORDIA·QVERE✦LIMITE·SVB·PRIMO·SVNT·VMBRE·LEG

VINVM·QVI·PANE·PRESVL·SACERINTVLIT·ARC	·C·IN·ABEL·PERIOITORE	·CARAM·PROLEM·PATER·ATAIARA	·INDVIT·HOC·TVO····CM·D·ESTIPITE·TRACTVS
REX·MELCHISED·	✠ OCCISIO·ABEL·	OBLATIO·YSAAC ✠	✠ EVA·TVLIT·BRVTV·

INAM·VENIENS·REPARARE·RVINAM✦QVE·PER·SERPENTEM

BINAXPS·SVB·SPECIE·MANIBVS·FRET·EQCE·SVIS·SE	·OSCVLO·TE·XPE·TRADIT·TRADITORIS·TE	·CENA·NOSTRA·RVINA·LEVATVR	·TOLLVNT·AB·ARBOR·E·CRVCIS·
CENA·DOMINI·	✠ IVDAS·OSCLATVR·DCM·	✠ PASSIO·DOMINI· ✠	✠ DEPOSIC·IO·XPI·

QVAM·ITRIBVIT·M·VNI·PRIG·FA···VNA·SECVNDO✦AN

MAN·TVON·OBSCVR·CLAVSV·TE·XPE·FIGVRA·	·ELOOVI·TVP·HDQ·TOABHVM·PERIMIT·OE·NEFAD·DE	·VECTE·CRVCIS·LIGNVM·BOTRO·XPI·LEGE·SIGNVM	·M·DEPOMIT·VESPERE·REGEM
MAN·TVRNA·AVREA·	✠ OCCISIO·ABNER·	BOTRVS·INVECT·E	✠ DPOSIC·ORE·CISI·RICHO

NSIS·FABRICAVIT·✦CHRISTO·MILENO·T·CENTE·DO·VICENO·DO✦PPO·SIT·STEPHAN

LILIENFELD

East wing of the chancel ambulatory, Lilienfeld

OPPOSITE PAGE:
Interior of the church, facing east

LILIENFELD WAS THE LAST OF THE TRIAD OF GREAT surviving Cistercian abbeys in Lower Austria to be founded, after Heiligenkreuz and Zwettl. The monastery lies in the valley of the Traisen River, surrounded by the mountains of the Prealps. Its founder was Duke Leopold VI, known as Leopold the Glorious, of the House of Babenberg, who united the duchies of Lower Austria and Styria under his rule in 1198. According to an inscription on the building, it was founded in 1202. Leopold chose Lilienfeld as his burial site. The convention, under Abbot Okerus, came from Heiligenkreuz in 1206. When the high altar and the *monasterium*—probably meaning the monks' chancel—were consecrated in 1230 by the archbishop of Salzburg, it seems that the east end, including the transept and the beginning of the main block, had been finished. Not long before this Duke Leopold had died in San Germano in Apulia; his corpse was brought to Lilienfeld and buried in the sanctuary of the church. The final consecration of the church took place around 1263. Meanwhile, with the death of Leopold VI's son, Duke Frederick II the Warlike, who fell in the Battle of the Leitha River against the Magyars in 1246, the reign of the Babenbergs ended, as Frederick was childless. His successor, for a brief period, was King Otakar II Přemysl of Bohemia, who was married to Margaret, Frederick the Warlike's sister, but he died in battle in Marchfeld against Rudolf von Habsburg in 1278. Otakar and his wife apparently supported continued construction of the church at Lilienfeld; Margaret was buried in the sanctuary in 1267.

At a length of 276 feet (84 m), the church is the largest medieval monastery church in Lower Austria. Its significance for the history of architecture is based primarily on its east end. Around the square, cross-rib-vaulted sanctuary, which terminates in five sides of a decagon, there is a two-nave, U-shaped ambulatory. The outer and inner aisles are the same height, which gives the space the form of a hall, comparable to Cistercian refectories and other two-nave monastic spaces. The twelve bays of the outer aisle served as chapels, and they were probably separated by low barriers; the inner aisle formed an ambulatory and a four-part corridor. In the main block, immediately in front of the crossing, the bays of the side aisles are nearly as tall as those of the middle vessel; this one bay was thus the beginning of a hall church. In the bays further to the west, however, the design returns to that of a traditional basilica. The reasons for this remain inexplicable.

Of the medieval monastery buildings, the convent, built around the middle of the thirteenth century, and quite long at 138 feet (42 m), is a particular jewel of the early Gothic. It is a classic example of the mason-architects love for vault ribs and arcades with strong profiles in different forms with reedlike columns and bud capitals. There were no fewer than 478 such columns, in red Lilienfeld marble, in this cloister.

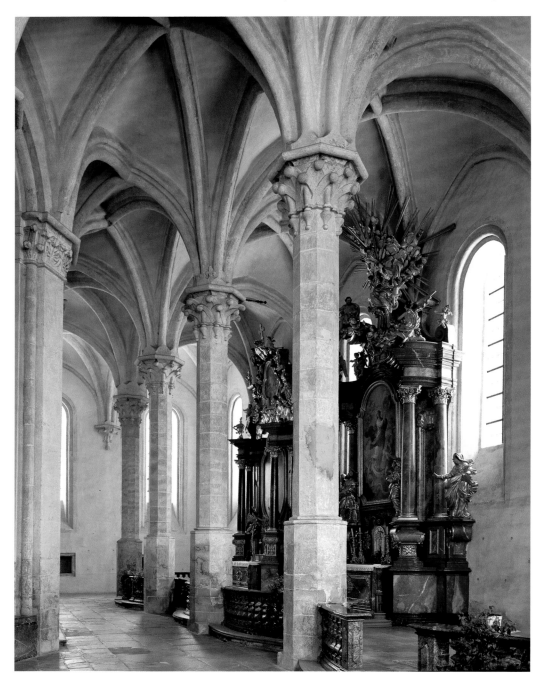

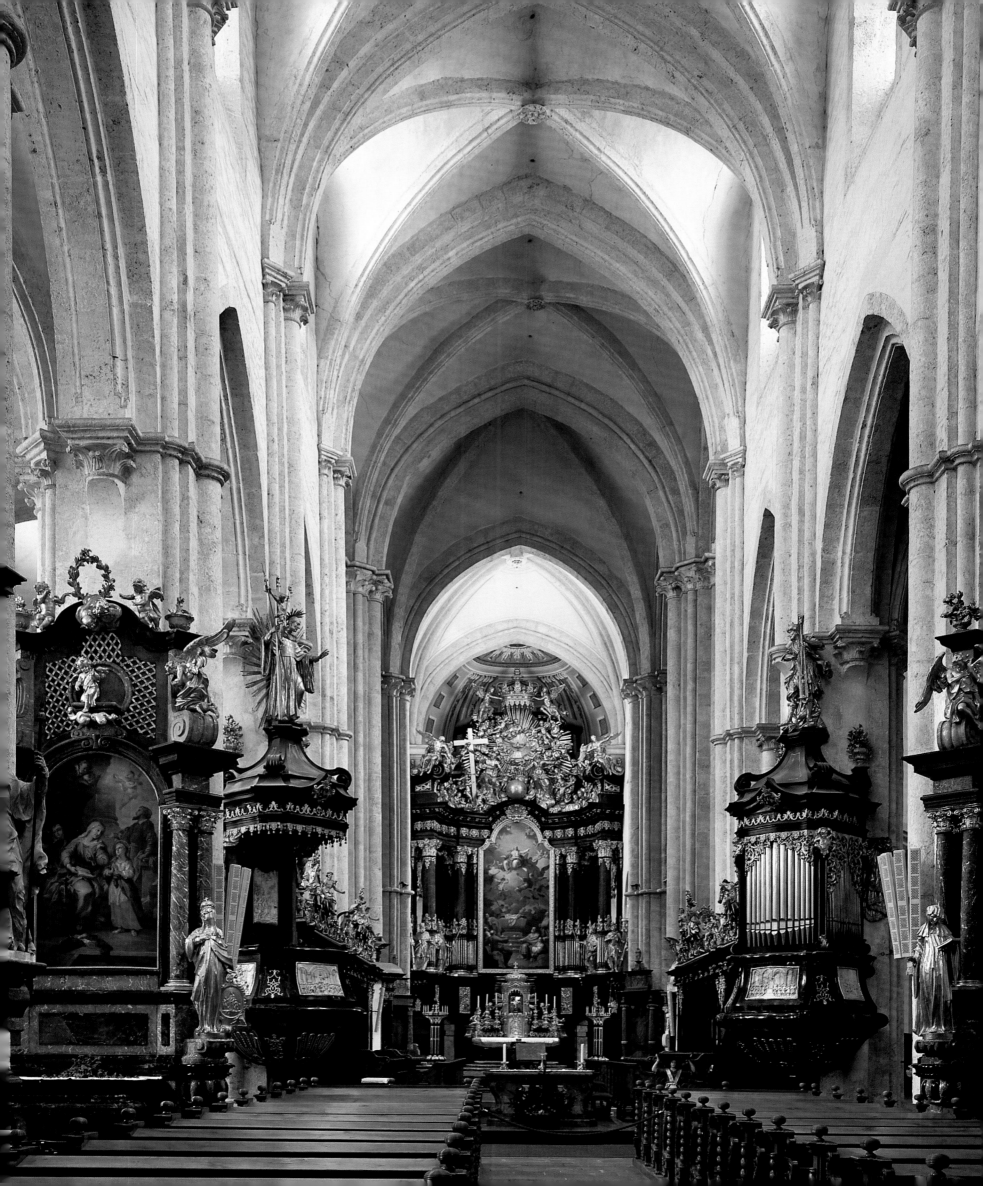

HEILIGENKREUZ

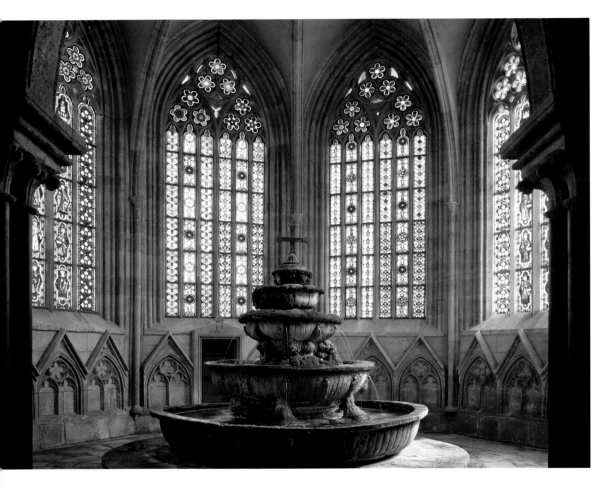

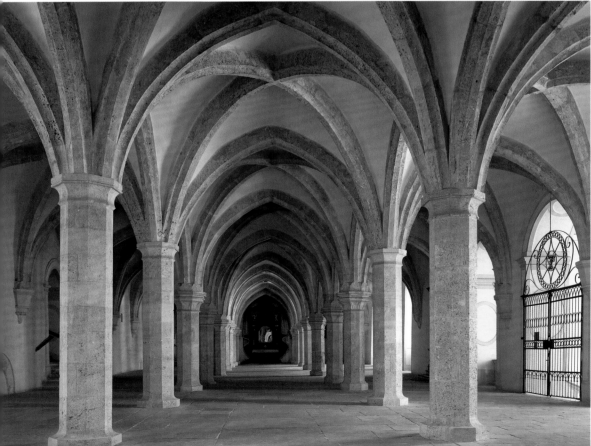

EILIGENKREUZ IN THE VIENNESE FOREST IS the oldest Cistercian monastery in the territories of the Babenberg margraves and dukes in present-day Austria. Its initiator was one of Margrave Leopold III's sons, Otto of Freising, who would later become famous as a historian and bishop of Freising. Through his mother, Agnes, who was the daughter of the Salic emperor, he was the half brother of the Hohenstaufen king Conrad III. When Otto returned from his studies in Paris in 1132, he was so impressed by the Morimond monastery that he entered there with fifteen of his fellow students. In 1138 he was elected abbot, but that same year he was named bishop of Freising. From Morimond, around 1133, he arranged for his father to found a Cistercian monastery on Babenberg lands, and his father made properties in the Viennese Forest available to that end. Around 1135–36 the first convention arrived from Morimond, under Abbot Gottschalf. During his reign as abbot, which lasted until 1147, the number of monks and conversi is said to have increased to three hundred. Shortly after the foundation stone for the church was laid by the bishop of Passau in 1136, Margrave Leopold died. A period of difficulty followed before Duke Henry II Jasomirgott (1141–77) became the monastery's crucial supporter. Records show that the church was consecrated in 1187, but it seems the transept and chancel were not completed until the thirteenth century. The main block is a bare pile basilica based on the bound system with a strikingly steep and narrow middle vessel. Not until one gets halfway up the naked, completely unarticulated ashlar walls are there three-part projections resting on terraced corbel stones for the arch ribs and cross ribs—all of which have a heavy, box profile.

The primitive stone heaviness of the Romanesque in the main block stands in utter contrast to the Gothic chancel that replaced an older chancel. Its donor is thought to have been Duke Albrecht I, to whom King Rudolf of Hapsburg had entrusted rule over the Austrian lands in 1283. The chancel was consecrated in 1295. It is a spacious, three-nave hall on a square ground plan, with a flat termination in the east and square bays framed by tall tracery windows. The four inscribed piers—looming bundle piers—turn the chancel into a clandestine central-plan space—as if the four-support room of a chapter house had been executed on a gigantic scale. The orientation of the middle vessel toward the especially splendid window in the middle of the east wall tends to create a longitudinal axis that is emphasized by the nave arcades that separate the aisles,

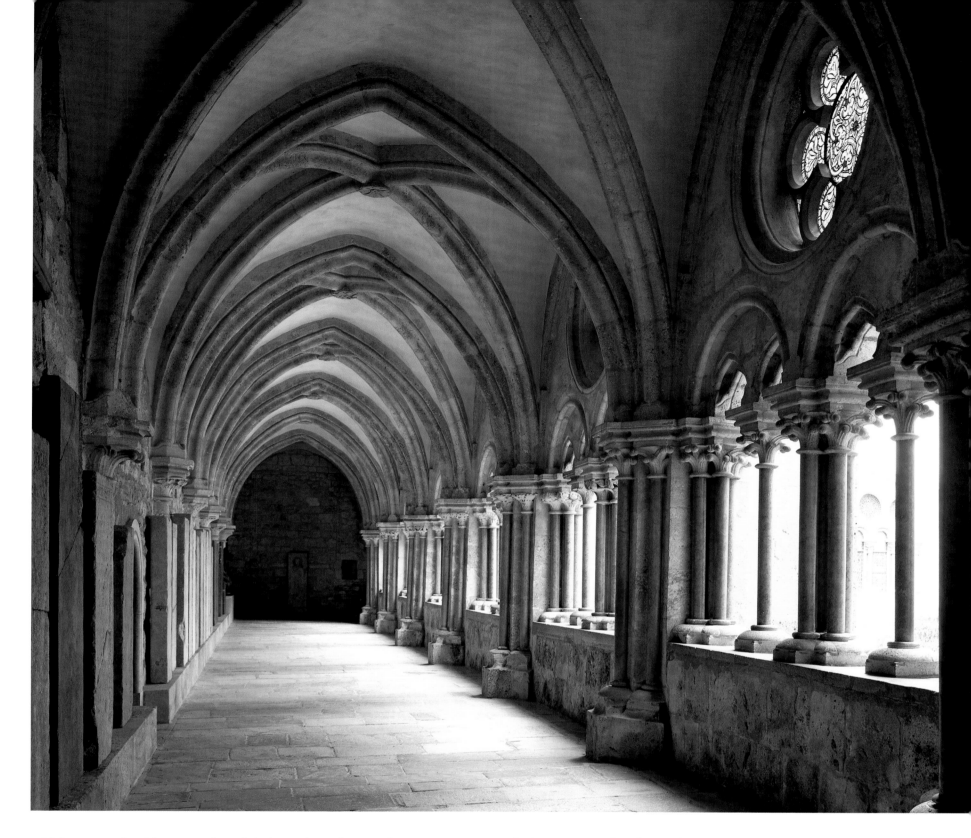

which are noticeably more forceful than the other vault arches. The chancel, which was utterly singular at the time it was built, is one of the spatial wonders of the Gothic. The great era of Austrian hall churches begins here.

The same workers also built the nine-sided well house in the enclosure—a jewel of blind tracery on the plinth wall, delicate astragal profiles in the window jambs, and magnificent four-course tracery windows, whose original grisaille glass has largely survived, as has the thirteenth-century window depicting the Babenberg margraves and dukes. The four wings of the cloister were built earlier than the well house, from about 1220 to 1250, with the support of Duke Frederick the Warlike, who was buried in the chapter house in 1246. In the arcade galleries, with their slender columns, bud capitals, and crown motifs, one sees the early Gothic unfolding, starting in the northwest corner, in a mastery of perfected form and an almost princely splendor—much like the closely related cloisters at Zwettl, Lilienfeld, and Klosterneuburg. This group of cloisters is unique. By contrast, the other rooms are of Cistercian plainness—the chapter house with four octagonal piers, the three-nave frater, and the three-nave dormitory, which is impressive for its angular bareness.

OPPOSITE PAGE:

Heiligenkreuz. TOP: *Well house;* BOTTOM: *Dormitory*

ABOVE:

The cloister, with the so-called Doorman's Gate, on the west side

PAGE 376:

Middle vessel of the church, facing west

PAGE 377:

Gothic chancel

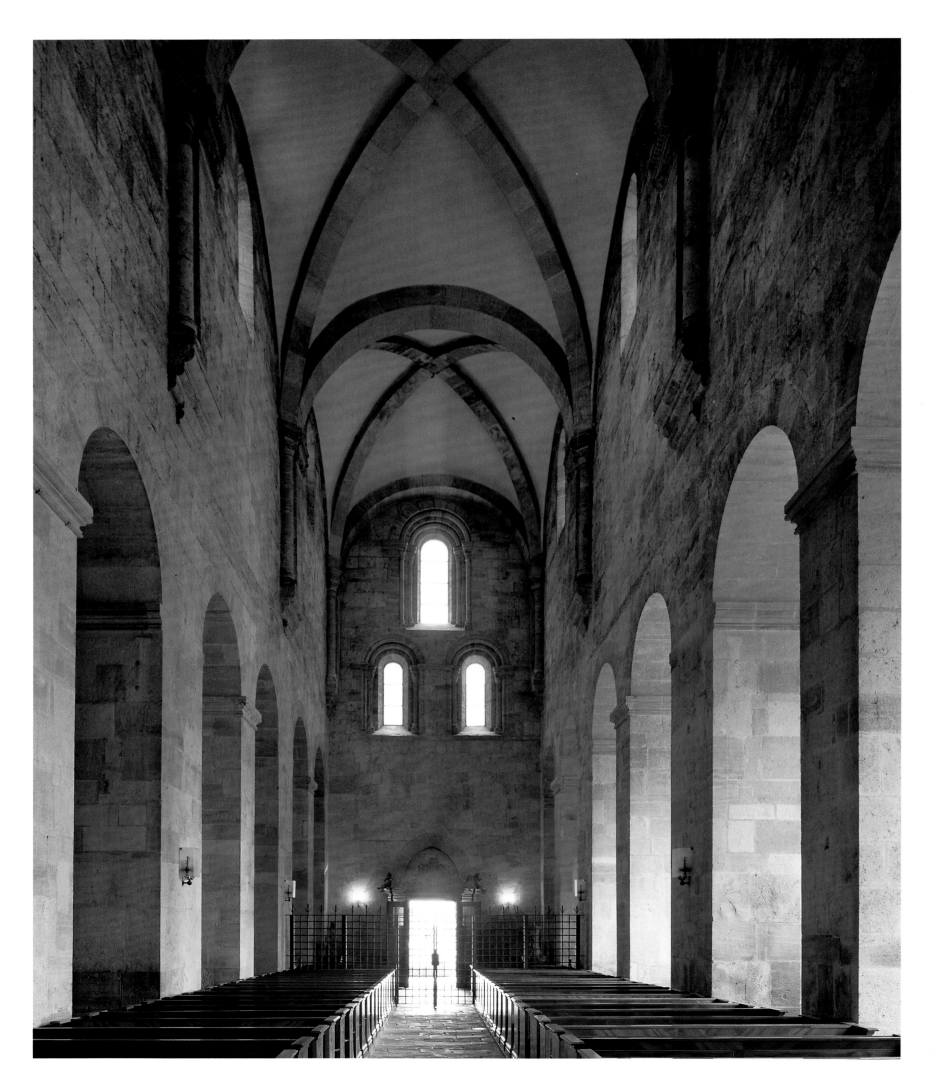

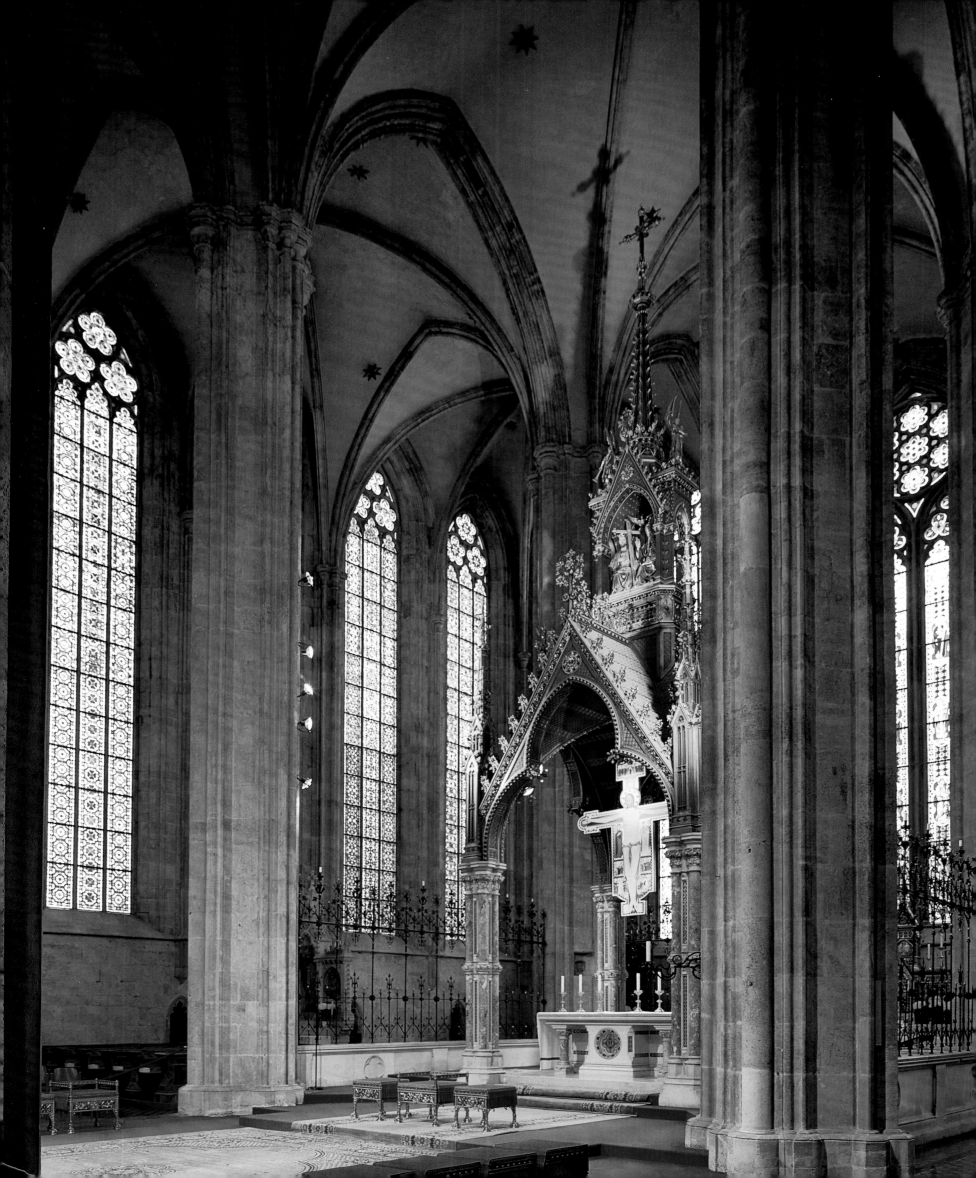

ZWETTL

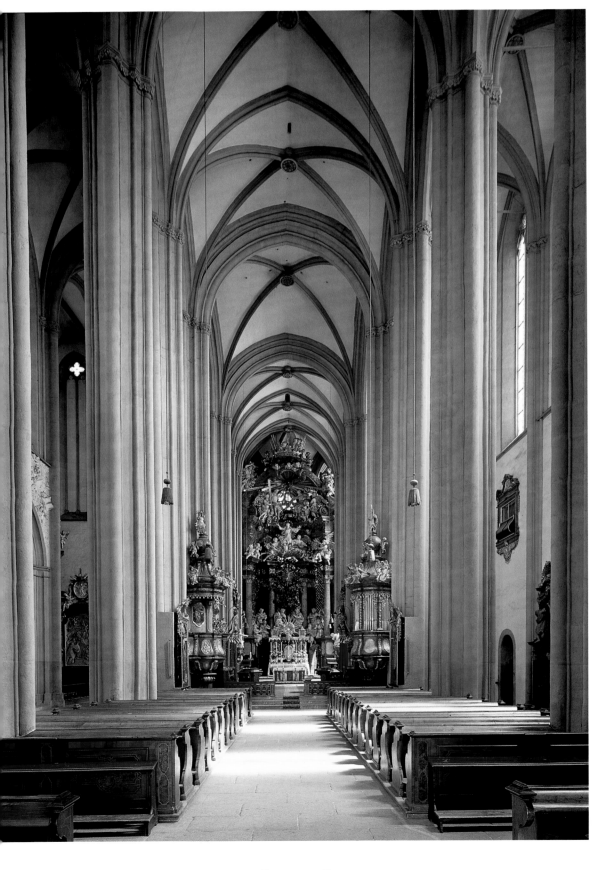

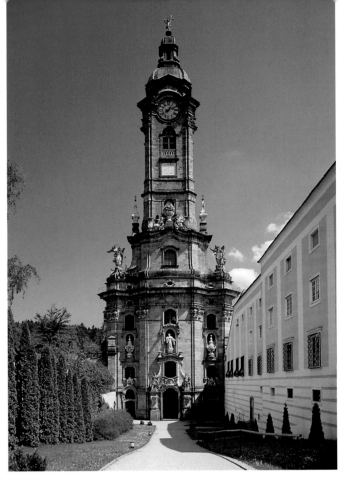

T HE CISTERCIAN MONASTERY ZWETTL, IN LOWER
Austria, lies in a forested area on the Kamp
River. Together with Heiligenkreuz and Lilien-
feld it is part of a triad of surviving Austrian Cistercian
monasteries that rank high in the history of architec-
ture. Zwettl's founder was Hadmar I von Kuenring, a
wealthy estate official for the Babenberg margraves who
brought the first convention to this remote forest near
his castle in 1138. Under Abbot Hermann they came
from the house monastery of the Babenbergs, Heili-
genkreuz, in the Viennese Forest, which had been
founded two years earlier. Its founder was buried in
Göttweig, however. According to legend, the site of the
founding on a plateau in the valley surrounded by for-
est was chosen because an oak tree there was green even
in the depths of winter on New Year's Day. The
monastery took the name Claravallis, even though it
was in the filiation of Morimond, not Clairvaux. The
name Zwettl is of Slavic origin; it means "clearing."

With the active support of the Kuenrings, the
church and the most important monastery buildings
were constructed immediately after the founding—in
the hard granite stone found in the area. They were con-
secrated in 1159. This first phase of construction, which
probably continued until around 1180, produced the
original dormitory, the chapter house, and the latrine
built on arches over the Mühlbach. These are the oldest
examples of Cistercian monastery architecture in Aus-
tria. The dormitory, which is not on the upper story, as
is usually the case, but partially subterranean, is an

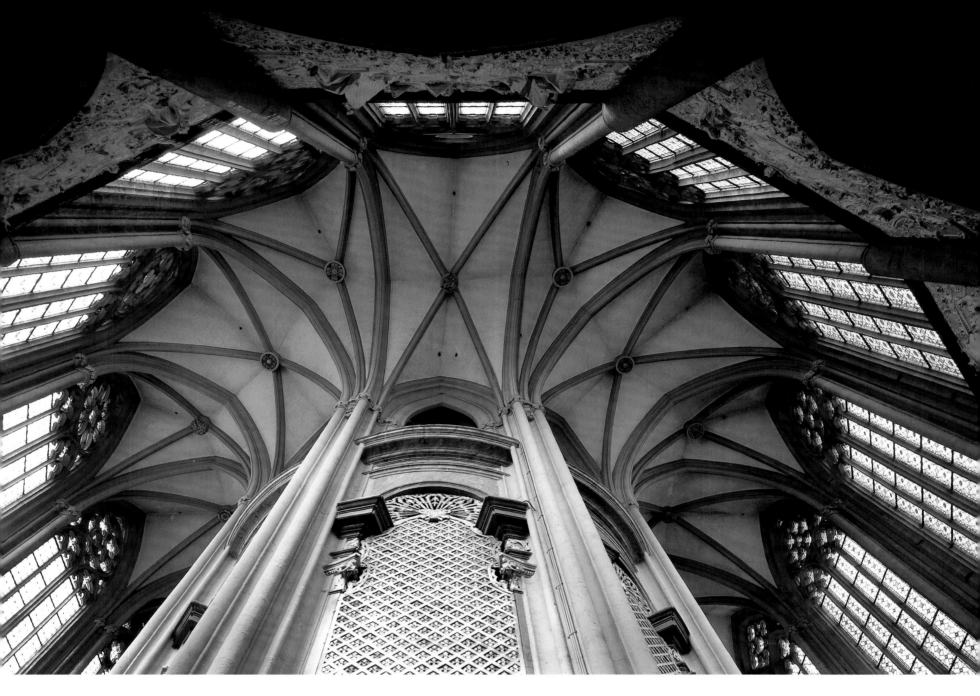

approximately quadratic room with a square pier as central support, arch ribs, and cast cross rib vaults on which the boards of the forms are still visible. The chapter house also embodies this same type of a single-support room, but here instead of groins the vaults have cross ribs whose profile is boxlike to match the arch ribs. The central bearing support represents a singular invention: below it is a normal column with a floor slab (plinth), base, and round shaft; at the head, however, there are four thick and four thin round projections, each with its own capital—these projections are mere stubs, and each is capped by a terraced corbel stone. This form replaces the column capital. It is an example of the Cistercian love of invention.

Beginning in 1204, under Hadmar II von Kuenring, a new cloister with four- and six-bay rib vaults was built. The Romanesque was gradually replaced by early French Gothic. The arcade galleries—in most sections of which two biforia are grouped by means of a relieving arch, which also encloses a crown opening—are irregular in design, betraying a constant search for better, more harmonious solutions, until finally in the south wing, in the well house built around 1240, a perfect Gothic systematic architecture was achieved. The formal character changes several times, and consequently the many small, reedlike columns in the four wings of the cloister—330 in all—reveal an inexhaustible diversity and richness of variety in the bud capitals, ribs, and round profiles. The cloisters at Heiligenkreuz and Lilienfeld, which are closely related to that of Zwettl but were built a little later, are more unified. Zwettl represented pioneering work in introducing the early Gothic, and it did so in hard granite, which made the work all the more difficult.

The present high Gothic church was begun on the east end in 1343. After the wreath of chapels was completed in 1348, construction was halted by an extensive epidemic of the plague; it continued again from 1360 until the consecration of the high altar in 1383. The master Jan came from the masons' guild of Saint Stephan, in Vienna.

OPPOSITE PAGE:
Zwettl. BOTTOM LEFT: *Interior of the church, facing east;* TOP RIGHT: *West facade of the church*

ABOVE:
Vaulting of the chancel ambulatory

The eastern bays of the main block followed in 1490–95. The Romanesque main block in the west survived until 1722, when it was gradually replaced by the present Gothic bay to conform with the rest of the church. The Baroque west facade was built at the same time by Josef Munggenast, based on plans by Matthias Steinl. The Gothic building is a three-nave hall church with looming bundle piers placed close together. The termination in the east is very important for late Gothic German architecture: a polygonal ambulatory chancel in the form of a hall with a series of rectangular and triangular bays in the ambulatory and a low wreath of radial chapels. The original plan was probably for a basilica, but after construction was interrupted it was built as a hall church instead. The result was one of the first "hall ambulatory chancels"—a building style to which the future would belong. The church's high Baroque, slightly projecting, and powerfully modeled west facade became Zwettl's landmark. Even without its tower it would be a finished, self-contained work, but the tower, which is 295 feet (90 m) tall, makes it something unique: a steep, narrow, powerfully looming architectonic sculpture.

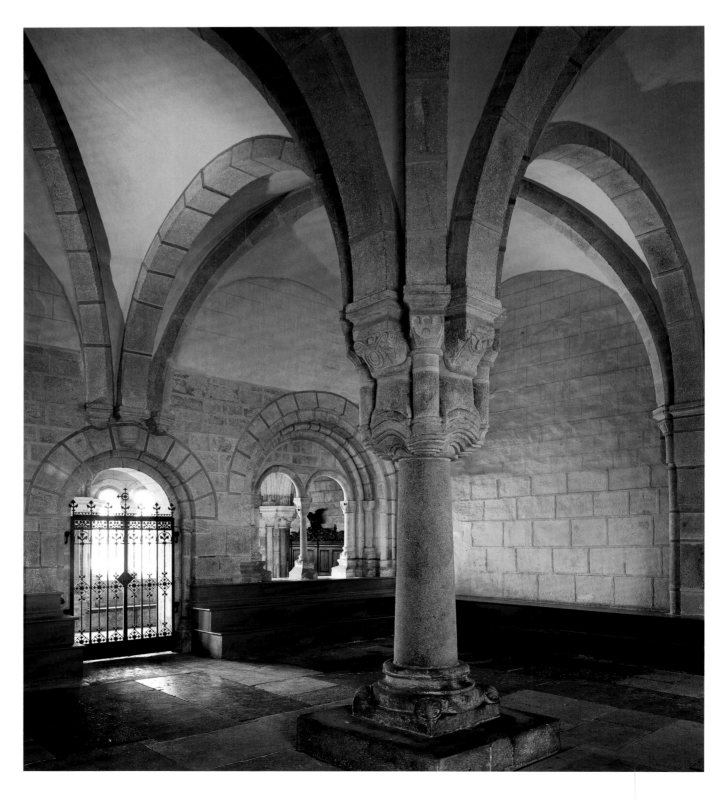

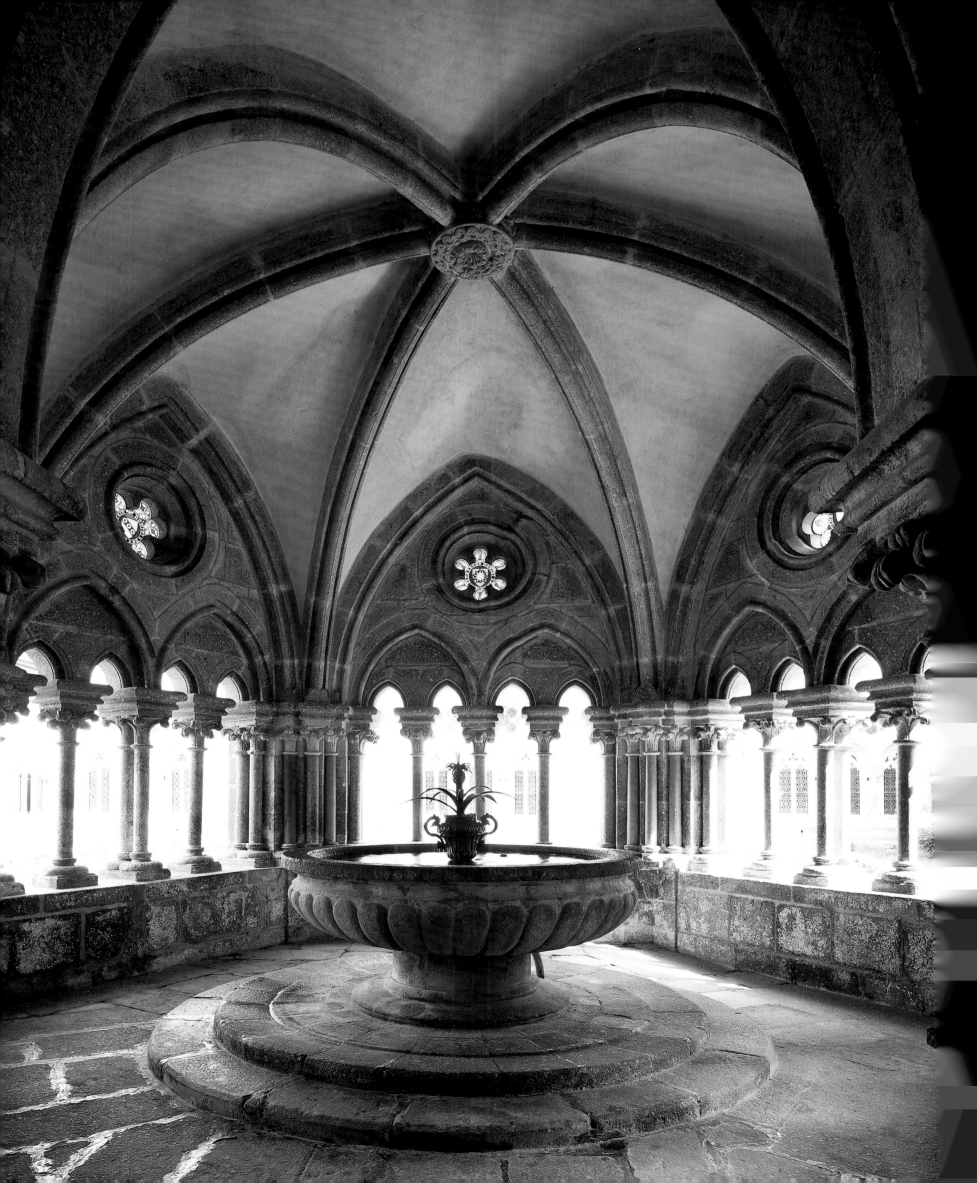

PRAGUE
BŘEVNOV
(BREUNAU)

BELOW:
Festive hall with ceiling fresco by Cosmas Damian Asam

OPPOSITE PAGE:
TOP: *The church from the southwest.*
BOTTOM: *Interior of the church, facing east*

THE FORMER BENEDICTINE ABBEY BŘEVNOV, formerly known in German as Breunau, lies in a Prague suburb near the White Mountain (Bílá Hora), where in 1620, at the start of the Thirty Years' War, Catholic troops defeated the Protestant "winter king" of Bohemia, Frederick of the Palatinate, setting the stage for the kingdom of Bohemia's becoming entirely Catholic again. Břevnov is Bohemia's oldest monastery. It was founded in 993 by Prince Boleslav II the Pious, who belonged to the Přemysl dynasty, and Vojtěch (Adalbert), bishop of Prague, who maintained close connections to Emperor Otto III and was martyred in 997 while doing missionary work among the Baltic Prussians (*Pruzzen*). Vojtěch was buried in the newly founded archdiocesan cathedral of Gnesen, in Poland (from 1039 in Prague), and he became the national saint of the Poles but not of the Czechs. The first monks in Břevnov came from the Alexius monastery on the Aventine in Rome, to which Vojtěch had withdrawn for a time. In the thirteenth century Břevnov received relics of Saint Margaret, who later become one of the first popular saints, as one of the fourteen holy helpers. The church and monastery were dedicated to her.

In the early and high Middle Ages Břevnov was the monastic center of the country, and it founded numerous other monasteries. When the monastery was destroyed by the Hussites in 1420, however, its convention withdrew to the Broumov (Braunau) monastery in northern Bohemia, which had been settled in 1296 by monks from Břevnov for more than two centuries. From 1420 onward a single abbot was responsible for both monasteries. In the seventeenth century the abbots returned to Břevnov. The monasteries flourished under Abbot Ottmar Zinke, who presided over an unprecedented period of building activity from 1700 to 1738, at Broumov, at the Wahlstatt monastery in Silesia that he had refounded (see pp. 388–89), and in Počaply on the Elbe. The priory Rajhrad (Raigern) in Moravia was also governed by Břevnov, and construction took place there as well. The abbot laid the foundation stone for the new

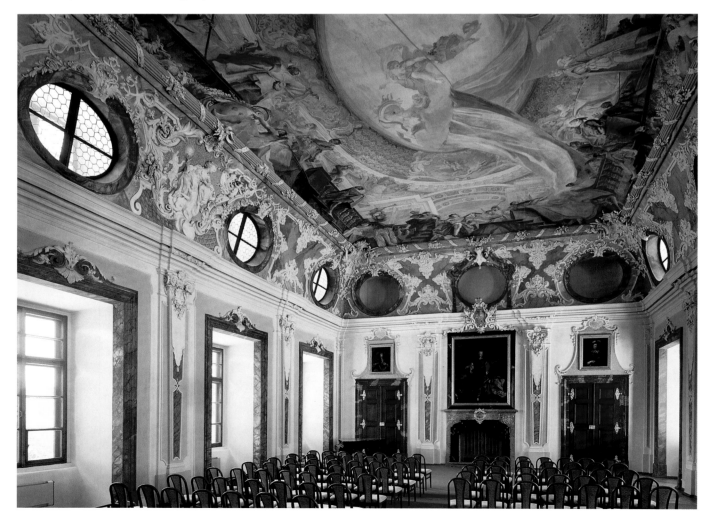

church and monastery at Břevnov in 1708. The architect of the church was Christoph Dientzenhofer, one of five brothers who emigrated from a farm in the Prealpine region of Upper Bavaria to Prague and became architects there. The church was completed in 1717; the monastery in 1740. In 1727 the leading Bavarian fresco painter, Cosmas Damian Asam, was brought from Munich to paint the ceiling fresco.

The church is one of the major works of the Bohemian high Baroque, known today as "radical Baroque." Like the closely related Jesuit Saint Nicholas's church in Prague's Lesser Town, it belongs to a group of churches with a main block whose walls and vault arches are curved throughout. The architecture is made dynamic; the space begins to oscillate and move. The diagonally aligned pier heads are typical: their points extend into the room like the bow of a ship, while the vault has alternating lenticular and sail-like fields. Also of great architectural importance is the rigidly articulated exterior, which is crowned with curved gables, a masterpiece of the moving, heavy pathos that characterizes the radical Baroque.

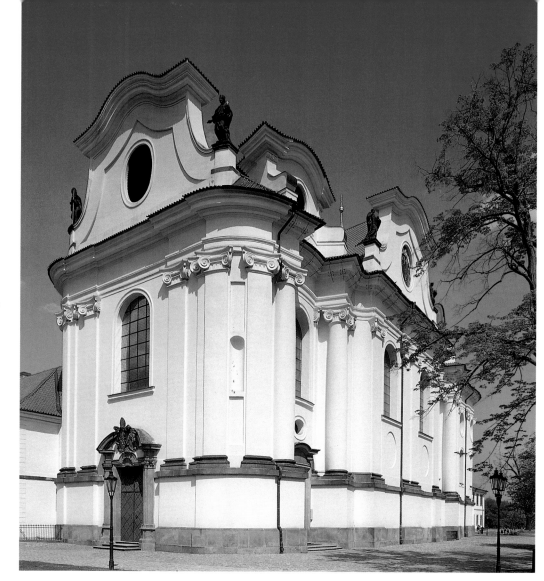

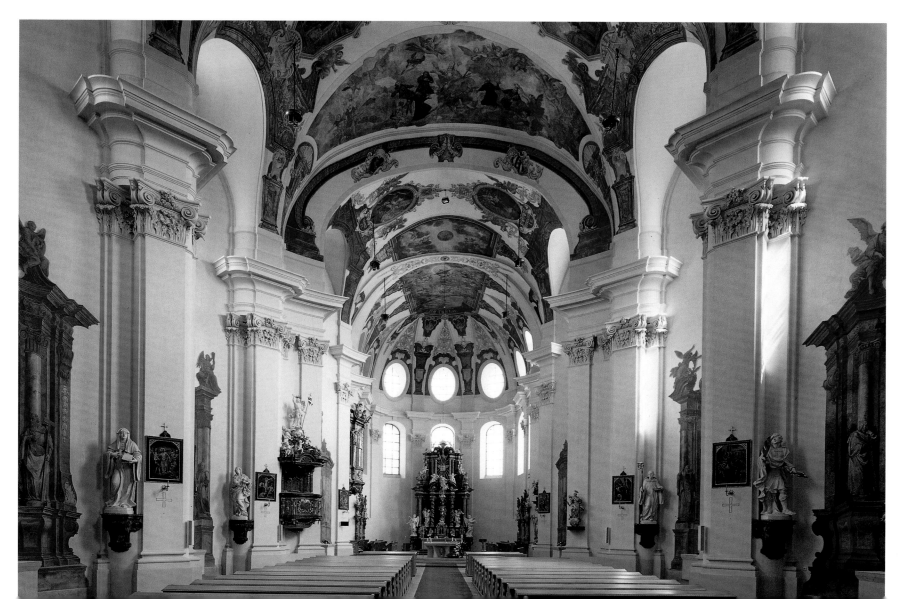

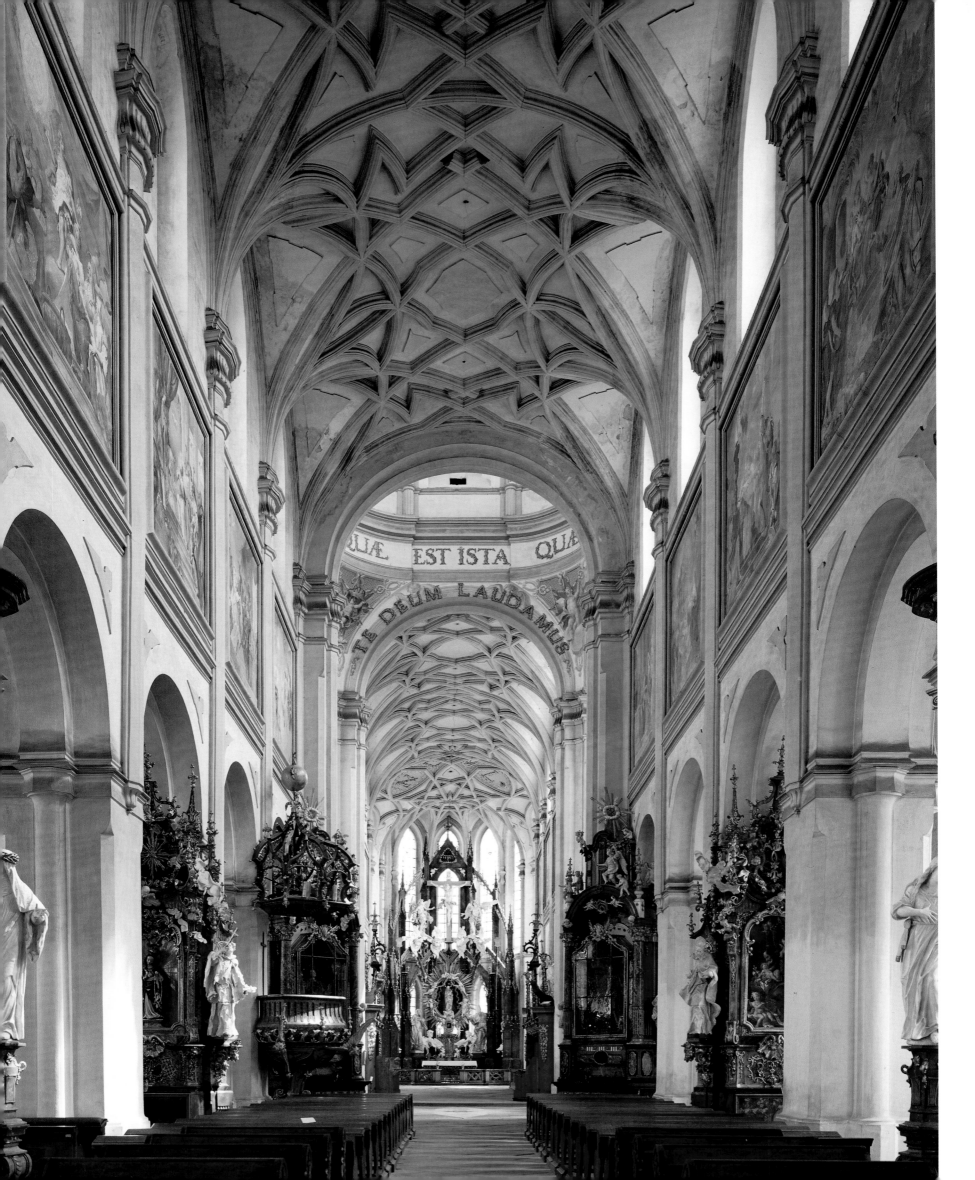

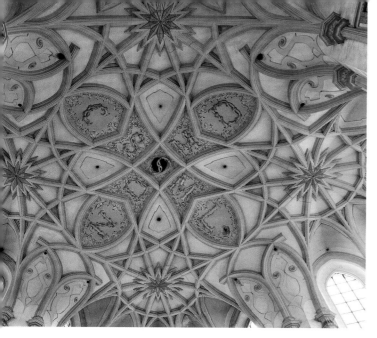

KLADRUBY
(KLADRAU)

OPPOSITE PAGE:
Interior of the church, facing east

ABOVE:
Chancel vault

BELOW:
The church from the southwest with triconch and crossing dome

THE FORMER BENEDICTINE ABBEY KLADRUBY (Kladrau) lies in southern Bohemia, not far from Plzen (Pilsen), near the German border. Together with the Cistercian church Sedlec, near Kutná Hora, its monastery church is the main example of that substyle within Baroque architecture known as Baroque Gothic, which was particularly widespread in Bohemia and is associated with the Italian-born architect Johann Santini Aichel. The monastery was founded in 1115 by Duke Vladislav I, who was buried here in 1125. According to tradition dating back to the Baroque era, it had been founded by Duke Svatopluk sometime before 1109, and his tomb is thought to be in the church as well. The monastery was intended to encourage colonization of the region.

In 1117 the original convention of Czechs was replaced by German monks from the Hirsau reform monastery Zwiefalten. Around the middle of the twelfth century Abbot Lambertus began construction of a large Romanesque church with a transept, but work was not completed until 1233. The church suffered heavy losses and damage during the Thirty Years' War. By the beginning of the eighteenth century it had recovered to such an extent that its energetic abbot, Maurus Fintzguth, the son of a serf, could begin renovation of the old church. Some time prior to 1711 he had asked the two leading architects in Prague, Christoph Dientzenhofer and Santini Aichel, for plans, and he decided on Santini, who was 13,000 gulden cheaper. The main block was built according to Santini's plans between 1712 and 1718, then work began on the east end and continued until 1726. In the main block, whose Romanesque walls were retained as much as possible, Santini added a vault with Gothic tracery in stucco. Based on an entirely new plan, he added a Gothic triconch, which the church had never had in the Middle Ages, to the east end of long chancel. The side conchae were intended for the tombs of the founders, Svatopluk and Vladislav, but it proved impossible to find Svatopluk's bones, and so only the northern concha has a ducal tomb. Inside, the light-filled triconch is one of the great fascinations of the Baroque Gothic, not least for its looped rib vault, which consists of several interlocking stars—symbols of the Virgin and the Woman of the Apocalypse. An equally imaginative invention is the Gothic exterior dome above the crossing, which is shaped like an enormous crown. The abbot rightly praised it as a dome in the Gothic style such as had never been seen before ("more Gotico nondum visa cupula"). The Gothic forms of the whole church are intended to emphasize that Kladruby was an old royal monastery under the patronage of the Bohemian crown and that the church was a symbol of the "pietas veterum Boemorum" (piety of old Bohemia).

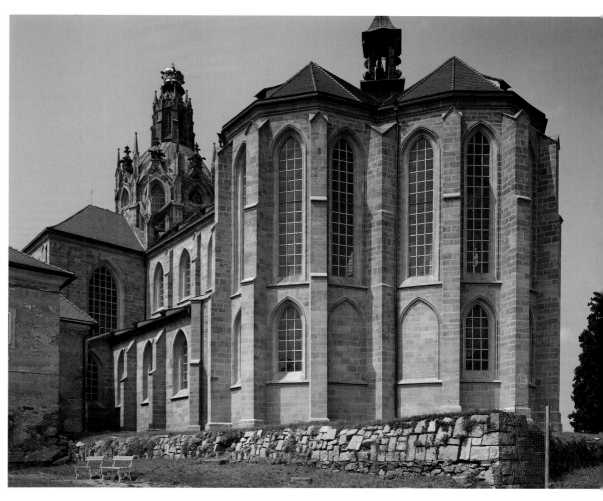

KRZESZÓW
(GRÜSSAU)

BELOW LEFT:
Facade of the church

BELOW RIGHT:
Interior of the church, facing east

OPPOSITE PAGE:
TOP: *The dome vault of the Piast mausoleum;* BOTTOM: *Interior of the Piast mausoleum*

THE SILESIAN MONASTERY KRZESZÓW (GRÜSSAU) lies in the border region between Silesia and Bohemia—now between Poland and the Czech Republic—at the eastern offshoots of the Giant Mountains, near the Waldenburger Bergland. At its peak the monastery owned over a hundred square miles (300 sq. km) with as many as thirty thousand subjects in about forty towns and two small cities. Grüssau was founded in 1242 by Duchess Anna, the widow of the Silesian duke Henry II, of the dynasty of the Polish Piasts, who had died the previous year fighting the Mongols in the

Battle of Legnica (Liegnitz). Anna, daughter of the Bohemian king Otakar I, brought Benedictine monks from Hradec Králové (Königgrätz) in central Bohemia, but they were unable to survive in the difficult forested terrain. Fifty years later, therefore, the Piast duke Bolko I von Schweidnitz-Jauer settled the monastery with Cistercian monks, who were better suited for colonization. They came from the Silesian monastery Heinrichau (Henryków), which in turn had been settled from Lubiąż (Leubus) (see pp. 390–91). Bolko was a grandson of the founder, Anna, and great grandson of Saint Hedwig (Jadwiga), the mother of the Henry who died in battle, who was from the southern German aristocratic family of Andechs-Meranien. Bolko established a house monastery with a burial site for the Schweidnitz line of the Piasts, of which he was a member, and he supported it with generous donations. When this line died out in 1392, the lands of the Grüssau monastery fell to the Bohemian kingdom, and so, like the rest of Bohemia, it came under Habsburg rule in 1526. In 1740

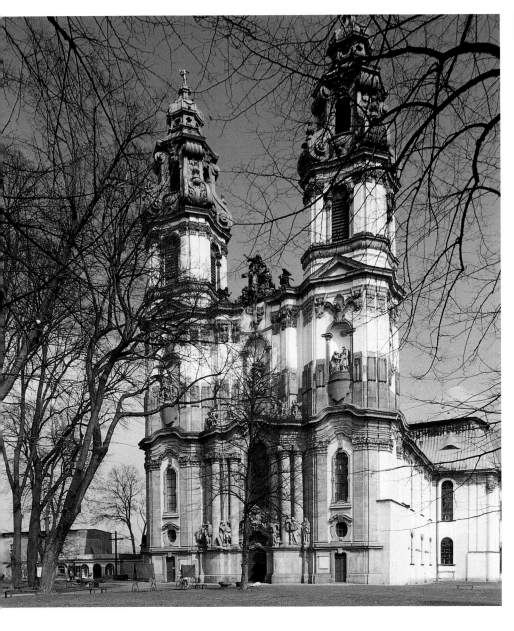

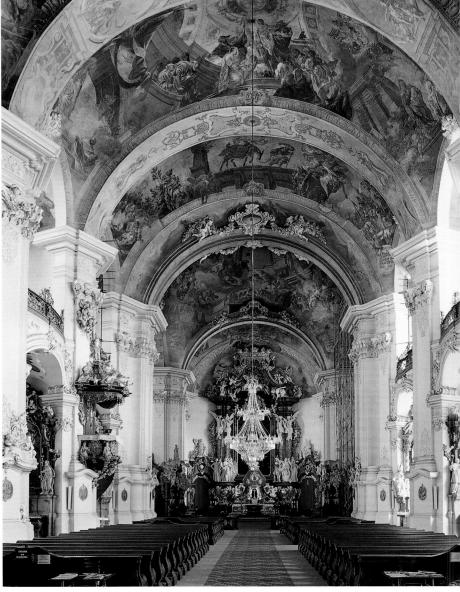

the land went to Frederick the Great of Prussia, as a consequence of the Silesian Wars. In 1810 Grüssau and sixty-eight other monasteries in the diocese of Breslau were secularized by edict of the Prussian king. After World War I Grüssau was settled by German Benedictines who had been driven from the Emmaus monastery in Prague. After World War II Polish Cistercians who had been driven from Lemberg settled here, and the Benedictines from Grüssau moved to the former knights' association in Wimpfen on the Neckar.

In the late seventeenth century Abbot Bernhard Rosa (1660–96) brought Krzeszów to a renewed flowering, so that the general abbot of Cîteaux remarked on a visitation there in 1684 that the monastery was "Germany's pride." After the Josephskirche was completed under Rosa, including fifty murals by Michael Willmann of Leubus (Lubiąż), the abbot who followed Rosa's successor, Innozenz Fritsch (1727–34), had the present monastery church built—the largest Baroque church in Silesia, at 262 feet (80 m) long. The plans were executed by the architect Anton Joseph Jentsch of Hirschberg (Jelenia Góra), but the plans seem to have been prepared in Prague. It is not known who was responsible for them. The two-tower facade is richly articulated by means of pilasters, columns, and curving entablatures. Its trademarks are an enormous entry aedicule with groups of three columns and two open dome peaks ornamented with billowing volutes. The plastic vigor of the modeling is reminiscent of works in sculpture. Perhaps the Prague sculptor Ferdinand Maximilian Brokoff, who designed the sculpture for the facade, was also involved in the architectural plans. The facade is the Silesian counterpart to Prandtauer's monastery church at Melk (see pp. 362–65) and Neumann's pilgrimage church Vierzehnheiligen. The interior of the church is a wall pier hall with galleries and pier heads aligned diagonally. It is in the tradition of Saint Nicholas church in Prague's Lesser Town, but the hall room here, by contrast, has vaults with broad band arches and Bohemian caps, and the east end is extended by a large crossing with transept arms and an altar room.

The exterior of the east end has an elaborate stately mausoleum for the Piast dukes Bolko I, Bernhard, and Bolko II of Schweidnitz-Jauer. It is a lavishly decorated double room with two domes, many columns, and ceiling frescoes by Georg Wilhelm Neunhertz depicting the history of the church. In 1774—when it was part of Prussia—a new imposing monastery site was begun to the south of the church, but only the southern wing, which is worthy of a princely residence, was completed.

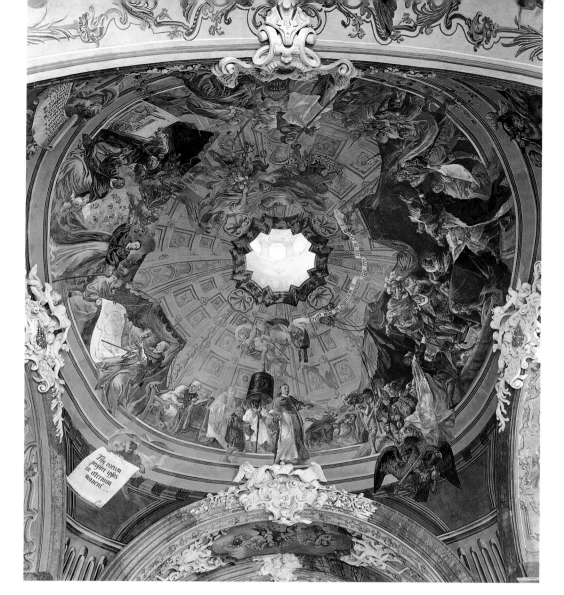

LEGNICKIE POLE
(WAHLSTATT)

BELOW:
Interior of the church

OPPOSITE PAGE:
Facade of the church

THE FORMER BENEDICTINE ABBEY WAHLSTATT— the German name means "battlefield"—lies near the Silesian city Legnica (Liegnitz), on the hilly banks of the Katzbach valley. In 1241 the Silesian duke Henry II, from the Polish Piast dynasty, was defeated and killed in battle by the equestrian army of the Mongols who had invaded Europe. Henry's mother, Hedwig, of the southern German aristocratic family of Andechs-Meranien, who would later be canonized, swore on her son's body that she would found a Benedictine monastery, but it was destroyed during the Hussite wars. In 1703 it was founded again by Othmar Zinke, the abbot of the Bohemian abbey Břevnov (see pp. 382–83). From 1723 to 1726 Zinke built new monastery buildings and from 1727 to 1731 a new church based on plans by the Prague architect Kilian Ignaz Dientzenhofer, and in 1733 he sent the Munich painter Cosmas Damian Asam, who was active at Břevnov at the time, to Wahlstatt to fresco the church vaults. The church, inside and out, is a major work of the "radical Bohemian Baroque": the two-tower facade is an architecture of powerful reliefs, with a central section placed on show like a monstrance raised high; the interior is an extended central-plan building with wall piers in the nave arcades and a wreath of six inward-curving column arcades that seem to make the core space move in curves. The church is an example of the "curved architecture" being built in Bohemia since the early eighteenth century, motivated by the Dientzenhofer family of architects who had moved from Upper Bavaria to Prague, especially Christoph and his son Kilian Ignaz.

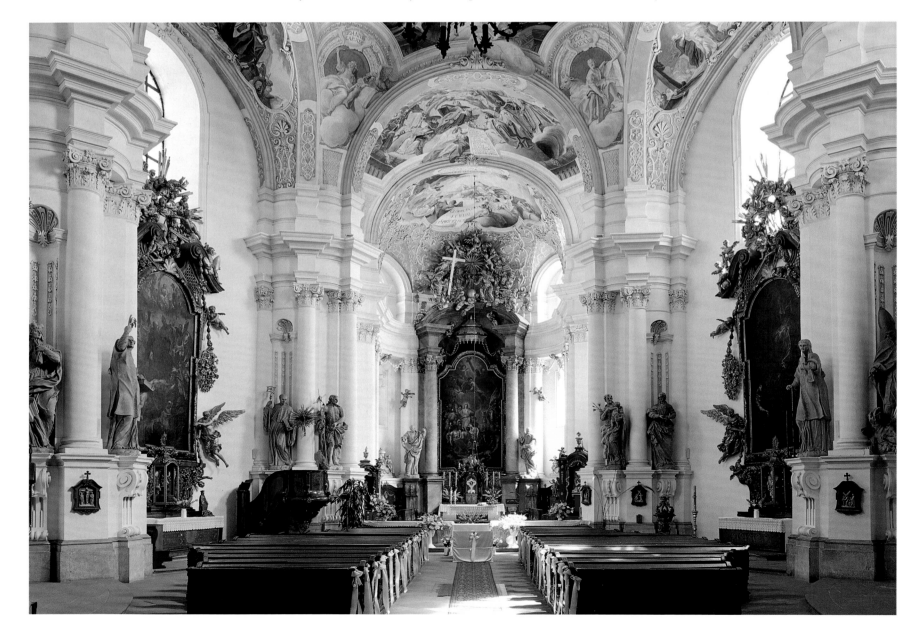

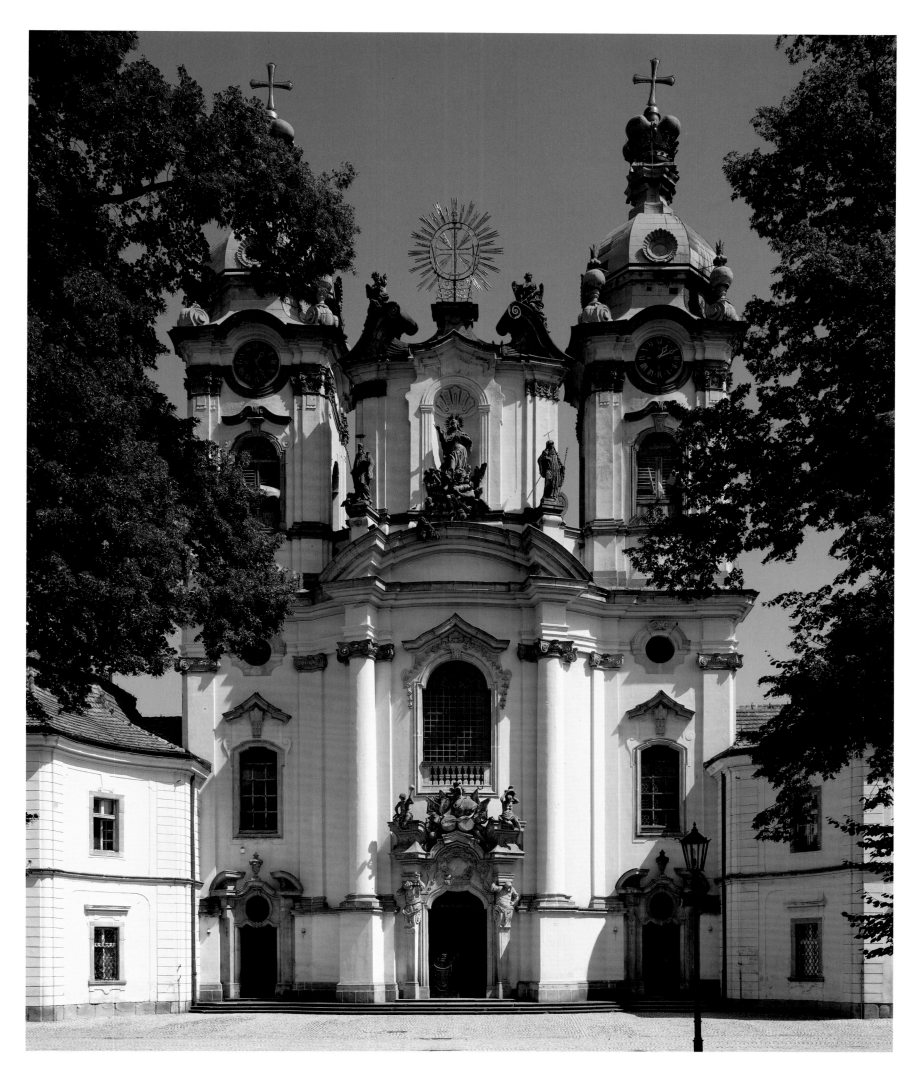

LUBIĄŻ
(LEUBUS)

Facade of the church and monastery of Lubiąż, facing the Oder

APPROXIMATELY THIRTY MILES NORTHWEST OF the Silesian capital Wrocław the former Cistercian monastery Lubiąż (formerly Leubus), the Silesian Escorial, lies on the right bank of the Oder River. The total length of the facade facing the Oder is 732 feet (223 m), making it one of the largest in Europe. The built area is approximately equal to that of El Escorial. The monastery was one of the largest property owners in Silesia. In the fourteenth century its property was said to include eight hundred square miles. In Leubus, where the Oder could be crossed by means of a ford, there was

an ancient Slavic settlement. Benedictines were settled here in the twelfth century, but Duke Bolesław Wysoki (the Tall), who, with the support of Emperor Fredrick Barbarossa, began to govern the area in 1163, probably had Cistercians brought from the Pforte monastery, near Naumburg, that very year. Not until 1175, the year the monastery's charter is dated, was the monastery moved to its present location. By way of Pforte, Walkenried, and Ebrach, Leubus was part of the filiation of Pontigny and had three daughter monasteries of its own: Mogiła, near Kraków, in 1218; Heinrichau (Henryków) in 1227; and Kamenz (Kamieniec Ząbkowicki) in 1247. Under the Silesian duke Henry I of the Piast dynasty (1201–38) the abbot of the time, Günther, decisively expanded the monastery. It now purchased or established no fewer than sixty-five villages and pressed to colonize the still sparsely populated country with the help of German settlers. The monastery's influence was felt as far away as Upper Silesia, which was ruled by the other line of the Piast dynasty, and far into the kingdom of Poland. Its development was aided by the numerous privileges it was granted, including the right to levy tithes and supreme jurisdiction in many of its properties. Thanks to its properties and privileges Leubus was able to recover quickly from the Mongol invasion of 1241, the storm of the Hussites in 1432, and the Thirty Years' War. This was not true, however, of the contributions of one hundred thousand talers that Fredrick the Great imposed on the monastery when Silesia was annexed to Prussia, as the monastery had sided with Austria. Following secularization in 1810 the buildings were used first as a stud farm, then as a psychiatric clinic, as a munitions factory prior to World War II, and then as a Soviet military hospital. Over this period, large parts of the decoration, including the interior decorations of the church and the stately Baroque library, were demolished or transported elsewhere. Today the buildings are being restored to museum quality.

What survives of the medieval monastery buildings are the church and the princes' chapel added north of it, a Gothic triconch structure that was donated by Duke Bolesław III of Liegnitz-Brieg (Legnica-Brzeg) in 1311, as a burial site for himself and his family. The monastery was begun in 1307, on the site of a Romanesque predecessor, and was consecrated in 1330. It is a barren Cistercian vaulted building of the high Gothic, and behind its flat-terminated sanctuary it has a U-shaped ambulatory. Until World War II the interior was a veritable paintings gallery by the Baroque painter Michael Willmann, who lived at Leubus and was also active in Krzeszów (Grüssau) (see pp. 386–87). The paintings, of which there were forty-

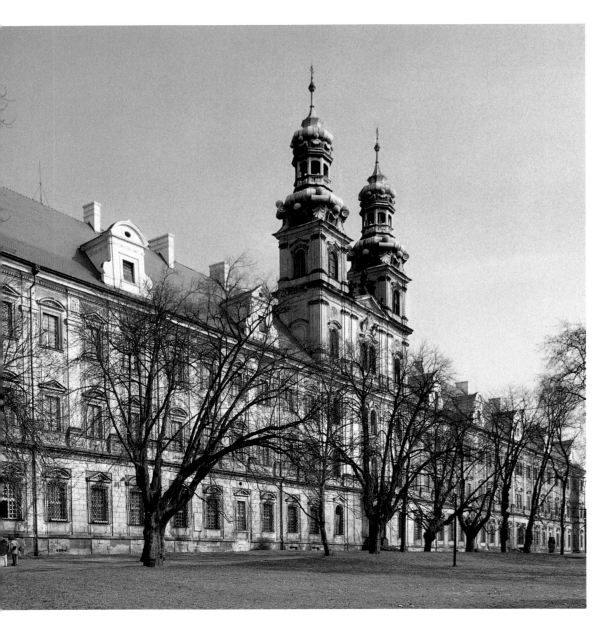

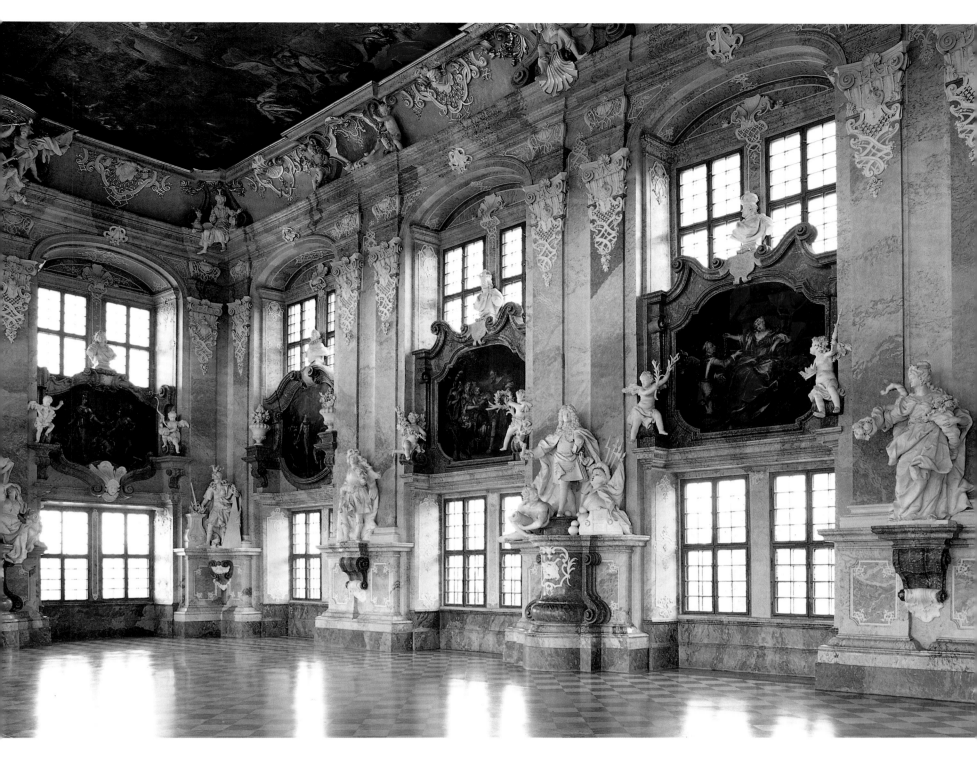

Princes' hall

seven, now decorate churches in and around Warsaw. The very lavish choir stall was also famous; it had been built from 1676 onward by the Austrian architect and sculptor Matthias Steinl, who held the title at the Viennese court of "imperial chamber ivory carver." The choir stall, which is known as the Angels' stall for the sculptures of ten angelic musicians and some fifty putti, was a major work of acanthus ornament. Apart from a few fragments, it was burned after 1945.

The monastery buildings were built from 1681 to 1720, spanning the reigns of three abbots. Despite the long period of construction they are uniform, as the original plan was followed through to the end. The unknown architect, who was probably from northern Italy, designed the wings as an endless series of pilaster bays of the grand order as well as the two-tower facade of the church that is integrated into the Oder facade. The princes' hall is well preserved and recently restored; it was decorated in the final years of the Habsburg reign. At forty-six feet (14 m) in height, it takes up two stories, and it is brightly lit on three sides through deep window bays. The art serves to glorify the house of the Habsburgs, as exemplified by the larger-than-life stucco figures of three emperors depicted as victorious generals. When Leubus became Prussian in 1740, and the abbot fled to Moravia, the monastery's chronicler wrote with resignation about the recently completed hall and its effect on the new masters: "As valuable as it is, it finds little approbation."

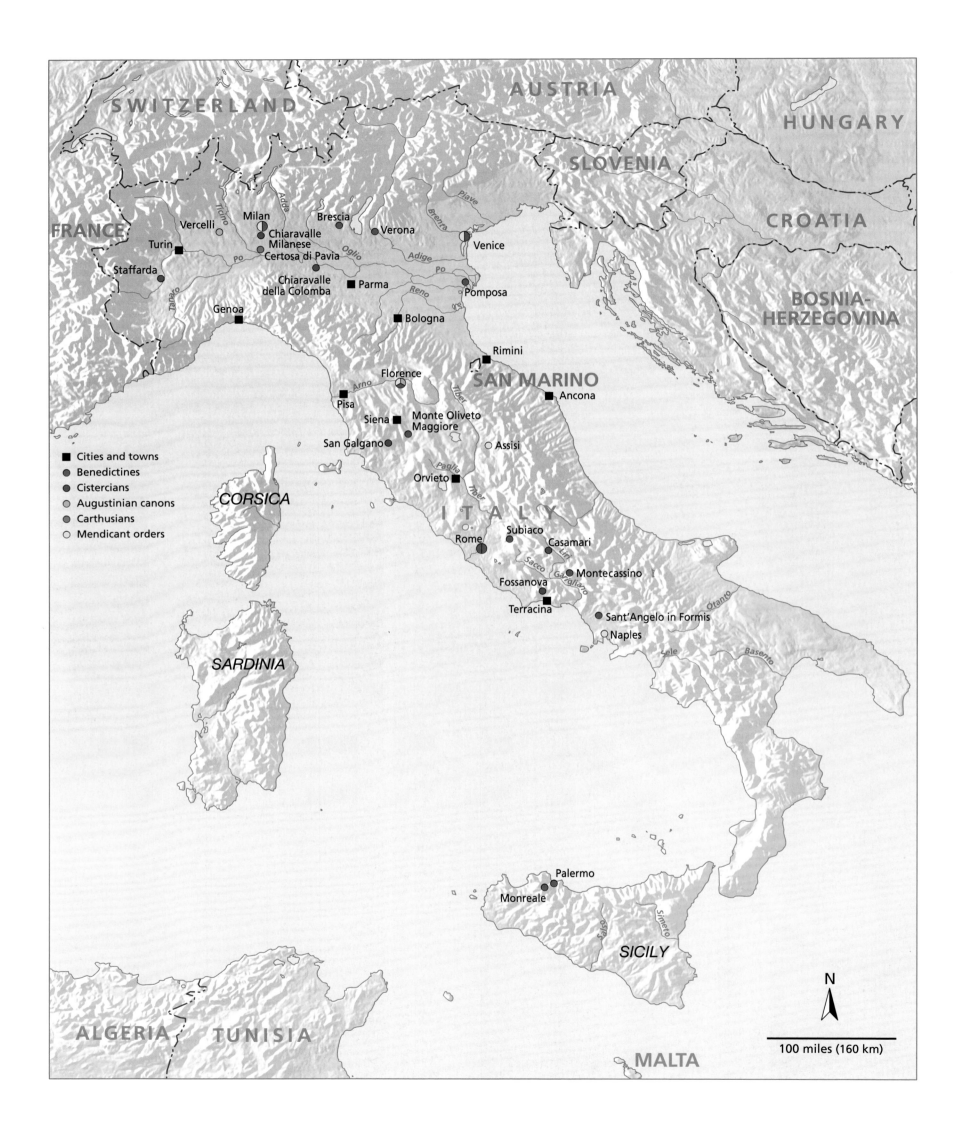

SWITZERLAND

AUSTRIA

HUNGARY

SLOVENIA

FRANCE

CROATIA

Vercelli
Milan
Brescia
Verona
Turin
Chiaravalle
Milanese
Certosa di Pavìa
Venice
Staffarda
Chiaravalle
della Colomba
Parma
Pomposa

BOSNIA-
HERZEGOVINA

Genoa
Bologna

Rimini

Florence
SAN MARINO

Pisa
Ancona

Siena
Monte Oliveto
Maggiore

San Galgano
Assisi

■ Cities and towns
● Benedictines
● Cistercians
● Augustinian canons
● Carthusians
○ Mendicant orders

Orvieto

CORSICA

I T A L Y

Rome
Subiaco
Casamari
Fossanova
Montecassino
Terracina
Sant'Angelo in Formis
Naples

SARDINIA

Palermo
Monreale

SICILY

ALGERIA TUNISIA

N

100 miles (160 km)

MALTA

ITALY

STAFFARDA

TOP RIGHT:
Cloister and flying buttresses of the
southern side aisle, Staffarda

BELOW:
Market hall

OPPOSITE PAGE:
Interior of the main block of the church

THE CISTERCIAN ABBEY STAFFARDA IN PIEDMONT lies isolated between Cavour and Saluzzo, where the Po valley begins below the snowy mountains of the French Alps and Monteviso towers to a height of 12,600 feet (3,841 m). Despite later alterations and restorations, the site is one of the best-preserved Cistercian abbeys in Italy. Staffarda was founded between 1127 and 1138 by the marchesi of Saluzzo, who had the swamps cultivated and established their burial site there in the thirteenth century. The first convention probably came from the Ligurian monastery of Tiglieto, founded in 1120 in the first filiation of La Ferté, which was the order's thirteenth foundation. Staffarda's expansive properties extended to the gates of Turin.

The late Romanesque church, which dates between 1150 and 1210, is a brick building with unmistakably distinctive bright stripes running through the piers and arches. It is a typical Lombard basilica with broad and

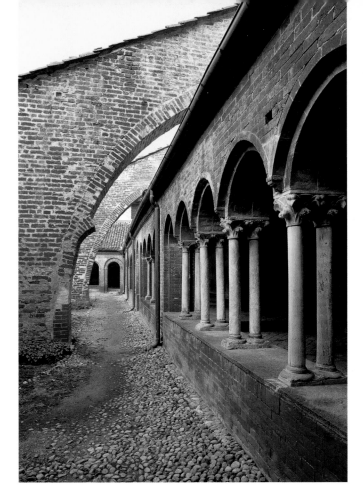

low proportions, towering nave arcades, cross-rib vaults, and massive quatrefoil piers, between whose round projections the edges of the core pier are still visible. The whole effect is of a sedate heaviness. On the exterior the thrust of the side aisle vaults had to be relieved by buttresses added later. On the south side they form great arches over the cloister. This creates an impressive contrast between the delicacy of the double columns and the wall-like mass of the buttresses.

The surviving parts of the buildings of the enclosure include the four-support chapter house and the two-nave frater. The well house, the old single-nave refectory, and the 230-foot (70-m) wing for the lay brothers, which was separated from the cloister by the conversi path, have all been lost or altered.

Also surviving is the *foresteria* to the south, the inn for male visitors that was built around 1230, with a two-nave refectory on the ground floor and a dormitory above. Architecturally the *foresteria* is of the same quality as the monks' buildings. An extremely unusual feature is the thirteenth-century market hall west of the conversi wing: a square building that opens on three sides through double arcades, it has a central support and four cross rib vaults with round arch sections. The piers are on masonry square blocks, and they are so low that it feels almost as if the space consists of vaults sitting on pedestals

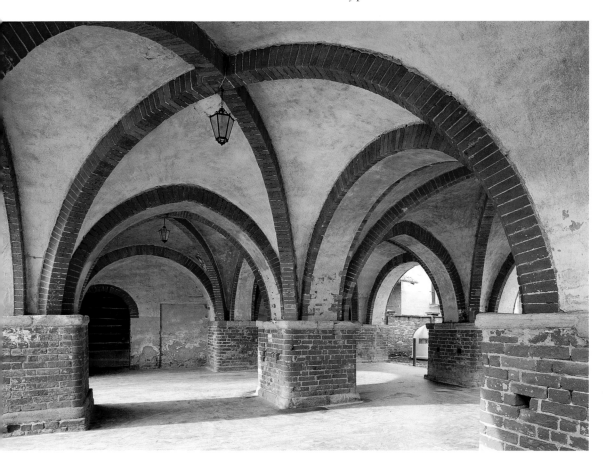

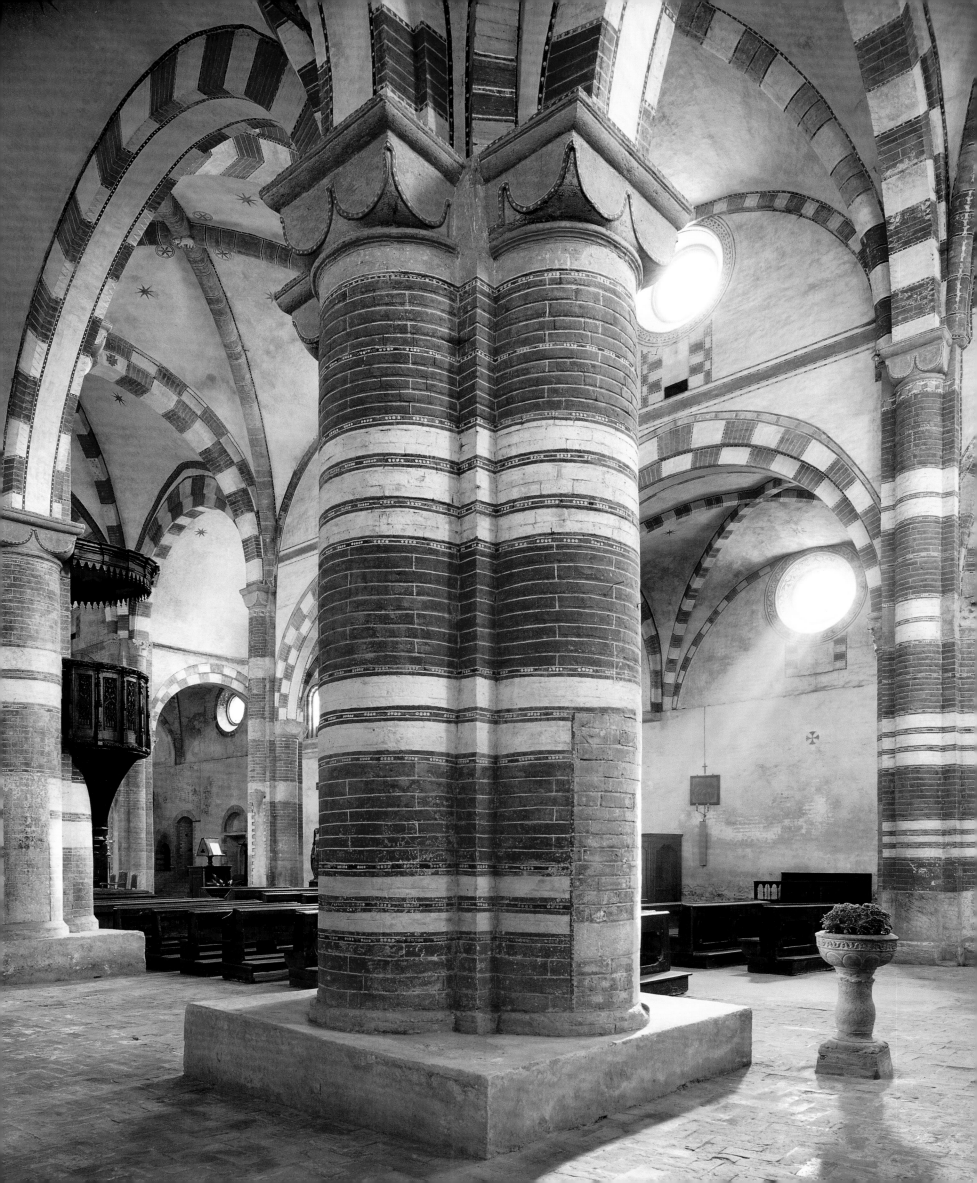

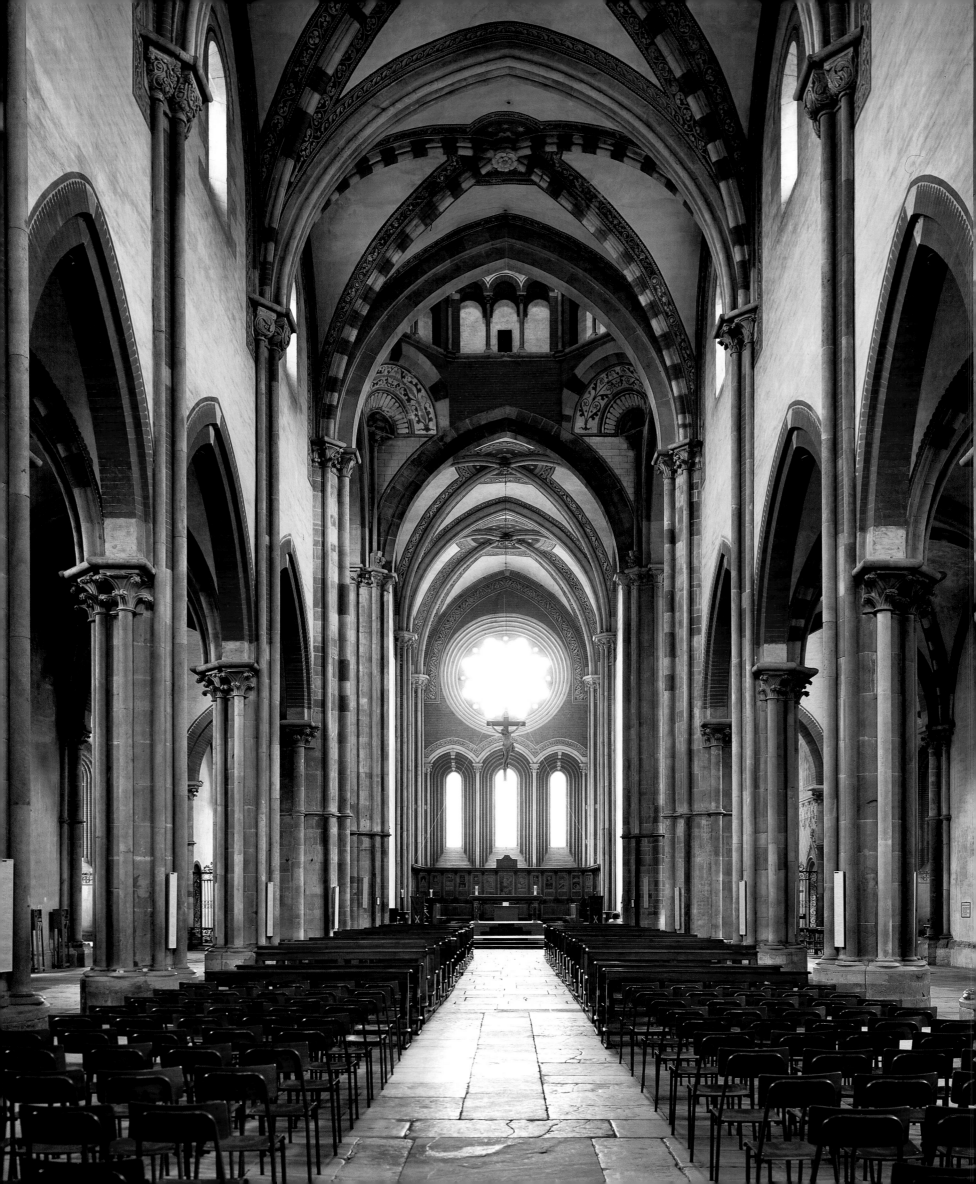

THE AUGUSTINIAN CANONICAL ASSOCIATION San Andrea in Vercelli, Piedmont, was founded in 1219 by Cardinal Guala Bicchieri (Bicheri). Born in Vercelli, as a papal legate Bicchieri had been part of the governing council in England after the death of John Lackland; there he had presided over the coronation of nine-year-old Henry III in 1216. In gratitude, Henry III granted him the income from Saint Andrew's Abbey in Chesterton. The cardinal brought the canons for San Andrea from Saint-Victor in Paris. Because it was well financed, the church was finished by 1227, the year the cardinal died. The first abbot, Tommaso da Parigi, known as Gallo, who is praised on his tomb inscription for his knowledge of architecture, was perhaps the architect. If so, he was the one who introduced elements of French Gothic to Piedmont.

The church is a basilica based on the bay system, with transept, five-part staggered chancel, and a tall octagonal crossing dome on squinches. French influence may be found on the exposed buttressing of the exterior and the pointed arches of the interior, based on a system of engaged pillars and ribs and on supports that

alternate with classical cantoned piers. The round, sculptural freedom of the projections recall English traditions, and the spatial proportions can also be traced to French Gothic. The nave no longer has the low, broad proportions so typical of the northern Italian Romanesque, but is instead tautly structured without being steep. On the whole, however, it retains a distinctive local overtone, particularly evident on the exterior, in the massive brick masonry and the dwarf gallery that terminates it above. The church and the monastery buildings around the cloister (whose supports are clusters of four thin columns) form an unusually self-contained architectural unity.

VERCELLI

OPPOSITE PAGE:
Interior of the church, Vercelli

BELOW:
Cloister and north side of the church

MILAN

SAN AMBROGIO, SANTA MARIA DELLE GRAZIE, SAN MAURIZIO

Carolingian paliotto *by Vuolvinius, San Ambrogio*

MILAN, WHICH FROM 286 TO 402 WAS THE CAPital of the western Roman empire, was an episcopal city from the early Christian period onward. Bishop Ambrose, one of the four Latin fathers of the church, was active there from 374 to 397. It was at his instigation that several churches were built outside the city walls, above the cemeteries, the most important of which, the *basilica martyrum,* was founded in 386 and held the bodies of Gervasius and Protasius, the patron saints of the city. The building was a three-nave column basilica 177 feet (54 m) long, with an apse attached directly to the nave. Ambrose was buried in the church in 397, and later the church took his name.

After Milan was made an archdiocese in 777, several monasteries were founded on the ancient early Christian religious sites, including San Vincenzo in 835 and San Simpliciano in 881. In the ninth century there were eight monasteries in and around Milan.

San Ambrogio is one of the oldest. In 784 Archbishop Peter established a Benedictine convent there. A little later, in 791, Charlemagne made the decision that the Benedictines would have to share the administration of their monasteries with canons the king appointed to Milan; this led to constant conflicts of authority that lasted centuries. The present church at San Ambrogio, a brick building 259 feet (79 m) long, replaced the early Christian basilica but retained its dimensions for the main block. The construction history is very complicated and the question of dating remains unsolved, and is probably insoluble. The main block is a gallery hall of broad and low proportions constructed according to the bound system—that is, with double bays in the middle vessel and supports that alternate powerful main piers at the ends of the bays with thinner intermediate piers at the center points of the bays. The broad, domelike vaults seem to have been the earliest large-format cross rib vaults in Lombardy. They were probably built around 1128, when the canons built their own tower above the north side aisle for their bells, in order to be independent of the monks' much older tower on the south side. According to contemporary records, the architect of the canons' tower also built the church. This would suggest the church might have been begun around 1098, together with the atrium in front of the church to the west, which according to an inscription was built that year.

To mark Ambrose's tomb, a tower was built above the last double bay, in front of the shallow barrel vault, but it collapsed in 1196. Soon thereafter the present octagonal tower was built in its lavish late Lombard Romanesque style, with two tiers of arcades. The interior contains a tower, a dome on a drum, that has been heavily restored. The facade, in harmony with the atrium and the unequal square monks' and the canons' towers, is considered to be San Ambrogio's architectural masterwork. Attached to the main block on the west is a narthex in the form of a two-story loggia, overarched and integrated by the broadly bulging diagonals of the roof. The loggia opens onto the atrium through two tiers of pier arcades; the higher one is terraced and in harmony with the diagonals of gables, rising toward the center. The windows below it are arranged in exactly the same way. The arcades and

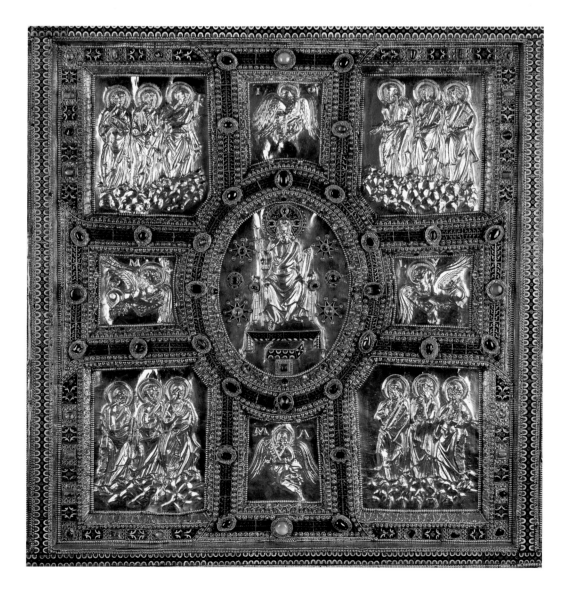

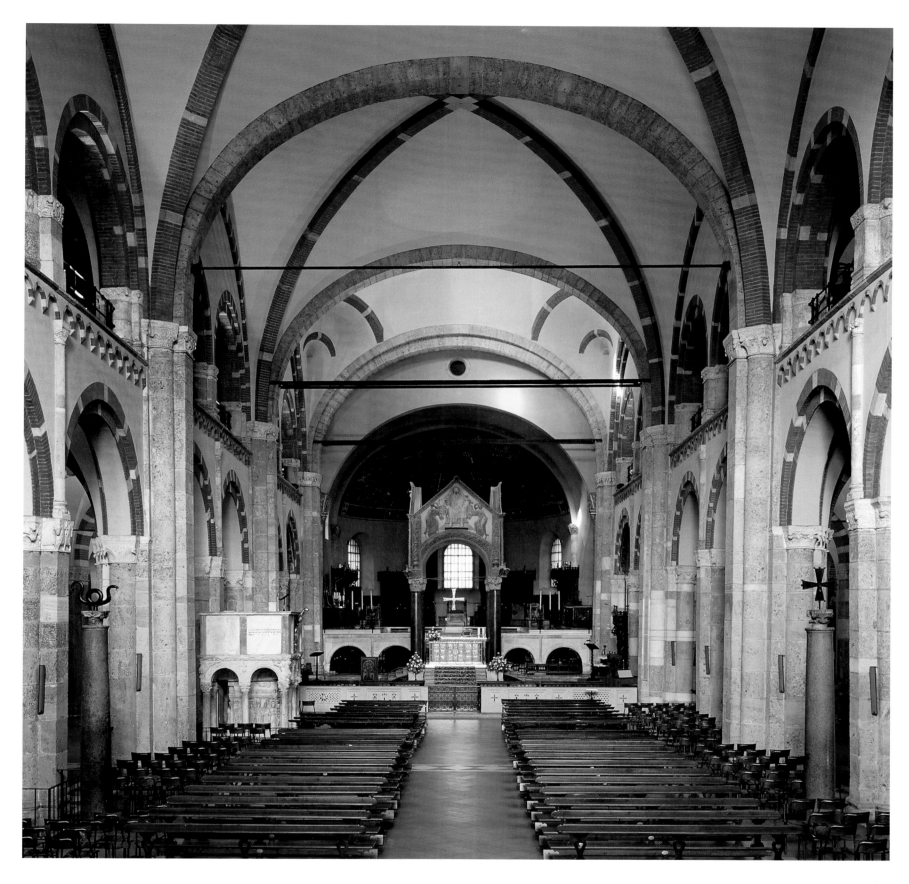

Nave facing east

the gable make the whole facade; it is at once imposing and inviting.

San Ambrogio was richly decorated. The surviving pieces from the early Christian period, the late fourth or early fifth century, include remnants of a wooden door with figured reliefs—the only known parallel to the famous door of Santa Sabina in Rome. The Carolingian *paliotto* at San Ambrogio is unique: a gold altar donated by Archbishop Angilbert II (824–859), which according to the inscription was made by "Vuolvini[us] magist[er] phaber" (master craftsman Vuolvinus). The altar, which at thirty-three by eighty-seven inches (85 × 220 cm) is astonishingly large for a goldsmith's work, stands over the tomb of Ambrose and the martyrs Gervasius and Protasius. The front, in richly filigreed enamel and precious stones, depicts Christ in Judgment between

symbols of the evangelists and the apostles in groups of three, with the acts of Christ on twelve fields next to them. The reverse side, to the left and right of an opening with a door, depicts twelve scenes from the life of Ambrose. On the wings of the door in the center Ambrose is depicted presenting the finished altar; next to this scene the saint is shown crowning the artist Vuolvinius, who is equal in size to the saint—an astonishing fact, indicating the goldsmith was a famous and admired artist. To set it off, the *paliotto* has a ciborium above it, with four Roman porphyry columns and four gables with polychrome and gilded stucco reliefs that probably date from the early eleventh century. The *paliotto* and ciborium together represent a unique ensemble in the history of medieval church decoration.

Another important work of decoration is the marble pulpit on the north side of the nave: dating from around 1130, it was reassembled from fragments of different eras after the east tower collapsed in 1196. It stands on the early Christian sarcophagus of Stilicho from the

fourth century. The residential wings of the canons, to the north of the church, are said to have been expanded and standardized at the request of Ludovico Sforza, duke of Milan, by the addition of a large courtyard, the design of which was entrusted to Donato Bramante, who would later design Saint Peter's in Rome. When the duke was taken prisoner by the French in 1499, and Bramante fled to Rome, only the wing parallel to the north side aisle had been finished. The rest was never finished. In 1497 Bramante had been commissioned by Cardinal Ascanio Sforza, the duke's brother, to design the monastery. It was executed with two cloisters, a Doric and an Ionic one, but not until the sixteenth century.

The mausoleum for Ludovico Sforza and his wife, Beatrice d'Este, was intended to be the most splendid building in Milan. He chose the Dominican church Santa Maria delle Grazie, which had been built shortly before, between 1466 and 1490. It is a low Gothic structure with three naves and side chapels. The duke had the church's chancel demolished and a new one,

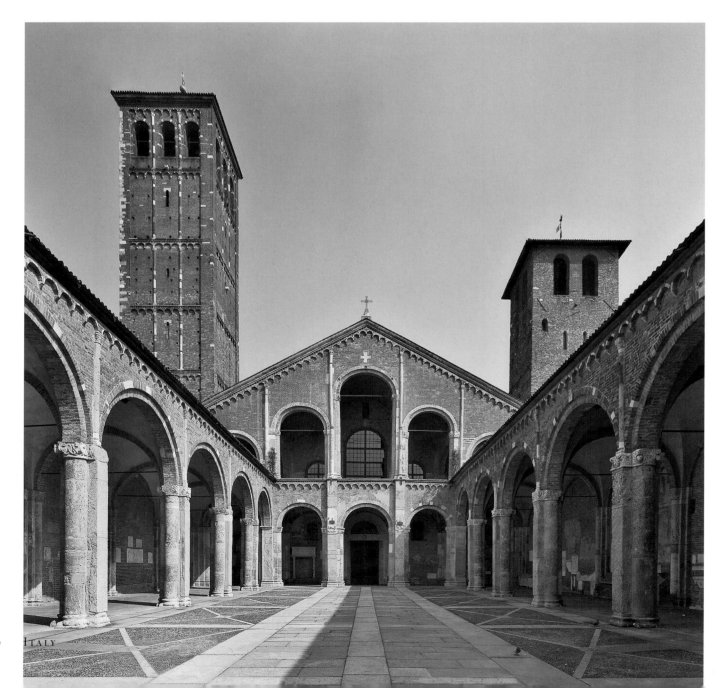

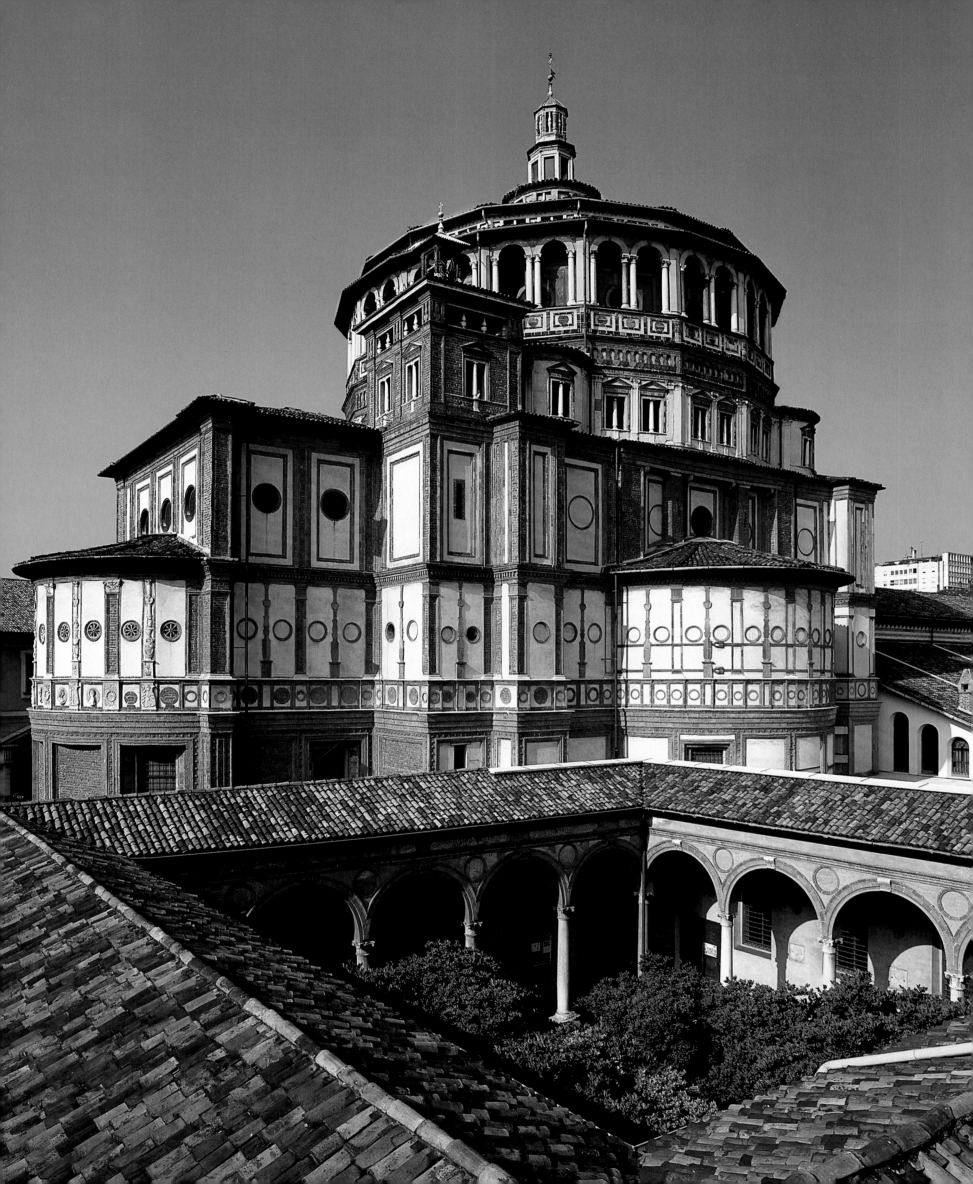

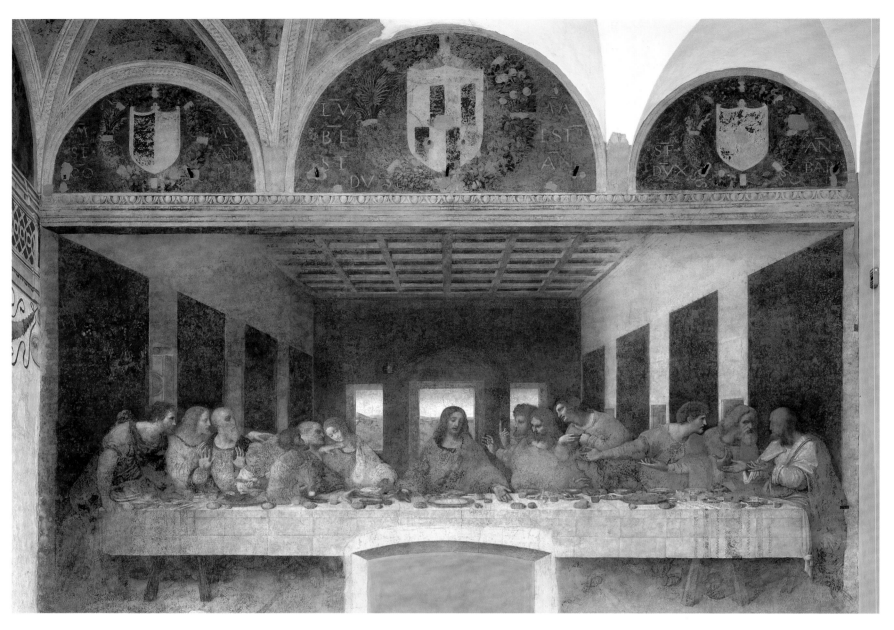

Leonardo da Vinci, The Last Supper, 1495–98, refectory of Santa Maria delle Grazie

intended to be his mausoleum, was begun in 1492. It was assigned to Bramante, but the local sculptor-architects Giovanni Antonio Amadeo and Giovanni Dolcebuono also participated in the project—unlike that of Bramante, their participation is documented. The new chancel is an immense square central-plan building with narrow side apses and a quadratic altar house that terminates in an apse; the whole culminates in a dome on a drum. Inside, the dome is round and sits on pendentives, but outside it is a polygonal, two-tier tambour with detailed articulation. It is topped by a typically Lombard tent roof. The vault of the dome cannot be seen from outside. The building masses, which tower high above the main block, are clear and simple stereometric forms conceived on a grand scale, whereas the surfaces, which alternate white stucco fields, terracotta ornament, and brick, are more ornamental in their effect. Together, they give an impression of the grandly decorative style, a basic feature of the Lombard architecture of this period. It is doubtful whether the exterior

structure of the dome was part of Bramante's design; northern Italian architects from Milan probably introduced their own ideas after his departure.

The convent buildings, which from 1558 to 1782 were the seat of the tribunal of the Inquisition, include a small, harmonious Renaissance cloister north of that chancel that is also attributed to Bramante. The duke donated the cloister in 1497 "out of love and devotion to the Dominican religion." The most famous work of the monastery, and a draw for visitors from all over the world, is Leonardo's *Last Supper* in the refectory, beneath the coat of arms of Ludovico Sforza (called "il Moro"). Leonardo painted the work between 1495 and 1498. He did not use the traditional fresco technique, which is weather-resistant, but instead painted in an oily tempera, with the consequence that the painting quickly deteriorated and became unsightly. Today it is a ruin. When seen from the correct position, the painted room in which the Last Supper takes place appears perspectively to be a continuation of the refectory. A new

aspect of the composition was the arrangement of the apostles into groups of threes. In turn the groups relate to Judas, who is otherwise usually isolated. The apostles respond to Christ, who calmly says: "one of you which eateth with me shall betray me," with great agitation. Their reaction is more evident in figures farthest away from the center of the painting, as shown by their averted gazes and gesturing hands. With this painting Leonardo broke from the more uniform arrangements of the apostles in quattrocento Florentine depictions of the Last Supper and infused new life in the action—namely, a psychologically motivated drama.

Another Milan monastery that was redesigned during the Renaissance is the Benedictine abbey San Maurizio, which was probably founded in the first half of the ninth century and then again in the eleventh century, the oldest of the city's seven nunneries. In 1503 the present church was begun; the basic structure was completed in 1518–19. The architect, a follower of Bramante, is not documented. The attributions range from the little-known Antonio da Lonate by way of Amadeo, Dolcebuono, and Cristoforo Solari on to the painters Bramantino and Zenale and the Vitruvian theoretician Cesariano. The church is divided into two parts: the nuns' church to the south, which takes up two-thirds of the space, and the people's church to the north. A partition wall, running precisely along the line of the ancient city wall, separates them. The structure of the wall pier arcades in the first level and gallery openings above, in the form of the *serliana,* are a combination of a colonnade and arcade that Bramante had introduced to Rome during this period. The lunettes of the walls above this have round oculi. The galleries make the space feel like a grand church at court. The interior is painted throughout by sixteenth-century Lombard painters, especially Leonardo's student Bernardino Luini and his sons Pietro and Aurelio—a donation paid by the Bentivoglio family. The church is notable not least because the nuns and the people are united under a single vault and yet remain separated.

*Interior of the church of San Maurizio, divided by a rood screen into the people's church (*LEFT*) and the nuns' church (*RIGHT*)*

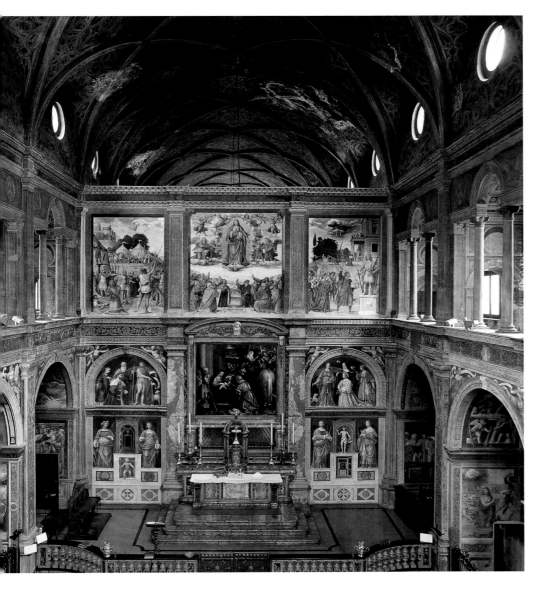

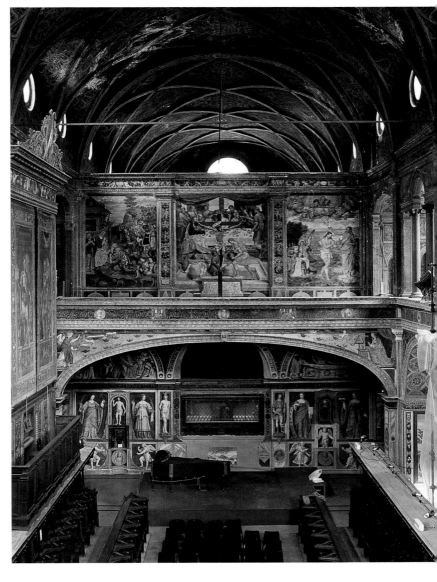

CERTOSA DI PAVIA

*View of the Carthusian monastery of
Certosa de Pavia, from the west*

OPPOSITE PAGE:
*South side of the church, with a view of
the small cloister*

IN THE FIFTEENTH CENTURY CARTHUSIAN MONAS-
teries were very desirable as burial sites for princely
houses because this was the strictest order, which
had devoted itself to prayer like no other. For that rea-
son, prayers of intercession from Carthusian monks
promised more to princely donors who were concerned
about their salvation. In 1385 the Burgundian duke Philip
the Bold, whose dazzling manner of holding court was
admired throughout Europe, had set an example by
founding the Carthusian monastery Champmol at the
gates of Dijon, where he resided (see p. 46). The chancel
of the church was destined to be his burial site, and the
monks there prayed constantly for him. A little later his
Italian brother-in-law Giangaleazzo Visconti, the first
duke of Milan, followed his lead. This man of innate
power was in the process of conquering northern and
central Italy, but he died suddenly in 1402, just as he was
about to besiege Florence. In 1496, he founded a Carthu-
sian monastery in an enormous park near his castle that
was a fenced-in wildlife preserve for hunting that was
roughly eight and a half square miles (22 sq. km). Want-
ing it to be exceedingly splendid and lavish, he made
available handsome sums for construction. Work stalled
after Giangaleazzo's death. It was resumed again in 1450
by the mercenary leader Francesco Sforza, who had
been named duke of Milan. He entrusted the direction
of construction to Giovanni Solari, who was essentially
responsible for the planning of the church. His son
Guiniforte Solari brought his father's plans nearly to
completion, except for the facade and minor elements
of the interior and exterior construction. The
monastery buildings around the large and small clois-
ters, completed in 1473, were built under his direction. In
1491, ten years after the death of the younger Solari,
Amadeo reworked the plans for the facade. The conse-
cration of the still unfinished church followed in 1497,
during the reign of Ludovico Sforza—just over a hun-
dred years after construction had begun. Work on the
facade dragged on for some time, finally concluding in
1549, following several changes in plan. The dome was
not totally completed until the end of the sixteenth cen-
tury. Then, between 1620 and 1625, a stately ducal palace
with an extended facade was built, following plans by
Francesco Maria Richini, on the right side of the
church's forecourt.

The monastery conforms to the ideals of the
Carthusian order only in that it has the requisite simple

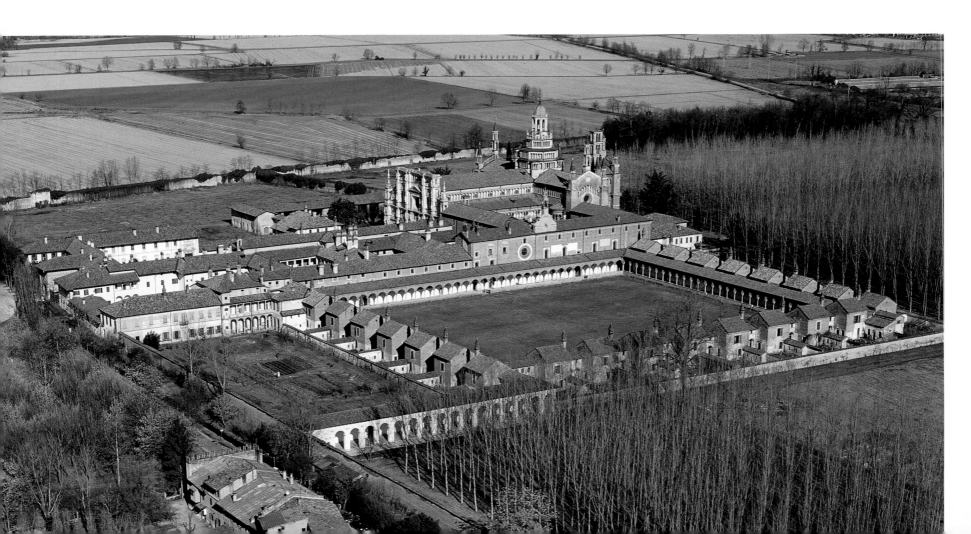

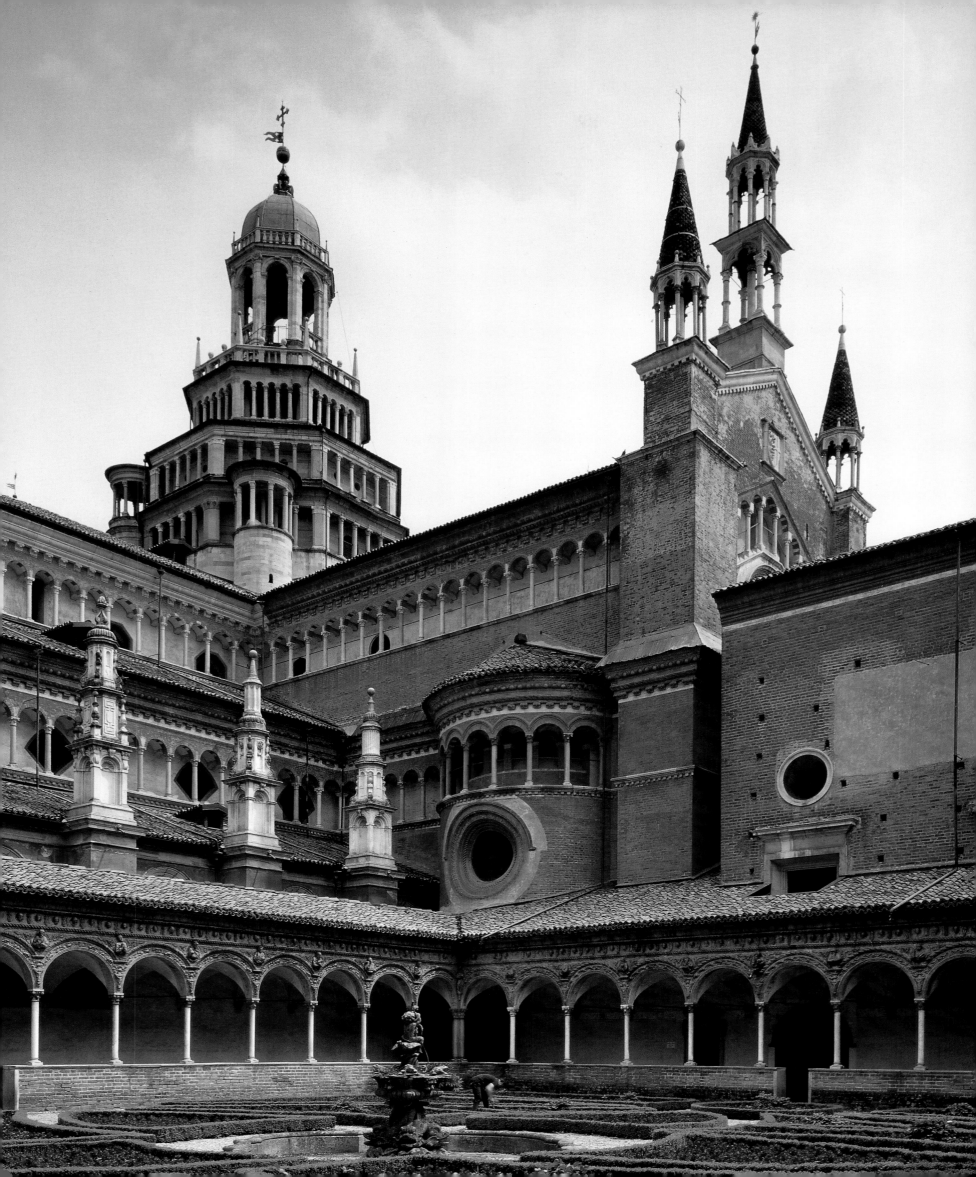

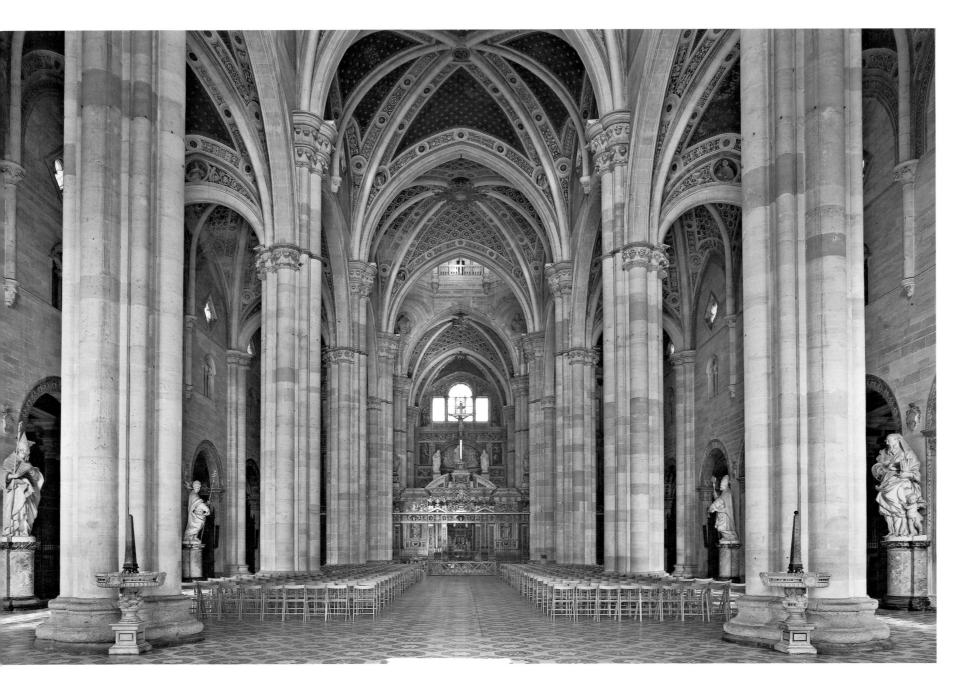

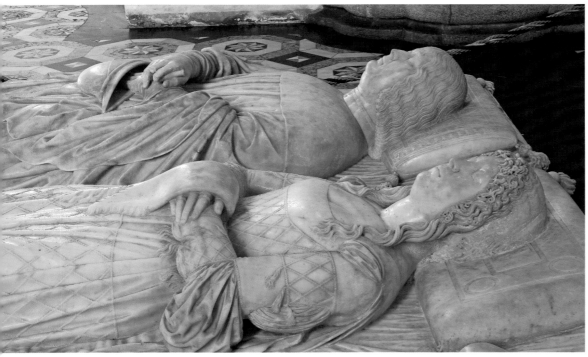

houses with gardens for the monks arranged around the large cloister, just like those found in every other Carthusian monastery. This one, however, is a double monastery, with twenty-four houses rather than the usual twelve; consequently the large cloister is 361 feet (110 m) long, about the size of a city square. By contrast, the small cloister, which lies immediately next to the south side of the church, is tiny and intimate, a delicate masterwork of quattrocento Lombard architecture.

The church inverts the simplicity called for by the Carthusians into its opposite: inside and out it is a resplendent ducal state building that has something nouveau riche about it. While the Carthusian church at Champol has only a single nave, in keeping with the practice of the order, the one in Certosa had to have three naves. Not only did it have a series of chapels in the main block, it had a transept with octagonal crossing

dome on squinches. The transept was made even more lavish by the addition of a triconch apse—three apses on either end, as well as in the chancel. The church's structure is that of a staggered hall with a slightly elevated middle vessel. Its clerestory windows, which are tiny oculi, are barely noticeable. The tower nave arcades of round arches may be seen as a typically Lombard variation on the Renaissance, with reminiscences of the Romanesque, whereas the six-part rib vaults with pointed arch sections are pure Gothic. This is a hybrid style that, in contrast to contemporary Florentine and Tuscan architecture, is remarkably indecisive.

The paintings of the Certosa are by Ambrogio Bergognone, a Renaissance painter of restrained temperament and tranquil peace of mind. The sculptural decorations—which unfold an opulent richness and decorative abundance, if not overabundance—were provided by Amadeo and Briosco and their school. In the north transept arm, somewhat lost, is the double tomb of Ludovico Sforza and his wife, Beatrice d'Este, who died after childbirth in 1497, at the age of twenty-two. The recumbent effigies of the couple, which the duke commissioned from Cristoforo Solari immediately after the death of his spouse, are delicately handled in the drapery especially, and their features display a noble grace, as was appropriate to the dignity of a ducal couple in the Renaissance. The tomb monument, originally placed in Bramante's chancel at Santa Maria delle Grazie in Milan, as was intended, was moved to Certosa in 1564.

The church's most powerful effect is achieved on the exterior of the main block, transept, and chancel, particularly when viewed from the small cloister. The building masses are enlivened by slight arcade galleries below the eaves of the middle vessel and the transept, on the side aisles as well as on the lower tier. These arcatures are the defining motif here, lending an impression of cheerful legerity to the building. As a result, the dwarf galleries of Romanesque architecture—that is, the motif so widespread in Lombardy and perhaps native to it—live on. Seen from outside, the quadruple terracing of the crossing tower seems to consist entirely of multiple tiers of column galleries, some in the form of colonnades, others arcades. Lombardy had a tradition of such towers as well—to which belongs, for example, the chancel tower of San Ambrogio in Milan, but also the

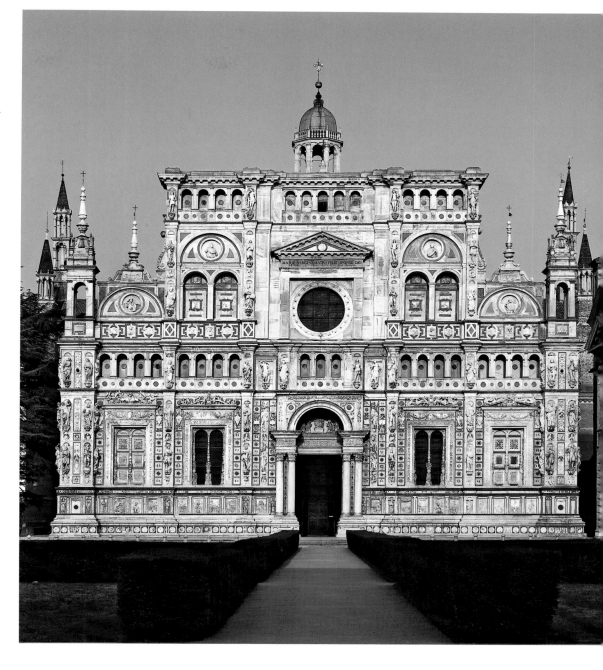

crossing tower of the Cistercian church Chiaravalle Milanese (see p. 408), which is more closely related to Certosa. This picture of architectonic splendor is brought to a conclusion by the three tabernacles on each of the gables of the transept and chancel. On the west facade this splendor spills into pomp. Out of a genuine horror vacui it is covered with tiny decorative forms, which individually are precious works but are lost in the dense texture of the ornament. This facade can be thought of as a perfect example of the basic tendency of the Lombard Renaissance: the grandly decorative, born to serve as ambitious and scandalously expensive status symbols of princes.

OPPOSITE PAGE:

TOP: *Nave of the church;* BOTTOM: *Tomb of Ludovico Sforza and Beatrice d'Este*

ABOVE:
West facade of the church

CHIARAVALLE MILANESE

TOP RIGHT:
Crossing tower, abbey church of
Chiaravalle Milanese

BOTTOM LEFT:
Interior of the abbey church, facing east

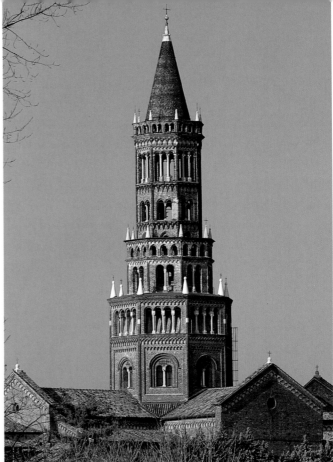

THIS CISTERCIAN ABBEY ON THE OUTSKIRTS OF Milan—today it lies within an industrial area— was the first Italian daughter monastery of Clairvaux, from which it took its name, as did three other monasteries in Italy. It was founded in 1135 by citizens of Milan. The Milanese rushed in enthusiastic droves to meet Bernard of Clairvaux when he returned from the Council of Pisa. The Milanese nobility offered him the office of archbishop, but he declined.

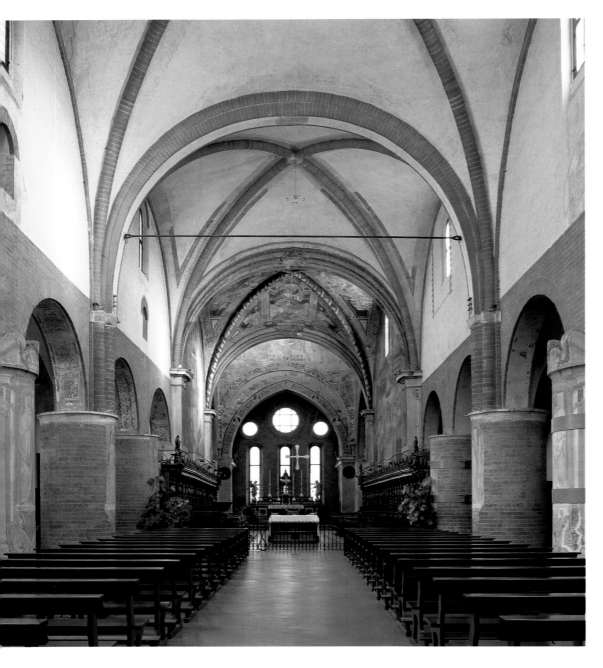

Bernard chose a site for the monastery that was four miles from the city, which was actually much too close by the statutes of the order. The church was probably begun around 1150–60, and its final consecration took place in 1221. At the beginning of the trecento its landmark, visible from a great distance, was built, probably based on plans by Francesco Pecorari of Cremona: the 207-foot- (63-m-) tall crossing tower with open arcade galleries, which recalls the tower of Saint-Sernin in Toulouse (see pp. 124–26), as well as the conical tops of the Cremona cathedral's campanile and the tower of San Gottardo in Corte in Milan. In fact, such towers were forbidden on Cistercian monasteries. The majority of the monastery buildings had to make way for the Milan-Genoa railway line in 1860, which ran directly through them.

The church, a brick structure, has the classic Bernardinian plan for the east end. The main block is a basilica based on the bound system. Typical features of the late Lombard Romanesque include the middle vessel's broad and sedately laid out proportions and its slightly domed cross rib vaults. Its trademarks are the piers in the form of ungainly, unarticulated wall cylinders. They are so short and thick that they look like massive barrels, not architectural supports at all. Moreover, since they are all the same, they do not conform to the bound system, in which the main and intermediate supports must be distinct. Only above the pier level do we find the articulation system that is appropriate to the vaults.

CHIARAVALLE DELLA COLOMBA

I n Emilia Romagna, in a poor region near the city of Fidenza, lies the former Cistercian abbey Chiaravalle della Colomba; today the Milan-Rome highway is just nine hundred feet (300 m) away. The name Chiaravalle refers to its mother monastery, Clairvaux, from which its first convention came; the Colomba refers to a legend that a dove pointed the way to the precise location for the settlement. The abbey was founded in 1136 by Bishop Arduino of Piacenza, at the prompting of Bernard of Clairvaux. Arduino's *Carta institutionis et statutum* and other sources offer quite precise information about the history of its development. According to these sources, permission to found the monastery was granted by Emperor Lothair of Supplinburg in 1133, during his Italian campaign. Bishop Arduino and the city of Piacenza provided a good economic basis: everyone who owned property near the monastery had to sell it for a fixed price. In addition, the nobility of the surrounding region were obliged to transfer their right to the monastery. Finally, the monastery was entitled to a tenth of the output of the surrounding properties. Hence it soon flourished and was able to found five daughter monasteries in direct filiation. It suffered a setback in 1248, however, when the troops of Emperor Frederick II destroyed the monastery buildings (but not the church).

Interior of the abbey church of Chiaravalle della Colomba, facing east

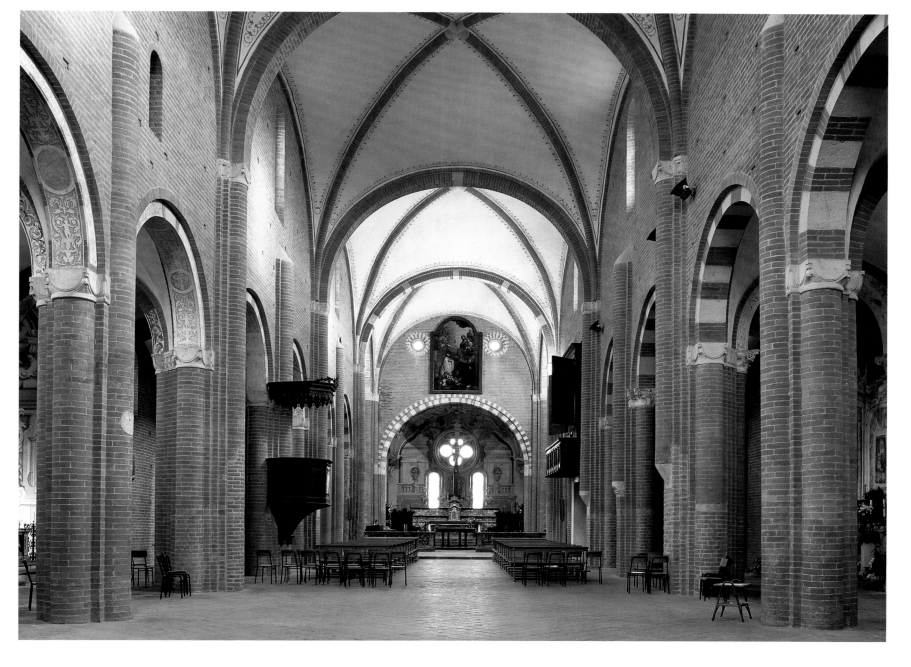

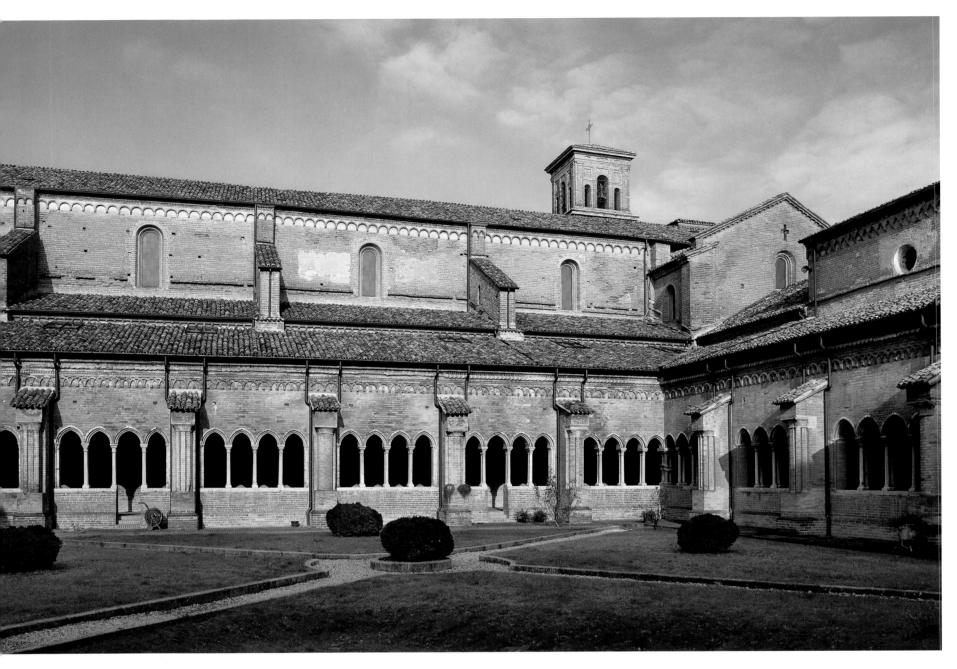

Cloister and south side of the church

No dates are documented for the construction of the church, which probably began around 1170 and was completed in the first half of the thirteenth century. The church, 213 feet (65 m) long, is a brick building. The arches of the nave arcades and the sanctuary, however, alternate brick and white ashlar, as does the portal of the narthex, which lends the whole a touch of the delight in decoration that is typical of northern Italy.

The east end of the church, which has a very low sanctuary with a flat termination and a much taller square crossing that reaches the height of the central nave, originally had short transept arms with just one chapel on either side of the sanctuary. Later the transept was extended by the length of two low bays in the north and south, no taller than the sanctuary, to make room for four more chapels. The main block, like that of Chiaravalle Milanese, is built according to the bound system, with four double bays that have slightly domed cross rib vaults with round arch sections. The proportions of the middle vessel are similarly broad and low, as is usually the case in Romanesque vaulted buildings in neighboring Lombardy. The system for the projections is based on the bound system in that the main piers that mark the corners of the double bays have three projections, while the intermediate piers at the center of the bay have just one or two. The projections of the main piers support the vault arches, whereas the intermediate piers break off below the clerestory windows and, since they serve no function for the vaulting system, are essentially pointless. This suggests that the plans were altered during construction. Originally, the plan was not for rib vaults with the present four parts but with six—that is, in addition to the present vault arches there would have been a transverse rib in the middle of the bay that would have sprung from the projections of the intermediate piers.

The west facade of the church traces the basilica cross section of the main block, which distinguishes it from the so-called shield facades common in northern Italy, which concealed this cross section. The ashlar wheel window modeled on San Zeno in Verona (see pp. 416–19) was added later. The narthex is an indispensable part of the facade's effect: in the center it has a large archway with three rhythmic openings and low galleries to the side; this group of three is harmonious with the facade wall behind it.

The cloister and the chapter house, both probably from the end of the thirteenth century, are all that has survived of the medieval buildings. The cloister—with its vaults, projecting buttresses, and delicate quadripartite arcades with double columns of Veronese marble—is considered one of the most beautiful in Italy. Its corners are emphasized by groups of four columns, with the added charm of a knot formed by a thick stone cylinder that snakes around the shafts and unites them. The arcades between the cloister and chapter house constitute another splendid example of decorative architecture, especially the tripartite arcade within a trefoil arch; its alternation of red and white stones and the relief pattern in the arch bay almost suggest an Islamic influence. There is no longer any trace of Cistercian simplicity here.

BELOW LEFT: *View of the cloister, past a four-column group of the corner;*
BELOW RIGHT: *Arcature between the cloister and the chapter house*

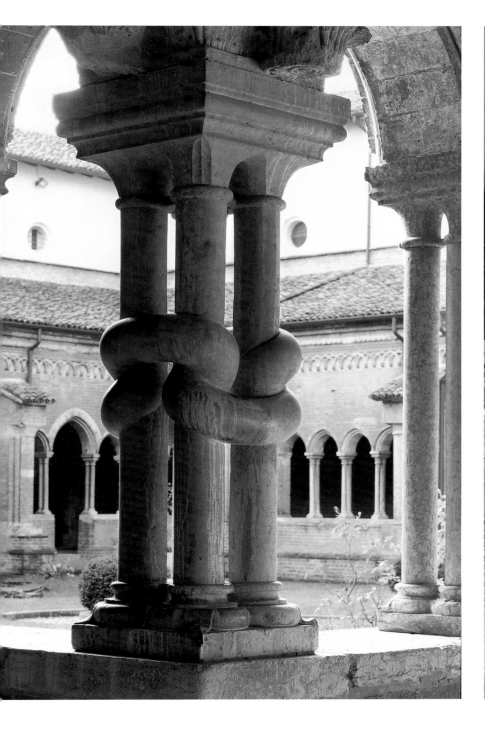

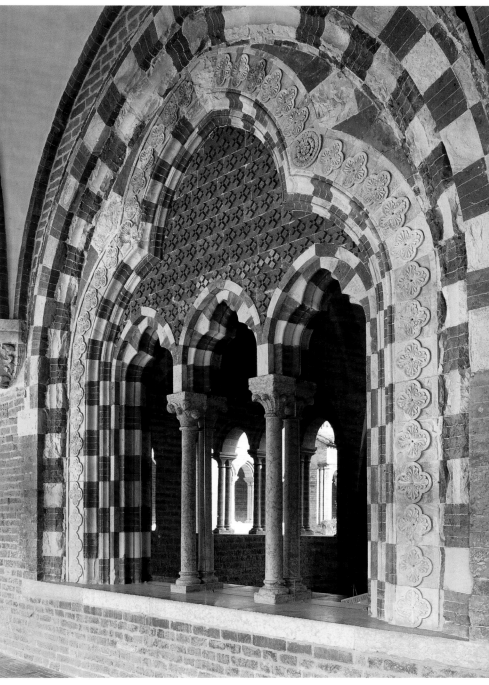

BRESCIA
SAN SALVATORE–SANTA GIULIA, SANTA MARIA IN SOLARIO

BELOW:
First courtyard, with view of San Salvatore and Santa Giulia

OPPOSITE PAGE:
Interior of San Salvatore

PAGE 414:
San Salvatore and Santa Giulia.
TOP: *The Desiderius Cross;*
BOTTOM: *Lombard peacock relief*

PAGE 415:
Upper church, Santa Maria in Solario

LYING ON THE EDGE OF THE ALPS EAST OF MILAN, the city of Brescia, known as Brixia during the Roman era, was conquered by the Lombards in 569 and made the center of a duchy. The city was supported by the last Lombard king, Desiderius, and his wife, Ansa, both from Brescia. However, Charlemagne, who had been married to one of Desiderius's daughters, crushed the Lombard kingdom and imprisoned its king in the Frankish monastery Corbie. According to local tradition, in 753, before she became queen, Ansa founded the nunnery San Salvatore–Santa Giulia, which was intended as a hospice for pilgrims to Rome, and the Shrine of Saint Michael on Monte Gargano. During her lifetime Ansa made arrangements for her burial site in the church and had the Lombard poet Paulus Diaconus compose an inscription for it whose record survives. The monastery was very important in the period following Lombard rule; it became the house monastery of the Carolingians, who sent their wives and daughters there—for example, Emperor Lothair I sent his wife, Ermengard, in 848. The present church San Salvatore is entirely in the early Christian tradition. It is a three-nave basilica with column arcades and three parallel apses in the east. It was originally twice as long as it is now. The western half was demolished in the sixteenth century when the new church, Santa Giulia, was built. The columns and capitals are nearly all spoils from late antiquity. The surviving decorations include not only the stucco ornament in the jambs of the arcades, but

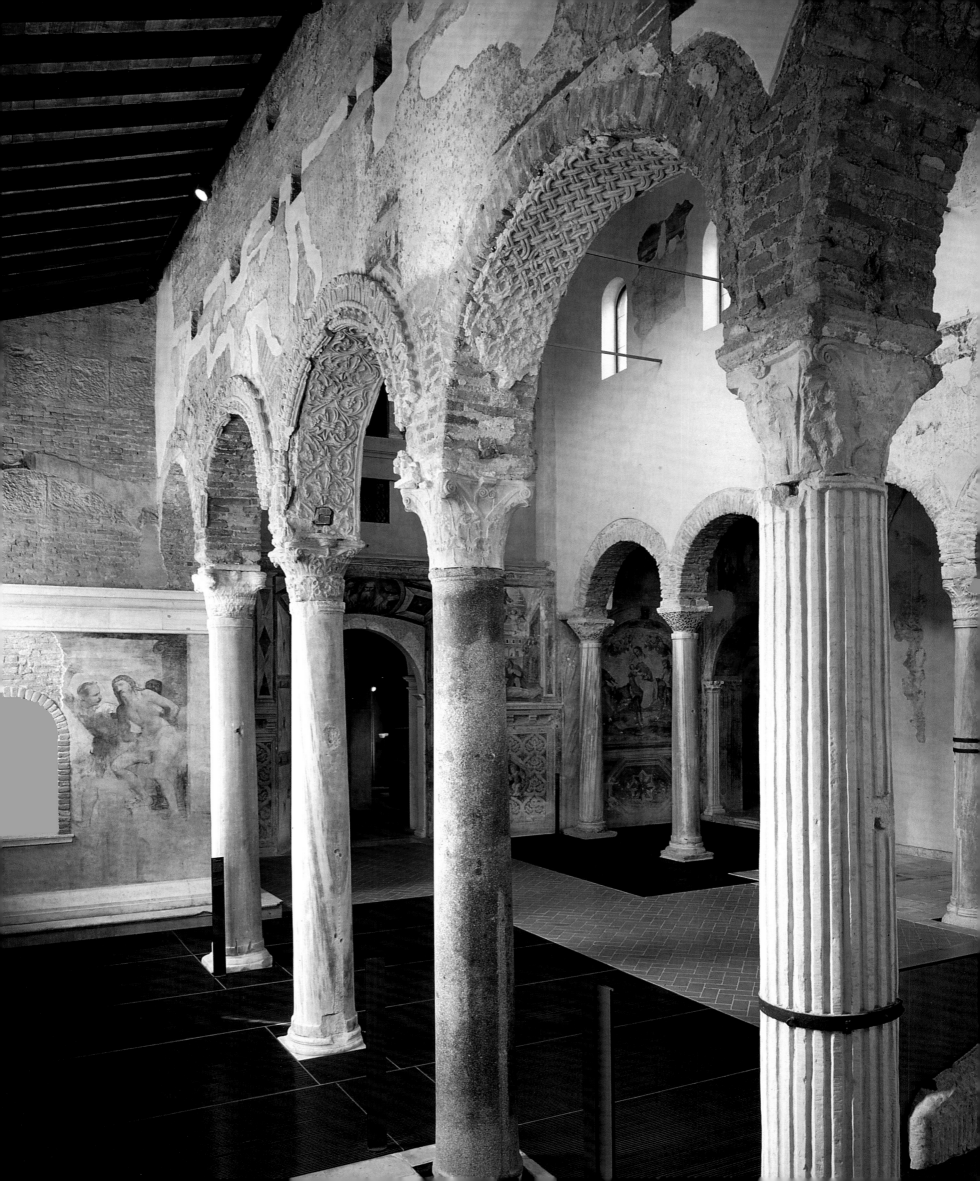

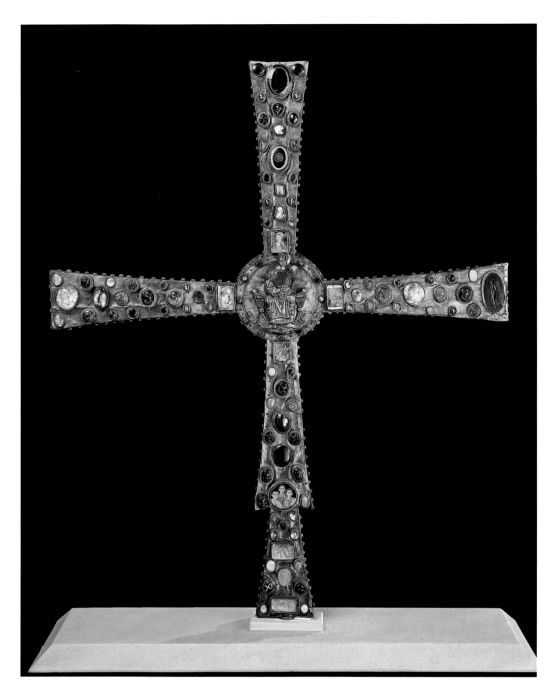

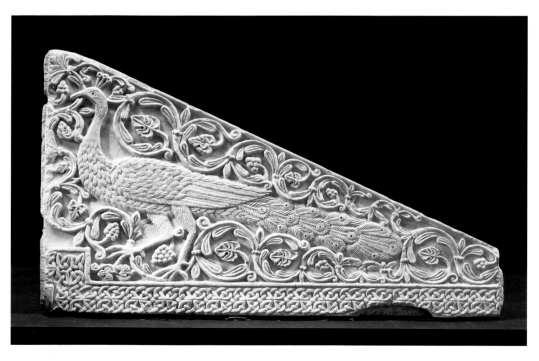

also traces of a fresco cycle in three superimposed registers on the upper walls of the nave: scenes from the life of Christ on top and saints' legends on the two lower registers, including Saint Julia, whose relics Desiderius had brought from Rome to Brescia around 760. The fragments of the fresco inscriptions that have survived happen to include a reference to Desiderius's reign (*regnantem Desiderium*). Under the east apse there are remnants of a hall crypt. Adjoining it to the west is a more recent crypt, from the twelfth century, with columns decorated by capitals produced in the circle of Benedetto Antelami, several of which have been exhibited in the museum since the nineteenth century. The more recent part of the crypt has no fewer than nine naves, and it looks like a forest of closely placed columns. San Salvatore is generally thought to have been built under Desiderius and Ansa, making it a major work of late Lombard court art. If that is correct, the older part of the crypt would thus be the oldest surviving hall crypt. Its construction and decoration, however, have also been dated to the ninth century, which would make it Carolingian.

The most important decorative items from the early period are the two Lombard marble reliefs that once decorated the steps of an ambo and depict peacocks, symbols of immortality, and the famous Desiderius Cross. The latter is work in gold that may date from the time of Desiderius and has been repaired and restored many times. The cross has numerous precious stones as well as ancient gems and cameos, and a triple portrait in gold leaf from the end of the third century, which was once considered to be a portrait of the Empress Gall Placida and her children. This portrait led to it being called the Cross of Galla Placida. The closest comparable piece is the cross in Oviedo in Spain.

The monastery was later expanded to an extended complex with three cloisters. Around the middle of the twelfth century a square two-story central-plan building was built south of the church Santa Maria in Solario; its lower story has four quadripartite vaults on a central pier, for which a Roman altar stone was used. On the upper story, squinches create a transition to the octagonal vaulting. On the exterior a dwarf gallery runs around the eight sides. The walls and squinches of the upper story were entirely covered with frescoes by the local painter Floriano Ferramola between 1513 and 1524, in a typically Lombard Renaissance decoration of the whole. The Desiderius Cross is now kept in this room. The entire monastery is the municipal museum.

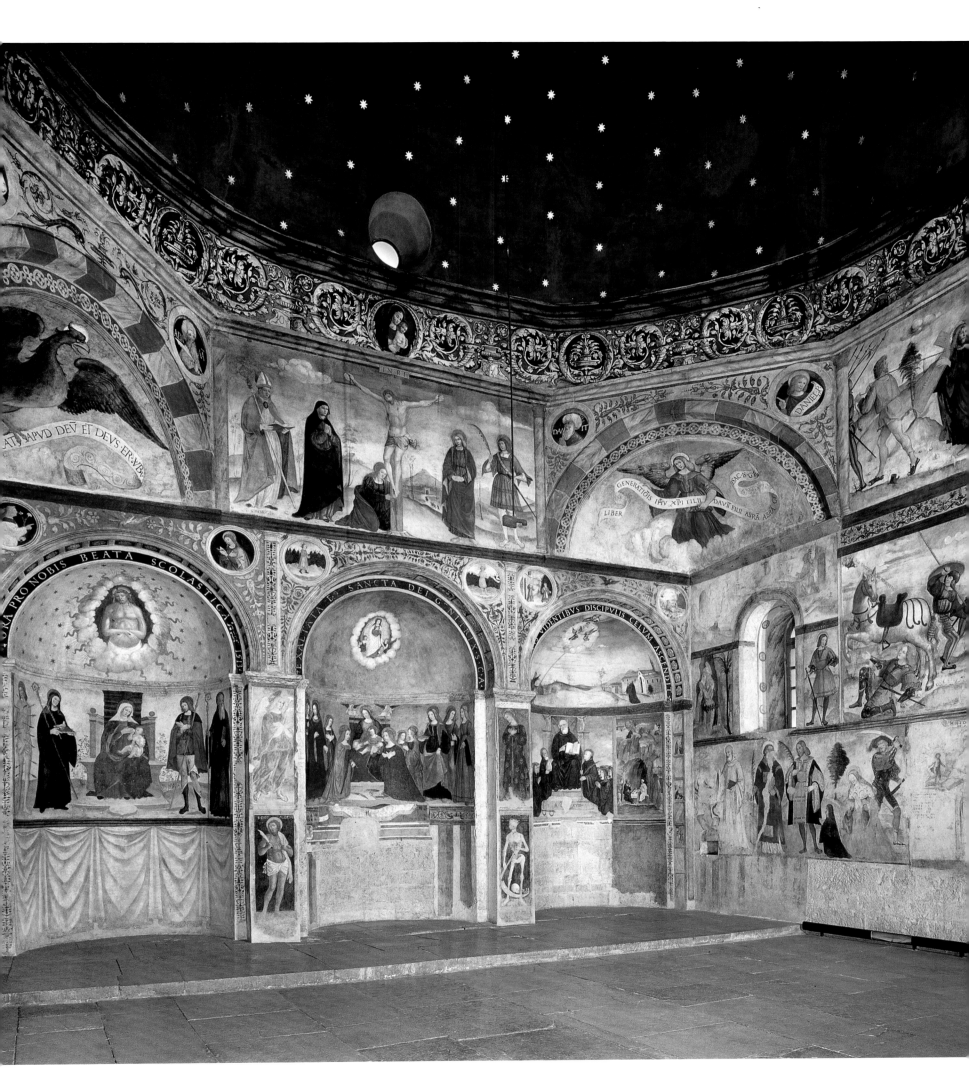

VERONA
SAN ZENO

The defensive tower, the church facade, and the campanile of San Zeno, seen from the west

THE FORMER BENEDICTINE MONASTERY San Zeno is named after the popular Bishop Zeno of Verona, the patron saint of the city, who was from northern Africa and reigned from 362 to 371–72. The monastery lies near an old cemetery outside the city center, and it had its own fortifications, of which a defensive tower from the twelfth or thirteenth century still stands, to the left of the facade. There was already a church here in the sixth century, as Pope Gregory the Great has testified. The church and monastery were destroyed many times, most recently by the devastating earthquake of 1117, which is said to have lasted thirty days and to have struck broad sections of northern Italy. The present church was built after the earthquake. Its building history has not been entirely clarified, particularly the dating. An inscription from 1178

on the campanile indicates that the tower was rebuilt fifty-eight years earlier and that the church was expanded and renovated forty years before. This can only be the date of completion. The reliefs alongside the west portal appear to have been executed a little earlier. According to the laudatory inscriptions, they were made by two different masters: Niccolò and Guglielmo. After completing his work at San Zeno, Niccolò was involved in the cathedrals of Ferrara (1135) and Verona (c. 1139). The towering campanile on the south side of San Zeno was added in 1178, according to the inscription. From that time until about 1200, Master Brioloto completed the upper part of the facade and added the large circular window: a wheel of Fortune with figures climbing up one side and falling down the other. One inscription warns against relying on Fortune, the sole ruler of mortals. Master Brioloto was probably also the one who gave final form to the portal and its baldachin-covered projection, and who fit the bronze doors, but not without slightly altering the arrangement of Niccolò and Guglielmo's reliefs. In the first half of the thirteenth century a crypt was built that extended the full width of the three naves: a nine-nave structure that opens onto the middle vessel through a triple arcade and offers a view into a forest of columns. One of the

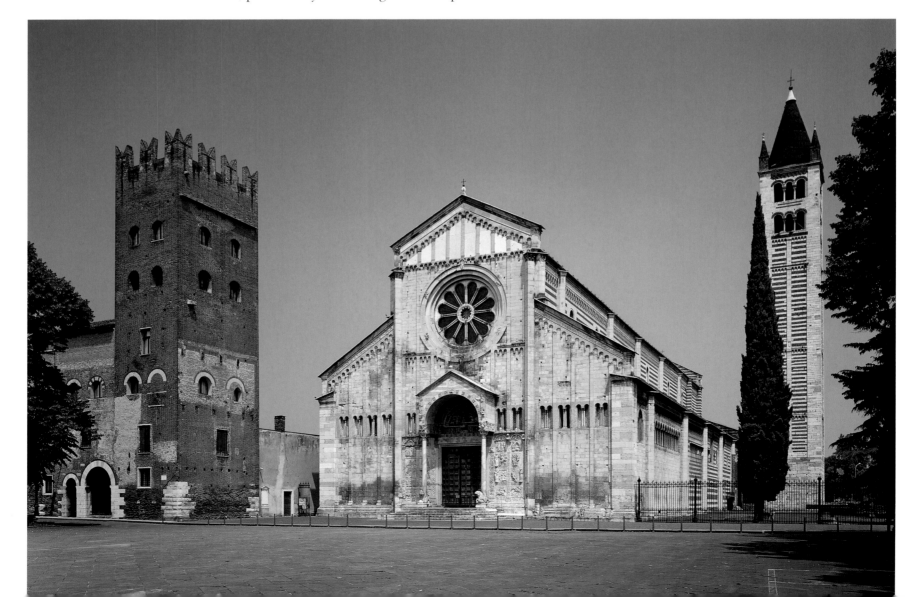

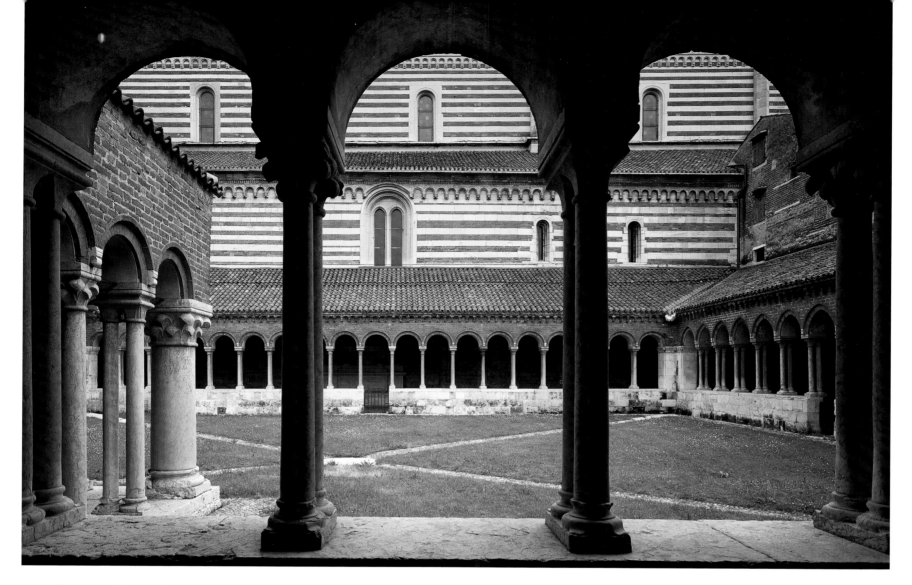

capitals is signed by "Adaminus da Sco. Gregorio" and dated 1225. The interior underwent another alteration from 1386 to 1398, when the Gothic chancel was attached and a wooden ceiling with a cloverleaf cross section was added in the middle vessel. At that time the flying buttresses that had spanned the middle vessel at every other pier were removed. They remained only in the west end.

In its original Romanesque state the church was about 245 feet (75 m) long: a basilica with no transept, in which cruciform piers with round projections alternate with slender monolithic columns. A characteristic feature is the alternation of brick with tufa, which makes the walls seem striped, especially on the exterior. Only the west facade is clad with travertine. Here continuous horizontal round projections are nearly the only articulation, spanning the entire facade like taut strings. The glory of the church is its portal. On the left side there are reliefs by Guglielmo depicting New Testament scenes from the Annunciation to the Crucifixion; on the right, reliefs by Niccolò with the story of the Creation. Along the bottom one sees legendary scenes from the life of the Ostrogoth king Theodoric the Great, who resided in Verona as well, thus he was known in

German legend as Dietrich of Bern (that is, Verona). The tympanum relief shows Saint Zeno transferring the standards to the people of Verona, probably an allusion to the fact that from 1136 onward the city was no longer ruled by despots, but by elected consuls.

The doors are the magnum opus of the portal. They consist of fifty-five cast bronze reliefs that are mounted to a wood core, just as the forms for the frame are. The left door has scenes from the New Testament; the right, scenes from the Old Testament. Two workshops can be clearly distinguished. One created the reliefs of the left door and several of those on the right. The former, with its scarcely articulated figures, just bodies consisting of masses and staring heads, is a naive primitivism that has something barbaric about it, like the Novgorod door made in Magdeburg after 1150. In the other workshop the style of the figures is more evolved, more closely observed, and more natural; these reliefs rise to the level of the stone reliefs by Niccolò and Guglielmo. The dating of the doors is disputed. The first workshop may have been active as early as the eleventh century; the second, perhaps toward the end of the twelfth, in connection with the completion of the facade under Brioloto.

ABOVE:
Cloister

PAGE 418:
Interior of the church, facing east

PAGE 419:
The Romanesque bronze doors of the west portal

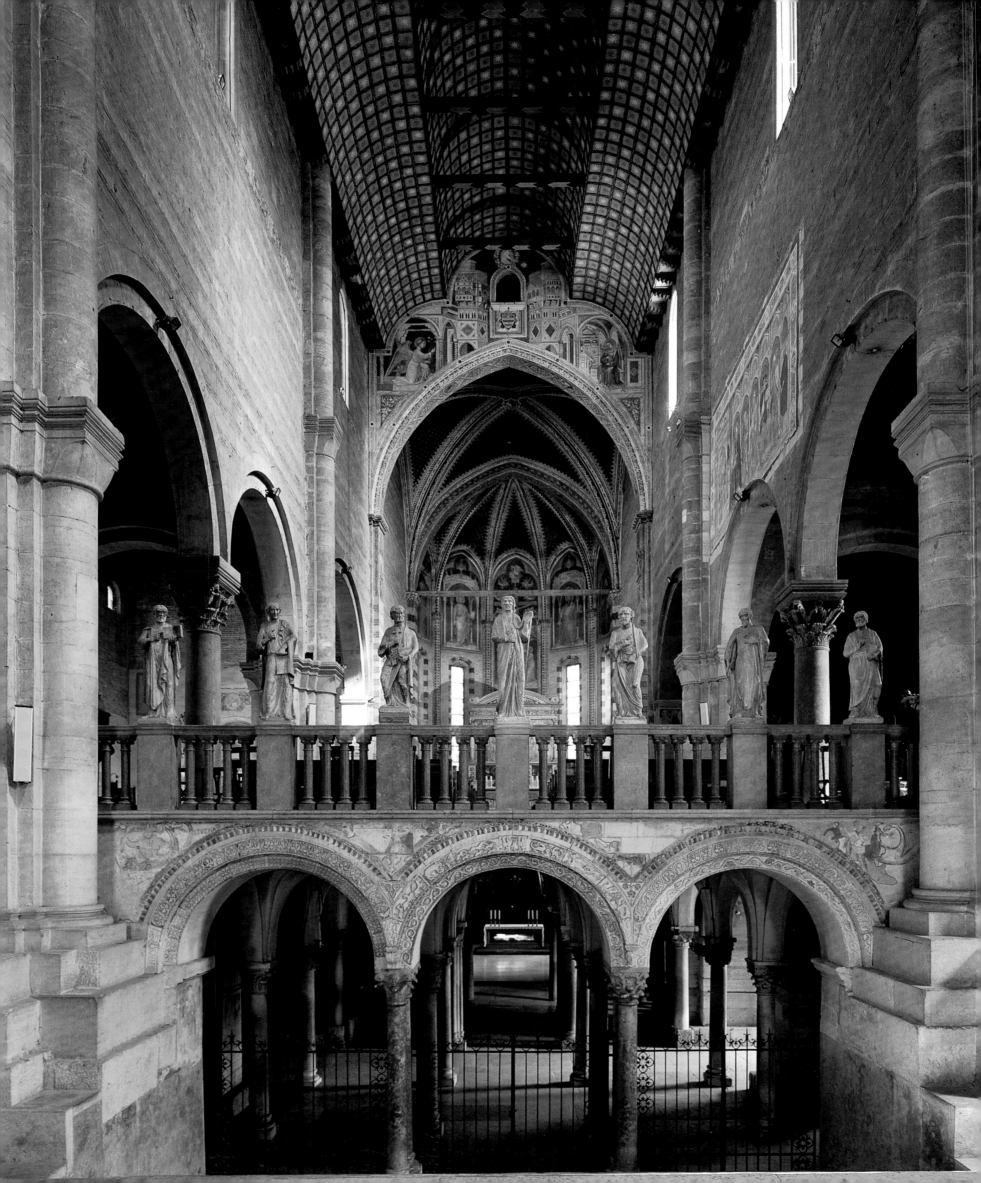

VENICE

SANTI GIOVANNI E PAOLO, SANTA MARIA GLORIOSA DEI FRARI, SAN GIORGIO MAGGIORE

AMONG VENICE'S MANY MONASTERY CHURCHES, those of the mendicant orders are the largest: the Dominican church Santi Giovanni e Paolo, called Zanipolo for short, and the Franciscan church Santa Maria Gloriosa dei Frari. Both are 328 feet (100 m) long. The mendicant orders arrived in Venice in 1225. Approximately a decade later Doge Giacopo Tiepolo allotted properties to them for monasteries. The Dominicans began their first church, which served as the burial site for several doges, in 1246; the Franciscans began theirs in 1250. After roughly a century both orders were in a position to begin new construction of the present, much larger churches—the Franciscans in 1330 and the Dominicans in 1333–34. It was not just the orders who were competing, but even more so the donors and benefactors who bore their costs. In the end the Dominicans had the advantage, since in 1437 the wealthy fraternity of the Scuola Grande di San Marco moved to the property directly adjacent to the Dominican monastery and immediately came out with donations. The consecration of Zanipolo is documented in 1430, and shortly thereafter, around 1440–50, the Frari church was completed.

The architectural showpiece of each church is the main apse, a multistory polygon set apart by lavish tracery windows. As the focal point of the church it offers a light-filled, exceedingly precious haven of brick and glass. Here the two orders tried to outdo each other. The Dominicans had completed the entire east end around 1368; the Franciscans, around 1380. It seems, however, that the main apse of the Frari did not live up to the

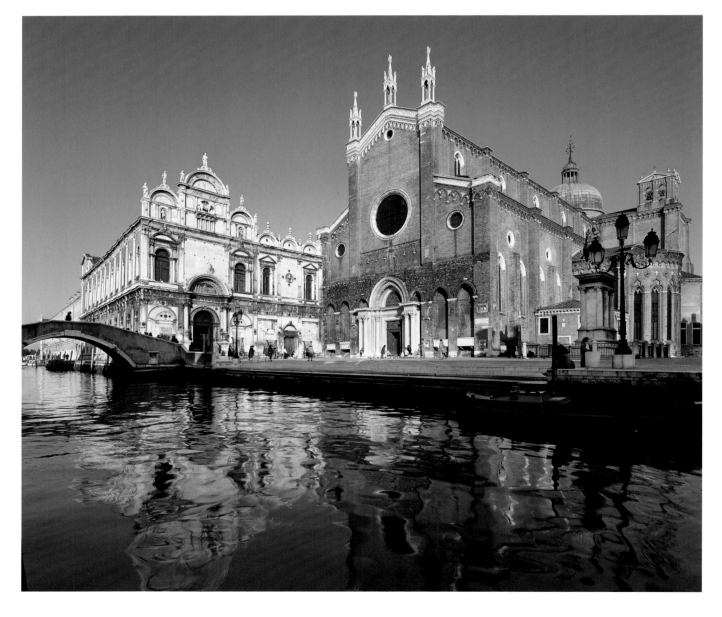

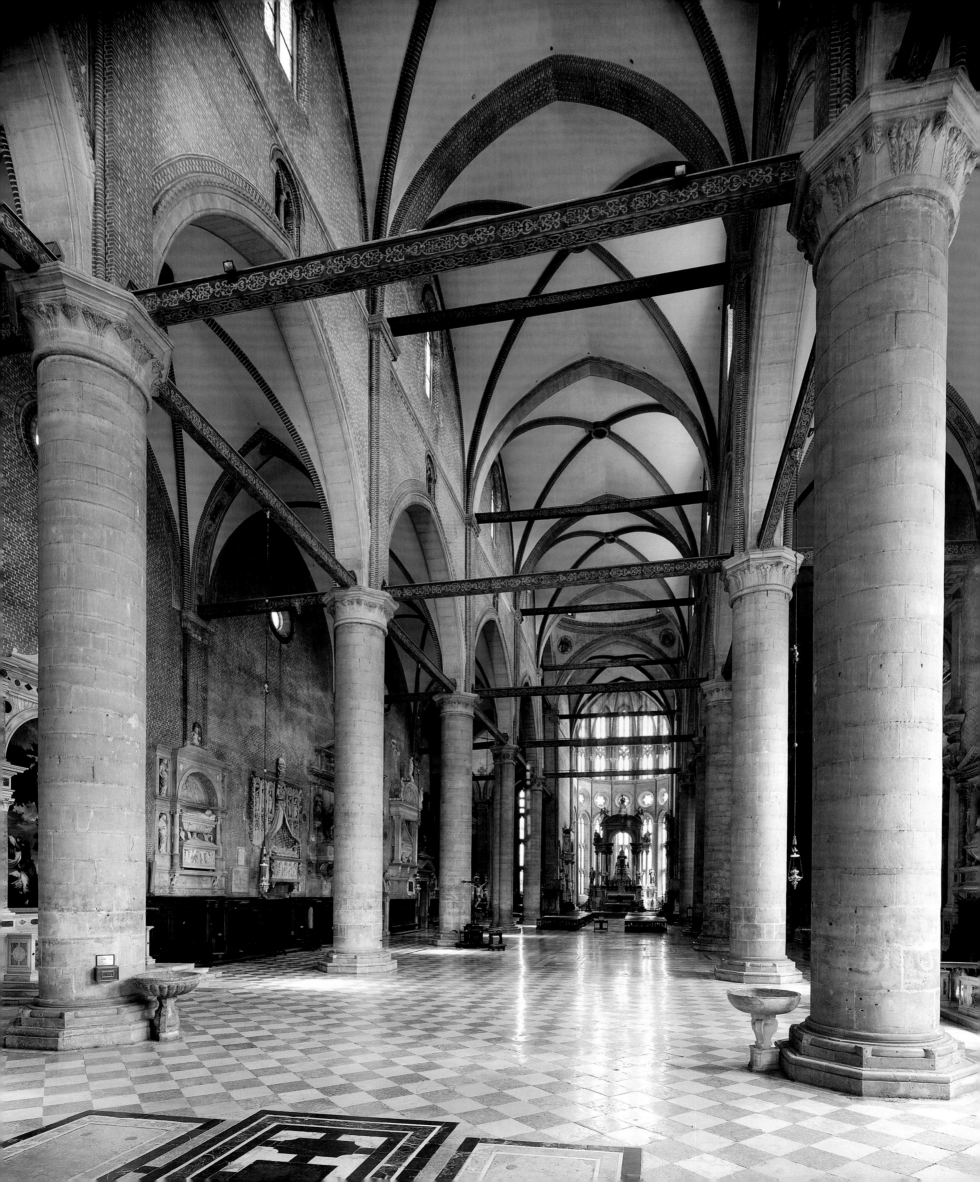

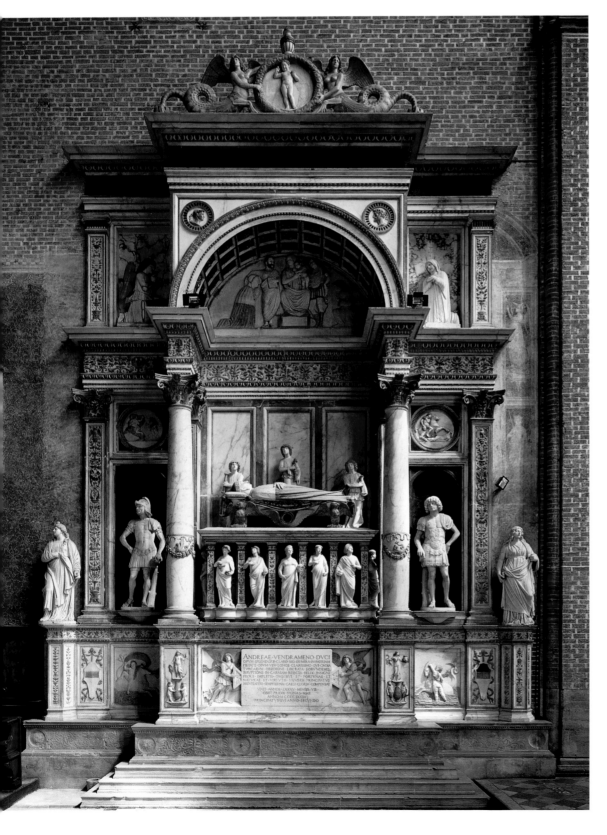

Tomb of Doge Andrea Vendramin, Santi Giovanni e Paolo

comparison with its competitor; in any case, the Franciscans replaced it with the present apse just a few decades later, at the start of the fifteenth century—to leave Zanipolo standing in its shadows. In response, the Dominicans were moved to rebuild the upper part of their own main apse, in order to achieve the height and the splendor of the Frari. The Scuola di San Marco made this financially possible for the Dominicans; they had an interest in giving the apse a splendid appearance if only because they had held their services in the apse since 1437.

The two churches are closely related in other respects, as well. There are chapels in the broadly projecting transept arms, and the crossing houses the sanctuary with the main apse—a layout that conforms to the Bernardinian plan of the Cistercians. The chapels do not have flat terminations but end in polygonal apses. In the Frari these and the main apse have the unusual feature that their centers are each taken up by one corner of the polygon, and are thus closed. In Zanipolo, more typically, a window is placed at the center.

The middle vessels of both churches have bays that are lateral rectangles, though nearly square, with round piers and towering nave arches. Because the pier arcades are so wide and tall, the side aisles have a real effect on the spatial image. The churches differ in their proportions. The middle vessel of the Frari church has an inside width of forty feet and ten inches (12.44 m), somewhat wider than Zanipolo, but at ninety-two feet (28 m) in height, it is more than thirteen feet (4 m) lower. This gives the main block an especially pronounced settled width, in comparison to which Zanipolo seems more vertical and steep.

Both churches are distinguished by robust wooden tie beams that reach across the length and width of the main block to form a rectangular, gridlike frame. In the lateral direction in the nave there are even two sets of joists, one above the other; the upper is attached to the impost of the vault, the lower to the pier capitals. This frame of beams mars the effect of the space, but is required by the statics, as the stability of the stone architecture was always imperiled by the miry subsoil, despite the pile work under both churches. The tie beams, which have both compression and tensile strength, not only brace the walls but also hold them together, and for that reason they were probably an element in the construction from the outset. Initially, however, the Frari had only the upper set of ties in the longitudinal direction. The lower ties were added as a precaution during an early-twentieth-century restoration.

In both churches the monks had their own chancel in the east end of the middle vessel, delimited by rood screens. Only the chancel in the Frari has survived, where according to an inscription the screens were completed in 1475 by Pietro Lombardo. The tall, round archway here represents a remarkable artistic idea that opened the monks' space to the church of the people. Optically, the archway offers a frame around the stone high altar retable of 1516 that towers in the distance, with an *Assumption* by Titian that is nearly twenty-three

had an immense influence on painting into the Baroque period. Even theology was influenced by it, for in 1950, when Pope Pius XII made the Virgin's bodily ascent to heaven official church dogma, he alluded expressly to Titian's painting, which had crucially affected the idea of ascension. Titian—who also painted for the Frari an altarpiece for the Pesaro family as well as his own tomb painting—was buried in the right side aisle in 1576.

In Zanipolo there is another renowned painting by Titian: the assassination of the Dominican inquisitor Petrus Martyr. In 1867 it was destroyed in a fire, along with the earliest large-scale altarpiece by Giovanni Bellini.

Since the middle of the fifteenth century the funeral ceremonies for the doges have been held in Zanipolo. The funereal pomp became more and more elaborate during the Baroque period, so to improve the view from the nave, the rood screens were removed in 1649. Twenty-seven of the doges have tomb monuments in Zanipolo, but just three in the Frari. The most famous tomb monument, known for its consummate

Interior of the church of the Frari, facing east, showing the chancel screen and view through to Titian's Assumption

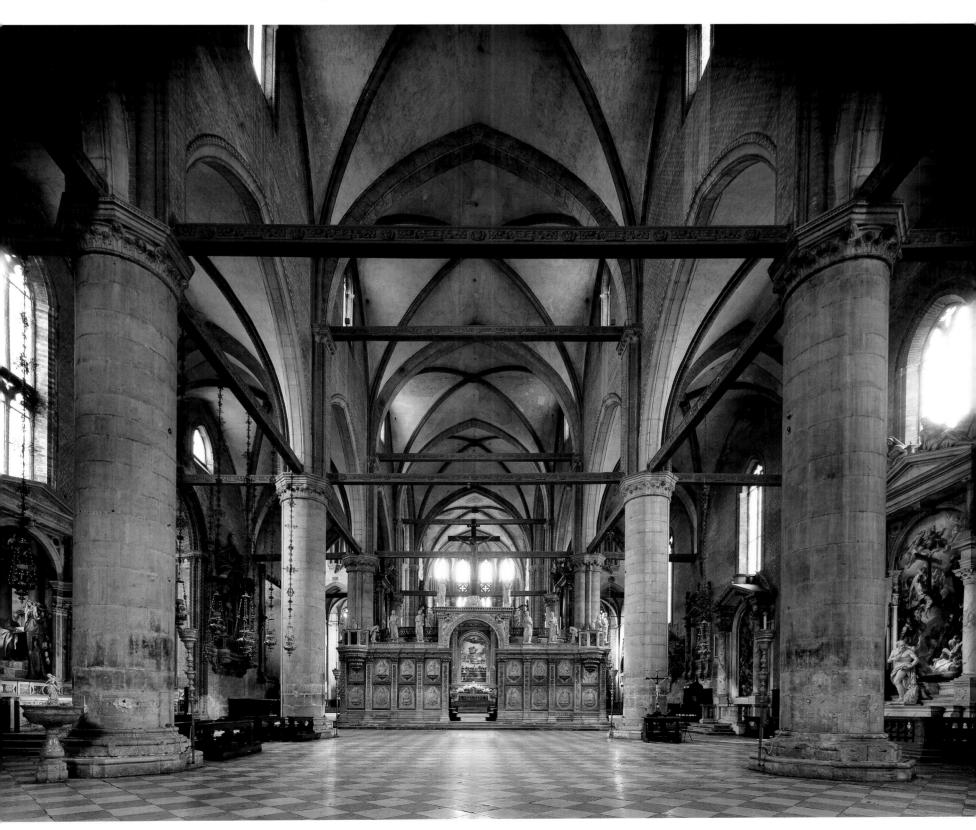

artistry, is that of Doge Andrea Vendramin (d. 1478), on the left side wall of Zanipolo's sanctuary. It originally stood in the Servite church, and was relocated here only in 1810. Begun in 1492, it is the work of Tullio Lombardo, one of the great masters of the Venetian Renaissance. The defining motif of the tripartite structure is a columned arch that projects from the center, surrounding the catafalque of the doge and framed by the receding sides. It is no coincidence that it recalls antique triumphal arches, without imitating them. In the relationship of the parts to one another, the whole is a perfected harmony—absolutely the classical Venetian tomb monument, and a counterpart to Andrea Sansovino's tomb monuments for the Roman cardinals in the chancel of Santa Maria del Popolo.

Zanipolo's towerless facade traces the basilica cross section of the main block. It is a looming brick building that, for all its simplicity, shows its pride through its proportions. It far surpasses the facade of the Frari church. At a right angle to Zanipolo's facade stands the early Renaissance facade of the Scuola Grande di San Marco: a richly decorated display front crowned by semicircular gables. In the typical Venetian fashion it is divided into two parts: the left side belongs to the hall; the right, to the lodging. The church forecourt is bounded by a canal. Diagonally to the right in front of the church the equestrian monument of Condottiere Bartolomeo Colleoni looms on its high pedestal—a major work by Florentine artist Andrea del Verrocchio, who prepared the model in 1481–88 that was cast by Alessandro Leopardi of Venice by 1496. Colleoni, depicted on a real battle horse as a fearless old soldier and frontline officer, requested in his will that the monument be placed in front of San Marco—meaning on the Piazza San Marco—but the Venetians did not place him before the church of San Marco, but in front of the Scuola—so the will was fulfilled to the letter, but not the spirit.

The Benedictine island monastery San Giorgio Maggiore is another world entirely. Its church's red hues and gleaming white facade of Istrian marble were calculated with the distant but unhampered prospect

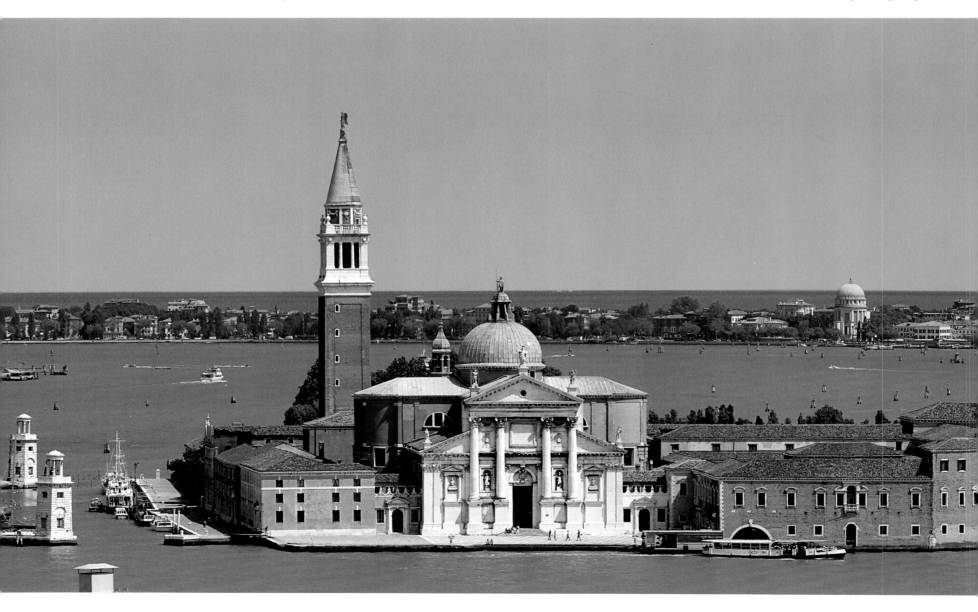

from the Piazzetta and the Doge's Palace. Its exposed site means the monastery is an important part of Venice's cityscape; it forms a counterweight to the Doge's Palace and its surroundings. The church, begun in 1566 and consecrated in 1610, is one of the major works by Andrea Palladio, the great artist among the Italian architects of the High Renaissance. Here too the facade is a cross-section facade. Palladio gave it a ceremonious theme by dramatizing its central section as a tripartite temple facade in a major order of classical antiquity, with colossal columns on high pedestals, flanked by lower sides in the minor order, articulated by pilasters rather than columns. Its counterpart is Il Gesù in Rome, built around the same time based on plans by Giacomo della Porta: a two-story cross-section facade in the minor order with no temple facade. Both facades established a type and were very influential.

The interior of San Giorgio is a cruciform basilica with pier arcades and projecting orders of half-columns and a continuous entablature—a building that achieves a clarity and harmony that is as pure as a bell: the perfection of the classical. It is dominated by proportions "that appear to be the only true ones for as long as they are before one's eyes," as Jacob Burckhardt wrote. Of the monastery buildings, grouped around two cloisters, Palladio's refectory and the stairwell built in 1641–43 by Baldassare Longhena, the architect of Venice's church of Santa Maria della Salute, are masterpieces of great importance for the history of architecture. The stairway leads along two inverse symmetrical arms of two flights that turn upward at right angles around a newel. Together with the open, two-story arcade gallery of the entrance side, the stairway offers a broad and splendid architectural prospect, similar to the large stairwells of the later Baroque castles north of the Alps, such as Schönbrunn in Vienna and Pommersfelden in Franconia, for which Longhena had created an important prototype.

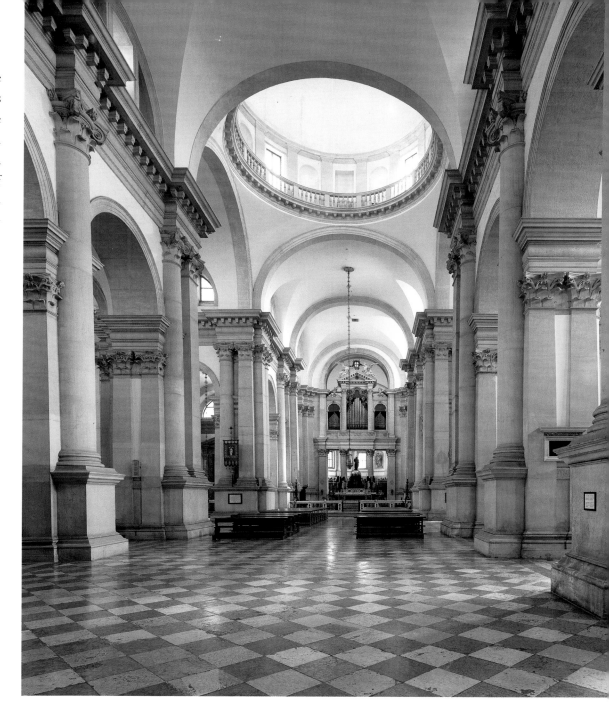

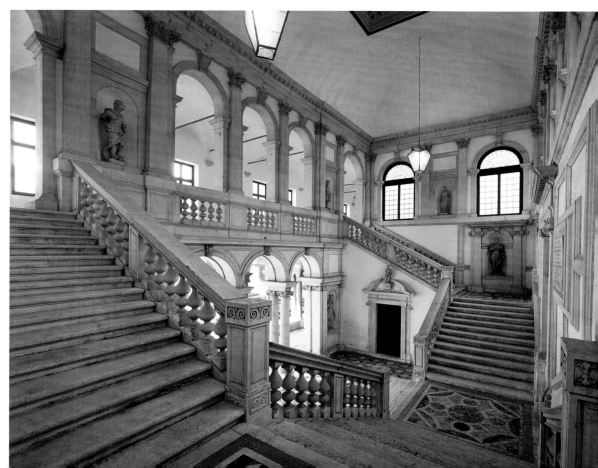

POMPOSA

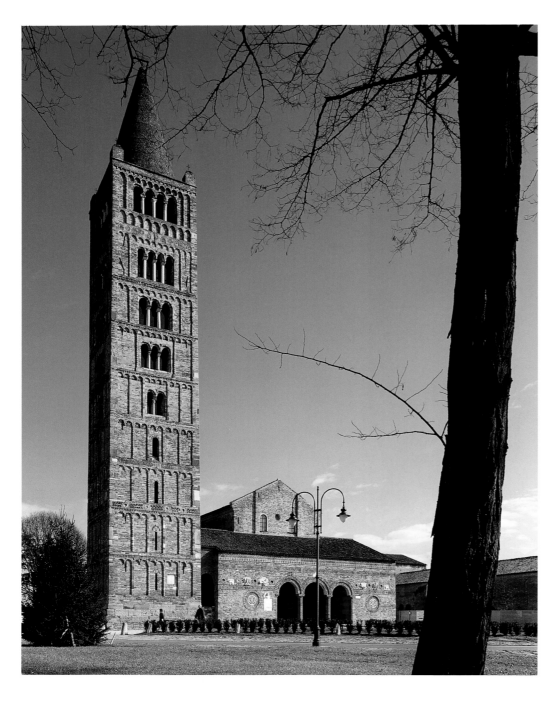

ABOVE:
West façade of the church and the campanile, Pomposa

OPPOSITE PAGE:
Nave of the church, facing east

Emperor Otto III and Pope Sylvester II granted Abbot Guido dominion over "insula Pomposiana" with independent jurisdiction and autonomy from the bishops of Ravenna. This privilege, which made Pomposa an imperial abbey, was repeatedly affirmed by all the Salic and Hohenstaufen emperors through Frederick II in 1220.

Under the great abbots Guido, Hieronymus, and Mainardus, the monastery—which was close to the hermetic reforms of Romuald and Peter Damian—became extremely important. There was a large library, and the monk Guido of Arezzo was active here when he developed the hexachordal system, the basis of our present-day musical notation.

Pomposa's landmark, visible far and wide, is its square campanile, which is 157 feet (48 m) tall. According to an inscription it was built under Abbot Mainardus in 1063, by the architect Deusdedit (God's gift): it is a typical Lombard showpiece with nine blocklike superimposed stories and pilaster strips and round-arched corbel tables. The open arcades increase from single openings to four as one moves from bottom to top. Like a watchman over the monastic island, the tower looms into the heights.

Alongside the tower, the church seems that much lower. It is a three-nave column basilica with an exposed roof framework and a main apse that is semicircular inside and polygonal outside. It was modeled on the early Christian basilicas in Ravenna from the fifth and sixth centuries. Unlike those, however, the columns were not newly made; spoils were used, which suggests the church was built long after the sixth century, perhaps around 800. The reconsecration took place in 1026. Later transverse walls were added in the side aisles for stability, which severely mars the look of the space. A characteristic feature of Pomposa is the trecento painting in the middle vessel, which covers every surface. Vitale da Bologna painted frescoes in the apse around 1351: a depiction of Christ enthroned in the mandorla and a Last Judgment on the west wall. Later other painters added scenes from the Old and New Testaments and the Apocalypse on the walls of the middle vessel, turning the church into a single paintings gallery.

Of the worldly monastery buildings the hall of justice west of the church, dating to the period just after 1000, is extremely interesting: it is a partially reconstructed rectangular building with a two-story open arcade gallery in front of its eastern side, facing the church. This medieval "palace of justice," which recalls the great hall of a palace, is a proud expression of the monastery's independent jurisdiction.

NOT FAR FROM FERRARA AND RAVENNA, THE Benedictine abbey Pomposa lies isolated on what was an island in the estuary of the Volano River—the most important waterway of the eastern Po valley during the Middle Ages—but has long since joined with the shore as a result of sedimentation. The monastery, first mentioned in 874, may have been founded as early as the sixth or seventh century.

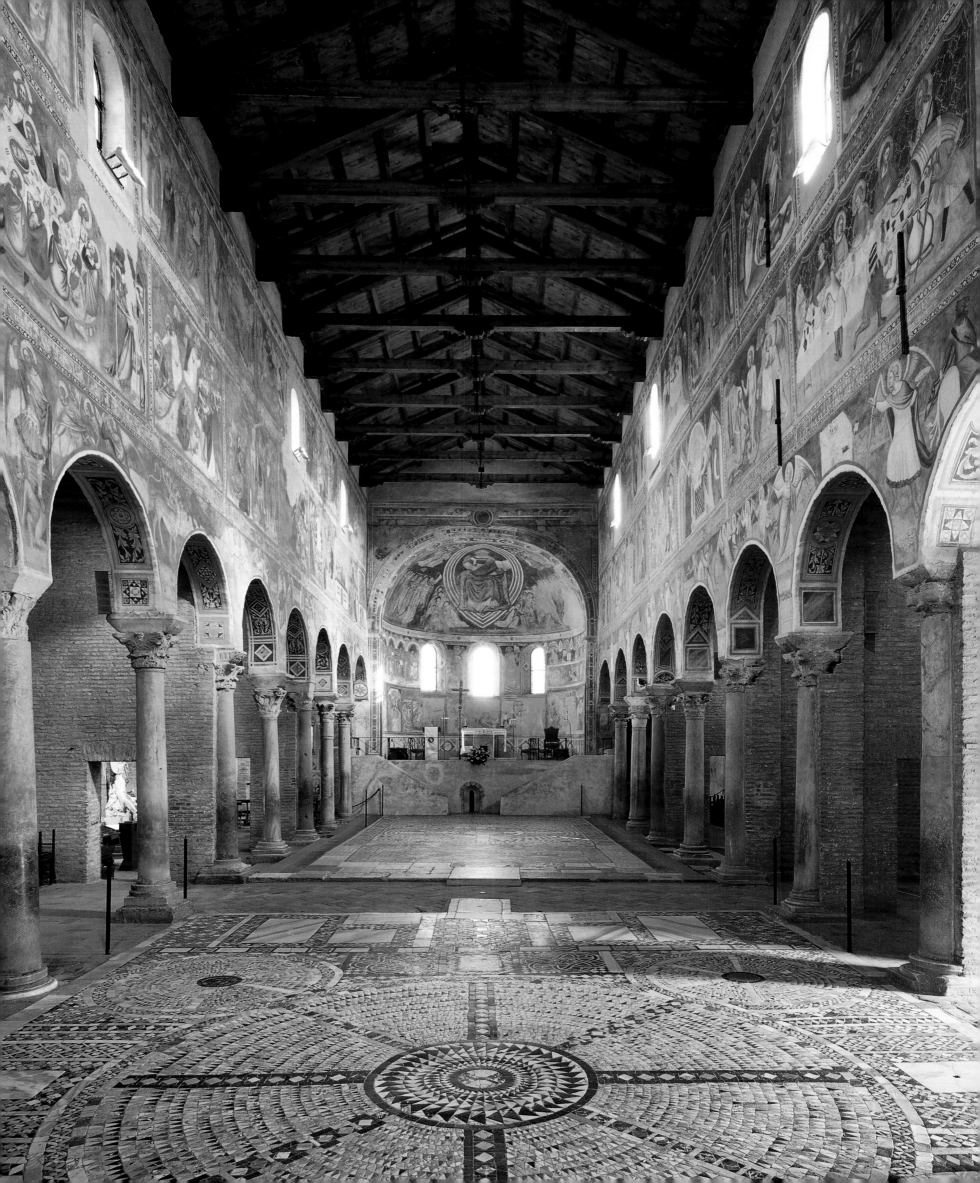

ASSISI
SAN FRANCESCO

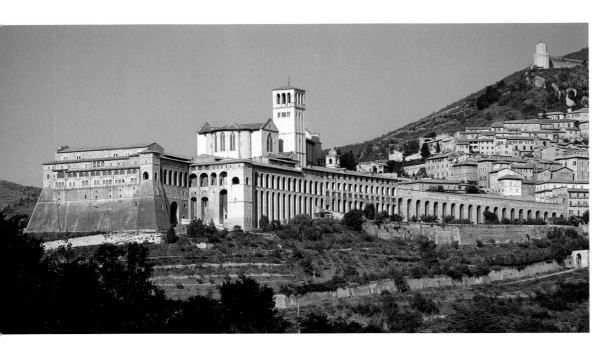

San Francesco, Assisi. ABOVE:
View of the monastery from the southwest;
BELOW: *View from the northeast*

OPPOSITE PAGE:
*Fresco decoration from Giotto's Life of
Saint Francis cycle in the upper church.*
TOP RIGHT: *The vault of the lower
church, with* The Apotheosis of
Saint Francis; BOTTOM LEFT:
Confirmation of the Rule by
Pope Innocent III; BOTTOM
RIGHT: Saint Francis Preaching
to the Birds

ASSISI, IN THE HEART OF UMBRIA, IS THE CITY
of Saint Francis. He lived there, founded his
order there, died there in 1226, and was buried
in the church of San Giorgio. In 1228 Pope Gregory IX,
who had excommunicated Emperor Frederick II the
previous year and had thus been exiled by the Romans,
came to Assisi, where he canonized Francis at his grave.
The following day, on a steep slope west of the city that
the municipal authorities had granted him, he laid the
foundation stone for a separate burial church for the
saint. In 1230 the bones were secretly transferred to its
crypt, which provoked an outcry. The pope, who placed
the church under the protection of the holy see and
gave it the honorary title "caput et mater" (head and
mother of all Franciscan churches), did not intend to
establish a simple mendicant church here, but rather a
place of worship and pilgrimage, and he did not avoid
any effort or expense. It was consecrated by Pope Inno-
cent IV in 1253. There was little room on the space for
the associated monastery, so it was necessary to create
immense substructures to the west and south, which
govern the overall view from the valley even more than
the church itself. The chancel of the church points not
to the east, facing the city, but to the west, facing the
valley, over which it can be seen from a great distance. It

is a one-nave building with a transept and a polygonal
apse attached directly to the crossing. The exterior is
marked by a square tower on the south side and bulky
flying buttresses that have an unusual semicircular
form—which Vasari called *torrioni* (little towers).

The building consists of two stories, with a lower
and an upper church. The lower one, later expanded by
adding side chapels, is low and compressed like a crypt.
The actual crypt, added in the twentieth century, is
below that. The overall appearance of the lower church
is determined by quadratic cross rib vaults that consti-
tute nearly the entire space. The ribs have a primitive
boxlike section. The ornamental painting of the ribs and
the edges of the vault caps is the only decoration in the
space, and it visually amplifies its importance. The
upper church is another world. Here the walls have a
Gothic, purely French system of projections, consisting
of engaged pillars for the vault ribs; the window walls
above the high wall base are set back a step, making
room for a walkway, like that of the Reims cathedral.
The square bay section, however, does not seem French
at all, nor does the balanced proportion of width to
height. This Gothic architecture, despite clear French
reminiscences, preserves the broad look of Italian and
Mediterranean churches and also their flatness of the
walls and vaults. The category of the single-nave double
church in which the lower aisle was shorter and the
upper one taller was unusual for Italy but common in
episcopal chapels in France—for example, at Reims. It
turned Assisi into a papal chapel. At the same time, this

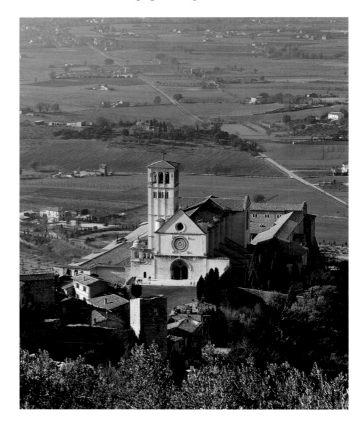

type was extended through the addition of a transept, giving the building the form of a cross, which was appropriate for Saint Francis, the first saint to have his stigmata recognized by the church.

Lavish decoration was planned for the church from the outset: the finest painters of the era were engaged for it. Here they created the work that would be crucial to the formation of style through the end of the trecento. The painting began in the lower church around 1260. This was followed by the stained glass in the upper church—the first in all of Italy. The oldest scenic murals were painted on the longitudinal walls of the lower church by the anonymous Master of Saint Francis using the *secco* technique; they comprise a cycle with the Passion of Christ on the one side and the Life of Saint Francis on the other. The earliest painter who can be identified is the Florentine artist Cimabue, who with his workshop created an extensive pictorial program in the transept and apse of the upper church. It is poorly preserved, and it was partly destroyed by the 1997 earthquake. With his paintings in the crossing and transept Cimabue established the system for the decoration of the main block. It began with scenic paintings in the upper part of the wall, which appear to be the

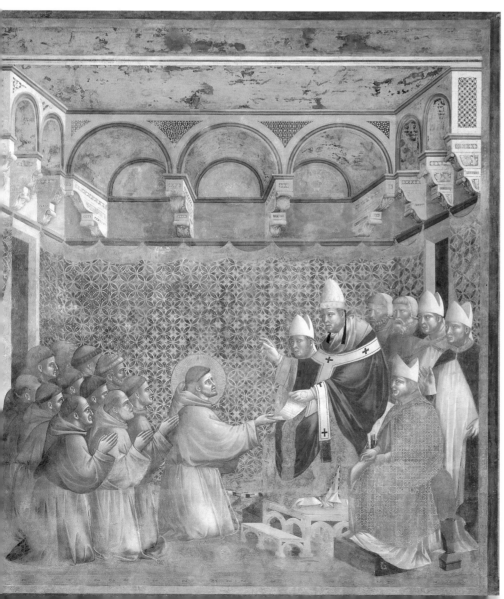

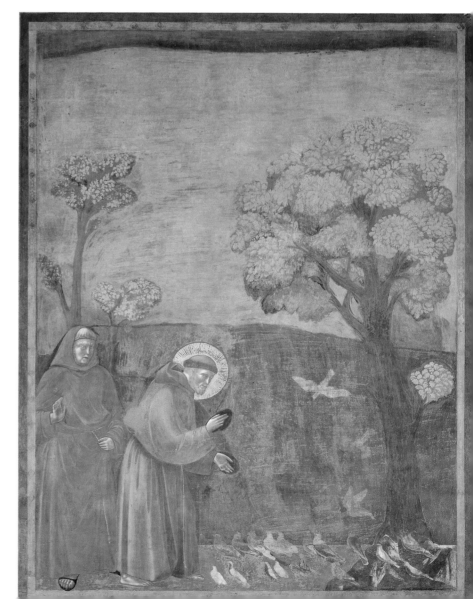

work of the Roman artist Jacopo Torriti, a member of the Franciscan order. Beginning around 1292–95 the young Florentine artist Giotto was active; the ground-breaking scenes of the story of Isaac can be attributed to him. The most famous cycle of paintings in Assisi depicts the twenty-nine scenes of the Life of Saint Francis on the base walls of the upper church. The scenes are from the vita composed by the general of the order, Bonaventura, declared to be the saint's official and only correct vita in 1266. The cycle is considered to be the work of Giotto and his workshop from around 1295–1300, although the attribution is not undisputed. It includes a depiction of the confirmation of the rule of the order by Pope Innocent III, in which Francis and his fellow monks are seen in a perspectively constructed space, kneeling humbly before the pope who is elevated on his throne surrounded by his cardinals. It also includes the famous fresco of Francis preaching to the birds. Both are paintings of quiet modesty. The four frescoes on the crossing vault of the lower church—with the apotheosis of Francis, enthroned on a cathedra like a doctor of the church, worshiped and lifted up by angels—are also thought to be by Giotto. The three other fields show allegories of Modesty, Poverty, and Obedience—the commandments for monks of all orders. Directly below this vault lies the saint's tomb. The paintings of the lower church and the chapel annexes were completed by followers of Giotto and by several other painters, including Pietro Lorenzetti and Simone Martini, both of Siena.

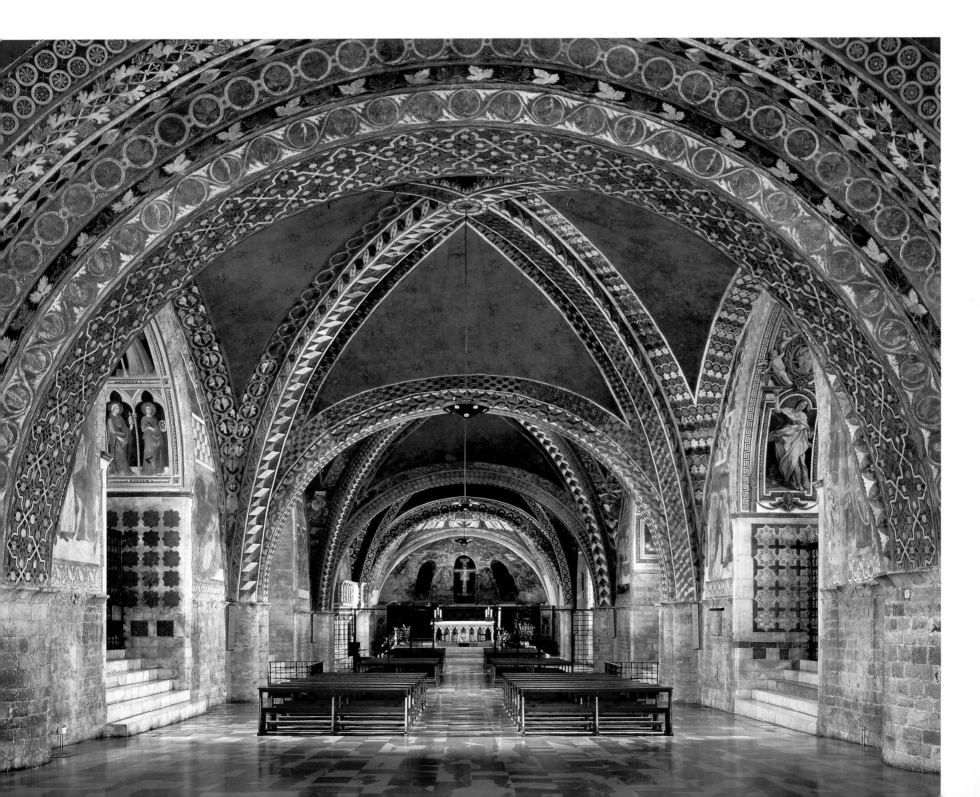

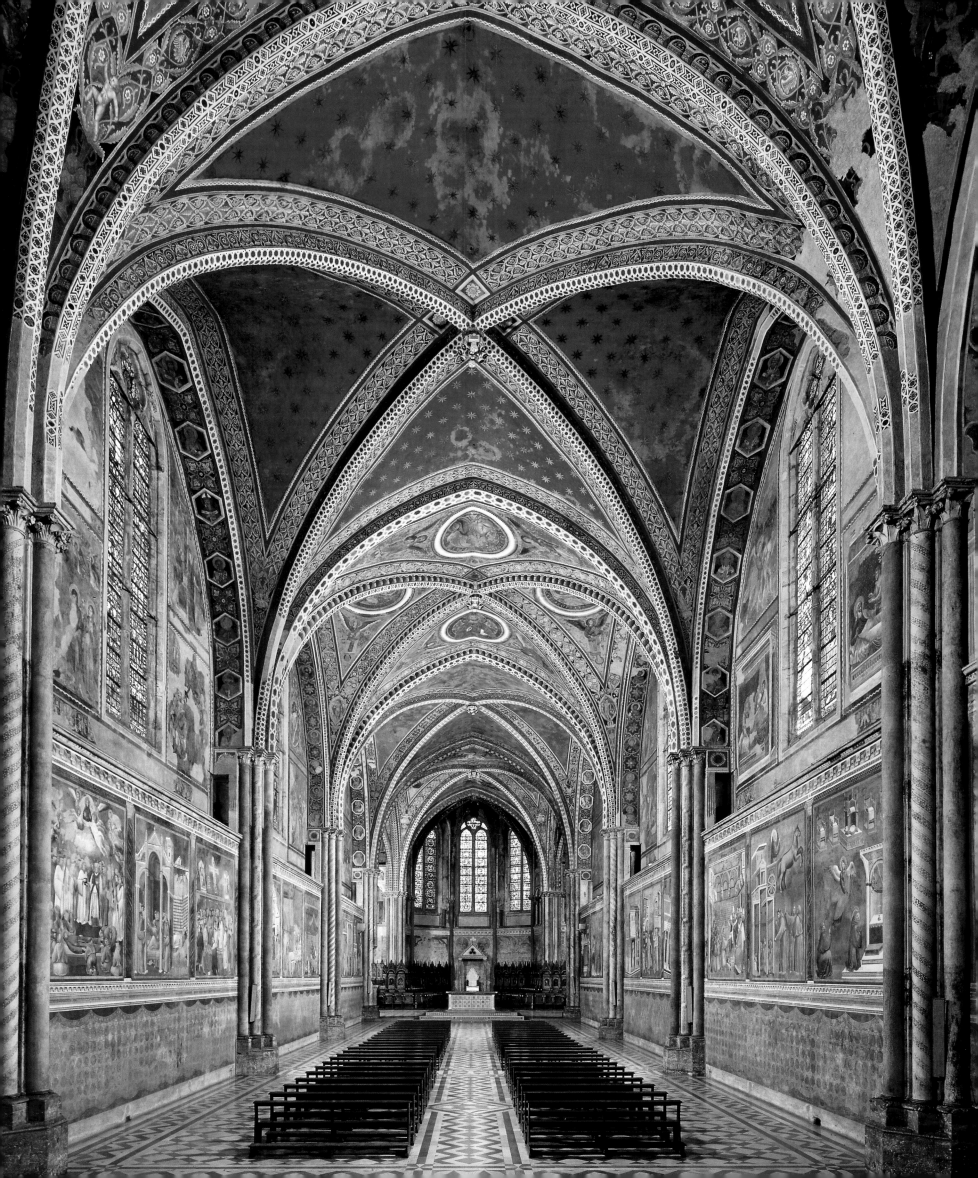

FLORENCE

SAN MINIATO, SANTA MARIA NOVELLA, SANTA CROCE, SAN LORENZO, SAN MARCO

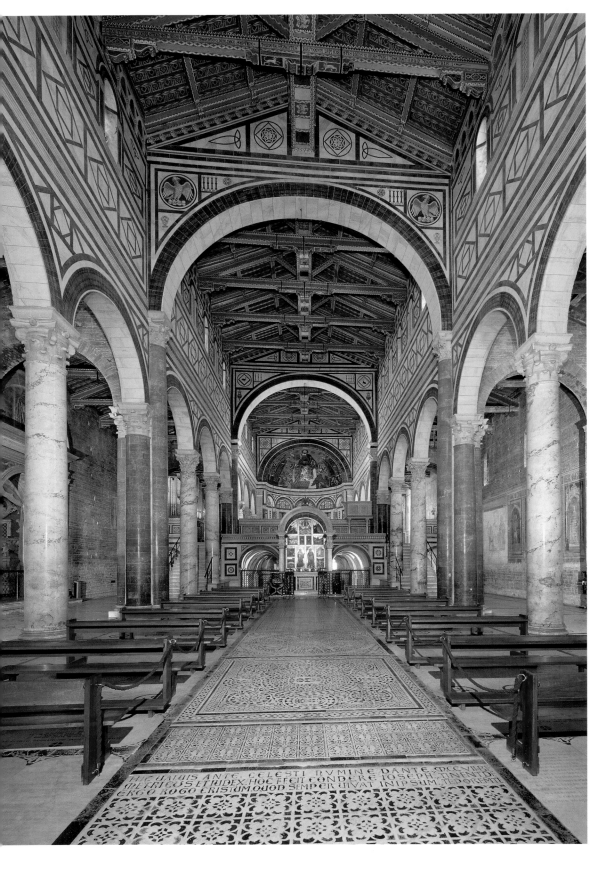

FLORENCE, THE CITY OF ART, IS ALSO A CITY OF monasteries. Many of them rank high artistically, either for their architecture or for their decoration with frescoes, stained-glass windows, altars, tomb monuments, pulpits, and other works. Florence is itself a total work of art, and the monasteries have a substantial part in this. Already in the Roman period the city on the Arno had a certain importance, but the rise of the Tuscan capital to a world metropolis of art began in the eleventh century, when Tuscia was ruled by Marchesa Matilda. Architecture in the city began to be oriented around Roman antiquity—far more intensely and precisely than in other cities. The result was a kind of first Renaissance, the "proto-Renaissance," whose defining building is Florence's baptistery. The main features of this trend are precious marble incrustations and articulations in which the Vitruvian orders of antiquity were revived with the motif repertoire of columns, pilasters, and entablatures, right down to such precisely studied details as the fluting on pilasters or the fascia of an architrave.

A model example for the proto-Renaissance and its delight in geometric surface ornament is the monastery church San Miniato, visible from far and wide on the edge of a mountain high above the city. Ever since the Carolingian period a Benedictine abbey had been located here on the tomb of the martyr Mennas; in 783 Charlemagne presented it with lavish donations. A new church, consecrated in 1018, was built with the support of the imperial couple, Henry II and Kunigunde. During this period the monastery joined the Cluniac reform. The present church was essentially built in the second half of the eleventh century. It is a column basilica with an exposed roof framework above three naves, and it has the distinctive feature that after every third arch there is a diaphragm arch on round engaged pillars that spans the nave. This produces a double pier alternation in the wall structure and a baylike subdivision of the room into three sections. The facade is generally considered to be especially felicitous, and is known for its beautiful site. The lower story has an arcade of five identical blind arches that bear no relation to the three naves of the basilica behind it. The upper story, by contrast, which was probably not added until the twelfth century, traces—in the form of its diagonals, middle section, and triangular gable—the cross section of the church and its roofs, with the result that the pilaster order used here does not align with that of the lower story. Nevertheless, the facade achieves a considerable degree of formally perfect equilibrium; at the same time, thanks to

432 ITALY

the incrustations in the fields, it offers an image of tasteful, never showy abundance—the whole facade is the epitome of harmony.

In the later Middle Ages the Dominicans and Franciscans began to dominate among the orders, as also happened in Venice, for example. Their monasteries, with the churches of Santa Maria Novella and Santa Croce, were located in opposite ends on the edge of the inner city, in the west and southeast, and ever since they have formed the two poles for the center. The Dominicans arrived in the city from Bologna in 1221 and took possession of the old Romanesque parish church Santa Maria delle Vigne, west of the cathedral. In 1246, under Prior Aldobrandino Cavalcanti, construction began on the church, although this was probably simply adding on to the old parish church, which faced

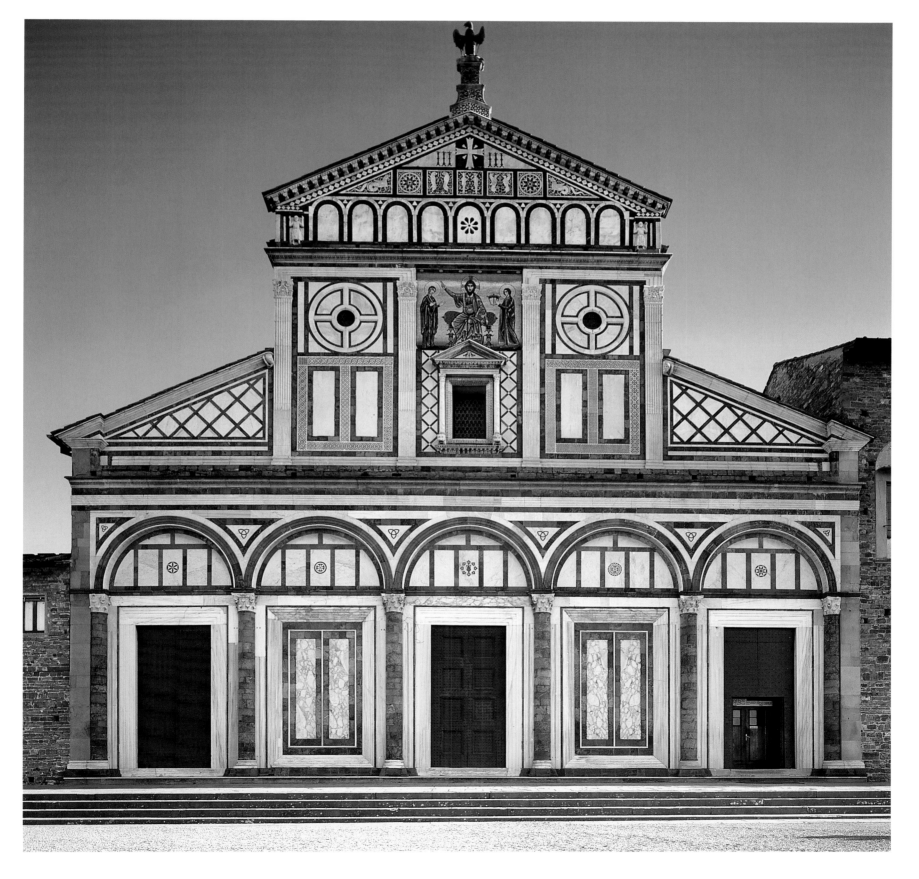

east. The present building, with its chancel facing north and its facade to the south, seems to have been begun later, based on a new plan that is mentioned in 1277. The church was completed in 1360 by the Dominican Jacopo Talenti, who resided in the monastery and directed the construction work from 1333 onward as *capomastro* (master builder). He was probably the brother of the architect of the cathedral of Florence, Francesco Talenti, under whose direction the top story of the cathedral campanile was being built at this time. The church is nearly 330 feet (100 m) long, and the chancel area has a boxlike sanctuary, a transept, and two chapels with flat terminations; it is clearly based on the Bernardinian plan of the Cistercians. The broad spaces and the bare flatness of the walls in the three-nave main block may be described as an example of the Italian variety of Gothic. The towering nave arcades, with broad profiles,

and the lower clerestory with only oculi for windows are also characteristic of this style. Michelangelo, who was not otherwise a supporter of the Gothic style, was especially fond of Santa Maria Novella.

The facade is one of the most famous works in the history of architecture. The lower section, with blind arcades and incrusted fields, predates 1360, as does the large wheel window. In the quattrocento the businessman Giovanni Rucellai had the facade completed according to plans by the great scholar and theoretician of art and architecture Leon Battista Alberti, from about 1458 onward. Alberti added a large order to the ground floor, including a central portal, and capped it with a tripartite rhythmic temple facade that becomes volutes on the sides. With this work Alberti established the prototype for countless later facades, including Il Gesù in Rome and its successors. Another noteworthy

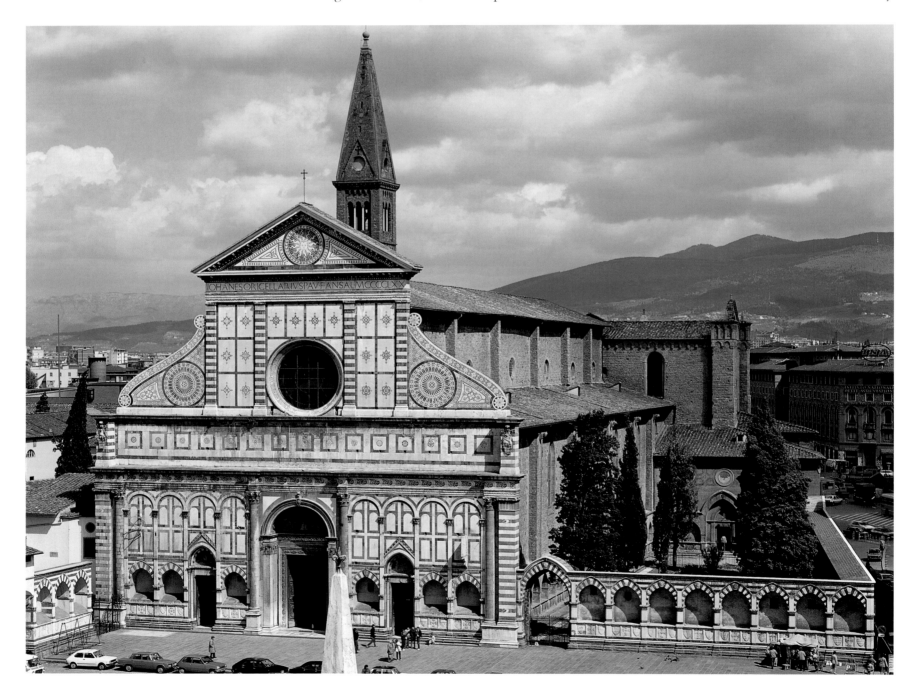

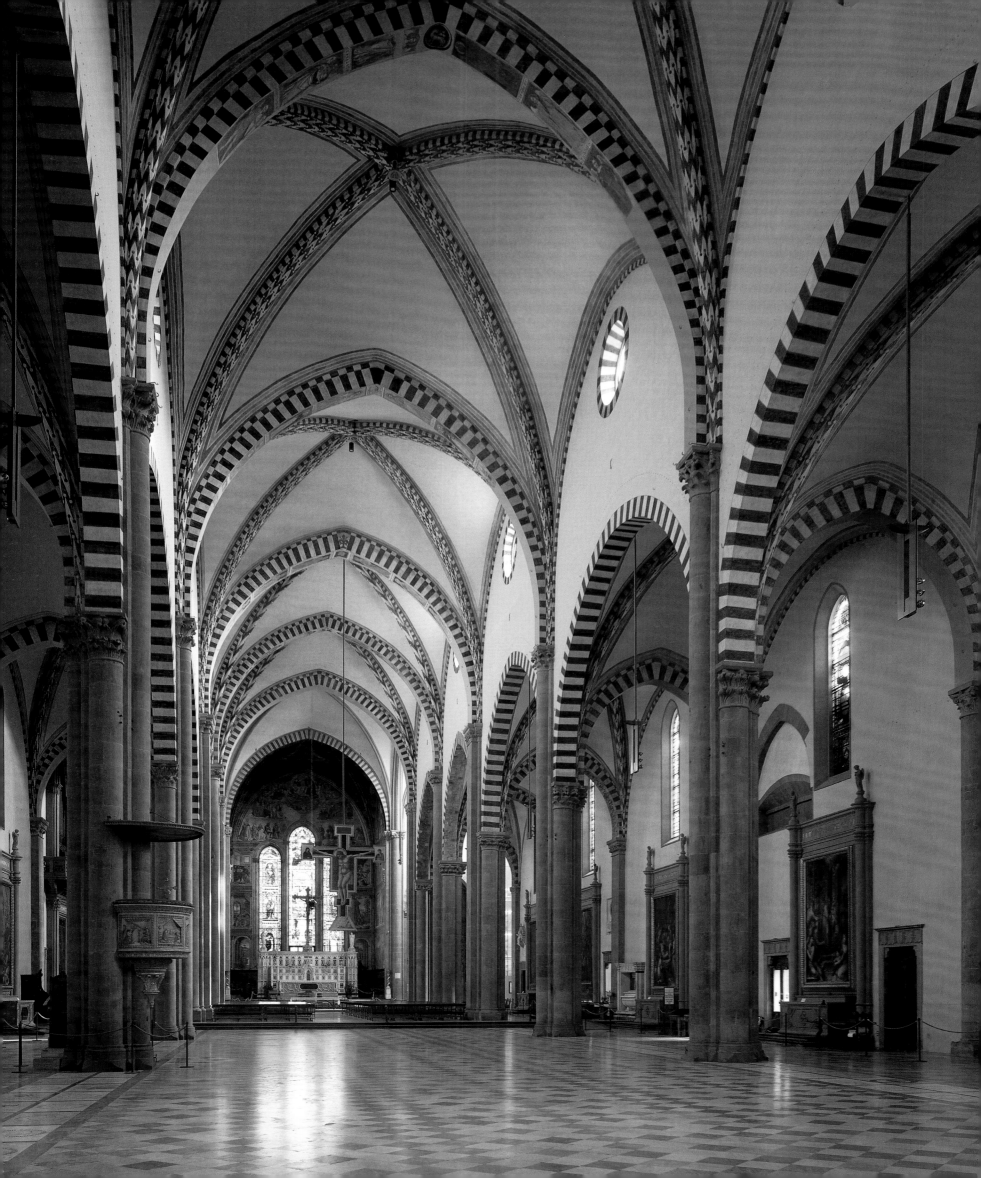

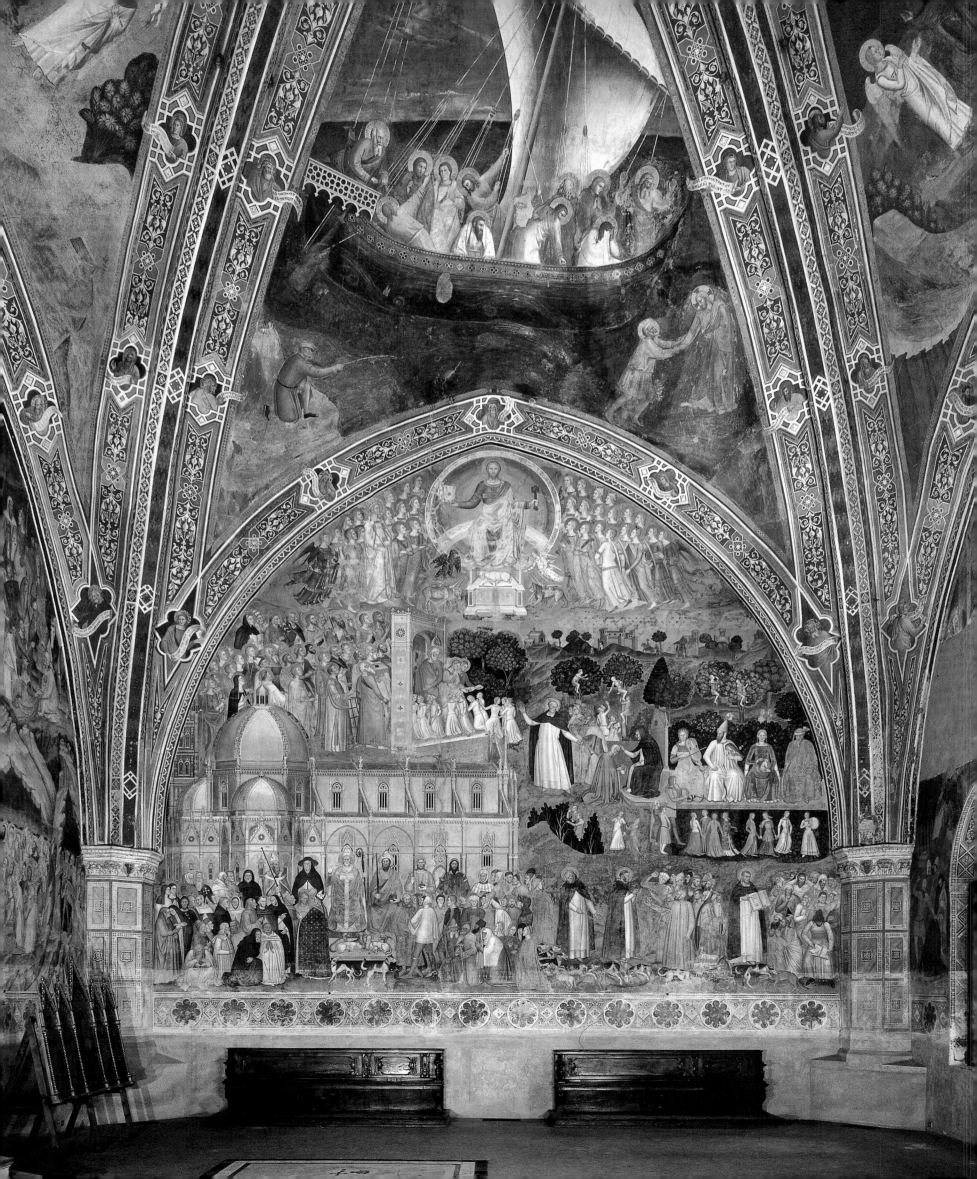

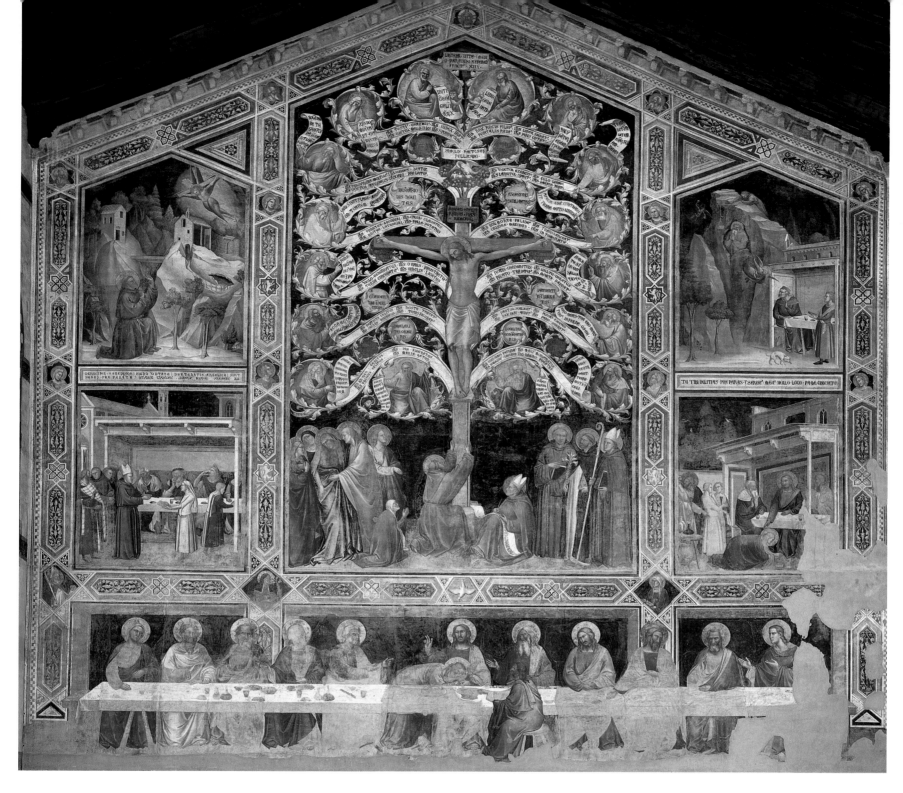

feature of the facades and the cemetery walls on the side are the many tomb niches with sarcophagi: the "Avelli." Wealthy citizens paid a great deal for such burial places. They also donated decorations for the interior of the church—frescoes in particular—in which some of the greatest Renaissance painters participated—beginning with Masaccio, whose *Trinity* fresco in the main block is a pioneering work in the precise use of central perspective in constructing a space; Domenico Ghirlandaio's rich scenery in his paintings for the sanctuary; and Filippino Lippi's work in the Strozzi Chapel.

The monastery buildings were also built under Jacopo Talenti's direction, for the most part. This includes the three cloisters (Chiostro Grande, Chiostro Verde, and Chiostro dei Morti) and the adjoining buildings with the chapter house. The outstanding frescoes of the monastery include Paolo Uccello's depiction of the Flood in the Chiostro Verde and those in the chapter house, which were commissioned from Andrea da Firenze by a private citizen in 1365. The hall is known as the Spanish Chapel because Eleonora of Toledo, wife of the first Tuscan grand duke, Cosimo de' Medici ("the Elder"), converted it into a chapel for her Spanish retinue. The overall program of the decorations is marked by Dominican conceptions. In the painting that shows the path to salvation Christ's church is depicted as the cathedral of Florence having a dome with no drum, as it was originally planned, and above it is Paradise, into which the people enter, guided by Dominicans.

OPPOSITE PAGE:

Andrea da Firenze, fresco depicting the Florence cathedral, in the Spanish Chapel (former chapter house), Santa Maria Novella

ABOVE:

Taddeo Gaddi, fresco with the Tree of Life and the Last Supper, refectory, Santa Croce

The Franciscan church of Santa Croce, the counterpart to Santa Maria Novella, has a completely different construction. Saint Francis of Assisi founded this monastery himself in 1226, shortly before his death, and in 1228 the first church is mentioned in a papal bull. A second, larger church was begun in 1252. Because this monastery continued to grow in importance for the city, construction of a third church was begun in 1295. Its dimensions were enormous: 377 feet (115 m) long, 125 feet (38 m) wide in the main block, and 246 feet (75 m) long in the transept. According to Vasari's testimony, the design was by Arnolfo di Cambio, the architect of the cathedral, which was begun at the same time. Work on Santa Croce continued for more than a century. It was not consecrated until 1443, by Pope Eugenius IV. The west facade was left unfinished as a shell until 1857–63, when Nicola Matas added the present neo-Gothic facade.

The three-nave, unvaulted main block, whose central nave is nearly 66 feet (20 m) wide, is Gothic, but because of its size and not least because of the exposed roof framework, it recalls the early Christian basilicas of Rome. The main block has the reserved, spare detailing typical of the Franciscan "sermon barns" of Italy. The east end is all the more elaborate for that. There are four chapels with flat terminations in each transept arm, just like the large Cistercian churches. The innermost chapels on the left and right of the sanctuary join with its large polygonal apse to form a tripartite prospect that, in the light of the colorful, brilliant stained-glass windows, seems like a vision of another world, a sacred place. This dramatic contrast to the more profane-seeming main block is one of the most compelling experiences in all Franciscan architecture. Soon after it was completed the whole east end and its chapels were decorated with admirable frescoes by the major figures of the early trecento—namely, Giotto and several of his followers: Taddeo Gaddi, Agnolo Gaddi, Bernardo Daddi, and Maso di Banco. The whole is a gallery of the finest Florentine trecento painting,

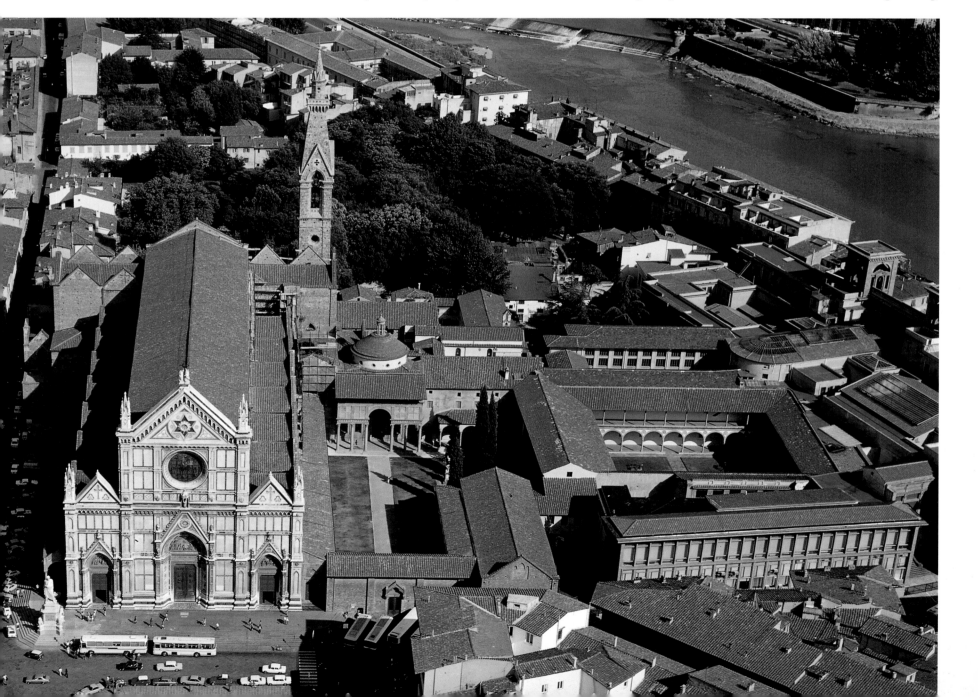

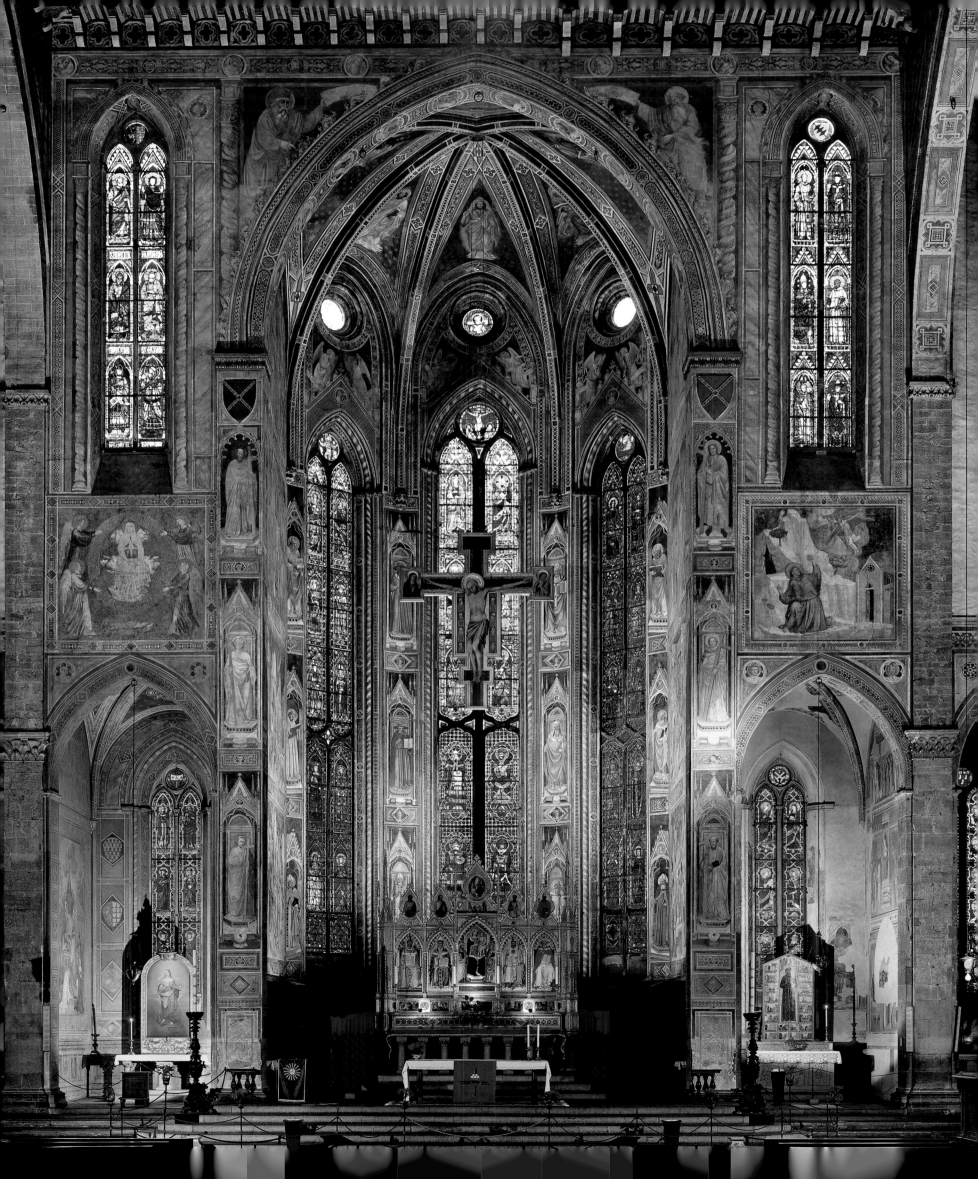

and the Dominicans of Santa Maria Novella at the time had little that could stand up to it.

To the south of the church, extensive monastery buildings surround a large cloister with wide round arches from the early Renaissance. Immediately adjacent to the church is the first courtyard, which replaced two smaller trecento courtyards. The refectory extends from the south side. Inside, on the end wall, Taddeo

own facade to the courtyard, with a central arcade and colonnades to the side. This major work of the early Renaissance, begun in 1430, was intended to be the burial site of the Pazzi family, and it also served the Franciscans as a chapter house. Brunelleschi repeated here the basic structure of his first work: the Old Sacristy of San Lorenzo, but he added barrel vaulted transept arms to the sides of the square, domed core. The resulting

Gaddi painted a fresco around 1330–40 that would greatly influence refectories in Florentine monasteries: *The Last Supper,* in whose presence the monks would take their own meals. Above it is one of Saint Bonaventura's visions: the crucifixion of Christ as the tree of life with the kneeling Saint Francis clasping the tree and Bonaventura writing. The Last Supper would later be depicted in refectories by Castagno in Santa Apollonia, Ghirlandaio in Ognissanti and San Marco, and Leonardo in Santa Maria delle Grazie in Milan.

The eastern termination of the first courtyard is the Pazzi Chapel by Filippo Brunelleschi, which presents its

structure of the later building, with its pilasters, entablatures, and vault arches, was far more complex. Today it offers several different possible readings or interpretations for the viewer, depending on his or her standpoint for considering the architecture.

In several respects the midpoint of Florentine Renaissance architecture is the canonical association of San Lorenzo. Ambrose, a doctor of the church, consecrated the first church here in 393, and in the eleventh century a new proto-Renaissance building was erected. The present San Lorenzo is the church of the Medici, who had their town palace just a hundred

yards from here. They absorbed the lion's share of the costs. In 1418 there was talk of constructing a new church with nine chapels in the chancel, like that of Santa Croce. In this context Brunelleschi was given a commission for the associated sacristy in 1419, which would also serve as the burial place for the Medici. Brunelleschi developed a pilaster and entablature order that was related to the vault arches—a completely new architectural system. Its repertoire of motifs was influenced by antiquity, and in this it was in accord with the proto-Renaissance; its system, however, had medieval or Gothic features in that it brought the substructure and the vaulting into a logical connection in a way that had nothing to do with antiquity. The sacristy become a seminal building for Renaissance architecture. Brunelleschi was later commissioned to design San Lorenzo as well. Here he applied his new system to the vaulted side aisles and chapels—everywhere possible, as if it had become the norm. He designed the middle vessel, however, as a column basilica with a flat ceiling, of the sort that had existed previously in the proto-Renaissance, perhaps even in San Lorenzo itself. Brunelleschi's second church took another step in the direction of rigor and consistency: it was Santo Spirito, the church for an Augustinian canonical association on the opposite side of the Arno, which is closely related to San Lorenzo.

During the cinquecento the Medici Pope Leo X wanted to make it emphatically clear that San Lorenzo was a Medici church by giving it a new facade, and Giuliano da Sangallo, Jacopo Sansovino, and Michelangelo all drew up plans. Nothing came of these plans, however; the facade is still a shell today. Instead, in 1519 the pope commissioned Michelangelo to build a Medici chapel that would be the northern pendant to the Old Sacristy. It was intended as a burial site for Lorenzo the Magnificent and his brother Guiliano, who had been assassinated as part of the Pazzi conspiracy, as well as for two younger members of the house of ducal rank. The architectural work that Michelangelo created was incomparably heavier than that of his predecessor, Brunelleschi: he added a floor in the interior and repeated the motif of the chancel arcades on the other three sides. In addition, Michelangelo sculpted tomb monuments for Lorenzo de' Medici, duke of Urbino, on the left wall, and for Giuliano de' Medici, duke of Nemours, on the right, with recumbent figures of *Day* and *Night* and *Morning* and *Evening*—masterworks of sculpture that have been admired, studied, and copied countless times since.

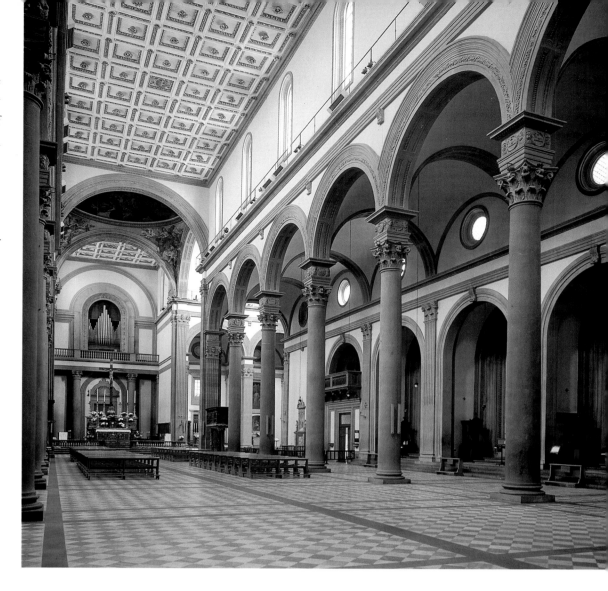

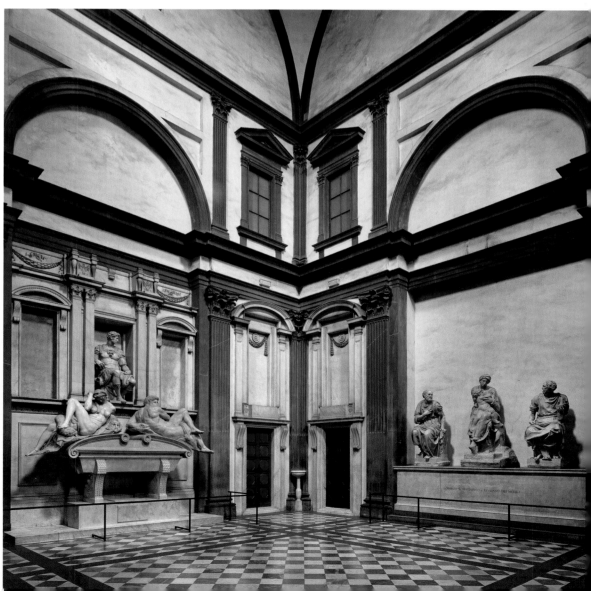

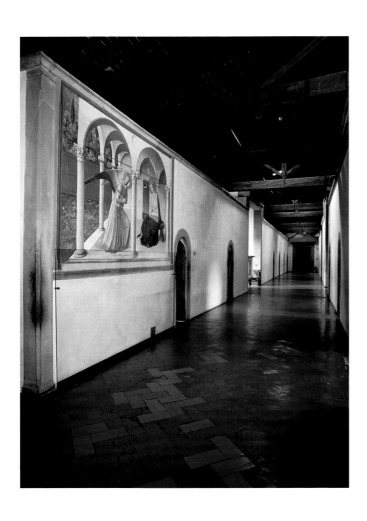

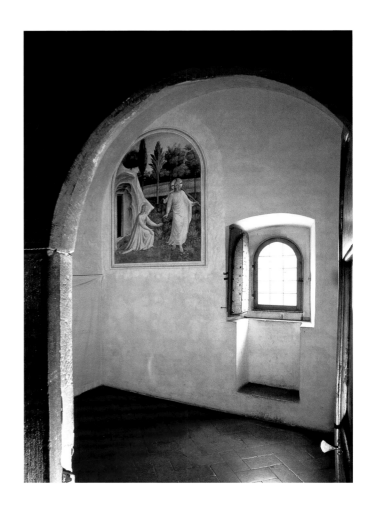

Fra Angelico, frescoes in San Marco.
TOP LEFT: *View of a monastery
corridor;* RIGHT: *Interior of a monk's
cell with a view of* Noli me tangere;
BOTTOM LEFT: Noli me tangere;
BOTTOM RIGHT: The Mocking
of Christ

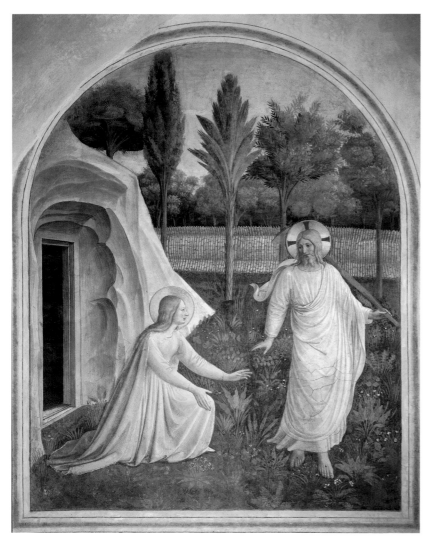

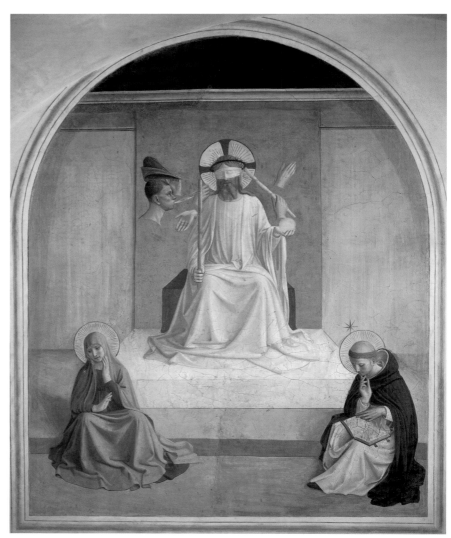

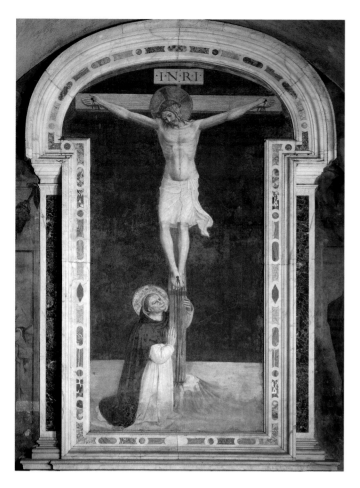

The fame of the San Marco monastery derives from its frescoes by Giovanni da Fiesole, known as Fra Angelico, who was himself a Dominican who worked there for ten years, from 1435 until his departure for Rome in 1445. In addition to a painting that was formerly on the high altar and the large fresco Crucifixion in the chapter house, he painted fifty other frescoes: one in each of the forty-five dormitory cells and several lunettes in the cloister area. It was a unique case of one painter decorating an entire monastery. Fra Angelico, who was otherwise a master of the melodies of colorful, lightly swinging garments and peaceful, artless sentiment, found a more monumental style here, with figures as weighty as stone. His *Noli Me Tangere* and *The Mocking of Christ*, both found in monks' cells, are exemplary of this, and they are two of this painter's finest works.

TOP LEFT:
Fra Angelico, fresco of the Crucifixion with a Dominican monk, cloister, San Marco

BELOW:
Michelozzo's interior of the library, San Marco

Another Medici gift to San Lorenzo was the library, the Biblioteca Laurenziana, which Pope Clement VII, also a Medici, had built according to designs by Michelangelo. The vestibule—the *ricetto*—was built only later, and finally at some point before 1560 Bartolomeo Ammanati installed the stairway according to a model by Michelangelo. The upper parts of the *ricetto* were not completed until the twentieth century. The Medici's final contribution to San Lorenzo was the bombastic, shockingly expensive Chapel of the Princes at the head of the chancel: a resplendently decorated and yet hollow and empty central-plan building that was begun in 1605 but not completed until the nineteenth century. The grand dukes of Tuscany from the Medici house were buried here.

Another monastery supported by the Medici family was San Marco, in the northern part of the city. The site originally belonged to the Vallombrosan order but had been entrusted to the Sylvestrines in 1299. Pope Eugenius IV assigned the monastery to the Dominicans of Fiesole in 1436. Cosimo de' Medici had Michelozzo di Bartolommeo restore the church and monastery buildings to a serviceable state. The new buildings for the monastery included a library—the first public one since antiquity. It is a three-nave, vaulted column hall whose narrow nave was the corridor that led to the books kept in the broader side aisles.

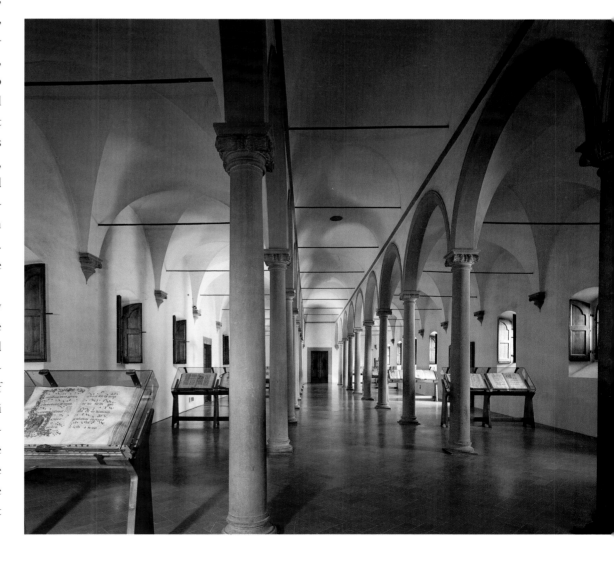

MONTE OLIVETO MAGGIORE

ONE OF THE LARGEST RURAL MONASTERIES IN Italy is Monte Oliveto Maggiore, roughly nineteen miles (30 km) southeast of Siena. It lies in the middle of an almost untouched forest landscape in the Crete, immediately next to washed-out loamy ravings, the *balzi,* which are found only in southern Tuscany and near Volterra. The founder, Giovanni Tolomei, who would later call himself Bernardo, after Bernard of Clairvaux, also founded an independent Benedictine congregation here at the same time, the Olivetans (Order of the Most Blessed Virgin Mary of Monte Oliveto). Tolomei, born in Siena in 1272, became a professor of law in his native city when he was just twenty, but in 1313 he and two noble friends, Patrizio Patrizi and Ambrogio Piccolomini, withdrew to his remote property to pursue a life in prayer and repentance. In 1319 he founded the monastery and congregation there, and the latter was confirmed by the pope in 1324. The Olivetans sought to reform Benedictine monasticism by means of strict fasting and precise adherence to the rules for prayer and work, and they soon had great success. In 1370 even Montecassino was caught up in the reform. During the fourteenth

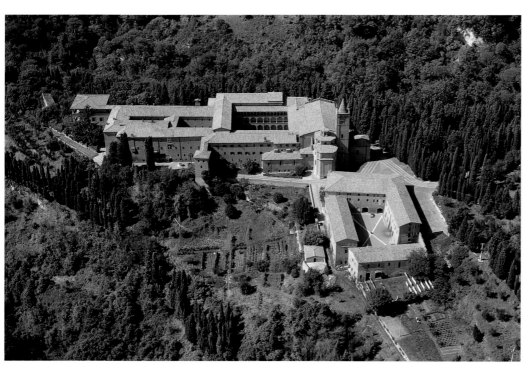

century the congregation had more than a hundred settlements, and the monks often transferred among them. Because offices were conferred for a limited time, there was constant movement within the order. The ranks of the Olivetans produced many artisans, as well as scholars who taught at the universities. Today the work of the monks in the mother monastery is focused on restoring books.

The monastery is surrounded on three sides by ravines; the fourth, where the gate is found, is protected by a thick defensive tower with crenellations. The overall layout is a multipart complex in brick with three cloisters and several chapels hidden in the woods. In 1377 the monks received papal permission to build a cemetery and twelve chapels with individual cells—which made each its own small hermitage—in the surrounding forest. The present chapels are of more recent vintage, however. The center of the monastery is the large cloister south of the modest one-nave church. It was built in three stages, under three different general abbots, from 1426 to 1443. The most elaborate wing is the western one, with three tiers of arcade galleries; the other wings have arcades only on the ground floor.

The monastery's artistic fame derives from the fresco cycle in the cloister. Abbot Domenico Airoldi of Lecco, who served twice as general abbot of the congregation, appointed the painter Luca Signorelli in 1495 and then in 1505 Antonio Bazzi, known as Sodoma, who completed the cycle in 1508. Its thirty-six paintings depict the life of Saint Benedict based on the vita written by Pope Gregory the Great. Eight scenes were painted by Signorelli and twenty-five by Sodoma, among which are the three illustrated here. In one Benedict kneels before his cave in Subiaco, and the monk Romanus, who was the only one who knew his hiding place, leaves a basket of food for him; meanwhile in the upper left the devil smashes with a stone the bells that Romanus used to announce his arrival. In the second scene Benedict is directing the construction of one of the twelve monasteries, although here it resembles a Renaissance loggia. In the third painting Benedict is seen at Montecassino, where two hundred bushels of flour miraculously appeared before the door. Thereafter the convention, which is seen at right eating in the refectory beneath a monk who reads to them, no longer had to starve. Similar miraculous events are the theme of most of the other frescoes as well. Signorelli's are more artistic than Sodoma's, but unfortunately they are not as well preserved.

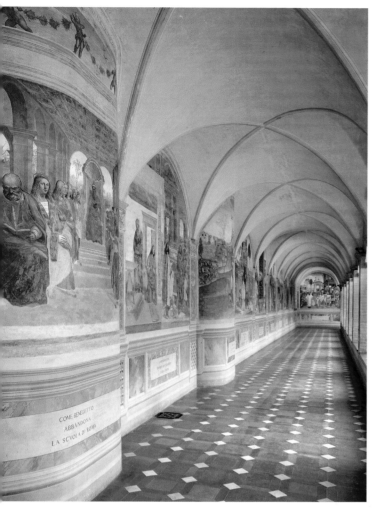

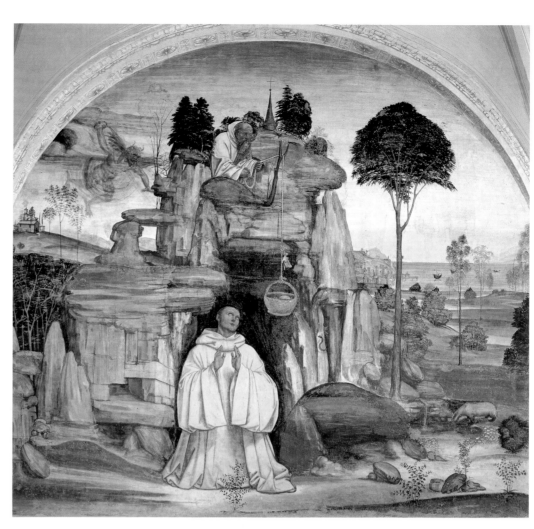

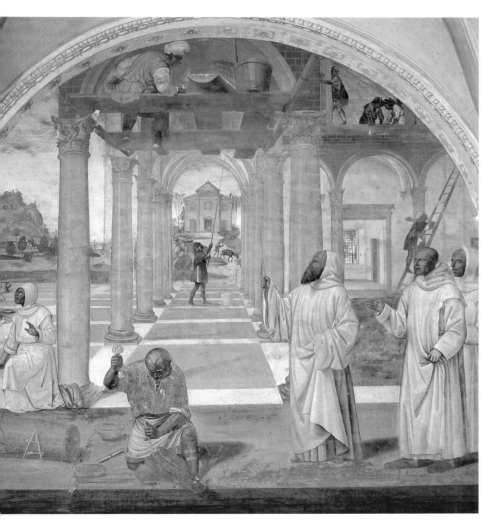

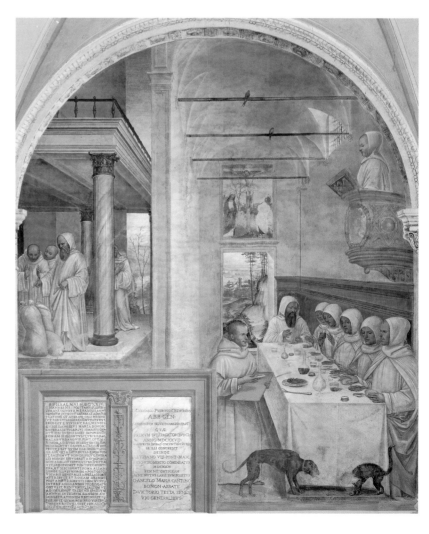

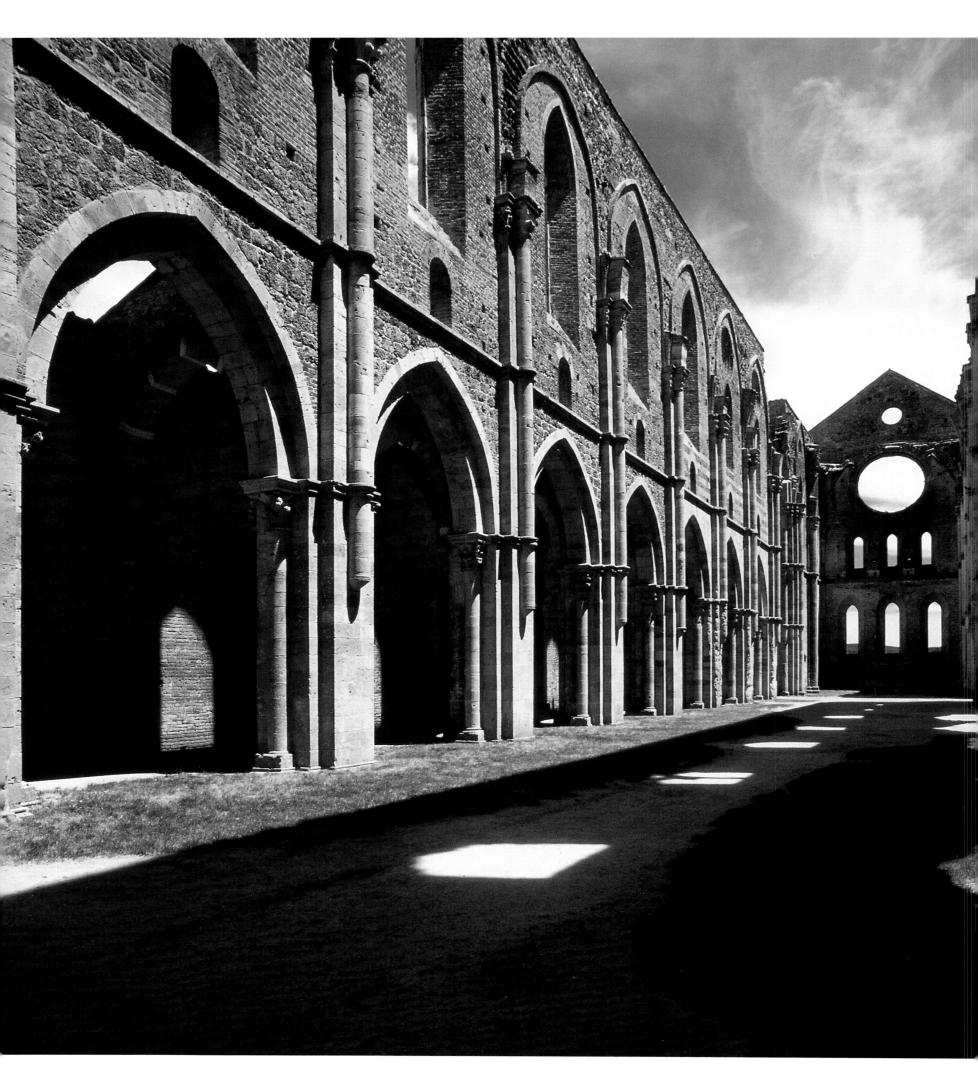

SAN GALGANO

THE FORMER CISTERCIAN ABBEY SAN GALGANO lies isolated between Siena and Massa Marittima in undeveloped Tuscan landscape below Monte Siepi. The knight Galgano Guidotti from nearby Chiusdino founded a hermitic settlement here after seeing the face of the archangel Michael in a dream, and he died on the mountain in 1181. He was canonized soon thereafter, and the bishop of Volterra had a circular, vaulted mausoleum built for him on the mountain. In 1196 a monastic community settled there, and in 1201 it was raised to the rank of a Cistercian priory and, soon thereafter, to that of an abbey, as a daughter monastery of Casamari in the filiation of Clairvaux. The monks moved from the mountain to the nearby valley. There, beginning around 1224, the *abbatia nova* (new abbey) was built. The construction of the church continued until the end of the thirteenth or beginning of the fourteenth century. At that time it was very wealthy, but it gradually declined in the sixteenth century. Around 1550 there were only five monks left there; in 1600 just one. One of the abbots *in commendam*, Girolamo Vitelli, sold the lead from the abbey's roofs in the sixteenth century; first the roof framework collapsed and then, in the eighteenth century, the vault as well. Today the church is a ruin, and there are only small remnants of the monastery buildings: the chapter house and the scriptorium.

Despite the missing vault, the church, which is about 246 feet (75 m) long, is well preserved. The masonry is part brick and part ashlar, and in places the two alternate, which is typical for Siena and is also found on the rotunda of Monte Siepi. In San Galgano the ground plan and structure of the church of the mother monastery, Casamari (see pp. 449–52), are repeated quite precisely: the east end is based on the Bernardinian plan, with a square sanctuary, two flat-terminated chapels in each transept arm, and a side aisle in the west. The main block is arranged according to the bay system. It has cruciform piers with round projections that, in the usual Cistercian style, are supported slightly above the ground on the side facing the

OPPOSITE PAGE:
Interior of the ruins of the abbey church of San Galgano, facing southeast

BELOW:
Church from the southwest

PAGE 448:
TOP: *Side aisle of the church*
BOTTOM: *East end of the church*

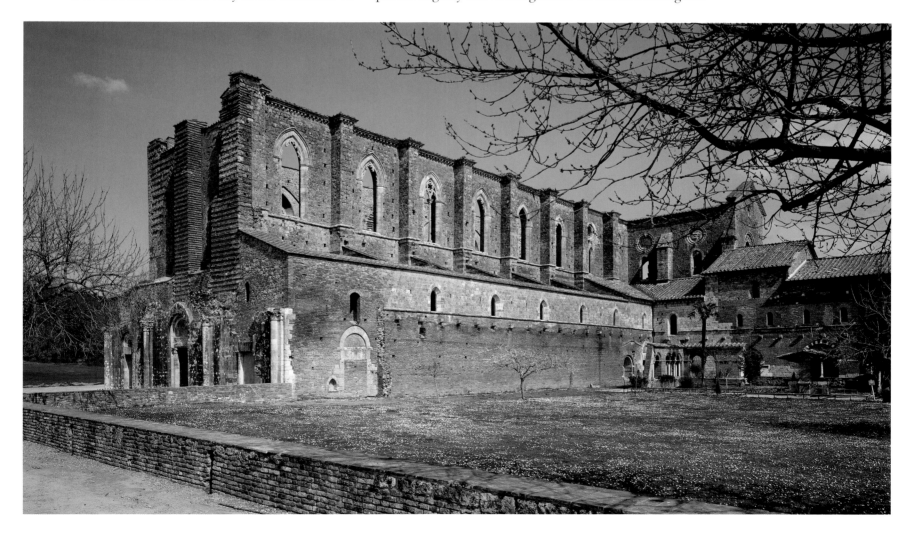

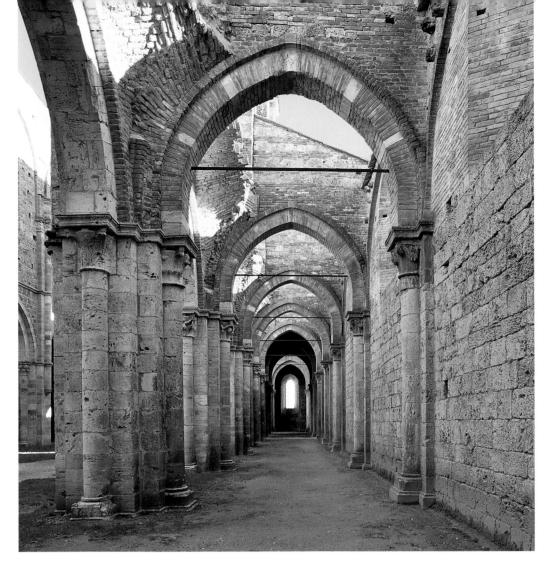

nave. In the transept and in the two eastern bays of the nave there are small windows in the clerestory and oculi with rosette tracery above that; in the six bays to the west of that, however, there are just small tracery windows. Particularly striking are the openings in the roof framework of the side aisles, exactly like those of Casamari or in the German Cistercian church Ebrach (see pp. 301–3). They are probably not galleries, but just openings to ventilate the roof framing.

The flat termination of the east wall of the sanctuary presents the focal point of the long regular space: an impressive group of windows with the main motif of a round window that dominates the view, staring like an ever-present eye above the two rows of small windows below it. The architecture of the church inside and out is articulated quite clearly. In the interior this is achieved by a system of projections: the rectangular projections and the semicircular ones that once supported the stepped arch ribs; on the exterior, it is the angular pier buttresses in regular rhythm. Precisely because it is a ruin in a beautiful landscape, it is a very special Cistercian experience. This lonely site was the crucial starting point of the Gothic style in Sienese Tuscany, which includes the cathedral of Siena.

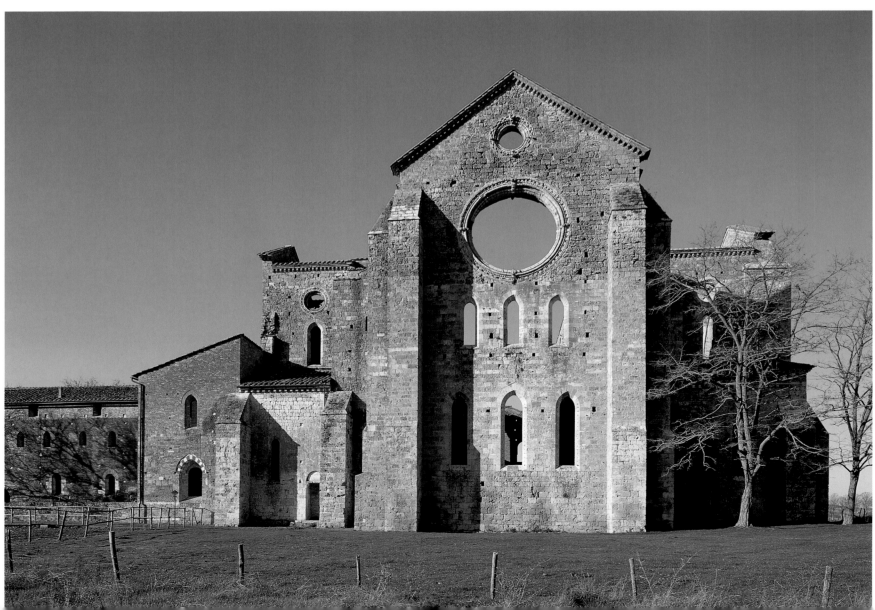

FOSSANOVA
CASAMARI

The two great Cistercian abbeys in Latium south of Rome—Fossanova, near Latina, and Casamari, near Forsinone—are as closely related as sisters in terms of the church construction. Fossanova is the older of the two. There had been a Benedictine monastery on the site since the ninth century; it was consecrated by Saint Stephen. Pope Innocent II entrusted it to Clairvaux in 1135. The first Cistercian convent came from Hautecombe in Savoyen. In order to drain the swamps, which were a constant source of malaria, the monks dug drainage ditches, the *fossa nova,* from which the monastery took its name. It earned a special place in the hierarchy of the order when its founding abbot, Gerard, was elected abbot of Clairvaux in 1170. He was the driving force behind the canonization of Bernard in 1174.

It is not known when construction on the church began; it was probably around 1170. The consecration of the high altar was conducted by Pope Innocent III in 1208 and the final consecration sometime before 1218. It has been thought that Emperor Frederick Barbarossa supported its construction—he is said to have been named as the donor in a mosaic inscription on the portal that has not survived—but that old legend lacks evidence. From later Hohenstaufens, however, Fossanova received many donations, including from Frederick II as late as 1221. The church is 230 feet (70 m) long and is constructed according to the Bernardinian plan with an east end with flat terminations and two chapels in each end of the transept. It is the earliest Gothic building in central Italy. The main block based on the bay system with laterally oblong bays in the nave and the whole wall structure correspond almost literally to the church of the primary abbey Pontigny (see pp. 174–77). The nave has quadripartite groin vaults with terraced arch ribs, as had been planned at Pontigny. The original plan for the main block at Pontigny was realized at Fossanova, elaborated with round arch openings above the nave arcades and by two cornices that wrap around the projections with annulets. The additional openings in the wall make the space seem steeper than that of Pontigny, even though the arch ribs of the vaults are not as pointed. The main difference lies in the proportions. The architect of Fossanova clearly came from the original home of the Cistercians, Burgundy, and brought the new Gothic style with him.

The exterior, articulated by angular pier buttresses, has a two-story octagonal stone crossing tower with a cupola, which was actually forbidden by the Cistercians. The construction of the tower is remarkable in that its

diameter is less than the width of the square of the crossing arches below it, which meant that a support construction with arches had to be installed above the crossing vault. The main motif of the west facade, a masterpiece of Cistercian architecture, is a rose window with twenty-four petals. Here, as opposed to the rosette of the east wall, the Gothic is fully developed. The shallow gables beneath the roof of the nave and above the portal, by contrast, recall the temple pediments of antiquity. It is impossible to say how the narthex—the traces of whose demolition are still visible—would once have altered this picture.

The monastery buildings south of the church have survived, for the most part, as has the cloister, which is among the best preserved of the early Italian Gothic. The

Below:
West facade of the church of Fossanova

Page 450:
Interior of the church of Fossanova, facing east

Page 451:
Interior of the church of Casamari facing east

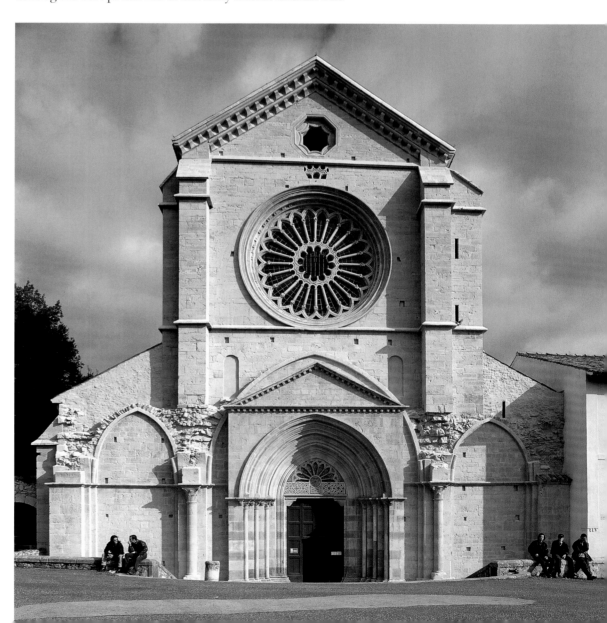

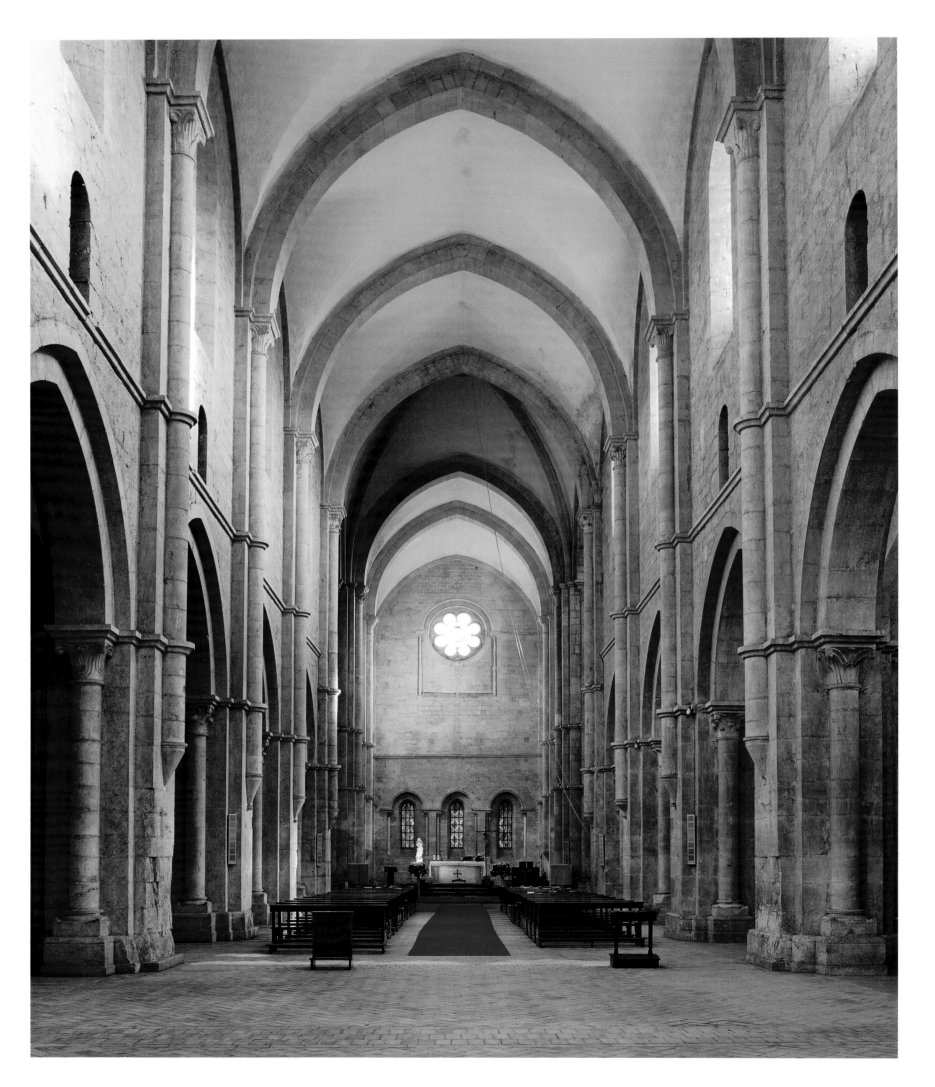

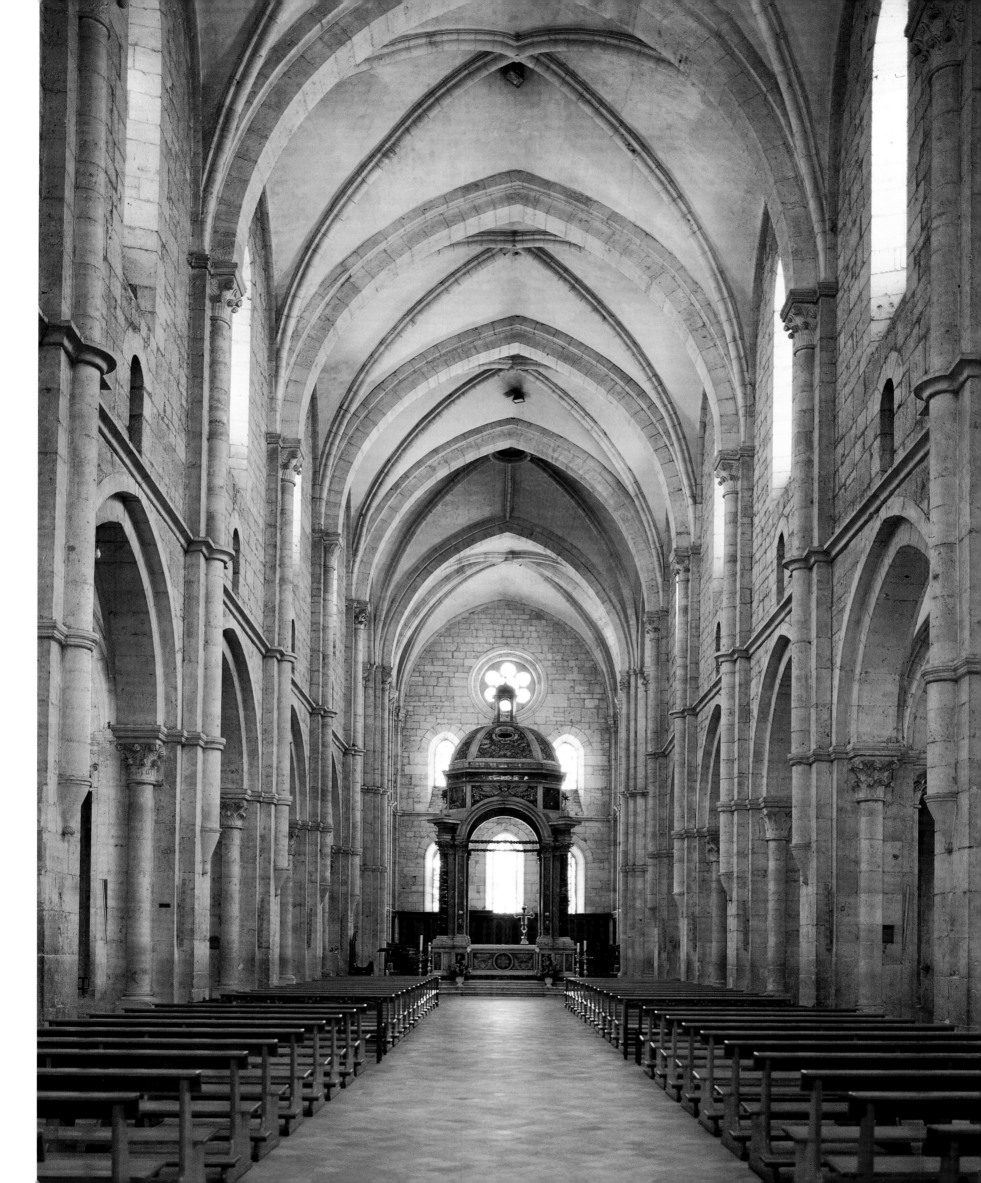

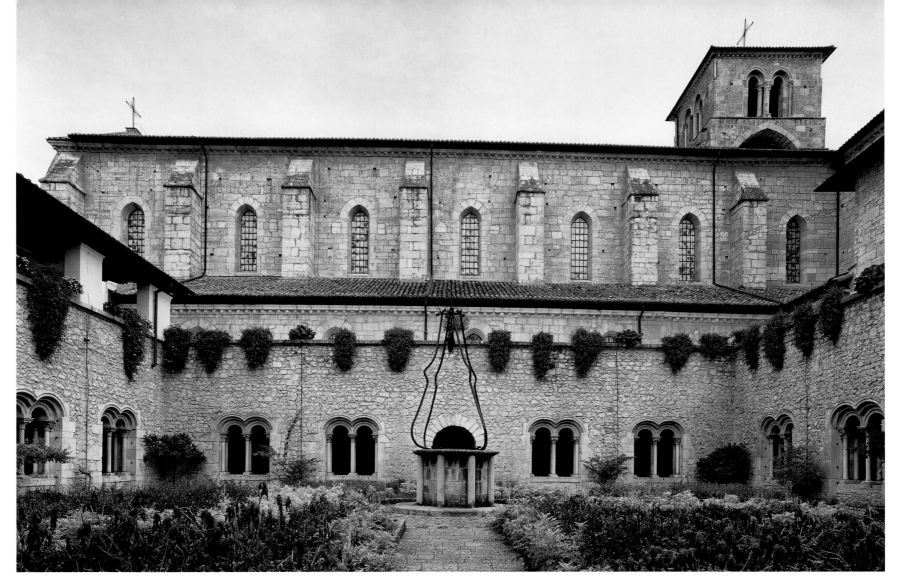

Above:
Cloister on the south side of the church
of Casamari

Opposite page:
Columns on the south wing of the cloister
of Fossanova

barrel-vaulted east, north, and west wings, which open onto the courtyard through arcade galleries with double columns and just a single passage in the center of each, are pure Romanesque from the late twelfth century. The rib-vaulted south wing, whose double columns in highly varied forms belong to the immediate followers of the Cosmati family, was built about a century later, as was the original square well house and the one-nave refectory, which is subdivided by flying buttresses and still has part of the original reading pulpit, including its stairs. The chapter house is also a distinguished example of Cistercian architecture, with two piers surrounded by small, monolithic round columns; profiles on the walls; and unusually robust, elaborately shaped ribs in the vaults. Beyond the monastery buildings stands the residence for pilgrims, which is famous because Thomas Aquinas died here in 1274 on his way to the Council of Lyons, where he was supposed to explain his doctrines.

In Casamari the history of Fossanova's construction repeated itself. There was a Benedictine monastery here that Eugenius III entrusted to Clairvaux in 1151. The present church, for which Pope Innocent III provided money, was under construction by 1203. When Honorius III consecrated the church in 1217 it probably just consisted of its eastern sections, up to the monks' chancel. Honorius financed it himself. The church is like a second version of Fossanova, but with somewhat lower and broader proportions and with rib vaults. The west facade—with its splendid triple-terraced portal whose archivolts are also lavishly contoured in seven steps, as if the statute calling for simplicity did not apply here—leads to a narthex; it opens to the exterior through three large archways. Fossanova's may have been similar.

Most of the monastery buildings are still standing in Casamari as well. The chapter house is a four-support room, which also has piers surrounded by small columns and elaborately shaped ribs in the vaulting; this room is another Cistercian masterpiece. By contrast, the quarry-stone cloister cannot stand up to that of Fossanova. Instead of continuous, grouped, or rhythmic arcade galleries, which so often set the tone, it has closed walls into which openings in the form of double arcades have been inserted at regular distances. The unfamiliar stretches of wall between the arcades evokes an impression of exceptional monastic severity but also of a certain stingy frugality, especially when the result is compared with Fossanova or the Roman cloisters of the Cosmati family (see p. 456).

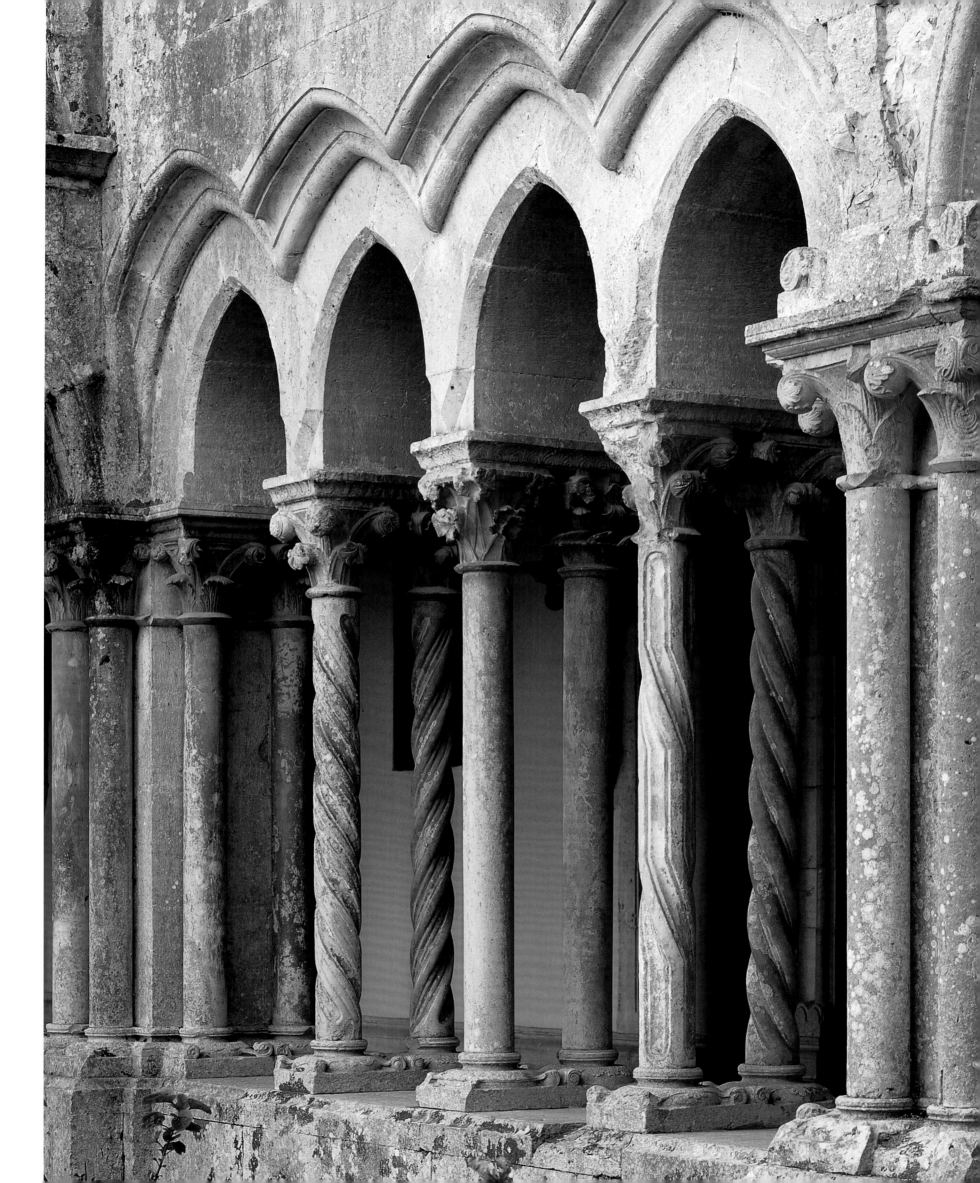

ROME

SANTA CECILIA, SANTI QUATTRO CORONATI, SAN PAOLO FUORI LE MURA

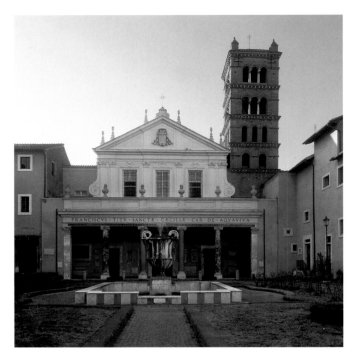

THE CHURCHES, ORATORIES, CHAPELS, AND monasteries in Rome are so numerous that it is scarcely possible to provide an overview of them. In the ninth century the city already had fifty-four monasteries; Ravenna, by contrast, had just sixteen; and Milan, Cologne, and Tours had eight each. Some of the churches of late antiquity were built at a time when there was not yet an organized form of monasticism. The monasteries and nunneries were later arrivals—for example San Paolo fuori le mura (Saint Paul outside the Walls). Santa Cecilia in Trastevere is one of the many column basilicas. It was commissioned by Pope Paschal I (817–824), who also had Santa Prassede and Santa Maria in Domenica built, and

the church was redecorated. Arnolfo di Cambio produced a tabernacle lavishly decorated with sculptures, which an inscription dates to 1293; the frescoes on the walls were probably painted thereafter. Apart from some fragments, the paintings on the side walls were destroyed in the eighteenth century as part of a

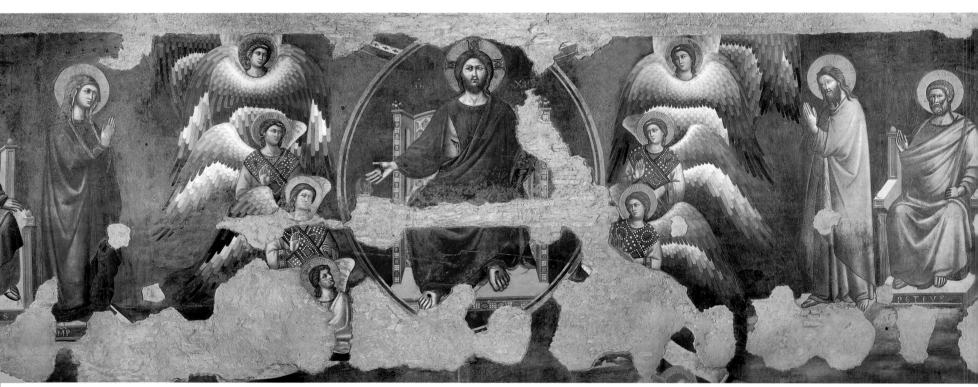

had all three decorated with mosaics in the apses. Santa Cecilia is an unusually spacious building in which the tradition of the late antique column basilica was revived. In the twelfth century the Romanesque campanile and the typically Roman narthex were added, but the facade of the church was not built until 1741, based on plans by Ferdinando Fuga. Around 1300

Baroque remodeling. The fresco *Last Judgment* that had decorated the wall of the entrance disappeared even earlier behind a newly installed nuns' gallery, after Santa Cecilia was entrusted to the Benedictine nuns of Santa Maria in Campo Marzo in 1527. Not until 1900 was at least the middle register of the *Last Judgment* uncovered again.

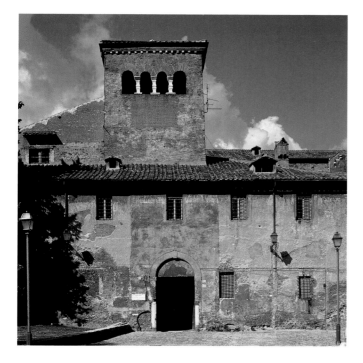

In his *Commentarii* of about 1447 the Florentine sculptor Lorenzo Ghiberti mentioned this fresco cycle and identified its painter as the Roman artist Pietro Cavallini, an attribution that Vasari adopted. Today the attribution is universally accepted. The fragment of the *Last Judgment* that has been uncovered shows Christ in judgment in a

Assisi, but Cavallini preserves an archaic, Byzantine mood that is lacking in Giotto.

Santi Quattro Coronati on the Caelius Hill was an important monastery. After 1138 it was occupied by Benedictines from Sassovivo; after 1580, by Augustinian nuns. During the Carolingian period it was heavily fortified and in the Middle Ages it served as a fortress where the clerics from the nearby Lateran could seek shelter. The square gate tower at the entrance to the atrium was part of this fortification. The monastery church was built on an early Christian religious site for the four martyrs of the fourth century—the *quattuor coronati* (four crowned men), as they were called from the sixth century on. Parts of the present apse, which faces west, date back to this religious site. Pope Leo IV (847–55) had an unusually large column basilica, which was 184 feet (56 m) long, constructed from antique spoils, but destroyed by the Normans in 1084. The western part of the Carolingian nave, which was 49 feet (15 m) wide, was built under Pope Paschal II (1099–1118)—retaining the old apse—as a basilica with three naves running the full length and galleries on the side. It was consecrated in 1116.

TOP LEFT:
Entrance to the monastery of Santi Quattro Coronati

BELOW:
Fresco with scenes of Constantine and Pope Sylvester, Sylvester Chapel, Santi Quattro Coronati. BELOW LEFT: The Emperor's Bridle Duty; BELOW RIGHT: The Delivery of the Tiara as a Symbol of Rule

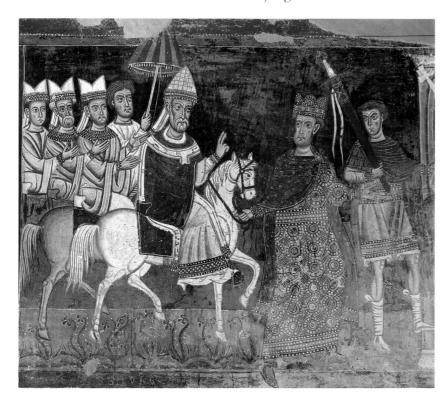

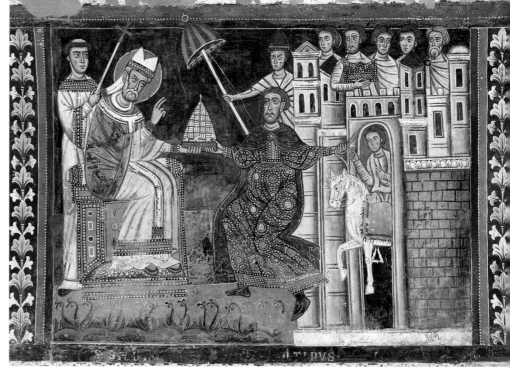

mandorla that extends across the entire wall. Christ is surrounded by the colorful feathers of angels' wings, by Mary and John the Baptist, and by the attendant apostles. The innovation of this painting was the sculptural modeling using color, light, and shadow, which aimed at greater naturalism and also an impression of physical weight—it is a Roman parallel to Giotto's frescoes in

On the north side of the atrium Stefano Conti, titular cardinal of Santa Maria in Trastevere, constructed a fortified residence shortly after Pope Innocent IV named him papal representative in Rome and then fled to France in 1244. The cardinal built the barrel-vaulted Capella die San Silvestro here in 1246 and had it decorated with a fresco cycle on the legendary story of the

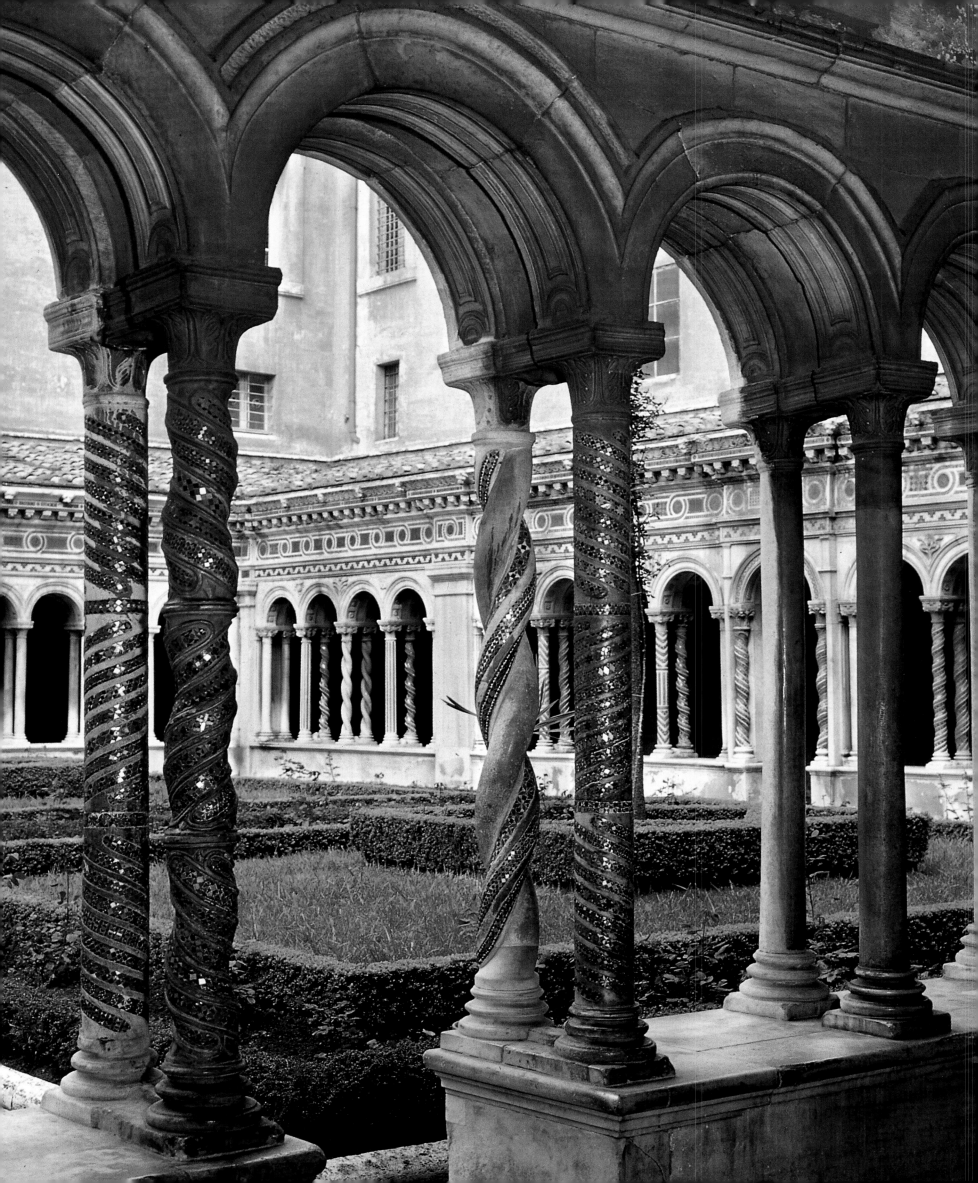

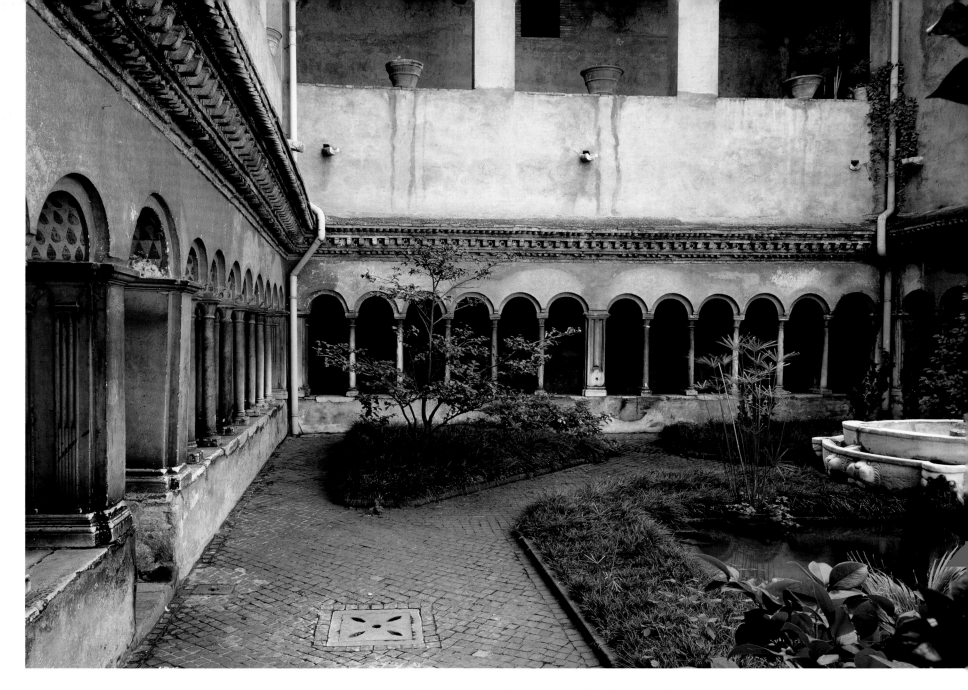

conversion of Emperor Constantine the Great by Pope Sylvester I. Against the backdrop of the final struggle between the Hohenstaufen emperor Frederick II and the popes Gregory IX and Innocent IV, the frescoes are pure anti-imperial propaganda. Frederick, who had lain siege to Rome in 1241, was excommunicated twice by Gregory and in 1245 had just been deposed by Innocent at the quickly convoked Council of Lyons. Two paintings in the cycle are especially politically charged. One shows Constantine transferring control over Italy and the Occident to the pope, kneeling before him and presenting the insignia of the tiara. In the second the emperor is holding the reins, like a stable boy, for the pope on a horse in front of the Lateran Palace. Both paintings allude to the Donation of Constantine, from which the popes derive a claim on primacy over all secular leaders, including emperors. This claim had been made a binding ecclesiastical law by the Decretum Gratiani of about 1140, even though the authenticity of this gift had been questioned since Emperor Otto III. The

proof that it was a forgery was finally provided by Nicholas of Cusa in the fifteenth century.

The monastery Quattro Coronati also has a quiet, peaceful arcade cloister from about 1210–20, one of the most characterful in Rome. The cloister at San Paolo fuori le mura was built a little later; it is a major work by the virtuoso stonemasons and sculptors of the Vasalettus family, who created here an inexhaustible compendium of decorative columns with colorful and gold-shimmering inlay work in various materials, including gleaming glass paste. Their particular specialty was columns *all'antica* twisted in many different ways. This cloister and the one at the Lateran are the most magnificent in Rome. They are examples of the decorative direction of the Roman marble works known as Cosmati work, named after another family of artists that was active across several generations.

OPPOSITE PAGE:
Cloister, San Paolo fuori le mura

ABOVE:
Cloister, Santi Quattro Coronati

SUBIACO
SAN BENEDETTO,
SANTA SCOLASTICA

Monastery of San Benedetto

SUBIACO HAS ONE OF THE RICHEST TRADITIONS of all Italy's religious sites; it was sanctified by both Benedict of Nursia and Francis of Assisi. It lies about twenty-five miles (40 km) east of Rome in a side valley in the foothills of the Abruzzi Appenines. There are two Benedictine monasteries in its immediate vicinity: halfway up the slope is Santa Scolastica and further up on the cliff, at an altitude of 2,100 feet (640 m),

is San Benedetto. The monasteries lie above the valley of the Aniene (ancient Anio) River, which flows on to Tivoli and continues from there to join the Tiber near Rome. In 304 the region fell under Roman control by confederation. Four of Rome's aqueducts were fed by water from the Anio. The first of these, the Anio vetus, was begun before 272 B.C.; the last, the Anio novus, in A.D. 38. Emperor Tiberius had a villa there. Soon after, Emperor Nero built there in grand style, creating three reservoirs in the river valley and an extensive villa on their banks; later the town of Sublaqueum (Sublacus) was founded. Emperor Trajan had a villa built here as well. The Via Tiburtina Valeria connected the town, which, like Tusculum or Tivoli, was a summer residence for wealthy Romans, with the capital.

The town became a Christian religious site thanks to Benedict of Nursia, the father of Western monasticism. His vita, the only known one, was written soon after his death by Pope Gregory the Great. Benedict was born around 480 in Nursia (Norcia), Umbria. He began his life of seclusion in the Sabian mountains and then was a hermit in a cave above Subiaco, where he hid for three years. Then he took over the leadership of a monastic community living nearby, but he soon returned to Subiaco. A number of ascetics followed him there. Benedict himself remained at the main settlement on the river bank but settled the others in twelve surrounding monasteries with twelve monks each. The Aniane valley thereafter came to be known as the Sacred Valley. According to later legend, Benedict was joined in Subiaco by his sister Scholastica, who, as her name suggests, was said to be his divinely inspired teacher. In 529 Benedict left the community, because a jealous priest had persecuted him, and moved to Montecassino, where he founded another monastery and composed the rule that from the early Middle Ages onward would form the basis for several orders, from the Benedictines to the Cistercians (see pp. 15–16). Scholastica followed him to Montecassino.

The monastery of Santa Scolastica seems to have been one of Benedict's original twelve monasteries. The earliest surviving references to it date from the eighth century. Abbot Leo III (932–961) led the abbey to its first heyday. In 999 Emperor Otto III is said to have spent several weeks here. The earliest information on the history of its construction is after the mid–eleventh century, under the French abbot Umberto and his successor, Giovanni. A church, campanile, dormitory, heated common room with marble columns, and a large infirmary at the entrance to the monastery were all built.

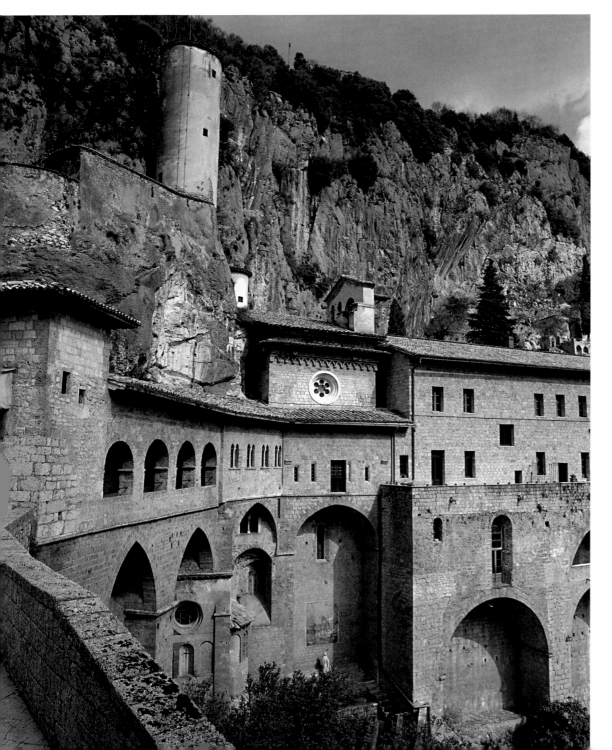

All that survives of this is the campanile, probably built around 1052–55. It is a square tower in the Lombard style with five stories separated by cornices and with bipartite and tripartite open arcades. The two upper stories have perforated round arch friezes—a popular decorative motif in the Romanesque style of northern Italy. The campanile is the earliest Lombard bell tower in central Italy. The most important part of the monastery architecturally is the old cloister. According to inscriptions it was built in two stages: in the early thirteenth century Master Jacobus of Rome built the limestone south wing, and the other three wings followed between 1227 and 1243, now executed in Carrara marble by the Roman artist Cosmas and his sons Lucas and Jacobus. The pieces were probably not produced on site but in a workshop in Rome. The cloister, with its alternating single and double, smooth and twisted columns, is a fine example of the famous Roman Cosmati cloisters—most closely related to Santi Quattro Coronati in Rome and Sassovivo in Umbria. The other monastery buildings, which are quite asymmetrically arranged, were added in later centuries: the atrium in the Gothic period; the large cloister, in the sixteenth century, but rebuilt after being destroyed in World War II; and the church, which does not match the rest of the ensemble at all, by Giacomo Quarenghi in the neoclassical period.

The monastery of San Benedetto, which is reached from Santa Scolastica by way of a long stairway lined by ancient holm oaks, was built above Benedict's cave, known as the *sacro speco*. For a long time there was a hermitage here; in the twelfth century a monastery was built. The building, which Pope Pius II compared to a swallow's nest clinging to the cliff, stands on enormous substructures with pier arcades of round and pointed

View of the monastery of Santa Scolastica

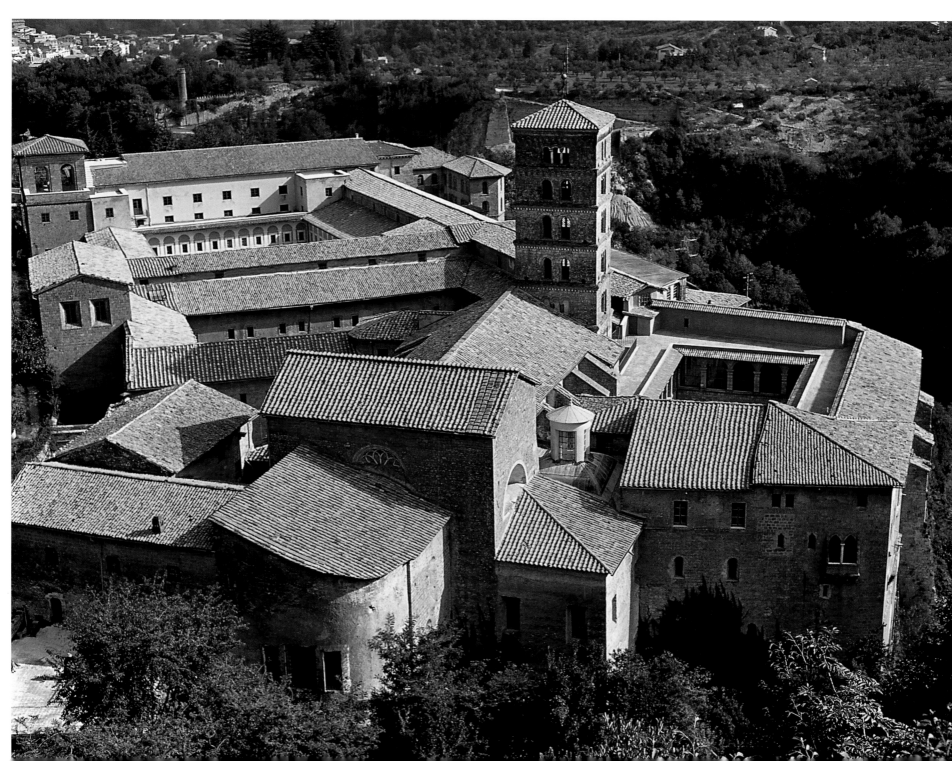

TOP RIGHT:
Fresco with a depiction of Francis of Assisi painted during his lifetime, Capella di San Gregorio, monastery of San Benedetto

BOTTOM LEFT:
Benedict in his cave letting a raven carry away the poisoned bread. Fresco in the lower church, monastery of San Benedetto

arches, like those of Roman aqueducts. The monastery is staggered on five different levels, each adjusted to accommodate the cliff, from the cave to the lower church and the upper church, which is a one-nave Gothic vaulted structure. The two churches, the chapels, and walls of the stairwells are entirely covered with frescoes from the eighth to the sixteenth centuries, some Roman and some Sienese or Umbrian. The lower church contains a large cycle with scenes from Benedict's life, including the attempted poisoning by the priest Florentius, who has poisoned bread sent to Benedict and his companions Maurus and Placidus in their cave. Benedict suspects the bread is poisoned, however, and tosses it to a tame raven, which carries it away to prevent further harm. This cycle from the first half of the thirteenth century is by the Roman painter Conxolus. The Capella di San Gregorio has Subiaco's

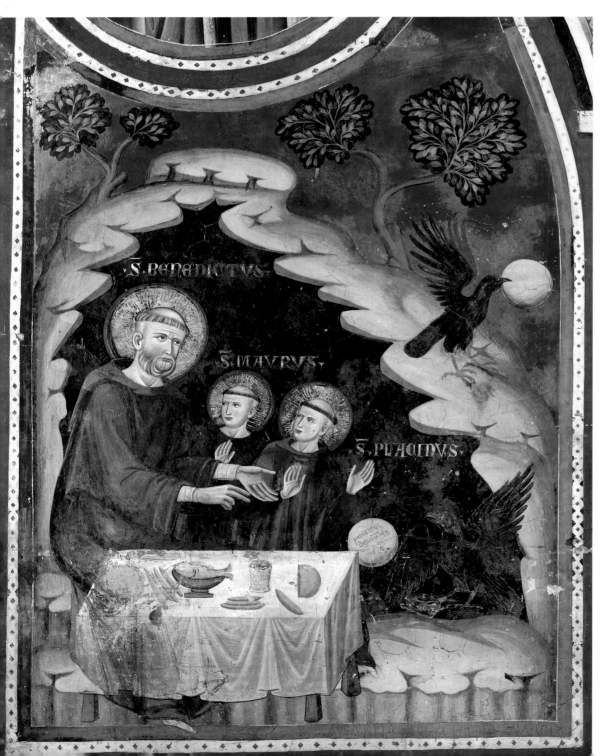

most famous fresco: it shows Francis of Assisi in the habit of the order, with a rope as a belt, and it was painted during his lifetime, before receiving the stigmata. He presents the monastery a greeting written on the scroll: "Pax huic domui" (Peace to this house). According to an old tradition Francis was in Subiaco in 1224. The painting may have been commissioned on that occasion or in memory of it by the monk who was depicted, in a tiny format, at Francis's feet at lower left, but who is only barely visible today. If only because of the difference in size, Francis, whose facial features may indeed be an attempt at a portrait, already looks like a saint in the company of many other saints.

SAN ANGELO IN FORMIS

(MONTECASSINO)

TOP LEFT:
Fresco portraying Abbot Desiderius, the monastery's founder; San Angelo in Formis

BOTTOM RIGHT:
Aerial photograph of the monastery of Montecassino, rebuilt after it was destroyed in World War II

HALFWAY BETWEEN ROME AND NAPLES, ON Monte Cassino, which is 1,670 feet (510 m) high, is the Benedictine mother monastery, founded around 519 on the site of a pagan temple by Benedict of Nursia. Here, sometime after 534, he wrote his rule, and he was buried here beside his sister, Scholastica. Around 589 the monastery was destroyed by Lombards, but then it was refounded in the eighth century and reconstructed by Willibald, who came from the English monastery Waltham. Carloman, the brother of Pépin the Short, lived here, as did Paulus Diaconus, the historian of the Lombards, at the end of his life. The monastery was destroyed a second time in 883 by the Saracens. After being refounded again in 883 Montecassino, which had joined the Cluniac reform, prospered under Abbot Desiderius (d. 1087), a friend of Pope Gregory VII. He was elected abbot in 1058 and, after holding that office for nearly thirty years, ascended to the papal chair as Victor III in 1086. In 1066 he began work on a new church, and it was consecrated as early as

1071: a three-nave column basilica 164 feet (50 m) in length, with a large atrium and a continuous transept that did not project very far and had three parallel apses. The church, which had mosaics in the apse and narthex and frescoes in the main block, was the model for the Campanian cathedrals Amalfi, Capua, Ravello, and Salerno. Desiderius also turned Montecassino, where two hundred monks lived, into a center of the arts, book illumination in particular, and maintained close relations with Constantinople: the church's bronze door, which was made in 1066 and has survived in part, came from there. The chronicle of Montecassino by Leo of Ostia (Leo Marsicanus) reports in detail on Desiderius. In 1349 the monastery fell victim to a devastating earthquake. Its reconstruction was financed by Pope Urban V, who resided in Avignon. During the Renaissance and Baroque the church and monastery buildings were largely reconstructed: the cloister that was located in front of the church like an atrium was built in 1513, probably based on plans by the Roman architect Antonio da Sangallo the Younger; this was followed by the larger cloister and its viewing loggia (the Paradiso) and finally the church, which was decorated by Luca Giordano and consecrated in 1727. Montecassino suffered its fourth

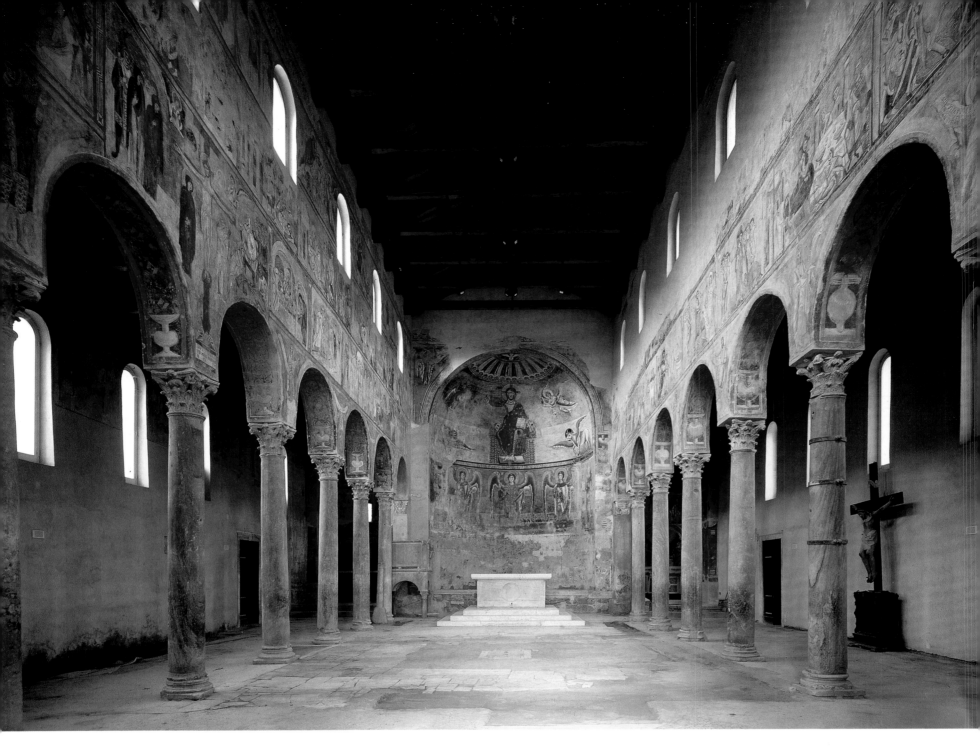

complete destruction in 1944, when the mountain was defended by German troops against the Allied forces over a period of four months and was bombarded. More than 30,000 people from all parts of the globe died in these battles. From 1950 to 1954 the monastery was reconstructed just as it had been.

The fresco cycle in San Angelo in Formis, near Capua, is like a reflection of the lost decorations of the church at Montecassino. The small church, a column basilica, was entrusted to Montecassino monastery in 1072, and Abbot Desiderius had it completely decorated with frescoes. The paintings are by Italian artists who seem to have used Byzantine models. It is the largest and best-preserved cycle of Romanesque mural paintings in Italy. About three-quarters of the original paintings, which numbered around sixty, have survived. To the left

in the apse, opposite Saint Benedict, Abbot Desiderius appears as a donor in the dedication painting; he has a square nimbus—symbolizing that he was alive at the time—and presents the church to Christ, who is enthroned in the center of the apse. The fresco program of the nave has three superimposed registers with scenes from the New Testament history of salvation, which move back and forth between the walls as the sequence progresses. The side aisles had Old Testament scenes, but most of these have been lost. Characteristic of this group of paintings is the use of ochers over a blue tonality and red spots on the cheeks—an unmistakable trademark. Even today the colors have preserved their unusual luminosity. The entire west wall is taken up by a Last Judgment, with the apostles as attendants and the separation of the chosen and the damned.

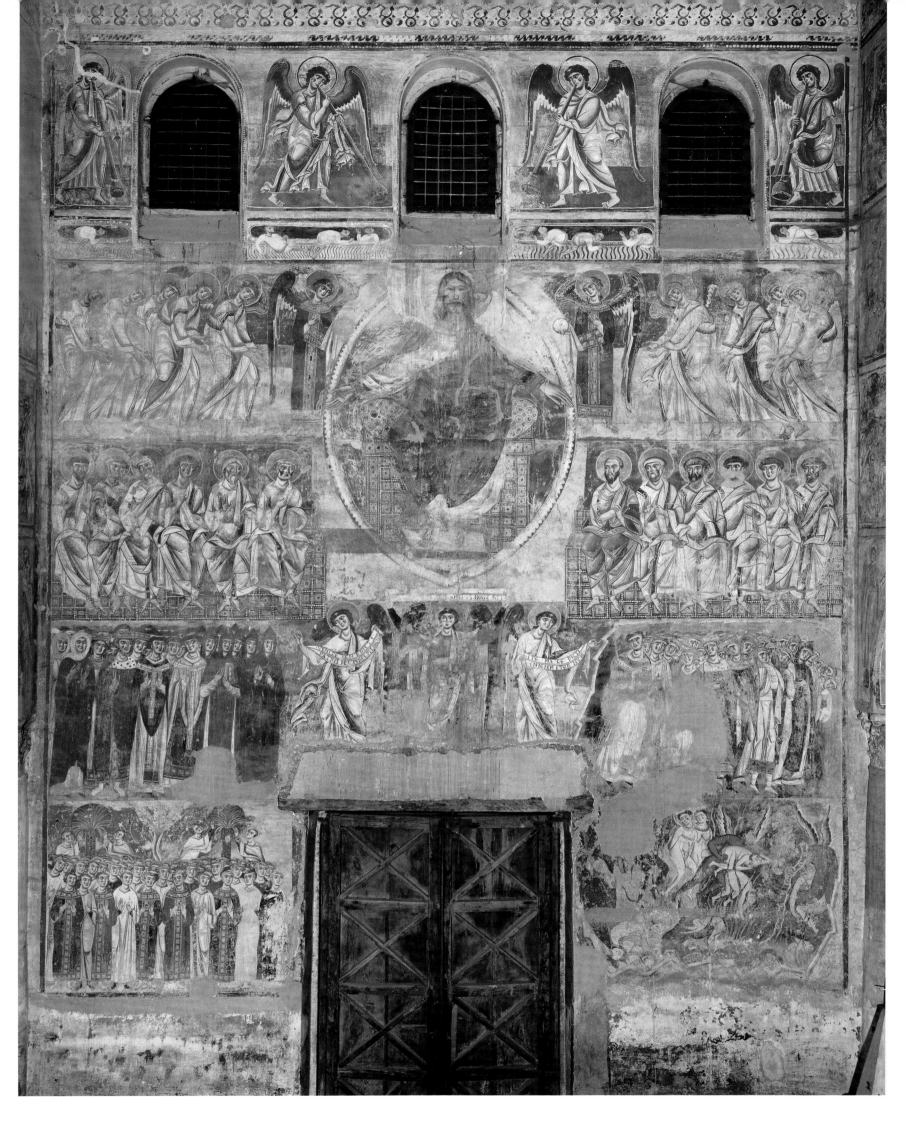

NAPLES
SANTA CHIARA

the latter's second wife, Maria of Valois, were largely destroyed. Today, the church interior, with the enormous dimensions of 302 by 98 feet (92 × 30 m), is an extremely barren hall—one of the large Franciscan "sermon barns" in Italy.

The monastery is famous above all for its unique cloister, the Chiostro delle Maioliche, whose side galleries enclose a remarkably large square, about 270 by 260 feet

Pergola with majolica piers inside the cloister, Santa Chiara

T HE NUNNERY OF SANTA CHIARA, OF THE ORDER of Poor Clares, originally lay outside the medieval city walls on the western edge of Naples, between gardens and fruit groves. Sancha of Mallorca from the house of Aragón, the wife of King Robert the Wise, founded it as a convent for two hundred nuns. In 1310 the church was begun, and in 1340 it was consecrated. Thereafter it served as a burial site for the house of Anjou and as a stage for state ceremonies. In the eighteenth century the interior was redesigned and lavishly decorated; in 1944, however, the interior decorations fell victim to a fire caused by bombing; the monumental Gothic tomb monuments of Robert the Wise, Duke Charles of Calabria, and

(82 × 78 m). At the request of the queen of Naples, Anna Amalia of Saxony, the courtyard was transformed into an exquisite pleasure garden by adding a cruciform pergola with an octagonal domed structure in the center. For walking in the shade, it once offered a vault of delicate slats overgrown with grape vines, but today that has been replaced by crude beams. The piers are clad with colorfully glazed majolica tiles by Tuscan artists. The tiles depict landscape motifs around the Gulf of Naples; they spirit the strollers away into a cheerful, carefree world, into blissful idylls, as if the lives of the order of Poor Clares had not been one of asceticism behind convent walls but an arcadian dream—the charm of rococo ladies.

SAN GIOVANNI DEGLI EREMITI

Two years after the Norman prince Roger II was recognized as king of Sicily by the antipope Anacletus II in 1130, he commissioned the construction of the monastery church San Giovanni degli Eremiti. The "Eremiti" probably refers to San Eremete monastery, which Pope Gregory the Great founded in 581. Roger brought the monks from the Benedictine reform church Monte Vergiliano, near Avellino in southern Italy, which had been founded by Guglielmo da Vercelli around 1120 and asserted itself as independent of the Cluniac reform. In 1148 Roger granted freedoms and privileges to his newly founded monastery. With the end of the Norman kings' rule in 1194, however, the abbey lost its independence and was taken over by Monreale.

South of the church once stood a small mosque, which had been built on an older monastery, which in turn seems to have been constructed on the ancient shrine of Hermes. San Giovanni is quite small and has a T-shaped ground plan. The main block, transept, and altar room are vaulted with domes. There are five domes in all; on the exterior they emerge from the cubic lower structure as bare, red-shaded half-spheres with no roofs. The lateral rectangular cloister has double columns that join to form bundles of four in the corners; it dates from the end of the twelfth century and lies to the northwest of the church. In the late nineteenth and earlier twentieth centuries all the later construction was removed from the whole complex, and lush vegetation took its place, so that the cloister and the church offer a fairy-tale picture of almost Oriental magic.

Cloister and church of San Giovanni degli Eremiti, from the northwest

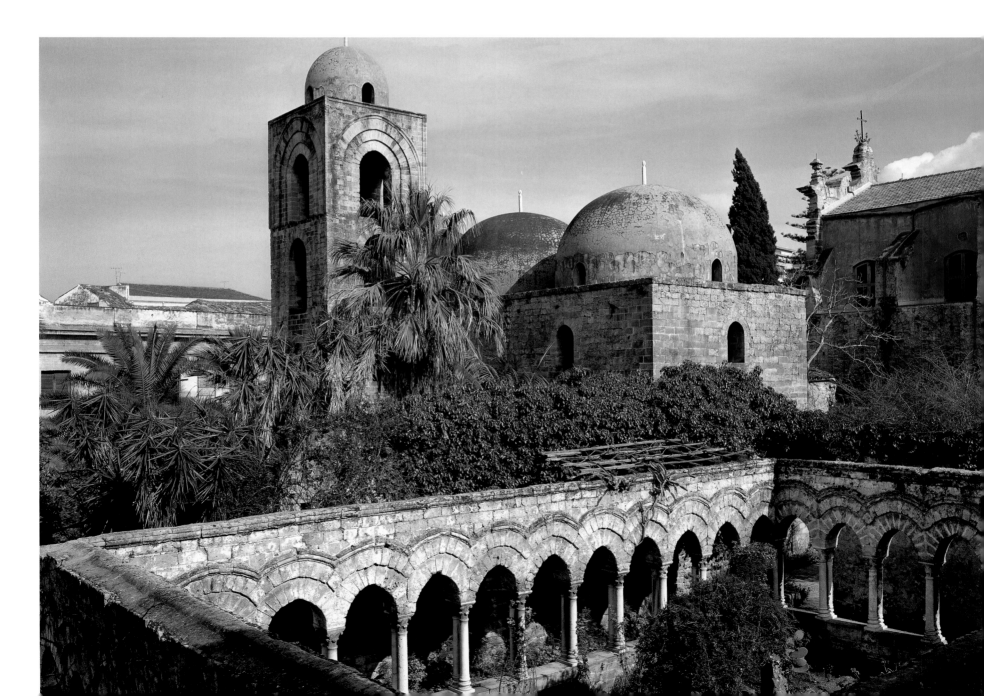

MONREALE

Aerial view of Monreale,
from the southwest

ONREALE LIES ON THE *mons regalis* (ROYAL mountain), in the immediate vicinity of the Sicilian capital, Palermo. Here William II, the last of the Norman kings in southern Italy, founded a Benedictine abbey in 1174 and declared it exempt of the archbishop of Palermo. The church was chosen as the royal burial site; consequently, the monastery received lavish gifts. Two years after it was founded, the convention of one hundred monks arrived from the Cluniac monastery La Cava, near Salerno. In 1183 Pope Lucius III, at the request of the king, raised Monreale to an archdiocese with the suffragans Catania and Syracuse. The

monastery remained, however, and its monks were not replaced by canons. As a result, it became a cathedral monastery—that was very unusual in Italy, but it had several parallels in England, such as the archbishopric cathedral of Canterbury. Pope Lucius explicitly emphasized when raising its rank that no king since antiquity had created a comparable work. King William's mother was buried in the new church in 1183 and William himself in 1189. The bones of his father, William I, were transferred here. At this time it seems the church, cloister, and decorations were largely finished. In the centuries that followed this ensemble was left untouched, probably because the church was praised as unique, sometimes even as the most splendid work in the world.

Architecturally, the church is composed of two opposed parts: a cruciform east end and a three-nave main block. The east end has three apses that point toward Palermo, with perforated pointed arches and precious inlay work, offering a resplendent prospect of overflowing royal splendor in which the Norman and

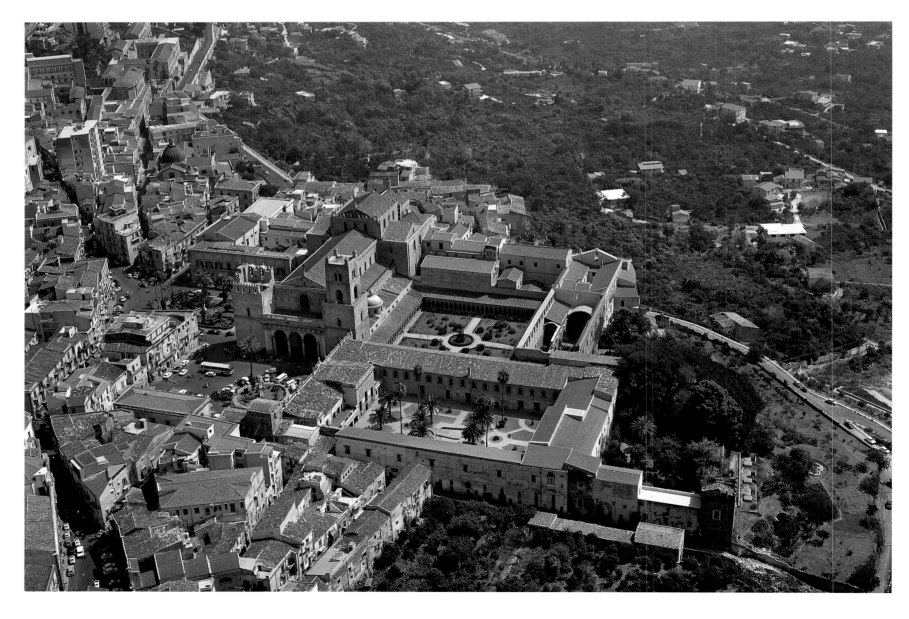

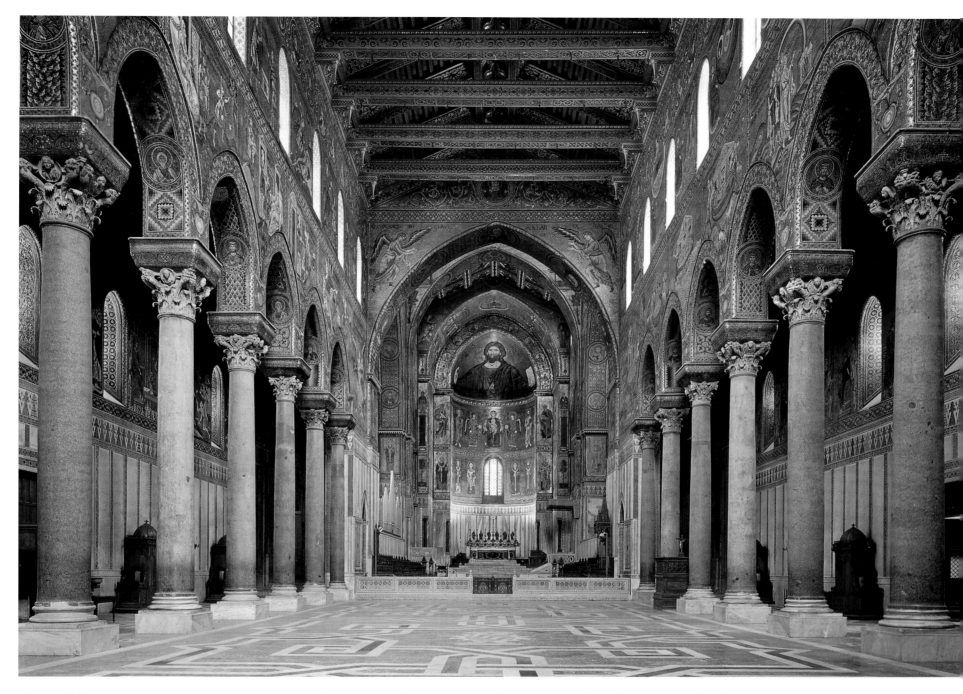

Islamic delight in ornament join to create something original and unmistakable. The main block is a basilica with column arcades, pointed arches, and exposed roof framework; the nave, which is more than three times as wide as the side aisles, is a broad, noble royal hall.

The world fame of Monreale, however, derives from its mosaics. Set against a gold ground, they cover all the interior walls of the church, occupying a surface of about 39,000 square feet (3,600 sq. m). The cycle, which includes some Greek inscriptions, is an offshoot of the highly developed art of Byzantine mosaic. It culminates in the oversized, half-length figure of Christ Pantocrator (Ruler of all) in the apse. His serious, inescapable gaze fills the entire church with a captivating omnipresence. It is one of the most compelling paintings ever made of Christ's all-embracing divine power.

The importance the king placed on decorations of great taste and expense may also be seen in the two bronze doors. One was created by Barisanus of Trani; the other, dated 1185, by Bonanus of Pisa. The latter is roughly 23 feet (7 m) tall and 11 feet (3.4 m) wide, making it the largest surviving bronze door of the Middle Ages. The size of the cloister also exceeds that of all comparable examples in Italy during this period. It has twenty-six arches stretching 154 feet (47 m) on each side—a series that never seems to end. The double columns of the arcades are ornamented with inlay of lava and glass mosaic stones, some of which are gold, and they support exceedingly lavish capitals. The high point is the well house in the southwest corner, which forms its own intimate arcade court—a delicate jewel from an Oriental fable.

ABOVE:
Interior of the church, facing east

PAGE 468:
Well house in the cloister

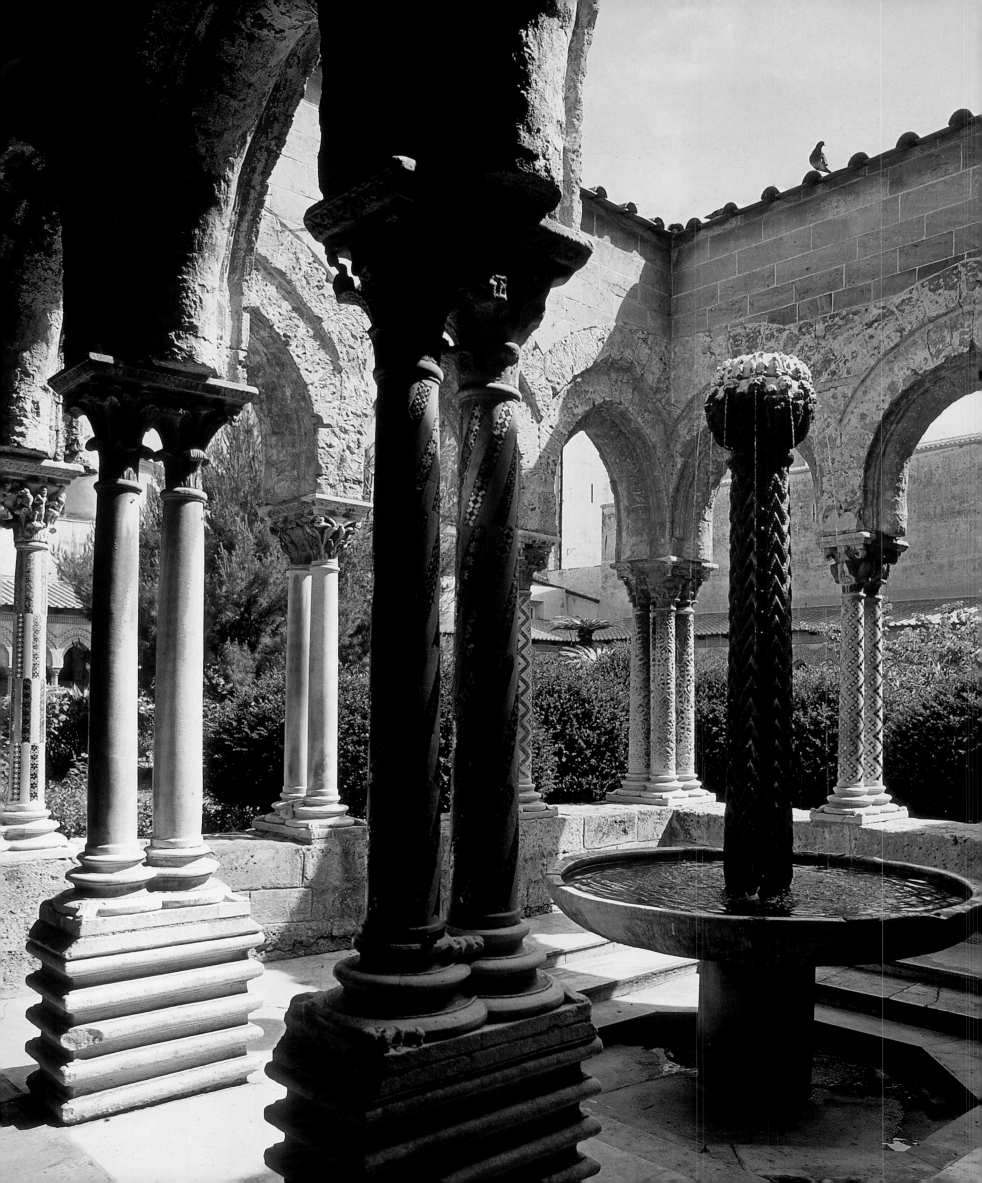

APPENDIX

GLOSSARY

ABBEY
A monastery or nunnery that is ruled by an abbot or abbess

AEDICULE
Latin for "small house." An architectural motif consisting of two columns, an entablature, and a gable

AMBO
A pulpitlike lectern

ANCHORITE
An early Christian hermit, originating in third-century Egypt, who lived a strictly ascetic lifestyle

APSE
A concha with an altar

ATRIUM
The forecourt of a church with walkways

AUDITORIUM see LOCUTORIUM

BARREL VAULT
A semicylindrical vault having either a semicircular or pointed cross section

BAY
A module of space determined by its supports or wall projections and the vault above them

BAY SYSTEM
In medieval architecture, a relationship of the bays with a lateral rectangular bay in the middle vessel and roughly square bays in the side aisles. Compare BOUND SYSTEM

BERNARDINIAN PLAN
The scheme for the east end of a Cistercian church consisting of a sanctuary with multiple chapels on the east side of the transept, usually with a flat eastern termination

BIFORIUM
An architectural motif consisting of a pair of arches and a relieving arch

BOUND SYSTEM
A bay arrangement of a church (usually Romanesque), in which two bays in the side aisle

are aligned on each side with a roughly square bay in the middle vessel (double bay), based on a quadratic schema for the ground plan

CALEFACTORY
A heated room, often the only room in the monastery that could be heated

CANON
A member of the clergy, such as of a cathedral chapter or a collegiate association, who led a communal life according to canonic rule and held common religious services

CANONESS
A woman, usually from the nobility, living in a monastery-like community with no oath, under an abbess, with joint religious services

CENOBITE
A monk within an association, particularly in the Eastern Church, living in a permanent ascetic community under unified leadership

CHANCEL or CHOIR
The place in a church for choral prayer, later the space in front of the high altar

CHAPTER HOUSE
The room of a monastery in which the daily chapter was read together and assemblies would be held

CLERESTORY
The uppermost story of the nave in a basilica, usually with windows

COLLEGIATE MONASTERY
A community of clerics under a common rule but outside of monastic orders

COMMENDAM
Administrative region or the house belonging to a religious order of knights, corresponding to a commandery. Compare MONASTERY *in commendam*

CONCHA
An architectural motif used to terminate a space. It consists of a semicircular wall with a spherical segment on top, usually a quarter sphere

CONFESSIO
From late antiquity to the Carolingian period, an anteroom to the tomb of a saint or martyr located beneath the altar of a church

CONGREGATION
A close association of monasteries within an order

CONSUETUDINES
The written guidelines of the customs of communal life at a particular monastery or association of monasteries

CONVENTUALS
Members of a monastery or convent

CONVERSI
The working lay brothers, as opposed to the choir monks, within a convention

CRUCIFORM PIER
A pier shaped like a cross with four projections, which are usually rectangular

DECORATED STYLE
English architecture of the high Gothic

DIAPHRAGM ARCH
A transverse arch with no vaulting function

EARLY ENGLISH STYLE
English architecture of the early Gothic

ENCLOSURE
The section of a monastery that was closed to the public and lay brothers and reserved for conventuals

EXEMPTION
The release of a monastery from the religious jurisdiction of a bishop, placing it under the direct authority of the pope

FILIATION
The foundation of monasteries from the mother monastery to the daughter monasteries and from those to more daughter monasteries, like the branches of a family tree

FLAMBOYANT STYLE
Literally, "flaming," French architectural style of the late Gothic

FRATER
Monks' workroom

GALILAEA
Forecourt or narthex of a church, where the monks began their processions

GRANGE
The agricultural farm of a Cistercian monastery, originally run by the lay brothers, later run by leaseholders or servants

GUARDIAN
The abbot of a Franciscan monastery

IMMUNITY
Independence of a monastery, later an order, from the territorial lord; subordination to the protecting power of the king

IMPERIAL MONASTERY
A monastery that was subordinate only to the king or emperor

IMPOST
A masonry unit or course that distributes the thrust at each end of an arch

LAURA
Monastery of the early Christian period with an irregular layout

LOCUTORIUM
Also called the *auditorium*. The room of a monastery in which the monks were allowed to speak to one another; a consultation room for visitors

MENDICANT ORDERS
Monastic orders that evolved from the medieval poverty movement, which rejected not only personal property but also community property

MINORITES
The first of the Franciscan orders, since 1517 a moderate faction

MONASTERY
From the Latin *monasterium* or *claustrum*; a communal residence for the monks or nuns of an order, often with its own businesses

MONASTERY *IN COMMENDAM*
A monastery whose office of abbot has been awarded by a king to someone other than a monk, particularly in the modern age in southern Europe

MOZARABIC STYLE
Art of the Christians subjugated by the Moors in Spain between the eighth and eleventh centuries

MUDEJAR STYLE
The artistic style practiced by Islamic artists after the Christian reconquest of Spain

NARTHEX
A vestibule leading to the nave

NAVE
The main section of a church, especially the long narrow central hall in a cruciform church that rises higher than the aisles on either side of it to form a clerestory

OCULUS (plural: oculi)
A round window at the top of a dome

ORDER (column or pier order)
Architectural system in antiquity and the modern era with the subcategories, including Doric, Ionic, Corinthian, Tuscan, and composite

PARADISE
The forecourt or narthex of a church

PENDENTIVES
Transitional forms consisting of sections of a sphere that connect a quadratic substructure to the baseline of a dome or drum

PERPENDICULAR STYLE
English architecture of the late Gothic

PILASTER
A shallow wall projection with base and capital, analogous to a column and its relationship to human proportions

PLATERESQUE STYLE
From the Spanish *plateresco*, meaning "like silver-work." A Spanish decorative style of the late Gothic

PRIMARY ABBEYS
The first four founding monasteries of Cîteaux

PRIOR
Head of a priory or a Dominican monastery; also, an abbot's representative

PRIORY
A monastery that is subordinate to an abbey, headed by a prior

PROPRIETARY MONASTERY
A monastery of the early Middle Ages that belonged to the secular donor or landlord who had the right to name the abbot or abbess and the members of the convention

PROVOST
From the Latin *praepositus,* meaning "placed in charge." An abbot's representative; later, head of smaller monastery (priory); also used as the title for the chief prelate of a cathedral chapter (cathedral provost) or a collegiate chapter (collegiate provost). In Germany, the term was also used for the head of an Augustinian canonical association

QUADRATIC GROUND PLAN
Division of the church into squares, with the crossing square as the basic unit; the side aisles are generally half the width of the nave

QUADRIPARTITE VAULT
A vault of four cells formed either by the intersection of two barrel vaults or by warping (self-vaulting), and having cambers (rises toward a center point). The sections are separated either by groins (groin rib vault) or by ribs (cross rib vault)

QUATREFOIL
Figure of four partial circles around a square core

QUATREFOIL PIER
Pier with a quatrefoil cross section

RAYONNANT STYLE
Literally, "radiant," French architectural style of the high Gothic

REFECTORY
The dining hall of a monastery

REGALIA
Secular goods and rights donated to a religious institution, e.g., imperial assets

ROOD SCREEN
The partition wall or tribune between the chancel and lay church

SANCTUARY
The part of the church with the holy of holies and the high altar, where the Sacrifice of the Mass is celebrated

SERLIANA
A tripartite architectural motif consisting of two side bays with an entablature and a central archway whose arch rests on the entablature

SQUINCHES
Transitions from a quadratic substructure to an octagonal vault by means of bridge arches that span the corners and the wall behind them

TRIFORIUM
A passageway that opens through a small arcade, usually under the clerestory

BIBLIOGRAPHY

Angerer, Joachim, and Gerhard Trumler.
Klösterreich: Die Stifte und Klöster in Bayern,
Österreich und der Schweiz. Vienna: Molden, 1978.

Aniel, Jean-Pierre. *Les Maisons de Chartreux.*
Bibliothèque de la société française
d'archéologie 16. Geneva: Droz, 1983.

Aubert, Marcel. *L'Architecture cistercienne en France 1–2.*
2nd ed. Paris: Les Editions d'art et d'histoire, 1947.

Backmund, Norbert. *Monasticon Praemonstratense:*
Id est historia circariarum atque canoniarum candidi et
canonici Ordinis Praemonstratensis. Vol. 1, 2nd ed.
Berlin: de Gruyter, 1983.

Badstübner, Ernst. *Klosterkirchen im Mittelalter:*
Die Baukunst der Reformorden. Munich: Beck, 1985.

Balthasar, Hans-Urs von. *Die großen Ordensregeln:*
Einsiedeln. 4th ed. Leipzig: St. Benno-Verlag, 1984.

Bazin, Germain. *Les Palais de la foi: Le monde des*
monastères baroques. 2 vols. Fribourg: Office du
livre, and Paris: Vilo, 1980.

Bernhard, Marianne. *Klöster: Hundert Wunderwerke des*
Abendlandes. Erlangen: Müller, 1994. Translated as
Monasteries: A Hundred Jewels of European Architecture
(Munich: I.P. Verlgsgesellschaft, 1998).

Binding, Günther, and Matthias Untermann.
Kleine Kunstgeschichte der mittelalterlichen
Ordensbaukunst in Deutschland. 3rd ed. Darmstadt:
Wissenschaftliche Buchgesellschaft, 2001.

Boockmann, Hartmut. *Der Deutsche Orden.* Munich:
Beck, 1981.

Braunfels, Wolfgang. *Abendländische Klosterbaukunst.*
5th ed. Cologne: DuMont, 1985. Translated by
Alastair Laing as *Monasteries of Western Europe:*
The Architecture of the Orders. Princeton, N.J.:
Princeton University Press, 1973.

Brooke, Christopher Nugent Lawrence. *The Monastic*
World 1000–1300. London: Elek, 1974.

Les Chartreux, le désert et le monde 1084–1984, neuvième
centenaire de la fondation de la Grande Chartreuse.
Exh. cat. Grenoble: À la Correrie, 1984.

Conant, Kenneth John. *Cluny: Les églises et la maison*
du chef d'ordre. Cambridge, Mass.: Mediaeval
Academy of America, 1968.

Dimier, M.-Anselme. *L'Art cistercien.* St. Leger
Vauban: Zodiaque, 1971.

————. *Les Moines bâtisseurs, architecture et vie monastique.*
Paris: Faillard, 1964. Translated by Gilchrist
Lavigne as *Stones Laid Before the Lord: A History*
of Monastic Architecture. Kalamazoo, Mich.:
Cistercian Publications, 1999.

————. *Recueil des Plans des églises cisterciennes, et*
Supplément. Commission d'histoire de l'Ordre
de Cîteaux 1 and 6. Paris: Grignan, 1949 and 1967.

Dimier, M.-Anselme, and Jean Porcher. *L'Art*
cistercien, France. 2nd ed. La nuit des temps 16.
La Pierre-qui-Vire: Zodiaque, 1974.

Dinzelbacher, Peter. *Bernhard von Clairvaux.*
Darmstadt: Primus-Verlag, 1998.

Dinzelbacher, Peter, and James Lester Hogg, eds.
Kulturgeschichte der christlichen Orden in
Einzeldarstellungen. Stuttgart: Kröner, 1997.

Duby, Georges. *Die Zisterzienser.* Geneva: Weber, 1968.

————. *Saint Bernard, l'art cistercien.* Les grands bâtis-
seurs 1. Paris: Arts et métiers graphiques, 1976.
New ed. *L'Art cistercien.* Paris: Flammarion, 1989.

Elm, Kaspar. *Beiträge zur Geschichte der Konversen im*
Mittelalter. Berliner Historische Studien 2.
Ordensstudien 1. Berlin: Dunker & Humblot,
1980.

————. *Erwerbspolitik und Wirtschaftsweise mittelalterlicher*
Orden und Klöster. Berlin: Duncker & Humblot,
1992.

Elm, Kaspar, ed. *Die Zisterzienser: Ordensleben zwischen*
Ideal und Wirklichkeit. Catalog and supplement.
Cologne: Rheinland-Verlag, 1980 and 1982.

Evans, Joan. *The Romanesque Architecture of the Order of*
Cluny. Cambridge: Cambridge University Press,
1938. Reprinted with a new foreword and addi-
tional bibliography. Farnborough: Gregg, 1972.

Eydoux, Henri-Paul. *L'Architecture des églises*
cisterciennes d'Allemagne. Paris: Presses
universitaires de France, 1952.

Fergusson, Peter. *Architecture of Solitude: Cistercian*
Abbeys in Twelfth-Century England. Princeton, N.J.:
Princeton University Press, 1984.

Greene, J. Patrick. *Medieval Monasteries.* Leicester,
England, and New York: Leicester University
Press, 1992.

Grégoire, Réginald, Léo Moulin, and Raymond
Oursel. *La civiltà dei monasteri.* Milan: Jaca Book,
1985. Translated as *The Monastic Realm.* New York:
Rizzoli, 1985.

Grote, Andreas E. J. *Anachorese und Zönobium: Der*
Rekurs des frühen westlichen Möchtums auf monastische
Konzepte des Ostens. Stuttgart: Thorbecke, 2001.

Hahn, Hanno. *Die frühe Kirchenbaukunst der Zisterzienser.*
Frankfurter Forschungen zur Architektur-
geschichte 1. Berlin: Gebr. Mann, 1957.

Hallinger, Kassius, ed. *Corpus Consuetudinum Monasticarum.*
Siegburg: Apud Franciscum Schmitt, 1963–.

————. *Gorze–Cluny: Studien zu den monastischen*
Lebensformen und Gegensätzen im Hochmittelalter.
Rome: Herder, 1950.

Hawel, Peter. *Zwischen Wüste und Welt: Das Mönchtum*
im Abendland. Munich: Kössel, 1997.

Heimbucher, Max. *Die Orden und Kongregationen der*
katholischen Kirche. 3rd ed. 2 vols. Paderborn:
F. Schöningh, 1933 and 1934. Reprint, 1980.

Hoffmann, Wolfbernhard. *Hirsau und die "Hirsauer*
Bauschule." Munich: Schnell & Steiner, 1950.

Holtz, Leonard. *Geschichte des christlichen Ordenslebens.*
2nd ed. Zurich: Benziger, 1991.

————. *Il monachesimo nel primo millennio.* Convegno
internazionale di studi. Rome: Casamari, 1989.
Rome: Atti, 1990.

Horn, Walter, and Ernest Born. *The Plan of St. Gall: A*
Study of the Architecture and Economy of, and Life in a

Paradigmatic Carolingian Monastery. 3 vols. Los Angeles, London, and Berkeley: University of California Press, 1979.

Jacobsen, Werner. *Der Klosterplan von St. Gallen und die karolingische Architektur.* Berlin: Deutscher Verlag für Kunstwissen, 1992.

Kinder, Terryl N. *L'Europe cistercienne.* Saint-Léger-Vauban: Zodiaque, 1997. Translated as *Architecture of Silence: Cistercian Abbeys of France* (New York: Abrams, 2000).

Klein, Peter K., ed. *Der mittelalterliche Kreuzgang: Architektur, Funktion und Programm.* Regensburg: Schnell & Steiner, 2003.

Knefelkamp, Ulrich, ed. *Zisterzienser: Norm, Kultur, Reform.* Berlin and Heidelberg: Springer, 2000.

Kominiak, P. Benedict, Jagues P. Cotè, and Cyrill Schäfer. *Loci ubi Deus quaeritur: Benediktiner in aller Welt / The Benedictine Abbeys of the Entire World.* In six languages: St. Ottilien: EOS, 1999.

Kuthan, Jiri. *Die mittelalterliche Baukunst der Zisterzienser in Böhmen und Mähren.* Munich and Berlin: Deutscher Kunstverlag, 1982.

Laabs, Annegret. *Malerei und Plastik im Zisterzienserorden.* Studien zur internationalen Architektur- und Kunstgeschichte 8. Petersberg: Imhof, 2000.

Laboa, Juan-María. *Atlante storico del Monachesimo Orientale ed Occidentale.* Milan: Jaca Book, 2002. Translated by Matthew J. O'Connell and Madeleine Beaumont as *The Historical Atlas of Eastern and Western Christian Monasticism.* Minnesota: Liturgical Press, 2003.

Lambert, Elie. *L'Architecture des templiers.* Paris: A. & J. Picard, 1955.

Lanczkowski, Johanna. *Kleines Lexikon des Mönchstums und der Orden.* Stuttgart: Reclam, 1993.

Le Bras, Gabriel. *Les Ordres religieux, la vie et l'art.* 2 vols. Paris: Flammarion, 1979 and 1980.

Legler, Rolf. *Der Kreuzgang: Ein Bautypus des Mittelalters.* Frankfurt: Lang, 1989.

Lekai, Ludwig. *Geschichte und Wirken der Weißen Mönche: Der Orden der Cisterzienser.* Cologne: Ambrosius Schneider, 1958.

Leroux-Dhuys, Jean-François. *Les Abbayes cisterciennes. Histoire et architecture.* Paris: Place des Victoires, 1998. Translated by Elizabeth Clegg, Caroline Higgitt, and Marie-Noëlle Ryan as *Cistercian Abbeys: History and Architecture.* Cologne: Könnemann, 1998.

Lussien-Maisonneuve, Marie-Josèphe. *Abbayes de France.* Geneva: Minerva, 1999.

Mettler, Adolf. "Die zweite Kirche in Cluni und die Kirchen in Hirsau nach den 'Gewohn-heiten' des XI. Jahrhunderts." *Zeitschrift für Geschichte der Architektur.* 3 (1909–10): 273–86 and 4 (1910–11): 1–16.

Nicolai, Bernd. *"Libido aedificandi": Walkenried und die monumentale Kirchenbaukunst der Zisterzienser um 1200.* Braunschweig: Braunschweig Geschichtsverein, 1990.

Norton, Christopher, and David Park, eds. *Cistercian Art and Architecture in the British Isles.* Cambridge: Cambridge University Press, 1986.

Prinz, Friedrich. *Askese und Kultur: Vor- und frühbenediktinisches Mönchtum an der Wiege Europas.* Munich: Beck, 1980.

———. *Mönchtum und Gesellschaft im Frühmittelalter.* Wege der Forschung 312. Darmstadt: Wissenschaftliche Buchgesellschaft, 1976.

Rahlves, Friedrich. *Kathedralen und Klöster in Spanien.* Wiesbaden: Rheinische Verlags-Anstalt, 1965. Translated by Monique Bittebierre as *Cathédrales et monastères d'Espagne* (Paris and Grenoble: Arthaud, 1965). Translated from the French by James C. Palmes as *Cathedrals and Monasteries of Spain* (London: Kaye, 1966).

Rainer, Braun. *Bayern ohne Klöster? Die Säkularisation 1802–03 und die Folgen.* 2nd ed. Exh. cat. Munich: Generaldirektion der Staatlichen Archive Bayerns, 2003.

Romanini, Angiola Maria. *L'architettura gotica in Lombardia.* Architetture delle regione d'Italia 2. Milan: Ceschia, 1964.

Rouchon-Mouilleron, Veronique. *Cloîtres: jardins de prières.* Paris: Flammarion, 2000. Translated as Klöster: *Universum der Stille und der Kontemplation* (Paris: Flammarion, 2003). Translated by Deke Dusinberre as *Cloisters of Europe: Gardens of Prayer* (New York: Viking Studio, 2001).

Rüffler, Jens. *Orbis Cisterciensis.* Berlin: Lukas-Verlag, 1999.

Schenkluhn, Wolfgang. *Architektur der Bettelorden: Die Baukunst der Dominikaner und Franziskaner in Europa.* Darmstadt: Primus Verlag, 2000.

Schiedermair, Werner. *Klosterland Bayerisch Schwaben: Zur Erinnerung an die Säkularisation der Jahre 1802–03.* Lindenberg: Fink, 2003.

Schneider, Ambrosius, ed. *Die Cistercienser: Geschichte—Geist—Kunst.* 2nd ed. Cologne: Wienand, 1977.

Schwaiger, Georg, ed. *Mönchtum, Orden, Klöster: Von den Anfängen bis zur Gegenwart; Ein Lexikon.* Munich: Beck, 1998.

Schwaiger, Georg, and Manfred Heim. *Orden und Klöster: Das christliche Mönchtum in der Geschichte.* Munich: Beck, 2002.

Sennhauser, Hans Rudolf. *Wohn- und Wirtschaftsbauten frühmittelalterlicher Klöster.* Veröffentlichungen des Instituts für Denkmalpflege der ETH Zürich 17. Zurich: VDF, 1996.

Sennhauser, Hans Rudolf, ed. *Zisterzienserbauten in der Schweiz, 1–2.* Veröffentlichungen des Instituts für Denkmalpflege der ETH Zürich 10.1–2. Zurich: Verl. der Fachvereine, 1990.

Stalley, Roger A.. *The Cistercian Monasteries of Ireland.* London and New Haven: Yale University Press, 1987.

Stephan, Madeleine, and Walter Stephan. *Benediktinische Stätten in Deutschland.* 2 vols. Münsterschwarzwarzach: Vier-Türme-Verlag, 1992.

Sydow, Jürgen, Edmund Mikkers, and Anne-Barb Hertkorn. *Die Zisterzienser.* Stuttgart: Belser, 1989.

Tellenbach, Gerd, ed. *Neue Forschungen über Cluny und die Cluniazenser.* Freiburg: Herder, 1959.

Untermann, Matthias. *Kirchenbauten der Prämonstratenser: Untersuchungen zum Problem einer Ordensbaukunst im 12. Jh. 29.* Veröffentlichung der Abteilung Architektur des Kunsthistorischen Instituts der Universität zu Köln. Cologne: Kunsthistorisches Institut, 1984.

———. *Forma Ordinis: Die mittelalterliche Baukunst der Zisterzienser.* Munich and Berlin: Deutsche Kunstverlag, 2001.

Weinfurter, Stefan. "Reformkanoniker und Reichsepiskopat im Hochmittelalter." *Historisches Jahrbuch der Görres-Gesellschaft 97–98* (1978).

Wollasch, Joachim. *Mönchtum des Mittelalters zwischen Kirche und Welt.* Munich: Fink, 1973.

Zadnikar, Marijan, and Adam Wienand. *Die Kartäuser.* Cologne: Wienand, 1983.

GROUND PLANS

Left: *Alcobaça*

Right: *Batalha*

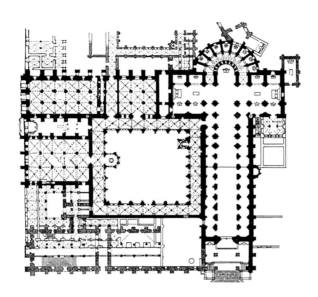

Left: *Belém*

Right: *Toledo, San Juan de los Reyes*

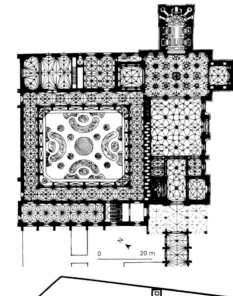

Left: *Las Huelgas Reales*

Right: *Poblet*

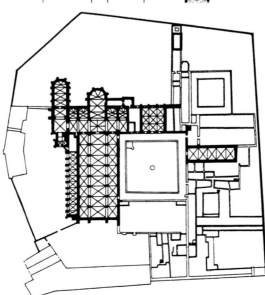

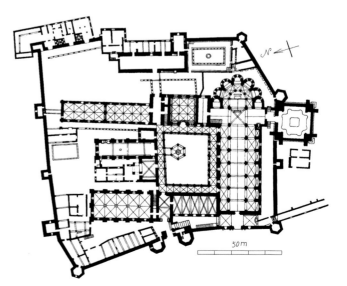

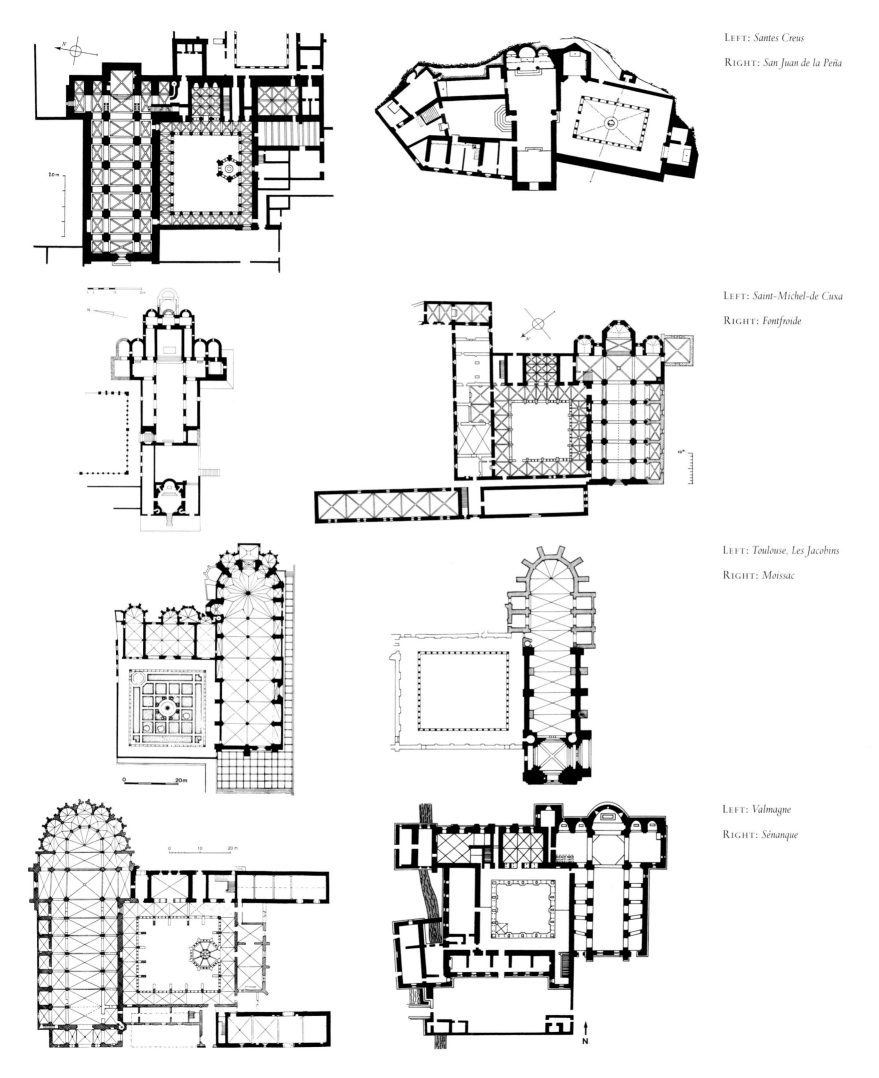

LEFT: *Santes Creus*

RIGHT: *San Juan de la Peña*

LEFT: *Saint-Michel-de Cuxa*

RIGHT: *Fontfroide*

LEFT: *Toulouse, Les Jacobins*

RIGHT: *Moissac*

LEFT: *Valmagne*

RIGHT: *Sénanque*

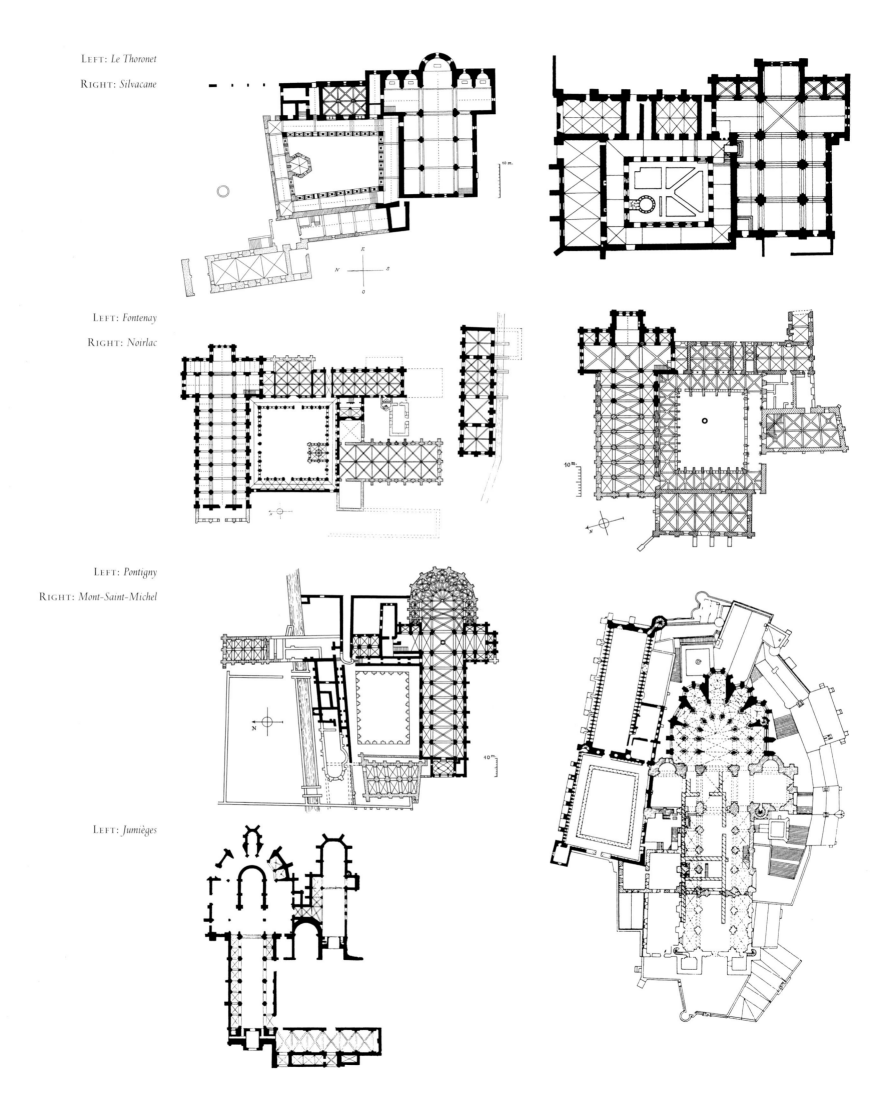

LEFT: *Le Thoronet*

RIGHT: *Silvacane*

LEFT: *Fontenay*

RIGHT: *Noirlac*

LEFT: *Pontigny*

RIGHT: *Mont-Saint-Michel*

LEFT: *Jumièges*

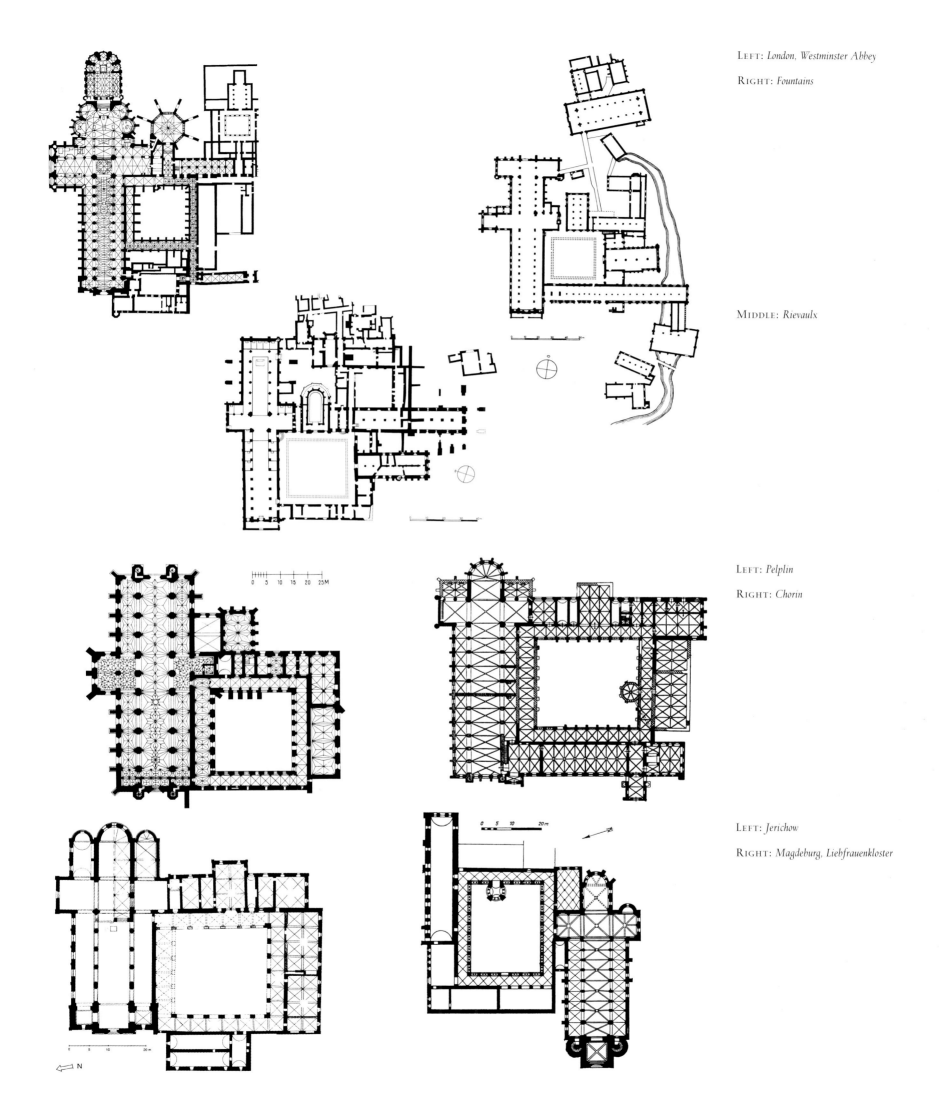

LEFT: *London, Westminster Abbey*

RIGHT: *Fountains*

MIDDLE: *Rievaulx*

LEFT: *Pelplin*

RIGHT: *Chorin*

LEFT: *Jerichow*

RIGHT: *Magdeburg, Liebfrauenkloster*

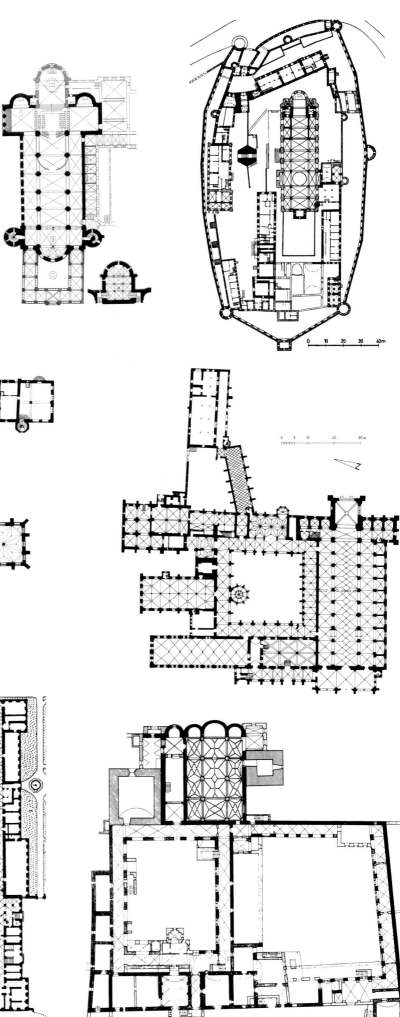

LEFT: *Paulinzella*

MIDDLE: *Maria Laach*

RIGHT: *Comburg*

LEFT: *Bebenhausen*

RIGHT: *Maulbronn*

LEFT: *Einsiedeln*

RIGHT: *Müstair*

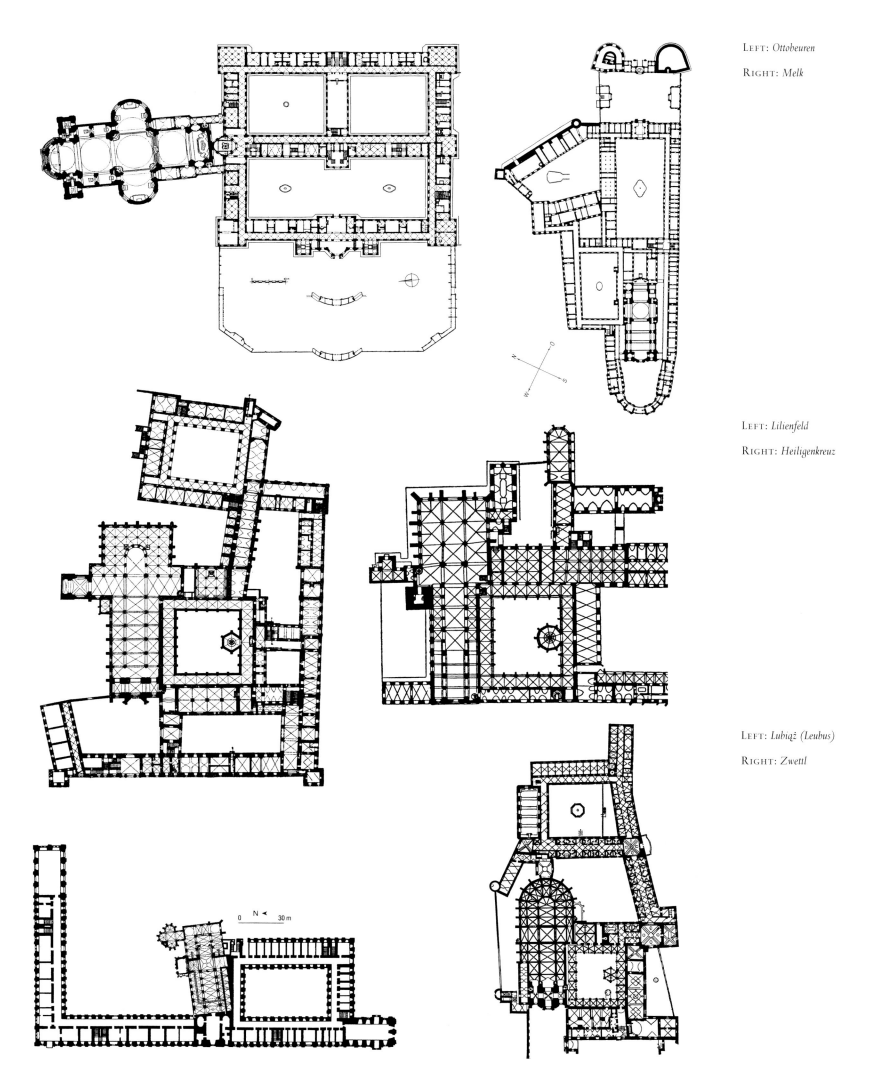

LEFT: *Ottobeuren*

RIGHT: *Melk*

LEFT: *Lilienfeld*

RIGHT: *Heiligenkreuz*

LEFT: *Lubiąż (Leubus)*

RIGHT: *Zwettl*

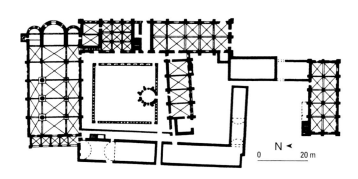

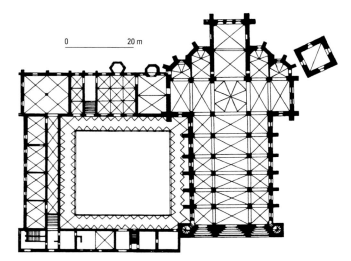

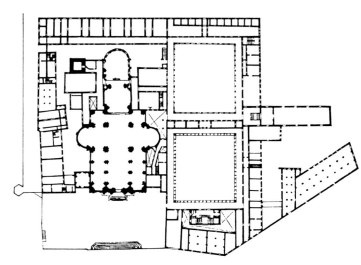

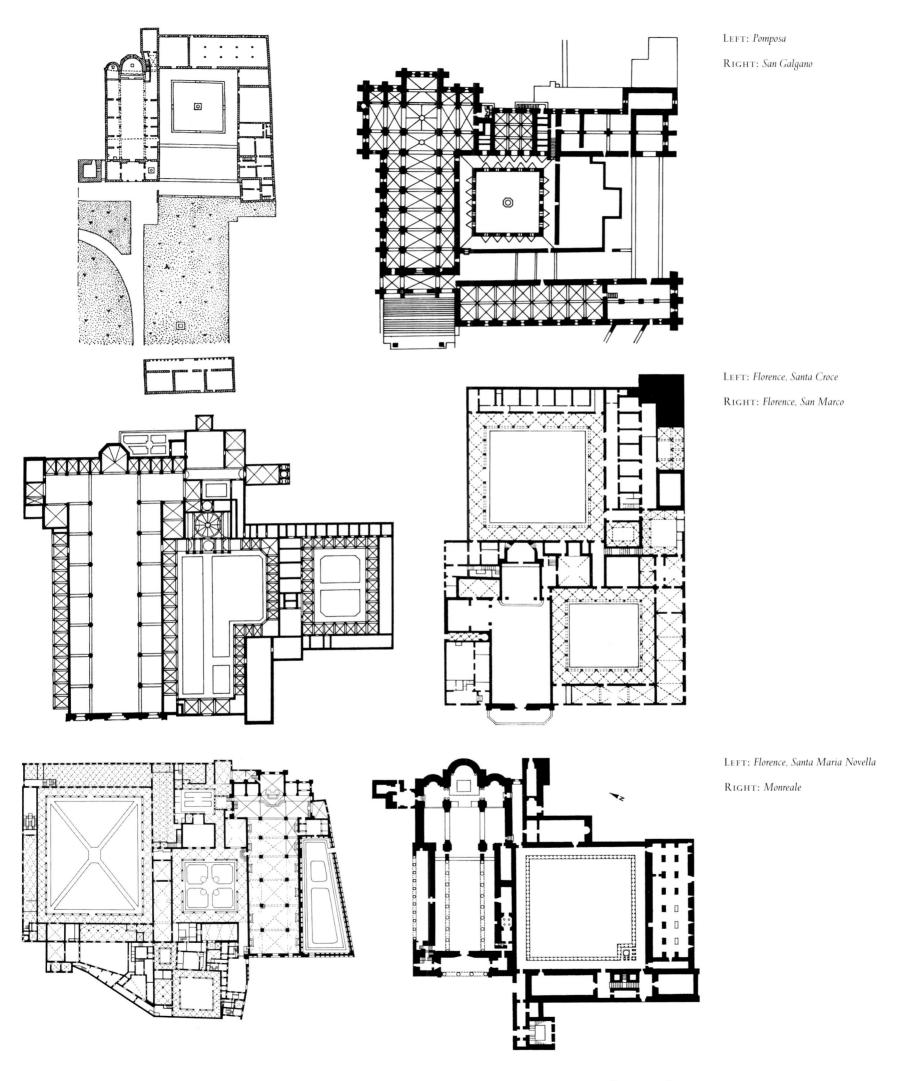

LEFT: *Pomposa*

RIGHT: *San Galgano*

LEFT: *Florence, Santa Croce*

RIGHT: *Florence, San Marco*

LEFT: *Florence, Santa Maria Novella*

RIGHT: *Monreale*

INDEX

ILLUSTRATION CREDITS

In memory of Marco Schneiders, who died unexpectedly in autumn 2003, shortly after completing the photographs for this volume.

Arsenale Editrice (Melo Minnella) 468

Dr. W. Bahnmüller, Geretsried 251, 316 top, 361 top

Bayerische Staatsbibliothek, Munich 12

Louis Berenger, Cerciat-Estadens 116 top, 124, 125, 126

Constantin Beyer, Weimar 278, 279, 280

Bibliothèque Nationale de France, Paris 21, 41, 42, 43, 46 top, 82

JB/arts Dr. Jörg Bodenbender, Eschenlohe 10

Jutta Brüdern, Brunswick 18, 26, 48 bottom, 256 top, 256 bottom, 257, 258 left, 258 right, 259 left, 259 right, 260, 261, 262, 263, 264 top, 264 bottom, 265, 266, 267, 269, 271, 274, 275, 276, 277 top, 282, 283 top, 284 left, 284 right, 286 left, 286 right, 287

Achim Bunz, München 316 bottom, 317

Caisse nationale des monuments nationaux Paris 214

Calw, Stadtarchiv 35

Cameraphoto Arte di Codato, Venice 416, 418, 420, 421, 422, 423, 425 top, 425 bottom, 426, 427

Elia Ciol and Stefano Ciol, Casarsa 428 top, 428 bottom

Editoriale Jaca Book (BAMS Photo Rodella) 404

Europa-Farbbildarchiv Waltraud Klammet, Ohlstadt 66, 74, 92 bottom, 216, 217, 226, 303, 310, 313, 329, 344, 352, 465, 466

Joachim Feist, Pliezhausen 9, 300 top, 305, 311 bottom, 347, 350, 351

Henri Gaud, Moisenay 29, 60, 61, 64 top, 64 bottom, 65 top, 65 bottom, 95 top, 95 bottom, 97 top, 97 bottom, 121, 123 top, 123 bottom, 134 top, 134 bottom, 135, 136, 137, 139, 140 top, 140 bottom, 141, 142 top, 142 bottom, 143 top, 143 bottom, 144, 145, 146, 147, 148 left, 148 right, 149 left, 149 right, 150, 151 top, 151 bottom, 159 left, 159 right, 160, 161, 162 top, 163, 164 top, 164 bottom, 165, 166 top, 166 bottom left, 166 bottom right, 167, 168, 169, 170 top, 170 bottom, 171 top, 171 bottom, 172 top, 172 bottom, 173, 174, 175, 176, 177, 178 top, 178 bottom, 179, 180, 181, 182 top, 182 bottom, 183, 184, 185 top, 185 bottom, 186, 187, 188, 189 top, 189 bottom, 190, 191 top, 191 bottom, 192 top, 192 bottom, 198 top, 202, 203, 204, 205, 206, 207, 208, 209, 210, 211, 233, 240 top, 240 bottom, 244, 245 top, 245 bottom, 246 top, 246 bottom, 247, 248, 249 top, 249 bottom, 300 bottom, 384, 385 top, 385 bottom, 389, 394 top, 394 bottom, 395, 396, 397, 408 top, 408 bottom, 409, 410, 411 left, 411 right, 448 top, 448 bottom, 449, 450, 451, 452, 453

Dominique Genet, Paris 195 left, 195 right, 196, 199

Göttweig, Benediktinerstift, Graphische

Sammlung (Photo: Gregor M. Lechner) 366

Kurt Gramer, Bietigheim-Bissingen 293 top, 301 top, 307, 332, 348, 368, 378 bottom

Grenoble, Musée Dauphinois 46 bottom

Hirmer Fotoarchiv Munich 8, 193,194 top, 201, 290 left, 290 right, 291, 343, 345, 353, 354, 441 bottom, 458

Michael Jeiter, Morschenich 27

Klosterneuburg, Stiftsmuseum 369, 370

Landesmedienzentrum Baden-Württemberg, Stuttgart 299 top, 299 bottom, 304, 306, 314

Miroslaw Lanowiecki, Wrocław 386 right, 387 top, 387 bottom, 388, 391

Fabio Lensini, Siena 445 top and bottom, 447

Ludwigsburg, Staatliche Schlösser und Gärten (M. Grohe) 298

Lunwerg Editores, Madrid (from *Monasterios en Espana,* original Spanish edition by Lunwerg Editores) 93

Joseph Martin, Madrid 5, 58 left, 58 right, 59, 62 top, 62 bottom, 63, 67 top, 67 bottom, 68 left, 68 right, 69, 70, 71 top, 71 bottom, 72, 73, 78 left, 78 right, 79, 83, 84 top, 84 bottom left, 84 bottom right, 85, 86, 88 top, 88 bottom right, 89, 90, 91, 92 top, 94 top, 94 bottom, 96, 98, 99 top, 99 bottom, 100 top, 100 bottom, 102, 103, 104, 107, 109 top, 109 bottom,110 top, 110 bottom, 111, 114, 117, 132 top left, 132 top right, 132 bottom, 198 bottom, 200

G. Paolo Marton, Treviso 417, 419, 443 bottom

Mazin, Rosine, Paris 197

Melk, Benediktinerstift (Photo: Baumgartner, Graz) 362, 364

Florian Monheim, Florian, Meerbusch 48 top, 80, 81, 115, 116 bottom, 118 top, 118 bottom, 119, 127, 128, 129, 130 top, 130 bottom, 131, 133, 154, 155, 156, 158, 213, 215 top, 215 bottom, 220 top, 221, 223, 224, 225 left, 225 right, 227, 228, 229, 230, 231, 232, 234, 235, 236 top, 236 bottom, 237, 238, 239, 241, 242, 243, 288 left, 288 right, 294, 297, 301 bottom, 302 top, 309, 335 top, 382, 383 top, 383 bottom

Bildarchiv Monheim, Meerbusch: Artur/Thomas Riehle 55 top; Artur/Wolfram Janzer 55 bottom; Markus Bassler 108; Achim Bednorz 77, 153, 308, 405; R. von Götz 254, 255 top, 255 bottom; S. Schütze-Rodemann 162 bottom, 212

Moviemaker Productiions (T. Keller), Reichenau Island 324, 325

Wolf-Christian von der Mülbe—Bildarchiv, Dachau 302 bottom, 339, 340, 341, 342

Musée d'Unterlinden, Colmar 13

Oronoz Archivo Fotografico, Madrid 87 top, 87 bottom, 88 bottom left

Pedicini, Archivio dell'Arte, Naples 464

Pubbliaerfoto, Varese 444, 461 bottom

Antonio Quattrone, Florence 6, 432, 433, 435, 436, 437, 440 left, 440 right, 441 top, 442 top and bottom, 443 top, 446, 454 top, 454 middle

Rapuzzi Fotostudio, Brescia 412, 413, 414 top, 414 bottom, 415

Daniele Resini, Venice 424

Réunion des musées nationaux, Paris (Photo: R. G. Ojeda) 2

Ghigo Roli, Modena 398, 399, 400, 401, 402, 406 top, 406 bottom, 407, 429 top, 429 bottom left, 429 bottom right, 430, 431

Arved von der Ropp, Vachendorf 289

Scala Archivio Fotografico, Florence 434, 438, 439, 455 top, 455 bottom left, 455 bottom right, 456, 457, 459, 460 top, 460 bottom, 461 top, 462, 463, 467

Sandro R. Scarioni, Bresso 403 left, 403 right

Eugen Uwe Schmitz, Worms 24 left, 24 right, 25, 292, 293 top, 295, 296 top, 296 bottom, 322 bottom

Ulrike Schneiders, Breitbrunn 138

Marco Schneiders, Lindau 11, 53, 152, 281, 311 top, 312, 315, 330, 331, 333, 336, 337, 346, 349, 356, 357, 358, 359, 360, 361 bottom, 363, 365, 367 top, 367 bottom, 371, 372, 373, 374 top, 374 bottom, 375, 376, 377, 379, 380, 381

Toni Schneiders, Lindau 1, 75, 76, 105, 120, 122, 318, 319, 320 top, 321 top, 321 bottom, 322 top, 323 top, 323 bottom, 326, 327, 328, 355, 378 top

Bernhard Schütz, Munich 250, 386 left, 390

Sigrid Schütze-Rodemann, Halle 101, 106, 268, 270, 272, 273, 277 bottom, 285

Simmons Aerofilms Ltd. 220 bottom

Stiftung Pro Kloster St. Johann in Müstair (Photo: S. Fibbi-Aeppli, Grandson) 334, 335 bottom

Studio Seewald–Hagen, Hanover 283 bottom

Dean and Chapter of Westminster, London 222

Zodiaque Fotothèque, St-Leger Vauban 157

The ground plans were taken from the archives of the author and Hirmer as well as from the following publications:

Matthias Untermann. *Forma Ordinis: Die mittelalterliche Baukunst der Zisterzienser.* Munich and Berlin, 2001.

Günther Binding and Mathias Untermann. *Kleine Kunstgeschichte der Mittelalterlichen Ordensbaukunst in Deutschland.* Darmstadt, 1985. 3d ed., 2001.

L'Art cistercien: France. La nuit des temps 16. La pierre-qui-vire, 1962.

Marianne Bernhard, *Klöster: Hundert Wunderwerke des Abendlandes.* Erlangen, 1994.

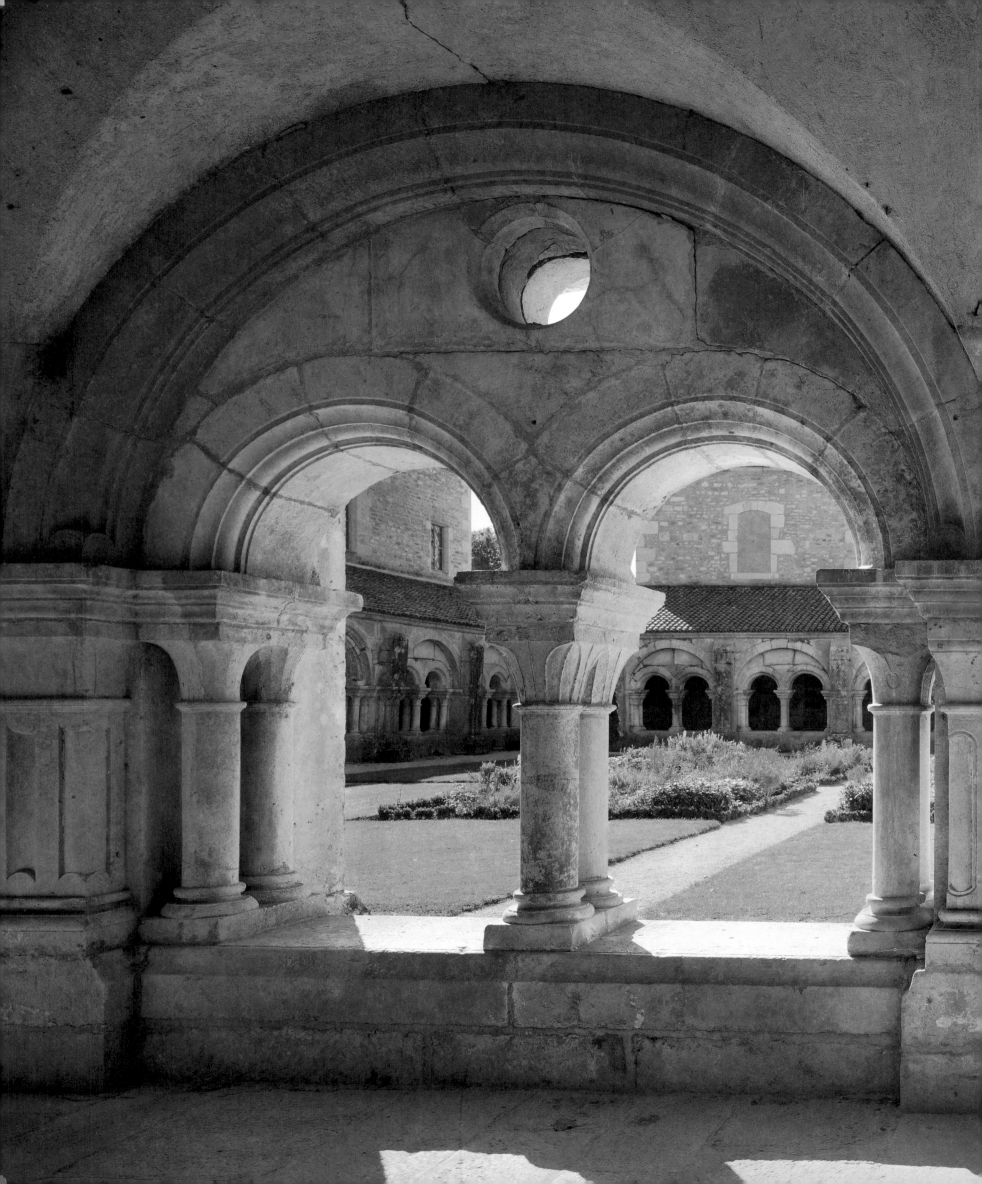